Medieval Academy Reprints for Teaching 2.

W9-AWP-989

Medieval Academy Reprints for Teaching

EDITORIAL BOARD

Jeremy duQ. Adams
Robert L. Benson
Madeline Caviness
Christopher Kleinhenz
Audrey Livernois
David Staines
Prudence Tracy

W. Eugene Kleinbauer

MODERN PERSPECTIVES IN WESTERN ART HISTORY

An Anthology of Twentieth-Century Writings on the Visual Arts

Published by University of Toronto Press
Toronto Buffalo London
in association with the Medieval Academy of America

© Medieval Academy of America 1989
Printed in Canada
ISBN 0-8020-6708-5

First published 1971 by Holt, Rinehart and Winston Inc.
This edition is reprinted by arrangement with W. Eugene Kleinbauer.

Like a bee, I shall gather all that conforms to the truth,
even extracting help from the writings of our enemies. . . .
So, as I would emphasize, I am not offering you my own conclusions,
but those which were laboriously arrived at
by the most eminent teachers, while I have only collected them,
and summarized them, as far as was possible, into one treatise.

John of Damascus, Prologue to *Fons scientiae*

Preface

My purpose in preparing this book has been to introduce students of the humanities to the variety of methods that scholars, mainly of this century, have adopted and developed for conveying what may be called their "perspectives" on the unfolding of the visual arts in the Western world. In large part an anthology, the book offers a group of writings that I have selected, in reflection of a personal point of view, among essays and from books by representative art historians of different nationalities. In all, the writings here reproduced deal with the visual arts from antiquity to the present. Their collection and reorganization in this form derived from the need my students and I felt, in a number of seminars on the historiography of art, for a suitable assemblage of writings, published together in one volume, that could serve as a guide for the discussion and evaluation of our discipline.

A collection that reproduces (with one exception) a single statement by each of the authors it anthologizes threatens to do injustice to the range of interests and scholarship pursued by minds as distinguished as those whose work I have drawn from. Even a volume composed entirely of the essays written by one scholar, such as the anthology that Hariolf Oberer and Egon Verheyen compiled and edited from the early writings of Erwin Panofsky (*Aufsätze zu Grundfragen der Kunstwissenschaft* [Berlin, 1964]), distorts through the very process of selection the fine comprehensiveness of its author's several points of view. On this occasion, however, my aim has been less to pay tribute to individual art historians than to present some of the major attitudes and modes of address that have proved productive in their solution of problems found significant in the practice of art history by 20th-century scholars.

The rationale, while not only excluding additional essays by the writers represented but preventing the inclusion of some examples of the work by many other prominent art historians of our century, does nonetheless make it possible to reproduce in their entirety independent papers and whole sections from book-length statements and to present them complete with their original annotations and illustrations. The search for perspectives required that the authors be permitted to make their presentations in

the full context of method and system—to raise their issues and develop their arguments to the conclusions that have seemed important for the book's objectives.

Among these perspectives is *connoisseurship,* and, although various connoisseurs have demonstrated slightly different techniques within the scope of the method, it seemed feasible to illustrate the approach with one essay. For it I have selected a celebrated paper by Richard Offner on Guido da Siena and have therefore omitted writings by such equally eminent connoisseurs as Wilhelm von Bode, Bernard Berenson, and Max J. Friedlaender. The choice here, as elsewhere in the anthology, was motivated, ultimately, by my own taste and judgment. With regard to *iconography,* a different problem presented itself. In modern iconographical research I find at least three principal preoccupations. Best known is the one exemplified by Erwin Panofsky's "major minor classic" on the "Arnolfini Double Portrait." A second iconographical endeavor concerns itself with an examination of the Classical tradition in Western art, a fundamental problem that has attracted the attention of many European and American scholars. For this I have chosen Kurt Weitzmann's paper entitled "The Survival of Mythological Representations in Early Christian and Byzantine Art and Their Impact on Christian Iconography." A third direction is evident in typological studies that examine changes in the form and meaning of a single motif. To illustrate this trend I have taken the brilliant formulation made by Karl Lehmann in "The Dome of Heaven."

The writers now included in the anthology have expressed themselves in a number of genres and could have been represented by papers elucidating ideas of quite a different sort. For instance, E. H. Gombrich has to his credit a number of important writings that are definitely iconographical in their approach. But from my vantage point he has made a more substantial contribution in his *Art and Illusion: A Study in the Psychology of Pictorial Representation* (New York, 1960). Because that book is so tightly coherent and absolutely unsuited to excerpting for the purpose of anthologizing it, I have selected a closely related paper prepared by the author on another occasion.

Much contemporary art history can trace its roots to the scholarship achieved at the turn of the century, specifically in the accomplishments of Heinrich Wölfflin, Alois Riegl, Aby Warburg, and Adolph Goldschmidt. Of these I have taken sections of books by Wölfflin and Riegl only, while Warburg and Goldschmidt are not represented at all. Scholar and teacher of rare talent, wide learning, and great influence, Goldschmidt made empirical and critically analytical investigations of medieval painting and sculpture that, published in the form of corpora, do not lend themselves to the selective intentions of the anthologist. They must be used complete as originally issued. For Warburg, I was not able to obtain an adequate translation of any of his important work, and, too, the evidence he uncovered and published—truly important findings—has in many instances been superseded by more recent research, making it seem outdated. Once completely translated, Aby Warburg's conception of art history could become better known in its essential modernity and brilliance.

A problem was posed by the unavailability of the published works of several art historians, most notably, Meyer Schapiro. This scholar's writings, appearing in widely scattered publications, have exerted such an impact on the study of Early Christian, medieval, Renaissance, and modern art that omission of his achievement leaves a significant lacuna. To account for Schapiro's contributions, as well as for those of other influential art historians, I have attempted to summarize their perspectives in the last part of my introduction.

Since art history can best be understood from actual applications, rather than from programmatic statements of methodology, it seemed appropriate to exclude articles

that expound method in theoretical terms: barren prescriptions, speculations on the nature of art history, interpretations of the historiography of art, investigations of art theory, and papers by aestheticians, philosophers, and professional art critics. The writings in this anthology, most of which concentrate on either medieval or Renaissance art, illustrate the application of various modern points of view and are offered to give the reader an understanding of the scholar in his workshop. They should provide some insight into how the several routes followed by scholars may lead to quite different perspectives. A sense of the give-and-take among learned men of individual persuasions should illuminate one of the vital aspects of their scholarship, here, modern art history in the West.

It is the degree to which the author's perspectives seemed to be "intrinsic" or "extrinsic," rather than their incidence in the development of modern art history, that informed the arrangement I eventually found comfortable for the contents of the anthology section of the book (Parts II and III). The critical apparatus for each article appears along with the text as the author originally prepared it, but for reasons of economy attendant on specialized books prepared for students, the halftone and line illustrations have been placed at the end of the text, their order following that of the selections. My editing of these pieces has been minimal, and I have made no effort either to revise the factual information and biographical references in the writings or to cite more current interpretations of the problems they treat (though a few are mentioned in the preface). With two exceptions, I have avoided reprinting statements that are available in inexpensive and generally distributed publications, and whenever my knowledge has permitted, I have cited in references the more readily accessible and less costly editions.

The introduction, which comprises Part I, is divided into three sections. The subject of the first section is the nature of art history as a humanistic discipline, that of section two certain determinants of art historical investigations, and of section three some of the more important genres subdividing modern scholarship. This final section is a historiographical sketch, presented largely in the form of a bibliographical essay in which the reader is directed to supplementary writings.

In the process of assembling the materials for the book's content I incurred many debts of gratitude that I wish to acknowledge to my students and academic associates at the University of California at Los Angeles. To my good friend and colleague Stephen S. Kayser I owe more than I can account for. He undertook the courageous and titanic task of attempting to translate into readable English the lone passage excerpted from Alois Riegl's book on the Dutch group portrait. In addition, Dr. Kayser was kind enough to read with great care a draft of my introductory essay and to offer gentle but firm and discriminating counsel. To Marcel Röthlisberger I want to express my appreciation for his translation, commissioned for this book, of the selection by Henri Focillon. Donald Drew Egbert, of Princeton University, gave me his encouragement during the initial preparations for the project and stimulated me to achieve greater substance in my own thinking about the ways and means of art history. Through the good offices of Holt, Rinehart and Winston, George Kubler, of Yale University, James D. Breckenridge, chairman of the Department of Art History at Northwestern, and Rensselaer W. Lee, of Princeton, offered me the benefit of their searching criticism. To all, I extend my sincere thanks.

Los Angeles W. Eugene Kleinbauer
February, 1971

Contents

Preface vii

part one INTRODUCTION 1

WHAT IS ART HISTORY? 1
DETERMINANTS OF ART HISTORICAL INVESTIGATION 13
GENRES OF MODERN SCHOLARSHIP 37

part two INTRINSIC PERSPECTIVES 107

CONNOISSEURSHIP

1 **Guido da Siena and A.D. 1221** 107
 RICHARD OFFNER

SYNTACTICAL ANALYSIS

2 **Geertgen tot Sint Jans' 'The Legend of the Relics
 of St. John the Baptist'** 124
 ALOIS RIEGL

FORMAL CHANGE

3 **Métamorphoses** 139
 HENRI FOCILLON

PERIOD DISTINCTIONS

4 **Principles of Art History** 154
 HEINRICH WÖLFFLIN

xi

DOCUMENTARY STUDIES IN ARCHITECTURAL HISTORY

5 S. Maria della Salute: Scenographic Architecture
 and the Venetian Baroque 165
 RUDOLF WITTKOWER

ICONOGRAPHY AND ICONOLOGY

6 Jan van Eyck's 'Arnolfini' Portrait 193
 ERWIN PANOFSKY

7 The Survival of Mythological Representations
 in Early Christian and Byzantine Art
 and Their Impact on Christian Iconography 204
 KURT WEITZMANN

8 The Dome of Heaven 227
 KARL LEHMANN

part three EXTRINSIC PERSPECTIVES 271
ART HISTORY AND PSYCHOLOGY

Psychology of Perception and Artistic Tradition

9 Light, Form, and Texture in Fifteenth-century Painting 271
 E. H. GOMBRICH

Psychoanalysis
10 A Psychotic Artist of the Middle Ages 285
 ERNST KRIS

ART HISTORY, SOCIETY, AND CULTURE

Context of Artistic Patronage
11 Art and Freedom in Quattrocento Florence 293
 FREDERICK HARTT

Theological Context
12 Religious Expression in American Architecture 312
 DONALD DREW EGBERT

Marxist Context
13 Reflections on Classicism and Romanticism 339
 FREDERICK ANTAL

Cultural Context
14 The Carolingian Revival of Early Christian
 Architecture 349
 RICHARD KRAUTHEIMER

ART HISTORY AND THE HISTORY OF IDEAS

Intellectual History (Geistesgeschichte)
15 **The New Relationship to Nature** 397
 MAX DVORÁK

Concepts of Periodicity
16 **Renaissance and Renascences** 413
 ERWIN PANOFSKY

Unit Ideas
17 **Ad Imaginem Dei: The Image of Man
 in Mediaeval Art** 432
 GERHART B. LADNER

Key to Sources of Illustrations 463

Plates **465**

Modern
Perspectives
in Western
Art History

PART I
INTRODUCTION

WHAT IS ART HISTORY?

It is far easier to pose than to answer the questions, "What is art history?" "What is not art history?" "What is the nature of art historical inquiry?"

First it is necessary to set apart *art* from *art history*. Art has been defined as a creative act, activity, or product of a human being:

> In diligence, a bee can be thy teacher.
> Dexterity? A worm may be more prone.
> In wisdom higher beings will be richer
> But art, oh man, hast thou alone.
>
> Friedrich Schiller, Die Gedichte

Art history, on the other hand, is an intellectual or scholarly investigation of specific works of art; it is a branch of knowledge or learning. The existence of concrete works of art does not imply the existence of a history of art. In fact, art history came into being only about four hundred years ago, while art itself was born many millennia before that. The converse is not true, of course, although upon occasion the scholar may deal with lost or destroyed works.

Art historians study both works of art and the historical evidence pertaining to them. Specifically they investigate the visual, that is, spatial, arts—architecture (a cathedral, piazza, or timber barn), sculpture (a marble statue, ivory carving, or chrome chair), and painting (oil on canvas, mosaic, icon, or lithograph). A work of art can be defined as a man-made object of aesthetic significance, with a vitality and reality of its own. Regardless of the medium of expression, a work of art is a unique, homogeneous, complex, irreplaceable, nonreproducible, in some ways even mysterious, individual whole.[1] These salient characteristics distinguish a building, sculpture, or painting from the other arts.

If a master copies one of his own works, he makes a new creation, another unique object existing in space. A photographer cannot adequately reproduce a work of art because of its three-dimensional nature and specific materials; buildings and sculpture are especially difficult to photograph, although even reproductions of paintings and the graphic arts suffer from the technical limitations of the camera. Moreover, the photographer may be tempted to try to transcend mere recording and create a new work of art by adopting a certain viewpoint, arranging the lighting, or developing the negative with certain values of texture, tone, and color. Hence the spatial arts differ from the other arts—literature, music, the cinema, the theater, and the dance. Literature and music can be preserved by translation into handwritten or published form or by memory, the cinema by prints of the original film. The theater and the dance pose different problems.

[1] For the question of the finished and the unfinished work of art, which is so significant for the study not only of Gothic cathedrals and some works in the *oeuvre* of Leonardo da Vinci and Michelangelo but also of contemporary art, see the papers by Joseph Gantner and Friedrich Gerke in Saarbrücken, Universität des Saarlandes, Philosophische Fakultät, *Das Unvollendete als künstlerische Form; ein Symposion* (Bern, 1959), and Panayotis A. Michelis, "Problems of the Finished and the Unfinished in Art," *Filosofia* XII (1961): 641–52.

On the one hand, a play or choreography can be preserved by written form or by memory; but on the other, each performance by an actor or dancer can be characterized as an individual work of art. However, these performances are man-made actions, not objects of permanent physical reality as are the spatial arts.

Art historians aspire to analyze and to interpret the visual arts by indentifying their materials and techniques, makers, time and place of creation, and meaning or function—in short, their place in the scheme of history. They concern themselves with unique historical phenomena, with aspects of human history. It is incumbent upon them to discover the historical niche that a work of art occupies and to assess that work in the light of its unique position. They therefore seek to identify its materials, technique, creator, school, period, and culture, as well as to relate it in a meaningful way to other works of art of the same school, period, and culture. At the same time they must remain sensitive to its essential aesthetic individuality.

The tasks confronting the art historian are as difficult as they are pleasurable, for he is dealing with art as a historical document that demands interpretation and evaluation. He performs his task through verbal discourse or historical writing, of which a multiplicity of genres flourishes in our day. This great variety of approaches constitutes the essence of modern art history.

Works of art interest laymen as well as art historians, and in all historical disciplines they serve as documents and illustrations of persons, events, and ideas. But for the history of art and a few related fields of learning they are objects worthy of investigation in and for themselves. These related fields include antiquarianism, aesthetics, art theory, and art criticism. The first deals with works of art and other man-made objects. Using an approach of the Aristotelian scientist, the antiquarian proceeds by the inductive methods of observation, description, and classification. Much in the way a geologist classifies different specimens of rock, he reports his results accurately and objectively, aiming for an orderly and consistent codification of the heritage of man's past. He is concerned with neither attribution to individual personalities, which in art history is the task of the connoisseur, nor identification and interpretation of subject matter or function, the task of the iconographer. He is a compiler, unconcerned with values or judgments. His findings often appear in journals of archaeology, anthropology, and ethnography. The art historian also deals with classification, not as an end in itself, but as a first step in establishing order among individual works of art.

The disciplines of aesthetics and art history are humanistic endeavors of learning that differ primarily in their emphasis. The term "aesthetic" was coined by the German philosopher Alexander Baumgarten (1714–62) in his *Meditationes* of 1735 (not in his *Aesthetica* of 1750, as is commonly believed). Aesthetics is that branch of philosophy that deals with problems of value arising out of the existence of works of art as physical entities; it is concerned with the processes and abilities involved in the creation, use, and enjoyment of art, and with the response of the beholder to the qualities inherent in works of art. To a large extent, it deals with recurrent patterns and the validity of standards of evaluation. The aesthetician seeks to establish categories of thought and systematic definitions in order to express particular points of view about the arts. He is interested in the various complex interrelationships of all the arts—music, literature, cinema, theater, and the dance, as well as the visual arts. The art historian is also interested in these interrelationships, but only insofar as they illuminate meaningful historical aspects of specific works. While the aesthetician arranges and

classifies his material and hypotheses according to the theories they illuminate, the art historian always deals with his material historically, usually setting it up chronologically, but occasionally ideologically. The aesthetician tries to learn the nature of art, to evolve a (nonhistorical) theory of art, to define such terms as "beauty," "aesthetic value," "truth," and "significance." The modern art historian avoids all such metaphysical speculation. In much of the Western world, and especially in the United States, art history today is nonphilosophical.

A very influential figure in 20th-century aesthetics has been the Italian philosopher Benedetto Croce (1866–1952), author of *Estetica come scienza dell'espressione e linguistica generale* (Milan, 1902 [*Aesthetic as Science of Expression and General Linguistic,* trans. Douglas Ainslie, 2d ed., New York, 1922; Noonday paperback]). Proceeding from an idealistic metaphysics, Croce has vigorously maintained the unity of the work of art: form and content are inseparable. Every work of art is a unique intuition-expression: "The total effect of the work of art is an intuition" (*ibid.,* p. 3). He defines intuition as "knowledge, free from concepts and more simple than the so-called perception of the real" (*ibid.,* p. 17). At the same time, the work of art is an expression of a state of emotion. Since every state of emotion is unique and original, every work of art is also unique and original. For Croce, art is not a physical unity but purely a matter of the mind; it is a completely internal event: "What is called *external* is no longer a work of art" (*ibid.,* p. 51). In his epistemological system the arts cannot be classified or even distinguished, because every work of art is a unique intuition-expression; there is no history of art, only a history of individual works and masters. Masaccio and Donatello cannot be explained by the Quattrocento; rather, the Quattrocento is explained by them. Masaccio, his work, and the beholder are identified; art criticism can only aspire to remove the obstacles to this identification and to evaluate the work as art or nonart. Croce rejects as external and irrelevant to the arts considerations of materials and technique, iconography, biography, social and cultural history, and the history of ideas. Thus his system is a radical monism that approaches in character a French Impressionist painting.[2] It has attracted a considerable audience.

Crocean doctrines have exerted an impact not only on art history but also on other disciplines dealing with the arts. They were continued by Lionello Venturi (1885–1961) (*History of Art Criticism,* trans. Charles Marriott [New York, 1936; Dutton Paperback])[3] and Roberto Longhi (born 1890), the two leading Italian art critics and historians for the past sixty years. Venturi's *History of Art Criticism* is probably the best known and most influential book in the English-speaking world that owes the substance of its critical thought to Croce's theory of aesthetics. In it he attempts to subsume art history and aesthetics under the general heading of art criticism. In German-speaking countries the major Crocean spokesman was Julius von Schlosser (1886–1938), and in England, R. G. Collingwood (1889–1943) (*The Principles of Art* [Oxford, 1938]).[4] In American scholarship of the history of art, Crocean ideas have had little noticeable impact, but in art criticism they have found a place in the work of Theodore Greene (*The Arts and the Art of Criticism* [Princeton, 1940]). In Renaissance literature they are evident in the writing of Joel E. Spingarn (*The New Criticism* [New York, 1911]).

[2] See Gian N. G. Orsini, *Benedetto Croce: Philosopher of Art and Literary Critic* (Carbondale, Ill., 1961).

[3] See also his paper "Gli studi di storia dell'arte medioevale e moderna," in his *Saggi di Critica* (Rome, 1956), pp. 277–306.

[4] See Merle Elliott Brown, *Neo-idealistic Aesthetics: Croce-Gentile-Collingwood* (Detroit, 1966).

Quite different from aesthetics or the philosophy of art is art theory, a discipline that is closely related to art history. From the viewpoint of the historian works of art must be experienced in the way their creators saw them. For the historian to try to discover and share this experience requires both aesthetic sensibility and an understanding of the attitudes and conditions that prevailed at the time the work of art was produced. The creative process is conditioned by a number of factors, among which may be the theories of the imitation of nature, expression, and decorum; that is, not only the suitable representation of typical aspects of human life but also what is decent and proper in taste, morality, and religion. It is necessary to understand these theories if one is to interpret the arts in a way that would have been intelligible to their creators and societies. However, the art theorist is preoccupied with this problem. His raw material is not the work of art itself but the theories that shaped and influenced it. To the art historian art theory is merely one important province that demands investigation and analysis. It equips him with some of the technical terminology he requires to explicate his points of view (for example, such terms as chiaroscuro, sfumato, eclecticism). Art history leads into art theory as much as art theory leads into art history. As Erwin Panofsky has aptly remarked, art theory "is to art history as poetics and rhetoric are to the history of literature" (*Meaning in the Visual Arts* [Doubleday Anchor Book: Garden City, N.Y., 1955], p. 20).

Distinguished examples of this genre of writing by art historians include two studies by Erwin Panofsky: *"Idea"; ein Beitrag zur Begriffsgeschichte der älteren Kunsttheorie* (Leipzig, 1924 [*Idea; a Concept in Art Theory*, trans. Joseph J. Peake, Columbia, S.C., 1968]), and *The Codex Huygens and Leonardo da Vinci's Art Theory* (London, 1940); Meyer Schapiro, "On the Aesthetic Attitude in Romanesque Art," in *Art and Thought*, ed. Iyer K. Bharatha (London,

1947), pp. 130–50; André Grabar, *L'Iconoclasme byzantin: Dossier archéologique* (Paris, 1957); Rensselaer W. Lee, "Ut Pictura Poesis: The Humanistic Theory of Painting," *Art Bulletin* XXII (1940), pp. 197–269 (Norton paperback); Anthony Blunt, *Artistic Theory in Italy, 1450–1600* (Oxford, 1940; Oxford paperback); Denis Mahon, *Studies in Seicento Art and Theory* (London, Warburg Institute, 1947); Wolfgang Hermann, *Laugier and Eighteenth-Century French Theory* (London, 1962); Rudolf Wittkower, "Imitation, Eclecticism, and Genius," in *Aspects of the Eighteenth Century*, ed. Earl R. Wasserman (Baltimore, 1965), pp. 143–61; George P. Mras, *Eugene Delacroix's Theory of Art* (Princeton, 1966); H. R. Rookmaaker, *Synthetist Art Theories* (Amsterdam, 1959); Mark W. Roskill, *Dolce's "Aretino" and Venetian Art Theory of the Cinquecento* (New York, 1968); and the remarkable collection of statements and writings by modern artists in Herschel B. Chipp, *Theories of Modern Art: A Source Book by Artists and Critics*, with contributions by Peter Selz and Joshua C. Taylor (Berkeley, 1968; University of California paperback). By far the most fundamental inquiry into art theory and literature, and indeed an indispensable bibliographical reference work and one of the monumental achievements of modern scholarship, is Julius von Schlosser's *Die Kunstliteratur* (Vienna, 1924; translated and revised in several Italian editions between 1935 and 1964). This book embraces the history of all writings on art, from Classical antiquity to about 1800, and exemplifies one of the chief concerns of the Viennese school of art history from the mid-19th century until World War II.

Another discipline that is closely linked to art history is criticism. Like aesthetics, criticism is a humanistic endeavor that deals with all the arts. The proper domain of any one critic is the description, interpretation, and evaluation of concrete works of art in a given medium of expression. Art criticism can be described as a

many-leveled activity. It comprises three basic aspects: the historical, the re-creative, and the judicial.[5]

One aspect of criticism aims at a historical understanding of works of art. The function of the historical critic is to reconstruct the unique aesthetic qualities of a work or group of works and to analyze all relevant documentary, social, cultural, and intellectual factors that may yield a fuller understanding of the work. He arranges his evidence chronologically or ideologically in order to formulate a conception of the original context of the work or works in question. He is, in other words, relating the work or works to the historical conditions of time and space; his perspective is always historically framed.

Historical criticism is the most objective aspect of art criticism and also the one that parallels and overlaps the aspirations and objectives of art history. Like the historical art critic, the art historian is called upon to determine which factors and problems are relevant to his area of inquiry. This task requires him to function as a critic, and every sound art historian aspires to fill this role. If he fails, he is a mere documentary historian of a lower order.

The other two aspects of criticism—the re-creative and the judicial—have traditionally stood beyond the domain of art history. Re-creative art criticism is concerned with determining the unique qualities of a master's work and relating these qualities to the values and needs of the beholder. It dispenses with historical evidence and takes the form of a literary expression that is itself frequently of high artistic merit, with an identity quite separate and different from that of its point of departure. The art historian is also confronted with the task of reconstructing the unique qualities of works of art and dis-

closing his findings to others. The difference between his discourse and that of the re-creative art critic is one of degree rather than kind: it lies in the objective relevance of that discourse to the work of art. The art historian's response is framed within an illuminating, historical matrix and is generally less re-creative than the response of the critic. Both the historian and the critic may be perceptive, sensitive observers, but the discourse of the former can be more readily checked empirically, since it is rooted in artistic fact; because it is less subjective, it is more universal in meaning. Re-creative criticism conveys primarily the critic's personal impression of the work of art, and it may therefore be more meaningful to him than to others. It tends to use precise words in vague and subjective contexts and to omit what the art historian would deem essential, while expanding material that he would deem unnecessary for attaining an enlightening historical viewpoint of the particular art in question.

A classic example of re-creative criticism is the work of the 19th-century English man of letters Walter Pater (1839–94). His *Studies in the History of the Renaissance* (London, 1873; Mentor Book) contains labored, yet imaginative and eloquent discussions of both art and literature. (His evocative description of Leonardo da Vinci's *Mona Lisa*—"she is older than the rocks among which she sits; like the vampire, she has been dead many times, and learned the secrets of the grave . . ."—is a tour de force that is not representative of his method.) Pater acknowledged that he wanted "to see the object as in itself it really is," and by metaphorical means he transforms one medium of expression—a picture, for example—into the different medium of a prose poem.[6]

[5] I adopt a common terminology, which is found, for example, in the useful book by Theodore M. Greene, *The Arts and the Art of Criticism* (Princeton, 1940), pp. 369–73.

[6] See René Wellek, "Walter Pater's Literary Theory and Criticism," *Victorian Studies I* (1957), pp. 29–46.

Metaphorical method has continued to this day in art criticism. The French Existentialist novelist and critic André Malraux (*Les Voix du Silence* [Paris, 1952; *The Voices of Silence*, trans. Stuart Gilbert, Garden City, N.Y., 1953]) tends toward a philosophy of pure sensation in his essentially unhistorical investigation of the visual arts ("it is not passion but the wish to prove something that destroys a work of art").[7] Re-creative criticism characterizes the work of other modern French writers (for example, Georges Duthuit, *Les Fauves* [Geneva, *The Fauvist Painters*, trans. Ralph Manheim, New York, 1950]), and also, in my estimation, some portions of the provocative monograph on ancient Greek architecture by the American architectural historian Vincent Scully (*The Earth, the Temple, and the Gods: Greek Sacred Architecture* [New Haven, 1962; Praeger paperback]).

Although art history is fundamentally different from re-creative art criticism, this does not mean that art historians neglect language, nor that their writing is wholly inartistic. They are obliged to communicate with others and must translate into words the aesthetic qualities of works of art, as well as their interpretations of those works. This requires the artistic skills of composition and style: art historians must be writers as well as scholars, and each part of their twofold task is as demanding as the other. Students of the visual arts nonetheless disagree about the literary capacity required to translate images into words. Roberto Longhi believes that art historical writing is truly a creative act, and indeed, he is a master of literary eloquence; his prose is so well orchestrated and subtle that his scholarship is sometimes classified as literature (*Piero della Francesca* [Rome, 1927; trans. Leonard Penlock with same title, London and New York, 1930]; *Il Caravaggio* [Milan, 1952]). Most Western art historians would perhaps maintain that their discipline is not an art but that it has aspects of one. Their writings are sometimes distinguished by their extraordinarily high literary value as well as their scholarship, for instance, the work of the American Rensselaer W. Lee ("*Ut Pictura Poesis*: The Humanistic Theory of Painting," *Art Bulletin* XXII [1940], pp. 197–269) and that of the German Wilhelm Fraenger (*Hieronymus Bosch: Das Tausendjährige Reich, Grundzüge einer Auslegung* [Coburg, 1947]; *The Millennium of Hieronymus Bosch*, trans. Eithne Wilkins and Ernst Kaiser [Chicago, 1951]; and a book on Bosch's painting of the Marriage at Cana, *Die Hochzeit zu Kana, ein Dokument semitischer Gnosis bei Hieronymus Bosch* [Berlin, 1950]).[8]

The third aspect of criticism can be called judicial. It evaluates the work of art in relation to other works of art as well as human values. Estimating the worth of art explicitly requires the application of a set of general standards. This task may, but need not, be undertaken after the critic is informed both about the factors that have lent shape to a work of art and about its major characteristics, such as materials and technique, form, function, and expression. The judicial critic applies to the work a set of standards, or canon, and delivers an evaluation. His standards may include formal excellence, originality or

[7] For an appraisal of the writings of Malraux, see William Righter, *The Rhetorical Hero: An Essay on the Aesthetics of André Malraux* (London, 1964); Harold Rosenberg, "Malraux and his Critics," *Art News Annual* XXXI (1966), pp. 133–7, 147–52; and Paul West, "A Narrowed Humanism: Pater and Malraux," *Dalhousie Review* XXXVII (1957), pp. 278–84.

[8] "Among the living men in Germany the one whose performance, in interpreting by language visual experiences, stands out, is perhaps—alongside Heinrich Wölfflin—Wilhelm Fraenger" (Max J. Friedlaender, *On Art and Connoisseurship*, trans. Tancred Borenius [London, 1942], p. 275).

adherence to tradition, truth or morality, and artistic significance. Ideally, these should be appropriate or relevant, for it is futile to demand of a work of art something it cannot do. Thus the standards are ideals, and the judicial aspect of criticism is the explicit evaluation of a work of art by reference to a selected set of relevant value possibilities or ideals.[9] The judicial critic can also be concerned with historical and re-creative criticism, but in practice he tends to confine his work to evaluation.

Some judicial critics attempt to establish the value of a work by reference to the normative criterion of formal artistic excellence: they judge or justify the visual arts by their artistic forms alone. In his book entitled *Art* (New York, 1913; Capricorn Book), the English critic Clive Bell (born 1881) originated the concept of "significant form" to describe the colors, lines, and shapes of the visual arts. The concept implied not that a work of art "signifies" something, but that it is significant in itself, for it possesses an artistic quality whose value is intrinsic. In spite of his omission of a clear definition of significant form, or perhaps because of it, his idea has been pursued by many critics, including Albert Barnes and John Dewey.

The concept was halfheartedly adopted by Roger Fry (1866–1934), the most influential art critic in England during the first third of this century and the first to "discover" the French Postimpressionist painters. In his best work, *Cézanne: A Study of His Development* (London, 1927; [Noonday paperback]), Fry evaluated the visual arts with almost exclusive reference to technique and to the plastic values of their compositions.[10] His criticism focused on the logic, coherence, and harmony of the "pure forms" in the visual arts; in other words, his own values were rooted in the classical ideals of Italian Renaissance art. In his attempt to establish the aesthetic integrity of the arts—in a basically flexible, rather than a systematic approach—Fry emphasized formal qualities and ignored (as did Bell) subject matter and the associations aroused by it: "I conceived early the form of the work of art to be its most essential quality . . ."[11] Yet his purely formal analysis of the art of Cézanne—the first such approach to the *oeuvre* of this great master—was indebted far less to Bell's theories than to the work of the great Swiss scholar Heinrich Wölfflin (1864–1945), whose *Die klassische Kunst: eine Einführung in die italienische Renaissance* (Munich, 1899, [*Classic Art: An Introduction to the Italian Renaissance,* trans. Peter and Linda Murray, New York, 1952]) and *Kunstgeschichtliche Grundbegriffe* (Munich, 1915 [*Principles of Art History,* trans. M. D. Hottinger, London, 1932]) Fry introduced to the Anglo-American world in critical book reviews. Indeed, the influence of Wölfflin has been extensive. His writings have contributed immensely to establishing the terminology of 20th-century art criticism and history. In his earlier and finest book, *Classic Art,* he writes about the painting and sculpture

[9] Cf. Greene, *The Arts and the Art of Criticism* (Princeton, 1940).

[10] One important theoretical source of Fry's views of the purely plastic qualities of the arts was the book by the American artist Denman Ross, *A Theory of Pure Design* (Boston, 1907). Though accepted as a British tradition, formalist art criticism (as distinguished from Wölfflin's formalist art history) has also been an American tradition, for which see Barbara Rose, "Introduction," in *Readings in American Art since 1900,* ed. Barbara Rose (New York, 1968). See also Berel Lang, "Significance or Form: The Dilemma of Roger Fry's Aesthetic," *Journal of Aesthetics and Art Criticism* XXI (1962), pp. 167–76.

[11] Roger Fry, *Vision and Design* (London, 1920), p. 194. For a brilliant essay by Fry, see "Seurat's La Parade," in *Burlington Magazine* LV (1929), pp. 289–93 (reprinted in his book *Seurat* [London, 1965], pp. 83–84).

of the Italian High Renaissance in acutely perceptive terms; he interprets this art formally and is largely unconcerned with the significance of subject matter or other determinants of the creative process.[12]

Pure formalist criticism continues to play a role in the interpretation of modern art. This approach characterizes the writings of such contemporary critics as Clement Greenberg (*Art and Culture: Critical Essays* [Boston, 1961; Beacon paperback]) and Michael Fried (introduction to *Three American Painters: Kenneth Noland; Jules Olitski; Frank Stella,* Harvard University, William Hayes Fogg Art Museum [Cambridge, Mass., 1965]), both of whom interpret 20th-century art in terms of artists grappling with particular formal problems. Most critics today, however, contend that modern art possesses other qualities in addition to the eloquence of form, and that it must be dealt with in the light of developments in society—a point of view held by some critics since the early 1930s, when Marxist doctrines became widespread.[13]

Judicial critics sometimes attempt to interpret and evaluate paintings, sculpture, and architecture as though they were analogous to the other arts. They may even emphasize actual parallelisms in the arts. This approach has a certain validity and is heuristically valuable if it helps the beholder to perceive and enjoy various levels of excellence. For example, Charles Selt-man (born 1886) compares ancient sculpture and painting to literature in his stimulating *Approach to Greek Art* (London, 1948). He conceives of art figuratively as poetry or prose, closely allied to these literary forms:

Art prose implies the imitation of the ordinary or natural form of *seen objects*, without metrical structure. Art poetry implies the use of a metrical, that is, patterned arrangement of *objects*, and art poetry employs forms and figurative uses differing from those of ordinary or natural *phenomena*. Prose art is descriptive and analytic; poetic art, organic and concrete. [p. 26]

Further, the visual arts can be either good or bad poetry or prose: "thus the Aphrodite of Melos is competent prose, the Medici Venus a piece of rhetoric, Canova's Venus in Florence, journalese. Or . . . to take the work of a single artist, Epstein's Night is poetry, his Genesis versification, his Day a jingling medley." [*ibid.*]

Like many other critics and art historians, especially those of German nationality, Seltman proposes an elementary yet fundamental link between media that is challenging but difficult to accept. One wonders whether a real analogy can be drawn between the sculptures of the Parthenon and the histories of Thucydides, between 4th-century art and rhetoric, between portraiture and biography, or

[12] Wölfflin acknowledges his indebtedness to the views of his friend the German sculptor Adolf von Hildebrand, who wrote *Das Problem der Form in der bildenden Kunst* (Strassburg, 1893 [*The Problem of Form in Painting and Sculpture,* trans. Max Meyer and Robert Morris Ogden, New York, 1907]). Hildebrand himself had been influenced by the work of the important art theorist Konrad Fiedler (*Über die Beurteilung von Werken der bildenden Kunst* [Leipzig, 1876; [*On Judging Works of Visual Art,* trans. 2d rev. ed., Henry Schaefer-Simmern and Fulmer Mood, Berkeley, 1957]). For Fiedler's writings, see *Konrad Fiedlers Schriften über Kunst,* 2 vols., ed. Hermann Konnerth (Munich, 1913/14). For a characterization of the framework within which Fiedler's arguments were conducted, see Michael Podro, "The Parallel of Linguistic and Visual Formulation in the Writing of Konrad Fiedler," *Filosofia* XII (1961), pp. 628–40. For the interrelationship of the aesthetic theories of Hildebrand, Fiedler, and others, consult Ernest K. Mundt, "Three Aspects of German Aesthetic Theory," *Journal of Aesthetics and Art Criticism* XVII (1959), pp. 287–310.

[13] An important early American reaction against the purely formalist criticism of modern art was Meyer Schapiro's penetrating criticism of Alfred Barr's *Cubism and Abstract Art* (New York, 1936), published as "Nature of Abstract Art," *Marxist Quarterly* I (1937), pp. 77–98.

between prose and representational art. Poetry and prose lack precision as categories, and the boundary between them is likely to be even less sharp in art than in literature. Seltman's observation that a rigid duality of temperament underlies all art is useful in pointing up different types of creative activity; but it seems unnecessarily limiting to acknowledge only *two* categories, particularly when we are faced with the extraordinarily varied accomplishment of artists like Pablo Picasso. While Praxiteles was no Picasso, and ancient Greek art clearly differs in character from modern art, it seems clear that even in ancient art we should look for a multiplicity of modes in creative activity rather than a simple dichotomy.[14]

A second type of judicial criticism evaluates the visual arts in relation to such values as truth, sincerity, and honesty. A foremost exponent of this mode of appraisal was the great English critic and advocate of British socialism John Ruskin (1819–1900). As do all moral critics, Ruskin looks at art in its social milieu. In his *Seven Lamps of Architecture* (New York, 1849) and *The Stones of Venice* (New York and London, 1851–53), Ruskin contends that great buildings are the expressions of their architects; they have a moral quality and exert a strong influence upon the society in which they appear. He asserts that "every form of noble architecture is in some sort the embodiment of the Polity, Life, History, and religious faith of

nations. . . . Architecture is the art which so disposes and adorns the edifices raised by man, for whatsoever uses, that the sight of them may contribute to his mental health, power, and pleasure." In his view, only pictures that engage the total human personality or intellect are marked by truth:

Truth has reference to statements both of the qualities of material things, and of emotions, impressions, and thoughts. There is a moral as well as material truth—a truth of impression as well as of forms—of thought as well as of matter; and the truth of impression and thought is a thousand times the more important of the two. [*Modern Painters*, vol. I, London, 1843, p. 104]

Ruskin's writings plead passionately for the social responsibility of art, which he finds moral in cause and effect. For him, good art is basically moral, and art is bad when it is immoral and insincere.[15]

One of Ruskin's severest critics was the noted Boswell and Johnson scholar Geoffrey Scott (1885–1929). In his masterly and widely known essay *The Architecture of Humanism* (Boston, 1914; Doubleday Anchor Book and Scribner paperback), Scott decries Ruskin's condemnation of Renaissance architecture and pleads systematically for a meaningful relationship between architecture and human values. Adapting Theodor Lipps' theory of empathy *(Einfühlung),* as had the German critic and art historian Wilhelm Worringer, he

[14] Kurt Badt's attempt to emulate literary criticism in his interpretation of one of Jan Vermeer's paintings is too rigid an analysis (*Modell und Maler von Jan Vermeer* [Cologne, 1961]).

[15] See his judgment of Theodore Géricault's painting *The Raft of the Medusa*, which he regarded as a typical example of what he termed "modern sensational drama": "I think it is the strangest form of curse and corruption which attends humanity, but it is a quite inevitable one, that whenever there is a ruthless pursuit of sensational pleasure it always ends in an insane and wolf-like gloating over the garbage of Death" (from a lecture Ruskin delivered in 1867 entitled "On the Present State of Modern Art"; quoted from *The Works of John Ruskin*, 39 vols., ed. E. T. Cook and A. Wedderburn [London, 1903–27], XIX: 212). In general, see Robert L. Herbert, ed., *The Art Criticism of John Ruskin* (New York, 1964; Doubleday Anchor Book). For Ruskin's impact on American criticism, consult Roger B. Stein, *John Ruskin and Aesthetic Thought in America, 1840–1900* (Cambridge, Mass., 1967).

maintains that "the arts must be justified by the way they make men feel."[16] After defining humanism as "the effort of men to think, to feel, and to act for themselves, and to abide by the logic of results" (*ibid.*, p. 144), he arrives at two complementary principles: "We have transcribed ourselves into terms of architecture" and *"we transcribe architecture into terms of ourselves"* (*ibid.*, p. 159). For Scott,

. . . this is the humanism of architecture. The tendency to project the image of our functions into concrete forms is the basis, for architecture, of creative design. The tendency to recognise, in concrete forms, the image of those functions is the true basis, in its turn, of critical appreciation. [*Ibid.*]

He points up a number of fallacies in modern architectural theory—for instance, he criticizes Louis Sullivan's widely accepted suggestion that form follows function—and presents as an alternative an impeccable defense of a return to the Classical tradition in Western architecture. This is his purpose in writing *The Architecture of Humanism.*

A third category of judicial criticism is concerned with the determination of artistic significance and greatness. By appealing to normative criteria, the critic attempts to distinguish the trivial or mediocre work from the significant or great one. The significant work of art is largely conditioned by its signification of, or reference to, a point beyond itself. This point is not imposed from without upon the creative effort of the artist, but is formed from the funded experiences and philosophy of life of the critic himself. Hence, artistic significance cannot be evaluated solely by aesthetic standards. Criteria used in arriving at such a determination would include artistic form, interpretation of subject matter, technical achievement, originality, artistic truth, morality, or a combination of some or all of these qualities. Similarly, artistic greatness is determined by the way a work of art moves us, and depends on such high standards of human or spiritual value as the depth and breadth of a master's insight into creation and life itself. If such an evaluation is to be made, the critic must possess a specific scale of values and philosophy of life.[17]

Only occasionally in Western Europe and America today do professional art historians assume the role of the judicial critic and evaluate the visual arts in terms of human values. When they do, it is almost always the art of the present day that interests them. Their criticism ranges between polar extremes, revealing that there is a multiplicity of vantage points in considerations of modern art, as there is in those of earlier art. This range of evaluation is exemplified by the work of two preeminent art historian-critics. On the one hand, the important and influential Viennese scholar Hans Sedlmayr (born 1896) has violently condemned modern art as a whole, finding in it a dissolution of catholic human values and standards, "the eruption of the extrahuman," which he traces back to Cézanne (*Verlust der Mitte* [Salzburg, 1948; *Art in Crisis, The Lost Center,* trans. Brian Battershaw, London, 1958]). He firmly maintains that significant works of art must strive to portray man and his place in God's ordered universe. A work that fails to serve this higher reality (for Sedlmayr an ideology) is insignificant and either a mere aesthetic object or an artifact. (See especially the collection of twelve essays written between 1947 and 1961, entitled *Der Tod des Lichtes. Übergangene Perspektiven*

[16] See Lipps' "Empathy and Aesthetic Pleasure" (trans. in *Aesthetic Theories: Studies in the Philosophy of Art,* ed. K. Aschenbrenner and A. Isenberg [Englewood Cliffs, N.J., 1965]).

[17] These problems require a comprehensive philosophical inquiry. They are perceptively sketched by Theodore Greene, *The Arts and the Art of Criticism* (Princeton, 1940), pp. 461–78.

zur modernen Kunst [Salzburg, 1964]).[18] On the other hand, the distinguished American scholar and teacher Meyer Schapiro (born 1904) has discerned that the painting and sculpture of our century are "more deeply personal, more intimate, and more concerned with experiences of a subtle kind" than the art of the previous century, revealing that modern artists have maintained "the critical spirit and the ideals of creativeness, sincerity and self-reliance, which are indispensable to the life of our culture" ("The Liberating Quality of Avant-Garde Art," *Art News,* June 1957, pp. 36–42).[19]

Generally, however, professional historians confine their scholarly interests to premodern art; in their writings they are not committed to a code of ethics, and they shun indulging in moral pronouncements. Any ethical criteria they incorporate in their assessment of the visual arts are rooted in what they regard as relevant historical conditions.

The division of criticism into three basic aspects (others could be defined as well) does not imply that a critic deals with the arts in accord with only one of these aspects.[20] Like art history today, modern criticism is a many-sided, many-leveled intellectual activity requiring flexibility,

insight, and imagination. The problem at hand dictates the treatment, and no single method or approach is always applicable or important to a given area of inquiry. Historians and critics alike adopt different approaches at different times, and may even use a meaningful, integrated variety of approaches to a single work or group of works.[21]

The prolific American writer Lewis Mumford (born 1895) has integrated historical and judicial criticism in his many influential studies of the social and cultural history of man and his environment (*Sticks and Stones; A Study of American Architecture and Civilization* [New York, 1924; Dover paperback]; *The Brown Decades; A Study of the Arts in America, 1865–1895* [New York, 1931]; *The South in Architecture* [New York, 1941]). With a philosophy formed under the influence of the writings of Patrick Geddes and Louis Sullivan, he has pleaded for meaningful relationships between, on the one hand, material and technical innovations and civilization, and, on the other, the human values of vitality, freedom, and tolerance. In a more recent series of writings he has "sought to deal in a unified way with man's nature, his work, and his life-dramas, as revealed in the development of contemporary West-

[18] The criticism and art history of Hans Sedlmayr have been searchingly evaluated by Lorenz Dittmann, *Stil-Symbol-Struktur; Studien zu Kategorien der Kunstgeschichte* (Munich, 1967), pp. 142–216. For an evaluation of German art criticism since World War II, see Josef P. Hodin, "Art History or the History of Culture: A Contemporary German Problem," *Journal of Aesthetics and Art Criticism* XIII (1955), pp. 469–77, and "German Criticism of Modern Art since the War," *College Art Journal* XVII (Summer 1958), pp. 372–81.

[19] Schapiro has written a number of papers of art criticism: "Rebellion in Art," in *America in Crisis; Fourteen Crucial Episodes in American History,* ed. Daniel Aaron (New York, 1952), pp. 203–42; "Gorky: The Creative Influence," *Art News,* September 1957, pp. 28–31; "On the Humanity of Abstract Painting," *Proceedings of the American Academy of Arts and Letters and the National Institute of Arts and Letters,* 2d ser., No. 10 (1960), pp. 316–23. For his contribution to the study of medieval and Renaissance art, see part III of this Introduction.

[20] For two different conceptions of contextual criticism, see Stephen Pepper, *The Basis of Criticism in the Arts* (Cambridge, Mass., 1945; Harvard paperback); and Lawrence D. Steefel, Jr., "Contextual Relativism," *College Art Journal* XXI (Spring 1962), pp. 151–5.

[21] See, for instance, the variety of approaches included in Gregory Battcock's *The New Art: A Critical Anthology* (New York, 1966; Dutton paperback original).

ern civilization. By intention, these books outline a philosophy, demonstrate a synthesis, and project further a new pattern of life that has, for at least a century, been in process of emergence" (*Technics and Civilization* [New York, c. 1934]; *The Culture of Cities* [New York, c. 1938]; *The Condition of Man* [New York, 1944]; *The Conduct of Life* [New York, 1951]).

In the work of another very prolific critic (who is also a philosopher, poet, art historian, and onetime editor of the *Burlington Magazine* [1933–39]), Sir Herbert Read (1893–1968), a flexibility and fluidity of thought emerges:

. . . I have never pretended to assess the value of particular works of art, or to arrange artists in an hierarchy of worth. It is not historical, for though I am conscious of connections, and eager to trace the re-emergence of traditions, I am not systematic enough to give the complete picture of a period, nor confident to define a school or classify a generation. The method I adopt may be called philosophic because it is the affirmation of a value-judgment. To be precise: I believe that among the agents or instruments of human evolution, art is supremely important. I believe that the aesthetic faculty has been the means of man first acquiring, and then refining, consciousness. Form, the progressive organization of elements otherwise chaotic, is given in perception. It is present in all skills—skill is the instinct for form revealed in action. Beyond this physiological

and instinctive level, any further progress in human evolution has always been dependent on a realization of formal values. [*The Philosophy of Modern Art*, London, 1952, Meridian paperback, pp. ix–x]

Read is an admirer of the work of the German aesthetician and historian Wilhelm Worringer, the French art historian Henri Focillon, the neo-Kantian philosopher Ernst Cassirer, and the British critics Roger Fry and Clive Bell; he has engaged in an avowed pluralism, or synthesis of viewpoints, that one is reluctant to categorize. Above all else he has been a great champion and promoter of 20th-century sculpture and painting.[22]

The disciplines of art criticism and art history interpenetrate and complement each other. Their relationship is apparent not only from their overlapping aspirations and objectives but also from the influence each has exerted on the other. In theory, the art historian should assume the functions of all aspects of criticism; but in practice, at least in the 20th century, art history has tended to be restricted in scope to historical criticism. The modern art historian's avoidance of re-creative and judicial criticism can perhaps be explained by his fear of being labeled unscientific, and by his discipline's specialization, which is, as we shall see, one of its current salient characteristics.

[22] For an appraisal of Read's work, see Solomon Fishman, *The Interpretation of Art; Essays on the Art Criticism of John Ruskin, Walter Pater, Clive Bell, Roger Fry, and Herbert Read* (Berkeley, 1963), pp. 143–86.

DETERMINANTS OF ART HISTORICAL INVESTIGATION

When thinking and writing about works of art, the historian is consciously or uncon-
sciously influenced by various determinants. He does not work without aspirations,
preconceptions, and suppositions. His training, knowledge, and experience provide for
him an intellectual platform from which to launch his inquiries. As an individual he is
a social phenomenon, a product of his period and environment. So rather than investi-
gate the visual arts in a vacuum insulated from external conditions and forces, he is
guided by the times to which he belongs, and he is a spokesman thereof. He stands not
without but within the moving stream of the course of history. How he approaches the
arts from that stream is dependent upon its various currents and bends, and upon his
position in relation to others in the stream. As he moves in the stream, his angles of
vision and views of the arts change constantly, and as this happens the art history he
writes changes and acquires new prospects. He can double back to previous points in
the stream, and even though he may attempt to accelerate the speed of the current,
he finds himself unable to move to the unchartered parts of the stream faster than the
current will carry him. He can assess art from the present and can look back into the
past to try to reconstruct its initial course; but he can hardly envisage its future destina-
tion. His perspectives are established by his preparation for the journey, by the point
at which he stands in the stream, and by the directions in which he may decide to look.

One of the strongest determinants in art historical writing is the scholar's conception
of history itself. He must have historical awareness if he is to think, talk, and write
intelligently about the visual arts. Art history is molded by a philosophy of history—by
an understanding of the general divisions of history, the nature of historical periods,
and the causes of historical change. These matters help determine how the art historian
arranges, classifies, and interprets works of art. All the data he observes and sets down
have reference to some historical notion or theory. Even the attribution of the term
"unique" or "original" to a work of art logically presupposes prior classifications of time
and place.

Works of visual art can, of course, be appreciated—just as Shakespeare's plays and
Beethoven's symphonies can be enjoyed—without historical awareness. They are physi-
cal objects that exist in the present and may convey values and meaning. But it is one
matter to find personal meaning and relevance in works of art and quite another to have
an understanding of them as products of man's heritage. With regard to the human
experience of art, there is a fundamental distinction between what is historical and past
and what is historical and present. The historically innocent spectator may see in a statue
something that would be quite meaningless to its sculptor. He can have only a limited
knowledge of what he is beholding. Further, knowledge must be distinguished from
understanding, which he may lack altogether. If the modern spectator aspires to have
an understanding of a work, he must be able to answer questions about it: who? what?
when? where? how? why? He will have to familiarize himself with the historical circum-
stances that surround and explain the work. In short, he must not only know it visually
but also understand it intellectually: he needs a *history* of art.

Some skeptics, such as Croce and his disciples, contend that there is no history of art,
only artists creating. Underlying this point of view is a belief in extreme individualism

and an assumption that artists—indeed all persons throughout history—are isolated organisms entirely disconnected from temporal and spatial conditions. According to this view every individual work of art is immaculately conceived in a creative vacuum. Time and space are denied as categories of reality, and society is assumed not to exist. The consequence of such extreme individualism is historical anarchy, a situation in which the products of human history are incommunicable and incomprehensible. This conception of history—this "antihistory"—cannot form a tenable hypothesis for the art historian. It fails to restore order out of chaos, allowing the creations of mankind to mingle in a "discontinuous meaningless flux."

The art historian must treat the work of art as a historical document. Of course, he also regards it as art, as we are reminded by a contemporary scholar:

... works of art, like other products of man's handiwork and imagination, are historical documents, and consequently are bound to reflect the time, place, and society in which they were produced. ... However, it must always be remembered that in making use of works of art in this way we are dealing with them from what is really a limited and secondary point of view, for obviously an artist is not primarily interested in producing an historical document. Instead he is intent on expressing something which he feels can best be said through the medium of his art; and on the originality of what he has to say depends, of course, much of the significance of his work. This dual aspect of a work of art—its importance as an historical document on the one hand, and its primary artistic significance on the other—serves to remind us that the artist, like any human being, is largely determined by history, yet at the same time may help to determine the course of history by means of what he expresses in his art. In short, works of art are both an effect and a cause of history. [Donald D. Egbert,

"Foreign Influences in American Art," *Foreign Influences in American Life; Essays and Critical Bibliographies*, ed. David F. Bowers, Princeton, 1944, p. 99]

Art historians readily acknowledge the visual arts as works of art, but they do not merely point out the aesthetic individuality of particular works and ignore the crucial questions of their stylistic roots and the position they occupy in the stream of history. An extreme view of aesthetic uniqueness is nonhistorical; it is a conclusion, not an explanation, and art historians seek to explain rather than conclude. While they are aware of, and moved by, the distinctive and exciting qualities of individual works, they treat these primary data as products of human history that exist in time and space. They approach the visual arts within the framework of a hypothesis about the nature of history. Their results will either agree with a general historical conception and thereby corroborate and enrich it; or they will cause a subtle or even a fundamental change in the general conception, and thereby shed new light on what was known before. But it is not the objective of the scholar to use art as a means to bolster or demolish some historical hypothesis. His point of departure is art rather than some philosophy of history, even though his inquiry is necessarily guided and influenced, consciously or unconsciously, by such a philosophy.

A vital aspect of the scholar's philosophy of history is a conception of the nature of time and its change.[23] To restore order and meaning to the mass of works of art, to give that mass shape, and to facilitate further knowledge and understanding of it, it is first necessary to arrange and classify the works in accord with chronological units, or time, and geographical sectors, or place. After the historian has gathered

[23] See J. van der Pot, *De periodisering der geschiedenis* (The Hague, 1951), and George Boas, "Historical Periods," *Journal of Aesthetics and Art Criticism* XI (1953), pp. 248–54.

the material that he regards as relevant to his area of inquiry, he arranges his works according to the categories of time and place. Let it be noted that meaningful historical inquiry subsumes both categories. To identify a picture as having been executed in the 16th century, or the early 16th century, or even the year 1510, has little value unless its provenance can also be identified, for a painting done at that time in Rome differs markedly from one executed in Cologne, Antwerp, or Moscow.

The art historian is interested in time periods and their sequence rather than a single period in isolation, because he often analyzes and interprets groups of works, or even a single one, in terms of works created at other times. If his point of departure is an early 16th-century Italian sculpture, he will investigate other Italian sculptures and perhaps also paintings and even buildings of the same provenance and period. In order to reconstruct the full original historical context of his sculpture, he may find it enlightening to investigate much earlier works in all media. For instance, a full understanding of the genesis and creation of Michelangelo's colossal statue of David in Florence could very well entail a study of colossal sculp- ture and other works of art executed in ancient Rome, as demonstrated in the recent book by Charles Seymour, *Michelangelo's David; A Search for Identity* (Pittsburgh, 1967).

General histories of Western art are commonly divided into four eras, or epochs: antiquity, the Middle Ages, the Renaissance, and the modern period.[24] Each of these is in turn subdivided into shorter phases. For instance, the Renaissance, a term usually, but not always, applied to the period in Italy from as early as about 1300 to as late as about 1600, is broken down by art historians into phases termed Early Renaissance, High Renaissance, Mannerism, and Late Renaissance.[25] While the four general epochs are largely mechanical devices of convenience and organization without intrinsic significance, their respective subdivisions have been established in relation to certain relevant aspects of human history, among them political, ecclesiastical, social, literary, and art historical. When art historians speak of art as being of this or that century, generation, or decade, they are using interpretative, evaluative terms, not merely chronological ones.[26] The identification of a work as belonging to the Italian Renaissance discloses a certain amount of infor-

[24] The concept of the Middle Ages originated during the Renaissance. It has been rejected by some modern historians (such as Wilhelm Dilthey). A few historians, including Karl Krumbacher (1856–1909), have advocated the division of history into an age before Christ and one after; this point of view, however, has met with no favor.

[25] See the article "Renaissance and Renascences" (1944) by Erwin Panofsky, which is reprinted in this book. Whether the term Renaissance should be applied to transalpine Europe of the 15th or even 16th century has been hotly contested among art historians. For interpretations of the term, see the useful survey by Wallace K. Ferguson, *The Renaissance in Historical Thought: Five Centuries of Interpretation* (Boston, 1948).

[26] A notable, though hardly influential, exception in art history is the German Wilhelm Pinder (1878–1949; *Das Problem der Generation in der Kunstgeschichte Europas* [Berlin, 1926]), who interpreted German art history within the contextual framework of European civilization. He was one of a number of European scholars, mostly German, who conceived of historical division in terms of the emergence of new generations, hence biological entities — an explanation that can be traced back to Antoine-Augustin Cournot's *Considérations sur la marche des idées et des événements dans les temps modernes*, 2 vols. (Paris, 1872). See Detlev W. Schumann, "The Problem of Cultural Age-Groups in German Thought," in *Publications of the Modern Language Association* LI (1936), pp. 1180–1207; and the essays in *History and the Concept of Time* (*History and Theory: Studies in the Philosophy of History*, Beiheft VI [Middletown, Conn., 1966]).

mation about that work; it tells various things to different art historians. Its further identification as Roman High Renaissance says a great deal more about it, imparting to it an art historical specificity that the more general attribution fails to convey.

Chronological connotations of terms that denote periods form the most common and least controversial element in modern art history. These terms carry other connotations, but they are not agreed upon as widely. For instance, the word Baroque, which was initially a derogatory term meaning bizarre, senseless, or in bad taste, is applied today not only to the historical period from the end of the 16th century to the second quarter of the 18th (significantly, even these limits are disputed), but also to the style of the visual and other arts of this period, and even to recurrent aesthetic characteristics appearing in the art of different historical periods.[27] When art historians use the term Baroque for the style of the visual arts in the period from about 1580 or 1600 to about 1725 or 1750, they do not imply that no other styles appeared at the same time and place. Since they tend to find more differences than similarities in the art of, for example, Caravaggio, Rubens, Rembrandt, Poussin, and Velázquez, they would disagree on the application of the term to all their works. Or if they agree that a meaningful number of qualities are shared by these works, they may still posit that different styles coexisted at the same time by pointing to the work of other, perhaps lesser known contemporary personalities that has nothing in common with the work of the masters; they may even find that different styles characterize works in different media—for example, Dutch 17th-century painting, but not architecture, is regarded as Baroque.

It is interesting that the recognition by art historians of the coexistence of various styles grew out of their awareness of developments in 20th-century art. In modern art history, the use of such terms as Baroque usually implies heterogeneity rather than homogeneity of artistic production in a given period. Art historians acknowledge that the Baroque style reveals itself with varying degrees of clarity in different works, none of which completely satisfies the ideal requirements. But as long as they find more coherence than divergence in the aesthetic qualities of the art of that period, their concept of Baroque style serves as an indispensable tool of scholarship.

The other use of the term, usually not capitalized, is applied to artistic traits that recur in different historical periods. Baroque in this sense is, as a rule, defined more generally and abstractly. It may be used by art historians to designate such qualities as heavy masses of forms, loose brushwork, and representation of emotion, which they find in some Hellenistic Greek paintings and sculpture, Roman paintings, and Cézanne's paintings of the 1860s, as well as in European art of the 17th century. This application of the term has in the past resulted in more confusion than clarifi-

[27] There is a large body of writings on the meaning of the Baroque. Especially useful is the essay by Ernest C. Hassold, "The Baroque as a Basic Concept of Art," *College Art Journal* VI (1946), pp. 3–28, which centers on the distinctions between the points of view of Heinrich Wölfflin and Dagobert Frey. Also valuable are Wolfgang Stechow, "Definitions of the Baroque in the Visual Arts," *Journal of Aesthetics and Art Criticism* V (1946), pp. 109–15; Bernard C. Heyl, "Meanings of Baroque," *ibid.*, XIX (1961), pp. 275–87; Otto Kurz, "Barocco: storia di un concetto," in *Barocco europeo e barocco veneziano*, ed. Vittore Branca (Florence, 1963); René Wellek, "Concepts of Baroque in Literary Scholarship," in *Concepts of Criticism* (New Haven, 1963). For recurrent types of artistic traits, see Thomas Munro, "Style in the Arts: A Method of Stylistic Analysis," *Journal of Aesthetics and Art Criticism* V (1946), pp. 128–58. •

cation, and it is thus far less frequent in the field today than the use of terms based on historical and artistic periods.

Many of the terms art historians use to describe chronological units derive from other humanistic disciplines.[28] The designations Neoclassic, Romantic, and Realistic are adopted from literary history, Reformation from ecclesiastical history, Louis XV and American Colonial from political history, and Mannerism, Impressionism, and Fauvism from art criticism. The multiplicity of sources of these terms may cause confusion and lead to vague and misleading notions about the art of the designated periods, and therefore their meanings must in each case be clarified. It should be stressed that such terms are not ordinarily invested with coherence or symbolic meaning in their own right;[29] they are simply convenient devices by which to describe generally accepted aggregates of aesthetic qualities in the art of a given time and place.

For the sake of clarification and communication, it is desirable for scholars to agree on one term for a historical period, even though it may subsume various attitudes and expressions. After about 1760, a large number of works in all media began to reflect new retrospective and archaeological attitudes toward ancient Greek and Roman monuments, history, and mythology. In the past, such labels as Neoclassicism, Romanticism, Romantic Classicism, Eclecticism, and "art around 1800" were attached to these works, and neither one nor all adequately conveyed their historical nature. A solution to the problem created by the disconcerting diversity of these labels was posed by Robert Rosenblum (born 1927) in his *Transformations in Late Eighteenth Century Art* (Princeton, 1967), a collection of stimulating essays that ranks as a major accomplishment of recent scholarship. To encompass all historical revivals, including Neoclassicism, Rosenblum has employed the broad concept of Historicism, which derives from the study of cultural history (of which the visual arts are a leading manifestation) and is found in many German historical inquiries.[30] He has consequently avoided the confusion arising from the use of such terms as Romantic Classicism, and at the same time under-

[28] René Wellek and Austin Warren, *Theory of Literature*, 3d ed. (New York, 1956; Harvest Book), pp. 262 ff.

[29] An exception to this general rule is found in F. Wylie Sypher, *Four Stages of Renaissance Style* (New York, 1955; Doubleday Anchor Book) and *Rococo to Cubism in Art and Literature* (New York, 1960; Vintage paperback).

[30] Historicism as a phenomenon of cultural history of the 18th century is defined and applied in the masterly work by Friedrich Meinecke, *Die Entstehung des Historismus*, 2 vols. (Munich, 1936); it is attacked as a concept by Karl R. Popper, *The Poverty of Historicism* (Boston, 1957; Harper Torchbook). Popper's work has influenced the art history of Ernst Gombrich, one of whose writings is reprinted in this book. Rosenblum is not the first art historian to apply Historicism to works of art. The term was used earlier by Nikolaus Pevsner in *An Outline of European Architecture* (Harmondsworth, Eng. and New York, 1942; Pelican Book); however, Pevsner restricted its use to architecture, while Rosenblum applies it to all media of artistic expression of the period with which he is concerned. Aspects of Historicism in later 19th-century art, as well as the suitability of the term for art historical scholarship generally, are examined by Pevsner and others in the collection of essays entitled *Historismus und bildende Kunst*, ed. Ludwig Grote (Munich, 1965), and by Pevsner alone in a paper conveniently reprinted in a collection of his writings, *Studies in Art, Architecture and Design*, 2 vols. (New York, 1968), II, pp. 242–59. For Historicism in German thought as a whole, see the stimulating book by Georg G. Iggers, *The German Conception of History: The National Tradition of Historical Thought from Herder to the Present* (Middletown, Conn., 1968).

scored the most important characteristic of the art of the time.

However tempting the approach may seem, modern historians seldom interpret the visual arts by direct reference to the conclusions of historians of the other arts, such as literature and music. Today it is generally recognized that the arts rarely pursue identical or parallel paths or progress at the same rate. Only when the art historian is able to discover specific analogies between the arts and to learn their cause is an emphasis on the interrelations of the arts justified and historically enlightening.[31] To be sure, there have been periods in human history when some of the arts were closely related; the papers found in this anthology by Krautheimer and Panofsky on the revival of antiquity by medieval and Renaissance man demonstrate the point. But the periods these scholars examine are closely defined and stand out as special cases in the stream of cultural history.

Problems of classification are not nearly as pressing in art history today as they were a generation ago, with the major exception of Mannerism.[32] A far more important determinant of art historical investigation is the problem of historical or stylistic change. In relating works to one another, the scholar is guided by some notion of the emergence and evolution of change. In 20th-century art history a number of such conceptions have been forwarded, either explicitly or implicitly, and many of them continue to flourish in the present day.[33] Since this problem is regarded by many leading specialists as the central issue in their discipline, it will be examined in the following pages at some length.

I am reluctant to admit that much of modern art history is dominated by the

[31] An absorbing introduction to the methodology of artistic interrelations is Dagobert Frey's *Gotik und Renaissance als Grundlagen der modernen Weltanschauung* (Augsburg, 1929). Appearing too late to be discussed here is Mario Praz's *Mnemosyne: The Parallel between Literature and the Visual Arts* (Princeton, 1970).

[32] Mannerism is the most overwrought concept that plagues modern art history, especially in recent years when a flood of papers on the subject has invaded public libraries and parlor coffee tables. As James S. Ackerman has so aptly put it, "the current bouquet of publications on this theme might be an obituary because most of the talking is about how to talk about art and not about art itself" ("Art," *Renaissance News* XVIII [1965], p. 75). From this heap of scholarship, the most enlightening definition that emerges of the artistic trends in Italian painting between the end of the High Renaissance and the Baroque is found in the two brilliant papers by Walter F. Friedlaender that appeared originally in German in 1925 and 1929 (*Mannerism and Anti-Mannerism in Italian Painting* [New York, 1957; Schocken paperback]). Of the most recent works on the subject I find the most profound to be John Shearman's *Mannerism* (Middlesex, 1967; Penguin Book). Apparently not realizing that Mannerism is far from a decided issue in art history, several literary historians and musicologists have accepted it as an established concept and applied it to their own disciplines: for example, Roy Daniells, *Milton, Mannerism and Baroque* (Toronto, 1963); Daniel B. Rowland, *Mannerism—Style and Mood: An Anatomy of Four Works in Three Art Forms* (New Haven, 1964). For criticism of their work, see the review by W. H. Halewood of Arnold Hauser's book on Mannerism in the journal *History and Theory* VII (1968), pp. 90–102.

[33] For an incisive evaluation of some of them, see the paper by Meyer Schapiro, "Style," in *Anthropology Today* (Chicago, 1953; University of Chicago paperback), conveniently reprinted in *Aesthetics Today*, ed. Morris Philipson (Cleveland and New York, 1961; Meridian paperback). The surveys by Hans Tietze, *Die Methode der Kunstgeschichte* (Leipzig, 1913), and Ernst Heidrich, *Beiträge zur Geschichte und Methode der Kunstgeschichte* (Basel, 1917), are by now outdated. For complementary ideas in history, see the collections of writings edited by Fritz Stern (*The Varieties of History, from Voltaire to the Present* [New York, 1956; Meridian paperback]), Hans Meyerhoff (*The Philosophy of History in Our Time* [Garden City, N.Y., 1959; Doubleday Anchor Book]), and Ronald H. Nash (*Ideas of History*, 2 vols. [New York, 1969; Dutton paperback]).

concept of evolution. This philosophy of history is Aristotelian in origin and was systematized rigorously and scientifically for the first time by Herbert Spencer and Charles Darwin, on whose views is based the modern concept of evolution in a large part of the Western world (outside of Germany and Russia). According to the Aristotelian philosophy of nature and culture, living creatures may be classified by genera and species, arranged in a serial order from the simplest to the most complex. Evolution is conceived as a "teleological process in time directed toward one and only one absolutely predetermined goal." [34] The notion that art and other aspects of culture also developed from simple to complex forms is likewise essentially Aristotelian. These views were current throughout the Middle Ages and the Renaissance and were reexamined systematically for the first time only in the late 18th and 19th centuries, largely in consequence of a renewed interest in biology. The first major reformulation was actually made by Hegel, whose concept of evolution profoundly influenced thinking in Germany and Russia; but in the English-speaking world it was the Darwinian concept that became widespread. In his *Origin of Species* (1859), Darwin held that all forms of life are genetically continuous and all life is a single process in which forms continually arise, mature, and die. He departed decisively from the Aristotelian view by introducing the factor of time to the sequence of forms. For Darwin, the relationship between the form of one species and that of another was temporal; for the Aristotelians, that relationship was eternal. The mechanical principle by which evolution occurs Darwin termed "natural selection," a process resembling the artificial selection by which domestic animals are bred. Holding that all species ultimately derive from a common organism, Darwin theorized that they evolved *gradually* through variation and natural selection: ". . . all forms of life made together one great system, for all are connected through generation."

Darwinism has, of course, profoundly influenced not only the study of biology but also historical thought, including art history and other aspects of human culture. With Darwin's views before them, 19th-century historians began to regard their raw material as progressive, and they could use evolution as a generic term to denote both historical and natural progress. [35] Moreover, Darwinism implied a shift of emphasis from the individual to the group or species. Because of the mechanistic character of the hypothesis, individual ability and intention were denied in favor of the process of the group.

Under the impact of Darwinism, art historians began to conceive of groups of art works as unfolding slowly and gradually, step by step, in a continuous linear sequence from, for example, simplest to most complex, and that sequence was equated with the concept of time, from earliest to most recent. Accepting the principle of gradual evolution and linear continuity, they treated works of art individually by their position in the temporal sequence and could explain their relation to the sequence historically (that is, stylistically) by reference to the transitions that occurred between the slight variations as well as the gradual modifications represented in the sequence. For the art historian, Darwinism was portentous; it seemed to simplify his tasks. For some it seems still to do just that.

One of the earliest art historical parallels to Darwinian thinking was that formulated

[34] F. S. C. Northrop, "Evolution in its Relation to the Philosophy of Nature and the Philosophy of Culture," in *Evolutionary Thought in America*, ed. Stow Persons (New Haven, 1950), p. 52.

[35] The classic study on the idea of progress is John B. Bury's *The Idea of Progress: An Inquiry into Its Origin and Growth* (New York, 1932; Dover paperback).

by the German architect and theorist Gottfried Semper (1803–79).[36] In *Der Stil in den technischen und tektonischen Künsten,* 3 vols. (Munich, 1860–63), he discusses the origins of art, "tracing in detail the law and order apparent in the process of creation and elaboration of artistic phenomena, . . . deriving general principles, the fundamentals of an empirical theory of art, from the data discovered" (*ibid.,* I: vi). For Semper, who read Darwin's *Origin of Species* as soon as it appeared, art is a biological organism and the history of art a continuous linear process of development going back into the remote, primeval past. Art originates from the specific nature of the material, the nature of the tools and methods of production, and the nature of the function that the work of art serves. Materials are the basis of his critical perspective, and changes in art are explained by the nature of material and technical innovations. Semper's method is empirical, genetic, and comparative. From the Darwinian concept of evolution he seems to have transferred to artistic development even the principle of the economy of nature, which said that nature operates with only a few basic types, varying, modifying, and assimilating them in a continuous temporal sequence. He excluded the possibility of abrupt and sharp changes or significant events altering the evolution of art, except at the time of its origin.

As brief a sketch as this does injustice to the total thought of Semper's work, but it is hoped that it points out some of his major ideas. Though Semper tended to reduce art to a result of purely mechanical and natural forces, his aesthetic materialism and method influenced a number of prominent architects and philosophers in

Europe. He seems to have been the first to adopt Darwinian thinking to the historiography of art.

A radically different theory of the evolution of art was formulated by the brilliant and widely influential Viennese scholar and teacher Alois Riegl (1858–1905). Riegl saw the periods he studied in terms of a continuous evolutionary and progressive process with the binding force of a natural law. He was the first art historian to discard the normative view, held since Winckelmann, that the historical course of art is marked by numerous phases of decline or decay. By enlightening the "dark ages," Riegl revolutionized the concept of art historical periods. From his penetrating investigation of ancient textiles (*Stilfragen* [Berlin, 1893]), Greco-Roman, Late Antique, and early medieval art (*Die spätrömische Kunst-Industrie* [Vienna, 1901]), and Baroque (*Die Entstehung der Barockkunst in Rom* [Vienna, 1908]), he concluded that artistic development in a given period is an internal, autonomous, and genetically progressive process, which is essentially unaffected by external factors such as function, climate, innovations in materials and technique, and social and cultural forces. In contradistinction to previous scholarship, he regarded the transitions from Egyptian and Near Eastern to Greek art, and from Greco-Roman to Late Antique and Early Christian art, as a single and even necessary evolutionary advance. For the stylistic possibilities open to artists Riegl formulated two antithetical categories, which he termed "haptic" and "optic," and he described the style in any given period in terms of an evolution from a haptic (tactile) mode of perception to an optic (visual) one.[37] Though they are only briefly sketched in

[36] See Leopold D. Ettlinger, "On Science, Industry and Art: Some Theories of Gottfried Semper," *Architectural Review* CXXXVI (July 1964), pp. 57–60; and Heinz Quitzsch, *Die ästhetischen Anschauungen Gottfried Sempers* (Berlin, 1962).

[37] "Natural objects reveal themselves to the *visual* perception of man as figures *isolated* yet at the same time connected with the universe (that is, with a practically unlimited section of it) inside an infinite whole" (Riegl, quoted by Paul Frankl, *The Gothic; Literary Sources and Interpretations through Eight Centuries* [Princeton, 1960], pp. 631–32).

his writings, Riegl also noted some stylistic connections in the art forms of different periods (for instance, Roman Imperial and Dutch Baroque portraiture) and related them to what he described as a "higher law," or universal principle, governing these periods. In this way he could regard his antithetical categories for a given era in terms of much longer spans of time in Western history.

The artistic development in an era was also described by reference to the much-debated concept of *Kunstwollen*, a verb (as Pächt has pointed out) by which Riegl meant to characterize the desire or impulse on the part of the artist (or period of artists) to confront and solve specific artistic problems.[38] He introduced this concept as a polemic against the then prevailing view of Semper and his followers that styles change because of innovations in materials and technique:

In contrast to this mechanistic concept of the character of a work of art, I have advocated . . . a teleological concept, by recognizing in a work of art the result of a definite and deliberate *(zweckbewusstes) Kunstwollen*, which wins out in the battle with usefulness, raw material, and technique. These three latter factors, therefore, lack the positive creative role which was assigned to them in Semper's theory, but they have rather an inhibiting, negative role; they form, as it were, the coefficients of friction of the total product. [*Die spätrömische Kunst-Industrie*, Vienna, 1901, p. 5]

Thus attention was shifted from a few external factors to the creative activity of the artist himself—a landmark in the historiography of art and a sort of scholarly prelude to Picasso's *Demoiselles d'Avignon* of 1907. Yet, since his concept of *Kunstwollen* lacked precise terminology and was based on an inadequate and dated psychology—assuming that artists always represent what they see, Riegl implied that a master could create whatever he wanted, regardless of ability or environmental conditions—it soon stirred a storm of controversy. Indeed, it has taxed the minds of some of art history's foremost spokesmen; it has by now been abandoned entirely.[39] But rejection of his concept of *Kunstwollen*, his scientific terminology, or even his quasi-Hegelian and proto-Spenglerian determinism fails to invalidate his scholarship, which abounds with acutely perceptive analyses of the syntactical structure *(Strukturprinzip)* of Late Antique, early medieval, Baroque, and especially 17th-century art. As is apparent in the selection from his remarkable study of Dutch group portraiture, which appears for the first time in English translation in this book, Riegl's scholarship clearly belongs to the 20th century. He not only presents a detailed analysis of the formal and symbolic values in the work of art, but also examines the relationship between the work and the beholder, and even between the work and aspects of social history. His lectures and publications exerted a profound impact on a large number of European scholars, including Max Dvořák, Wilhelm Worringer, Hermann Egger, Hans Tietze, Paul Frankl, Hans Sedlmayr, Guido von Kaschnitz-Weinberg, and to some extent even Henri Focillon, all of whom tried further to

[38] Otto Pächt, "Art Historians and Art Critics: Alois Riegl," *Burlington Magazine* CV (1963), pp. 188–93. *Kunstwollen* simply has no English equivalent. See the paraphrase by Meyer Schapiro in "Style," *Anthropology Today* (Chicago, 1953), p. 302: ". . . conception of art as an active creative process in which new forms arise from the artist's will to solve specifically artistic problems."

[39] The most useful criticisms of Riegl's concept of *Kunstwollen* have been made by Erwin Panofsky, "Der Begriff des Kunstwollens," in *Zeitschrift für Asthetik und allgemeine Kunstwissenschaft* XIV (1920), pp. 321–39 (republished in the author's *Aufsätze zu Grundfragen der Kunstwissenschaft*, ed. and comp. Hariolf Ober and Egan Verheyen [Berlin, 1964], pp. 33–47), and Edgar Wind, "Zur Systematik der künstlerischen Probleme," in *Zeitschrift für Asthetik und allgemeine Kunstwissenschaft* XVIII (1925), pp. 438–86, and XXV (1931, Beilageheft); pp. 163–68.

develop and enrich aspects of Riegl's ambitious approach to the visual arts.[40]

An evolutionary approach to the history of art was taken by another important scholar working in Vienna, the Czech-born Josef Strzygowski (1862–1941). Appointed professor at the Art Historical Institute of Vienna University in 1910, he profoundly influenced the study of Early Christian art through his teaching as well as his writings —hundreds of monographs and papers that became widely known. Before Strzygowski, specialists had regarded the city of Rome and its famous catacombs as the birthplace of Christian art, an attitude evident in the writings of Riegl himself.[41] Strzygowski startled his colleagues with the publication of *Orient oder Rom?* in 1901, the first serious work by a European scholar to point to the eastern provinces of the Roman Empire, rather than the Eternal City, as the source of the formal and conceptual qualities of many Early Christian monuments.[42] In that book, the problem of the origins and development of Late Antique, Early Christian, and Byzantine art is seen with new eyes and the monuments are examined in considerable detail.

By recognizing the key role of Christian doctrines in the transformation of Greco-Roman attitudes and beliefs, Strzygowski shifted attention from Rome to the ancient Near East. By reference to specific works in all media—monuments that he had studied firsthand as early as 1889 during expeditions to Greece, Asia Minor, Armenia, and Russia—he traced step by step the "evolutionary process" of the development of art during the first millennium A.D. With relentless energy he pursued and expanded his points of view in subsequent studies that dealt with the architecture of Asia Minor (*Kleinasien: ein Neuland der Kunstgeschichte* [Leipzig, 1903]), the carved façade of the palace at Mschatta in Jordan ("Mschatta, Kunstwissenschaftliche Untersuchung," *Jahrbuch der preussischen Kunstsammlungen* XXV [1904], pp. 225–373; Strzygowski was instrumental in having the façade transferred to its present location in the State Museums at Berlin), Coptic art (*Koptische Kunst* [Vienna, 1904]), the art and architecture of Christian and Moslem Mesopotamia (*Amida* [Heidelberg, 1910]), and the architecture of Armenia (*Die Baukunst der Armenier und Europa,* 2 vols. [Vienna, 1918]; which, while de-

[40] Of the many essays written on Riegl and his scholarship, see especially the one by Hans Sedlmayr in Max Dvořák's *Gesammelte Aufsätze zur Kunstgeschichte,* ed. Johannes Wilde and Karl M. Swoboda (Munich, 1929); and Pächt, "Art Historians and Art Critics: Alois Riegl," *Burlington Magazine* CV (1963), pp. 188–93.

[41] The "Roman point of view" was vigorously maintained as late as a generation ago (Emerson Howland Swift, *Roman Sources of Christian Art* [New York, 1951]). An excellent account of the Orient-or-Rome polemic has been given by John Bryan Ward Perkins in "The Italian Element in Late Roman and Early Medieval Architecture," *Proceedings of the British Academy* XXXIII (1947), pp. 163–94 (also a separate reprint). Today, the body of art works from the Early Christian period is far larger than in 1901, and the question is not one of Rome or the East but is more complex. For this problem see the brilliant evaluation by Otto J. Brendel of developments in the historiography of ancient art ("Prolegomena to a Book on Roman Art," *Memoirs of the American Academy in Rome* XXI [1953], pp. 7–73, esp. 27 ff.).

[42] Appearing one year before Strzygowski's *Orient oder Rom?* was Dmitrii Vlas'evich Ainalov's *Ellinisticheskie osnovy vizantiiskogo iskusstva* (*The Hellenistic Origins of Byzantine Art,* trans. Elizabeth Sobolevitch and Serge Sobolevitch, ed. Cyril Mango, [New Brunswick, N.J., 1961]), which expressed a similar point of view. His work, however, was known to Western scholars in the form of a German résumé of some twenty pages (Oskar Wulff, in *Repertorium für Kunstwissenschaft* XXVI [1903], pp. 35–55). For a fine appraisal of Ainalov's contribution, see Cyril Mango's preface to the aforementioned 1961 English translation.

pendent upon the research of Armenian scholars, remains his most impressive work). In these writings he laid down his essential method of trying to establish what he called "the facts of evolution" by detailed stylistic analysis and comparison of specific works. He later wrote: "the history of art must work itself free from the mere comparative study of monuments; it must concentrate upon the work of art and its values, absolute and evolutional, and so find a path of its own."[43] He relegated to a place of little importance what he labeled the "false methods" of philological, historical, paleographic, philosophical, and aesthetic inquiry, methods upon which the Viennese school of art history had always relied. Thus he established a fundamental distinction between his approach and that of such art historians as Riegl and Dvorák. Vienna now had two schools of art history.

Strzygowski's scholarship from the end of World War I until his death during World War II remained as prolific and fervent as before, but it became increasingly infected with racial ideologies allied to those of German National Socialism.[44] After identifying what he regarded as close formal affinities between, for example, the motifs of Chinese bronzes and those of Near Eastern carved ornaments (an observation he published as early as 1904), he pointed to northern Iran as the active nerve center from which these artistic currents radiated to the Near East. For the origins of the "pure expressions" of the art of the nomadic Aryans, he began a wild-goose chase that terminated somewhere between the Oxus and China. This search forced

him to postulate the onetime existence of certain monuments and artistic movements, such as the "Hvarenah-Landschaft" and Mazdean art, for which no shred of solid evidence was found. He was well aware of these difficulties, and even declared: "most important, perhaps, is my rejection of the old view that surviving monuments can be relied on for decisive results, either per se or as facts determining date; this is a view which would place history at the mercy of chance" (Origin of Christian Church Art [Oxford, 1923], p. 192).

A focus on the later writings of Strzygowski and their racial ideologies obscures his earlier scholarship, much of which remains basic to the study of Early Christian art. Along with the writings of the Russian scholar Dmitrii Vlas'evich Ainalov (1862–1939), who worked independently of his colleague in Austria, the early publications of Strzygowski expanded the investigation of the sources of Christian art and extended the horizons of Continental art history to non-European shores — to the eastern Mediterreanean, Armenia, Persia, and even the Far East. Strzygowski's oeuvre reveals the mind of a great scholar — although not that of a great humanist — who worked within the framework of an evolutionary approach to the development of Christian art, and who could examine specific traits in detail at the same time as constellations of salient characteristics. His points of view and the method within which they were formulated influenced scores of European students and followers (Oscar Wulff, Ormonde M. Dalton, and Ernst Diez, to name only a few), as well as such American scholars as Charles Rufus

[43] See his "Grundsätzliches und Tatsächliches," in Die Kunstwissenschaft der Gegenwart, in Selbstdarstellungen, ed. Johannes Jahn (Leipzig, 1924), pp. 157–81; and his Origin of Christian Church Art, trans. O. M. Dalton and H. J. Braunholtz (Oxford, 1923), pp. 189–229 (containing Strzygowski's bibliography to date of publication).

[44] See his Die Krisis der Geisteswissenschaften (Vienna, 1923), apparently the first attempt to apply racist ideas to historians of art rather than to the origins of art.

Morey. Some of the early hypotheses in Strzygowski's pioneering contribution still remain valid.[45]

Differing radically from Darwinism and its modifications and echoes are the cyclical conceptions of historical evolution.[46] Cyclical theories were widespread in Western art history until recent times. They were formulated clearly in the 18th and 19th centuries, but as theories of history they are very old, having occurred first in ancient Greece and Rome (with Plato and Polybius) and later in the Renaissance and post-Renaissance periods (with Machiavelli and Vico). Since antiquity, various cyclical notions of evolution have been propounded: dichotomies (order-disorder); three-phase rhythms (rise-decline-fall, or thesis-antithesis-synthesis); and four-, five-, and six-phase rhythms (birth, adolescence, maturity, old age, and death).

One version of the cyclical theory has its counterpart in biological analogies, such as the fixed life cycle of a single organism —a cycle embodying several rhythms, for instance, birth, maturity, and decay. This organismic cyclical theory implies the presence of some kind of vital force producing the recurrent cycle and giving it significance. This is the historical theory of the arts that is broadly sketched in one of the earliest Western art histories, that of the Florentine painter, architect, historian, and critic Giorgio Vasari (1511–74). His *Lives of the most eminent Painters, Sculp-* *tors and Architects* (1st ed., 1550; enl. ed., 1568) contains, in addition to biographies and anecdotes of artists that are of fundamental documentary value today, a cyclical scheme of the development of the arts.[47] Invoking what is tantamount to a biological metaphor, Vasari points out three phases *(età)* of artistic evolution in his scheme of "modern" (that is, Renaissance) art: infancy (the art of Giotto), adolescence (the art of Brunelleschi, Donatello, and Masaccio), and maturity (the art of Michelangelo). (Whether Vasari accepted the idea of an inevitable decline after Michelangelo is in my view unclear in his writings.) His cyclical theory implies a historical evolution of art and culture through three determined, therefore typical, phases.

Vasari did not systematically apply this conception of evolution to the visual arts. His main preoccupation in the *Lives* was the presentation of stories of artists (rather than works of art).[48] It was only about the mid-18th century that the cyclical conception of history was given systematic application by a scholar dealing specifically with the visual arts. That scholar was Johann Joachim Winckelmann (1717–68), the father of modern archaeology, who is sometimes recognized as the originator of "modern art history." (Though he dealt primarily with works of art and some of their salient qualities, rather than with histories of artists, his major concern was perhaps the application of an expressive

[45] One of Strzygowski's theories has recently been reexamined in the light of new evidence and found to be legitimate (Walter Horn, "On the Origins of the Mediaeval Bay System," *Journal of the Society of Architectural Historians* XVII [1958], pp. 2–23). For an objective appraisal of Strzygowski's scholarship, see Ernst E. Herzfeld, Wilhelm R. W. Koehler, and Charles R. Morey, in *Speculum* XVII (1942), pp. 460–61; and Paul Lemerle, in *Revue Archéologique* XX (1942/43), pp. 73–78.

[46] See Grace E. Cairns, *Philosophies of History* (London, 1962).

[47] Vasari's cyclical scheme is found in his introduction to the biographies. For an important recent appraisal of the latter, see Svetlana L. Alpers, "Ekphrasis and Aesthetic Attitudes in Vasari's *Lives*," *Journal of the Warburg and Courtauld Institutes* XXIII (1960), pp. 190–215.

[48] Vasari's anecdotes about artists must be treated with caution, as pointed out by Ernst Kris and Otto Kurz, *Die Legende vom Künstler* (Vienna, 1934).

theory to ancient works.)[49] In his *Ge-schicte der Kunst im Alterthum* (Dresden, 1764 [*The History of Ancient Art,* 4 vols., trans. G. Henry Lodge, Boston, 1872]), Winckelmann writes that "the history of art must teach us the origin, growth, change and decline of art together with the various styles of people, periods and artists, and it must prove these propositions, as far as possible, with the aid of the surviving monuments of antiquity" (1764 German ed., p. 5).[50] After systematically collecting all available evidence, including numismatics and ancient authors' references to works of art, he described an evolution of ancient Greek sculpture in four stages, proceeding from its earliest origins to its "perfection" in the age of Praxiteles, and its subsequent change and ultimate decline and fall. While he rejected the idea of cyclical necessity, he applied the analogy of growth and decline to the history of ancient art. His views and ideals deeply influenced the Enlightenment, and especially German intellectual thought as seen in Lessing, Herder, Schiller, and even Goethe.[51]

Another conception of the cyclical theory is the spiral movement of human history that is known from the philosophical system of Georg Wilhelm Friedrich Hegel (1770–1831). In Hegel's work, all Romantic conceptions of art and aesthetics attained full development. He dropped the biological metaphor and replaced the idea of straight-line continuity with the dialectical method. He postulated that man, nature, and history are all organic parts of a single world process to which everything belongs and without which nothing can be understood. He devised an elaborate metaphysical system whose cornerstone is the idea of progress, which is said to take place only through a constant struggle, a triadic formula of thesis-antithesis-synthesis. In this struggle any one stage, called a thesis, is bound to be negated by an antithesis, and this in turn produces a synthesis, which forms another thesis, and so on, in a spiral crescendo of developmental accretion from lower to higher levels of reality. Eventually, a reconciliation of contradictions is attained in a consummate synthesis, which is the complete concrete realization of what Hegel describes as the "Absolute Infinite Spirit." For Hegel, this single cycle of spiral progress is eventful, violent, and revolutionary, for the element of struggle implies some kind of underlying vital force or spirit. This is Hegel's dynamic logic.

In Hegel's system, art, along with philosophy and religion, is the embodiment of the Absolute Infinite Spirit.[52] All art evolves from the spirit that it expresses. Hegel distinguished between form and content in the work of art, that is, between the "visual shaping" and the "idea"; he maintained that the function of art is to reconcile these two opposed components into a free, united totality. His dialectic method

[49] This evaluation has been proposed by Leopold D. Ettlinger in *Art History Today* (London, 1961), pp. 7–9.

[50] The first book with the title "History of Art" was written by a director of the French Academy, Pierre Monier (*Histoire des Arts qui ont rapport au dessein . . .* [Paris, 1698]), and is largely a compilation of facts concerning artists from antiquity to the 16th century, hence in the biographical tradition of Vasari and others.

[51] The classic monograph on Winckelmann is C. Justi, *Winckelmann, sein Leben, seine Werke und seine Zeitgenossen,* 2 vols. (1866–72, republ. as *Winckelmann und seine Zeitgenossen* [Cologne, 1956]). The impact of Winckelmann's thought on German intellectual life in the 18th century is examined briefly by Henry C. Hatfield, *Winckelmann and His German Critics, 1755–1781* (New York, 1943).

[52] See Jack Kaminsky, *Hegel on Art: An Interpretation of Hegel's Aesthetics* (Albany, 1962), with references to earlier literature on the topic.

of thesis, antithesis, and synthesis led him, therefore, to describe the history of art in three stages. He termed these stages the symbolical, the classical, and the romantic. The symbolical was identified with Oriental (Asiatic and Egyptian) art, the classical with Greco-Roman art, and the romantic with Christian-Germanic art. He was the first Western thinker whose art historical perspectives extended to Oriental art as a whole, and thus—the weakness of his dialectical method notwithstanding —he made a substantial contribution to the historiography of art.

Hegelianism is important for art history today largely because of its impact on Marxist art historians and critics.[53] The idea of secular progress was given a cyclical formulation by Karl Marx (1818–83) under the influence of Hegel's dialectical, single-cycle philosophy of history.[54] For Hegel, the forces involved in the dialectical process were essentially intellectual and spiritual; for Marx, matter rather than mind was the ultimate reality and determinant of evolution. Though there are marked differences between Hegelian idealistic content and the Marxist materialistic content of the dialectical historical process, Hegelians and Marxists alike postulate that reality is essentially historical and evolutionary in character, and

that the evolutionary process is determined by the Hegelian dialectic of thesis, antithesis, and synthesis. For both, the laws that determine the evolution of cultural institutions, and the natural processes in organic and inorganic nature, are identical.[55]

Developing some of the views sketched briefly in the writings of Marx and Engels, 20th-century Marxist critics and historians uphold the concept of cultural evolution and progress and maintain that works of art, like all aspects of a culture existing within a given class society, are determined fundamentally by socio-historical conditions, and especially by basic economic conditions, namely the methods of production and distribution of the means of subsistence.[56] Thus they assert that necessary connections exist between the visual arts and social and economic conditions, and that they can always be discovered, indeed that the visual arts cannot be explained until these connections are revealed. Since in Marxist Leninism, art "expresses" or "reflects" reality, and reality is a revolutionary development, Marxists argue that changes in art are evolutionary and revolutionary and that the function of art and of its creator is to serve society. By basing their criticism not on the values intrinsic to works of art but on such values

[53] For a recent defense by an art critic of the Hegelian conception of historical progression, in an interpretation of 20th-century painting, see Michael Fried's introductory essay to the Fogg Art Museum catalogue *Three American Painters: Kenneth Noland; Jules Olitski; Frank Stella* (Cambridge, Mass., 1965).

[54] For Marxist views on art, see Karl Marx and Friedrich Engels, *Literature and Art: Selections from their Writings* (New York, 1947). See also Melvin Rader, "Marx's Interpretation of Art and Aesthetic Value," *British Journal of Aesthetics* VII (1967), pp. 237–49.

[55] As is pointed out in the excellent interpretation of these views by F. S. C. Northrop, "Evolution in its Relation to the Philosophy of Nature and the Philosophy of Culture," in *Evolutionary Thought in America*, ed. Stow Persons (New Haven, 1950), pp. 44–84. See also R. G. Collingwood, *The Idea of History* (London, 1946; Oxford paperback), pp. 122–26.

[56] The first Marxist to discuss the arts systematically and rigorously was the Russian Georgi Plekhanov (1856–1918), whose study on 18th-century French art and society that appeared in Russian in 1918 was translated in the 1930s (*Art and Society*, trans. Paul S. Leitner et al, introd. by Granville Hicks [New York, 1937]), facilitating a dissemination of his views abroad, including the United States, where for a short time they influenced a number of important art historians and critics to varying degrees. For Marxism in modern art history, see part III of this Introduction.

as freedom or proletariat control of the means of production, they make artistic quality a relative matter. Theirs is a historical perspective that is fundamentally removed from judicial criticism by virtue of its scientifically predictable, rather than aesthetic, basis. [57]

By far the most influential, although controversial, cyclical conception of Western art history that has been derived systematically from an enormous amount of visual data was that formulated by Heinrich Wölfflin in 1915, in his *Kunstgeschichtliche Grundbegriffe; das Problem der Stilentwicklung in der neueren Kunst.* [58] That no other book in 20th-century art history has received so much critical attention—praise and condemnation alike—is proof in itself that Wölfflin was one of the greatest art historians of his day. After publishing several early studies, including his finest book, *Die Klassische Kunst* (Munich, 1899), which contains some of the most perceptive formal analyses ever written of Italian High Renaissance painting and sculpture, Wölfflin wanted to demonstrate fundamental differences in the mass of Renaissance and Baroque art. To do this he arrived at a set of fundamental conceptual tools *(Grundbegriffe)* to describe the opposed styles of the High Renaissance and the Baroque. His polarities are: *Das Lineare und das Malerische* (the linear and the "painterly"), *Fläche und Tiefe* (plane or parallel surface form, and recession or diagonal depth form), *Geschlossene Form und offene Form* (closed or tectonic form, and open or a-tectonic form,) *Vielheit und Einheit* (multiplicity or composite, and unity or fused), and *Klarheit und Unklarheit* (clear and relatively unclear). These five pairs of polar concepts were formulated to set apart clearly and definitely the linear works of such artists as Leonardo da Vinci and Dürer from the painterly works of such artists as Rembrandt and Velázquez. They describe all media of artistic expression—architecture, sculpture, and the so-called decorative arts, as well as painting. For Wölfflin, they oppose each other as two modes of vision, as two histories of *seeing* ("every artist is confronted with particular visual possibilities to which he is bound. . . . Seeing in itself has its history, and the discovery of these visual strata must be regarded as the primary task of art history" [*Principles of Art History,* London, 1932, p. 11]). He propounded that styles have an inherent tendency to change, and that the evolution from the High Renaissance to the Baroque was an internal, logical development that could not be reversed ("the painterly mode is later [than the linear] and is not truly

[57] The greatest living Marxist critic is the Hungarian Georg Lukács (born 1885). He has written many papers and monographs, including *Beiträge zur Geschichte der Ästhetik* (Berlin, 1954) and *Probleme des Realismus* (Berlin, 1955). See Victor Zitta, *Georg Lukács' Marxism Alienation Dialectics, Revolution; A Study in Utopia and Ideology* (The Hague, 1964), with an introduction by Harold D. Lasswell. One of the most influential Marxist interpretations of the arts has been published by the Austrian poet and critic Ernst Fischer (born 1899): *The Necessity of Art, A Marxist Approach* (Baltimore, Md., 1963; Pelican Book; first pub. in German, 1959). See also the many works of John Berger (e.g., *The Success and Failure of Picasso* [Baltimore, 1965; Pelican Book]).

[58] Translated by M. D. Hottinger from the 7th edition as *Principles of Art History; the Problem of the Development of Style in Later Art* (London, 1932; Dover paperback). A section of this book is published in this anthology. Wölfflin's principles were first formulated in a lecture delivered to the Prussian Academy on December 7, 1911 ("Das Problem des Stiles in der bildenden Kunst," *Sitzungsberichte der Kgl. Preussischen Akademie der Wissenschaften* [Jahrgang 1912], pp. 572–78). After Wölfflin published his *Grundbegriffe* in 1915 and took cognizance of his critics, he recanted some of his views ("'Kunstgeschichtliche Grundbegriffe.' Eine Revision," *Logos: Internationale Zeitschrift für Philosophie der Kultur* XXII [1933], pp. 210–18, and repub. in his *Gedanken zur Kunstgeschichte* [Basel, 1941]); but his revisions have little affected scholarship.

intelligible without the earlier" [*ibid.,* p. 18].[59] A pure empiricist who never mistook description for explanation, he refused to speculate about the causes of this development.

Wölfflin's conceptual tools were based on the morphological structure of the visual arts ("our categories are merely forms . . ." [*ibid.,* p. 227]). When he speaks of "Classic" and "Baroque," his concepts have not a normative, but merely a descriptive, significance. He thought they could be used to define differences in national styles as well as period and artistic styles. Moreover, the concepts could be applied to other historical periods, though in a less clearly defined form ("certain homonymous developments from the linear to the painterly have taken place more than once in the West" [*ibid.,* p. 232]). For instance, he equated the concepts of the High Gothic with those of the High Renaissance, and the concepts of Late Gothic with those of the Baroque.

Wölfflin's refined model of the cyclical evolution of the visual arts had an immediate and widespread impact not only on art historical studies but also on literary scholarship, musicology, and even economics.

The transfer of his antithetical categories to other disciplines[60] brought out some of their weaknesses. In art history these shortcomings have long been seized upon by his critics. The strongest objection has been that Wölfflin overlooked that phase (or attitude) of Italian painting known as Mannerism, which encompassed a large group of works produced in Italy between the High Renaissance and the Baroque. Wölfflin was not unaware of these works, which in 1899 he summarily dismissed as a decline from the norms of the High Renaissance. Ever since the response by Max Dvořák and others to German Expressionism and Surrealism, Mannerism has come to be recognized by most scholars as a style characterized by positive formal and symbolic qualities. Wölfflin's critics have also pointed out, rightly, that the *Grundbegriffe* cannot be applied to the art of other periods. Though Wölfflin states explicitly that some "Baroque" traits occur in the 16th and 18th centuries, and that artistic homogeneity is lacking in the High Renaissance and the Baroque, he excludes the possibility of the coexistence of several modes of vision in a single period or in an individual work.[61] His model is inapplica-

[59] As early as his first publication, *Renaissance und Barock* (Munich, 1888 [trans. Kathrin Simon, Ithaca, N.Y., 1966; Cornell paperback]), in which the nature and origins in 16th- and 17th-century architecture in Italy are examined, Wölfflin conceives of changes in style as part of an inevitable internal development unaffected by such external factors as individual genius or society. The methodology and perspective of this book caused Paul Frankl (1878–1962) to compose a gentle but firm analytical critique (*Die Entwicklungsphasen der neueren Baukunst* [Leipzig, 1914; *Principles of Architectural History: The Four Phases of Architectural Style, 1420–1900,* trans. James F. O'Gorman, Cambridge, Mass., 1968]). This critique formed the basis of Frankl's *Das System der Kunstwissenschaft* (Brno, 1938), the bulkiest (some 1,000 pages) and most weighty theoretical treatise by an art historian of our times. In his *System,* Frankl evolved the antithetical categories of a style of Being and a style of Becoming, which are defined by reference to the formal qualities of works of art, and which are subject to a cyclical conception of development.

[60] For instance, by Oskar Walzel to literature, and by Curt Sachs to music. Dagobert Frey has perceptively analyzed the reasons these literary historians and musicologists failed in their attempts to apply Wölfflin's *Grundbegriffe* to their own fields (*Gotik und Renaissance als Grundlagen der modernen Weltanschauung* [Augsburg, 1929]).

[61] In a later book he undertakes a comparison of Italian and German art of the years from about 1490 to 1530 and postulates the existence of national concepts of form that shape the art of these nations through their history (*Italien und das deutsche Formgefühl* [Munich, 1931; *The Sense of Form in Art: A Comparative Psychological Study,* trans. Alice Muehsam and Norma Shatan, New York, 1958; Chelsea paperback]).

ble, for instance, to art at the time of the emperor Justinian (527–65) or Charlemagne (768–814), when the so-called linear and painterly modes existed side by side, sometimes in the same work. Nor is it applicable to 19th- and 20th-century art, which Wölfflin himself recognized ("We must only, in reference to modern art, reckon with a fundamentally different point of departure" [*ibid.*, p. 232]).

In answer to his thesis that stylistic changes come about by changes in the artist's eye, it has been observed that the human eye is not as wholly organic and psychologically predictable an organ as Wölfflin believed it to be (Panofsky). Moreover, because of the internal necessity of his developmental scheme, artistic personalities become irrelevant, for they cannot do whatever they wish or are able to do, thus leading to an "art history without names" ("Naturally, for purposes of illustration, we could only proceed by referring to the individual work of art, but everything that was said of Raphael and Titian, of Rembrandt and Velázquez, was only intended to elucidate the general continuity, but not to set forth the special value of the selected works" [*ibid.*, p. 226]). Because the development from the High Renaissance to the Baroque is seen as inevitable, no account is taken of the various historical determinants of the visual arts, such as function and social and cultural forces. Wölfflin, who rejected the prevailing views of Dvořák and Warburg that ideas are a primary cause of artistic expression, implied that styles have an inherent tendency to change regardless of external forces. With purely visual qualities lying at the core of his categories, and subject matter merely described, Wölfflin is unconcerned with iconographic or social inquiry—a point to which critics have drawn attention, claiming this neglect

may vitiate his thesis and method. On this score it is necessary to put Wölfflin in historical perspective. His concepts evolved at the time of Postimpressionism, when formal values were regarded as far more important than symbolic values, and they reflected the doctrine of art for art's sake. That doctrine, which holds that art is unrelated to the ideas of its time, was propounded by a group of European Romantics that included Flaubert, Gautier, Baudelaire, Pater, and Oscar Wilde. For Wölfflin, then, the history of art is the history of visualization.

His almost Kantian rigidity notwithstanding, it must be emphasized that Wölfflin's model was derived from a vast amount of visual data, from individual works of art rather than historical conceptions and metaphysical speculation.[62] From the point of view of the art historian, this is the strength of his conceptual framework. Though today most critics declare his framework untenable, they nevertheless continue to refine and apply his terminology, and especially his basic morphological comparative approach, in their own inquiries, be they formal, iconographic, or contextual. If students of the arts today continue to object to his formulations, it is perhaps because modern art history is antagonistic toward broad conceptual tools, toward Wölfflin's belief that "the course of the development of art . . . cannot simply be reduced to a series of separate points" (*ibid.*, p. 6). Even if the modern art historian is highly specialized and untheoretical, he is hard put to deny that in his day Wölfflin provided a plethora of new insights into the arts.

Wölfflin's use of antithesis betrays a major tendency in German scholarship of the late 19th and early 20th century. We have already found such a dichotomy in the work of Riegl (haptic and optic), and

[62] This is not to deny that Wölfflin had been strongly influenced by the aesthetic theories of von Hildebrand and Fiedler, as indicated above. The point is that Wölfflin proceeded from the visual arts to his model, and not vice versa.

we shall come to it again, near the end of this introductory essay, in an important book by Riegl's most gifted student, Max Dvořák (idealism and naturalism).[63] The observation of antithetical categories occurs also in the work of Wilhelm Worringer (1881–1965). A major exponent of German Expressionism, Worringer married Lipps' theory of empathy to Riegl's concept of *Kunstwollen*. In his widely read essay *Abstraktion und Einfühlung; ein Beitrag zur Stilpsychologie* (his doctoral dissertation of 1907, published the following year [*Abstraction and Empathy; a Contribution to the Psychology of Style*, trans. Michael Bullock, London, 1953; Meridian Book]), Worringer intended to make a "contribution to the aesthetics of the work of art, and especially of the work of art belonging to the domain of the plastic arts" (*ibid.*, p. 3).[64] He observes a distinction between geometrical (abstract) and organic (empathic) forms in the whole history of art, Eastern and primitive as well as Western. Abstract aesthetic styles characterize peoples oppressed by nature and involved with spiritual reality, while organic styles characterize peoples who have an affinity for nature and find spiritual satisfaction in

it. For Worringer, the cause of this opposition of styles is to be traced to the various *Weltanschauungen*, or total global outlooks, that underlie artistic creation—a concept akin to Riegl's *Kunstwollen*. (The consequences of such a position for later German thought were indeed fateful.)

In recent art historical scholarship, the major theoretical treatise on the problem of historical change is George Kubler's *The Shape of Time: Remarks on the History of Things* (New Haven, 1962; Yale paperback). Kubler's work is a rarity in contemporary historiography because it is written by a native American, and American art historians have generally avoided writing books of a theoretical nature.[65] Meyer Schapiro's often quoted paper entitled "Style" (*Anthropology Today* [Chicago, 1953; University of Chicago paperback]) is largely a searching review of the strengths and deficiencies of the theories of style of other art historians. Schapiro himself does not propose any new theory of style, concluding that "A theory of style adequate to the psychological and historical problems has still to be created."[66] Kubler (born 1912), on the other hand, builds up a powerful arsenal

[63] See my remarks on page 8 about Charles Seltman in regard to prose and poetry.

[64] Worringer further developed his ideas in his *Formprobleme der Gotik* (Munich, 1912 [*Form in Gothic*, London, 1957; Schocken Book]). In later years he published a book on Egyptian art (Munich, 1927 [*Egyptian Art*, trans. Bernard Rackham, London, 1928]) and a book on the origins of panel painting (*Die Anfänge der Tafelmalerei* [Leipzig, 1924]). For his antithetical categories, see the discussion by the English philosopher and critic Thomas E. Hulme, *Speculations; Essays on Humanism and the Philosophy of Art*, ed. Herbert Read (London, 1924), pp. 82–94. These categories directly inspired Charles Seltman in his essay "Art and Society" (*The Studio* CVL [1953], pp. 98–114), where he conceives of two different kinds of art emerging within the framework of social history: "In those ages when men have subjected their minds and souls to Authority and have allowed others to tell them what to think, unrealistic or abstract art has been the rule. But when there has existed a high degree of liberty of thought—whence comes Humanism—then corporeal art has prevailed" (p. 98). He finds abstract art to be far more common than corporeal art in the history of art.

[65] Richard Bernheimer (1907–58) wrote *The Nature of Representation: A Phenomenological Inquiry*, ed. H. W. Janson (New York, 1961) in this country, but he was born and trained in Germany.

[66] Schapiro defines style as "above all, a system of forms with a quality and a meaningful expression through which the personality of the artist and the broad outlook of a group are visible. It is also a vehicle of expression within the group, communicating and fixing certain values of religious, social, and moral life through the emotional suggestiveness of forms" (p. 287). See also Julius von Schlosser, "Über 'Stilgeschichte' und 'Sprachgeschichte' der bildenden Kunst," *Sitzungsberichte*

of carefully reasoned and stimulating conceptual weapons in order to confront specifically the problem of describing change in the visual arts: hence his tremendous importance.[67]

Putting to use his wide knowledge of the concepts of anthropology, the history of science, biology, that branch of linguistics called glottochronology, and in some measure mathematical and philosophical inquiry, as well as the thought of the French art historian Henri Focillon, Kubler proposes the thesis of a linked succession of human productions, including art, that are distributed in time as early and late versions of the same action. Instead of viewing works of art as parts of static categories of style, and the whole history of art as comprising a large number of apparently disparate periods, he emphasizes continuous change in the flow of human materials. "The aim of the historian, regardless of his speciality in erudition, is to portray time. He is committed to the detection and description of the shape of time" (The Shape of Time, p. 12). One of his aims is to connect art history with the history of material culture. As a fundamental concept, he maintains that every work of art, and indeed "all materials worked by human hands," arises "from a problem as a purposeful solution." Once these artistic problems are identified, they will be propagated through "prime objects" and "replications" in "temporal sequences" of varied duration and shapes (including what he terms fast and slow happenings). For Kubler, "prime objects and replications denote principal inventions, and the entire system of replicas, reproductions, copies, reductions, transfers, and derivations, floating in the wake of an important work of art" (ibid., p. 39). "Linked solutions," or series, disclose themselves as open or closed "formal sequences" in time. Most of the linked solutions "are still open to further elaboration by new solutions," but "some are closed, completed series belonging to the past" (ibid., p. 33). Changes take place in the sequences and, while subject to interference from images and meaning, seem to follow "the rules of series." Several formal sequences may coexist within such a complex thing as a Gothic cathedral; indeed "every thing is a complex having not only traits, each with a different systematic age, but having also clusters of traits, or aspects, each with its own age, like any other organization of matter" (ibid., p. 99). Within each sequence, the prime objects function as mutant genes do, propagating change through minute though sometimes significant variations.

These are only a few of the challenging propositions in The Shape of Time. They aspire to replace the static stylistic categories of a Wölfflin or a Riegl with the fundamental concept of changes occurring in long durations of different morphologies. Through his concepts of linked solutions and formal sequences, Kubler

der Bayrischen Akademie der Wissenschaften, Phil.-Hist. Abteilung 1 (1935), pp. 3–39; James S. Ackerman, "Style," in Ackerman and Rhys Carpenter, Art and Archaeology (Englewood Cliffs, N.J., 1963), pp. 164–86.

[67] Kubler is a noted specialist in the art and civilization of Spain and ancient America and has published a large number of distinguished studies, including: The Religious Architecture of New Mexico in the Colonial Period and Since the American Occupation (Colorado Springs, 1940); Mexican Architecture of the Sixteenth Century (New Haven, 1948); The Art and Architecture of Ancient America (Baltimore, 1962); with Martin Soria, Baroque Art and Architecture in Spain and Portugal and their American Dominions, 1500–1800 (Baltimore, 1959); trans., introd., and notes to Felix da Costa, The Antiquity of the Art of Painting (New Haven, 1967); The Iconography of the Art of Teotihuacán (Washington, D.C., 1967); Studies in Classic Maya Iconography (Hamden, Conn., 1969). At Yale University he has been teaching the historiography of art as well as courses dealing with the art of ancient America.

"discards any idea of regular cyclical happening on the pattern of 'necessary' stylistic series by the biological metaphor of archaic, classic, and baroque stages." For the shapes of time, he replaces biological with historical time: "Sequence classing allows us to bridge the gap between biography and the history of style with a conception less protean than biological or dialectic theories of the dynamics of style, and more powerfully descriptive than biography" (ibid., p. 36). His theory is designed to handle difficult problems— or so they have seemed to some—such as the investigation of the oeuvre of great masters—Michelangelo, El Greco, and Goya—who straddle several art historical periods. It enables us to conceive of such things as portraits and landscape paintings as artistic problems that are not peculiar to individual periods or creators but belong to the whole history of art. In this way, the barriers are broken down between Western art on the one hand and "primitive" and Oriental art on the other, and even those barriers currently existing, for many, between art history and such fields as cultural anthropology, archaeology, and the whole history of science. Kubler submits that "a rapprochement between the history of art and the history of science can display the common traits of invention, change and obsolescence that the material works of artists and scientists both share in time." But perhaps the greatest appeal of The Shape of Time derives from its proposal of a valid alternative to the traditional methods in art history—formal analysis and iconography—of which not only Kubler but many other specialists also are especially critical.

These are inherent difficulties in Kubler's thesis and in the concepts upon which it was constructed. For one thing, he equates works of art with other manmade objects, including tools and machines. In the preceding pages we have suggested that a major task of the art historian is to try to reconstruct the unique aesthetic and technical qualities of the work or works with which he is concerned —a task which demands that he distinguish art from other things.[68] Secondly, Kubler's thesis asks us to focus on individual characteristics or aggregates thereof, rather than on the whole work of art. According to his schema, it is necessary to single out these traits—although, in my opinion, his exposition is not fully clear as to how they can be identified—and therefore to examine only some aspects, however significant, of works of art. Moreover, artistic personality, which, to be sure, Kubler does not ignore, is relegated to a position of secondary importance: "Biography is a provisional way of scanning artistic substance, but it does not alone treat the historical question in artists' lives, which is always the question of their relation to what has preceded and to what will follow them" (ibid., p. 6). Thirdly, Kubler is concerned more with the description than with the explanation of the change of things in time. We have seen that other concepts of stylistic change can be criticized for their failure to account satisfactorily for the reasons that different modes of artistic expression manifest themselves. Kubler's thesis seems to be open to the same charge.

These apparent limitations fail to invalidate the concepts in The Shape of Time. It remains a closely written little book based on the observation of empirical evidence as well as theoretical speculation, and far more cogently argued than any summary can possibly indicate. In its challenge to current methods in art history, Kubler's thesis represents an important contribution to the historiography of art.

This brief summary may suggest that the study of the visual arts has been guided by

[68] Whether art historians can continue to maintain this point of view may well depend on their response to the course of contemporary art, especially that of the 1960s, which has been breaking down the traditional distinction between the "fine arts" and the "applied arts."

various conceptions of history and historical change. Aristotelianism, Hegelianism, and especially Darwinism rank among the most influential ideas in the historiography of art—a fact that is disclosed by an analysis of the contributions of some of the more celebrated scholars, but one that is too rarely recognized or admitted by art historians themselves. Yet these very conceptions have been singled out as the major flaws in older scholarship. Writers have been praised for the precision with which they handle documentary evidence and analyze the inherent qualities of works of art, while their writings are rejected for their theoretical bases. In fact, the contributions of some scholars have been extolled for the seeming absence of any historical theory. The work of the German art historian Adolph Goldschmidt is a case of point. (In spite of his disdain for theoretical speculation, careful inspection of his writings would doubtless reveal some historical and conceptual presuppositions.) Some art historians condemn, or remain indifferent to, scholarship that is moulded by a recognizable philosophy of history; such an attitude was implicit in much American scholarship prior to the 1960s. Of course, the disavowal of such points of view also issues from a philosophy of history and causal explanation that is necessarily theoretical in its presuppositions. Nonetheless, the position of such disbelieving art historians may be vindicated by the possibility that there are no general patterns in history after all, the brilliant speculations of a Spengler or Toynbee notwithstanding. It is plainly evident that there are too many significant lacunae in our knowledge of the *oeuvres* of individuals and groups of artists and of the documentary evidence connected with them for historical generalizations to be made. But after all, art historians must make some attempt to generalize if they aspire to communicate their specialized knowledge.

The many attempts by scholars to relate the visual arts to notions and theories of evolution and progress disclose a tendency to make art history a science, to create an objective and systematic investigation of the arts, or what German scholars term *Kunstwissenschaft*.[69] This tendency is found in European, especially German, scholarship, most conspicuously in certain writings by Hans Sedlmayr in the 1930s. Drawing upon the thought of the logical positivists in the philosophy of science, the distinguished Viennese art historian and critic attempts to establish an ideal, rigorous *Kunstwissenschaft* through his proposal of two sciences of art. The task of the first science is to observe, record, and organize data, such as historically documented facts and certain salient qualities of works of art; the second science, the higher of the two, strives to analyze and evaluate the principles of their structural composition. The second science must proceed from the data organized in the first, though it may help to explain the organization of those data. It is suggested that the second science operate with the methods of Gestalt psychology as a reliable means of explaining the structural principles of works of art, which for Sedlmayr tend to be formal rather than symbolic and largely divorced from their social and cultural milieu. For the structural analysis of a work, the scientific observer must possess the "correct mental set," and this is known only after all the facts are accounted for; then he can check and verify the formal relations underlying the principles of the work. Sedlmayr has applied this rigorous scientific method to two case studies in architecture, one of the period of the Byzantine emperor Justinian the

[69] See E. H. Gombrich, "Kunstwissenschaft," in *Atlantisbuch der Kunst* (Zurich, 1952), pp. 653–64; and Claus Zoege von Manteufel, "Kunstwissenschaft als Wissenschaft," in *Kunstgeschichtliche Studien für Kurt Bauch zum 70. Geburtstag von seinen Schülern*, ed. Margrit Lisner and Rüdiger Becksmann (Munich, 1967), pp. 301–12.

Great (527–65),[70] the other of Francesco Borromini (*Die Architektur Borrominis* [Berlin, 1930]). While these studies have contributed to our knowledge of that architecture, they can be criticized harshly for their incorrect application of the "mental sets" and their placement of works of art in theoretical strait jackets.[71]

The ideal art history is certainly not a science, the contrary claims of some critics notwithstanding. The concepts and methods of the natural sciences are inapplicable to art historical inquiry. The art historian is interested in works of art as something to be investigated; the scientific historian looks at his subject matter as something that helps him to investigate. The visual arts cannot be subjected to controlled experimentation without disregard for their aesthetic individuality. The data of the art historian are unique, while those of the scientific historian are specimens of a class, or cognate occurrences under a law. The former approaches his material with personal involvement, perceptiveness, and sensibility, the latter with impartiality and rigorous objectivity. The one is as concerned with the unique aesthetic qualities of a work as with those it shares with different works, while the other seeks out the common and uniform. The art historian is as concerned with the particular as with the general, with the uncommon as with the common, and he shuns the tendency of the scientific historian to empty works of their aesthetic significance and drain away their aesthetic integrity.

Nevertheless, art history shares some aspects of the natural sciences.[72] Both require imagination, insight, common sense, erudition, accuracy, and scrupulousness with regard to fact. Both proceed from illuminating hypotheses, precise observation, logical analyses, and various critical devices of testing and evaluation. Yet even these similarities in methodology fail to yield an equation of art history and science. The judgments of the art historian are not correct or incorrect in the way a hypothesis in science is; rather they are illuminating for the time and place in which they are made. Art historians may approach art and work around it, but they can never penetrate its mysterious core in the way a scientist seeks out the truth of his theories and hypotheses. Let it be emphasized that art historians tend rather to assess than to conclude. They are not interested in formulating general principles or laws that are verifiable or falsi-

[70] In two papers: the first, "Das erste mittelalterliche Architektursystem," in *Kunstwissenschaftliche Forschungen*, vol. II, ed. Otto Pächt (Berlin, 1933), pp. 25–62; the second in *Byzantinische Zeitschrift* XXXV (1935), pp. 38–69. For a recent criticism of this work, see Friedrich W. Deichmann, "Wandsysteme," *Byzantinische Zeitschrift* LIX (1966), pp. 334–58.

[71] See the instructive comments by Meyer Schapiro in "The New Viennese School," *Art Bulletin* XVIII (1936), pp. 258–66. Sedlmayr's *Strukturanalyse*, or configurational analysis, approach to art survives in some of his more recent writings, for instance his interpretation of Vermeer's *Allegory of Painting* (conveniently republished in Sedlmayr's collection of essays *Kunst und Wahrheit: Zur Theorie und Methode der Kunstgeschichte* [Hamburg, 1958], pp. 161–72) and *Die Entstehung der Kathedrale* (Zurich, 1950), which is searchingly reviewed by Paul Frankl in *The Gothic* (Princeton, 1960), pp. 753–59. For Sedlmayr's bibliography from 1923 to 1961, see *Festschrift für Hans Sedlmayr*, ed. Karl Oettinger and Mohammed Rassem (Munich, 1962), pp. 349–55. *Strukturanalyse* is seen at work in writings by other scholars, for instance Friedrich Matz, *Geschichte der griechischen Kunst*, 2 vols. (Frankfurt, 1950). The work of some of Sedlmayr's disciples is found in *Probleme der Kunstwissenschaft*, ed. Hermann Bauer, 2 vols. (Berlin, 1963–67), the first volume of which has been harshly criticized by E. H. Gombrich in *Art Bulletin* XLVI (1964), pp. 418–20, with a rejoinder in *ibid.*, XLVII (1965), pp. 307–9.

[72] See especially the valuable discussion by Edgar Wind, "Some Points of Contact between History and Natural Science," in *Philosophy and History: Essays Presented to Ernst Cassirer*, ed. Raymond Klibansky and H. J. Paton (Oxford, 1936), pp. 255–64.

fiable by controlled observation or experimentation. Modern art history neither knows nor seeks unalterable principles or laws; instead, it undertakes to identify and explain the main characteristics of individual works and the nature of the relationships among groups of works.[73]

Today, art history is, on the whole, empirical and specific rather than speculative and sweeping. Our modern age, with its scientific and technological bias, has made man skeptical about the idea that perceptual experience alone can disclose what the world is really like. Before our day, historians proceeded from reason or faith, relying mainly on their memories and perceptions to form judgments. Today they feel compelled to combine ordinary perceptual experience with inductive procedure. Adopting the tools of scientific method, they observe and accumulate data and formulate theories and hypotheses only if the data are repeatable, as in controlled laboratory experimentation. For the history of art, the consequence of such attitudes has been cautiousness, skepticism, and indeed theoretical paralysis. There is in our day a dearth of widely accepted generalizations, and the introduction of new generalizations and especially of new theories and hypotheses is too often greeted with closed minds.

Like the social sciences, modern art history is marked by specialization. The interest of too many art historians centers on the *oeuvre* of one artist or the works of a narrowly defined group or school. Art historians often work within a single period, and sometimes even with a single medium of artistic expression. This has led, for example, to an increasing separation of ancient art history and especially architectural history from art history, at least in American scholarship.[74] The spe-

cialization that characterizes the discipline today cannot be attributed solely to the impact of scientific attitudes. Another factor is at work. In the 20th century there has been a tremendous wealth of discoveries in archives and other collections of documents, and in excavations, iconographical research, and other forms of scholarly activity. The publication of these finds is often in widely scattered journals and in different foreign languages, only some of which can be mastered by any one scholar. Thus, since the acquisition of all new information would absorb too much of the scholar's time and energy, he is perforce required to specialize. And as he increasingly does so, he must also narrow his perspectives, with the result that the increase in his factual information and knowledge runs the danger of being inversely proportional to his understanding and ability to communicate the broad concepts of his discipline.

Though specialization continues to increase, some art historians have avoided it by becoming involved in related branches of learning. Realizing that the visual arts comprise more than purely formal and symbolic qualities—a notion that has come from an increased understanding of the complexity both of the motivations and actions of man and of his products—they have begun to test the methods, concepts, and findings of such disciplines as sociology, anthropology, glottochronology, the history of science, psychology, psychoanalysis, and even mathematics. Such an involvement is still in a state of infancy, but pioneering attempts by such scholars as E. H. Gombrich, Hans Sedlmayr, Kurt Badt, George Kubler, and Erwin Panofsky, to name a few, intimate how significant a contribution can be made toward a deeper and fuller understanding of the visual arts

[73] Compare the remarks by Robert Stover, *The Nature of Historical Thinking* (Chapel Hill, N.C., 1967).

[74] See James S. Ackerman "On American Scholarship in the Arts," *College Art Journal* XVII (1958), pp. 357–62.

by removing the barriers between the various branches of humanist learning. To quote the noted historian of the Renaissance Paul Kristeller, addressing himself to the scholarship of Erwin Panofsky:

Panofsky conceives of the visual arts as a part of a universe of culture that also comprises the sciences, the philosophical and religious thought, the literature and scholarship of the Western world in the various phases of its history. This is the kind of 'true humanism' of which we are badly in need, and in spite of our present grim outlook, there is some hope for the future of our civilization as long as its cause is being upheld by scholars of Panofsky's caliber. [Art Bulletin XLIV (1962), p. 67]

GENRES OF MODERN SCHOLARSHIP

A multiplicity of genres flourishes in modern art history: indeed, this may be regarded as its salient characteristic. The variety of approaches to the visual arts can be said to fall under two rubrics: intrinsic and extrinsic perspectives. These classifications, though somewhat arbitrary, are established for the sake of convenience. Intrinsic perspectives focus on describing and analyzing the inherent qualities of the work of art. They deal with materials and technique; problems of authorship, authenticity, dating, and provenance; formal and symbolic characteristics, and function. In other words, they proceed from the work of art itself and aim to delineate its properties. Many scholars hold that art historical inquiry should be limited to these matters, and they restrict their investigations accordingly. Others maintain that a full understanding of the work of art requires an examination of the various conditions surrounding and influencing it. Their frame of thought may be described as extrinsic. They are intent on investigating in full the circumstances of the work's time and place, including artistic biography, psychology and psychoanalysis, social, cultural, and intellectual determinants, and the history of ideas. They focus on the artist, the nature of the creative process, and the forces that lend shape and color to the artist's work. In many cases this line of investigation has its point of departure in the work itself, but the description and examination of the inherent qualities of the work lead the scholar directly to external evidence for their interpretation. Thus, by definition, extrinsic approaches have a much wider frame of reference than intrinsic approaches.

In the following pages, I will attempt to analyze these perspectives by providing a brief historical introduction to the major genres in modern art history and some representative examples of each.[75] It will be a sketch rather than a full-length portrait of the history of art in our day, but I hope that it will afford the reader some notion of the constellations of thought and the investigative techniques and methods that have been employed. The reader is forewarned that this presentation will tend to dehumanize the personalities and accomplishments of particular art historians, who will be treated in terms of method and interpretation rather than individually.[76] Many of the scholars

[75] A classic study of recent art history in America is Erwin Panofsky's "Three Decades of Art History in the United States" (*Meaning in the Visual Arts* [Garden City, N.Y., 1955; Doubleday Anchor Book], pp. 321–46). See also James S. Ackerman and Rhys Carpenter, *Art and Archaeology* (Englewood Cliffs, N.J., 1963), pp. 196–229; Luigi Salerno, *Encyclopedia of World Art*, s.v. "Historiography"; Rudolf Wittkower, "Art History as a Discipline," *Winterthur Seminar on Museum Operation and Connoisseurship, 1959* (Winterthur, Delaware, 1961), pp. 55–69; Leopold D. Ettlinger, *Art History Today* (London, 1961); Jacques Lavalleye, *Introduction aux études d'archéologie et d'histoire de l'art*, 2d ed. (Tournai, 1958); Alfred Neumeyer, "Victory without Trumpet," *Frontiers of Knowledge in the Study of Man*, ed. Lynn White, Jr. (New York, 1956), pp. 178–93; and the revealing work of Colin Eisler, "Kunstgeschichte American Style: A Study in Migration," *The Intellectual Migration: Europe and America, 1930–1960*, ed. Donald Fleming and Bernard Bailyn (Cambridge, Mass., 1969), pp. 544–629. Udo Kultermann's *Geschichte der Kunstgeschichte* (Vienna, 1966) focuses on German scholarship in an anecdotal manner.

[76] Nonetheless, let us point to the pertinent observation by the eminent historian of the Soviet Union Edward Hallett Carr: "Before you study the history, study the historians." And: "Before you study the historian, study his historical and social environment. The historian, being an individual, is also a product of history and of society; and it is in this twofold light that the student of history must learn to regard him" (*What Is History?* [London, 1962; Vintage Book], p. 38).

who will be mentioned (and even more who will not) have used a number of methods and expressed diverse points of view in their writings, revealing not only intellectual growth but also flexibility of thought. This wide-ranging treatment of works of art characterizes the most brilliant and persuasive minds in art history but can only be alluded to here. The reader interested in the varied approaches of individual scholars is advised to acquaint himself directly with their writings. For this purpose, some selected references have been included in the notes that accompany the following pages.

The logical starting point for any investigation is the work of art itself, for it alone can justify interest and scholarship in art history. When proceeding from the object, the art historian is first called upon to examine its physical properties: size, condition, materials, and technique of execution. Close analytical examination of these properties can disclose invaluable clues about the creator, date, and provenance of the work.[77] For a painting, the species of wood or the texture of the canvas and the pigments used can provide the evidence on the basis of which these important questions of concern to all art historians can be answered. If a picture assumed to be by Albrecht Dürer is discovered to be painted on oak rather than lime wood, and if it is known that oak was used in the Netherlands but not in southern

Germany during Dürer's lifetime, then it would be safe to assume that either the picture was done during his sojourn in the Netherlands about 1520 or 1521, or it is by another artist altogether. Shadowgraphs and photomicrographs of the surfaces of paintings can be used to ascertain both authenticity of attribution and the changes in the technique of an artist, and chemical tests of pigments can lead to a determination of the age of a painting. Scientific techniques are clearly of great assistance to the art historian. In fact, with forgeries appearing on the market in increasing numbers, or at least with growing cleverness of execution—particularly in ivory carvings supposedly of medieval date—scientific methods of analysis are becoming indispensable aids to art-historical investigation. At the same time their uses are limited. X rays taken over a decade ago of the 15th-century Ghent Altarpiece revealed various layers of paint of different ages but failed to resolve the problematic issue of which portions of the altarpiece were executed by Hubert van Eyck and which by Jan, or even whether both brothers worked on the masterpiece.[78] There is far more to art history than the use of scientific techniques.[79]

The value of technical studies has been admirably stated by Alan Burroughs in *Art Criticism from a Laboratory* (Boston, 1938), and by Arthur P. Laurie in *New Light on Old Masters* (London, 1935) and *The Technique of the Great Painters* (Lon-

[77] See Max J. Friedlander, *On Art and Connoisseurship* (London, 1942; Beacon paperback).

[78] The results have been published by Paul Coremans, *L'Agneau Mystique au Laboratoire* (Les Primitifs Flamands, III. Contributions à l'étude des primitifs flamands, 2 [Antwerp, 1953]). See Mojmír S. Frinta, *The Genius of Robert Campin* (The Hague, 1966).

[79] For instance, the computer is likely to aid art historians in answering questions about changes in style and connoisseurship; it cannot become a substitute for their thinking ("Editorial," *Burlington Magazine* CX [1968], pp. 173–4). See, however, Jules Prown, "The Art Historian and the Computer: An Analysis of Copley's Patronage 1753–1774," *Smithsonian Journal of History* I (1966), pp. 17–30; *John Singleton Copley*, 2 vols. (Washington, D.C., 1966): I, pp. 101–99. See further in *Computers for the Humanities? A Record of the Conference Sponsored by Yale University . . .* January 22–23, 1965 (New Haven, 1965), esp. pp. 113–16.

don, 1949).[80] Photomicrographs of selected portions of some paintings and drawings by Rembrandt have been used by Laurie to ascertain authorship (*The Brush-work of Rembrandt and His School* [London, 1932]). The findings of Laurie and other specialists have been utilized by Jakob Rosenberg in undertaking the question of Rembrandt's technical means and their stylistic significance (in a chapter of his *Rembrandt: Life and Work* [Cambridge, Mass., 1948; rev. ed., London, 1964; Phaidon paperback]). Underpainting, or sinopia, in the 14th and early 15th centuries as revealed in Italian wall decoration is discussed by Ugo Procacci in *Sinopie e affreschi* (Milan, 1961); his presentation has greatly enhanced our understanding of the materials and technique of muralists of that time. In general, questions of materials and technique and the findings of conservationists are reported in two journals. *Technical Studies in the Field of the Fine Arts* (since 1932), edited by George L. Stout (born 1897), and *Art and Archaeology Technical Abstracts* (formerly *Abstracts of the International Institute for the Conservation of Museum Objects*), published since 1955.

In architectural history, especially of the pre-Renaissance period, the study of materials and building methods can be of great assistance in dating monuments and understanding their structural and even formal principles. It is known that in the Middle Ages, certain geographical centers tended to perpetuate the use of certain materials and building techniques, which evolved slowly and gradually (barring technological innovations). If the dates of some buildings in a city or region are known from historical sources, a careful examination of their materials and tech-

niques and those of undocumented buildings can lead to the establishment of relative chronologies. Such analyses are laborious but result in important disclosures. From the 19th century to the second third of the 20th this approach typified French scholarship of medieval architecture, and it is still useful. It has been employed with brilliant results in the study of Byzantine architecture by Friedrich W. Deichmann (*Studien zur Architektur Konstantinopels im 5. und 6. Jahrhundert nach Christus* [Baden-Baden, 1956]), John Bryan Ward Perkins (a chapter of *The Great Palace of the Byzantine Emperors*, second report, ed. David Talbot Rice [Edinburgh, 1958]), and others. It has also led to an increased understanding of medieval architecture, as is impressively evident from the researches of Arthur Kingsley Porter (*Lombard Architecture*, 4 vols. [New Haven, 1915–17]) and Walter Horn ("Romanesque Churches in Florence," *Art Bulletin* XXV [1943], pp. 112–31), among others. In the field of 19th- and 20th-century architecture, the architects themselves have helped make scholars aware of the vital role played by materials in the genesis and evolution of new modes of expression; see, for example, the remarks by Dankmar Adler, Louis Sullivan's partner, in "The Influence of Steel Construction and of Plate Glass upon the Development of the Modern Style" (*Inland Architect and News Review* XXVIII [1896]). Because materials have become so important, discussion of them is indispensable to most studies of modern architecture (for example, Nikolaus Pevsner, *Pioneers of the Modern Movement, from William Morris to Walter Gropius* [London, 1936; *Pioneers of Modern Design*, Penguin Books, 1964], and Henry Russell Hitchcock,

[80] See also George L. Stout, *The Care of Pictures* (New York, 1948), and the papers by E. H. Gombrich, Otto Kurz, Joyce Plesters, and Denis Mahon, in *Burlington Magazine* CIV (1962), as well as the bibliography cited by these specialists.

In the Nature of Materials: 1887–1941; The Buildings of Frank Lloyd Wright [New York, 1942], the basic study of the works of Wright). Occasionally, materials become the focal point of whole monographs (Sigfried Giedion, Bauen in Frankreich; Eisen, Eisenbeton, 2d ed. [Leipzig, 1928]; J. Gloag and D. Bridgewater, Cast Iron in Architecture [London, 1948]; Peter Collins, Concrete: The Vision of a New Architecture; A Study of Auguste Perret and his Precursors [New York, 1959]; Carl W. Condit, American Building: Materials and Techniques from the First Colonial Settlements to the Present [Chicago, 1968; University of Chicago paperback]).

In our times, a fundamental departure from the traditional uses of, and attitudes toward, materials appropriate for the making of art is evident in painting and sculpture as well as architecture. The creations of the Cubists are a case in point. For many of his constructions, Picasso selected not marble or bronze but materials that had been processed and shaped to serve utilitarian functions—for instance, scraps of wood from boxes and canvas stretchers. He assembled unconventional materials into unexpected, homogeneous, and aesthetically significant works. Since the early experiments of Picasso and Braque, artists have considerably widened the range of materials and the aesthetic effects they produce. The elaboration of the surface of a painting or sculpture with cloth, plastics, and laminated wood, by such artists as Alberto Burri, Robert Rauschenberg, and George Sugarman, has even led to a reformulation of the established definitions of the media of painting and sculpture. The various approaches to these arts in our century are discussed by Andrew C. Ritchie in Sculpture of the Twentieth Century (New York, 1952); Carola Giedion-Welcker in Contemporary Sculpture; An Evolution in Volume and Space (New York, 1955); William Seitz in The Art of Assemblage (Garden City, N.Y., 1961); and Robert Rosenblum in Cubism and Twentieth-Century Art (New York, 1961; Abrams paperback).

Some art historians have dealt with materials and techniques for very different reasons. They have maintained that these aspects of a work of art are its salient characteristics, that the material and technical factors of the visual arts are their determinants, and that style is to be defined by reference to them.

As was pointed out earlier, Gottfried Semper propounded that changes in art are caused by environment and changes in materials and technique. Though his "materialistic" views were attacked and discarded by Riegl and his followers, they continue to reverberate in the writings of more than a few modern art historians. The work of Sigfried Giedion (1888–1968), a student of Wölfflin and the single most influential historian of modern architecture among scholars and architects alike, is marked by a decidedly technological bias (Space, Time and Architecture; The Growth of a New Tradition [Cambridge; Mass., 1941]). Largely unconcerned with the social aspects of buildings, though not of artistic personality, Giedion contends that the new requirements in modern architecture could not be met until the materials and technology necessary for their fulfillment were discovered. Another scholar who was even more strongly influenced, consciously or not, by the views of Darwin and Semper is the prominent American historian of ancient Greek art Rhys Carpenter (born 1889). In his recent major study, Greek Sculpture, a Critical Review (Chicago, 1960), Carpenter endeavors to demonstrate "that sculptural styles are not casual mannerisms, such as an artist might at any time invent and popularize, but are strictly conditioned by evolutionary laws which are in turn dependent upon the unchangeable dictates of the mechanism of human vision." His frame of reference focuses upon technical procedures: "the technique of the artist's craft is the mirror in which the

pageant of changing and evolving style is reflected" (*ibid.*, p. v). Though his writings abound with perceptive and subtle formal analyses of Greek sculpture—his account of the work of Polyclitus is especially enlightening—his theories have not found wide acceptance among historians of ancient art.

More influential in Europe and especially in the United States has been the work of Henri Focillon (1881–1943), the first in France (during the 1930s) to take cognizance of Viennese *Kunstwissenschaft* and to liberate French and medieval art history from its philological and archaeological strait jacket.[81] As did Wölfflin and Riegl, Focillon posited an autonomous internal development of forms, which he often characterized by reference to a triadic formula—experimental, classical, and baroque (*Vie des Formes* [Paris, 1934; *The Life of Forms in Art*, 2d English ed., enl., trans. Charles B. Hogan and George Kubler, New York, 1948]). Rather than invoke Riegl's concept of *Kunstwollen*, Focillon emphasized the role of materials and technique in the creative process: "the examination of technical phenomena not only guaranteed a certain controllable objectivity, but afforded an entrance into the very heart of the problem, *by presenting it to us in the same terms and from the same point of view as it is presented to the artist*" (*The Life of Forms in Art*, 1948, p. 36). Defining art largely by its material qualities, he proposed that "technique is not only matter, tool and hand. . . . it is also mind speculating on space." For Focillon, it is this interaction of matter and mind that most clearly exposes the creative art.

While Focillon's major theoretical treatise is *Vie des Formes*, his frame of reference is best seen in use in his stimu-

lating and most mature book, *L'art des sculpteurs romans* (Paris, 1931), of which the chapter entitled "Métamorphoses" is published in this book in English translation. Of metamorphoses in medieval art he put forward the following in his *Vie des Formes:*

The most rigorous rules, apparently intended to impoverish and to standardize formal material, are precisely those which, with an almost fantastic wealth of variations and of metamorphoses, best illuminate its superb vitality. What could be more removed from life, from its ease and its flexibility, than the geometric combinations of Moslem ornament? These combinations are produced by mathematical reasoning. They are based upon cold calculation; they are reducible to patterns of the utmost aridity. But deep within them, a sort of fever seems to goad on and to multiply the shapes; some mysterious genius of complication interlocks, enfolds, disorganizes, and reorganizes the entire labyrinth. Their very immobility sparkles with metamorphoses. Whether they be read as voids or as solids, as vertical axes or as diagonals, each one of them both withholds the secret and exposes the reality of an immense number of possibilities. An analogous phenomenon occurs in Romanesque sculpture. Here, abstract form is both stem and support for a strange, chimerical image of animal and human life; here monsters that are shackled permanently to an architectural and ornamental definition are yet endlessly reborn in so many different ways that their captivity mocks both us and itself. Form becomes a *rinceau*, a double-headed eagle, a mermaid, a duel of warriors. It duplicates, coils back upon, and devours its own shape. Without once trespassing its limits or falsifying its principles, this protean monster rouses up, and unrolls its demented existence—an existence that is merely the turmoil and the undulation of a single, simple form. [*ibid.*, p. 6]

Focillon thus propounds that the life of art lies in the transformation of forms,

[81] For Focillon's accomplishment, see *Bibliographie Henri Focillon*, comp. Louis Grodecki (New Haven, 1963), and the sympathetic appraisal by Focillon's disciple Jean Bony, in the introduction to Focillon's *Art of the West in the Middle Ages*, ed. Jean Bony, trans. Donald King, 2 vols. (London, 1963; Phaidon paperback).

and that this life can be manifested in the infinite metamorphoses that evolve from a single central theme. At the risk of over-simplification, it may be said that his thought is framed by an acceptance of Wölfflin's and Riegl's doctrines of an autonomous development of forms and by a rejection of idealist aesthetics, reverting, as it were, to the materialist doctrine of Semper and his adherents.

Focillon added a new coordinate to the map of French art history. He unfettered the shackles of its philological and archaeological tradition and exposed it to broader horizons. Since the 1930s, a considerable number of historians on both sides of the Atlantic have fallen under his influence. In the years before his death in 1943, Focillon was a visiting professor in the Department of Art History of Yale University, where his lectures and writings assumed a position of authority. His inspiration is evident in the varied work of a number of art historians at Yale, including George Kubler, Carroll L. V. Meeks, and George Heard Hamilton.

Focillon's concern with the metamorphoses of great central themes has been shared by a few Europeans, among them the Lithuanian art historian Jurgis Baltrušaitis (born 1903). In his early scholarship on the medieval art of Georgia and Armenia, and in his important book on Romanesque sculpture where a "law of the frame" is postulated (La Stylistique ornamentale dans la sculpture romane [Paris, 1931]),[82] Baltrušaitis reveals an interest in both form and iconography. After he moved to Paris in 1947, he took up the theme of Focillon's metamorphoses in several stimulating papers (Le Moyen âge fantastique; antiquités et exotismes dans l'art gothique [Paris, 1955]; Anamor-phoses, ou perspectives curieuses [Paris, 1955]; Aberrations: quatre essais sur la légende des formes [Paris, 1957]). In these works, he seeks out possible connections between the art of the Orient and that of the Latin Middle Ages. He followed Focillon (his father-in-law) in becoming a visiting lecturer at Yale University.

Focillon's work seems also to have exerted an influence on the scholarship of Charles Sterling (born 1901), author of La Nature morte de l'antiquité à nos jours (Paris, 1952 [Still Life Painting from Antiquity to the Present Time, new rev. ed., trans. James Emmons, New York, 1959]), as well as on André Chastel.

In interpreting the artistic process and artistic changes, few modern art historians attach very much importance to materials and techniques. These do not in themselves create artistic idioms. Significant changes in the formal qualities of works of art can take place without appreciable change in materials and techniques, and vice versa, although changes in the two usually go hand in hand. The introduction of new techniques accounts for only the physical potentialities and limitations of works of art. In the case of oil painting in early Netherlandish art at the beginning of the 15th century, it took a Jan van Eyck to discover the possibilities of the new medium (though not the medium itself) and to exploit them. The technique and the physical properties of the material substance are important to his paintings only on the strength of their formal and symbolic qualities. Other factors were at work, foremost among them the intelligence and skill of the creator and the social and intellectual forces at work in his day. And certainly the new medium by itself fails to explain the course early

[82] Part of this book can be found in English translation in Art History: An Anthology of Modern Criticism, ed. Wylie Sypher (New York, 1963; Vintage Original), pp. 116–31. For a perceptive examination of this essay, see Meyer Schapiro's work on schematism in Romanesque art ("Über den Schematismus in der romanischen Kunst," Kritische Berichte zur kunstgeschichtlichen Literatur [Leipzig, 1932–33], pp. 1–21).

Netherlandish artists followed after Jan van Eyck. Since the contributions of Riegl, Croce, and Freud, it has been not matter but mind that has had the upper hand in the historiography of art.

But mind has not replaced matter in the methodologies of connoisseurship and other important branches of modern art history. The aim of connoisseurship is to restore works of art to their original positions—of time and place—in the stream of creative production. It tackles questions of authenticity and attribution, hence dating and provenance. It generally deals with painting and sculpture, occasionally with architecture, which, because it is the work of many hands rather than one or a few, is not as susceptible to connoisseurship's techniques. Of course, in the case of individual architects it may be very useful: its techniques may be employed to define the *oeuvre* of Frank Lloyd Wright, for example, and to relate it to the work of his followers in the Prairie School.

Since the objective of the connoisseur is ordinarily confined to the determination of authenticity and authorship, his field is regarded by some as a branch of study separate and distinct from art history. This point of view is espoused by a minority of scholars and is difficult to uphold.[83] In order to achieve his goals, the professional connoisseur is perforce required to have an intimate familiarity with large numbers of monuments, as well as a substantial historical knowledge of the art of the period in which he is a specialist.

On these grounds alone, connoisseurship may be defined as a branch, and indeed an important branch, of the history of art. Only if it is assumed that the proper business of the art historian is other than this— that his objective is, for example, to establish iconographic or social connections among works of art and to evolve theories of stylistic development—can a wedge be driven in between connoisseurship and art history. It is far preferable to conceive of art history as a broad humanistic discipline whose primary datum is the work of art and whose angles of vision may be adjusted to many foci.

The tasks confronting the connoisseur are demanding and exacting.[84] Above all, they require long, intimate experience with original works of art. Sound connoisseurs are not armchair wizards who go about their business by examining photographs, but scholars who handle and observe critically the actual work of art, either within or outside of its original environment. They strive "to know the object as it really is" by an "immediate visual apprehension of its shape" (Richard Offner). Apprehending the shape of a work of art requires close and repeated observation of its physical and formal qualities. Not only the size, condition, medium, technique, and quality, but also the formal traits of a work are the pieces of evidence that guide the connoisseur in pronouncing judgment on authenticity and authorship.[85] Occasionally, such scientific aids as X rays and infrared photographs are called upon to reveal original

[83] One such scholar is Rudolf Wittkower ("Art History as a Discipline," *Winterthur Seminar on Museum Operation and Connoisseurship, 1959* [Winterthur, Delaware, 1961], pp. 56–57). In this regard, Erwin Panofsky's witty pronouncement comes to mind: "The connoisseur might be defined as a laconic art historian and the art historian as a loquacious connoisseur." But he is quick to add that the great connoisseurs have been anything but laconic.

[84] For a fundamental essay on the techniques of connoisseurship, see Bernard Berenson, "Rudiments of Connoisseurship," in *The Study and Criticism of Italian Art*, 2d ser. (London, 1902 [*The Rudiments of Connoisseurship*, Schocken Book]), pp. 111–48.

[85] For the problem of quality in art, see Jakob Rosenberg, *On Quality in Art; Criteria of Excellence, Past and Present* (Princeton, 1967), and the important remarks by E. H. Gombrich on this book (in *New York Review of Books*, February 1, 1968).

aspects of the work (especially if it has been damaged or overpainted) that even the trained human eye cannot perceive, but as a general rule the connoisseur's eye and visual memory are the critical tools at his disposal. For art after the late Middle Ages, archival documentation often proves enlightening in revealing the original context of the work; but this information is used to confirm, rather than guide, the observations of the connoisseur, who lays primary emphasis on the visual qualities of the work itself.[86] Signatures and dates inscribed on paintings and sculptures may also be useful but are regarded with the utmost caution because of the possibility of emendation or forgery, as the essay by Richard Offner on the Italian painter Guido da Siena (republished in this book) discloses.

The techniques of modern connoisseurship were anticipated in the writings of European scholars as early as the second quarter of the 19th century. The first important historian to undertake a serious study of individual works of art and the problem of their attribution was Carl Friedrich von Rumohr (1785–1843). In his *Italienische Forschungen,* 3 vols. in one (Berlin, 1827–31), he endeavored to attribute works to their masters by gathering all relevant source material (Vasari's *Lives,* for example) and investigating it with the tools of a philologist. His primary

concern, however, was the stylistic evolution of painting and sculpture, which he sought to establish by focusing on formal qualities. It is important to note that he did this without resorting to the emotional generalizations and aesthetic theories that colored the writings of his predecessors (such as Winckelmann) and even his contemporaries. Von Rumohr's work marks the introduction of an empirical method into the systematic study of the history of painting and sculpture, which was taken up and developed by German art historians, especially those working in Berlin, from Johann David Passavant (1787–1861) to Adolph Goldschmidt (1863–1944) and his pupils.[87]

Outside Germany at this time, the leading connoisseurs were Sir Joseph Archer Crowe (1825–96) and Giovanni Battista Cavalcaselle (1820–97). Crowe was an English newspaperman and diplomat with a broad cultural background, Cavalcaselle an Italian political patriot and activist who was trained as an artist. These two Romantics joined forces at mid-century and coauthored a number of books[88] that ranged from general surveys of Flemish and Italian painting to monographs on individual Italian masters—all of which received wide European acclaim in their day and were subsequently translated into various languages, further increasing their influence.[89] As had Von Rumohr, Crowe and Cavalcaselle examined original source

[86] For a brief but excellent study that demonstrates how prints and drawings as well as X-ray photographs can be useful in solving problems on attribution, see J. LeRoy Davidson and Julius Held, "A Rubens Problem," *Gazette des Beaux Arts* XXIII, 6th ser. (1943), pp. 117–22 and my comments that follow, on an important attribution by Morelli (p. 45, note 92).

[87] Von Rumohr's accomplishment is discussed by Wilhelm Waetzoldt in *Deutsche Kunsthistoriker,* 2 vols. (Leipzig, 1921), I, pp. 292–318.

[88] Cavalcaselle contributed the bulk of specific observations of the individual works and made the line drawings, while Crowe supplied the general historical background.

[89] Their five major works are: *The Early Flemish Painters: Notices of their Lives and Works* (London, 1857); *A New History of Painting in Italy, from the Second to the Sixteenth Century,* 3 vols. (London, 1864); *A History of Painting in North Italy . . . from the Fourteenth to the Sixteenth Century,* 2 vols. (London, 1871); *Titian: His Life and Times; With Some Account of his Family,* 2 vols. (London, 1877); and *Raphael: His Life and Works; With Particular Reference to Recently Discovered Records, and an Exhaustive Study of Extant Drawings and Pictures,* 2 vols. (London, 1882–85), the subtitle of the last characterizing their approach to works of art.

material (such as the writings of Van Mander and Vasari), though they were unfamiliar with philological tools, and inspected firsthand most of the paintings they introduced. They were primarily interested in tracing the development of individual artists, "from their early efforts to their decline and fall," and in classifying schools of painting. And they shunned theoretical speculation, as did their colleagues in Berlin, in favor of the empirical observation of formal qualities.

As a method, connoisseurship was first formulated and rationalized by the Italian Giovanni Morelli (1816–91). Trained as a physician (though he never practiced), an expert in comparative anatomy, and even a senator, Morelli aimed simply to attribute paintings to the hands of master artists, and to do so he concentrated on the least significant details, such as fingernails, nostrils, and ear lobes, drawings of which pepper the pages of his *Kunstkritische Studien über italienische Malerei,* 3 vols. (Leipzig, 1890–93 [*Italian Painters; Critical Studies of their Works,* 2 vols., trans. Constance Foulkes, London, 1892–93]).[90] He focused on these traits rather than on the more general ones of compositional devices, proportions, gestures, and color, because he believed that the former required the least energy and thought and thus revealed artistic personality most clearly—a point of view borne out by modern psychology.[91] He classified these details systematically and rigorously (he regarded his approach to attribution as something of an exact science) and thereby was able to correct the attributions of a large number of important Renaissance paintings in Italian and German galleries, including Giorgione's *Sleeping Venus* in the Gemälde-Galerie in Dresden, which had previously been attributed both to Titian and to Sassoferrato after a Titian original.[92]

Since Morelli considered the results reached by his method the product of science rather than of intuition, some critics labeled his approach a form of charlatanism and wizardry, although certain of them applied it in their work (for instance, Max J. Friedlaender). Their attacks notwithstanding, the Morellian method functions as the backbone of connoisseurship in our day. It has been applied by the greatest connoisseurs of the 20th century, though its concept has been broadened to the extent that not only the least significant but also the most significant formal traits of works of art are critically observed. Even content is taken into consideration, for some subjects are known to have been treated in some places only at certain times.[93] Still, the objective of Morelli and his followers always remains

[90] I am indebted to the brilliant criticism of Edgar Wind, "Critique of Connoisseurship," in *Art and Anarchy* (London, 1963; Vintage Book).

[91] As shown, for example, in the work of Sigmund Freud. Similarly, the German art historian Aby Warburg discovered that it was not the most talented but the weakest hand that followed most closely the complex iconographical program in the murals in the Salone dei Mesi of the Palazzo Schifanoia at Ferrara, a discovery that he was able to confirm by archival documentation (as pointed out by Edgar Wind in *Zeitschrift für Ästhetik und allgemeine Kunstwissenschaft,* XXV [1931, Beilageheft], pp. 163–79). For the work of Freud and Warburg, see pp. 64–65, 70–71.

[92] In 1880, Morelli attributed the so-called Venus figure of Giorgione and the landscape and the new obliterated figure of Cupid to Titian (X-ray examination has confirmed the existence of the Cupid). In making his attribution, he referred to an account by Marcantonio Michiel of a painting in the house of Jeronimo Marcello in 1525. Morelli's attribution has not remained entirely unchallenged. See Ludwig Baldass, *Giorgione,* trans. J. Maxwell Brownjohn (New York, 1965), pp. 162–64.

[93] See Bernard Berenson, *Three Essays in Method* (Oxford, 1927), in which simple iconographical investigation is loosely combined with the techniques of connoisseurship in the Morellian tradition. This book shows that Berenson was uncomfortable with iconographic analysis.

in sharp focus: to determine the authenticity and authorship of works of art.

The most important accomplishment of connoisseurs is the publication of the corpus and the *catalogue raisonné*, both of which comprise lists of the works of an artist, a group of artists, or a school, and enable the art historian to proceed from his primary data to an interpretation of those data. For ancient Greek art, some of the major catalogues have been produced by Adolf Furtwängler (1853–1907) (*Die antiken Gemmen*, 3 vols. [Leipzig, 1900]); Gisela M. A. Richter (born 1882) (*The Sculpture and Sculptors of the Greeks*, new rev. ed. [New Haven, 1950], and *The Portraits of the Greeks*, 3 vols. [London, 1965]); Margarete Bieber (born 1879) (*The Sculpture of the Hellenistic Age*, rev. ed. [New York, 1961]); Sir John Beazley (born 1885) (*Attic Black-Figure Vase-Painters* [Oxford, 1956] and *Attic Red-Figure Vase-Painters* [Oxford, 1942]); and Humfry Payne (1902–36) (*Necrocorinthia; A Study of Corinthian Art in the Archaic Period* [Oxford, 1931]). Mention must also be made of the international work *Corpus Vasorum Antiquorum* (begun 1921), of which over 100 fascicles have appeared.

Many of the fundamental corpora for medieval and Byzantine art were produced by the German scholar of rare talent, Adolph Goldschmidt (1863–1944). Distrusting metaphysical speculation on the nature of art history and disavowing the aesthetic theories of such men as Wölfflin and Riegl, Goldschmidt concentrated on grouping works of art and describing them analytically, formally, and historically. His work on medieval and Byzantine manuscripts, ivories, and other forms of sculpture has occasionally been emended but never discarded; it includes *Die Kirchen-*thür des Heiligen Ambrosius in Mailand; ein Denkmal frühchristlicher Skulptur* (Strassburg, 1902); *Die deutschen Bronzetüren des frühen Mittelalters* (Marburg an der Lahn, 1926); *Die deutsche Buchmalerei*, 2 vols. (Florence, 1928 [*German Illumination*, 2 vols, Florence, 1928]); *Die Elfenbeinskulpturen aus der Zeit der karolingischen und sächsischen Kaiser VIII.–XI. Jahrhundert*, 4 vols. (Berlin, 1914–26); and, with Kurt Weitzmann, *Die byzantinischen Elfenbeinskulpturen des X. bis XIII. Jahrhunderts*, 2 vols. (Berlin, 1930–34). Goldschmidt's contribution is to be measured not only by these monumental publications, but also by the large number of his students, most of whom have assumed important museum and teaching positions in the United States and in Europe (Erwin Panofsky, Hans Swarzenski, Rudolf Wittkower, Kurt Weitzmann, Hanns Kauffmann, Ernst Gall, Alexander Dorner, Alfred Neumeyer, Walter Paatz, Ludwig Baldass, Hans Jantzen).[94]

Other indispensable corpora for the study of Early Christian and medieval art include three works by Josef Wilpert (1857–1944), *Roma sotterranea: Le pittura delle catacombe Romane*, 2 vols. (Rome, 1903). *Die römischen Mosaiken und Malereien der kirchlichen Bauten vom IV. bis XIII. Jahrhundert*, 2d ed., 4 vols. (Freiburg im Breisgau, 1917), and *I Sarcofagi Cristiani Antichi*, 2 vols (Rome, 1929–32); and three works by Richard Delbrueck (1875–1957), *Die Consulardiptychen und verwandte Denkmäler*, 2 vols. (Berlin, 1929), *Antike Porphyrwerke* (Berlin, 1932), and *Spätantike Kaiserporträts von Constantinus Magnus bis zum Ende des Westreichs* (Berlin and Leipzig, 1933).

In Morelli's field, Italian art, a number of connoisseurs have made lasting con-

[94] Some of these art historians settled in the United States, where Goldschmidt visited several times, twice as guest lecturer at Harvard University (he was the first German art historian to come to this country to teach after World War I). For an evaluation of his scholarship, see Kurt Weitzmann in *College Art Journal* IV (1944), pp. 47–50; Carl Georg Heise, *Adolph Goldschmidt zum Gedächtnis, 1863–1944* (Hamburg, 1963); Hans Kauffmann in *Neue Deutsche Biographie* (Berlin, 1964), VI, pp. 613–14.

tributions. Connoisseurship in the field of Renaissance painting is virtually synonymous with the name of Bernard Berenson (1865–1959), who, though he never taught in a university, nonetheless exerted a wide influence through his publications and his personal library, which he opened to students (an institution known as I Tatti, near Florence, Italy). For his methodology, he was deeply indebted to Morelli (see "Rudiments of Connoisseurship," in *The Study and Criticism of Italian Art*, 2d ser. (London, 1902 [repub. as Schocken Book entitled *Rudiments of Connoisseurship*]). His principal contribution lies in his lists of paintings that he attributed to various hands (*The Drawings of the Florentine Painters Classified, Criticised and Studied as Documents in the History and Appreciation of Tuscan Art*, 2 vols. [New York, 1903]; *Italian Pictures of the Renaissance; A List of the Principal Artists and Their Works* [Oxford, 1932]).[95]

While Berenson dealt for the most part with Quattrocento and Cinquecento art, the American scholar Richard Offner (1889–1965) concerned himself with the art of the Trecento. Offner's major work is his *Critical and Historical Corpus of Florentine Painting* (New York, 1931 ff.), but his principles and keen visual analysis are also seen at work in a number of masterly papers ("Giotto, Non-Giotto," *Burlington Magazine* LXXIV [1939], pp. 258–69, and LXXV [1939], pp. 96–109 [repub. in *Giotto: The Arena Chapel Frescoes*, ed. James Stubblebine, New York, 1969, pp. 135–55; Norton paperback]; "Guido da Siena and A.D. 1221," *Gazette des Beaux Arts*, 6th ser., XXXVII [1950], pp. 61–90, 155–64, the latter reprinted in this book).[96] Both Berenson and Offner were gifted with tenacious and accurate visual memories, so necessary

to the connoisseur in successfully carrying out his task.

The field of medieval and "Renaissance" Spanish painting is covered by the fourteen volumes by Chandler R. Post (1881–1959), *A History of Spanish Painting* (Cambridge, Mass., 1930–66). For German and Flemish painting the basic corpus was produced by Max J. Friedlaender (1867–1958)—*Die altniederländische Malerei*, 14 vols. (Berlin, 1924–37; currently being republished in English as *Early Netherlandish Painting*). As did Berenson, but not Offner (who taught at the Institute of Fine Arts of New York University), Friedlaender avoided university life and seems never to have delivered a public lecture. Contributions to the scholarship of the transalpine and cisalpine art of this period were also made by two connoisseurs with artistic sensibilities, Wilhelm von Bode (1845–1929) and Adolfo Venturi (1856–1941).

Von Bode prepared the groundwork for scholarship in the study of Dutch Baroque art with his *Studien zur Geschichte der holländischen Malerei* (Braunschweig, 1883) and *Rembrandt und seine Zeitgenossen: Charakterbilder der grossen Meister der holländischen und vlämischen Malerschule im siebzehnten Jahrhundert* (Leipzig, 1906 [rev. 2d ed. trans. Margaret L. Clark as *Great Masters of Dutch and Flemish Painting*, London, 1909]). Subsequent contributions were made by Cornelis Hofstede de Groot (1863–1930) in *Beschreibendes und kritisches Verzeichnis der Werke der hervorragendsten holländischen Maler des XVII. Jahrhunderts*, 10 vols. (Esslingen, 1907–28), of which the first eight have been issued as *A Catalogue Raisonné of the Works of the Most Eminent Dutch Painters of the Seventeenth Century*,

[95] See Meyer Schapiro, "Mr. Berenson's Values," *Encounter* XVI (January 1961), pp. 57–65.

[96] Offner has written up his methodological principles in a short paper entitled "Connoisseurship," published in *Art News*, March 1951, pp. 24–25. His guiding "principles" have had an impact on American scholarship, for instance on an important aspect of the work of Millard Meiss ("The Problem of Francesco Traini," *Art Bulletin* XV (1933), pp. 96–173; *Giotto and Assisi* (New York, 1960; Norton paperback).

trans. and ed. E. G. Hawke, 8 vols. (London, 1908–27). Since these pioneering studies were made, various scholars have increased our knowledge and understanding of the *oeuvres* of individual masters (for example, the monographs on Rembrandt by Kurt Bauch, Otto Benesch, Jakob Rosenberg, and Seymour Slive).

The field of Spanish Baroque art and its antecedents has recently attracted the attention of scholars outside Spain. Some recent *catalogues raisonnés* that stand out as fine contributions to this field are Harold E. Wethey, *Alonso Cano: Painter, Sculptor, Architect* (Princeton, 1955) and *El Greco and His School*, 2 vols. (Princeton, 1962), and the two volumes written by José López-Rey in the United States, *Velázquez: A Catalogue Raisonné of his Oeuvre, with an Introductory Study* (London, 1963) and *Velázquez' Work and World* (London, 1968).

Even though connoisseurship in the Morellian tradition is far less common today than it was in the first decades of this century, it is nevertheless here to stay, in spite of recent advances in scientific techniques to assist in the determination of authenticity and attribution. Of course, its need is now less pressing. With problems of attribution to major masters and groups or schools of artists no longer critical, historians have shifted their attention to other aspects of the visual arts and have applied different techniques of analysis. In contemporary scholarship there is a trend to integrate the results of connoisseurship with those of other techniques, such as iconography, psychology and psychoanalysis, and social and cultural history. This assimilation of tech-

niques is evident in a number of stimulating recent studies, for instance, Millard Meiss, *Painting in Florence and Siena after the Black Death* (Princeton, 1951; Princeton paperback); Walter F. Friedlaender, *Caravaggio Studies* (Princeton, 1955; Schocken Book); Rudolf Wittkower, *Gian Lorenzo Bernini, the Sculptor of the Roman Baroque* (London, 1966); Edgar Richardson, *Washington Allston, a Study of the Romantic Artist in America* (Chicago, 1948; Apollo Edition); Robert Rosenblum, *Transformations in Late Eighteenth Century Art* (Princeton, 1967, Princeton paperback).

Such works are not altogether uncommon in contemporary scholarship. But investigations pertaining to the formal analysis of styles occur more frequently.[97] A number of examples will suffice to bear this out. Formal studies in medieval architectural history have been exceedingly common since the 19th century: for example, Ernst Gall, *Die gotische Baukunst in Frankreich und Deutschland* (Leipzig, 1925), and Louis Grodecki, *L'Architecture ottonienne; au seuil de l'art roman* (Paris, 1958). Although Erwin Panofsky (1892–1968) was by no means a pure formalist, his *Die deutsche Plastik des elften bis dreizehnten Jahrhunderts*, 2 vols. (Munich, 1924) remains an indispensable analysis of the formal changes in medieval German sculpture.[98] The history of the introduction of pictorial space, an essential aspect of form, into Italian art during the 13th, 14th, and 15th centuries, has been treated by John White (born 1924) in his impressive book, *The Birth and Rebirth of Pictorial Space* (London, 1957; 2d ed., London, 1967). But above all, the formalist tradition of Heinrich Wölfflin's early works,

[97] See René Wellek, "Concepts of Form and Structure in Twentieth-Century Criticism," in his *Concepts of Criticism*, ed. Stephen Nichols, Jr. (New Haven, 1963; Yale paperback), pp. 54–68.

[98] Medieval sculpture had been a favorite topic of investigation of one of Panofsky's mentors, Wilhelm Vöge (1868–1952): e.g., *Die Anfänge des monumentalen Stiles im Mittelalter: Eine Untersuchung über die erste Blütezeit französischer Plastik* (Strassburg, 1894); and *Bildhauer des Mittelalters; gesammelte Studien*, papers published posthumously in Berlin in 1958, with an introduction by Panofsky that has been translated into English by E. C. Hassold, in *College Art Journal* XXVIII [1966], pp. 27–37). See Carl Georg Heise, *Wilhelm Vöge zum Gedächtnis* (Freiburg, 1968).

especially his superbly written *Classic Art* of 1899, is much in evidence in recent scholarship; for instance, in two monographs by Sidney Freedberg (born 1914), *Painting of the High Renaissance in Rome and Florence,* 2 vols. (Cambridge, Mass., 1961), and *Andrea del Sarto,* 2 vols. (Cambridge, Mass., 1963). Freedberg's monographs are visually intensive inquiries into the development of an artist's, or artists', formal style and its affinities with the work of other masters of the time. Echoes of Wölfflin's *Principles of Art History* (first pub. 1915) can be detected in some papers by Theodor Hetzer (collected in his *Aufsätze und Vorträge,* 2 vols. [Leipzig, 1957]). Like Panofsky, Hetzer (1890–1946) was a student of both Vöge and Adolph Goldschmidt, as well as of Wölfflin himself.[99] A much refined application of Wölfflin's basic conceptual tools, though not his old-fashioned aesthetic psychology of vision, seems evident in Walter F. Friedlaender's widely read book *Mannerism and Anti-Mannerism in Italian Painting* (New York, 1957; Schocken Book), one of the most important definitions, and indeed the most persuasive stylistic characterization, of Mannerist art of 16th-century Italy.[100] Contrary to Wölfflin, however, Friedlaender (1873–1966) discussed the external forces that lent shape to the visual arts. He did not ignore the symbolic qualities of the arts, a point as evident in this basic work as in his widely used textbook *David to Delacroix,* trans. Robert Goldwater (Cambridge, Mass., 1952; Schocken Book), and his major monographs, *Caravaggio Studies*

(Princeton, 1955; Schocken Book) and *Nicolas Poussin, A New Approach* (New York, 1966).

These studies are but a few examples of a formal approach to art history today; they indicate not only that this approach is a major genre in current scholarship, but also that it is common in all fields of art history. However, as Walter Friedlaender's writings suggest, art historians today are conscious of qualities other than the purely formal ones. The very complexity of 20th-century art has made scholars aware of the need for a new formal vocabulary and more subtle and refined analyses than are found in the writings of Wölfflin and his contemporaries.[101]

Documentary studies have proven to be valuable contributions to our understanding of the arts. They are especially frequent in the architectural history of the Middle Ages, the Renaissance, and the Baroque period, for which the reporting and evaluation of literary, archaeological, and photographic evidence provides the historical backbone. One of the monumental works in this field of inquiry was that by Howard Crosby Butler (1872–1922) of Princeton University: *Publications of the Princeton University Archaeological Expedition to Syria in 1904–5 and 1909* (Leiden, 1909–20). A. Kingsley Porter (1883–1933) of Yale and Harvard universities made an equally important contribution to our knowledge of medieval architecture and sculpture in his *Lombard Architecture,* 4 vols. (New Haven, 1915–17), *Romanesque Sculpture of the Pilgrimage Roads,*

[99] See Friedrich Klingner, *Theodor Hetzer* (Frankfurt am Main, 1947).

[100] First published as "Die Entstehung des antiklassischen Stiles in der italienischen Malerei um 1520," *Repertorium für Kunstwissenschaft* XLVI (1925), pp. 49–86, and "Der Antimanieristische Stil um 1590 und sein Verhältnis zum Übersinnlichen," *Vorträge der Bibliothek Warburg 1928–1929* (1930); pp. 214–43.

[101] See Lawrence D. Steefel, Jr., "Contextual Relativism," *College Art Journal* XXI (Spring 1962), pp. 151–55. For a discussion of the evolution of complex forms (social systems, ideas, and so forth) in modern times, see Herbert A. Simon, *The Sciences of the Artificial* (Cambridge, Mass., 1969), pp. 88–118. One of the most persuasive critical essays on contemporary art to appear in recent years is Sheldon Nodelman's "Sixties Art: Some Philosophical Perspectives" in *Perspecta: The Yale Architectural Journal* XI [1967], pp. 72–89).

10 vols. (Boston, 1923), and *The Crosses and Culture of Ireland* (New Haven and London, 1931). For his conception of art history, see his paper "Kunst und Wissenschaft," in *Die Kunstwissenschaft der Gegenwart in Selbstdarstellungen,* ed. Johannes Jahn (Leipzig, 1924), pp. 77–93. The basic corpus of the architecture of Early Christian and medieval Rome has been published under the supervision of Richard Krautheimer (born 1897) as *Corpus Basilicarum Christianarum Romae. The Early Christian Basillicas of Rome, Fourth–Ninth Centuries,* 5 vols. (3 vols. to date; Vatican City, 1937–70). Our knowledge of Early Christian, Byzantine, Armenian, and Islamic architecture has been immeasurably enhanced by the exhaustive researches of Josef Strzygowski (*Kleinasien* [Leipzig, 1903]; *Amida* [Heidelberg, 1910]; *Die Baukunst der Armenier und Europa,* 2 vols. [Vienna, 1918]. The indefatigable researches of Keppel Archibald Cameron Creswell (born 1879) have resulted in two monumental corpora of Muslim architecture: *Early Muslim Architecture, Umayyads, early Abbāsids and Tūlūnids,* 2 vols. (Oxford, 1932–40; 2d ed. of vol. 1, 1969); and *The Muslim Architecture of Egypt,* 2 vols. (Oxford, 1952–59). Friedrich Wilhelm Deichmann (born 1909) has added substantially to the body of information on the art and architecture of Early Christian Ravenna in *Ravenna: Hauptstadt des spätantiken Abendlandes,* 3 vols. (Wiesbaden, 1969). The Early Christian and Byzantine monuments of Greece have become known to scholars through a massive number of publications by Georgios M. Soteriou (born 1880), Anastasios K. Orlandos (born 1890), and Andreas Xyngopoulos (born 1891), writing in modern Greek.[102] Otto Demus (born 1902), professor of art history at the University of Vienna, has made a lifetime study of Byzantine and medieval art generally, and of the Venetian church of San Marco specifically (with Ernst Diez, *Byzantine Mosaics in Greece, Hosios Lucas and Daphni,* [Cambridge, Mass., 1931]; *Byzantine Mosaic Decoration: Aspects of Monumental Art in Byzantium* [London, 1948]; *The Mosaics of Norman Sicily* [London, 1950]; "Die Entstehung des Paläologenstils in der Malerie," in *Berichte zum XI. Internationalen Byzantinisten-Kongress, München 1958,* no. IV, 2 (1960), pp. 1–63; *The Church of San Marco in Venice; History, Architecture, Sculpture* [Washington, D.C., 1960]; *Romanische Wandmalerei* [Munich, 1968]; *Byzantine Art and the West* [New York, 1970]). During the past two decades, Walter Horn (born 1908) has been investigating the bay-divided timber architecture of the Middle Ages in transalpine Europe and assessing its importance for a clearer understanding of medieval buildings in general ("On the Origins of the Mediaeval Bay System," *Journal of the Society of Architectural Historians* XVII [1958], pp. 2–23; *The Barns of the Abbey of Beaulieu at Its Granges of Great Coxwell and Beaulieu-St. Leonards* [Berkeley, 1965]; and, with Ernest Born, a monumental work on the plan of St. Gall, forthcoming).[103] Kenneth John Conant (born 1894) has summarized a lifetime of excavations and research on the monastery at Cluny in his Pelican History, *Carolingian and Romanesque Architecture, 800–1200* (Baltimore, 1959; 2d ed., 1966) and in *Cluny, les églises et la maison du chef d'ordre Mâcon* (Cambridge, Mass., and Mâcon, 1968). Important documentary studies of Gothic archi-

[102] For an appraisal of Early Christian archaeology, see Richard Krautheimer, "Riflessioni sull' architettura paleocristiana," in *Atti del VI Congresso Internationale di Archeologia Cristiana, Ravenna 23–30 Settembre 1962 (Studi di Antichità Cristiana,* vol. 26 [Vatican City, 1965]), pp. 567–79.

[103] Horn's stimulating article on the medieval bay system has been republished in the handy collection of writings edited by Harold Spencer, *Readings in Art History,* 2 vols. (New York, 1969; Scribner's paperback), I, pp. 217–50.

tecture have been published by Ernst Gall (1888–1958), Paul Frankl (1878–1962), Sumner Crosby (born 1909), and Robert Branner (born 1927). The fields of Renaissance and Baroque architecture have attracted a larger number of students, who have made contributions of lasting value. One of the foremost scholars working in both fields is Rudolf Wittkower (born 1901), who has written a number of important monographs: "Michelangelo's Biblioteca Laurenziana," *Art Bulletin* XVI (1934), pp. 123–218; "Carlo Rainaldi and the Roman Architecture of the Full Baroque," *Art Bulletin* XIX (1937), pp. 242–313; and "S. Maria della Salute: Scenographic Architecture and the Venetian Baroque," *Saggi e memorie di storia dell' arte* III (1963), pp. 31–54, republished in this volume. Further documentary studies that may be mentioned include: James S. Ackerman, *The Architecture of Michelangelo*, 2 vols. (London, 1961) and *Palladio* (Baltimore and Harmondsworth, Eng., 1966; Penguin Book); David Coffin, *The Villa d'Este at Tivoli* (Princeton, 1960); John P. Coolidge, "The Villa Giulia: A Study of Central Italian Architecture in the Mid-Sixteenth Century," *Art Bulletin* XXV (1943), pp. 177–225; Anthony Blunt, *François Mansart and the Origins of French Classical Architecture* (London, 1941) and *Philibert de l'Orme* (London, 1958); Wolfgang Lotz, *Vignola-Studien (Würzburg, 1939)*, "Die ovalen Kirchenräume des Cinquecento," *Römisches Jahrbuch für Kunstgeschichte* VII (1955), pp. 7–99, and "Redefinitions of Style: Architecture in the Later 16th Century," *College Art Journal* XVII (1958), pp. 129–39; Bates Lowry, "Redefinitions of Style: High Renaissance

Architecture," *College Art Journal* XVII (1958), pp. 115–28; Howard Hibbard, "Architecture of the Palazzo Borghese," *Memoirs of the American Academy in Rome* XXVII (1962), pp. 1–149; Earl E. Rosenthal, *The Cathedral of Granada: A Study in the Spanish Renaissance* (Princeton, 1961); Hans Sedlmayr, *Österreichische Barockarchitektur, 1690–1740* (Vienna, 1930) and *Johann Bernhard Fischer von Erlach* (Vienna, 1956); Wilhelm Pinder, *Deutscher Barock: die grossen Baumeister des 18. Jahrhunderts* (Königstein im Taunus, 1940); Richard Pommer, *Eighteenth-Century Architecture in Piedmont: The Open Structures of Juvarra, Alfieri, and Vittone* (New York, 1967); Carroll L. V. Meeks, *Italian Architecture, 1750–1914* (New Haven, 1966); and Emil Kaufmann, *Architecture in the Age of Reason; Baroque and Post-Baroque in England, Italy, and France* (Cambridge, Mass., 1955; Dover Book). For architecture since the French Revolution, on both sides of the Atlantic, there are important papers and books by Donald D. Egbert, Siegfried Giedion, Fiske Kimball, George Kubler, Nikolaus Pevsner, Vincent Scully, Reyner Banham, Bruno Zevi, and especially Henry Russell Hitchcock, the distinguished dean of modern architectural history.

Historical inquiry into the content of the visual arts is known as iconography.[104] Its methods range from the description and classification of themes, attitudes, and motifs to the identification of meaning of individual works of art. Since it proceeds from specific works, iconography may be termed an intrinsic approach, although methodologically it leads directly

[104] The following account of iconography is based on the fundamental formulation by Erwin Panofsky, *Studies in Iconology; Humanistic Themes in the Art of the Renaissance* (New York, 1939; Harper Torchbook). A slight revision of the first chapter of this book ("Iconography and Iconology: An Introduction to the Study of Renaissance Art") appears in his *Meaning in the Visual Arts* (Garden City, N.Y., 1955; Doubleday Anchor Book). Panofsky's views have been elaborated by a number of scholars; see, for instance, Rudolf Wittkower, "Interpretation of Visual Symbols in the Arts," in *Studies in Communication*, introd. B. Ifor Evans (London, 1955), pp. 109–24. Cf. Nelson Goodman, *Languages of Art; An Approach to a Theory of Symbols* (Indianapolis and New York, 1968).

into extrinsic approaches when it seeks to explain the content of art.

One of the first tasks of the iconographer is the identification of the persons, objects, and motifs that are represented by artistic forms. Similar to formal analysis, this activity calls for the recognition of a certain configuration of lines, volumes, and color as a man, building, flower, and so forth. These are identifications of the *natural meanings* of persons, objects, and motifs. A second level of iconographic activity entails the discovery of the *conventional meanings* of forms: the man as Christ, the building as a martyrium, and the flower as a lily. Conventional meanings are ascertained by consulting textual sources and/or traditional artistic representations of the same persons, objects, and motifs. For example, a depiction of thirteen men seated at a dinner table may be identified as Christ and His disciples at the Last Supper, by reference to the New Testament and/or similar representations in other works of art. This method of identification is known as iconographic analysis. A third, deeper level of activity is termed iconology. This method of inquiry starts out with the correct iconographic analysis of a work of art and attempts to divine its intrinsic meaning or content. The intrinsic meaning "may be defined as a unifying principle which underlies and explains both the visible event and its intelligible significance, and which determines even the form in which the visible event takes shape."[105] "In thus conceiving of pure forms, motifs, images, stories, and allegories as manifestations of underlying principles, we interpret all these elements as . . . 'symbolical values'" (*ibid*, p. 31).[106] Iconologists

deal with the work of art as a symptom of something else which expresses itself in a countless variety of other symptoms, and . . . interpret its compositional and iconographical features as more particularized evidence of this "something else." The discovery and interpretation of these "symbolical values" (which are often unknown to the artist himself and may even emphatically differ from what he consciously intended to express) is the object of what we may call "iconology" as opposed to "iconography." [*ibid*, p. 33][107]

Within the symbolical forms are condensed symptoms of the historical, political, scientific, religious, and economic tendencies of the period in which the work was produced. Iconologists seek to discover and interpret the many symptoms together in relation to the work of art. In endeavoring to penetrate the links that are assumed to exist between image and thought, they value the work of art as a document of its master's personality, of essential attitudes of the human mind, and of the prevailing *Weltanschauung*, or total global view at the time of its creation.[108]

Iconography is an intellectual activity in which the specialist can encounter a number of difficulties when he tries to coordinate visual images with textual sources.[109] Artistic traditions may intrude

[105] Panofsky, *Meaning in the Visual Arts* (Garden City, N.Y., 1955; Doubleday Anchor Book), p. 28.

[106] The concept of "symbolical forms" was adopted from the writings of the eminent neo-Kantian philosopher and historian Ernst Cassirer.

[107] The wording of this passage contains a few significant changes from that of the original publication of 1939.

[108] Consult W. S. Heckscher, "The Genesis of Iconology," in *Stil und Überlieferung in der Kunst des Abendlandes* (*Akten des XXI. Internationalen Kongresses für Kunstgeschichte, Bonn, 1964,* III [1967]), pp. 239–62.

[109] See Erwin Panofsky, "Traffic Accidents in the Relation between Texts and Pictures," *College Art Journal* I (1942), p. 69; and *Early Netherlandish Painting*, 2 vols. (Cambridge, Mass., 1953), I, p. 378.

upon the data of a textual source, as, for instance, when pagan images are adapted to Christian themes (for example, the four Evangelists modeled upon ancient portraits of philosophers, and perhaps also representations of the poet inspired by the muse).[110] Another problem arises in the case of a textual image that was familiar to everyone for centuries but that failed to be represented in art until both the temper of the times demanded it and there was a capacity to produce it. While the Crucifixion is described at length in the New Testament, surviving monuments suggest that the subject was not represented in Christian art until the first decades of the 5th century.[111] Meyer Schapiro has sought to demonstrate why at a certain point in time an artist could take up an Augustinian metaphor ("'Muscipula Diaboli;' The Symbolism of the Mérode Altarpiece by the Master of Flémalle," Art Bulletin XXVII [1945], pp. 182–7).[112] Although as early as the 9th century, theologians began to write that a ray of light passing unchanged through glass might symbolize the Incarnation, it was not until about 1400, when artists became fascinated with the qualities of light, reflection, and translucence, that the simile was represented on canvas (as contended by Millard Meiss, in "Light as Form and Symbol in Some Fifteenth-Century Paintings," Art Bulletin XXVII (1945), pp. 175–81).[113] In another situation, the written word may be misinterpreted through the course of time, and the images based on the changed interpretation of the word can become invested with a new symbolic content and represented with attributes quite different from those associated with the original word; cases in point are the Renaissance images of Father Time, which derive from the Classical concepts of Kronos as the father of gods and men and of Chronos as the "father of all things" and the "wise old builder," which are popular on New Year cards in the present day.[114] Also, clerical errors can creep into sources and cause innovations in the texts thus illustrated (for instance, the word glauco in the phrase caput glauco amictu coopertum was misread as galeatum, so that the tragic Saturn, the god of loneliness, silence, and deep thought, was painted as an elderly and gloomy soldier, his head "behelmeted" rather than "veiled with a grayish kerchief").[115] Lastly, a written account may serve as an intermediary link between two visual images, the second of which may then, in turn, lead to a reformulation of the original text (as, it would seem, in the

[110] The fundamental study of this problem is Albert M. Friend, Jr., "Portraits of the Evangelists in Greek and Latin Manuscripts," Art Studies V (1927), pp. 115–47, and VII (1929), pp. 3–29. The image of the poet inspired by the muse (which in ancient art survives, for instance, in ivory carvings) is an early example in a tradition of two-figured compositions that has continued to the present day (its survival is seen in some paintings by Picasso and Joan Miró). This series of images could be dealt with by the concepts in George Kubler's Shape of Time (New Haven, 1962; Yale paperback).

[111] The earliest extant depiction of the Crucifixion is on an Italian ivory casket assigned to the early 5th century (illus. in Wolfgang F. Volbach, Early Christian Art, photog. Max Hirmer, trans. Christopher Ligota [New York, 1961], Pl. 98).

[112] Republished in Renaissance Art, ed. Creighton Gilbert (New York, 1970; Harper Torchbook), pp. 21–42.

[113] Republished in Renaissance Art, ed. Creighton Gilbert (New York, 1970; Harper Torchbook), pp. 43–68. It is instructive to compare the approach of Meiss to that of E. H. Gombrich in his paper that appears in this anthology.

[114] As demonstrated by Panofsky, "Father Time," in Studies in Iconology; Humanistic Themes in the Art of the Renaissance (New York, 1939; Harper Torchbook), pp. 69–93.

[115] Panofsky, Renaissance and Renascences in Western Art, 2 vols. (Stockholm, 1960), I, p. 105 (also Harper Torchbook).

Calumny of Apelles, the subject of one of Sandro Botticelli's mythological paintings).[116]

The tasks confronting the iconographer require varying degrees of experience and knowledge tempered by common sense. The discovery of the natural meanings of artistic forms depends upon practical experience, while the identification and interpretation of conventional meanings presupposes knowledge and understanding of other representations of the same subject matter and the textual sources on which they are based. The identification and interpretation of the intrinsic meaning of works of art calls for an almost encyclopedic knowledge of the history of ideas, social and religious institutions, and intellectual attitudes of an age, and therefore for the ability to read a number of foreign languages (no translation is completely trustworthy, for every one becomes an interpretation). These tasks demand that the iconologist be a humanist and have the resources of a cultural historian at his disposal. In the hands of lesser men the method is downright dangerous.

Iconographers must be fully familiar with the technical and formal aspects of the works they are investigating. They must know whether the formal qualities they seek to identify are original or subsequent alterations, indeed whether all the original forms are present. Knowledge of the fact that Giorgione's painting of the Sleeping Venus originally included a representation of a cupid figure (mentioned in 16th-century texts and confirmed by X rays), or that the two columns in the background of Titian's Pesaro Madonna (in Venice) may not be by the Master's hand or even contemporaneous with the rest of the picture, will have a direct bearing on iconographical analysis and iconological synthesis (as well as formal analysis!). Ignorance of such facts will result in interpretations

that may be intellectually stimulating and perhaps also illuminating, but fragmentary or simply wrong, and hence unhelpful for an understanding of the work at hand.

Iconographers sometimes arrive at different interpretations of the same work; the Great Frieze from the Villa of the Mysteries at Pompeii, Botticelli's Mythologies, and Vermeer's Allegory of Painting are cases in point. They may agree on the artistic and textual sources drawn upon by an artist but disagree on the intrinsic meaning that, deliberately or unconsciously, he intended. As is the case when the original features of a work are not known, the different interpretations rendered by these iconographers may add to our general knowledge of the intellectual and cultural history of the period but contribute little to our specific understanding of the work itself. Quite different is the opinion of a connoisseur regarding authorship, or the visual analysis of a pure formalist, both of whose observations are relevant to the art at hand.

The nature of the iconographic method makes it easy for the art historian to equate great works with lesser ones and with those that have textual sources. Iconographers are indeed sometimes accused of being unable to distinguish a true masterpiece from an inferior work, and of treating all art merely as a group of documents. While the accusation may hold for second-rate iconographers and those interested in art primarily for its documentary value, to level the accusation at a fully knowing iconographer is to betray a misunderstanding of the method. A genuine iconographic study must be viewed in its proper framework.

In his search for the meaning, or layers of meaning, concealed in visual symbols, the iconographer is presented with the difficulty of knowing where to stop, for scholarship in this genre has demonstrated

[116] See E. H. Gombrich, "Botticelli's Mythologies," Journal of the Warburg and Courtauld Institutes VIII (1945), pp. 7–60.

how easy it is to discover meanings in each and every visual form realized by an artist, especially of the Renaissance and Baroque period (Jan van Eyck, Giorgione, and Nicolas Poussin readily come to mind). To prevent the possibility of reading too much into a work, or of forcing it into a preconceived scheme, the iconographer must inquire "to what extent such a symbolic interpretation is in keeping with the historical position and personal tendencies of the individual master" (Panofsky). Moreover, his arguments must depend clearly on the works of art themselves and not be given the authority of the texts on which the works are based. Iconographic research is subject to the danger of a circular argument.[117]

In his first programmatic statement about iconology—published in 1939 (New York) as *Studies in Iconology,* although formulated at least a decade earlier—Panofsky declared that the principal objective of the method is to discover and interpret symbolic values, "which are generally unknown to the artist himself and may even emphatically differ from what he consciously intended to express" (p. 8). The iconologist was to strive to understand the ideas and thought embodied by, and implicit in, visual forms.[118] Artistic creation was held to be largely an unconscious and irrational activity, just as the

proponents of formal analysis in the visual arts had assumed. In his attempt to reach a deep understanding of the meaning of a work of art, the specialist can then logically integrate the methods of formal analysis and iconological inquiry, for both approaches are based on the same conception of the nature of artistic creation.

In his magisterial *Early Netherlandish Painting,* 2 vols. (Cambridge, Mass, 1953), Panofsky espouses a radically different point of view about the nature of artistic behavior. Addressing himself to the meaning of some works by Jan van Eyck, in the programmatic chapter entitled "Reality and Symbol in Early Flemish Painting: 'Spiritualia sub metaphoris corporalium,'" he asserts that the great Flemish master "could endow with the semblance of utter verisimilitude what was in fact utterly imaginary. *And this imaginary reality was controlled to the smallest detail by a preconceived symbolical program*" (p. 137, italics mine). By this last assertion Panofsky completely reverses the position he maintained in his *Studies in Iconology.* As Otto Pächt emphasized in his important criticism of *Early Netherlandish Painting,* Panofsky now stipulates that artistic creation is a rational act, that artists—at least Jan van Eyck—consciously devised and expressed elaborately detailed pro-

[117] For this danger to which iconography and iconology are subject, see E. H. Gombrich, *Art and Scholarship* (London, 1957; reprinted in *Meditations on a Hobby Horse, and Other Essays on the Theory of Art* [London, 1963]). For a classic example of a fundamental difference in opinion between two eminent specialists about the interpretation of medieval religious art, consult Meyer Schapiro, "The Religious Meaning of the Ruthwell Cross," *Art Bulletin* XXVI (1944), pp. 232–45; Ernst H. Kantorowicz, "The Archer on the Ruthwell Cross," *ibid.,* XLIII (1960), pp. 57–9; Schapiro, "The Bowman and the Bird on the Ruthwell Cross and other Works: The Interpretation of Secular Themes in Early Mediaeval Religious Art," *ibid.,* XLV (1963), pp. 351–7. In his interpretation of the cross, Schapiro argues persuasively that not all figures represented in works of medieval art should be understood as religious in content. Compare Fritz Saxl, "The Ruthwell Cross," *Journal of the Warburg and Courtauld Institutes* VI (1943), pp. 1–19.

[118] Such a task was undertaken by Panofsky in his early writings and is indicated by some of their titles, e.g., "Perspektive als symbolische Form," *Vorträge der Bibliothek Warburg 1924–1925* (Leipzig, 1927), pp. 258–330 (*La prospettiva come "forma simbolica," e altri scritti,* comp. and ed. Giulio D. Neri, trans. Enrico Filippini [Milan, 1961]).

grams of "disguised symbolism" in their works.[119] For Panofsky, the task of the iconologist is now to decode and interpret the ideas that underlie visual symbols rather than those that are reflected by them. The point is illustrated by Millard Meiss' paper on "Light as Form and Symbol in Some Fifteenth-Century Paintings," in which the first correctly observed rays of sunshine passing through glass are not interpreted as "symbolical form" but understood as a deliberately intended symbol of supranatural radiance.[120] The art historian is now supposed to investigate the rays of light in some of Van Eyck's paintings, not as unintentional carriers of meaning, but as actual embodiments of the interpretation of the artistic motif itself.[121]

Early Netherlandish Painting and a few other recent writings represent a radical departure from the prevailing conceptions of artistic creation as largely an irrational activity. Hence they pose a dilemma for the specialist who wants to integrate the methods of formal analysis and iconological inquiry. If the formal qualities expressed by an artist are supposed to issue from irrational and intuitive activity, and the symbolical qualities from rational and nonintuitive behavior, how can the methods of the two approaches be synchronized to reach an understanding of the inner meaning of a work of art? Only if the presuppositions of the art historian about the

nature of creative activity are consistent can a meaningful synthesis of the two methods be achieved and the ultimate significance of the work of art be brought to light.

The roots of iconographic investigation lie in 19th-century European scholarship. In early studies, emphasis was laid on the identification of themes, motifs, and attributes of paintings and sculptures and their textual sources. One of the best known scholars in this genre was the Frenchman Emile Mâle (1862–1954), a student of medieval and Renaissance art who brought distinction to French art history. The author of many books, he is perhaps most remembered for *L'Art religieux de XIIIe siècle en France; étude sur l'iconographie du moyen âge et sur ses sources d'inspiration* (Paris, 1898 [*The Gothic Image, Religious Art in France of the Thirteenth Century,* trans. Dora Nussey, New York, 1963; Harper Torchbook]), which translated into English in 1902 and into German in 1907, has had far-ranging influence. In recent times, other European iconographers and related specialists have produced large-scale studies, especially dictionaries and encyclopedias of fundamental importance: Hans Aurenhammer, *Lexikon der christlichen Ikonographie* (Vienna, 1959 ff.); Theodor Klauser, ed., *Reallexikon für Antike und Christentum* (1950 ff.); L. Réau, *Iconographie de l'art chrétien,* 3 vols.

[119] Pächt's review appeared in *Burlington Magazine* XCVIII (1956), pp. 110–16, 266–77. For a criticism of Panofsky's earlier approach to iconography, see C. Gilbert, "On Subject and Non-Subject in Italian Renaissance Pictures," *Art Bulletin* XXXIV (1952), pp. 202–16, and Panofsky's reply in the Torchbook edition of his *Studies in Iconology* (1962), p. v–vi.

[120] *Art Bulletin* XXVII (1945), pp. 175–81, repub. in *Renaissance Art,* ed. Creighton Gilbert (New York, 1970; Harper Torchbook), pp. 43–68.

[121] As Pächt brings out (*Burlington Magazine* XCVIII [1956], p. 276, note 39), Meyer Schapiro's viewpoint as expressed in his interpretation of the mousetrap symbol in the Mérode Altarpiece is a more plausible evaluation of the historical situation (in *Art Bulletin* XXVII (1945), pp. 182–7). Schapiro regards the symbolism not as deliberately disguised by the Master of Flémalle, but as implicit—for the artist and the contemporary beholder—in the objects under consideration, because a certain allegorical meaning was traditionally associated with them. And, for Schapiro, the symbols of the painting presuppose the development of realism rather than explain it; indeed, he emphasizes that "the introduction of nature and, with it, of the domestic human surroundings into painting can hardly be credited to a religious purpose." (*ibid.,* p. 185)

(Paris, 1955–59); Engelbert Kirschbaum, ed., *Lexikon der christlichen Ikonographie* (1968 ff.); Raimond van Marle, *Iconographie de l'art profane au moyen-âge et à la renaissance et la décoration des demeures,* 2 vols. (The Hague, 1931/32); B. Knipping, *De Iconografie van de Contra-Reformatie in de Nederlanden,* 2 vols. (Hilversum, 1939/40); Guy de Tervarent, *Attributs et symboles dans l'art profane, 1450–1600; Dictionaire d'un langage perdu,* 3 vols. (Geneva, 1958–64); Andor Pigler, *Barockthemen; eine Auswahl von Verzeichnissen zur Ikonographie des 17. und 18. Jahrhunderts,* 2 vols. (Budapest, 1956).[122]

About the time of World War I, iconography became established in the United States as a major branch of scholarship. It followed different paths, the first one originating at Princeton University early in this century, and a second at the Institute of Fine Arts of New York University in the 1930s. Charles Rufus Morey (1877–1955) was responsible for both its establishment at Princeton and the training of students in its methodology.[123] He was also instrumental in introducing art history into the curricula of higher learning in this country and was one of the founders of its leading journal, the *Art Bulletin* (begun in 1913). Trained in Classical languages and literature, Morey became interested in the refractions and transmutations of pagan images in Early Christian and then medieval art, as well as the problems posed by these transformations. In 1918 he founded the Index of Christian

Art at Princeton and guided its growth and development until his death in 1955; at present the Index contains over 500,000 subject entries and 125,000 photographs of Christian art dating from before 1400, and copies of it are located at the Vatican, Utrecht, Washington, D.C., New York, and Los Angeles.[124] The Index has served as an indispensable research tool for iconographical studies in Late Antique, Early Christian, Byzantine, and Western medieval art, and it is used by historians, literary historians, theologians, and art historians alike. It has stimulated the study of such art in the United States.[125]

Morey and the students he attracted to Princeton have produced a number of important studies. Iconography has served as an analytical tool for their research, largely for the ascertainment of the provenance, dates, and prototypes of manuscript illuminations, sarcophagi, ivory carvings, and metalwork. Their basic approach can best be gleaned from their publications. Following many other specialists in Early Christian art, Morey was influenced by the concepts and theories of Strzygowski and Ainalov. In an early paper he formulated a working hypothesis about "Hellenistic naturalism," "Latin realism," and "Celto-Germanic dynamism" that could be used to discuss some of the major traits in numerous examples of medieval painting ("Sources of Mediaeval Style," *Art Bulletin* VII [1924], pp. 35–58).[126] Of Byzantine art Morey would later write:

[122] For the work of these scholars, consult J. Bialostocki, *Encyclopedia of World Art,* s. v., "Iconography and Iconology."

[123] See the sympathetic appraisal by Erwin Panofsky, "Charles Rufus Morey (1877–1955)," in *American Philosophical Society Year Book* (1955), pp. 482–91.

[124] Helen Woodruff, *The Index of Christian Art at Princeton University; A Handbook* (Princeton, 1942). The copy at the Metropolitan Museum of Art is not up to date.

[125] See Kurt Weitzmann, "Byzantine Art and Scholarship in America," *American Journal of Archaeology* LI (1947), pp. 394–418.

[126] Of this work, Panofsky has observed that it "dared reduce the complexity of mediaeval art to three great currents much as Johannes Kepler had reduced the complexity of the solar system to three great laws" ("Three Decades of Art History in the United States," *Meaning in the Visual Arts* [Garden City, N.Y., 1955; Doubleday Anchor Book], p. 326).

The division of late antique style into the two-dimensional mode inherited from the Neo-Attic wing of Hellenism, and on the other hand the picturesque spatial impressionism that has often been associated with Alexandria, is a consideration without which no theory of the formation of Byzantine art can be valid. ["The Byzantine Renaissance," *Speculum* XIV (1939), p. 159]

Though such hypotheses have now been discarded, they possessed great heuristic value in their day. A useful summation of Morey's theories can be found in his *Mediaeval Art* (New York, 1942) and *Early Christian Art: An Outline of the Evolution of Style and Iconography in Sculpture and Painting from Antiquity to the Eighth Century* (Princeton and London, 1942), both of which appeared in the same year (a second edition of the latter came out in 1953). These publications disclose that Morey had the capacity not only to examine in detail specific symbolic, and in some measure aesthetic, qualities as well as clusters of traits, but also to evolve a broad view of Early Christian and Western medieval art that unites in a single scheme the hundreds of scattered works produced during a period of over 1,000 years. In this regard, the scope of Morey's work has hardly been equaled and never surpassed in recent scholarship.[127]

Earl Baldwin Smith (1888–1956), one of the first scholars Morey brought to Princeton, published a number of iconographic studies on sculpture and especially architecture: *Early Christian Iconography and a School of Ivory Carvers in Provence* (Princeton, 1918); *The Dome; A Study in the History of Ideas* (Princeton, 1950); and *Architectural Symbolism of Imperial Rome and the Middle Ages* (Princeton, 1956). His major contribution was *Egyptian Archi-*

tecture as Cultural Expression (New York and London, 1938; Century House paperback). In this perceptive study, Smith takes into account not only the formal and iconographic, but also the social and environmental factors influencing the development of ancient Egyptian architecture.

Another Morey disciple was Myrtilla Avery, whose paper "The Alexandrian Style at Santa Maria Antiqua, Rome" (*Art Bulletin* VII [1925], pp. 131–49) contains a brilliant synthesis and further development of the concepts and doctrines of Strzygowski and Ainalov, as well as of Morey himself. Avery's work, in turn, wielded an influence on Early Christian and early Western medieval scholarship for well over a decade.[128] Morey and his students also devoted their energies to the publication of corpora of manuscripts: Morey and Leslie W. Jones, *The Miniatures of the Manuscripts of Terence Prior to the Thirteenth Century* (*Illuminated Manuscripts of the Middle Ages*, vols. 1–2) (Princeton, 1930–31); Avery, *The Exultet Rolls of Southern Italy* (*Illuminated Manuscripts of the Middle Ages*, vol. 4) (Princeton, 1936–37); Ernest T. DeWald, *The Stuttgart Psalter, Biblia Folio 23, Wuerttembergische Landesbibliothek, Stuttgart* (*Illuminated Manuscripts of the Middle Ages* vol. 2) (Princeton, 1930), *The Illustrations of the Utrecht Psalter* (*Illuminated Manuscripts of the Middle Ages*, vol. 3) (Princeton, 1932), and *The Illustrations in the Manuscripts of the Septuagint*, 3 vols., ed. Ernest T. DeWald et al (Princeton and London, 1941 ff.). Only occasionally did the Princeton school publish genuine iconographic papers, in the narrow sense of the term (a representative example is J. Carson Webster, *The Labors of the Months in Antique and Medieval Art to the End of*

[127] Some pertinent observations on Early Christian art are found in Meyer Schapiro's harsh criticism of Morey's *Early Christian Art* (in *Review of Religion* VIII [1944], pp. 165–86). For Morey's bibliography, see *Art Bulletin* XXXII (1950), pp. 345–49.

[128] For example, in the widely quoted doctoral dissertation of Ernst Kitzinger, *Römische Malerei vom Beginn des 7. bis zur Mitte des 8. Jahrhundert* (Munich, 1934) and in other writings by this noted scholar, who now teaches at Harvard University.

the *Twelfth Century* [Evanston and Chicago, 1938]). Morey also trained Edward Capps, Jr., Perry B. Cott, Donald D. Egbert, Joseph C. Sloane, and Andrew S. Keck, all of whom made important contributions to the study of the art of the 1st millennium and later.

Perhaps the most imaginative and broadly oriented of all Princetonians was Albert M. Friend, Jr. (1894–1956), another Morey pupil whose scholarly interests ranged from Byzantine manuscript illumination and Carolingian art to Albrecht Dürer and Northern Renaissance art. During World War I he undertook a doctoral dissertation on Carolingian ivory carving, only to discover at the end of the war that Adolph Goldschmidt had begun to publish a monumental corpus of the same material. Friend's attribution of some ivories and goldwork to the Court School of Charles the Bald remains a brilliant piece of scholarship, although today his findings are not generally accepted ("Carolingian Art in the Abbey of St. Denis," *Art Studies* I [1923], pp. 67–75). His investigation of portraits of the Evangelists in Western and Byzantine manuscript painting, on the other hand, was a pioneering work that has never been followed up ("Portraits of the Evangelists in Greek and Latin Manuscripts," *Art Studies* V [1927], pp. 115–47, and VII [1929], pp. 3–29). From a careful analysis of the Eusebian canon tables illustrated in the Book of Kells, he concluded that artistic connections exist with Carolingian manuscript illumination (in *Mediaeval Studies in Memory of A. Kingsley Porter,* ed. Wilhelm R. W. Koehler [Cambridge, Mass., 1939], pp. 611–66). Though his interest in later medieval and Renaissance art was manifested largely in his lectures to undergraduates at Princeton University, he did publish one paper on this material ("Dürer and the Hercules Borghese-Piccolomini," *Art Bulletin* XXV [1943], pp. 40–9).

The contribution of Albert Friend should be measured principally by his expert and inspiring guidance for a decade as Director of Studies of the Dumbarton Oaks Research Center for Byzantine Studies in Washington, D.C. Friend molded Dumbarton Oaks into the world's leading center for Byzantine scholarship. He invited international specialists in theology, history, literature, and philology, as well as art history, to come to the Center as either permanent or visiting scholars so that they could work side by side and occasionally launch joint attacks on major problems. Symposia on these problems were encouraged, a superb working library built up, and a copy of the Princeton Index of Christian Art installed. Important field work was undertaken at such major monuments as the Hagia Sophia and the Kariye Djami in Istanbul, and magnificent publications eventually resulted from this work: for example, Robert Van Nice, *Santa Sophia in Istanbul: An Architectural Survey* (Washington, D.C., 1966 ff.), representing over 35 years of painstaking measurements and beautifully detailed drawings; Paul A. Underwood, *The Kariye Djami,* 3 vols. (New York, 1966 [a fourth volume is in preparation]); Ernst Kitzinger, *The Mosaics of Monreale* (Palermo, 1960); and some major papers on other mosaics that have been published in the *Dumbarton Oaks Papers* and elsewhere. Friend himself undertook research on Byzantine monuments during his tenure as director of Dumbarton Oaks but was unable to complete it for publication.[129] Since his death, Dumbarton Oaks has been pursuing a dif-

[129] For example, Friend planned a monograph on the Church of the Holy Apostles at Constantinople, in collaboration with Glanville Downey and the late Paul A. Underwood. The ambitious monograph was never completed in the form envisaged by Friend, but Downey has published a major part of the textual evidence pertaining to the church (*Nikolaos Mesarites: Description of the Church of the Holy Apostles at Constantinople* [*Transactions of the American Philosophical Society,* n. s. XLVII (1957), pp. 855–924]). Downey teaches history at Indiana University.

ferent path; today it does not seem to encourage art history.

At Princeton University today the tradition of distinguished scholarship in medieval art history is maintained by Kurt Weitzmann (born 1904).[130] A student of Julius von Schlosser (for a brief period) and Adolph Goldschmidt (under whose direction his doctoral dissertation on Byzantine ivory caskets was written in 1930), Weitzmann is a leading specialist, if not the foremost authority, on Byzantine illuminated manuscripts, icon paintings, and ivory carvings. Even before Morey extended an invitation to him to come to Princeton in the mid-thirties, he had coauthored with Goldschmidt the monumental *Byzantinischen Elfenbeinskulpturen des X. bis XIII. Jahrhunderts*, 2 vols. (Berlin, 1930–34) and alone wrote *Die byzantinische Buchmalerei des IX. und X. Jahrhunderts* (Berlin, 1935), both of which remain fundamental corpora and disclose his capacity for hard concentration on individual works of art. These books continued the tradition of Goldschmidt's publications. Once at Princeton, however, he expanded his great teacher's perspectives through detailed iconographic research, prompted in no small measure by the work of the "Princeton school." He formulated concisely and concretely an ingenious method for determining the visual and textual sources of medieval illuminated manuscripts (*Illustrations in Roll and Codex, A Study of the Origin and Method of Text Illustration* [Princeton, 1947; 2d ed., 1970]), of which he gave a working demonstration in his Joshua Roll monograph of 1948 and in a large number of papers (for example, "The Psalter Vatopedi 761: Its Place in the Aristocratic Psalter Recension," *Journal of the Walters Art Gallery* X [1947], pp. 20–51). He has also dealt with the question of possible Jewish influences on illustrations of the Old Testament ("Zur Frage des Einflusses jüdischer Bilderquellen auf die Illustration des Alten Testamentes," in *Mullus: Festschrift Theodor Klauser* [Münster, 1964], pp. 401–15); "Book Illustration of the 4th Century: Tradition and Innovation" (in *Akten des VII. Internationalen Kongresses für christliche Archäologie, Trier 5–11 September 1965*, 2 vols. [Vatican City and Berlin, 1967], I, pp. 257–81); "The Narrative and Liturgical Gospel Illustration" (in *New Testament Studies*, ed. M. Parvis and A. P. Wikgren [Chicago, 1950]); and even Armenian illuminated manuscripts (*Die armenische Buchmalerei des 10. und beginnenden 11. Jahrhunderts* [Bamberg, 1933]).[131] These studies, which have immeasurably expanded our knowledge and understanding of Early Christian and Byzantine art, show that his method involves a correlation of precise iconographic analysis and stylistic observation and draws upon relevant historical and other textual evidence. In his recent work on the important 6th-century apse mosaic of the monastery of St. Catherine on Mount Sinai, he demonstrates why formal qualities must sometimes be interpreted in the context of their iconographic and specific dogmatic and liturgical program (*Monastery of Saint Catherine at Mount Sinai:*

[130] A number of important studies with an iconographic orientation originated at Princeton under the supervision of Friend and Weitzmann: for instance, John R. Martin, *The Illustrations of the Heavenly Ladder of John Climacus* (Princeton, 1954), especially valuable for its insights into Byzantine monasticism of the "Second Golden Age"; James D. Breckenridge, *The Numismatic Iconography of Justinian II (685–695, 705–711 A.D.)* (New York, 1959); William C. Loerke, "The Miniatures of the Trial in the Rossano Gospels," *Art Bulletin* XLIII (1961), pp. 171–95; George Galavaris, *Illustrations of the Liturgical Homilies of Gregory Nazianzenus* (Princeton, 1969).

[131] See also his important paper, "Die Illustration der Septuaginta," *Münchner Jahrbuch der bildenden Kunst*, 3d ser. III/IV (1952/53), pp. 96–120, and his book *Ancient Book Illumination* (Cambridge, Mass., 1959). Some of Weitzmann's widely scattered papers are being collected for publication in 1971 under the editorship of Herbert L. Kessler.

The Church and Fortress of Justinian, coed. with George Forsyth, 2 vols. [Ann Arbor, Mich., 1970]).[132] The approximately 2,000 Byzantine icons at Mount Sinai have also absorbed his energies in a number of widely scattered papers of the past decade and in a promised forthcoming corpus (see Weitzmann et al, *A Treasury of Icons: Sixth to Seventeenth Centuries, from the Sinai Peninsula, Greece, Bulgaria, and Yugoslavia* [New York, 1967]).

Yet another major interest of this perspicacious scholar is the survival and revival of the Classical tradition in art, a topic that also absorbed the energies of Von Schlosser, Goldschmidt, and Friend: *Greek Mythology in Byzantine Art* (Princeton, 1951); and *Geistige Grundlagen und Wesen der Makedonischen Renaissance* (Cologne and Opladen, 1963), which summarizes his earlier scholarship on the subject. This concern is also the topic of an essay republished in this book, "The Survival of Mythological Representations in Early Christian and Byzantine Art" (*Dumbarton Oaks Papers* XIV [1960], pp. 43–68).[133] The pursuit of the Classical

tradition in Western art characterizes a number of modern iconographic studies that have appeared on both sides of the Atlantic during this century.

Since they bear directly on the link between image and thought, the transmission and transformation of Classical themes and motifs always engaged the attention of Erwin Panofsky, that humanist of tremendous learning, wit, and warmth, who above all others was responsible for the formulation and application of the modern methods and techniques of iconography and iconology and their dissemination in both the United States and Europe. After completion of his doctoral dissertation on Albrecht Dürer's theory of art, which was accepted by Wilhelm Vöge in 1914,[134] he prepared a study of Dürer and Classical antiquity.[135] During the time from 1921 until 1933, when he was successively privatdozent and professor at the University of Hamburg, Panofsky developed close friendships with Aby Warburg (1866–1929),[136] an art historian of extraordinary humanistic interests, and the eminent neo-Kantian philosopher and

[132] See George H. Forsyth, "The Monastery of St. Catherine at Mount Sinai: The Church and Fortress of Justinian," *Dumbarton Oaks Papers* XXII (1968), pp. 1–19.

[133] See also Weitzmann's "The Classical in Byzantine Art as a Mode of Individual Expression" (in *Byzantine Art: An European Art, Lectures* [Athens, 1966], pp. 149–77).

[134] Sections of Vöge's still valuable book *Die Anfänge des monumentalen Stiles im Mittelalter; Eine Untersuchung über die erste Blütezeit französischer Plastik* (Strassburg, 1894) have been translated into English and published in *Chartres Cathedral*, ed. Robert Branner (New York, 1969; Norton paperback), pp. 126–49.

[135] "Dürers Stellung zur Antike," *Jahrbuch für Kunstgeschichte* I (1921/22), pp. 43–92 ("Albrecht Dürer and Classical Antiquity," in Panofsky's *Meaning in the Visual Arts* [Garden City, N.Y., 1955; Doubleday Anchor Book], pp. 236–85).

[136] Panofsky's interest in the legacy of Classical antiquity in the works of Dürer was probably inspired by a pioneering paper by Aby Warburg that appeared in 1905 (repub. in Warburg's collected writings, *Gesammelte Schriften*, 2 vols. [Leipzig, 1932]). However, he also studied with Adolph Goldschmidt, who was himself interested in the problem ("Das Nachleben der antiken Formen im Mittelalter," *Vorträge der Bibliothek Warburg, 1921–1922* [Leipzig, 1923], pp. 40–50). A problem fundamental to the study of Western art, the tradition of antiquity always fascinated Panofsky, who continued to think and write about it until his death (e.g., "Renaissance and Renascences," *Kenyon Review* VI [1944], pp. 201–36, which appears in this book; *Renaissance and Renascences in Western Art* [Stockholm, 1960; 2d ed., 1965; Harper Torchbook], the result of lectures he delivered in Stockholm; and an interesting paper on tradition in English art, "The Ideological Antecedents of the Rolls-Royce Radiator," *Proceedings of the American Philosophical Society* CVII [1963], pp. 273–88).

historian Ernst Cassirer (1874–1945).[137] These sagacious thinkers, along with Fritz Saxl (1890–1948), composed the original nucleus of what was eventually founded as the Warburg Institute, located first in Hamburg and later in London. The influence of these scholars on Panofsky's intellectual development was profound.

With Saxl, Panofsky coauthored two studies. The first dealt with the transmission and transformation of astrological lore and pagan antiquity: Dürers 'Melencolia I,' eine quellen- und typengeschichtliche Untersuchung (1923), recently enlarged with the collaboration of Raymond Klibansky into a monumental 429-page new edition (Saturn and Melancholy; Studies in the History of Natural Philosophy, Religion and Art [London, 1964]). The second was a paper entitled "Classical Mythology in Medieval Art" (Metropolitan Museum Studies IV (1933), pp. 228–80).[138] Saxl had studied under Dvorák and Wölfflin but was attracted far more to the mind and personality of Warburg, whose broad interests he sought to develop.[139] In his major contribution to scholarship, Mithras, typengeschichtliche Untersuchungen (Berlin, 1931), Saxl examines the relations between the images and the thought of one of the all-powerful syncretistic religions of Late Antiquity. The method employed in this investigation of Mithraism calls upon the evidence of not only specific works of art, but also epigraphy, history, philosophy, and religious doctrine.[140]

The first genuinely iconological work by Panofsky was his Hercules am Scheidewege und andere antike Bildstoffe in der neueren Kunst (Leipzig, 1930), a masterly book in which the transformations of a major antique theme are described and explained as cultural symptoms. This study was followed by others, including "Jan van Eyck's Arnolfini [Double] Portrait" in 1934 (reprinted in this book), which was his first publication in the field of early Netherlandish painting.[141] These papers led him to the formulation of the methods and techniques of iconology that he published in Studies in Iconology (New York, 1939), a book whose importance for the historiography of art rivals that of Riegl's Spätrömische Kunst-Industrie (1901) and Wölfflin's Kunstgeschichtliche Grundbegriffe (1915), and which, like Wölfflin's book, has left an imprint outside of art history. But Panofsky was not the only scholar who was pursuing these interests during the 1930s.[142]

Under the guidance first of Fritz Saxl and later of E. H. Gombrich, the Warburg

[137] See The Philosophy of Ernst Cassirer, ed. Paul A. Schilpp (Evanston, Ill., 1949); also below, p. 65.

[138] For an early application of the techniques of psychoanalysis to the iconographic work of Panofsky and Saxl on Dürer's Melancholia, see Alfred von Winterstein, "Dürers 'Melancholia' in Lichte der Psychoanalyse," Imago XV (1929), pp. 145 ff.

[139] Some of Saxl's papers were collected and published posthumously in Lectures, 2 vols. (London, 1957). For an appraisal of his accomplishment, see the remarks by Gertrud Bing that introduce Fritz Saxl, 1890–1948: A Volume of Memorial Essays from His Friends in England, ed. D. J. Gordon (London and New York, 1957).

[140] Compare Leroy A. Campbell, Mithraic Iconography and Ideology (Leiden, 1968).

[141] Republished in Renaissance Art, ed. Creighton Gilbert (New York, 1970; Harper Torchbook), pp. 1–20. See also Panofsky's Early Netherlandish Painting, 2 vols. (Cambridge, Mass., 1953), I, pp. 201–3.

[142] Although Panofsky's exposition of the method has wielded by far the most influence in the field, other specialists had articulated on iconology for at least twelve years before the publication of his book: Emile Mâle, "La Clef des Allégories peintes et sculptées au XVIIe et au XVIIIe siècle," Revue des Deux Mondes XXXIX (May 1, 1927), pp. 106–29, where the term iconology, suggested to

Institute in London has attracted a number of great minds, not only art historians but also historians and philosophers,[143] and these scholars have produced some stimulating iconographic and iconological papers. These include Wolfgang Stechow, *Apollo und Daphne* (Berlin, 1932); E. H. Gombrich, "Botticelli's Mythologies" (*Journal of the Warburg and Courtauld Institutes* VIII [1945], pp. 7–60); Rudolf Wittkower, "The Vicissitudes of a Dynastic Monument: Bernini's Equestrian Statue of Louis XIV" (in Millard Meiss, ed., *De artibus opuscula XL: Essays in Honor of Erwin Panofsky*, 2 vols. [New York, 1961], I, pp. 497–553). But as a rule they have turned their attention to other disciplines, such as psychology and the sociology of knowledge.[144] The scholar (formerly connected with the institute) who has developed the iconological aspects of Warburg's art history most perspicaciously is Edgar Wind (born 1900). After a thorough training in mathematics and philosophical studies, Wind began to write a number of papers and books of a definite iconological bent. With the force of sheer brilliance, his careful and precise reading of, and inference from, pertinent texts leads easily to the solution of "unresolved residues of meaning" in selected works of European

art from the Early Renaissance to the 19th century. His major contribution to date is *Pagan Mysteries in the Renaissance* (New Haven, 1958; enl. and rev. ed., Harmondsworth, Eng., 1967; Penguin Book), the chief aim of which is to "elucidate a number of great Renaissance works of art" by masters such as Botticelli, Michelangelo, and Titian. Maintaining that ideas forcefully expressed in art were alive in other areas of human endeavor, he does not "hesitate to pursue philosophical arguments on their own terms, and in whatever detail they may require" (*ibid.*, p. 14). Since "the presence of unresolved residues of meaning is an obstacle to the enjoyment of art," he adopts an "iconographical approach" (he does not use the term iconology), because "it may help to remove the veil of obscurity which not only distance in time (although in itself sufficient for that purpose) but a deliberate obliqueness in the use of metaphor has spread over some of the greatest Renaissance paintings" (*ibid.*, p. 15). His extraordinary breadth of knowledge attracts not only art historians but students of other disciplines as well, especially philosophy and literature.[145]

As important and impressive as their scholarship appears, the heirs to Aby War-

Mâle by Cesare Ripa's *Iconologia* (first pub. 1593, reprinted many times thereafter, and trans. into four languages), was introduced into art history; and Godfried J. Hoogewerff, "L'Iconologie et son importance pour l'étude systématique de l'art chrétien," *Rivista di archeologia cristiana* VIII (1931), pp. 53–82. However, while referring to iconographic investigation rather than iconology in his *Studies in Iconology*, Panofsky sketched the nature of the latter method in the foreword (dated 1929) to his *Hercules am Scheidewege*. At least three scholars of different European nationalities were therefore evolving the techniques of the method at the same time. For this see William S. Heckscher, "The Genesis of Iconology," in *Stil und Überlieferung in der Kunst des Abendlandes* (*Akten des XXI. Internationalen Kongresses für Kunstgeschichte, Bonn, 1964* [1967], III, pp. 260–2).

[143] The Warburg Institute functions as a research center for mature scholars in diverse disciplines. Graduate students who want to pursue art history in London attend the Courtauld Institute.

[144] The latter subject was of great interest to Warburg Institute visitor Karl Mannheim (see his profound *Essays on the Sociology of Knowledge*, ed. Paul Kecskemeti [London, 1952]).

[145] His dissertation was *Ästhetischer und kunstwissenschaftlicher Gegenstand* (Hamburg, 1922), partly reprinted as "Zur Systematik der künstlerischen Probleme," *Zeitschrift für Ästhetik und allgemeine Kunstwissenschaft* XVIII (1924), pp. 438–86. Other spirited writings by Wind include

burg cannot be said to have followed up fully his wide-ranging historical perspectives, but rather only aspects of them.[146] A contemporary of Riegl, Dvorák, Wölfflin, and Goldschmidt, and no less pioneering and influential a scholar, Warburg was preoccupied with the visual arts as cultural phenomena. He sought not so much the possible sources of works of art as identification and explanation of their cultural backgrounds. He refused to allow his creative scholarship "to be hemmed in by the restrictions of the border police," by which he meant the prevailing formalist approach of Wölfflin and the methods of Riegl and Dvorák. Warburg thought it was possible to demonstrate, for specific conditions of time and place, how the visual arts express the perceptions and experiences of man. The qualities of form through which man expresses these perceptions and experiences Warburg called *Pathos-formel,* which are roughly equivalent to what rhetoricians term *topoi.*[147] He discovered and traced these *Pathosformel* by scrutinizing all relevant evidence, the range of which is remarkable: archives, family diaries, psychology, folklore, mythology, religion, philosophy, ethnography, grand opera, astrology. He even made a trip to New Mexico in 1895/96 to witness firsthand the "living paganism" of the Pueblo Indians, and wrote about American chapbooks.

In his study of Renaissance, and especially of Quattrocento, art, Warburg was vitally concerned with the Classical tradition as an index of that art's cultural influences, a topic that his followers have avidly pursued. Yet the scope of Warburg's work and interests is broader and deeper than that of such iconologists as Panofsky and Wind, who focus more on the search for possible sources (visual or textual) of

"The Revolution of History Painting," *Journal of the Warburg and Courtauld Institutes* II (1938/39), pp. 116–27; *Bellini's Feast of the Gods: A Study in Venetian Humanism* (Cambridge, Mass., 1948); *Art and Anarchy* (London, 1963; Vintage Book); and "Michelangelo's Prophets and Sibyls," *Proceedings of the British Academy* LI (1965), pp. 47–84. His monograph *Giorgione's Tempesta* is forthcoming. Wind emigrated to the United States in 1942 and has taught at the University of Chicago (1942–44) and Smith College (1944–55). For an evaluation by an undergraduate student who attended Wind's iconographically oriented lectures, see the letter published by Colin Eisler, "Kunstgeschichte American Style: A Study in Migration," in *The Intellectual Migration: Europe and America, 1930–1960,* ed. Donald Fleming and Bernard Bailyn (Cambridge, Mass., 1969), p. 618.

[146] The writings of Warburg, Saxl, Wind, Panofsky, and Gombrich are critically examined by Carlo Ginzburg, "Da A. Warburg a E. H. Gombrich (Nota su un problema di metodo)," *Studi medievali,* 3d ser. VII (1966), pp. 1015–65. Warburg, scion of a Hamburg banking family who renounced a share of the family fortune for the subsidy of a personal scholarly library in 1901, never published a book; his papers are collected and edited in *Gesammelte Schriften,* 2 vols. (Leipzig, 1932 [*La rinascità del paganesimo antico, contributi alla storia della cultura,* comp. Gertrud Bing, trans. Emma Cantimori, Florence, 1966]). For keen insights into the complex points of view and interests of Warburg, see Edgar Wind, "Warburgs Begriff der Kulturwissenschaft und seine Bedeutung für die Ästhetik," *Zeitschrift für Ästhetik und allgemeine Kunstwissenschaft* XXV (Beilageheft, 1931), pp. 163–79; Fritz Saxl, "Rinascimento dell'Antichità" *Repertorium für Kunstwissenschaft* XLIII (1922), pp. 220–72; and the fascinating paper by William S. Heckscher, "The Genesis of Iconology," in *Stil und Überlieferung in der Kunst des Abendlandes (Akten des XXI. Internationalen Kongresses für Kunstgeschichte, Bonn, 1964* [1967], III, pp. 239–62).

[147] The idea of the *Pathosformel* was inspired by the title of Charles Darwin's book *The Expression of the Emotions in Man and Animals* (1872). And Wind has shown that the nature of Warburg's concept of the symbolic expression of the human mind was inspired by the works of the German writer on aesthetics Friedrich Theodor von Vischer (1807–87).

representational art.[148] Of all scholarship in the arts, it is indeed the writings, lectures, and library of Aby Warburg that identify art history as an aspect of cultural history or *Geisteswissenschaften*.[149]

The iconological method of Panofsky and other members of the Warburg Institute became known in the United States before the 1939 appearance of *Studies in Iconology*, for Panofsky first came to this country by invitation in 1931 and began teaching in New York and Princeton. Some of his Hamburg students also migrated here and published iconographic studies: Adolf Katzenellenbogen, *Allegories of the Virtues and Vices in Mediaeval Art from Early Christian Times to the Thirteenth Century* (London, 1939) and *The Sculptural Programs of Chartres Cathedral: Christ, Mary, Ecclesia* (Baltimore, 1959; both Norton paperbacks); H. W. Janson, *Apes and Ape Lore in the Middle Ages and the Renaissance* (London, 1952); William S. Heckscher, "Bernini's Elephant and Obelisk," *Art Bulletin* XXIX (1947), pp. 155–82. Significantly, most of the major American scholars who either studied under Panofsky or collaborated with him have produced only a few strictly iconographic papers. The greater part of their contribution reveals an assimilation of his point of view in combination with other methods, and is distinguished by a broader and higher orientation as is the late scholarship of Panofsky himself (for instance, the work of Millard Meiss, Meyer Schapiro, and Frederick Hartt).[150]

Certain theoretical and technical aspects of the visual arts—perspective and proportion, for instance—lend themselves to the methods of iconographic research. Erwin Panofsky's "Die Perspektive als symbolische Form" (in *Vorträge der Bibliothek Warburg, 1924/25* [1927], pp. 258–330; reprinted in Hariolf Oberer and Egon Verheyen, eds. and comps., *Aufsätze zu Grundfragen der Kunstwissenschaft* [Berlin, 1964]; also in Italian trans.) is a masterly inquiry into the various conceptions of space from antiquity to the present day and their relation to the changing *Weltanschauungen* of the times.[151] In another richly documented study Panofsky analyzes not only the appearance but also the meaning and significance of various canons of proportion that occur in the history

[148] To be sure, Panofsky wrote critical essays on the movies and Booth Tarkington: "On Movies," in *Bulletin of the Department of Art and Archaeology, Princeton University* (1936), pp. 5–15; "Style and Medium in the Motion Picture," *Critique* I (1947), pp. 5–28; "Humanitas Tarkingtoniana," in Princeton University Library, *An Exhibition of Booth Tarkington's Works* (Princeton, 1946), pp. 1–4.

[149] The term *Geisteswissenschaften* has been variously translated as "the social sciences," "the humanities," or simply, "human studies." In the 1920s there were some 65,000 volumes in Warburg's library.

[150] Millard Meiss, "The Madonna of Humility," *Art Bulletin* XVIII (1936), pp. 434–64, and "Light as Form and Symbol in Some Fifteenth-Century Paintings," *Art Bulletin* XXVIII (1945), pp. 175–81; (reprinted in *Renaissance Art*, ed. Creighton Gilbert [New York, 1970; Harper Torchbook], pp. 43–68); Meyer Schapiro, "Cain's Jaw-bone That Did the First Murder," *Art Bulletin* XXIV (1942), pp. 182–7; Frederick Hartt, "*Lignum Vitae in Medio Paradisi*, The Stanza d'Eliodoro and the Sistine Ceiling," *Art Bulletin* XXXII (1950), pp. 115–45.

[151] Both the title and the substance of Panofsky's essay were directly inspired by a work of the philosopher Ernst Cassirer, *Philosophie der symbolischen Formen*, 3 vols. (Berlin, 1923–29 [*The Philosophy of Symbolic Forms*, 3 vols., trans. Ralph Manheim, New Haven, 1953–57]). Indeed, Panofsky's essay may be regarded as an illustration of Cassirer's philosophy as applied to painting and sculpture. See Katherine Gilbert, "Cassirer's Placement of Art," in *The Philosophy of Ernst Cassirer*, ed. Paul A. Schilpp (Evanston, Ill., 1949), pp. 605–30; and Harry Slochower, "Ernst Cassirer's Functional Approach to Art and Literature," *ibid.*, pp. 631–59.

of Western art (1921; trans. by the author as "The History of the Theory of Human Proportions as a Reflection of the History of Styles," in *Meaning in the Visual Arts* [Garden City, New York, 1955; Doubleday Anchor Book]).

A related interpretation of the perspective devices, proportions, and other formal qualities of the figures in church mosaics of the middle Byzantine period (that is, from about 850 to 1200) has been made by the Austrian Byzantine scholar Otto Demus (*Byzantine Mosaic Decoration; Aspects of Monumental Art in Byzantium* [London, 1948]). In this basic study, Demus interprets the formal and symbolic qualities of the decoration as aspects of a coherent scheme or system that the artists followed under the close supervision of learned theological advisers.

The techniques of iconographic research are as applicable to architecture as they are to painting and sculpture. For the greater part of history, churches, monasteries, palaces — even houses and skyscrapers in this century — have been erected to convey symbolic significance. The study of a building's content — that is, the connections between its shape or design and its dedication or function — is known as the iconography of architecture. Its programmatic formulation is relatively recent: its introduction about the time of World War II in both Europe and the United States, by scholars working independently of one another, marked a departure from the archaeological, technical, formalistic, and documentary studies that had been the common approaches to architectural history since the 19th century.[152]

Though a number of scholars have dealt with the iconography of architecture, none has worked exclusively within it. One of the leading students of this genre is Richard Krautheimer (born 1897), who has submitted a number of papers dealing with the meaning of Early Christian and early medieval buildings ("Introduction to an 'Iconography of Mediaeval Architecture,'" in *Journal of the Warburg and Courtauld Institutes* V [1942], pp. 1–33; "Sancta Maria Rotunda," in *Arte del primo millennio, Atti del II° convegno per lo studio dell'arte dell'alto medio evo tenuto presso l'Università di Pavia nel settembre 1950,* ed. Edoardo Arslan [Turin, 1953], pp. 21–7). His studies demonstrate how medieval man was prone to take the symbol for the real thing, having lacked modern man's ability to make the distinction between the two.[153]

About the time Krautheimer was developing his interests, Karl Lehmann (1894–1960) was taking a similar approach in a masterly study entitled "The Dome of Heaven" (*Art Bulletin* XXVII [1945], pp. 1–27; reprinted in this book, which traces the direct passage of this idea from paganism to Christianity. And simultaneously in Europe, a similar interest in architecture was demonstrated by André Grabar (born 1896) in his monumental *Martyrium: Recherches sur le culte des reliques et l'art chrétien antique,* 3 vols. (Paris, 1943–46), and by Jean Lassus in his stimulating *Sanctuaires chrétiens de Syrie, essai sur la genèse, la forme et l'usage liturgique des édifices du culte chrétien en Syrie, du IIIe siècle à la conquête musulmane* (Paris, 1947). Shortly thereafter, a

[152] There had been a few iconographic studies of architecture before the war: for instance, Joseph Sauer, *Symbolik des Kirchengebäudes und seiner Ausstattung in der Auffassung des Mittelalters* (Frieburg im Breisgau, 1902; 2d ed., 1924); Hans Sedlmayr, "Die Area Capitolina des Michelangelo," *Jahrbuch der preussischen Kunstsammlungen* LII (1931), pp. 176–81.

[153] For other contributions by Krautheimer, see below. One of his students, Irving Lavin, recently made an important contribution to the study of medieval architectural iconography ("The House of the Lord: Aspects of the Role of Palace Triclinia in the Architecture of Late Antiquity and the Early Middle Ages," *Art Bulletin* XLIV (1962), pp. 1–27).

number of studies on the iconography of architecture were published by both American and European scholars: Earl Baldwin Smith (1888–1956), *The Dome: A Study in the History of Ideas* (Princeton, 1950), and *Architectural Symbolism of Imperial Rome and the Middle Ages* (Princeton, 1956); Hans Sedlmayr (born 1896), *Die Entstehung der Kathedrale* (Zurich, 1950), collected papers in his *Epochen und Werke; gesammalte, Schriften zur Kunstgeschichte,* 2 vols. (Vienna, 1956); Alfred Stange (born 1894), *Das frühchristliche Kirchengebäde als Bild des Himmels* (Cologne, 1950); Otto von Simson (born 1912), *The Gothic Cathedral; Origins of Gothic Architecture and the Medieval Concept of Order* (New York, 1956; 2d ed. rev., with additions, 1962; Harper Torchbook); Günter Bandmann (born 1917), *Mittelalterliche Architektur als Bedeutungsträger* (Berlin, 1951); and, in the field of Renaissance architecture, Rudolf Wittkower, who, as pointed out above, has been associated with the Warburg Institute (*Architectural Principles in the Age of Humanism* [London, 1949; Random House paperback]). For the iconography of the Capitol in Rome, there is an important recent interpretation by Herbert Siebenhüner (born 1908), *Das Kapitol in Rom; Idee und Gestalt* (Munich, 1954).

Lehmann's paper on "The Dome of Heaven" also illustrates how a particular theme, motif, or technique of one or any number of historical periods can be treated. Such typological studies have been common since the start of this century, especially among European scholars: for instance, Adolfo Venturi, *La Madonna; Svolgimento artistico delle rappresentazzioni della Vergine* (Milan, 1900); André Grabar, *L'Empereur dans l'art byzantin; recherches sur l'art officiel de l'empire d'Orient* (Paris, 1936); Moritz Hauptmann, *Der Tondo; Ursprung, Bedeutung und Geschichte des italienischen Rundbildes in Relief und Malerei* (Frankfurt am Main, 1936); Kenneth Clark, *The Nude: A Study in Ideal Form* (New York, 1956; Doubleday Anchor Book); John Pope-Hennessy, *The Portrait in the Renaissance* (New York, 1966). In American scholarship, typological monographs have been far less frequent; two representative examples are Clarence Ward's *Mediaeval Church Vaulting* (Princeton, 1915) and the fine work of Carroll L. V. Meeks, *The Railroad Station; An Architectural History* (New Haven, 1956). Two such studies that are of a definite iconographic bent have been published by ·scholars connected with the Institute of Fine Arts of New York University: Dorothy C. Shorr, *The Christ Child in Devotional Images in Italy during the Fourteenth Century* (New York, 1954), and Mirella Levi D'Ancona, *The Iconography of the Immaculate Conception in the Middle Ages and Early Renaissance* (New York, 1957). In his *Transformations in Late Eighteenth Century Art* (Princeton, 1967), Robert Rosenblum, a former student of Walter Friedlaender at the Institute of Fine Arts, assimilates iconographic method with other approaches in a broadly oriented examination of the art and architecture that he subsumes under the rubric of Historicism.

So far this section has dealt with intrinsic approaches to the visual arts, entailing materials and technique, connoisseurship, formal analysis, iconography, and function. In such approaches, qualities inherent in the work of art itself are analyzed, and external data such as artistic biography, the psychology of artistic personality, social forces, cultural history, and the history of ideas are considered only to the extent that they may illuminate meaningful aspects of the inherent qualities of the work. However, many art historians are primarily interested in these external data for the light they shed on art. They maintain that works of art are historical entities that concern human behavior and relate to the social and cultural history of man. In this respect, their orientation is more broadly based than that of scholars

who restrict their interests to the intrinsic qualities of the visual arts. These broader perspectives are classified as extrinsic.

Although learning the biography of an artist is certainly no legitimate substitute for studying his work—and it has been stressed repeatedly in these pages that the work of art is the natural point of departure for the art historian—biographical data and the writings and statements of masters can provide valuable insights into the creative process and the nature of the work of art. So important can this material be, that to overlook or ignore it may result in a partial or even incorrect understanding of the work. And yet it must be properly evaluated. Biography can inform us of the personality and events in the life of an artist but not necessarily of the nature of his work, which is not simply a reflection or expression of the events in his life.

An artist may deliberately or even unconsciously conceal or transfigure his intentions, thoughts, and experiences in his work. For instance, among past masters Poussin is one of the best documented. Both he and his close circle of friends and admirers wrote about his art articulately, intelligently, and at length, and these letters and statements provide a mine of information about his working method and general attitudes toward his environment. But the great Baroque master, whom the critic William Hazlitt deemed the "most poetical of all painters," apparently incorporated in his paintings a dense matrix of philosophical and intellectual ideas that are nowhere evident in the utterances of the artist or his confidants, as Anthony Blunt has persuasively contended in a recent major monograph on the "pictor philosophus" (Nicolas Poussin, 2 vols. [New York, 1967]). If Blunt's carefully reasoned arguments about the complex, hidden meanings in many of Poussin's paintings are correct—he has found in them a syncretic mixture of Stoic thought and Christian theology—then it is plain that a biographical approach to the artist will not help us grasp the shape of the content of his oeuvre.

In dealing with biographical and other documentary evidence, the art historian must be on his guard against what Edgar Wind has called the "dialectic of the historical document."[154] When the specialist in Cubism, for example, points to Picasso's theoretical utterances as evidence to explain the style of his Cubist works, his investigation can only become an inquiry concerning the role of theory and ideas in the artistic process of Picasso. Whatever insights the specialist thinks he might gain from such written evidence ought to be used for a proper understanding of that process. For as Wind points out, "Every document participates in the structure which it is meant to reveal."[155]

The work that is ordinarily acknowledged as the first art history, Giorgio Vasari's Lives of the Most Eminent Painters,

[154] "Some Points of Contact between History and Natural Science," in Philosophy and History: Essays Presented to Ernst Cassirer, ed. Raymond Klibansky and H. J. Paton (Oxford, 1936), p. 257. See also Carl L. Becker, "What are Historical Facts?" Western Political Quarterly VIII (1955), pp. 327–40 (repub. in Ideas of History, ed. Ronald H. Nash, 2 vols. [New York, 1969; Dutton paperback]; and Edward Hallett Carr, What Is History? (London, 1962; Vintage Book), pp. 1–24.

[155] Michael Jaffé has published in exemplary fashion one of the most important discoveries in recent years, a group of documents concerning the young Rubens' altarpieces in Rome's Chiesa Nuova ("Peter Paul Rubens and the Oratorian Fathers," Proporzioni IV [1963], pp. 209–41). These documents enable us to follow step by step the chronology, execution, and vicissitudes of the paintings. Equally impressive are the many publications of the Italian scholar Carlo Pedretti that present the documents concerning Leonardo da Vinci: e.g., Leonardo da Vinci on Painting: A Lost Book (Libro A) reassembled from the Codex Vaticanus Urbinas 1270 and from the Codex Leicester (Berkeley, 1964); A Chronology of Leonardo da Vinci's Architectural Studies after 1500 (Geneva,

Sculptors and Architects, 2 vols. (Florence, 1550; expanded ed. in 3 vols., 1568), is a classic example of an almost exclusively biographical approach to the visual arts. It presents the histories of artists rather than the history of art, and even though it contains a cyclical conception of artistic development, its primary purpose is biographical. Vasari's work is a valuable record of events and statements by artists; however, scholars using the *Lives* have shown that some of this material, and especially those sections dealing with artists who worked before Vasari's time, is legendary, incorrectly reported, or strongly biased,[156] and thus it must be evaluated with great care. Nonetheless, no art historian specializing in Italian art of the period from Giotto to Michelangelo dares to ignore the *Lives.*

Vasari's histories of the lives of artists established a genre of writing that was taken up by subsequent commentators and has survived to the present day.[157] Especially in the study of modern art, the biographical approach is as common as it is important. The many books by John Rewald (born 1912) on Impressionist and Postimpressionist painters are largely full-dress biographies: for example, *Cézanne et Zola* (doctoral diss., 1936 [*Paul Cézanne: A Biography,* trans. Margaret Liebman, New York, 1948; Schocken Book]); *Post-impressionism from Van Gogh to Gauguin* (New York, 1956; 2d ed., 1962). The books by Alfred H. Barr, Jr. (born 1902) on Matisse, Picasso, and other masters are fundamental presentations of biographical and other documentary evidence concerning their lives and work (*Picasso; Forty Years of His Art,* ed. Alfred H. Barr, Jr. [New York, c. 1939]; *Picasso; Fifty Years of His Art* [New York, 1946]; and *Matisse: His Art and His Public* [New York, 1951]).[158] Even source books of basic theoretical documents in 20th-century art, such as Herschel B. Chipp's *Theories of Modern Art: A Source Book by Artists and Critics,* with contributions by Peter Selz and Joshua C. Taylor (Berkeley, 1968; University of California paperback), make significant contributions toward a deeper understanding of the ideological milieu of artists and of entire art movements.[159]

As important as these contributions are, they are limited in scope and offer only

1962); and *Leonardo da Vinci: The Royal Palace at Romorantin* (Cambridge, Mass., 1970). Archival research is arduous work that often yields discouraging results; occasionally, however, it can shed new light not only on great works of art but also on incidental matters. In this regard see Erice Rigoni, "Il pittore Nicolò Pizolo," in *Arte Veneta* II (1948), pp. 141–7 (trans. as "The Painter Niccolò Pizzolo" in *Renaissance Art,* ed. Creighton Gilbert [New York, 1970; Harper Torchbook], pp. 70–91).

[156] See, for instance, Ernst Kris and Otto Kurz, *Die Legende vom Künstler; ein geschichtlicher Versuch* (Vienna, 1934).

[157] Such an approach did not originate with Vasari; indeed, it can be traced back to antiquity. But Vasari was the first to present artistic biography in an extensive and systematic fashion. Consult the survey in Evert van der Grinten, *Enquiries into the History of Art-Historical Writing* (Venlo, 1955).

[158] Or for that matter, the conversation of the famous collector Gertrude Stein (1874–1946) with Picasso and Matisse (*Matisse, Picasso and Gertrude Stein* [Paris, 1933]; *Picasso* [Paris, 1938]).

[159] Chipp's major work is but one of many such collections by American and European specialists. But avoiding the shortcoming of most source books, Chipp has attempted to relate the statements and writings of artists to broad environmental conditions. Compare the works edited by: Robert Goldwater and Marco Treves, *Artists on Art, from the Fourteenth to the Twentieth Century* (New York, 1945); Elizabeth G. Holt, *From the Classicists to the Impressionists; A Documentary History of Art and Architecture in the Nineteenth Century* (New York, 1966; Doubleday Anchor Book); Robert L. Herbert, *Modern Artists on Art; Ten Unabridged Essays* (Englewood Cliffs, N.J., 1964); and the many volumes of H. W. Janson's *Sources & Documents in the History of Art.*

partial interpretations of works of art. A deeper understanding demands consideration not only of biographical and documentary evidence, but also of aesthetic and relevant environmental factors. Such a broadly conceived study of an artist's work may be termed contextual in approach, and such monographs have been appearing with greater frequency in the past twenty years.

A few of the more distinguished examples of this genre of scholarship by Americans and Europeans include: Kenneth Clark, Leonardo da Vinci; An Account of his Development as an Artist (Cambridge, 1939; Penguin Book); Erwin Panofsky, Albrecht Dürer, 3d ed. (Princeton, 1948); Richard Krautheimer and Trude Krautheimer-Hess, Lorenzo Ghiberti (Princeton, 1956); Charles De Tolnay, Michelangelo, 5 vols. (Princeton, 1943–60); Rudolf Wittkower, Gian Lorenzo Bernini, the Sculptor of the Roman Baroque, 2d ed. (London, 1966); Walter F. Friedlaender, Caravaggio Studies (Princeton, 1955; Schocken Book); Anthony Blunt, The Art of William Blake (New York, 1959) and Nicholas Poussin, 2 vols. (New York, 1967); Henry Russell Hitchcock, The Architecture of H. H. Richardson and His Times, rev. ed. (Hamden, Conn., 1961; MIT paperback); Jules Prown, John Singleton Copley, 2 vols. (Washington, D.C., 1966); E. Maurice Bloch, George Caleb Bingham, 2 vols. (Berkeley, 1967); Robert Rosenblum, Jean-Auguste-Dominique Ingres (New York, 1968); and James S. Ackerman, Palladio (Baltimore and Harmondsworth, Eng., 1966; Penguin Book).

A second extrinsic approach to art history is related to biography in that it concerns itself with a study of the psycho-logical and psychoanalytic aspects of artistic creation. The psychoanalytic approach probes the depths of individual consciousness and the unconscious. It has been fairly common since the latter part of the 19th century, but it received a systematic frame of reference only with the work of Sigmund Freud (1856–1939). A prime example of Freud's interpretation of the visual arts is his well-known essay of 1910, "Leonardo da Vinci; a Psychosexual Study of a Childhood Reminiscence" (Leonardo da Vinci: A Study in Psychosexuality, trans. A. A. Brill [New York, 1916; Vintage Book and Doubleday Anchor Book]).[160] In this work, Freud proceeds from a single piece of evidence—a sentence contained in one of the master's notebooks—and tries both to characterize his personality and to erect a complex art historical superstructure around the contents of his works (he was fully cognizant of the tentative nature of his method and his findings). For instance, Freud suggests that the figures of the Virgin and St. Anne in Leonardo's famous painting in the Louvre represent a compositional innovation that refers to the artist's childhood experience of having a natural mother and a stepmother, and that the smiles of the Mona Lisa and the Virgin in the Louvre painting refer to the childhood memory of an affectionate mother. Freud thus tried to explain some of the formal and symbolic qualities of Leonardo's paintings by psychoanalytic means. It is now known that his paper was based on a mistranslation of Leonardo's work and that he overlooked many relevant artistic, historical, and social factors (as demonstrated by Meyer Schapiro, "Leonardo and Freud: An Art-Historical Study," Journal of the History of Ideas

[160] The Leonardo paper was Freud's first (and favorite) study concerned with art. His second was "The Moses of Michelangelo," which he published anonymously in 1916 (trans. in Freud's Collected Papers, 5 vols., authorized trans. under supervision of Joan Riviere [London, 1948–56], IV, pp. 257–87; conveniently available in the Harper Torchbook of his On Creativity and the Unconscious. On Freud see Roger Fry, "The Artist and Psychoanalysis," in The New Criticism; An Anthology of Modern Aesthetics and Literary Criticism, ed. Edwin B. Burgum (New York, 1930), pp. 193–217; and E. H. Gombrich, "Freud's Aesthetics," Encounter XXVI (1966), pp. 30–40.

XVII [1956], pp. 147–78; reprinted in *Renaissance Essays,* ed. Paul Kristeller and Philip Paul Wiener [New York, 1968; Harper Torchbook]);[161] but his theories and false conclusions fail to invalidate the psychoanalytic approach to the visual arts. Freud raised important questions about Leonardo and his work that had been unsuspected by earlier scholars—questions that throw a spotlight on basic aspects of the creative process. He was himself aware of the limitations of the scope of his work. He admitted that he was not qualified as an expert in matters of style and technical accomplishment, that his interests were restricted to aspects of content, and that psychoanalytic method cannot explain the nature of the creative process. His contribution to a specific understanding of the visual arts must be evaluated accordingly. It must also be measured by the widespread influence it has had not only on other psychologists and psychoanalysts, but also on art historians, critics, aestheticians, even philosophers, historians, and sociologists. Freud's work, along with that of Karl Marx, has been the greatest intellectual influence in our century.[162]

One of Freud's principal disciples was Ernst Kris (1900–57), a Viennese art historian turned psychoanalyst[163] who made a number of lasting contributions in the field of psychoanalytic ego psychology. For instance, his remarkable paper "A Psychotic Artist of the Middle Ages" (1936; reprinted in this book) deals with the close relationship between an artist's "psychoanalytic" life history and his work. The paper was republished by Kris in *Psychoanalytic Explorations in Art* (New York, c. 1952), a collection of essays that represents some twenty years of his research in the psychology of art and clinical psychoanalysis. These writings demonstrate how intensively he investigated the role of the unconscious in the artistic process, and how the tools of psychoanalysis can be applied to the study of this area of creative activity. By his own admission, Kris offers no systematic methodology by which to tackle these problems; but by researching the literary content of specific cases, he is able to forward a number of

[161] See also Meyer Schapiro, "Two Slips of Leonardo and a Slip of Freud," *Psychoanalysis: Journal of Psychoanalytic Psychology* IV (1955–56), pp. 3–8.

[162] Consult the bibliography compiled and edited by Norman Kiell, *Psychiatry and Psychology in the Visual Arts and Aesthetics: A Bibliography* (Madison, Wis., 1965). See also E. H. Gombrich, "Psycho-Analysis and the History of Art" (1953; repub. in *Meditations on a Hobby Horse and Other Essays on the Theory of Art* [London, 1963]) and the fine survey by Ernst Kris, *Psychoanalytic Explorations in Art* (New York, c. 1952), pp. 13–63 (also a Schocken Book). In general, see Marie Jahoda, "The Migration of Psychoanalysis: Its Impact on American Psychology," in *The Intellectual Migration: Europe and America, 1930–1960,* ed. Donald Fleming and Bernard Bailyn (Cambridge, Mass., 1969), pp. 420–45. For the interpenetration of art history and psychology, see E. H. Gombrich, "The Use of Art for the Study of Symbols," *American Psychologist* XX (January 1965), pp. 34–50 (altered and trans. into German by Gombrich as "Vom Wert der Kunstwissenschaft für die Symbolforschung," in *Probleme der Kunstwissenschaft,* ed. Hermann Bauer, 2 vols. [Berlin, 1963–67], II, pp. 10–38). The applicability of psychoanalysis to the humanities is discussed in Otto Rank et al, *Psychoanalysis as an Art and a Science* (Detroit, 1967).

[163] Kris was but one of the many students of the Viennese art historian Julius von Schlosser—successor to Max Dvořák and great humanist scholar. Some of his other productive students (to name a few) are Hans Sedlmayr, Charles De Tolnay, Otto Pächt, Gerhart Ladner, Otto Kurz, Ernst H. Gombrich, and Kurt Weitzmann. The work of the Viennese school of art history is examined by Julius von Schlosser in *Die Wiener Schule der Kunstgeschichte* (Mitteilungen des Österreichischen Instituts für Geschichtsforschung, Erganzungs-Band XIII, no. 2 [1934]). For an evaluation of Von Schlosser himself, see Otto Kurz, "Julius von Schlosser; Personalità-Metodo-Lavoro," *Critica d'arte* XI/XII (1955), pp. 402–19.

working hypotheses that may some day yield a valid methodology. On the whole, his work represents a fundamental contribution to our understanding of the creative process and thus of the visual arts.[164]

During the last two decades, E. H. Gombrich has studied the history of representational images in terms of findings and hypotheses in the psychology of perception ("Meditations on a Hobby Horse or the Roots of Artistic Form," in *Aspects of Form: A Symposium on Form in Nature and Art,* ed. Lancelot Law Whyte [New York, 1951; Indiana paperback]; repub. in his *Meditations on a Hobby Horse, and Other Essays on the Theory of Art* [London, 1963]). The topics in this pioneering paper were further developed in his *Art and Illusion: A Study in the Psychology of Pictorial Representation* (New York, c. 1961; Bollingen paperback), a book of great erudition and considerable originality that is as controversial as it is profound, indeed perhaps the most epoch-making book in the historiography of art since Panofsky's *Studies in Iconology* of 1939 (and significantly, like the latter, published in the Anglo-American world). A Socratic questioner, Gombrich asks: "Why does representational art have a history?" Granted that Titian and Picasso, Leonardo and Constable, Hals and Monet all were interested in representing the visible world, why, he asks, did they represent it in such different ways? For those who had previously asked themselves this question, the answer was almost always framed in terms of either technical advances or the desire on the part of the artist to imitate nature. Gombrich argues that the artist's point of departure is not the observation and imitation of nature but the experience of works of art: that all representational art remains conceptual, a manipulation of a vocabulary, and that even the most naturalistic art generally starts from what may be termed schemata, which are modified and adjusted until they appear to match the visible world. Historical changes in representational art thus occur when the artist checks the traditional schemata against nature—a process of making and matching.[165] The importance of *Art and Illusion* has been appraised by the noted British aesthetician Richard Wollheim as follows:

The supreme merit of *Art and Illusion* is that it permits criticism. It states a large number of decidable questions, and gives to them answers that are interesting, clear and lucid. In other words, Professor Gombrich has taken hold of a subject that is habitually given over to vacuity and pretentiousness, and he has bestowed upon it some of the precision, the elegance and the excitement of a science. ["Art and Illusion," in *Aesthetics in the Modern World,* ed. Harold Osborne, New York, 1968, p. 261]

In some recent papers Gombrich has elaborated upon the theories and findings in *Art and Illusion.* In "Moment and Movement in Art" (*Journal of the Warburg and Courtauld Institutes* XXVII [1964], pp. 293–306) he raises some questions that had long been neglected by art historians about the problem of representing time and space in the visual arts. His "Visual Discovery through Art" (*Arts Magazine* XL [November 1965], pp. 17–28) is concerned

[164] Other related works by Kris include two collaborative efforts, one with Otto Kurz, *Die Legende vom Künstler; ein geschichtlicher Versuch* (Vienna, 1934), the other with E. H. Gombrich, *Caricature* (Harmondsworth, Eng., 1940).

[165] One important and acknowledged early source of Gombrich's interest in these matters is the work of the classical archaeologist and theorist Emmanuel Löwy (1857–1938) (*Die Naturwiedergabe in der älteren griechischen Kunst* [Rome, 1900; *The Rendering of Nature in Early Greek Art,* trans. J. Fothergill, London, 1907]). In this still valuable work, Löwy examines the evolutionary development of ancient Greek art and identifies memory images as the source of natural representations.

with the problems in *Art and Illusion* in their perceptual aspects. His paper "Light, Form and Texture in Fifteenth-Century Painting" (*Journal of the Royal Society of Arts* CXII [October 1964], pp. 826–49; reprinted in this book) is an application of the methods set forth in *Art and Illusion* (especially on pages 279–82) to specific examples of Flemish and Italian painting. One may also cite his provocative reevaluation of the causes of the new direction taken by the arts at the start of the Italian Renaissance ("From the Revival of Letters to the Reform of the Arts: Niccolò Niccolì and Filippo Brunelleschi," *Essays Presented to Rudolf Wittkower on His Sixty-fifth Birthday,* ed. Douglas Fraser et al, 2 vols. [London, 1967], II, pp. 71–82. The approach of this paper lies at the core of "The Leaven of Criticism in Renaissance Art," in *Art, Science, and History in the Renaissance,* ed. Charles S. Singleton (Baltimore, 1967), pp. 3–42.

The nature of representation has also been investigated by Richard Bernheimer (1907–58), formerly professor of fine arts at Bryn Mawr College and a member of the Institute of Advanced Studies at Princeton. His *Nature of Representation: A Phenomenological Inquiry,* ed. H. W. Janson (pub. posthumously, New York, 1961) bears a complementary relationship to Gombrich's *Art and Illusion,* although Bernheimer confines himself to the semantics of "the function and inner structure of artistic representation." His main purpose is to demonstrate "that representation has an inner structure of its own, akin to but by no means identical with that possessed by various categories of signs; and finally that the function most akin to representa-

tion is not, as semanticists suppose, that of signification, but the much neglected and little-known one of substitution."[166] Much of his book pertains to an elucidation of this function and is closely written, based on an analytical method. *The Nature of Representation* is a work of great erudition and stimulation.

Less theoretical and speculative but equally profound are the observations of William M. Ivins, Jr. (1881–1961), who critically investigated communication by representational images (*Prints and Visual Communication* [Cambridge, Mass., 1953]). After having served as curator of prints at the Metropolitan Museum of Art in New York City for some 30 years, Ivins wrote this book in order "to find a pattern of significance in the story of prints." He convincingly argues that people have become "aware of the difference between pictorial expression and pictorial communication of fact" only since the invention and development of the photographic process. Because they are exactly repeatable pictorial statements, prints have exerted a profound effect upon the development of Western European thought and culture by providing descriptions that words could not convey with similar precision. The interests and insights of Ivins bring to mind the recent work of André Malraux (*Psychologie de l'Art,* 3 vols. [Geneva, 1947–50]) and also the sensational and highly popular commonplaces of Marshall McLuhan.[167]

Since the pioneering work of Wolfgang Köhler (*Gestalt Psychology* [New York, 1929]) and Kurt Koffka (*Principles of Gestalt Psychology* [New York, 1935]), various isolated attempts have been made to apply

[166] Bernheimer disclosed his concern for these problems as early as 1939 (in two papers entitled "In Defense of Representation" and "Concerning Symbols," in Bernheimer, Rhys Carpenter, K. Koffka, and Milton C. Nahm, *Art, A Bryn Mawr Symposium* [Bryn Mawr, Pa., 1940]). He also wrote a fascinating study, *Wild Men in the Middle Ages: A Study in Art, Sentiment, and Demonology* (Cambridge, Mass., 1952).

[167] For the "cut-rate salvation" of such McLuhan books as *The Medium Is the Massage* and *The Mechanical Bride,* see Anthony Quinton's critical remarks in *New York Review of Books,* November 23, 1967, pp. 6–14. For Malraux, see page 6.

the vocabulary and doctrines of Gestalt psychology to art history and criticism.[168] In an early study by an art historian, Hans Sedlmayr endeavors to derive a psychology of style from the constructs of Gestalt psychology by an analysis of certain patterns in the churches designed by the Italian Baroque architect Francesco Borromini (*Die Architektur Borrominis* [Berlin, 1930]). More recently, Rudolf Arnheim (born 1904) has produced a number of theoretical papers in which he seeks to demonstrate the importance of Gestalt psychology in offering a penetrating language of experience for art history and criticism (*Art and Visual Perception: A Psychology of the Creative Eye* [Berkeley, 1954] and *Toward a Psychology of Art: Collected Essays* [Berkeley, 1966], both available as University of California paperbacks; and *Picasso's Guernica: The Genesis of a Painting* [Berkeley, 1962]).

Psychoanalysts and Gestalt psychologists writing on art generally confine themselves to detailed explanations of phenomena within fairly clearly defined limits. A danger in these studies is the temptation to apply the explanations of individual phenomena to larger groups, movements, or periods of art history in which identical or similar phenomena occur.[169] For instance, in his *Collective Dream in Art; A Psycho-Historical Theory of Culture Based on Relations between the Arts, Psychology, and the Social Sciences* (Cambridge, Mass., 1957; Schocken Book), Walter Abell (1897–1956) attempts to establish a psycho-historical theory of culture, which

suggests that art can not be fully comprehended in its own intrinsic terms as artists and critics have sometimes assumed, in terms of psychic processes as most psychoanalytical writers have assumed, or in terms of technological-economic processes as the economic determinists have maintained. As it is conceived here, art—and with it culture in general—is an outcome of the interplay between these varied and contrasting aspects of experience. Its roots are at once immaterial *and* material, personal *and* collective, psychological *and* technological. [*ibid.*, pp. 4–5]

The introduction of large-scale unifying hypotheses, such as the theory of unconscious mental activity, based on individual case studies, must be treated with due caution. On the whole, such hypotheses have met with little critical acclaim by art historians.

Far more convincing from the vantage point of the art historian are those studies by specialists that try to combine psychological and psychoanalytic techniques with the more conventional methodology of art history. The art of Van Gogh and Cézanne especially has been the subject of such an analysis, for instance, in Kurt Badt's philosophically provocative monograph *Die Kunst Cézannes* (Munich, 1956 [*The Art of Cézanne*, trans. Sheila A. Oglivie, Berkeley, 1965]), a work that includes an interpretation of the psychological

[168] Before he died in 1967, Köhler delivered four lectures at Princeton that have been published, together with an introduction by Carroll C. Pratt, as *The Task of Gestalt Psychology* (Princeton, 1969). Work was continued in this area of psychology by such specialists as Frederick Perls, Ralph Hefferline, and Paul Goodman, all three of whom collaborated on the book *Gestalt Therapy: Excitement and Growth in the Human Personality* (New York, 1951).

[169] For penetrating criticism of this approach to the visual arts by an art historian, a sociologist, and two literary historians, see, respectively, Meyer Schapiro, "Style," in *Anthropology Today*, ed. A. L. Kroeber (Chicago, 1953; University of Chicago paperback, reprinted in *Aesthetics Today*, ed. Morris Philipson [Cleveland and New York, 1961; Meridian Book], pp. 81–113, esp. 108–12); Arnold Hauser, *The Philosophy of Art History* (New York, 1959; Meridian Book), pp. 43–116; and René Wellek and Austin Warren, *Theory of Literature*, 3d ed. (New York, 1956; Harvest Book), pp. 81–93.

sources of inspiration for the master's series of paintings representing card players. As stimulating as any recent work on Van Gogh or Cézanne are Meyer Schapiro's brief and incisive introductory essays to the instructively annotated collections of color plates in *Vincent Van Gogh* (New York, 1950) and *Paul Cézanne* (New York, 1952), as well as his papers on these masters ("On a Painting of Van Gogh," *Perspectives U.S.A.*, no. 1 [Fall, 1952], pp. 141–53; "The Still-Life as a Personal Object—A Note on Heidegger and van Gogh," in M. L. Simmel, ed., *The Reach of Mind: Essays in Memory of Kurt Goldstein, 1878–1965* [New York, 1968], pp. 203–9). A broadly oriented interpretation of Cézanne's still-life of apples is evident in Schapiro's well-documented work entitled "The Apples of Cézanne: An Essay on the Meaning of Still-Life," in *Art News Annual* XXXIV (1968), pp. 35–53. After examining the master's practice and his utterances in letters and conversations, Schapiro discards the view held by such critics as Roger Fry and artists like Erle Loran (*Cézanne's Composition*, 3d ed. [Berkeley and Los Angeles, 1963]) that Cézanne saw in the objects he painted only a problem of form and color. While he does not underestimate Cézanne's feeling for the beauty and poetic connotations of the things he depicted, Schapiro interprets the artist's preference for the still-life of apples as the "game of an introverted personality

who has found for his art of representation an objective sphere in which he feels self-sufficient, masterful, free from disturbing impulses and anxieties aroused by other human beings, yet open to new sensation." Schapiro believes that the choice of objects was personal and deliberate rather than accidental; in his "habitual representation of the apples as a theme by itself there is a latent erotic sense, an unconscious symbolizing of a repressed desire," hence a close relationship between the artist and the things he painted.

Such recent contributions by Schapiro as those on Van Gogh and Cézanne cannot be labeled psychoanalytically oriented, for as the brief summary above may suggest, they are methodologically more complex. Very much aware of, and sympathetically responsive to, the wide spectrum of conventions and expressions in modern art, Schapiro and his students at Columbia University have found it necessary to evolve new terminologies and concepts—drawing not only upon psychology and psychoanalysis but also upon phenomenology and in some measure existentialism—and to synchronize them logically and methodically with more traditional, formal, and iconographic points of view in applying them to specific works of art.[170] One of the major focal points for this group of specialists is the problem of the role of body imagery in the art of our times; it has been examined in some papers

[170] Phenomenology is the philosophical movement that grants absolute and total respect to the "given," as distinct from the inferred and conjectured. It is a complex method of inquiry that was first formulated by Edmund Husserl at the beginning of this century. See F. Kaufmann, "Art and Phenomenlolgy," *Philosophical Essays in Memory of Edmund Husserl*, ed. Marvin Farber (Cambridge, Mass., 1940), pp. 187–202; and I. L. Zupnick, "Phenomenology and Concept in Art," *British Journal of Aesthetics* VI (1966), pp. 135–41. Schapiro's interpretation, especially of Cézanne, parallels at times that of the French phenomenologist Maurice Merleau-Ponty (1908–61), author of a number of influential works including *Phénoménologie de la perception* (Paris, 1945 [*Phenomenology of Perception*, trans. Colin Smith, London, 1962]). But Schapiro does not take phenomenology as his point of departure; he seems to have arrived at a phenomenological interpretation of Cézanne's oeuvre after a detailed consideration of the painter's life and art and study of Roger Fry's writings on Cézanne and Fritz Novotny's *Cézanne und das Ende der wissenschaftlichen Perspektive* (Vienna, 1938), both of which he acknowledges.

by Matthew Lipman, Lawrence D. Steefel, Jr., Albert Elsen, and Theodore Reff.[171] The manner in which these younger American scholars conceive of the problem is perhaps best summed up in the words of Lipman:

We see . . . that the body provides an inexhaustible source for a vocabulary of expressive forms, a vocabulary that is continually being enriched. Whether we consider the immense sensuous appeal of the living body, the equally powerful ascetic revulsion from it as loathsome, or any of the host of intermediate experiences, we are compelled, I think to reckon with the response to the body as an integral and ineradicable component of artistic and aesthetic experience. ["The Aesthetic Presence of the Body," *Journal of Aesthetics and Art Criticism* XV (1957), p. 434]

Their point of view has added an exciting new dimension to art historiography and criticism.[172]

The more abundant the written documentation on a master, either from his own hand or from that of his contemporaries, the more promising the psychoanalytical study. This has determined whatever success we measure in the last-mentioned works of Cézanne and Van Gogh, all written by art historians. But art historians have had no monopoly on this avenue of approach. Thus H. R. Graetz, who has written extensively on general psychopathology and the nature of psychotherapy, devoted a monograph to The *Symbolic Language of Vincent van Gogh* (New York, 1963), which some specialists in late 19th-century art consider to be the most persuasive psychoanalytical study of Van Gogh and his paintings. The shorter work by Karl Jaspers, *Strindberg und Van Gogh: Versuch einer pathographischen Analyse unter vergleichender Heranziehung von Swedenborg und Hölderlin* (Berlin, 1949), adopts a related method and is also highly regarded.

While the psychological and psychoanalytic approaches to the visual arts stress individuality, the social historian views the arts in the light of their collective political, economic, and social background. These historians contend that since art is a creation of man, a social phenomenon, it is a social institution, hence a study of the social framework of the artist is the proper business of the historian: "everything in history is the achievement of individuals; individuals always find themselves in a certain definite situation in time and place; their behavior is the product both of their inborn

[171] Lipman, "The Aesthetic Presence of the Body," *Journal of Aesthetics and Art Criticism* XV (1957), pp. 425–34; Steefel, "Contextual Relativism," *College Art Journal* XXI (1962), pp. 151–5, and "Body Imagery in Picasso's 'Night Fishing at Antibes,'" *ibid.*, XXV (1966), pp. 356–63; Elsen, "Lively Art from a Dying Profession, The Role of the Modern Artist," *Journal of Aesthetics and Art Criticism* XVIII (1960), pp. 446–55; Reff, "Cézanne's Bather with Outstretched Arms," *Gazette des Beaux Arts* LIX, 6th ser. (1962), pp. 173–9. See the point of view of Meyer Schapiro that is quoted by R. W. Davenport and W. Sargent in *"Life* Roundtable on Modern Art," *Life* (October 11, 1948), p. 58.

[172] See also the recent interpretation by George Heard Hamilton (in *Claude Monet's Paintings of Rouen Cathedral* [London, 1960]): ". . . the 'Cathedrals' must be thought of as the revelation of a physiologically complicated and psychologically continuous experience which can only be known by the spectator when he sees (or imaginatively reviews) the series as a whole. To isolate one painting from the group is to disturb if not to destroy the complex, for the form (which is multiple in space) and the content (which is durational in time) can not be known apart from the group as a whole. Each painting is only one item in a sequence which is the outward and visible sign of an inward psychological, and hence spiritual, adventure" (p. 27).

capacities and of the situation."[173] Many students of the arts, especially connoisseurs, pure formalists, and those upholding the doctrine of art for art's sake, refuse to accept this basic premise and maintain that an investigation of such external evidence as social institutions is irrelevant to the proper understanding of art, or at least that it is relevant only to the extent that such institutions may aid in the identification of the subject matter of individual works. Some scholars view the social approach to art with caution and skepticism (a trend discernible in contemporary Renaissance scholarship), largely because of the difficulty in defining precisely the nature of the relation of art and its social background. This is indeed the fundamental problem confronting the social history of art. In the case of art of the distant past, documentary evidence is not ordinarily sufficient or revealing enough to allow such definitions to be formulated. For the works of an artist, group, or movement a variety of definitions may be proffered, each based on an interpretation of the evidence at hand. But then it must be recognized that all art history is interpretative, that every analysis is *an* interpretation, not *the* interpretation, and that every interpretation has its own vantage point and focal power—an observation no less applicable to connoisseurs and formalists than to iconographers and social historians.

Different types of sociological explanations of the visual arts have been posited by historians.[174] According to one point of view, a class or group in society *causes* works of art to come into existence. Thus, Frederick Antal (1887–1954), in a paper reprinted in this book, posits that the very existence of Jacques Louis David's painting *The Oath of the Horatii* was "determined by the strong feeling of opposition then prevailing against the demoralized Court and its corrupt government" ("Reflections on Classicism and Romanticism," *Burlington Magazine* LXVI [1935], p. 160). Or, in the most ambitious and most adversely criticized social history of art ever written in the Western world, Arnold Hauser finds that material facts are the ultimate causes of the visual arts (*The Social History of Art,* 2 vols. [London, 1951; Vintage Book]).[175] These historian-sociologists seem to be proceeding from the Euclidean principle that things related to the same thing are related to each other, when they hold that what is true of the effects of one kind of social factor is true of all the effects of that social factor. Hauser states that "all factors material and intellectual, economic and ideological, are bound up together in a state of indissoluble interdependence." As a rule, these social historians seek out underlying laws or principles that will be valid in all circumstances.

A second type of sociological explana-

[173] Arnold Hauser, *The Philosophy of Art History* (New York, 1959), p. vi. For a related evaluation of the determinist nature of history, see the brilliant paper by Edward Hallett Carr, *What is History?* (London, 1962; Vintage Book), and the writings republished in Ronald H. Nash, ed., *Ideas of History*, 2 vols. (New York, 1969), II, pp. 300–50.

[174] For the ensuing discussion, I am indebted to the pertinent observations of Richard Wollheim, "Sociological Explanation of the Arts: Some Distinctions," in *Atti del III Congresso Internazionale di Estetica, Venezia 3–5 settembre 1956* (Turin, 1957), pp. 404–10. Causal connections are analyzed by N. R. Hanson, "Causal Chains," *Mind* LXIV (1955), pp. 289–311. The scope and limitations of the sociological approach to the arts have been evaluated most searchingly by Arnold Hauser, *The Philosophy of Art History* (New York, 1958; Meridian Book), pp. 1–40.

[175] For this widely discussed book, see the criticism of Josef P. Hodin in *College Art Journal* XII (1953), pp. 303–9, and E. H. Gombrich in *Art Bulletin* XXXV (1953), pp. 79–84 (reprinted in his *Meditations on a Hobby Horse and Other Essays on the Theory of Art* [London, 1963]).

tion holds that works of art are expressive, or reflective, of social factors. For instance, Hauser characterizes Mannerism as "the artistic expression of the crisis which convulses the whole of Western Europe in the sixteenth century and which extends to all fields of political, economic and cultural life" (Arnold Hauser, *The Social History of Art*, 2 vols., trans. Stanley Godman [London, 1951], I, p. 361),[176] and Antal says of Jacques Louis David's *Oath of the Horatii* that "this picture is the most characteristic and striking expression of the outlook of the bourgeoisie on the eve of the revolution" and that the "historically inevitable style of David's picture . . . accurately reflected its social background" (Frederick Antal, "Reflections on Classicism and Romanticism," *Burlington Magazine* LXVI [1935], p. 160). Both statements speak not of art *and* certain social factors, but of art *because of* certain social factors. As Wollheim has pointed out, this type of explanation differs from a causal one in that we are presumably able to observe directly the connection between art and its social determinants: the physiognomy of a work of art reveals the social environment of its time and place of creation. Such a line of reasoning makes it unnecessary to look at other works of art of the same time and place, as is required in the case of causal explanations, because it does not presuppose any general connection between kinds of art and kinds of society.

The fallacy of these so-called expressive explanations is that art is not always a mirror of society. What may be true of one work by a Mannerist artist, or by David, is not necessarily true of his other works. Sociological interpretations should be proposed only after a careful examination of all available evidence regarding connec-

tions between the work of art and social factors.

A third type of sociological explanation may be termed "anecdotal," to adopt again the terminology of Wollheim. Such explanations speak in terms of general correlations and parallelisms between art and society. They establish no specific links and proffer no laws or principles that connect art with social factors. And they tend to treat correlations on a work-by-work basis. Such explanations are like common sense generalizations, in that they posit a relevance between the phenomena they link. There is no close examination of these phenomena, nor are ultimate causes of works given. While such explanations may seem preferable to causal and expressive explanations, they must be regarded as incidental to a specific understanding of the works themselves. If there is to be a meaningful social history of art, the nature of the correlation between art and society must be documented and analyzed precisely and explained in concrete terms.

Works of art appear in a social context, as part of a culture, whether they are of the Middle Ages or the 20th century. Discussing them in the light of their social context would presumably enhance our understanding. But establishing concrete links between works of art and specific social factors is a perilous business, because the interrelations of art and society are, as a rule, too general to allow any one factor to be identified as the point of departure. As two modern critics of literary history have observed:

The social situation, one should admit, seems to determine the possibility of the realization of certain aesthetic values, but not the values themselves. We can determine in general outlines what art forms are possible in a given

[176] (The historical accuracy of this statement may be questioned.) A related interpretation is found in Hauser's recent work, *Mannerism: The Crisis of the Renaissance and the Origin of Modern Art*, 2 vols. (London, 1965), which is discussed on page 97.

society and which are impossible, but it is not possible to predict that these art forms will actually come into existence. [Wellek and Warren, *Theory of Literature*, 3d ed., New York, 1956, p. 106]

The causal and expressive sociological explanations of the arts can be traced back to some scattered remarks by Marx and Engels, and ultimately to Hegel. Such explanations run through the writings of modern Western students following a Marxist line as a major theme runs through a piece of music. The monumental volume *Florentine Painting and Its Social Background; The Bourgeois Republic before Cosimo de' Medici's Advent to Power: Fourteenth and Early Fifteenth Centuries* (London, 1948) by Frederick Antal, a pupil first of Heinrich Wölfflin and later of Max Dvorák, is one of the most ambitious attempts by a scholar trained as an art historian to interpret the art of Trecento and Quattrocento Florence in accordance with Marxist thought. In this widely discussed study, Antal maintains that works of art, along with other aspects of a culture within a class society, ought to be explained as the product of the material conditions of that society. As Antal's critics have pointed out, however, the chief weakness of his monograph is not so much its application of Marxist thinking to Florentine art as its neglect of important archival and documentary sources that throw light on many aspects of the relation between Florentine art and society.[177] The merit of the book lies in the fact that it raises meaningful questions about this relationship, rather than in its presentation of the Marxist concept that the work of art is "a creative experience fused in the crucible of life."

More strictly orthodox Marxist interpretations of the visual arts have been numerous in Europe and virtually nonexistent in the United States. Francis D. Klingender (1907–55), a sociologist by training and experience who was deeply interested in the visual arts, pointed to both "a continuous tradition of realism" that began with Paleolithic cave paintings and has lasted to the present day and a "tradition of spiritualistic, religious or idealistic art" that began when "mental labour was divided from material labour" and has been continuous "until it will vanish with the final negation of the division of labour — i.e. in a Communist world" (*Marxism and Modern Art; An Approach to Social Realism* [London, 1943], pp. 47–8):[178]

During this entire period of development, i.e. as long as society is divided into classes, the history of art is the history of the ceaseless struggle and mutual inter-penetration of these two traditions. A Marxist *history* of art should describe, first, the *struggle* which is *absolute* between these two opposite and mutually exclusive trends and secondly, their fleeting, conditional and *relative union*, as manifested in the different styles and in each work of art, and it should explain both these aspects of art in terms of the social processes which they reflect. Marxist *criticism* consists in discovering the specific weight within each style, each artist and each single work of those elements which reflect objective truth in powerful and convincing imagery. But it should always be remembered that, unlike science which reduces reality to a blue-print or formula, the images of art reveal reality in its infinite diversity and many-sided richness. And it is in its infinite diversity and many-sided richness that art, too, must be appreciated". [*ibid.*, p. 48]

In his more widely read work, *Goya in the*

[177] See the critical reviews by Theodor Mommsen, in *Journal of the History of Ideas* XI (1950), pp. 369–79, and Millard Meiss, in *Art Bulletin* XXXI (1949), pp. 143–50.

[178] This statement brings to mind attempts by German art historians and critics of the late 19th and early 20th century to simplify and reduce the whole history of art to polar opposites (for example, Wölfflin, Riegl, and Worringer). In a posthumous book, *Animals in Art and Thought*, ed. Evelyn Antal and John Harthan (London, 1970), Klingender examines, among other things, how artists and writers have used animal imagery to symbolize their religious, social, and political beliefs.

Democratic Tradition (London, 1948; Schocken Book) he informs the reader that he has

approached the works of Goya primarily by studying their content. From that content I have attempted to deduce both their theme in the narrow sense of the word and their style. I have tried to show that there is a close connection between the wider social experience which Goya shared with his contemporaries and his own attitude to that experience on the one hand, and the formal characteristics of his style on the other; that, indeed, the many conflicting tendencies of his style development can only be interpreted as the necessarily varying expressions of as many social moods and attitudes. [p. xiii]

Thus the Marxist creed is asserted.[179] In a paper originally published in Russia in the mid-1930s, Alexander Romm offers an orthodox Marxist interpretation of the art of Henri Matisse (*Matisse: A Social Critique,* trans. Jack Chen [New York, 1947]). Such a point of view typifies 20th-century art history in the Soviet Union and its satellites as well as in Communist China.[180] Application of Marxist methods and models in American scholarship appeared only in the 1930s and was far more common in literary criticism than in art history and criticism (see, for instance, the ambitious work by Granville Hicks, *The Great Tradition; An Interpretation of American Literature since the Civil War* [New York, 1933]). From 1934 to 1937, the Artists' Union of New York published the magazine *Art Front,* edited by Ben Shahn and Stuart Davis, to which William Gropper, Maurice Becker, and Meyer Schapiro contributed.[181] Among the most notable Marxist interpretations of the visual arts by American art historians and critics at this time are Milton Brown's little book, *The Painting of the French Revolution* (New York, c. 1938), and Meyer Schapiro's "Nature of Abstract Art" (*Marxist Quarterly* I [1937], pp. 77–98), a spirited review of Alfred Barr's *Cubism and Abstract Art.*[182] The Marxist interlude in American scholarship of the visual arts was both short-lived and confined to the New York area. Significantly, it was at this time in New York City that Sidney Hook (born 1902) began to establish his reputation as America's leading scholar and theoretician of the varieties of Marxism (and as her most distinguished and articulate exponent of pragmatism and democracy on the philosophical scene) through his teaching at Washington Square College and the publication of such books as *Towards the Understanding of Karl Marx: A Revolutionary Interpretation* (New York, c. 1933) and *From Hegel to Marx; Studies in the Intellectual Development of Karl Marx* (New York, 1950; Ann Arbor paperback).[183]

Far more important than Marxism for

[179] See also the work edited by him entitled *Hogarth and English Caricature* (London and New York, 1945) and his *Art and the Industrial Revolution* (London, 1947).

[180] In the U.S.S.R. there has been a rather strict adherence to the tenets of "socialist realism" laid down by the Communist Party in the 1930s. But new and different applications and interpretations of Marxist thought characterize art history and criticism outside the Soviet Union, for instance in France, Czechoslovakia, and Cuba.

[181] As pointed out by Donald Drew Egbert in *Socialism and American Art in the Light of European Utopianism, Marxism, and Anarchism* (Princeton, 1967; Princeton paperback), pp. 116, 119. Egbert's important book is a revision and expansion of a chapter of *Socialism and American Life,* ed. Donald D. Egbert and Stow Persons, 2 vols. (Princeton, 1952), in which the reader will find an excellent bibliographical essay on Marxist art history, theory, and criticism (vol. II, pp. 419–510).

[182] Compare Schapiro's "Race, Nationality and Art," *Art Front* II (1936), pp. 10–12. For this scholar's work in medieval art history, the best of which in my opinion appeared in the 1930s, see page 93.

[183] For a recent appraisal of the accomplishment of Hook, a disciple of John Dewey, see Andrew J. Reck, *The New American Philosophers; An Exploration of Thought since World War II* (Baton Rouge, La., 1968), pp. 164 ff.

the American historiography of art during these years was the migration of a number of notable scholars to this country in consequence of Hitler's rise to power—for instance, Paul Frankl, Otto Brendel, Otto von Simson, Richard Krautheimer, Karl Lehmann, Walter Friedlaender, Kurt Weitzmann, Wolfgang Stechow, and Erwin Panofsky.[184] Charles Rufus Morey, in an act of academic magnanimity rarely approached, invited Weitzmann to Princeton (Weitzmann had published work whose results directly challenged those of Morey), while Walter W. S. Cook found permanent positions for Lehmann, Friedlaender, and Panofsky at the Institute of Fine Arts in New York City, of which he was then chairman. As Panofsky reminds us, Cook used to say, "Hitler is my best friend; he shakes the tree and I collect the apples."[185] New points of view thus became available to American students and mature scholars alike, and the focus of American art history was enlarged. Concomitantly, it is probably fair to say that the intellectual horizons of these refugees were broadened by their exposure to American scholarship, which, as Panofsky himself points out, had experienced a "Golden Age" in the decade before 1933, to wit, the important work of such specialists as A. Kingsley Porter, Chandler R. Post, Fiske Kimball, Richard Offner, Rensselaer Lee, Meyer Schapiro, Millard Meiss, and the whole "Princeton school."

Marxist interpretations are not without value. Indeed, as Meyer Schapiro has observed, "The great interest of the Marxist approach lies not only in the attempt to interpret the historically changing relations of art and economic life in the light of a general theory of society but also in the weight given to the differences and conflicts within the social group as motors of development, and to the effects of these on outlook, religion, morality, and philosophical ideas."[186] But the Marxist, like the Freudian, is unable to provide satisfactory explanations for the inherent formal qualities, or style (in the narrow sense), of works of art. In fact, not one of the extrinsic perspectives of the visual arts is capable of such explanations. The value of these orientations lies largely in their contribution to a deeper understanding of the general social and intellectual context from which the arts evolve.

The different approaches to the visual arts are, of course, derivative; their underlying assumptions, points of view, and techniques of investigation are borrowed in large measure from other disciplines. It has already been pointed out that Wölfflin's formalist art history was inspired by the work of certain philosophers and aestheticians, and Gombrich's *Art and Illusion* by studies in the psychology of perception. The social history of art is certainly no exception. The indebtedness of such social historians as Hauser and Antal to the theoretical foundations of Marx and Engels is clear. Those social histories of art that are not essentially Hegelian or Marxist find their origin in the work of such 19th-century philosophers as Jean Guyau and Hippolyte Taine. The poet-philosopher

[184] See Colin Eisler, "*Kunstgeschichte* American Style: A Study of Migration," in *The Intellectual Migration: Europe and America, 1930–1960*, ed. Donald Fleming and Bernard Bailyn (Cambridge, Mass., 1969), pp. 544–629, esp. the list of names on p. 629.

[185] Erwin Panofsky, "Three Decades of Art History in the United States; Impressions of a Transplanted European," in his *Meaning in the Visual Arts* (Garden City, N.Y., 1955; Doubleday Anchor Book), p. 332.

[186] "Style," in *Anthropology Today*, ed. A. L. Kroeber (Chicago, 1953; University of Chicago paperback), p. 311 (reprinted in *Aesthetics Today*, ed. Morris Philipson [Cleveland and New York, 1961; Meridian Book], p. 113). For a useful list of books and papers in English on Marxist interpretations of the arts, see Lee Baxandall, ed., *Marxism and Aesthetics: A Selective Annotated Bibliography* (New York, 1969).

Guyau drew attention to the importance of art for social solidarity and moral progress in his exaggeratedly ethical work, *L'Art au point de vue sociologique* (Paris, 1889). More influential was the position of the philosopher-critic Taine, who held that "in order to comprehend a work of art, an artist, or a group of artists, we must clearly comprehend the general and intellectual conditions of the times to which they belong" (*Philosophie de l'art; leçons professées à l'Ecole des Beaux-Arts* [Paris and New York, 1865]). Taine contended that "when we have considered race, milieu and moment, we have exhausted not only all real causes, but even more all the possible causes of movements."[187]

Scholars engaged in research in the genre of the social history of art that is neither Hegelian nor Marxist attempt to relate specific works of art to certain particular or general factors operative within the social context. The factors most often examined are artistic patronage, religious and political phenomena, and the general cultural context of the time.[188] Patronage has been a major aspect of the genesis of the visual arts for the greater part of history, even including the modern period, when not only private patrons but museum curators and directors, and governments as well, have played no small role in the artistic world. An analysis of patronage can disclose relevant information about the materials, technique, size, location, function, and especially the choice of subject matter of a work. Under a commission, the patron can dictate certain things—for example, that the artist is to

fresco a wall in the refectory of a church, to represent the Crucifixion, and to complete the project within a specified period of time. Further, by offering a high fee he can guarantee that the work will be entirely by the hand of the master (a lower fee will secure him a work by the master and his assistants). What the patron cannot determine is the intrinsic formal qualities of the work—though it is true that certain traditions, especially in iconography, may dictate the choice of colors and so forth—and therefore while investigation of patronage can shed light on many important external conditions of a work of art, it generally leaves unanswered the questions of why an artist created the work with certain inherent formal qualities. Such questions obviously cannot be ignored by the art historian who seeks a full understanding of the work.

As pointed out above, patronage was among the topics of immediate interest to Aby Warburg. In his paper entitled "Bildniskunst und florentinisches Bürgertum" (1902), he examines the mentality and artistic taste of Florentine middle-class patrons at the time of Lorenzo de' Medici.[189] He asks why these patrons wanted their portraits painted by Flemish artists and why they collected Flemish art so enthusiastically. After careful examination of a vast amount of archival and documentary evidence, he reaches the conclusion that these patrons appreciated in Flemish art the heaviness of the expensive garments depicted, since they were themselves yarn dyers and silk manufacturers.

Warburg's investigation of Renaissance

[187] At first Taine excluded value from criticism; he later realized his mistake and recanted in his *Philosophy of Art*, in which a double scheme of social and aesthetic value is proposed. On Taine, see Sholom J. Kahn, *Science and Aesthetic Judgment: A Study in Taine's Critical Method* (New York, 1953).

[188] The convenient survey of "sociological" explanations of the visual arts by Frederick Antal in actual fact includes examples of iconographic, iconological, and psychological as well as sociological approaches ("Remarks on the Method of Art History," *Burlington Magazine* XCI [1949], pp. 49–52, 73–5; reprinted in the author's *Classicism and Romanticism, with Other Studies in Art History* [New York, 1966], pp. 175–89).

[189] Republished in Warburg's *Gesammelte Schriften*, 2 vols. (Leipzig, 1932).

patronage was followed by no major studies for nearly two generations; however, a number of papers have appeared in recent years. Martin Wackernagel's (1881–1962) *Der Lebensraum des Künstlers in der Florentinischen Renaissance* (Leipzig, 1938), a weighty social and intellectual history of Renaissance art from about 1420 to 1530, inquires into the demands of different kinds of individual patrons and guilds and their motives and tastes. The important patronage of the Medici and their role as arbiters of taste are perceptively examined in the well-documented paper by E. H. Gombrich "The Early Medici as Patrons of Art," in his *Norm and Form: Studies in the Art of the Renaissance* (London, 1966). Another recent essay of importance for an understanding of the interdependence of artists and patrons in the early Italian Renaissance, and a challenging hypothesis about the fundamental change in the style of the visual arts at that time, is Frederick Hartt's "Art and Freedom in Quattrocento Florence" (New York University, Institute of Fine Arts, *Essays in Memory of Karl Lehmann*, ed. Lucy F. Sandler [Locust Valley, N.Y., 1964], pp. 114–31; also reprinted in this book. Hartt (born 1914), whose study was stimulated by Renaissance historian Hans Baron's *Crisis of the Early Italian Renaissance: Civic Humanism and Republican Liberty in an Age of Classicism and Tyranny*, 2 vols. (Princeton, 1955), shows that Florentine artists were concerned over the fate of their society, deeply committed to its preservation, and responsible in large measure for the growth of its ideals. He also suggests that the guilds may have played a formative role in the emergence of the new Renaissance style in Florentine painting and sculpture. A related point of view underlies Hartt's examination of 16th-century Mannerist art, "Power and the Individual in Mannerist Art," in Millard Meiss et al, eds., *Studies in Western Art*, 4 vols., *Acts of the Twentieth International Congress of the History of Art, 1961* (Prince-

ton, 1963), vol. II: *The Renaissance and Mannerism*, pp. 222–38. Renaissance patronage is also discussed in a chapter of Rudolf and Margot Wittkower's *Born Under Saturn: The Character and Conduct of Artists; A Documented History from Antiquity to the French Revolution* (London, 1963; Norton paperback). Lastly, we may refer to George L. Hersey's impressive monograph *Alfonso II and the Artistic Renewal of Naples 1485–1495* (New Haven and London, 1969), in which "seven linked studies which range through the literature, the portraits, the urbanism, the chief buildings, and the funeral sculpture" demonstrate that, among other things, the renewal of the Duke of Calabria, Alfonso II, "expressed certain constant ideas: the legitimacy of the Aragonese house, the power of the Crown over the barons, and the need for a Florentine alliance to keep up Naples' political momentum" (*ibid.*, p. vi).

Inquiries concerning patronage in the Baroque period have been frequent in recent years. The major study is Francis Haskell's *Patrons and Painters; A Study in the Relations between Italian Art and Society in the Age of the Baroque* (New York, 1963), in which the author clearly forewarns that "any attempt to 'explain' art in terms of patronage has been deliberately avoided." Fritz Saxl has sought a partial explanation for the lack of a specific hero in Aniello Falcone's battle pictures in the social type and taste of that 17th-century artist's Neapolitan patrons ("The Battle Scene without a Hero," *Journal of the Warburg and Courtauld Institutes* III [1939–40], pp. 70–87). Anthony Blunt has examined the influence that Mme. de Rambouillet and the aristocratic Précieux exercised on the art of 17th-century France ("The Précieux and French Art," in *Fritz Saxl, 1890–1948: A Volume of Memorial Essays*, ed. Donald J. Gordon [London and New York, 1957], pp. 326–38). A pitfall of such studies is their underlying assumption that the acceptance of certain art works

by a group of patrons or a class is proof that the style was generated by them.

In some chapters of *Joseph Wright of Derby: Painter of Light*, 2 vols. (London and New York, 1968), Benedict Nicholson deals with the sitters and purchasers of portrait paintings and attempts to demonstrate how the social position of the sitter influenced the character of portraiture from Van Dyck to the end of the 18th century. Nicholson prudently refrains from trying to explain how the style of these paintings evolved in this period and simply refers to the social background of the sitters and the tastes of the patrons; he has contributed to our understanding of the typological development of 17th- and 18th-century portraiture.

Studies in patronage of the commissioned art and architecture of our own day can be especially rewarding, provided that the client-artist relationship can be documented. One of the most remarkable recent papers in 20th-century architectural patronage is W. H. Jordy's investigation of Howe and Lescaze's building for The Philadelphia Saving Fund Society in Philadelphia ("PSFS: Its Development and Its Significance in Modern Architecture," *Journal of the Society of Architectural Historians* XXI [1962], pp. 47–83). With a wealth of documentary evidence and eyewitness testimony at his disposal, Jordy is able to examine closely the entire decision-making history of the project, and he identifies the contributions of the different specialists and the consequences of the various social and economic pressures on it. For the role of patronage in American 19th-century art there is the valuable study by Lillian B. Miller, *Patrons and Patriotism: The Encouragement of the Fine Arts in the United States, 1790–1860* (Chicago, 1966).

Thus, investigations of artistic patronage constitute an important genre of writing within the social history of art. It has been suggested that other factors as well played formative roles in artistic creation. Among them are religious institutions and movements. In a study coauthored by André de Ridder, in which stress is laid on technique and technical procedure, Waldemar Deonna has emphasized the relationship between ancient Greek art and social life, in all its different aspects, noting especially the religious origins of this art (*L'art en Grèce* [Paris, 1924; *Art in Greece*, trans. V. C. C. Collum, New York, 1927]). Deonna proposes that art "was for long only a form of cult" (p. 57), that Greek art is "the docile servant of official religion," and that "it keeps this character, which is older in origin than any other, throughout its entire existence" (p. 54), also that "religion penetrates even the industrial arts destined to practical ends" (p. 58), indeed that "religion . . . is responsible for the spirit in which the artist treats his themes and which changes with the changes in belief" (p. 59). Guido von Kaschnitz-Weinberg (1890–1958), a disciple of Alois Riegl, has contended that all ancient Greek architecture derives from the phallic cult brought into the Mediterranean basin by Nordic, Indo-Germanic tribes, and that ancient Roman architecture is based on the worship of mother earth in underground chambers (the womb). [190]

The ambivalence in the formal and symbolic qualities of the 7th-century Ruthwell Cross has been related by Meyer Schapiro to the struggle for power between the Roman and Northumbrian churches ("The Religious Meaning of the Ruthwell Cross," *Art Bulletin* XXVI [1944], pp. 232–45). The church history of Ireland from the

[190] In his *Die mittelmeerischen Grundlagen der antiken Kunst* (Frankfurt am Main, 1944). This and other writings of Kaschnitz-Weinberg have been republished in *Ausgewählte Schriften*, prepared by Helga von Heintze et al, 3 vols. (Berlin, 1965). On his scholarship see Otto Brendel, "Prolegomena to a Book on Roman Art," *Memoirs of the American Academy in Rome* XXI (1953), pp. 61–7; Hans Sedlmayr, *Riegls Erbe: Guido von Kaschnitz-Weinberg und die Universalgeschichte der Kunst*, Munich, Universität Kunsthistorisches Seminar, Hefte 4 (Munich, 1959).

arrival of St. Patrick to the Viking domination enters into the interpretation of the meaning and significance of the carved standing crosses of these islands in the stimulating book by A. Kingsley Porter, *The Crosses and Culture of Ireland* (London, 1931).

The famous plan of St. Gall, the earliest extant medieval architectural drawing, has been interpreted as "a product of the monastic reform movement" of the early 9th century (Walter Horn, "On the Author of the Plan of St. Gall and the Relation of the Plan to the Monastic Reform Movement," in *Studien zum St. Galler Klosterplan*, ed. Johannes Duft [St. Gallen, 1962; *Historischer Verein des Kantons St. Gallen; Mitteilungen zur vaterländischen Geschichte*, 42]).[191] The relation of Grünewald's paintings to the artist's religious beliefs has been critically examined by Stephen S. Kayser ("Grünewald's Christianity," *Review of Religion* V [1940], pp. 3–35). In his *Caravaggio Studies* (Princeton, 1955; Schocken Book), Walter F. Friedlaender includes a chapter on "Caravaggio's Character and Religion," in which he surveys the religious climate in Rome during Caravaggio's productive years, from 1600 to 1606, and uncovers parallels between his paintings and the religious attitudes of St. Filippo Neri and the "low church" of Rome in this period: "Caravaggio's realistic mysticism is the strongest and most persuasive interpretation of the popular religious movements of the period in which he lived" (*ibid.*, p. 121). Important aspects of 18th-century Dutch patronage and collecting are thoroughly studied in a monograph by Clara Bille, *De Tempel der Kunst of het Kabinet van den Heer Braamcamp*, 2 vols. (Amsterdam, 1961). Edgar Munhall has examined the religious overtones of Greuze's *L'Accordée de Village*, or *Village Bride*, of 1761, a painting of importance as a reflection of the moral-

izing current in 18th-century French art ("Greuze and the Protestant Spirit," *Art Quarterly* XXVII [1964], pp. 1–23). Donald D. Egbert has undertaken "to show how the architecture of American churches, meeting houses, and synagogues has tended to exemplify, in highly tangible form, important aspects of prevailing religious beliefs and practices" ("Religious Expression in American Architecture," in *Religion in American Life*, ed. James Ward Smith and A. Leland Jamison, vol. III: *Religious Perspectives in American Culture* [Princeton, 1961], pp. 361–408; reprinted in this book). Lastly, one can mention the interpretation of Renaissance architecture as the "daughter of religion" by Heinrich von Geymüller (1839–1909), in his *Architektur und Religion* (Basel, 1911).

Otto von Simson has examined three Ravenna churches erected during the emperor Justinian's reign, "to see them against the entire panorama of the age in which they were executed and in the political atmosphere of which they were a part" (*Sacred Fortress: Byzantine Art and Statecraft in Ravenna* [Chicago, 1948]). He finds that "the imaginative creations of the architect and the mosaicist were designed to mirror the decisive political issues of the age. . . . This art is 'propaganda' in the grand sense, called into being in a moment of historical emergency and intended to sway the minds of a generation by the power of intuitive vision" (*ibid.*, p. vii). In several recent studies, the noted Byzantinist Ernst Kitzinger (born 1912) critically examines the intensified cult of images in the era between the reign of Justinian the Great and the outbreak of iconoclasm in the early 8th century ("The Cult of Images in the Age before Iconoclasm," *Dumbarton Oaks Papers* VIII [1954], pp. 83–150; "On Some Icons of the Seventh Century," *Late Classical and Mediaeval Studies in Honor of Albert Mathias*

[191] Horn has a monumental study forthcoming on the plan of St. Gall, with drawings by the architect Ernest Born.

Friend, Jr., ed. Kurt Weitzmann [Princeton, 1955], pp. 132–50). While he denies any "easy causal relationship" between the spiritual development revealed by the theoretical statements of the period, and the stylistic trends revealed by the painting of the period ("developments in the realm of form cannot have been contingent on the work of theorists" [*ibid.,* p. 146]), and is fully cognizant of the role of artistic genius in the evolution of aesthetic innovations, Kitzinger nonetheless does detect evidence of a correlation between the two phenomena, a "tangible link" between the early Byzantine artist and his social, intellectual, and religious milieu. He specifically finds that the texts are "but reflections and sublimations of beliefs drastically and spontaneously expressed" in everyday practice:

Thanks to the fact that [post-Justinianic] literature has so much to say about images, their uses and their nature, the scholar has a chance, rare in the medieval field, to interpret the specifically artistic achievement not merely in terms of a general Zeitgeist, nor through comparisons with cultural endeavors in other fields, but in the light of a profound change which the Zeitgeist is known to have wrought in the attitude towards religious art. [*ibid.,* p. 146]

In a more recent paper, Kitzinger posits: a "*Zeitgeist* may be a historian's construct —a mere methodological crutch—but I do not see how any really deep and meaningful interpretation of a major historical style can do without it or some equivalent term" ("On the Interpretation of Stylistic Changes in Late Antique Art," *Bucknell Review* XV [December 1967], p. 8). In all his contributions to scholarship he reveals how deeply he has thought about the interpretation of stylistic phenomena in terms of larger and deeper historical trends and attitudes.[192]

In a masterly study of Byzantine monasticism generally, and of Climax illustration specifically, John Rupert Martin of Princeton University seeks "to shed more light on the problem of scenes from the monastic life in Byzantine art" (*The Illustrations of the Heavenly Ladder of John Climacus* [Princeton, 1954]). After a careful iconographic study of the extant illuminated manuscripts of the *Heavenly Ladder* of John Climacus of Mount Sinai, and a historical survey of monasticism in the Byzantine Empire during the 10th and 11th centuries, Martin arrives at the following interpretation:

The advances of asceticism could not fail to foster a style distinguished by its other-worldly character—the expression, in visible form, of the monastic principle of "renunciation of life." In like manner, the new iconography, with its emphasis on monks and monkish deeds, is seen to be the inevitable corollary of the growth of ascetic zeal. It was under these

[192] A. Kingsley Porter University Professor at Harvard University since 1967, Kitzinger has written a number of other important studies: "Notes on Early Coptic Sculpture," *Archaeologia* LXXXVII (1937), pp. 181–215; *Early Medieval Art, with Illustrations from the British Museum Collection* (London, 1940; Midland Book); "The Horse and Lion Tapestry at Dumbarton Oaks: A Study in Coptic and Sassanian Textile Design," *Dumbarton Oaks Papers* III (1946), pp. 1–72; "Studies on Late Antique and Early Byzantine Floor Mosaics. I. Mosaics at Nicopolis," *ibid.,* VI (1951), pp. 81–122; "Mosaic Pavements in the Greek East and the Question of a 'Renaissance' under Justinian," in *Actes du VIe Congrès International d'Etudes Byzantines, Paris 1948,* 2 vols. (Paris, 1951), II, pp. 209–23; "Byzantine Art in the Period between Justinian and Iconoclasm," in *Berichte zum XI. Internationalen Byzantinisten-Kongress, Munich 1958* (Munich, 1958), iv, no. 1, pp. 1–50; *Encyclopedia of World Art,* s.v. "Mosaics;" *The Mosaics of Monreale* (Palermo, 1960); "A Marble Relief of the Theodosian Period," *Dumbarton Oaks Papers* XIV (1960), pp. 17–42; "The Hellenistic Heritage in Byzantine Art," *ibid.,* XVII (1963), pp. 95–115; "The Byzantine Contribution to Western Art of the Twelfth and Thirteenth Centuries," *ibid.,* XX (1966), pp. 25–47. See also note 128.

conditions, when the heroic past once more loomed large, and when monasticism could produce a personage of the stature of Symeon the Younger, that the illustration of the *Heavenly Ladder* was begun. [p. 163]

Before the 20th century the study of medieval liturgy was the almost exclusive province of theologians and church historians. Religious, specifically liturgical, problems were rarely incorporated into the body of medieval art history or even medieval history. On the other hand, since the middle of the 18th century, historians and specialists in the art of antiquity had investigated the cults and religious institutions of Greece, Rome, and the Near East as cultural phenomena. Only when the close ties in the study of medieval and modern history were severed, and the distinction between the profane and sacred removed, did scholars of the Middle Ages begin to examine the relationship between art and liturgy. One of the foremost students of these connections was Ernst H. Kantorowicz (1895–1963), a gifted historian, iconographer, and art historian whose works of interest to students of the visual arts include: *Laudes Regiae: A Study in Liturgical Acclamations and Mediaeval Ruler Worship* (Berkeley and Los Angeles, 1946); *The King's Two Bodies; A Study in Mediaeval Political Theology* (Princeton, 1957); "The Baptism of the Apostles," *Dumbarton Oaks Papers* IX/X (1955/56), pp. 203–51; and his papers entitled "The King's Advent" (1944) and "Gods in Uniform" (1961), which have been conveniently reprinted in his *Selected Studies* (Locust Valley, N.Y., 1965). The interdependence of Early Christian and early Western medieval art and liturgy has, of course, attracted the attention of other German scholars (including Wolfgang Schöne, Victor H. Elbern, Otto von Simson, and Erich Dinkler). It has been studied in

the architecture of these periods by Friedrich Wilhelm Deichmann and especially Richard Krautheimer ("Mensa-coemeterium-martyrium," *Cahiers archéologiques* XI [1960], pp. 15–40). Only occasionally have such problems been tackled by American-born students (Ilene H. Forsyth, "Magi and Majesty: A Study of Romanesque Sculpture and Liturgical Drama," *Art Bulletin* L [1968], pp. 215–22).

The paper by Johannes Wilde (born 1891) "The Hall of the Great Council of Florence" (*Journal of the Warburg and Courtauld Institutes* VII [1944], pp. 65–81) [193] is exemplary not only for its demonstration of the relations between the Council Hall and political events and ideas, but also for the precision of its method in handling the relevant documentary evidence and in reconstructing the architectural and decorative features of this destroyed monument. From his examination of the structure Wilde makes the following deductions:

The Council Hall, erected by the government which followed on the November revolution of 1494 in Florence, was the direct result of the new constitution and, at the same time, its expression in monumental form. The political ideas of the new regime determined the shape of the building and also the plan of its decoration in all its details. This is one of the rare cases where a clearly definable historical occurrence expressed itself immediately in a work of art or—to put the statement in reverse form—where the existence and significance of a work of art can be completely explained by reference to a political event.[p. 65]

It was for the Council Hall of Florence that Leonardo da Vinci and Michelangelo were commissioned by the Signoria to fresco monumental battle pictures.

A recent contribution to our understanding of the genesis of Michelangelo's colos-

[193] Republished in *Renaissance Art*, ed. Creighton Gilbert (New York, 1970; Harper Torchbook), pp. 92–132.

sal statue of David in Florence has been furnished by Charles Seymour, Jr., in a paper that takes into account relevant contemporary political and social as well as aesthetic factors (*Michelangelo's David; A Search for Identity* [Pittsburgh, 1967]). The relation of religious and political factors to the visual arts has been examined by Anthony Blunt in a provocative paper on El Greco's painting *The Dream of Philip II* ("El Greco's 'Dream of Philip II': An Allegory of the Holy League," *Journal of the Warburg and Courtauld Institutes* III [1939–40], pp. 58–69). Meyer Schapiro has examined some works of Gustav Courbet and deduced that this French artist followed a path "from an originally aggressive conception of realism, with something of the social preoccupations of the second Republic" ("Courbet and Popular Imagery," *Journal of the Warburg and Courtauld Institutes* IV [1940–41], pp. 164–91). In the fundamental study of the relationship between socialism and American art, Donald D. Egbert discusses certain important events of political, social, and artistic radicalism and their impact on artists and their works ("Socialism and American Art," in *Socialism and American Life,* ed. Donald D. Egbert and Stow Persons, 2 vols. [Princeton, 1952]; Egbert's essay is reprinted and expanded in a Princeton paperback entitled *Socialism and American Art in the Light of European Utopianism, Marxism, and Anarchism*).[194]

The official policies of the Third Reich regarding modern artists and art engaged the scholarly attention of interested specialists as early as 1936, when Emil Wernert published his *L'Art dans le III^e Reich; une tentative d'esthétique dirigée* (Paris). After the fall of the Nazi regime, Paul Ortwin Rave (*Kunstdiktatur im Dritten Reich* [Hamburg, 1949]) and Hellmut Lehmann-Haupt (*Art under a Dictatorship* [New York, 1954]) elaborated further on

Wernert's material. But the best documented and most stimulating analysis and interpretation of the visual arts in Nazi Germany has been written by the young American scholar Barbara Miller Lane, *Architecture and Politics in Germany, 1918–1945* (Cambridge, Mass., 1968). Mrs. Lane undertakes to show why "the Nazi regime repudiated some types of art and endorsed others" and to learn the reasons for the great significance of the visual arts and specifically architecture in the confused and contradictory cultural ideology of the new government. After a painstaking examination and careful evaluation of vast reservoirs of archival and other documentary material bearing on these questions, she finds that

the Nazis exercised control over architectural style not simply because it was the habit of the new regime to regulate public opinion. They did so because they saw architectural styles as symbols of specific political views, and they believed this to be more true of architecture than of the other arts. This belief was not, however, the product of the "totalitarian" structure of the Nazi state. The Nazis inherited a political view of architecture from the Weimar Republic, and any discussion of Nazi architectural policy must trace the sources of this inheritance in the republican period. [pp. 2–3]

Her results bring to light what she calls "a long-standing tendency in Germany to regard the arts as a focus of political concern."

For James S. Ackerman, study of the economic history of the Venetian Cinquecento reveals a great deal about the function and design of the secular architecture of Andrea Palladio (*Palladio* [Baltimore and Harmondsworth, Eng., 1966; Penguin Book], and *Palladio's Villas* [Locust Valley, N.Y., 1967]). Improved methods of farming, most of all the introduction of the cultivation of corn in the 16th century,

[194] See also his most recent work entitled *Social Radicalism and the Arts: Western Europe; from the French Revolution to 1968* (New York, 1970).

and reclamation in the swamplands and deltas throughout the terra firma, gave rise to a need on the part of the capitalist nobility of Venice for great estates that would be functional and utilitarian as well as appropriate symbols of a dignified aristocratic life. Although the new economic and social situation did not in itself produce a mature Palladian villa, Ackerman persuasively contends that it affected in no small measure the new directions in villa building, and especially the simple classical grandeur and magnificence of the estates designed by Palladio.

Ecological practices in Byzantium and Syria have been interpreted by Oleg Grabar as a major factor in the original creation of Umayyad palaces ("Islamic Art and Byzantium," *Dumbarton Oaks Papers* XVIII [1964], pp. 67–88). In this rapid but masterly sketch that evaluates the artistic relations between Islam and Byzantium — and the important province of Islamic art, like those of India and the Far East generally, has been neglected in our own pages — Grabar conceives of the Umayyad palace as the result of the peculiar combination of four factors: "a highly developed agricultural infrastructure created several centuries earlier; the emigration of large landowners; the existence of an aristocratic ruling group; and the availability of themes, ideas, tastes, and modes of behavior drawn from the entire breadth of the newly conquered world and amalgamated with older Arabian habits" (*ibid.,* p. 77). In the same paper, Grabar deals with the iconography of power in early Islamic art, pointing out that the most characteristic "decorative" objects and motifs of Islamic art "possess also a level of social, intellectual, or even religious meaning hitherto rarely seen" (*ibid.,* p. 79). This was first demonstrated by Richard Ettinghausen (born 1906) in many writings

as early as 1943.[195] Ettinghausen, Grabar, and other specialists have fundamentally changed our romantic conception of Islamic art as purely ornamental and devoid of meaning.

The social history of art includes the history of taste — that is, the history of art theories, of exhibitions, art collecting, and art dealing.[196] The first scholarly treatment of the history of art collecting was by Julius von Schlosser in *Die Kunst- und Wunderkammern der Spätrenaissance; Ein Beitrag zur Geschichte des Sammelwesens* (Leipzig, 1908). More recently, this problem has been dealt with in popular writings, such as Francis Henry Taylor's *Taste of Angels: A History of Art Collecting from Rameses to Napoleon* (Boston, 1948), and Gerald Reitlinger's *Economics of Taste,* 3 vols. (London, 1961–70). For a penetrating scholarly survey of the education of painters and sculptors from the time of Leonardo da Vinci to the 20th century, and an evaluation of artistic education in the light of prevailing aesthetic, political, social, and economic factors, see Nikolaus Pevsner, *Academies of Art, Past and Present* (Cambridge and New York, 1940). Leonardo's *Mona Lisa* in the history of taste is examined by critic George Boas in *Wingless Pegasus, a Handbook for Critics* (Baltimore, 1950). The Gothic in the history of taste has been treated in a popular work by Kenneth Clark (*The Gothic Revival, an Essay in the History of Taste,* rev. and enl. ed. [New York, 1950; Penguin Book]) and in a remarkable scholarly contribution by Paul Frankl (*The Gothic: Literary Sources and Interpretation through Eight Centuries* [Princeton, 1960]).

The history of art can be regarded as an aspect of cultural history when the visual arts are perceived as a manifestation of culture and if the historian seeks to paint a comprehensive, structurally coherent

[195] "The Bobrinski Kettle; Patron and Style of an Islamic Bronze," *Gazette des Beaux Arts* XXIV, 6th ser. (1943), pp. 193–208; *Arab Painting* (Geneva, 1962); and other works.

[196] For definitions of taste, see Meyer Schapiro, *Encyclopedia of the Social Sciences,* s.v. "Taste."

portrait of the total way of life in the historical period or periods with which he is concerned. To perceive, visualize, and articulate such a portrait entails making a sweeping analysis and synthesis of all relevant human institutions, attitudes, motives, and products. [197] This goes beyond the objectives of art history, which traditionally has restricted itself to a study of just one manifestation of human endeavor, the visual arts. When art historians regard the arts as a representative sphere of cultural activity and interpret them in relation to the total expression of human activity and thought, they intrude upon the province of cultural history.

As a genre, cultural history began with Voltaire and Herder in the mid-18th century and reached a high level in the work of Jacob Burckhardt (1818–97), a Swiss historian and art historian who is today acknowledged almost universally as the cultural historian par excellence. His epoch-making essay Die Cultur der Renaissance in Italien; Ein Versuch (Basel, 1860 [available in a number of translations entitled Civilization of the Renaissance in Italy]) raised cultural history to a position of authority among historical genres. In full command of a vast amount of historical data and with a rare ability to synthesize, Burckhardt presents an original interpretation of the Italian Renaissance from 1300 to 1600. While aspects of his interpretation have been subject to review and emendation, his fundamental thesis remains unchanged: "the fifteenth century is, above all, that of the many-sided man." [198] Into a tapestry of general themes, he weaves his profound knowledge of social and political institutions, individualism, the revival of antiquity, morality, and religion. Man is the center of Burckhardt's work. Curiously, his most prized evidence, the visual arts, which he had treated both in his earlier essay Die Zeit Constantin's des Grossen (Basel, 1853 [available in translations entitled The Age of Constantine the Great]) and in a subsequent study on Renaissance architecture (with Wilhelm Lübke, Geschichte der neueren Baukunst [Stuttgart, 1867])—architecture interested him more than sculpture and painting— are left out of his Civilization save for passing reference. [199]

Burckhardt remains at all times simple. Rather than present his material in accordance with a precisely defined methodological framework or philosophical system—he especially attacked philosophers of history, such as Hegel, who held that the course of world history was invested with a rational and rationally understandable purpose—he paints a historical picture of situations and general conditions (Zustandsschilderung) with impressive artistic finesse. A harmonious balance is achieved between historical objectivity and aesthe-

[197] For a survey of definitions of cultural history, see Alfred L. Kroeber and Clyde Kluckhohn, Culture; A Critical Review of Concepts and Definitions (Cambridge, Mass., 1952; Vintage Book). For cultural history as a genre of scholarship, see Felix Gilbert, "Cultural History and its Problems," in Rapports de XI Congrès International des Sciences Historiques, Stockholm, 21–28 Août 1960 (Goteborg, 1960), vol. I, pp. 40–58; Karl J. Weintraub, Visions of Culture: Voltaire, Guizot, Burckhardt, Lamprecht, Huizinga, Ortega y Gasset (Chicago, 1966; University of Chicago paperback); and Jacques Barzun, "Cultural History as a Synthesis," in The Varieties of History, ed. Fritz Stern (New York, 1956; Meridian Book), pp. 387–402.

[198] See Paul O. Kristeller, "Changing Views of the Intellectual History of the Renaissance since Jacob Burckhardt," in The Renaissance; A Reconsideration of the Theories and Interpretations of the Age, ed. Tinsley Helton (Madison, Wis., 1961).

[199] For an insight into how Burckhardt regarded art, one need only look at the subtitle of his 1,000-page guidebook to the art treasures of Italy: Der Cicerone. Eine Anleitung zum Genuss der Kunstwerke Italiens (Basel, 1855 [The Cicerone; An Art Guide to the Enjoyment of Italian Art, ed. A. von Zahn, trans. A. H. Clough, London, 1873]).

tic composition, forming a style that may be termed "historical impressionism." For Burckhardt, the task of the cultural historian is to present the "small and single detail as symbol of a whole and large view, the biographical detail as symbol of a broader general aspect."[200] And it was the permanent, rather than the accidental and changing aspects of the intellectual attitudes of man during a single cultural epoch that found their way from his palette to his canvas.[201]

Because Burckhardt's cultural history always singled out the visual arts as the highest of all human creative activities, it attracted a large number of art critics and scholars of different nationalities.[202] The renewed interest in the Italian Renaissance is exemplified by the art criticism in Hippolyte Taine's *Philosophie de l'art en Italie; leçons professées à l'Ecole des Beaux-Arts* (Paris and New York, 1866)[203] and Walter Pater's *Studies in the History of the Renaissance* (London, 1873). The two most influential late 19th-century interpretations of Italian Renaissance art in the Burckhardtian tradition are one volume of John Addington Symonds' (1840–93) massive

seven-volume work, *Renaissance in Italy* (London, 1875–86; Capricorn Book), and the three-volume *Histoire de l'art pendant la Renaissance* (Paris, 1889–95) by Eugène Müntz (1845–1902). Symonds' conception of the Renaissance closely followed Burckhardt's work, and indeed was under its direct influence, but his writing is more in the vein of re-creative art criticism or literature than Burckhardt's objective historical presentation.[204] The view of the French art historian Müntz (1845–1902), however, closely approaches the cultural perspectives of Burckhardt. His imposing volumes on Renaissance art history, as well as his monographs on Raphael (Paris, 1881), Donatello (Paris, 1885), and Leonardo da Vinci (Paris, 1899) fill in what Burckhardt had omitted in his *Civilization*. In its comprehensive nature, Müntz's work has had no sequel.

Other studies have been written in the Burckhardtian tradition, but they are far more restricted in scope. Hubert Janitschek's (1846–93) *Die Gesellschaft der Renaissance in Italien und die Kunst* (Stuttgart, 1879) deals with aspects of the Renaissance, such as artistic patronage, while

[200] Werner Kaegi, *Jacob Burckhardt; eine Biographie*, 4 vols. (Basel, 1947–67), II, p. 290. This is the most comprehensive biography of a modern historian ever written. For an appraisal of Burckhardt's art history, see Wilhelm Waetzoldt, *Deutsche Kunsthistoriker*, 2 vols. (Leipzig, 1921–24), II, pp. 172–209; Klaus Berger, "Jacob Burckhardt as an Art Historian," in University of Kansas, Museum of Art, *Jacob Burckhardt and the Renaissance: 100 Years After* (1960), pp. 38–44; Herman A. E. van Gelder, *Jacob Burckhardts Denkbeelden over Kunst en Kunstenaars* (Amsterdam, 1962); and E. H. Gombrich, *In Search of Cultural History: The Philip Maurice Deneke Lecture 1967* (Oxford, 1969), pp. 14–25. For Burckhardt's conception of Rubens as an artist, see his *Errinerungen aus Rubens* (Basel, 1898 [*Recollections of Rubens*, ed. H. Gerson, trans. Mary Hottinger, London, 1950]).

[201] Probably the best writing on crises in history, a problem of great interest to art historians, is Burckhardt's published lecture "The Crisis of History" (orig. pub. in *Weltgeschichtliche Betrachtungen*, ed. J. Oeri [Berlin, 1905]; in his *Force and Freedom. Reflections on History*, ed. James Hastings Nichols, trans. Werner Kaegi [New York, 1943; Beacon Book]). For the collected works of the Swiss historian, see *Jacob Burckhardt-Gesamtausgabe*, comp. Emil Dürr, 14 vols. (Stuttgart, 1930–33).

[202] The basic discussion of the Burckhardtian tradition in the historiography of art is Wallace K. Ferguson's *The Renaissance in Historical Thought; Five Centuries of Interpretation* (Boston, 1948), pp. 238 ff. and passim. I have profited greatly from this evaluation.

[203] See also the anthology by Jean-François Revel, *Taine: Philosophie de l'art* (Paris, 1964).

[204] For a recent appraisal of the personality and accomplishment of Symonds, see Phyllis Grosskurth, *John Addington Symonds: A Biography* (London, 1964).

Carl Justi (1832–1912) treats artistic biography in the light of the cultural milieu (*Diego Velázquez und sein Jahrhundert* [Bonn, 1888; *Diego Velasquez and His Times*, rev., trans. Prof. A. H. Keane, London, 1889]). Burckhardt's thesis of the rise of individualism in the Renaissance led to a wide interest in biography, and Justi and many other art historians and historians of the late 19th century avidly pursued this approach. Thus, Eugène Müntz was the editor of *Les Artistes célèbres*, which appeared in 57 volumes between 1886 and 1906 (Paris). Moreover, it should be noted that the cultural interpretations of Janitschek, Justi, and Burckhardt were the single most persuasive formative influence on the interests of Aby Warburg and his interpretation of art history as cultural history, or *Geisteswissenschaft*. Warburg had studied under Janitschek and Justi and was a great admirer of the work of Burckhardt. Significantly, Warburg confined his interests largely to the 15th century.

In the study of the Middle Ages, Burckhardt's most direct heir was the Dutch cultural historian Johan Huizinga (1872–1945). Following the Swiss scholar, Huizinga regarded the visual arts and literature as the main sources for the investigation of man and his accomplishments in certain cultural epochs. Emphasizing the intellectual and creative, rather than the material aspects of civilization, he examined the particular modes of medieval thought and feeling; but he differed from Burckhardt in that he refrained from attributing a few definite dominating ideas to a single cultural period—a task he left to future generations. (For, in his own words, "the true questions of cultural history are problems of the forms, of the structure and the function of social phenomena.") After assembling and evaluating enormous amounts of evidence, Huizinga arrived at fresh and stimulating ideas. In *Waning of the Middle Ages; A Study of the Forms of Life, Thought and Art in France and the Netherlands in the Fourteenth and Fifteenth Centuries* (first pub. in Dutch, 1919; Doubleday Anchor Book), the 14th and 15th centuries are seen as the termination of the medieval period rather than the transition to the Renaissance, and the art of the brothers Van Eyck and their contemporaries is studied "in connection with the entire life of their times." For Huizinga, "the significance, not of the artists alone, but also of theologians, poets, chroniclers, princes and statesmen, could be best appreciated by considering them, not as the harbingers of a coming culture, but as perfecting and concluding the old" (unpaginated preface to Doubleday Anchor edition).

The Burckhardtian tradition has remained evident in recent decades in the great emphasis placed on the study of Italian Renaissance art, especially in the curricula of many American universities, where departments of art make a course on Italian Renaissance art the core of their undergraduate programs. In American scholarship, the field of Renaissance art is perhaps more populated than any other. On the other hand, increased specialization on the part of art historians has led to studies of Renaissance art that are far more limited in scope than Burckhardt's visions of culture. There is no longer interest in re-creating the Burckhardtian panorama: time has caused aspirations to change.

Richard Krautheimer, in his wide-angled perspective of Carolingian architecture, seen in relation to the total background of Carolingian culture, may be regarded as a modern heir to the tradition of Burckhardt's cultural visions ("The Carolingian Revival of Early Christian Architecture," *Art Bulletin* XXIV [1942], pp. 1–38; slightly revised version in Krautheimer, *Studies in Early Christian, Medieval, and Renaissance Art*, ed. James S. Ackerman et al [New York, 1969], pp. 203–56; this version republished here). That paper is more limited in scope than the large-scale topics investigated by Burckhardt but is reminiscent of the Swiss scholar's ability to project the

visual arts into a cultural matrix. In exemplary fashion, Krautheimer perceptively analyzes the literary and archaeological evidence for certain important transalpine and cisalpine monuments and interprets them as an important instrument of Carolingian policy as seen in its total framework. His paper represents a fundamental contribution to our understanding of early medieval architecture and ranks as one of the classic studies of modern art history. [205]

In his essay "Rebellion in Art," Meyer Schapiro has examined the events surrounding the Armory Show of 1913 and that show's crucial importance for the subsequent development of modern art in America (in *America in Crisis: Fourteen Crucial Episodes in American History,* ed. Daniel Aaron [New York, 1952]). Rather than focus on specific works of art, Schapiro interprets the show in the light of the prevailing aesthetic, social, intellectual, and cultural values and conditions. In his vision of culture he, too, may be regarded as a modern heir to Burckhardt. This broadly conceived method, so difficult to define succinctly, is also used discriminately by Schapiro in his valuable studies of medieval art, especially Romanesque sculpture. As a historian closely examines the euphony, rhythm, and meter of a work of literature, so Schapiro perceptively identifies and incisively analyzes the structural composition of medieval works of art and tries to uncover the layers of meaning hidden in the syntax of their forms. He generally emphasizes the freedom of the medieval craftsman rather than his indebtedness to artistic tradition. (Compare the paper by Weitzmann in this book). Ultimately, Schapiro relates the formal and symbolic qualities to a broad historical context of social, cultural, and other environmental factors, and at least in one important study he finds, after a survey of all available documentary evidence, that "not in Souillac alone but throughout Romanesque art can be observed in varying degree a dual character of realism and abstraction, of secularity and dogma, rooted in the historical development and social oppositions of the time" ("The Sculptures of Souillac," in Wilhelm R. W. Koehler, ed., *Medieval Studies in Memory of A. Kingsley Porter,* 2 vols. [Cambridge, Mass., 1939], II, pp. 359–87). His stance was molded in some measure by his attraction to Marxist philosophy in the 1930s, at which time he viewed art as an expression of class. [206] But Schapiro's scholarship in medieval art cannot be labeled Marxist, and indeed it is difficult to categorize his major contribution by reference to any genre of art historical writing: it is *sui generis.* From the point of view of methodology, it is interesting to observe that while Kurt Weitzmann, who has spelled out his precepts for the study of Byzantine manuscripts in *Illustrations in Roll and Codex* and other publications, has had a following of students who have applied his method, Schapiro has yet to formulate his approach

[205] See also Krautheimer, "The Constantinian Basilica," *Dumbarton Oaks Papers* XXI (1967), pp. 115–40; "Constantine's Church Foundations," in *Akten des VII. Internationalen Kongresses für christliche Archäologie, Trier 5–11 September 1965,* 2 vols. (Vatican City and Berlin, 1969), I, pp. 237–54. A synthesis of the documentary, archaeological, liturgical, and the social and intellectual aspects of historical periods is also evident in his basic handbook, *Early Christian and Byzantine Architecture* (Harmondsworth, Eng., and Baltimore, 1965), and in his large monograph in collaboration with Trude Krautheimer-Hess, *Lorenzo Ghiberti* (Princeton, 1956), now reissued in a two-volume edition, with new documentation. Some of his other major contributions to medieval and Renaissance art history, including studies on Alberti, are presented in James S. Ackerman et al, eds., *Studies in Early Christian, Medieval, and Renaissance Art* (New York, 1969). Krautheimer's achievement must also be measured in terms of his many students, among whom may be listed James S. Ackerman, Howard Saalman, Irving Lavin, Leo Steinberg, and Richard Pommer.

[206] See his "Nature of Abstract Art," *Marxist Quarterly* I (1937), pp. 77–98.

methodically (this is not even done in his famous 1953 essay entitled "Style") and appears to have no students in medieval art who have been able to follow up his flexible and wide-ranging method. He is among the few practicing scholars who deal with art of several chronologically distinct periods, as our frequent mention of his work on the Renaissance and modern periods indicates.[207] His interests also pertain to many fields of inquiry, cultural anthropology included.[208]

About 1910, Franz Boas evolved his cultural anthropology, in which he attempts to combine an alleged historical method with skepticism of specific historical interpretations (*The Mind of Primitive Man* [New York, 1911]; and *Encyclopedia of the Social Sciences*, s.v. "Anthropology"). About a generation later, Alfred L. Kroeber proposed that cultural phenomena are susceptible to specific historical interpretations (*Configurations of Culture Growth* [Berkeley and Los Angeles, 1944]; *Style and Civilization* [Ithaca, N.Y., 1957]).[209] Though he has explored various cultural achievements in human history, Kroeber confines himself largely to theoretical views. Under the influence of the work of Kroeber as well as Henri Focillon, George Kubler has examined the topics of *Mexican Architecture of the Sixteenth Century*, 2 vols. (New Haven, 1948) by fusing the techniques of demography and ecology with an analysis of social, economic, and political phenomena.

Cultural history is related to *Geistesgeschichte*, a specifically German method of inquiry that originated in the second half of the 19th century and has persisted to the present day. A branch of the history of ideas, *Geistesgeschichte* might be rendered in English as "intellectual history" (or, even less accurately, as the "history of the human mind"). Philosophically, it evolved from the tradition of Hegelianism and other forms of 19th-century Romantic thought and attained its first positive statement in the work of Wilhelm Dilthey (1833–1911), a great German philosopher and historian and the father of the modern history of ideas. Dilthey posited that the

[207] Schapiro's important papers on medieval sculpture include: "The Romanesque Sculpture of Moissac," *Art Bulletin* XIII (1931), pp. 248–351 and 464–531; "From Mozarabic to Romanesque in Silos," *ibid.*, XXI (1939), pp. 312–74; "The Sculptures of Souillac," in Wilheim R. W. Koehler, ed., *Medieval Studies in Memory of A. Kingsley Porter*, 2 vols. (Cambridge, Mass., 1939), II, pp. 359–87; "A Relief in Rodez and the Beginnings of Romanesque Sculpture in Southern France," in Millard Meiss et al, eds., *Studies in Western Art*, 4 vols., *Acts of the Twentieth International Congress of the History of Art, 1961* (Princeton, 1963), vol. I: *Romanesque and Gothic Art*, pp. 40–66. His method and points of view are also seen at work in his essays "On the Aesthetic Attitude in Romanesque Art" (in *Art and Thought*, ed. Iyer K. Bharatha [London, 1947], pp. 130–50) and *The Parma Ildefonsus: A Romanesque Illuminated Manuscript from Cluny, and Related Works* (New York, 1964), as well as his studies "The Religious Meaning of the Ruthwell Cross," *Art Bulletin* XXVI (1944), pp. 232–45; "The Bowman and the Bird on the Ruthwell Cross and other Works: The Interpretation of Secular Themes in Early Mediaeval Religious Art," *ibid.*, XLV (1963), pp. 351–7; "Two Romanesque Drawings in Auxerre and Some Iconographic Problems," in *Studies in Art and Literature for Belle da Costa Greene*, ed. Dorothy Miner (Princeton, 1954), pp. 331–49; "An Illuminated English Psalter of the Early Thirteenth Century," *Journal of the Warburg and Courtauld Institutes* XXIII (1960), pp. 179–89; and an enlightening paper on "The Place of the Joshua Roll in Byzantine History," *Gazette des Beaux Arts* XXXV, 6th ser. (1949), pp. 161–76, to which one can instructively compare the far more iconographically oriented study by Kurt Weitzmann, *The Joshua Roll* (Princeton, 1948).

[208] For a critical appraisal of humanistic scholarship in 20th-century anthropology, see Eric R. Wolf, *Anthropology* (Englewood Cliffs, N.J., 1964).

[209] The latter book is reviewed by Meyer Schapiro in *American Anthropologist* LXI (1959), pp. 303–5.

study of the cultural sciences should not be subordinated to that of the natural sciences, as had been held by contemporary German academic philosophers.[210] An Idealist rather than a Positivist, Dilthey professed belief in a world of the spirit, which man creates in time through his feeling, will, and intellect.[211] Man reacts to what the external world ought to be, or to become, in a *Weltanschauung*, or total global outlook. These *Weltanschauungen* are the principal sources of our knowledge of the human mind. They "are not produced by thinking," but by the "living experience" *(Erlebnis)*, or philosophical and theoretical utterances, of man.

For Dilthey, the history of ideas includes a study of both rational and irrational (or imaginative) thoughts. His own work on the history of the human mind focused on literature, poetry, music, and philosophy but, by personal choice, excluded the visual arts and social and political ideas.[212] It was left for others to relate the visual arts to a study of the concept of the human mind.

The first art historian to establish *Geistesgeschichte* as a branch of study in his discipline was the brilliant successor in Vienna of Alois Riegl, Max Dvořák (1874–1921), author of fundamental studies on the arts of early Christianity, the Middle Ages, the Van Eyck brothers, and Mannerism. Inspired by Dilthey's historical approach to the theory of *Weltanschauung*, Dvořák interpreted the visual arts as the expression and spiritual manifestation of a unified totality of thought underlying all aspects of cultural and other human phenomena. His interpretation of art history as *Geistesgeschichte* is apparent in his major work, *Idealism and Naturalism in Gothic Art* (trans. R. J. Klawiter [Notre Dame, Ind., 1967; first pub. 1918]), a chapter of which appears in this book.[213] In this study, Dvořák deals with medieval art generally and Gothic sculpture and painting specifically. Proceeding ingeniously from analogies he draws between the visual arts and other contemporary phenomena, he finds the basis of the arts in a *Weltanschauung* of medieval Christianity. Rather than explain the arts as causally determined by events in the development of new economic, social, or religious thought, and believing that the spiritual qualities of medieval art cannot be extrapolated from the writings of the great theologians of the

[210] See *Wilhelm Diltheys gesammelte Schriften*, 14 vols. (Leipzig and Berlin, 1914–66), vol. I: *Einleitung in die Geisteswissenschaften* (first pub. 1883). For his views on *Weltanschauung* (he left his system incomplete, for he was unable to reconcile his incompatible conceptions of *Weltanschauungen*), see *Dilthey's Philosophy of Existence: Introduction to Weltanschauungslehre*, trans. with intro. by William Kluback and Martin Weinbaum (New York, 1957). The best modern evaluation of the concept of *Weltanschauung* is Karl Mannheim, "On the Interpretation of *Weltanschauung*," in his *Essays on the Sociology of Knowledge* (London, 1952), pp. 33–83 (orig. pub. 1923 in German). In general, see the comments of Erich Rothacker, *Einleitung in die Geisteswissenschaften* (Tübingen, 1920).

[211] In this regard, it may be pointed out that Alois Riegl interpreted the content of the Dutch group portrait by means of the concepts of emotion, will, and attention (see the selection from his work in this anthology).

[212] Dilthey's method provided a powerful stimulus to many analytical and synthetic studies originally published in Germany, such as Max Weber's *Protestant Ethic and the Spirit of Capitalism*, trans. Talcott Parsons (London, 1930; first pub. 1904–05) and Alfred von Martin's *Sociology of the Renaissance*, trans. W. L. Luetkens (London, 1944; Harper Torchbook; first pub. 1932).

[213] "Idealismus und Naturalismus in der gotischen Skulptur und Malerei," *Historische Zeitschrift* CXIX (1918), pp. 1–62, 185–246 (also in a separate reprint, 1918); republished posthumously by his students Karl Maria Swoboda and Julius Wilde in a book aptly entitled *Kunstgeschichte als Geistesgeschichte; Studien zur abendländischen Kunstentwicklung* (Munich, 1924). The bibliography of and about Dvořák can be found in the translation of *Idealism and Naturalism* (1967).

period, he finds parallelisms between the visual arts and these other phenomena. For instance, medieval art and medieval philosophy are not caused by each other, but are the product of the total framework of the prevailing global outlook. For Dvořák, medieval art both derives from and reflects this prevailing outlook.

Dvořák could arrive at such an outlook because of his assumption of strict continuity in the evolutionary process, a belief that was held by Riegl and was current in Viennese art scholarship early in this century.[214] (Riegl said that "every style aims at a faithful rendering of nature and nothing else, but each has its own conception of nature. . ." [Die spätrömische Kunst-Industrie, Vienna, 1901, p. 212]). Dvořák conceived of the whole of artistic development from the Middle Ages to Impressionism as a continuous and progressive process in which artists achieved greater and greater naturalism through greater and greater technical and artistic accomplishments.[215] Later in his career, when he began to reflect on Postimpressionism and especially the art being created in Europe in his own day, Dvořák realized that an abrupt and significant change had taken place in art, and consequently revised his theory of historical continuity. It was Expressionism and Surrealism that led him to startling reformulations of his theory about the art that is now known—thanks to his pioneering scholarship—as Manner-

ism.[216] At the end of his life (like Riegl, he was only 47 when he died) he had perceived three revolutionary breaks in the continuity of Western art: early Christianity, Mannerism, and Expressionism and Surrealism. Thus he had reverted essentially to the historical notions of his predecessor, Riegl.

Like Burckhardt, Dvořák was a synthesizer of vast amounts of cultural data; he tried to control his material by postulating that a conflict of the antithetical categories of idealism and naturalism pervaded medieval art. For him, the history of art had been the history of naturalism; but the emergence of German Expressionism and related contemporary art movements caused him, in the second decade of this century, to think also of idealism—that is, of expressive and spiritual qualities that lend shape to the creative process. He found in the art of the Gothic period a conflict between naturalism and idealism and saw that this conflict was paralleled by the contemporary philosophical dispute between realism and nominalism, and that the parallel between the arts and philosophy was anchored in the spiritualism of the Christian Middle Ages.[217] Dvořák writes with brilliance as he turns the torchlight on medieval art and culture. His work seems to enlighten as it illuminates. Indeed, his lectures in Vienna and his papers assumed a position of great authority in European art history (they have not

[214] For the following, I am greatly indebted to the penetrating criticism of Arnold Hauser, The Philosophy of Art History (New York, 1959).

[215] This point of view is apparent in Dvořák's valuable study of the art of the brothers Van Eyck ("Das Rätsel der Kunst der Brüder van Eyck," Jahrbuch der kunsthistorischen Sammlungen des Allerhöchsten Kaiserhauses XXIV [1904], pp. 161–317; rep. as a separate paper, 1925).

[216] See Dvořák's paper that has been translated in part by John Coolidge ("El Greco and Mannerism," Magazine of Art XLVI [1953], pp. 14–23). It was originally delivered as a lecture in 1920, two years after his Idealism and Naturalism in Gothic Art, and published posthumously in Kunstgeschichte als Geistesgeschichte (Munich, 1924). It is regretted that Coolidge failed to include in his English translation of the El Greco paper those passages of Dvořák's work that reveal his interpretation of the visual arts as Geistesgeschichte.

[217] A similar interpretation characterized his lectures on the history of Italian art, published posthumously as Geschichte der italienischen Kunst im Zeitalter der Renaissance; akademische Vorlesungen, 2 vols. (Munich, 1927–29).

had an important influence on American scholarship because of their untranslatability), a position rivaled only by that of Heinrich Wölfflin in Germany.[218] With Dvořák's example guiding their work, many art historians, especially Viennese and East European, have looked for analogies between the visual arts and expressions of thought. They have assumed that there must exist discoverable relationships among contemporary works of art on the one hand, and literature, music, philosophy, religion, science, economics, and other branches of human endeavor, on the other. Some of them have produced nothing more concrete than an "intuitive morphology."[219] Others have made stimulating interpretations of art history either as *Geistesgeschichte* or viewed in the light of the prevailing *Weltanschauung* of a period or culture. As we have seen, Antal and Hauser have written social histories of the arts and both studied under Dvořák. Dvořák's point of view is reflected not so much in Hauser's *Social History of Art*, 2 vols. (London, 1951) as in his recent monograph *Mannerism: The Crisis of the Renaissance and the Origin of Modern Art*, 2 vols. (London, 1965).[220] In this weighty publication, Hauser postulates a coherence and unity

of the funded experience of a given period, and from this experience tries to extrapolate the attitudes that can be seen in its art forms. For Hauser, "the spiritual climate of the age . . . entailed similar formal solutions in the different arts." The distinguished Rembrandt scholar Otto Benesch (1896–1964), who studied under Dvořák, has written several studies that attempt to follow up his teacher's interpretation of art history as *Geistesgeschichte* (*Artistic and Intellectual Trends from Rubens to Daumier as Shown in Book Illustration* [Cambridge, Mass., 1943]; *The Art of the Renaissance in Northern Europe: Its Relation to the Contemporary Spiritual and Intellectual Movements* [Cambridge, Mass., 1945]). Benesch feels that "the task of the historian of our time is to keep strictly to the problems of his proper field, but to demonstrate them under the visual angle of the cultural totality of which they form a part" (*ibid.,* p. 169).[221] Dagobert Frey (1883–1962), another student of Dvořák, has also interpreted art history as cultural and intellectual history (*Gotik und Renaissance als Grundlagen der modernen Weltanschauung* [Augsburg, 1929]).[222] Baroque art has been seen as *Geistesgeschichte* in a study

[218] The methods of Dvořák and Wölfflin are compared in the doctoral dissertation of Walter Boeckelmann, *Die Grundbegriffe der Kunstbetrachtung bei Wölfflin und Dvořák* (Dresden, 1938).

[219] Karl Manheim, *Essays on the Sociology of Culture*, ed. Ernest Manheim (London, 1956), pp. 32ff., who in this regard cites the work of Richard Hamann (*Der Impressionismus in Leben und Kunst*, 2d ed. [Marburg, 1923]) and Wilhelm Hausenstein (*Barbaren und Klassiker; ein Buch von der Bildnerei exotischer Völker* [Munich, 1922]; *Vom Geist des Barock* [Munich, 1920]). One notable attempt to apply Dilthey's types of *Weltanschauung* to music and painting is Herman Nohl's *Die Weltanschauungen der Malerei* (Leipzig, 1908), as pointed out by Wellek and Warren, *Theory of Literature*, 3d ed. (New York, 1956), pp. 117–18. According to Nohl, Rembrandt, Rubens, and Berlioz belong to Dilthey's objective idealists; Velázquez, Hals, and Schubert to his realists; and Michelangelo and Beethoven to his subjective idealists. Nohl thus adopts a physiognomic theory of art history, in which the *Weltanschauungen* of works of art can be read directly from them.

[220] Originally published as *Der Manierismus: Die Krise der Renaissance und der Ursprung der modernen Kunst* (Munich, 1964). See the instructive criticism of this book by William H. Halewood, in *History and Theory* VII (1968), pp. 90–102.

[221] For his contribution to Rembrandt studies, see *Otto Benesch: Collected Writings,* ed. Eva Benesch, vol. I: *Essays on Rembrandt* (London, 1969). An appraisal of the accomplishment and personality of Benesch can be found in the foreword by J. Q. Van Regteren Altena to *Otto Benesch: Verzeichnis seiner Schriften,* comp. Eva Benesch (Bern, 1961).

[222] Most of the second chapter of this brilliant essay has been translated in *Art History: An Anthology of Modern Criticism,* ed. Wylie Sypher (New York, 1963; Vintage Book), pp. 153–72.

by Werner Weisbach (1873–1953), *Der Barock als Kunst der Gegenreformation* (Berlin, 1921). The same scholar has written of the art of the Romanesque period that it represents "the ideas, concepts and precepts which were *leitmotifs* of the reform" of the Cluniac order and related movements (*Religiöse Reform und mittelalterliche Kunst* [Zurich, 1945]). Dvořák's example also inspired a major attempt to formulate in concrete terms a specific art historical methodology (Robert Hedicke, *Methodenlehre der Kunstgeschichte* [Strasbourg, 1924]). His influence is also apparent in Erwin Rosenthal's *Giotto in der mittelalterlichen Geistesentwicklung* (Augsburg, 1924) and Georg Weise's *Die geistige Welt der Gotik und ihre Bedeutung für Italien* (Halle, 1939). In his pioneering paper "The Architecture of Mannerism (*The Mint: A Miscellany of Literature, Art and Criticism* I [1946], pp. 116–38),[223] Nicholas Pevsner examines about a dozen buildings of 16th-century Italy "to prove the incompatibility of their formal and emotional character with that of works both of the Renaissance and Baroque, and then point to certain characteristic events in contemporary thought and feeling to show the same spirit at work in history and architecture." His interpretation of Mannerist architecture would seem to have been inspired by the work of Dvořák and Wilhelm Pinder. In another recent discussion of Mannerism, the German scholar Gustav René Hocke (born 1908)— a student of Ernst Robert Curtius (author of *Europäische Literatur und lateinisches Mittelalter* [Bern, 1948; *European Literature and the Latin Middle Ages*, trans. Willard Trask, New York, 1953; Harper Torchbook])—has assembled a vast amount of source material and observations, which he employs in order to try to document analogies between 16th-century Italian painting and 20th-century Dada and Surrealism (*Die Welt als Labyrinth: Manier und Manie in der europäischen Kunst* [Hamburg, 1957]). The parallels and analogies he traces through the centuries are explained by the existence of what he terms basic underlying modes of artistic expression *(Ur-Ausdruckszwänge).* His work is stimulating but carries little conviction. *Geistesgeschichte*, in particular that of Dvořák, has strongly colored the prolific writings of Josef Paul Hodin (born 1905), whose interests have centered on expressionistic painting (which is omitted from Hocke's book), and especially that of contemporary artists with whom direct personal contact was made (*Edvard Munch, der Genius des Nordens* (Stockholm, 1948); *Oskar Kokoschka, the Artist and His Time; A Biographical Study* [Greenwich, Conn., 1966]). For Hodin, "Only living contact with the artist can establish unequivocally what he had in mind."[224]

Though not a student of Dvořák, the eminent Norwegian archaeologist Hans Peter L'Orange (born 1903) has allied himself with the interpretations of Dvořák and his followers in his recent paper *Art Forms and Civic Life in the Late Roman Empire,* trans. Dr. and Mrs. Knut Berg (Princeton, 1965, first pub. 1958). In what amounts to a brilliant summation of his own scholarship in Late Antique and Early Christian art, L'Orange attempts to relate the salient formal qualities of the architecture and sculpture of the Tetrarchy to the social and intellectual tenor of the age.[225] In both the

[223] A revised version of this paper has been published in Harold Spencer, ed., *Readings in Art History*, 2 vols. (New York, 1969; Scribner paperback), II, pp. 119–48.

[224] Josef P. Hodin, *The Dilemma of Being Modern; Essays on Art and Literature* (London, 1956), p. 222. While living contact may disclose the intentions of the artist, it does not necessarily, if at all, reveal to the critic or scholar the full range of environmental factors that contribute to the genesis of a work of art, since the critic or scholar may not be able to determine them, as he is himself intimately a part of them.

[225] The earlier works of L'Orange remain basic to the study of his field of interest: *Studien zur Geschichte des spätantiken Porträts* (Oslo, 1933); *Studies on the Iconography of Cosmic Kingship*

arts and the social structure of this time, he detects parallel patterns of strict regularity and symmetry, uniformity and immobility. For L'Orange, the parallelisms point to "the spiritual mentality of the period," the causes of which are left unexplained. While he seems to allude to a "time-spirit" or *Zeitgeist,* he avoids the temptation to uncover principles or laws in the anecdotal parallelisms he has described.

Though the scholarship of Dvorák and his followers is impressive, an analysis of it brings out the dangers and pitfalls in the method of *Geistesgeschichte.* Historians employing it assume a tight coherence and unity of all cultural activities and products of a period. As Idealists, they hold that each period has a *Zeitgeist,* or "spirit of the time," and that all the activities and products of that time are both the point of departure and final destination of the *Zeitgeist* as manifested in its total world view (especially evident, for instance, in Spengler's closed cultural cycles).[226] The basic methodological problem confronting these historians is whether the coherence and unity of all cultural phenomena should be expressed in terms of causality, reflection, or parallelism. In other words, the problems arising from the types of explanation offered by *Geisteswissenschafter* are essentially the same as those offered by the social historians of art, as pointed out above. Dvorák, we have seen, speaks in terms of parallelisms between the cultural phenomena of a period. But it has been

suggested that the arts of a given period are not always completely parallel, so that speaking in terms of analogies can be misleading (see page 18).

When in American scholarship the "history of ideas" method is discussed, the name of A. O. Lovejoy (1873–1962) immediately comes to mind, for it was this historian of literature and philosophy more than any other scholar who not only introduced the method but also put it to work convincingly, in such a work as *The Great Chain of Being; A Study in the History of an Idea* (Cambridge, Mass., 1936; Harper Torchbook).[227] Rather than deal with large systems or aggregates of idea complexes, as in the history of philosophy or *Geistesgeschichte,* Lovejoy restricted his investigation to the elemental component parts, namely the "unit-ideas," which are to be found within the system or complexes:

By the history of ideas I mean something at once more specific and less restricted than the history of philosophy. It is differentiated primarily by the character of the units with which it concerns itself. Though it deals in great part with the same material as the other branches of the history of thought and depends greatly upon their prior labors, it divides that material in a special way, brings the parts into new groupings and relations, views it from the standpoint of a distinctive purpose. Its initial procedure may be said—though the parallel has its dangers—to be somewhat analogous to that of analytic chemistry. In dealing with the his-

in the *Ancient World* (Cambridge, Mass., 1953); and with Armin von Gerkan, *Der spätantike Bildschmuck des Konstantinsbogens* (Berlin, 1939).

[226] According to H. W. Eppelsheimer ("Das Renaissanceproblem," *Deutsche Vierteljahrschrift für Literaturwissenschaft und Geistesgeschichte* IX (1933), p. 497), *Geistesgeschichte* attempts to "reconstruct the spirit of a time from the different objectivations of an age—from its religion down to its costumes. We look for the totality behind the objects and explain all facts by this spirit of the time" (quoted by Wellek and Warren, *Theory of Literature,* 3d ed. [New York, 1956], p. 119). For Spengler's views, see his "Der Untergang des Abendlandes, eine neue Geschichtsphilosophie," (in *Revue politique internationale* XIII [1920], pp. 81–102; published in 1923 (Munich)as *Der Untergang des Abendlandes* [*The Decline of the West,* trans. Charles F. Atkinson, 2 vols., New York, 1927–28]).

[227] Lovejoy, together with George Boas, began publication of the *Journal of the History of Ideas* in 1940. In Germany, and in the tradition of Dilthey, its counterpart is the *Archiv für Begriffsgeschichte,* begun in 1955 by Erich Rothacker.

tory of philosophical doctrines, for example, it cuts into the hard-and-fast individual systems and, for its own purposes, breaks them up into their unit-ideas. [*The Great Chain of Being*, 1936, p. 3][228]

He defines these generic classes, or unit-ideas, as:

types of categories, thoughts concerning particular aspects of common experience, implicit or explicit presuppositions, sacred formulas and catchword specific philosophic theorems, or the larger hypotheses, generalizations or methodological assumptions of various sciences. [p. 3]

He treated the life histories of ideas as they are embodied in the intellectual thought of a person or large group, and as a rule in terms of their genetic succession through various periods of history regardless of geographical boundaries. Hence, in *The Great Chain of Being* he pursues one of the most persistent and important ideas in Western thought from Plato and Aristotle down to the 19th century.[229] A major criticism of his method, or more precisely of his application of it, has been that the mere similarity between two unit-ideas is insufficient to establish their direct historical connection if they are recurrent rather than continuing, that is, if they are adopted by persons quite independently of one another.[230] If a unit-idea has a single continuous history, the historian of ideas must establish historical links

rather than point to parallels (as in *Geistesgeschichte*). In either case, the historian of ideas seeks to uncover the intellectual content of cultural and other human products, and to probe—as an iconologist does—their intrinsic meanings and implications. A second major criticism of the method points out that the historian of ideas tends to overlook or ignore the underlying psychological and social processes in which ideas are embedded and from which the selection of certain ideas is made. A broader picture of human activities and products can be obtained by combining the history of ideas with social history.[231]

The history of ideas has attracted the interest of a number of Western art historians on both sides of the Atlantic. Erwin Panofsky may have pursued it more than any other scholar in the visual arts. One of his broadly oriented interests was the Renaissance, "which started in Italy in the first half of the fourteenth century, extended its classicizing tendencies to the visual arts in the fifteenth, and subsequently left its imprint upon all cultural activities in the rest of Europe" (*Renaissance and Renascences in Western Art* [Stockholm, 1960], p. 42). In a series of lectures delivered in the early 1940s, Panofsky vigorously defended the Renaissance as a static concept of style, and as a result of these lectures published his interpretation in a famous paper entitled "Renaissance and Renascences" (in *Kenyon Review* VI [1944], pp. 201–36; reprinted in

[228] See also Lovejoy's *Essays in the History of Ideas* (Baltimore, Md., 1948; Cap. Putnam paperback); and George Boas, *The History of Ideas: An Introduction* (New York, 1969).

[229] See also Lovejoy et al, eds., *A Documentary History of Primitivism and Related Ideas* (Baltimore, 1935); and Robert Goldwater, *Primitivism in Modern Painting* (New York and London, 1938 [*Primitivism in Modern Art*, rev. ed., New York, 1967; Vintage Book]).

[230] As pointed out by Maurice Mandelbaum, "The History of Ideas, Intellectual History, and the History of Philosophy," in *The Historiography of the History of Philosophy*, Beiheft 5: *History and Theory* (The Hague, 1965), pp. 33ff.

[231] Mannheim, *Essays on the Sociology of Knowledge* (London, 1952), pp. 180 ff.; Wellek and Warren, *Theory of Literature*, 3d ed. (New York, 1956), chapter 10; Hajo Holborn, "The History of Ideas," *American Historical Review* LXXIII (1968), pp. 683–95.

this book), which he expanded in his *Renaissance and Renascences in Western Art* (Stockholm, 1960, 2nd ed., 1965). In these writings he perceptively examines the Renaissance as a periodic concept and relates the ideas manifested by it to earlier revivals or "renascences," specifically those of the Carolingian period (the topic of Richard Krautheimer's paper of 1942) and the 12th century in Western Europe. Panofsky distinguishes these three periods by what he terms the principle of disjunction: the earlier revivals adopt either Classical forms without their themes, or themes without their forms, but never together, while *the* Renaissance—which, in accord with a traditional point of view, he limits to Italy—brought about a reintegration of Classical form and content. To his way of thinking, the two earlier movements were "limited and transitory," the Italian Renaissance "total and permanent."

This is a valid interpretation of developments in Western art history, and while it did not originate with Panofsky, it is eloquently defended in his widely quoted writings.

In another important essay, this great humanist investigates the problem of the parallelisms between Gothic architecture and Scholasticism (*Gothic Architecture and Scholasticism* [Latrobe, Pa., 1951; Meridian paperback]). Lucidly examining the alleged interdependence in far greater depth than in previous scholarship (a century before, Gottfried Semper had commented casually that Gothic architecture is scholasticism in stone), Panofsky finds that the step-by-step development of scholastic thinking is integrally correlated with the step-by-step development of Gothic cathedrals built in the Ile-de-France between about 1130 and 1270. He seeks to demonstrate that "at least some of the French thirteenth-century architects did think and act in strictly scholastic terms" and assimilated the "controlling principles" (identified as *manifestatio* and *concordantia*) and methods of procedure of Scholasticism and then expressed these principles and methods in the style and structure of their buildings (*ibid*, p. 87). The correlation Panofsky exposits is one rather of "genuine cause and effect" than of mere parallelism or coincidental simultaneity (*ibid.*, p. 20).

Essentially the same method of investigation underlies Gerhart Ladner's paper *Ad Imaginem Dei: The Image of Man in Mediaeval Art* (Latrobe, Pa., 1965, reprinted in this book).[232] A student of Julius von Schlosser and the Viennese school of art history, and a successful practicing historian as well as art historian, Ladner (born 1905) advances the thesis that the Christian doctrine of man's image-likeness with God, as interpreted by theologians from the early Church Fathers to Bernard of Clairvaux, may be reflected in the representation of man in medieval sculpture and painting. Fully aware that "a direct causal nexus between such theological views and the practice of art cannot be established," Ladner proposes "that these views and their vicissitudes represent attitudes of the mind which among other

[232] This essay is an extension to the visual arts of certain concepts found in his *Idea of Reform; Its Impact on Christian Thought and Action in the Age of the Fathers* (Cambridge, Mass., 1959; Harper Torchbook). See also his brilliant essay "*Homo Viator*: Mediaeval Ideas on Alienation and Order," *Speculum* XLII (1967), pp. 233–59. He is the author of the basic corpus of medieval papal iconography (*I ritratti dei papi nell' antichità e nel medioevo* [Vatican City, 1941 ff.; available also in a German ed.]) and has written a number of papers on specific art historical topics (e.g., "The So-called Square Nimbus," *Mediaeval Studies* III [1941], pp. 15–41; "The 'Portraits' of Emperors in Southern Italian *Exultet* Rolls and the Liturgical Commemoration of the Emperor," *Speculum* XVII [1942], pp. 181–200; "Die italienische Malerei im 11 Jahrundert," *Jahrbuch der kunsthistorischen Sammlungen in Wien,* n.s. V [1931], pp. 33–160).

things nourished the conception of the human image which can be perceived in the works of art themselves" (p. 69).[233]

One of the outstanding French scholars of our day, André Chastel (born 1912), has authored several important studies concerning the relation of intellectual history to the visual arts in the Italian Renaissance. His *Marsile Ficin et l'art* (Geneva, 1954) contributes significantly to our knowledge and understanding of the cultural and intellectual history of the Renaissance by examining the relationship between the art and the philosophical movements of the age, especially the Neo-Platonism of Marsilio Ficino. In *Art et humanisme à Florence au temps de Laurent le Magnifique; études sur la renaissance et l'humanisme platonicien* (Paris, 1959), Chastel interprets the art of Florence in the generation 1470–1500 in the light of the intellectual events of the period, and, with a wealth of documentary evidence, finds striking but general analogies between Florentine art and ideas.[234]

In an important paper entitled "The Renaissance Concept of Artistic Progress and Its Consequences," E. H. Gombrich examines the familiar Renaissance concept of artistic progress and its effect on the masters who shared it.[235] Gombrich points out that in this period, "the artist had not only to think of his commission but of his

mission," and that "this mission was to add to the glory of the age through the progress of art." Rather than speaking merely of this important idea *and* art, he attempts to demonstrate how the idea actually entered into the artist's thought processes, hence into the very fabric of specific works of art.

Expecting to find scientific empiricism reflected in the naturalism of 17th-century art, James S. Ackerman (born 1919) discovered the contrary and, moreover, that the scientist had affirmed the ancient traditions of ennoblement and decorum ("Science and Visual Art," in Stephen Toulmin et al, *Seventeenth Century Science and Arts,* ed. Hedley H. Rhys [Princeton, 1961]). In this period there were no exact parallels between the visual arts and the so-called scientific revolution of Galileo, Descartes, and Kepler.[236] Painting was not responsive, as literature was, to scientific images of nature. The cultural unity that existed in the 17th century was "due less to the influence of scientific discovery on the artist than to the influence of aesthetic and ethical traditions on the scientist."

Charles De Tolnay (born 1899), on the other hand, has sought to interpret some works in the *oeuvre* of Pieter Bruegel the Elder as evidence of a pantheistic monism

[233] See the critical review by Ernst Kitzinger in *Speculum* XLIII (1968), pp. 355–9. A related interpretation of the history of the image of God incarnate and of man in medieval Christianity is found in Wolfgang Schöne, "Die Bildgeschichte der christlichen Gottesgestalten in der abendländischen Kunst," in Wolfgang Schöne et al, *Das Gottesbild im Abendland* (Witten, 1959), pp. 7–56.

[234] Chastel adopts as his own Henri Focillon's motto "the history of art is the history of the human spirit through forms."

[235] First published in *Actes du XVIIme Congrès International d'Histoire de l'Art* (The Hague, 1955); subsequently reprinted in the author's *Norm and Form: Studies in the Art of the Renaissance* (London, 1966). The classic study in the area is J. B. Bury, *The Idea of Progress: An Inquiry into Its Origin and Growth* (New York, 1932; Dover paperback).

[236] Cf. Erwin Panofsky, *Galileo as a Critic of the Arts* (The Hague, 1954) and "Artist, Scientist, Genius: Notes on the 'Renaissance-Dämmerung,'" *The Renaissance: A Symposium* (New York, 1952), pp. 77 ff. (rev. and pub. in Wallace K. Ferguson et al, *The Renaissance: Six Essays* (New York, 1962; Harper Torchbook); also the paper by the philosopher and historian of scientific ideas, Giorgio de Santillana, "The Role of Art in the Scientific Renaissance," in Institute for the History of Science, University of Wisconsin, 1957, *Critical Problems in the History of Science; Proceedings . . . September I–II, 1957,* ed. Marshall Clagett (Madison, Wis., 1959), pp. 33 ff. (repr. in Santillana's *Reflections on Men and Ideas* (Cambridge, Mass., 1968), pp. 137–66).

like that of Cusanus or Paracelsus (*Pierre Bruegel l'ancien,* 2 vols. [Brussels, 1935]). Though it contains valuable insights, this study has not met with critical acclaim. More persuasive is the exploration by Kurt Badt (born 1890) of the cloud studies of 1821 and 1822 by the Romantic painter Constable (*John Constable's Clouds,* trans. Stanley Goodman [London, 1950]). In this essay, philosophically oriented, the German art historian and artist undertakes "to perceive and to describe the influence which science had on imagination and the creative arts of painting and poetry at the beginning of the nineteenth century" (*ibid.,* p. 62). He demonstrates that Constable's art was indebted to two of the naturalists of his age, Howard and Forster, and shows how a common intellectual atmosphere connected these very different men who were all interested in nature and in the beginnings of a scientific understanding of nature.

The relations between the visual arts and the concepts of individualism, genius, and loneliness have been examined in three studies by Rudolf Wittkower: *The Artist and the Liberal Arts* (London, 1952); "Individualism in Art and Artists," *Journal of the History of Ideas* XXII (1961), pp. 291–302; and sections of his and Margot Wittkower's *Born under Saturn: The Character and Conduct of Artists* (London, 1963; Norton paperback).

Donald D. Egbert has traced "The Idea of 'Avant-garde' in Art and Politics" from the work of Henri de Saint-Simon (1760–1825) to the present day, especially in Marxist-dominated societies (in *American Historical Review* LXXIII [1967], pp. 339–66).[237] In a masterly paper, the same American scholar has dealt at length with "The Idea of Organic Expression and American Architecture" (in *Evolutionary Thought in America,* ed. Stow Persons [New Haven, 1950], pp. 356–96). He finds that the "idea

of organic expression as a philosophical and scientific doctrine has significant implications for the history of American architecture as well as of American life in general . . . and this despite the fact that it is primarily a biological concept, naturalistic in tendency, whose complete validity for art has justly been questioned, especially by those critics whose philosophy of art has either a humanistic or a supernaturalistic basis" (*ibid.,* pp. 388–9).

In his *Changing Ideals in Modern Architecture, 1750–1950* (Montreal, 1965; McGill paperback), architectural historian Peter Collins investigates American and European buildings of the past two hundred years in terms of the history of ideas. He endeavors to explain what Revivalism, Rationalism, Eclecticism, and Functionalism meant to the architects who practiced them, and concerns himself with the impact of various ideas of the arts and sciences on architectural theory.

After undertaking detailed research on about 150 sites of ancient Greek temples, Vincent Scully (born 1920), another noted historian of modern architecture, has advanced the fundamental concept of these temples as "physical embodiments of the gods in sacred places . . . as unique unions of the natural and the man-made" (*The Earth, the Temple, and the Gods: Greek Sacred Architecture* [New Haven, 1962; Praeger paperback]). In his sensational book, Scully conceives of space as the factor instrumental in the genesis of architecture—a point of view vigorously maintained by the Italian architect Bruno Zevi in *Architecture as Space; How to Look at Architecture,* trans. Milton Gendel, ed. Joseph A. Barry (New York, 1957)—and stipulates a reciprocal relationship between the topography of ancient Greek temples and their morphology. Putting to use his thorough familiarity with Greek mythology, poetry, and other forms of

[237] See also the study by Renato Poggioli; *The Theory of the Avant-Garde,* trans. Gerald Fitzgerald (Cambridge, Mass., 1968).

literature, he arrives at a mythological and religious meaning for the siting and designing of these buildings. While Scully's thesis lacks conviction because of the absence of documentary written sources proving that the Greeks had themselves conceived of their temples in such a manner, it has introduced a new, profound current in the stream of our historical awareness of ancient architecture.[238]

The most ambitious attempt to demonstrate how the visual arts "have expressed American ways of living and how they have been related to the development of American ideas, particularly the idea of democracy" has been made by Oliver W. Larkin in *Art and Life in America* (New York, 1949; rev. and enl. ed., 1966). One of the most widely used survey books of American art in this country, this study is a history of the cultural and intellectual development of the United States as shown in its visual arts. But the most perceptive and imaginative book written on the entire development of American painting (in itself a rarity in contemporary scholarship) is John McCoubrey's *American Tradition in Painting* (New York, 1963). Inasmuch as many different ideas and movements characterize the development of American art, specialists have seldom been able to describe and interpret them by reference to viable theses. McCoubrey courageously rises to the task by finding that "our art is possessed by the spaciousness and emptiness of the land itself" (p. 8). His interpretation would seem to derive largely from Frederick Jackson Turner, an eminent Harvard University historian early in this century (1861–1932), whose "frontier

thesis of American history turned our empty spaces and grand canyons into a kind of extended, cactus acropolis upon which lived—side by side—John J. Astor and the American cowboy as Athenian caryatids of democratic purity and aggressive industrial innocence."[239] After rapidly sketching the major figures and ideas in American painting from the Limners to Kline and Rothko, McCoubrey sums up his eloquent presentation in the following manner:

It would therefore appear that a unique combination of circumstances has given American art not the homogeneity of a style but basic similarities beneath a chaotic variety of individual styles. Of special service to the American artist has been an abiding, if unstated, distrust, not only of the image itself but also of the immediate and material splendors of the whole Western tradition of painting. American realism, born paradoxically out of that distrust, has been obsessed with objects at the expense of those unifying elements which, in traditional painting —or at least in the tradition of baroque painting —subordinate the separateness of things to a satisfying wholeness. As a true realist, the American painter has never controlled what he has chosen to paint; he has only looked upon it and allowed what he has seen to remain inviolate, as though he had never been there at all. He has always been, since his beginnings, not a baroque but a modern man. [p. 123]

The history of ideas examines works of art as documents and illustrations of prevailing unit-ideas or idea complexes, for which reason the method possesses great exegetic value. At its best, the method reveals how ideas were understood systematically and clearly by artists and how

[238] His thesis brings to mind the work of Guido von Kaschnitz-Weinberg. For the extraordinary breadth of ideas in the accomplishment of Scully, who is also a renowned lecturer, see also his *Shingle Style: Architectural Theory and Design from Richardson to the Origins of Wright* (New Haven, 1955); *Frank Lloyd Wright* (New York, 1960; Braziller Book); *Modern Architecture; The Architecture of Democracy* (New York, 1961; Braziller Book); and *American Architecture and Urbanism* (New York, 1969).

[239] Quoted from the important statement by David Sewell on the course of American art, in *College Art Journal* XXVIII (1969), p. 448. McCoubrey has applied the thesis of Turner's *Frontier in American History* (New York, 1920).

they are embodied (or rejected) in their works. But the gain in our grasp of the intellectual attitudes of artists represents a loss in our grasp of the distinctive aesthetic qualities that characterize their individual works. The history of ideas treats the visual arts not as art but as intellectual phenomena. It clouds an understanding of the significance of art as art. At the same time, the method reminds us of the function of art history as a humanistic discipline: to try to understand, intellectually, the visual arts as products in time and space. To this end, the history of ideas can make, and indeed has made, a substantial contribution.

PART II
INTRINSIC PERSPECTIVES

CONNOISSEURSHIP

1 Guido da Siena and A.D. 1221

RICHARD OFFNER

Born in Vienna in 1889, Richard Offner studied at Harvard University and received his doctorate in the history of art under the brilliant scholar Max Dvořák at Vienna in 1914. Early in his scholarly career, he became closely associated with the famous expert in Italian art, Bernard Berenson (1865–1959), who had refined the techniques of connoisseurship that had been formulated and rationalized by the Italian Giovanni Morelli in the second half of the 19th century. Some years after joining the faculty of the newly created Department of Fine Arts of New York University in 1923, he (with art historians Walter W. S. Cook and Fiske Kimball) cofounded the Institute of Fine Arts of that university, which was immediately to become one of the leading centers of graduate studies in the history of art in the Western hemisphere.

Offner, who died in 1965, was an authority on Italian painting of the Middle Ages and the Renaissance, especially of the 14th century. He concentrated nearly all his relentless energy on the monumental and fundamental *Critical and Historical Corpus of Florentine Painting*, the first volume of which appeared in New York in 1931. In contrast to the long and important lists of attributions published by Berenson, Offner's *Corpus* contains careful documentation of the reasons for his attributions of specific works to individual masters. By his example, Offner gave American scholarship in Italian art international standing. (Berenson lived in Italy after graduating Harvard University and never gave formal university courses, though he freely consulted with people in his home outside Florence.) Offner's knowledge of early Italian painting was incomparable, and his connoisseurship had achieved technical refinement; his method was based on his conviction that the history of art "should be evolved directly out of its concrete examples" and begin with the individual work of art, thereby becoming released from the verbal prison in which he thought scholarly writings had placed it. He taught the importance of long, patient effort in the close examination of style, and exacting interpretation and evaluation in the use of documentary evidence. His lessons were well learned by his American and Italian students, including Millard Meiss, Robert Goldwater, and James Stubblebine.

In the following paper, Offner scrutinizes the painting of a Madonna now in the Palazzo Pubblico at Siena, a work that is both the cornerstone in our knowledge of the *oeuvre* of Guido da Siena and a milestone in Sienese painting of the Trecento. Although the panel is signed Guido da Siena (ME GUIDO DE SENIS DIEBUS DEPINXIT AMENIS . . .) and dated 1221, Offner employs the techniques of an expert connoisseur possessing great technical and historical knowledge to demonstrate that the inscription has nothing to do with the original painting and that the date of 1221 is erroneous.

For a more recent treatment of the works and the importance of Guido da Siena, see the monograph by James Stubblebine, *Guido da Siena* (Princeton, 1964). For other contributions by Offner, consult his *Studies in Florentine Painting, the Fourteenth Century*

Reprinted with the permission of Mrs. Offner from *Gazette des Beaux Arts* XXXVII, 6th series (1950), pp. 61–90.

(New York, 1927); *Italian Primitives at Yale University* (New Haven, Conn., 1927); "A Portrait of Perugino by Raphael," *Burlington Magazine* LXV (1934), pp. 245–57; "Giotto, Non-Giotto," *ibid.*, LXXIV (1939), pp. 258–69, and LXXV (1939), pp. 96–109 (conveniently repub. in *Giotto: The Arena Chapel Frescoes*, ed. James Stubblebine [New York, 1969], pp. 135–55; Norton paperback); "The Barberini Panels and Their Painter," in *Medieval Studies in Memory of A. Kingsley Porter*, ed. Wilhelm R. W. Köhler (Cambridge, 1939) I, pp. 205–53; "A Ray of Light on Giovanni del Biondo and Niccolò di Tommaso," *Mitteilungen des Kunsthistorischen Institut in Florenz* VII (1956), pp. 173–92; "Light on Masaccio's Classicism," in *Studies in the History of Art Dedicated to William E. Suida on His Eightieth Birthday* (New York, 1959), pp. 66–72; and of course the many volumes of his *Critical and Historical Corpus of Florentine Painting.*

I doubt whether any other Dugento master has provoked as much discussion as Guido da Siena, and whether any discussion has proved as inconclusive. After all the pother, the date 1221 inscribed on the footstool of his cardinal work, the Palazzo Pubblico *Virgin* (Fig. 1),* still remains—for some unshakeable spirits at least—a capital enigma. With most—like holy writ with some—it has resisted all the dictates of their better judgment, and either awed or baffled by the picture, they have boggled at deciding whither and how far to extend the field of their questioning. The few who have given this work closer study have been erudite without being critical, and have learnedly ignored or misread the visual evidence, and most of all the clear traces of the time in which alone the picture could have been painted.[1] But the problem of this panel—which is central to the problem of Guido and of the XIII Century in general—cannot be resolved until it has been grasped in terms of its style, and until these terms have been converted into factors of its period.

And yet there is singularly little disparity among the works attributed to Guido,[2] and one may assume wide agreement on what he—and his circle—painted. The fact is the few paintings generally attributed to him are so characteristic in form and so definite in their limitations that there is small room for confounding them with the work of any other master.

One sole panel, the dossal No. 7 in the Academy in Siena (Fig. 2),[3] attributed to him (or to a close follower), bears a credible date, and since its readings vary immaterially, it should serve as a means of anchoring the period of his activity. As to its authenticity, although it is neither documented nor bears his signature, its accord with the only panel bearing Guido's name, the *Virgin* in the Palazzo Pubblico, is nevertheless radical and conclusive. The other paintings that join this group, like the Uffizi and Galli-Dunn *Virgins* (Figs. 3 and 4), should hardly require the formality of a demonstration. But in order to provide a concrete basis for their association and to make certain that the date inscribed on the

*Illustrations accompanying this selection appear on pages 465 to 467.

[1] Notes to this selection begin on page 120.

Ed. note: In 1949, as Offner's paper went to press, the *Madonna and Child* in Siena was cleaned and restored. As a result, C. Brandi (and E. Carli) ("Relazione sul restauro della Madonna di Guido da Siena del 1221," *Bollettino d'arte*, XXXVI [1951], pp. 248–60) concluded that the inscription is contemporary with the rest of the painting. Brandi's evidence was the discovery that the pink of the Madonna's undergarment overlaps the blue ground of the inscription in one place and that one of the gold striations of that garment runs down over a part of the lettering. Since we are certain that the inscription has nothing to do with the original painting and, as Offner has demonstrated, 1221 is an unacceptable date for stylistic reasons, we must assume that the garment was at least touched up when the panel was thoroughly repainted in the shop of Duccio in the early 14th century. See James H. Stubblebine, *Guido da Siena* (Princeton, 1964), pp. 30–31.

polyptych guides us securely in the dating of the other panels, I shall first isolate those particulars in it that are proper at once to the group and the period.

The most revealing among these are to be found in grosser aspects of the painting, such as the panel-shape and its proportions, and in such parts chiefly as the frame and molding, though these are generally overlooked, being among the physically more determinate and conspicuous elements in the panel. They release their evidence more directly than the painted areas of the work, because these are more deeply and darkly involved in complexities of the artist's personality. Such elements and parts, indeed, are given; and they are accepted by the artist without reservation because they satisfy specific and purely practical conditions imposed upon him by the occasion, the site and by local tradition. They thus may be said to reflect the regional and chronological character, and serve to refer the work more directly to its time and place.

Now the dossal No. 7 in the Siena Academy is among the earliest surviving compartmented panels in Italian painting. It retains the Romanesque gable which, together with the articulated system, constitutes one of the several forms of polyptych in the last generation of the XIII Century, a panel-form unencountered prior to this date, and persisting in these two main features beyond the Deodato Orlandi of 1301 in Pisa. In these respects it is virtually identical with No. 6 in Siena (Fig. 5), a fact that brings both (Nos. 6 and 7 in Siena) within the same phase of Sienese evolution. Moreover, the frame of No. 7 (as of No. 6), consisting of two raised and rounded elements running lengthwise along the edges of the frame and enclosing a flat interval between them, occurs here for the first time. Since it appears as late as Vigoroso's—somewhat retarded—polyptych of 128? in Perugia (Fig. 6),[4] we may assume that a frame of this form endured at least for the brief period con-

tained between these two dated dossals. It is to this period that the frame of the Palazzo Pubblico *Virgin* would seem to belong. It repeats the semi-circular cross-section of the two moldings that run along the inner and outer limits and enclose the flat band of dossal No. 7. The dark blue or black of this band has, in the Palazzo Pubblico panel, been replaced by a modern gilding which disguises the original intention. If we look for the source of this type of frame, the available evidence will lead us back to the primitive flat molding beyond Coppo's Orvieto panel (Fig. 7), in which the dark colored stripe is adorned with a modest ornament that was to blossom into the decorative frieze of the Cimabuesque *Virgin* in the Louvre and the Rucellai altarpiece.

But the correspondence of the Siena Academy and the Palazzo Pubblico panels does not end here. It continues in the structure and cross-section of the arch over the individual figures. Consisting of a flat arc in shallow relief surmounted by a narrow molding superimposed upon it, this kind of arch is unknown prior to 1270 in any reasonably datable painting. The arch persists, however, in Siena in the dossal No. 6, in Vigoroso's dossal and in the Palazzo Pubblico panel, with the material difference only that the latter two show two ridges in the molding or upper member instead of one, and the less conspicuous difference that the spacing and relief in the last panel are of a somewhat more urbane or tempered taste—a quality that holds also for the molding in Meliore's signed and dated polyptych of 1271, which is a more progressive version of that in the No. 7 dossal in the Siena Academy, approximating in its modulation the Palazzo Pubblico molding. But the presence in these three panels of a molding of similar shape —which differs radically from all others— would tend to confine them irresistibly to the interval between 1270 and 1285. It should, conversely, balk a much earlier dating for any of these panels. On the

other hand, the similarities in the cross-section of the molding between Vigoroso's and the Palazzo Pubblico panels would bring the execution of these two more closely together than the Palazzo Pubblico and the Siena Academy dossals.

But the particular that draws the Palazzo Pubblico panel to the group and period of dossal No. 7, is the cusping. This form, like so many others, is encountered in the panel painting of this region for the first time around 1270 over the central figure in dossal No. 7, is repeated in dossal No. 6, in another now in the collection of Avv. Lodovico Rosselli in Rome, and throughout Meliore's dossal of 1271 in the Florentine Academy. It would seem soon thereafter, and with small exception, to have been temporarily relinquished in half-length polyptychs for the round arch, which we find used throughout in Vigoroso's polyptych (about 1280)—a form elaborated and refined by Duccio at the dawn of the next century.[5] At all events, in Siena—and in Italy generally—Dugento instances of it in full-length altarpieces occur without exception late within this period. The cusp reappears, to be sure, though in a much modified form, but then in the advancing Gothic of the succeeding century. The presence of the cusp in such full-length panels as the admittedly late St. Peter (Fig. 8) and the somewhat earlier Galli-Dunn altarpieces would generally indicate a stage beyond cusped panels in half-length of the type just described.

Although the genius and execution of these two panels are profoundly divergent, numerous external analogies make it clear they were painted within the same narrow compass of time, while they isolate them from other panels of the same milieu. Both are distinguished by the single semicircular relief of the molding, which is simply one of the two ridges of the frame favored in Guido's workshop. It is worth noting that this type of molding is used all over the St. Peter altarpiece, and almost exclusively in Sienizing works painted in

the seventies and after, as, for example, in the overdated St. John altarpiece in Siena, in a full-length Guidesque Madonna in Montaione, and in the Madonna del Voto in the Siena cathedral.

Again, in both the Galli-Dunn and St. Peter panels we find angels in the spandrels, that in pattern, in posture, in the arrangement of hands and wings, and to a considerable extent also in the drapery, are virtually identical. The affinity between the two works, however, most significant for their relative chronology, is in the bilateral perspective which, though hopelessly bungled in the Galli-Dunn panel, is of a similar intention. Whereas there can be little doubt about the lateness of the St. Peter, the extent to which the Galli-Dunn panel retains certain elements of the two Siena Academy dossals should help to clinch the late dating. On the other hand, it is chiefly the timid conservatism in the execution and the design, due to an assistant at his age past learning new tricks, and the unseemly cramping of the lower register of the composition that might incline one to demur at placing this panel as late as its probable period. The case of the St. Peter panel is not very different: its painter leans on a superseded formula, but his free handling of the architecture and detail of the throne, and his milky color dissociate the period of the panel from the two Siena dossals.

By sharing not only the cusp, but also the composition (identical in both), the Palazzo Pubblico and Galli-Dunn Virgins are forced into the same period, into a part of it which professes a relative advance beyond the conventions of the two dossals in respect to the feature already cited.

The angels in the spandrels (Figs. 9 and 10) upon the shoulders of the cusped arch of the Palazzo Pubblico Virgin, that in their disposition and postures recall the angels in the Dugento Nativity, suggest an advanced phase among the works of Guido's circle (a conclusion that may be inferred from their non-occurrence prior to 1270),

and especially because they return in a corresponding part of the Duccio panel in Perugia painted in the early Trecento.

If we now turn to the characteristics of the type and the pictorial style of dossal No. 7 (Fig. 2) with which I began, we shall discover them in the long blunt face, in the sharpness with which it detaches itself by a defining edge of shadow from the neck, in the low forehead, in the long tubular nose and small nasal wing, in the dying flicker in the eye, in the deep furrow cut under it, in the loosely shaped iris caught in a sickle of white light, in the long smooth cheek that burns with an unnatural flush, in the thick ear set upright and pierced by a long narrow cavity, in the soft impassive mouth, in the long spike-like fingers, most of all in the heavy outline that immobilizes the shapes and seldom persuades us of the continuity of the planes back of the figures. The hard mold of the head joined to the placid expression tells the tale of unstirred depths, unredeemed by that sensitiveness of emotion that was to become the most typical and inalienable of Sienese qualities, with only the Virgin conceding a faint spark of inner animation. Although the body does not want in attributes of substance and function, they seldom transcend a descriptive or suggestive intention, while the inflexible Child of No. 7 shows little of the range of movement and looseness of construction attained in the Palazzo Pubblico panel. The drapery seems to have especially preoccupied Guido and, as among the Sienese generally, in his works it woos the body it covers. He seeks at once to render the heavy texture of the stuff and to betray the yielding consistency of the flesh underneath. It is to this end very largely that its main lines as well as the striations upon it follow the bulge of the larger shapes. And it is indeed by these qualities that the angels of the Palazzo Pubblico panel may be said to foreshadow the angels of the Rucellai altarpiece (Fig. 11), at least as much as to revert to the dossal No. 7.

In the respects mentioned, the dossal may be said to be based upon the same formula and the same habits of shaping and of marshalling of pattern as we find in the Palazzo Pubblico panel. If we allow for the repainting and daubing over of the angels in the gable of the latter,[6] we shall discover essential correspondences between the Evangelist and the Magdalen in the one and the right angel in the gable of the other, and perhaps more clearly still between the Evangelist and the angels in the spandrels (Figs. 9 and 10), while the hands of the Virgin and the Baptist in the dossal recur in exact likeness in the angelic figures of the Palazzo Pubblico panel. The Evangelist is draped like the Christ in the Palazzo Pubblico gable, while the Virgin's mantle has slipped down off her shoulder and is caught in the crook of her arm in the same way as in the angel on the left in the other panel. So close indeed are these analogies that the panels must needs have been painted by the same hand. But these very affinities, together with the host of their imponderable implications serve to reveal differences of a greater freedom in the Palazzo Pubblico panel in the rendering of form as well as in the distribution. Such differences are of a kind that persuade us of a lapse of years between the two works, a fact further confirmed by the divergencies latent within the correspondences between the dossal No. 6 and the Palazzo Pubblico panel, and particularly between the Evangelist of the one and the angels at the Palazzo Pubblico, and between the Peter and James of this dossal and the blessing Christ in the Palazzo Pubblico panel (Fig. 1). The chronological position of this panel becomes clearer, however, if considered in the light of the evolution of the posture of the full-length *Virgin* in Tuscany.

This evolution would seem to begin with a frontal symmetry, such as in Siena we first meet with in the Chigi-Saracini (Fig. 13), Tressa and Opera del Duomo *Virgins*, a posture that had maintained itself the

more stubbornly from the earlier centuries into the XIII as the Virgin's head came to break through the frame upward beyond the picture area. For it thus established a central prominence and a pattern which held it fast in an inflexible tradition for some time after the figure had shown a tendency to liberate itself. Her head had to be brought down eventually and contained within the rectangular boundaries of the panel before she could regain her freedom from formal limitations and assume more natural attitudes. This was accomplished by a reversion to the XII Century Hodegetria, which, however, we do not encounter in Siena until well past the middle of the Dugento in the next surviving instance of the Madonna and Child subject. And this is, in the history of Sienese painting at least, the Palazzo Pubblico panel.

Here the determining factor is the three-quarter view of the Virgin, the lower half of whose figure is virtually in profile, seen i.e. from one side, a view that accords with the lower half of the throne seen from the same angle. Such a view was chosen with a specific artistic purpose, namely, that of affording a more gradual and more protracted recession in both than we find in any other work of Guido's circle. But the posture of the Madonna causes an overlapping of the nearer over the farther leg—a device intended to create a succession of retreating masses in order to generate a space-illusion. More than that, this posture of the Virgin, in which the feet are placed at the right extremity of the footstool while the torso turns outward, describes a movement, reflected in the rotation of the Child, new to Tuscan painting. But the posture does not originate with Guido: it merely emphasizes by deliberate exaggeration, and carries one step further, the posture of the Florentine Coppo di Marcovaldo's Madonna in the Servi in Siena (Fig. 15) dated 1261[7] which is the earliest instance of a change from a bilateral position of the legs of the Virgin to a lateral view in the Dugento. Coppo's position was still tentative, and though the feet are shifted toward one side, it amounts to but a slight displacement of an earlier formula; but it meant an advance much more significant than the advance beyond it of Guido's Madonna. Guido's modification may be explained by his being the younger painter (as I believe) and therefore farther along in the line of evolution. Coppo's frontal throne, moreover, and the small full-length angels' precarious occupancy of a measureless ether without specific relation to the Virgin, should establish the earliness of this picture with respect to Guido's Madonnas in similar posture: i.e., the Florentine Academy, Galli-Dunn and Palazzo Pubblico panels, as well as the Arezzo Virgin of his circle.

The history of perspective should help further to stabilize the chronological position of Guido's Palazzo Pubblico Virgin. Prior to Coppo the perspective in painted images followed a course between the enthroned Christ in S. Angelo in Formis and the Christ in the Duomo of Tivoli, although the mosaic Virgin of the Scarcella of the Baptistery in Florence, dated 1225, reverted to a remoter age, to VI Century Ravenna, Parenzo and the Carolingians. In Tuscany in the earlier XIII Century, the composition kept a single depth within which it moved forward from a dominant plane through a succession of overlapping stages. This plane was generally represented by the architecture of buildings or of a throne which served also to suggest the site. The linear perspective, which in classic or naturalistic epochs carried the eye into the picture, was shunned or reduced to a minimum. Hence, space was not continuous as in conventional perspective, if only because the recurrence of formal episodes would have violated the simple surface organization. Linear perspective was used almost exclusively to affirm the physical existence of objects. It must be remembered that a devotional panel must satisfy a twofold requirement:

that of maintaining the terms of the subject and of the content in a clear well-balanced distribution. There was accordingly only as much perspective admitted into the painting as the design would tolerate. In fact, other factors of external appearance, like shape e.g., had to submit to its tyranny as well.

With Coppo and because of him, the attitude toward perspective changed. His Sienese *Madonna* (Fig. 15) was the first instance in XIII Century panel painting of an effort to lead the lines of the perspective inward. But it was a shy beginning, and its purpose limited. For as in Romanesque painting before him, his perspective served primarily to convey the material thickness of the object without establishing its relation to the void. It was not yet allowed its fuller spatial implication. Coppo's perspective in Siena was a symmetrical system by which the lines of a simple bilateral architecture initiated a recession toward a central vanishing point and by which the eye of the spectator was placed at a point opposite. The space was rigidly limited in depth—by a tacit but implacable tradition, despite the spatial paradox of the two angels whose cubic occupancy is hypothetical and cannot easily be accounted for. But the perspective was subordinated to the flat and symmetrical verticality of the design which must, for the present at least, retain its historic authority.

It should be noted, however, that the perspective was restricted to the architecture alone. For the figure—like the symmetrical setting—which constituted virtually the whole of the subject matter, spiritual and religious, refused to undergo the distortion to which the perspective with its foreshortening would tend to subject it for some time to come, as long at least as the subject matter retained a major importance. With the advent of the naturalistic aspect of even this inchoate perspective, the figure rejected also the immobilization imposed upon it by symmetry in favor of a more naturalistic posture.

But if the tendency of the perspective in Coppo's Sienese *Madonna* was to center the spectator's eye, the eye had not yet found a consistent level. In the still imperfect spatial integration, the seat of the throne and the footstool, each severally imposed its own level. An attempt to reconcile the two levels was to be made in Coppo's Orvieto panel (Fig. 7) in accordance with his major objective to create a unified space, only now the central position of the eye had to be sacrificed. What happened indeed is that the eye was placed a trifle lower in respect to the throne—though still above the level of the seat—then shifted a little to the left in respect to the footstool. Despite the advances over the Siena *Virgin* (Fig. 15), the Orvieto panel (Fig. 7) still reposes upon the same conventions. Though the footstool belonged to an ancient scheme and though it bore the same relation to the throne as in many works preceding it by centuries and generations, it still responded to the naturalism required of it. It superseded the footstool in Siena which submits completely to the regular symmetry of the grand scheme of composition. What the Orvieto footstool had gained in the consistency of the level, it lost in that of centralization.

But Guido was born to a maturer stage in the history of these problems. From the first, he broke through the integrity of the primitive bi-dimensional design and the single depth, and in the Arezzo, Palazzo Pubblico and Galli-Dunn panels the lines of his perspective invested objects with increased massiveness and spread a greater void around them. These lines retreated into the picture in clearer view and to a more sensible and more calculable depth than in Coppo. Moreover, their space-generating function was no longer to be neutralized by symmetry.

In these works a single eye-level was already approximated even though the eye of the spectator shifted. And yet the fact

that Guido had in them advanced appreciably beyond Coppo cannot be in doubt. That he was not only experimental but adventurous as well is proved, however, by the Florentine Academy picture in which the eye-level had been lowered and the overlapping of the receding seat by the throne-post had been attempted—even if somewhat awkwardly carried out—to suggest a perspective not successfully represented before the early XIV Century. Here, at any rate, for the first time in the Dugento, the painter approximated a unity of point of view. The perspective of the throne in the Palazzo Pubblico painting would have to be interpreted as a progressive element, which, considered on its own merits, would tend to place it evolutionistically later than the Coppo *Virgin*, and latest among the other of Guido's full-length *Virgins*. If Coppo's is the earlier work, then we should have reason to consider such prominent particulars as the draping of the mantle, the angularity of its border, the white kerchief over the Virgin's head, the white cloth under the Child and the scarf around his waist, his bared legs, the encircled bird, as appropriated from the Florentine.[8]

But there are more essential grounds for this view, and these are implied in Coppo's more radical preoccupation with artistic problems. The transition from Coppo's Siena to his Orvieto composition alone marks a profound artistic revolution: the change from a dual to a unified space.[9] Coppo's Sienese panel shows the Madonna, the Child, the throne and its base occupying a touchable proximity, in which all the solids are implicitly related to the ground, while the figures of the small angels are left hanging in the spatial abstraction of the gold, which may be said to symbolize an indeterminate depth. But there is no provision for binding them physically to the nearer mass. The Orvieto panel not only relieves the cramped ratio between the size of the throne and the two principals, but it brings the two angels into actual contact with them, thus achieving a unity of site as well as a logical association among all the figures and objects more nearly in accord with visual experience of nature.

But apart from this, the mastery of plastic form declared for the first time by a Western painter of our era in terms of constructive light, and the immediate implication of function in form, make it certain that it was Coppo and not Guido that contrived a posture (Servi, Siena) intended to serve the realization of space. The fact that he relinquished this posture in the Orvieto panel bears witness only to the energy and resourcefulness of his creative fantasy, manifested besides in the increasing share of the Child in the mood of his Mother.

Coppo's experiments in space, nevertheless, are carried further in Guido's panel at the Palazzo Pubblico. Here for the first time, the Infant Christ breaks through the closely locked unity of the Virgin and Child group. He ceases to be merely an accompaniment to the Virgin and from conformity is converted into an autonomous agent, anticipating, in Italy at least, the Child in such Virgin and Child compositions as those of the Lorenzetti, of Lorenzo Veneziano, of Fra Filippo Lippi, Verrocchio and others, in which the Child's response to his Mother acquires a lingering emphasis.

In relaxing the earlier closeness of the two figures, the Child in the Palazzo Pubblico panel is held at half arm's length, but by stretching the interval between them the artist suggests also the counter-pull toward the center to the end of dramatizing the relation that draws them together. The action is thereby emphasized, and serves in turn to give a more positive artistic value to the intervening space. But that space is enhanced by the unwonted smallness of the Child as compared to the scale of the Virgin. Clearly, the purpose here is to generate accomodating room, and every term within the frame

sustains the same objective. This becomes the more evident in the higher ratio between the size of the figures and the total area, and also in the fact that so much free space surrounds the solid objects, in the long dimensions the eye has to traverse along the surface, such as those created by the border of the mantle, by the long forearm and hand of the Virgin, by the reach from her thigh to her knee, by the spread of the Child's arms and by the sweep of curve from his toes to his crown. The arch of the throne subtends a greater area than in earlier panel representations of the same subject, and the lower part of the throne stretches across a greater width and measures a greater emptiness in the wide angle of its receding side. The purpose of these devices becomes clearer if we contrast precisely these aspects and particulars in the Palazzo Pubblico altarpiece with the corresponding ones in its replica, the Galli-Dunn Madonna (Fig. 4), where despite the same iconography the space-factor is absent from the painter's intention. At the same time, the relative abstraction of these devices is made to accord with a heightened reality in the things represented—things which have been given a more physical character and more active expression through an individualization of shape, of movement and of surface. As a result, we arrive not only at a more definite sense of a concrete world, but the assumption of a less limited universe as well.

The effect thus produced is shared by intimations of a similar nature in the psychology. The illusion of expanse between the figures is seconded by the Child's upward glance, but chiefly by those of the angels that seem to command the vast celestial spheres—glances which now become more convincing because they have been given the proper distance and direction. The whole composition is spanned by a cusped molding of greater range than anywhere else in this period, barring only that in the admittedly late Peter panel

in the Siena Academy, painted in Guido's studio.

The exploitation of space in the Palazzo Pubblico panel goes a long way—though to a somewhat different purpose—beyond the spatial assays of Coppo and of the other two full-length Madonnas painted in Guido's workshop, and incalculably further than the dossal of 1270. Its amplitude results in a kind of space-physiognomy that reaches its historic resolution among its younger contemporaries: in the Cimabuesque Virgin of the Louvre (Fig. 16) and in the Rucellai altarpiece (Fig. 12). But the spatial attributes peculiar to the Palazzo Pubblico Virgin could be explained only if it followed in time Coppo's Siena Madonna and immediately preceded the latter two. On the other hand, it belongs to an order of formal and spatial expression undreamed of in any work approximating the date inscribed on it.

But the actual headway made by the Palazzo Pubblico Virgin in spatial articulation and spatial resonance is in direct ratio to the increased size of the panel.[10] It is its scale that first strikes upon our attention. For this is in fact the earliest example of the giant Madonna series, that continues with the Rucellai, the Louvre, and Sta. Trinità altarpieces, all of which originated in the same collective bias as that which produced the great crosses within the generation that saw the Gothic take root in Tuscany. And the size of the Palazzo Pubblico panel is perhaps the first and final reason why it could not have been painted before the end of the third or the beginning of the fourth quarter of the Dugento. If we cast out eyes backward over the Romanesque age preceding it, we shall look in vain for such enraptured zeal for magnitude, since the painting in the concluding phases of that age inclined essentially to human scale and was calculated for close view. As the tendency to quiescence, conveyed and embodied in the symmetrical frontality of that earlier period, was a psychological accompaniment of the small-

ness, so was the later manifestation of physical size, organically related to the expanded space and liberated movement we find in our panel.

Among features of secondary importance, the one that commits the Palazzo Pubblico panel to a late moment in the Dugento is the ornament. Generally speaking, ornament springs from different sources of the creative organism and works for the most part with other media than representative painting. It disavows objective reality, the fullness and diversity of the external world, and draws upon the abstractions to which observed shapes have become epitomized by a process of constant elimination. In renouncing solid substance, it reduces it to rhythmic line and pattern, fleshless and without dimension, as poetry tends to assimilate its matter to meter. It thus produces artistic results of a content different from that of representative painting, of divergent effect, and is subject consequently to different standards of measure and appraisal. As a rule, free of the complexities of natural appearance and eluding the idiosyncracies of personality, the handwriting of ornament becomes more easily legible than representations of natural shapes. And being less personal in their associations, its forms are generally more directly traceable to the geographic area of the single artist, to a group as readily as to a person, to a period as to a point in time, to a tendency as to an individual.

Now, the halo of the Virgin in the Palazzo Pubblico panel (Fig. 17), in which the decorative motif in pointed outline is spread against a pointed ground,[11] reverts to the dossal No. 6, which must have shared the style of the halos, as it shares that of the painting, with No. 7, whose gold is totally new. The four-leaf four-petal motif stems from there (where incidentally it abounds in variants), as well as the stamped discs in the halo border. But the structure of the halo and the working out of the leaf-design are advanced far beyond any known before

the Rucellai altarpiece. To begin with, the border, instead of the single circular band of earlier halos, is here accentuated by five supplementary circles, a motif not used again until considerably later in the schools of Duccio and the Florentine painters of the miniaturist tendency. However, the main field is accorded all the room necessary to display the opulence of its foliations and the ample surging rhythm of the scroll, to which this halo owes a character new to the Dugento. The movement of the main stalk keeps the large recurring phrase and fabric of the design in evidence among a wealth of fugitive episodes and of minor involutions which curl back upon themselves like contrapuntal complications in a polyphonic strain, at once echoing and opposing the leading melody. Here, contrary to the rule, and departing from the type of halo in the dossal No. 6, the forms used vary in kind: they run from abstractions of pure pattern as in the heart-shaped expletives, in the scattered discs, and in the leaf-petal figure, to vegetation that simulates nature. Consequently, as against the halo of the middle of the century, the Palazzo Pubblico halo is charged with associations of a totally different order, and its content has become appreciably richer. But it departs from earlier Dugento tradition also in that the pointed ground no longer maintains a geometric flatness, but suggests the depth and twilight of water, which contrasts with the blind opacity of the gold around the halo. The leaf-petal and the heart-shaped figures seem to lie quiescent upon the surface of this phantom depth, the rest of the foliage moving below it at different levels. And while the foliage writhes across the halo with the indolent cadence of a monster, it expands in three dimensions, evoking a cubic volume by its spiral arrangement, by a system of overlapping, and by the coiling of its leaves and stems like tentacles around the vigorous stalks.

Although the scroll occurs, as we know, much earlier in Tuscany, it exists almost

solely in the thin, winding tendril-like track the artist's tool had left in the gold. The flat symmetrical pattern too appears before this, but in the Palazzo Pubblico halo we find plant motifs for the first time imitating organic life, and borrowing its weight, thickness, its movement and spatial implications, in order to convey a sense of the potential energy of growth, while wearing a garland around the Virgin's head. Both figure and halo being brought closer to a natural order thus become more intimately related to each other. Our halo, nevertheless, does not surrender its decorative characer, and though it draws on nature, its various elements are idealized by being brought down to a single dominant plane, and by maintaining one color, that color gold—a color not to be found in nature.

The Palazzo Pubblico halo is not only remarkable as an artistic expression but astonishing in its new effect. Were it not that it follows the technical procedure of dossal No. 6, we might be tempted to place it considerably later. All its essential elements and technique, however—the combined pointed and linear system of contouring the pattern against a pointed ground, the kind of leaf used, its indentations, the ribs and their radiations—are anticipated in this work, and in identical execution. It displays a freedom of invention, and a poetic quality disclosing a side of Guido's genius hitherto unnoticed and already foreshadowed in the dainty fancy of the sylvan motifs in the gable of the Sienese dossal No. 7 and in the stuffs hanging behind the *Madonnas* of his atelier. In fact, the Palazzo Pubblico halo is unique in its period and surpasses in expressiveness the mechanically repetitious halos of the end of the century. The only examples to match it are in Duccio's *Maestà*, where indeed we find its plume-like leaves curling similarly at the tip, with a similar veining, if a somewhat greater virtuosity in the drawing. But there alone. For though richer in decorative idiom, in

motif, and in pictorial suggestiveness, the Rucellai halos aim at totally divergent effects. It is thus among still later painting that we must look for parallels. But since they occur nowhere else, we are forced to conclude that the Palazzo Pubblico halo could not have been executed before a period that would have given Guido time to evolve beyond his own modest and conservative efforts around 1270.

In all the foregoing respects of panel-shape, of size, of frame, of attitude, of action, of the Mother and Child relation, of the distribution of mass, of perspective and the evocation of space, of the tooled ornament, of the accord with the dated dossal No. 6, the Palazzo Pubblico panel bears no visible relation to the only work dated close to the date it bears, the 1215 altar-frontal (Fig. 18), nor to any of the three early Dugento Sienese Virgins, nor to the Siena Academy *Cross*.[12] And even if we concede to Guido a Metuselehan durability, it would still be rather whimsical to imagine him painting the Palazzo Pubblico panel as a very precocious youth, especially since the No. 7 dossal confronts us with a much less evolved style some fifty years later. Such interpretation of human development would reverse every known instance of it in history. For similar reasons it would seem unlikely that the Palazzo Pubblico panel was painted before 1275. These manifestations assume greater authority as they reflect characteristics proper to this late period, and as they follow from causes that could not have produced them before. Yet the evidence, in itself undeniable, is contradicted by an inscription (Figs. 19 and 20) that explicitly dates the painting 1221. The dilemma thus created has found a simple means of solution with certain students, namely to lean upon the dumb testimony of the numerals and to reject the validity of that which is specifically artistic or art-historical, and is the proper business of criticism to read, consider and interpret, as indeed I have

tried to do. And having done this, I now feel constrained to read, consider and interpret the inscription as well.

Since the Palazzo Pubblico (Fig. 1) and Galli-Dunn (Fig. 4) panels are virtually identical throughout, we may assume that they were originally alike in those parts that are now either damaged or repainted. If such a postulate is admitted, we are committed to the inference that the footstool under the feet of the Palazzo Pubblico *Virgin,* now transformed by restoration, was originally not very different from the footstool in the Galli-Dunn picture. Having suffered no modifications in the shapes and proportions nor, also, in the placing and the perspective, this work provides us with the most probable likeness of the footstool at one time in the Palazzo Pubblico panel. The most conspicuous change from the former appearance of this footstool was to show it in perspective from the right, the reverse therefore of the perspective of the throne. But the original footstool at the Palazzo Pubblico underwent further metamorphoses at the hands of the later painter. This may be surmised from the rather high footstool of the Galli-Dunn *Virgin.* It seems the footstool in the Palazzo Pubblico has been flattened to a relatively low structure, much flatter than that of the Galli-Dunn picture, and lower even than the already low footstool of the *Madonna* from Guido's workshop in the Academy in Florence. If we continue our conjectures on the basis of the latter, such reduced height of the footstool was very likely all that was left uncovered by the Virgin's drapery, which hung over the edge of the footstool in the Palazzo Pubblico as it does now in the Academy picture. Moreover, in defiance of the prevailing fashion, the footstools in the Galli-Dunn and Academy paintings had been thrown into a central perspective very probably in adherence to that of Coppo's footstools in Siena and Orvieto.

But even if we dispensed with such evidence from the Guido workshop, the dou-ble perspective of the Palazzo Pubblico *Virgin* would have to be regarded as an alteration made after the period in which the panel was originally painted. For if the distortions of perspective abound before the naturalistic discoveries of the Quattrocento, if thrones, whether frontal or in perspective, are accompanied by footstools seen from the left or from the right, I doubt whether any Italian master of the XIII Century would have committed the barbarism of shifting the spectator from one side to the other of the same composition as does the restorer of the Palazzo Pubblico panel. Least of all is it likely that the master who originally planned the Palazzo Pubblico picture would have so defeated his purpose of artistic and spatial unity as to split the spectator's point of view. At all events, there is no other instance known to me in the whole range of Italian painting in which the throne is seen from one side and the footstool from the side opposite. On the other hand, perspective of the footstool if not frontal generally tends to follow the perspective of the throne.

But this is not the only violence committed by the restorer. He and he alone would have so ignored or defied the logic of representation as to place the inscription where we now find it. For it would have been a piece of the most outrageous impropriety in the original master to start the inscription on the insubstantial black strip that hangs in a void and to continue it on the outer face of the solid footstool, so that it rests at once against an immaterial and an actual object. The original painter would have conceived the inscription in terms of the available space without finding himself reduced to this awkward anomaly in the hope of providing room for the integral statement. But the reason for this breach of taste and usage is not hard to guess: the words were not conceived for the present occasion nor for this place. They were composed for another panel and were lifted word for word, with hardly

a change in the orthography, in order to relieve a later predicament. As he respected the general lines of the composition, so the painter who restored and altered Guido's panel took over the inscription as he found it under dossal No. 7 in order to retain the semblance of authenticity. At present, the inscription on this dossal is incomplete because the two end figures and the parts of the legend originally under them are missing, and consequently also the name of the artist, but from the "x" of the otherwise effaced DE-PINXIT onward it coincides with the Palazzo Pubblico inscription in every particular. Thus, we are forced to assume that the craftsman of resources as modest as the one who copied unchanged a text already used for a similar purpose, and one as perplexed in planning its disposition could hardly have been the original painter of the Palazzo Pubblico panel. But there are further indications to prove that this inscription is not contemporary with the original painting. In forming the individual letter, the writer varied the line from airy thinness to heavy thickness in order to achieve a flexuous character, and a more rhythmic modulation than any writing prior to 1275, bringing its style closer to the calligraphy in Duccio's Maestà than to that of dossal No. 7. Of a much more mannered Gothic than the last, the letters of the Palazzo Pubblico inscription are set in close alignment so as to flow in an arabesque approximating cursive script. The historian will find this to contrast sharply with the staccato character of the more traditional style, both in the series and in the single elements. Although the conventions of Dugento writing change at an uneven pace and new types replace the old slowly, certain letters of the alphabet in the Palazzo Pubblico inscription are of a kind and design that deserve attention, for they occur here with striking repetition. Such, for example, is the letter "v" (or "u") in which the straight vertical stroke is on the left and not on the right as in the

inscription from which it is copied. On the other hand, it corresponds to Duccio's "v" in the instance cited. Less conclusive but revealing the same tendency is the appearance of an "A" which flaunts a caret to close the angle at the peak. But whether the letters are as late or not, they certainly cannot be of the period of the date inscribed on the painting. For if confronted with the Romanesque writing in the frame of the dossal of 1215 at the Siena Academy, their pure Gothic characters are found to be, as Milanesi has already noted, of a totally different and much later structure and style. Very strange, moreover, would be the incongruity—acquiesced in by the champions of the authenticity of the inscription—of writing placed upon the vertical plane of the platform at so early a date, and only less amazing than the claim of similar earliness for the original portions of the painting, even if one were to overlook the objections to the inscription itself! On the other hand, such placing begins to occur only in the early XIV Century with the very master whose style is found in the heads of the principals and whose letters so closely resemble those of the Palazzo Pubblico inscription: namely, Duccio in his Maestà.

But apart from the above difficulties we have reason to suspect embarrassments encountered here and there in the setting down of the legend, that must have driven our helpless restorer to despair. Thus, e.g., by miscalculating the length of the total space at his disposal, he had more than the room necessary left for the ANO. D. These words, however, he improvidently contracted, going out of his way to elide several letters far beyond current custom, only to find that the two words must stand isolated from their neighbors. More clumsy still is the upright placing of the M̃, when it should properly have been made to run with the receding plane of the footstool. Last of all, and most remarkable, is the ungainly tilt of the remaining letters of the date, out of plumb and at jarring variance

with this plane which is, of course, vertical: all this, no doubt, due to an elementary misconception of its structure—a misconception akin to the painter's confounding of matter and abstraction already demonstrated.

Although by no means easy to dispute, it is easier to question the authenticity of the inscription than to account for so extravagant a blunder as that of setting down a date approximately fifty years earlier. The most stubborn obstacle to a solution of the problem is encountered in those minds which, in artless or hardened prejudice, regard any assertion made with authority as canonical. For such persons, as for the defenders of the early date, antiquity by itself invests all early evidence with infallibility. But in any period of the past as now, the date which we read today might easily have been set down in thoughtless or mechanical transcription, possibly by some apprentice or assistant in Duccio's workshop who probably omitted one or two Roman numerals. There are no instances wanting of works bearing wrong dates through mere inadvertency.

The chief reason why the Palazzo Pubblico date has proved plausible and has by some been accepted without question is that its language is more easily apprehended than the language of form. Surely such prostrate deference is partly due to the fact that respected writers have used little imagination and less insight in dealing with the problem, and perhaps most of all to the mighty rumble of the engines of dialectics that rest upon an insecure structure of word patterns—instead of the testimony of the eye—and upon downright delusion. But when a date is correctly read but too literally interpreted, what a disastrous dislocation of history and what a resulting sense of the hopelessness of our methods! Among other things, such a reading has provided us with one of the classical instances of anachronism in the critical literature of recent generations.

Milanesi's emendation of the date to 1281 (published as early as 1859 in *Della vera età di Guido pittore Senese,* Firenze) is the likeliest of all those hitherto suggested even if his ostensible grounds, though carefully considered, are not always positive. Whether the date is acceptable or not, he has demonstrated with a fair measure of probability that the Palazzo Pubblico *Virgin* cannot have been painted in the first half of the century by confrontation of our *Madonna* with the works that chronologically align themselves with the dossal dated 1215 in the Siena Academy. His date was arrived at by a just intuition of the style of the Palazzo Pubblico panel and by the ingenious hypothesis that an "L" before an "X" after the two "XX"'s of the Roman numerals had been obliterated. Whether this explanation matches an actuality we can only surmise, his date would accord perfectly with my own conclusions. But since an inscription is but a literary comment upon an organism to which it is artistically extrinsic, why should not the work be allowed to speak, since it is the pictorial language by which alone we can gauge it and reach the secret of its essential qualities? For as we have seen, the work emerges out of a reservoir of its own traditions, out of a collective genius rooted in its own soil, like life itself subject to its environment, and therefore by irreversible law committed to one region and not another, and to one period, by factors deep within it—factors that are visible and not verbal, unique and not conceptual, concrete and not theoretic.

NOTES

1 Edgell, in his *History of Sienese Painting,* quotes the important opinions regarding the date up to the publication of his book in 1932. Weigelt, who on four separate occasions (from 1911 to 1931) has subjected the Palazzo Pubblico Guido to careful study, oscillates between the early

date and the middle of the century. Since then the following writers have taken a definite position on the date. For the date of 1221: Brandi (in: "l'Arte," XXXVI, 1933, p. 13), Vavala (in: "Burlington Magazine," 1934, I, p. 254), d'Ancona (*les Primitifs italiens*, Paris, p. 87), Lavagnino (*Il Medioevo*, Torino, 1936, p. 418) and Bacci (*Dipinti ineditie sconosciuti . . . in Siena e nel contado*, Siena, 1939, p. 3); for a later date: Meiss (in: "Burlington Magazine," 1937, II, p. 18: third quarter) and Coletti (*I Primitivi*, I, Novara, 1941, p. 28: 1261). (The present article was written in May 1949 and its appearance delayed as part of the "Gazette des Beaux-Arts'" delay in publication.)

2 There can be little difference of opinion regarding Guido's style, in spite of differences among the works in which he had a likely share due to various degrees of admixture of other hands. The two works that bear his authoritative stamp are the dossal No. 7 in the Siena Academy and the Palazzo Pubblico panel. The former of these was certainly originally signed with his name; the latter has never been seriously called in question. The scenes from the Life and Passion of Christ which presumably formed part of the same panel vary profoundly in quality, but must be in large part at least attributed to Guido himself. For the rest, the Galli-Dunn and the Florence Academy *Madonnas*, though by inferior hands, most closely adhere to Guido's style and may be spoken of therefore as typifying it. This is somewhat less true of the dossal No. 6 in the Siena Gallery, of the Platt *Madonna*, now in Princeton, and of the *Madonna del Voto* in the Sienese Duomo. To a somewhat later stage in the activity of his workshop belongs the *St. Peter* altarpiece (Fig. 8). The *Madonna* in Arezzo and another one in the Siena Academy (No. 16), once dated 1262, display a style which though of his workshop differs essentially from his own. They show, however, unmistakable influence of Coppo's pictorial technique as we find it in the Orvieto *Madonna*, and may indeed reflect Guido's earlier otherwise unknown phase.

3 This dossal bears the following damaged inscription: . . . X . . . AMENIS. QUE. XTS. LENIS. NULLIS. VELIT. ANGERE PENIS ANNO. DNI. MILLESIMO. DUCENTESIMO. SEPTUAGESIMO. Since it was originally in seven compartments and the first part of the inscription was severed with the leftmost figure, and since, moreover, the first word was apparently DEPINXIT, we may conjecture that what preceded it originally was the painter's name. Besides, we must assume on the basis of a word-for-word identity between this inscription as it now stands and that of the Palazzo Pubblico panel, that the missing words at its beginning were the same as those at the beginning of the Palazzo Pubblico inscription. One's ingenuity is taxed, however, to guess what originally followed the final word of the date, which barely reaches the figure of the Magdalen. It is probable, however, that another numeral (word) at least, the month and the day, concluded it.

4 I am inclined to accept the last reading of the date in Vigoroso's polyptych in Perugia by the authors of the Giotto catalogue (Giulia Sinibaldi and Giulia Brunetti) as 1280. Some authors, including the last, admit the possibility, as I myself should, of an effaced numeral following the third "x" (e.g., Thieme-Becker, XXXIV, 1940, p. 358).

The essential traits of Vigoroso's only known work have not yet been clearly distinguished or properly appraised. Vigoroso's peculiarities are to be found in his type: in his long narrow faces anticipating Giovanni di Paolo and El Greco, the animal gentleness of the glance, and in the angels, chiefly in their Kaffir-like heads heaped with tufted hair, and the lofty brows. Knowing him for an eclectic, one is not astonished at the Byzantine expression and dress which suggest works as remote as the frontal atrium figures at S. Angelo in Formis and No. 20 in the Pisan Pinacoteca. Those who have studied Vigoroso's polyptych have emphasized his Cimabuesque affinities and some have considered him Florentine in his total character rather than Sienese. And Florentine he is in several of his derivations such as the gauffered edge of the drapery, the austerity of his male figures, and their glance which rests intently or fiercely on a particular object. Vigoroso betrays his source even farther back within the same tradition: in Coppo di Marcovaldo. For while the cut of the features is paralleled in the Cimabuesque altarpiece at the Louvre and in the S. Croce *Cross*, the modeling that carves out the features so concisely in light and shadow reverts to works like Coppo's much earlier *Virgin* in Orvieto.

The correspondence—in figures otherwise so diverse—of the upper part of Vigoroso's female saint and of Coppo's *Virgin* can be explained only as due to deliberate and direct imitation, since the scheme of the lighting, of the cast shadow, the pattern of the crown, its manner of resting on the head, the white veil, its arrangement and the zigzag course of its border, the spacing of parallel folds over the large skull, their drop over the shoulders are identical in both.

But this is hardly the whole story. Vigoroso's own unmistakable personality apart, what is left over in this polyptych originates in Siena itself. It is true Guido's share is smaller than would be expected in shaping Vigoroso's style. Actually I find signs of contact between the two masters in little more than such grosser features as the arches, the moldings: in the architectural character in fact, of the main part of the polyptych. The gentle postures, the sheepish glance of certain of the figures, and the full smooth lips come out of Duccio's tradition; Duccio, it goes without saying, in his earliest known phase—the phase we find in his Rucellai altarpiece of 1285, and indeed as he might have looked in works of earlier date now lost that provided the Florentines with reason for calling him to paint their Madonna. The Child repeats the much younger master's Rucellai Infant in as close an adaptation as was possible in a short panel, a fact that accounts for the awkward displacement of the lower part of his body and legs. The softness of the drapery, again, of the veil over the head of the female (St. Margaret) might be mistaken for a later addition, but for the fact that its texture already occurs in the loin-cloth of the Cimabuesque *Cross* in S. Croce and the angels of the Rucellai panel; the secret of its weight and weave, betrayed in the serpentine movement of the delicate black edge, can only be of Duccesque origin, however. But most of all the elegance of the fragile and narrow shoulders is as un-Florentine as it is Sienese, even though we shall not find them again until the next generation in the School of Simone and ever after in Sienese painters in every generation until Simone's tradition fades in the sterile dusk of the local Mannerism.

5 The form of dossal used by Vigoroso in this painting represents a stage beyond Guido's dossal No. 7. The next stage is marked by the Duccesque polyptych in the Siena Academy No. 28, wherein a horizontal element is superimposed upon the round arch to serve as a base for the pinnacles (see also: Weigelt, *Duccio*, 1911, pp. 223–224). At the same time, Duccio separates the single saints by vertical divisions which function as supports for the arches as well as for the pilaster-like elements that rise upon the capitals to the cornice. Duccio's scheme is thus an effort to impose by articulation the logic of architectural interrelation between the various components of the polyptych upon the structure in order to give it the visible appearance of an organism.

6 The Duccesque repainting is today visible in the heads, arms, hands and legs of the Virgin and the Child, in the veil under the Virgin's maphorion, in the white stuff on which the Child is seated. To the same repainting, I now attribute the platform and the inscription. But Duccesque additions apart, the picture has been dishonored by a film of dun pigment and grime-filled varnish worn in places and covering the original surface in patches, especially in the blue drapery of the Virgin's kerchief and, to a small extent, the six angels in the spandrels. In the dimmest obscurity of the XVIII Century, the two panels in the gable were subjected to a daubing, but it was the XIX that must carry the stigma for the repainting of the flesh (now largely gone from the two principal faces), of the total repainting of the lower throne, the cushion and the mantle of the Virgin, its lining and some of the borders. The lower part of the throne, as we now see it, is superimposed upon Guido's original, and bears some resemblance to thrones in Duccio's circle and less so to thrones in Roman painting of the same period. The closest approximation is to Deodato Orlandi's throne in Pisa and to thrones in his environment.

7 Those who have seen radiographs of the original heads under the Duccesque repainting (made by the Instituto Centrale di Restauro in Rome), cannot fail to be moved by the emotional vitality. The figures seem to draw their expression from a deeper source than any Dugento Sienese figures known, and emanate a spiritual force and gravity that foreshadows Cimabue. The posture of the Servi panel, though copied by the Magdalen Master, was not, however, to enjoy the same favor in Florence, where the more traditional posture of the Orvieto *Virgin* was destined to supersede it.

8 There is one other similar instance of imitation of Coppo in Guido's immediate circle. This
time, however, it is an adapation from Coppo's Orvieto panel from which a Guido follower
(probably the painter of Christ and the Virgin in the Convento delle Clarisse, Siena, a prob-
ability already noted) borrowed the Madonna in a tabernacle in the Czartoryski Museum,
Cracow (Fig. 14) (in Vol. No. 235, Cat. No. 178). The Child derives from the Palazzo Pubblico
panel but the Virgin can originate only in Coppo's Orvieto panel: especially the placing and
movement of her body, her left hand supporting the Child, and the *contrapposto* by which her
right leg is directed toward her right while her torso rotates toward her left.

9 For similar ends, as well as for that of centralizing movement and action, Coppo adapted the
contrapposto in the Madonna. This *contrapposto* seems in painting not to have been used
before the earlier XII Century, probably not much before the apsidal *Virgin* in S. Silvestro,
Tivoli, and later in the façade mosaic of S. Maria in Trastevere. It recurs probably by way of a
secondary tradition in a *Virgin* in S. Sebastiano, Rome (frescoed according to Wilpert between
1216–1217), in the Yaroslavl Museum *Virgin* of the XIII Century, and for the first time in
Tuscany in Coppo's Orvieto *Virgin*, painted probably between 1265–1270. Coppo's motif would
seem to have been known in Guido's milieu where it appears in the Cracow tabernacle (see
note 8, Fig. 14), but it becomes altered by what would seem to have been a Cimabuesque
innovation (S. Trinità *Madonna*): that of raising the profiled knee by placing the corresponding
foot on a raised step. This change triumphs over the unseemly and awkward necessity of
leaving the foot of the raised leg without proper support as in Coppo's Orvieto *Virgin*. The
new version of the motif survives in the St. Martin Master's Moscow panel (see: V. Lazareff,
"The Burlington Magazine," Vol. LXVIII, Feb. 1936, pp. 61–73), and generally in Tuscan
masters accessible to Cimabue's influence (Deodato, Pisa) including Duccio's *Madonna with
Three Franciscans*, which is certainly directly Cimabue-inspired, and a *Madonna and Scenes*
in the Kaiser Friedrich Museum in Berlin. The later XIII Century non-Tuscan *Madonnas* in
contrapposto—Rome, Aracoeli and S. Maria Sopra Minerva; Washington, Byzantinizing *Vir-
gin* (formerly Hamilton Collection); Borghese Gallery *Virgin* from Gaeta—seem to have both
feet planted on the same level.

10 The dimensions of the *Madonna* panel are 2 m. 83 × 1 m. 94, of the gable 0 m. 79 × 1 m. 94.
The total height, therefore, is 3 m. 62. The measurements of Coppo's works come closest to
these: the S. M. Maggiore *Madonna di Carmelo* measures 2 m. 50 × 1 m. 23, the Orvieto Servi
Madonna 2 m. 38 × 1 m. 35. The still later *Madonnas* such as the Uffizi Cimabue are 3 m.
85 × 2 m. 23, the Louvre School of Cimabue 4 m. 24 × 2 m. 76, whereas the Rucellai is
4 m. 50 × 2 m. 90. Thus, the size of the Palazzo Pubblico panel would be normal for the
period to which all of its stylistic characteristics commit it.

11 Guido, in the Palazzo Pubblico halo, uses line for the first time in Siena to reinforce the
pointed contour. But as in so many other ways, he is also in this anticipated by Coppo in the
1261 *Virgin* and in the Arezzo *Cross*; So the stamped circles that occur in the main field of the
angel halos in the Palazzo Pubblico panel appear, before Guido's use of them, in the S. Maria
Maggiore *Madonna di Carmelo*.

12 If Weigelt's plausible hypothesis ("Burlington Magazine," July 1931, p. 15) that two shutters
containing episodes from the life of Christ originally flanked the Virgin be correct, the few
surviving scenes would confirm the lateness of the *Virgin*. Their style certainly commits them
to the same period and would provide further evidence against an early date both for the
Madonna and Guido. The implication of late period in the small scenes is even clearer than in
the monumental parts, and consists in the more populous composition, in the large areas
allowed to the upper space, in the more naturalistic response of the figures to their environ-
ment, in the perspective and scale of the architecture, factors none of which can anticipate
Duccio's system in his *Maestà* by much more than a generation. Perhaps the most explicit
sign of lateness is in Guido's *Crucifixion* in the Siena Pinacoteca, a scene which though
sparing in figures, closely follows Cimabue's fresco of the same subject in Assisi. Guido bor-
rows its distribution, grouping, and the placing and posture of its principal figures. The
mannered posture of the crucified alone doesn't occur, and is indeed unimaginable before
1270.

SYNTACTICAL ANALYSIS

2 Geertgen tot Sint Jans'
'The Legend of the Relics of St. John the Baptist'

ALOIS RIEGL

As have several art historians of the past hundred years, Austrian born Alois Riegl (1858–1905) turned to the study of art history from another subject—in his case law and philosophy. After being graduated from the Austrian Institute of Historical Research in Vienna, where he learned to use the methods of philology, paleography, diplomatics, and art history, Riegl became keeper of textiles at the Austrian Museum for Applied Arts, the Kunstgewerbemuseum, in Vienna. In 1891 he published a book on ancient textiles, *Altorientalische Teppiche* (Leipzig), which to this day is highly regarded by most specialists. Two years later, another of his books appeared, *Stilfragen* (Berlin, 1893), which deals with the method for investigating the history of ornament, deriving its points of view from a firsthand knowledge of original works of art. In 1897, he joined Franz Wickhoff (1853–1909) as professor of art history at Vienna University, a post he held until his death at the age of 47. During his last years, his poor health notwithstanding, he assumed the post of head of the Austrian Monuments Commission and published two important books, in 1901 *Die spätrömische Kunst-Industrie* ("Late Roman Arts and Crafts," pub. Vienna), an outline of the development of sculpture and painting in the later Roman Empire (now available in an Italian trans.), and in 1902 a masterly study of the Dutch group portrait from Geertgen tot Sint Jans to Rembrandt, a portion of which appears below for the first time in English translation, rendered by Stephen Kayser for this anthology.

Riegl's interests covered a wide range, from ancient Oriental art to Baroque art (his lectures on the latter were published posthumously as *Die Entstehung der Barockkunst in Rom* [Vienna, 1908]), and his ideas, based on empirical observation, were continually changing, adhering to no single system. Although today the terminology and the psychological and historical notions of his writings are regarded as outdated and untenable, his analyses of the syntactical structure of individual works of art, that is, the relation of composition and formal conventions on the one hand, and themes or thematic values and social history on the other, are as perceptive and incisive as any to be found in the pages of art historical scholarship. His method is beautifully exemplified by the following selection from his pioneering work on the Dutch group portrait, and this writing points up the fact that Riegl exerted a deep influence on the scholarship of so many prominent European art historians of our century, including Max Dvořák, Wilhelm Worringer, Paul Frankl, Hans Sedlmayr, and Henri Focillon.

But the real significance of Riegl's work lies in his exploration of periods of art—the late Roman and the Baroque—that in his day were either unfamiliar or disdained as

Translated by Stephen S. Kayser from Alois Riegl, *Das Holländische Gruppenporträt*, reprinted under supervision of Karl M. Swoboda, notes by Ludwig Münz, 2 vols. (Österreichischen Staatsdruckerei, 1939), vol. I, pp. 7–25. Copyright by Druck and Verlag der Österreichischen Staatsdruckerei. Originally published in *Jahrbuch der kunsthistorischen Sammlungen des Allerhöchsten Kaiserhauses* XXIII (1902), pp. 71–278.

representing a decline from Classical norms. With his writings, such terms as primitive and barbarian lost their pejorative connotations, and the traditional barriers between the "major arts" and the "minor arts" were torn down. Because of Riegl, art historians have been able to esteem a gem-studded fibula as highly as a cathedral and can use both to shed light on the "dark ages."

Translator's Note

To the best of my knowledge, the following attempt to translate a large portion from Alois Riegl's writings into English is the first of its kind. All who have paved a way through the thicket of the original Riegl texts know how enlightening they appear on the one side, and how obscure on the other, and how forbidding they become if one dares to think of the possibility of translating them. That does not have its basis only in the fact that Riegl's self-stylized and willful terminology changes its meaning constantly. It seems much more conditioned by the form in which his most influential writings have come down to us; with few exceptions, they are based on his lecture courses and are not "books" in the true sense—even those published during his short lifetime, such as the one on the Dutch group portrait, of which a portion is presented here. Sentences of nearly 150 words can be found in this original text. Their rendering into English, with its preference for brevity, precision, and clarity, can only call for the excuse that every translation must by necessity become an interpretation. Furthermore, as indicated, Riegl's terminology is by no means consistent, and even if it were, at times there are almost insurmountable difficulties in the nomenclature of both German and English. The terms subjective and objective are a case in point. Were it only for their proper adaptation in translating a text in which they are clearly used in an up-to-date manner, I would not mention them. However, in Riegl's terminology they deviate considerably even from the general German usage, as has been pointed out by previous historians. The ensuing translation tries to avoid the most striking misunderstandings regarding those terms, but no guarantee can be given, for too-great clarification entails the danger that the interpretation would have moved too far from the original. On the other hand, the accumulated verbiage of Riegl's mammoth sentences sometimes blocked the road toward literal translation so completely that detours had to be taken and the monsters dismembered, by which procedure it may not be altogether impossible that here and there the original became somewhat more intelligible.

In view of all these difficulties and the occasional obscurity of the text, undoubtedly enhanced in the translation, the question can be asked why this portion of Riegl's writings is presented here in English at all. In addition to the evaluation of Riegl's achievement given in the introduction to this book, it may be said that after a lifelong acquaintance with Riegl's legacy, it seemed to me that the chosen portion was best suited to give an insight into the workings of his thoughts. In his essay on Alois Riegl (published in the *Burlington Magazine* CV [1963], pp. 188–93), Otto Pächt said: "I know of few more instructive things than to watch Riegl in his efforts to learn from the works of art the questions which they want to be asked and elicit from them the answers" [p. 193]. The selection given here permits such an observation. It comprises Riegl's treatment of the painting *The Legend of the Relics of St. John the Baptist* by Geertgen tot Sint Jans, who was born in Leyden and died, sometime between 1485 and 1495, at the age of about 28. The lengthy discussion of the picture serves as a prelude to Riegl's penetrating analysis of the Dutch group portrait. The late Paul Frankl (*The Gothic* [Princeton, 1960], pp. 634–5) wrote of this treatise: ". . . one may briefly characterize this masterly work, the

value of which can hardly be overestimated, by saying that it interprets the element of content psychologically by means of the concepts of will, emotion, and attention, that is to say with reference to the persons represented in the paintings, who are objectively connected with each other by the action of the picture but who in the course of its development establish a connection with the spectator by their glances and attention. This 'subjective objectivism' is one stage of a long process that ends in impressionism and parallels step by step the development of form, namely, from isolation to connection and the conquest of intermediate space *(Freiraum)"* (*The Gothic* [Princeton, 1960], pp. 634–5). No more suitable introduction to the following excerpt may be found.

The group portrait could not originate before the rise of the individual portrait, and that happened in the Netherlands during the first third of the 15th century. At first, the individual portrait does not claim to be self-contained; rather, it was introduced as a mere appendix to history painting. The painter continued to concentrate on cult images, the sight of which was to transmit the quieting assurance of immortality and redemption; but he now added the image of the donor, including the latter's individual physical characteristics, in order to bring him into direct contact with those redemptive powers. Medieval philosophy, which had tolerated the physical solely as a necessary indication of the existence of the only thing worth considering, the spiritual, thereby appears decisively overcome on the one side, as attention is drawn to the more perishable properties of the individual bodies, while on the other, especially in Netherlandish art, the medieval concept still persists, inasmuch as it characterizes the portrayed figures distinctly as nothing but individual carriers of spiritual functions. This fact can be proven beyond doubt especially by comparing Netherlandish with Italian portraits, which remain to be discussed. True, Jan van Eyck painted self-contained likenesses; yet, long after him we frequently find, in the case of Memling, for instance, independent portraits in the gesture of praying without a special aim of devotion as in the movable altar. We may therefore

safely assume that the group portrait, too, must have started in the liturgical picture, insofar as it originated during the earlier period, that is, before the Reformation.

Indeed, we are able to show that the initial beginnings of the group portrait go back to the 15th century in paintings that called for several donors instead of one. To be sure, the family portrait has to be excluded here;[1] however, if we find, for instance on the wings of an altar by Memling of 1479 in the Bruges Hospital of St. John, two male and two female regents on either side, we can already establish a certain relationship with the later group portrait, inasmuch as these persons were strangers to each other in their descendance, yet united temporarily in the pursuit of certain earthly goals. On the other hand, the essential difference still exists that these figures appear without the faintest, if only symbolic, interrelation, each one devoted to its private patron, while their common activity takes place in selfish motivation for the heavenly reward, the assurance of which the jointly dedicated painting was to serve.

Still, it cannot be conceived why in Netherlandish art with those inclinations, entire compositions should not in similar fashion have found their way into church paintings. Because of the destruction by the iconoclasts and the dispersion of the preserved art works of old Holland, a precise statement in that direction has become highly difficult for us. Dr. Gustav

[1] Notes to this selection begin on page 137.

Glück, who for years has given special attention to this field of art history, was able to name a single appertaining painting: the one by Geertgen tot Sint Jans (Gerrit of Haarlem) with three representations from the legend of the Baptist, done for the prebend of the Johannite order in Haarlem, at present in the Kunsthistorisches Museum of Vienna (Fig. 1).* Its origin would go back deep into the 15th century, if one could give credence to the dating by Van Mander, who mentioned the picture under the vague characterization *"eenigh mirakel oft onghemeen historie"* [a miracle of unusual story]; but it has always been maintained, and rightly so, last by Dr. Fortunat von Schubert on the basis of the costumes, that the painting could hardly have been executed long before the year 1500. On the other hand, inasmuch as the master must already have been dead quite a while at the time of Dürer's Netherlandish journey, the painting in question originated at least two to three decades before the oldest known real group portraits.

It is to be divided into three diagonal strips, one above the other: on top, the burial of the remains of the decapitated Baptist; at the bottom, the burning of his bones by Emperor Julian the Apostate; in between, the discovery of those relics, which escaped destruction, by the Johannites who carry them to their monastery in solemn procession. We are interested here mainly in the last representation (Fig. 2). Behind three coffins, the lid removed from the one in the middle, we see a group of twelve men: five of them reveal their identity as Johannites through the Maltese cross on the left side of the mantle. One of them is fetching a bone from the open coffin; another, half kneeling, hands one of the bones to a third; still another bone is already in the hand of a fourth. The remaining men are more or less passive participants in the scene. Following the di-

agonal strip toward the upper right, we observe beyond some bushes another group of five people, in whom, as it will be shown presently, we have to recognize the just-mentioned Johannites, distinguished by the cross, on an ascending path leading to the gate of the monastery, where they are met by a procession of singing brethren with crosses, banners, and hymn books in hand (Fig. 3).

For the time being, we may anticipate as established the result of an investigation soon to be undertaken, that we are confronted here with portrait heads—at least partially, because it has to be decided, above all, whether and how far the designation group portrait can be applied to this painting. That it is not a pure example of one is immediately evident in the pictorial unification of two totally different legendary scenes. Moreover, this painting is unlike a true group portrait in that it does not represent a corporation for the pursuit of earthly and communal goals, because these Johannites, much more than the regents of the Bruges Hospital, had no other intention than the attainment of eternal bliss, which could be reached only individually and not for the rest of the members. Therefore, the group portrait is still quite closely related to the religious story picture, not only outwardly, but also according to its innermost purpose. Only insofar as we have in it a number of portrait heads shown together in a group may we label the picture a prelude to the group portrait. We now have to ascertain whether Geertgen, who according to Van Mander's story lived in close confraternity with the Johannites of the Haarlem prebend, has indeed portrayed living individuals here.

A comparison with the figures of the lowermost scene yields worthwhile points for the answer to that question. The heads portrayed therein show relatively elaborate variations in their outer characteris-

* Illustrations accompanying this selection appear on page 468.

tics: in the manner of wearing hair and beards, in their attitudes, attire, and even in their features. Once having examined them, one keeps each head in mind, because every one offers something rather special compared to his neighbor, even upon the first superficial glance. If one turns from here immediately to the twelve above, their apparent uniformity becomes striking: the attire of all is almost totally the same, and the heads, save one with a beard, are related also in their types, as though according to a natural tribal rule, with no variations even in the way they turn. Yet, each one of their heads is treated so individually that confusion with any other seems impossible. Why did the master make his task of differentiating these twelve heads so difficult? He must have had an urgent need for it, and that could not have been any other but relating them to certain living individuals used as models.

Still further proof of this, to the degree of evidence, can be furnished. It has been said that of the twelve at the coffin, only five are characterized as Johannites, by the cross on the mantle and the almost identical garb; whether the remaining seven are to be identified as lay brothers I must leave to the experts in local history;[2] likewise the fixing of exact dates for the event depicted. The above-mentioned five reappear further to the right, where they let us recognize exactly the same heads as before to the left, in spite of their smaller dimensions. The one who had been shown previously as speaking has now taken the two longer bones; the master has portrayed him unmistakably, with his swollen lower eyelids and the long straight nose, as well as his purple undergarment. The smaller, slightly notched bone still rests in the hands of the same man, who is given away by his sharply pointed chin and the obtuse-angled space between forehead and nose. A third figure, with protruding cheekbones, follows below, presenting the longest of the relics to another; and this one, too, with his small

frame, wide cheeks, bent nose, protruding lips, and devout looks, we find in the upper group farthest to the left. To the fifth in the upper group, between the last two mentioned, can therefore correspond down below none other than the one who bends over the opening of the coffin and whose head is shown in total foreshortening. Granted, this is a highly nonportraitlike pose, but one for which a rather simple explanation can be found, inasmuch as the head shown in the upper part with the crooked and deformed mouth and other disproportions reveals an unusual ugliness that may have made it unbearable to even the—in this respect—less sensitive Netherlanders—be it the painter or the patron—to repeat the representation at closer range. Of the four heads mentioned first, the conformity between the two groups is firmly established and cannot be explained in any other way than the reliance of the artist on living models whose portraits were to be painted. Accordingly, the same can therefore be assumed regarding the seven lay brethren in the lower group, among whom we also have to look for our painter. How far this goes also for the participants in the procession is judged less reliably. For our task, only the lower group of twelve people is obviously under consideration.

If we undoubtedly have before us twelve individual portraits, we may now ask by what integrating means of an inner, psychical attitude and outer, physical setup are those portraits raised to a higher unity, and from an outer juxtaposition of individual likenesses to a group portrait?

Whoever has trained his eye—as have most art historians nowadays—in front of Italian works of art will be of the opinion that in the case in question, the inner unity has by necessity already been given through the narrative character of the subject matter, including all participants in one story by characterizing one sector of them as engaged in action, the rest as passive bystanders. Now, the event of the

discovery of the mortal remains is enacted by three Johannites; the other nine just stand by. It is already noticeable here that the latter do not pay any visible attention to the activity of the former; not one of the nine looks at those who have just discovered their precious prize. Thus the unity joining those engaged in action with the spectators is missing. And if we investigate further, we will see the same interrelation between the individual actors and the onlookers, nay between both and the aim of their doings, although in this, the inner discrepancy appears less obvious and objectionable. The Johannite who lifts a bone from the coffin looks into the case, but not at the find in his hand; the one who kneels at his side and passes a just-discovered bone to a third Johannite glances in the direction of his action, but neither at the thing found nor at the recipient, who also leaves the spectator in doubt regarding the actual object of his attention. Moreover, the passive figures fall into two groups, a smaller one to the left of those who are active, a larger one to the right of them. But the effect of this distinction is neutralized by one member of the left group who turns directly toward the right one. On the left, one man orates, to whom perhaps the two others listen, but without strengthening this impression for the viewer in the way they look or turn. It is also possible that the first one stretches out his arms only in order to receive the bone from the one in front, whose circumstance reveals that he is the same Johannite who in the upper group holds both bones in his hands. Even this would not explain his passivity and that of those near him. The members of the group to the right also behave in a motionless, erect manner, while turning in a three-quarter twist to either side of the picture, their eyes in the same direction; they relate to the one in front of them, who is evidently conceived also as speaking, as he points with his left hand at those who found the bones. Thus, also among the passive fig-

ures we observe two playing a part, but without a distinct aim, since they turn toward their listeners with neither their limbs nor their glances. Furthermore, there are seven listeners, but without a distinct object of attention, as they do not turn toward the speakers in a precise manner. We thereby arrive at the surprising conclusion that, although the legendary event furnished the means by itself to arrive at a unifying interpretation, the painter has done all he could to reverse the situation in order to blot out the unity of action and to represent the figures as mutually independent of each other and of their action.

This phenomenon is too singular and too important basically, not to force the clarification of its far-reaching impact upon us immediately. To accomplish that, we may interrupt briefly the discussion of the portrait group in the center of the painting and watch how the same Dutch master may have acted in a different case, in which he had to depict a historical scene but without a portrait. The [subject of the] burning of the bones of the Baptist by the imperial apostate easily furnishes such an opportunity. If there were ever a subject strongly calling for subordinate treatment it is this one, which had to present the highest authority of the Roman Empire as the responsible instigator of a wicked act. Consequently, the inner unity is warranted in this scene to a comparatively much higher degree. The imperial actor with crown, s cepter, and ermine cloak not only occupies the most distinguished spot on the stage but also makes a commanding gesture with his right hand that at first glance might be interpreted as an order to the executioners to throw the bones into the fire, to set the bellows in motion, and to strew the ashes to the winds. At least two of the five persons assembled around the fire, aside from the emperor, turn their heads and look directly at him. However, upon closer inspection the question arises why the emperor does not look

straight at the fire but turns his eyes upward, why one of his attendants stares vacantly and, particularly, why the other member of the entourage, along with the executioner who holds the bellows, turns toward the emperor while both point at the fire with the left forefinger. With this gesture, through which they draw the emperor's attention to the blaze, they directly counteract the subordinating effect of the imperial action; they even do away with it: the emperor changes from an active commander into a passive participant. Now one becomes aware that the emperor's gesture is by no means energetic enough to be regarded as a pure utterance of his will, and that just as much malicious joy over the detrimental deed is mixed with it; the grim satisfaction expressed in his features almost makes him say: "Good; go on burning." The iconographic explanation of this scene may therefore state that the attendants and the executioner ask the emperor whether they did all right, and the emperor affirms it. If one looks here for an action as an utterance of will in the Italian manner, the scene remains incomprehensible; what takes place instead is rather a mental intercommunication in which emotion and attention play a much greater role than the will, revealing themselves upon a closer look that was peculiar only to the Northerners. It follows that the Dutch master aimed at two objectives in painting the legend: he deprived the main action as much as possible of every subordinating effect, first by introducing contrasting side shows, and second, by attempting to replace the active will and its possible domination of the events with an expression of passive feelings, and particularly by the attentiveness which unites the active with the passive. The first destroys the concept of unity in the Italian sense, because the unified action is abolished and dispersed; the second produces a substitute for it, in which the specific Dutch or, if you will, the Germanic peculiarity lies. With this, we arrive again

at an art historical phenomenon of basic importance that calls for more thorough consideration.

The psychical expressions of life [die psychischen Lebensäusserungen] that can find manifestation in a work of art are will, feeling, and attention. The will is a purely active expression; it therefore finds its translation in deeds. Every representation of an action as such is at once the rendering of a wish uttered. Action means the triumph of man over the environment as a force opposing it; the will thereby intends to isolate and carry away the acting individual from his surroundings by subordinating them. The art of the ancient Near East has based its concept exclusively upon will: the heads of its figures are absolutely spiritless, but inasmuch as they are totally involved in action (even with their eyes directed at the onlooker), not distracted to the right or left, they convey the expression of concentrated, willful energy. The outside world as such left these Orientals wholly indifferent, as they saw nothing in it but an object for the vanquishing power of their will. The entering of the Indo-Germanic tribes into the art life of antiquity meant an emancipation of sentiment. Against the active will that pushes aside and victoriously subordinates everything, there rises that second kind of mental attitude, the recognition of which in a work of art already presupposes a higher degree of subjectivity as inner experience in a special relationship of passivity toward the outside world. By it, the individual feels affected in his will, either attracted or repelled and, correspondingly, reveals a feeling of either pleasure or dislike (pathos in the antique sense). In the first case, the will capitulates before the world outside; in the second, it apparently combats it. The Greeks of antiquity, as it were, emancipated sentiment only in the form of their "pathos," evidently because only in that way, aside from feeling, could the omnipotent selfish will find expression (tragic grandeur). But

the third category as well, attention, which makes an object only understandable through a subject, was known to antiquity, which made it a basic attitude, although within certain narrow boundaries, especially in the early times of the Roman Empire. The individual opens himself to the outside, but not in order to subdue it, neither to join it lustily, nor to withdraw from it in dislike, but rather in pure unselfish interest. Attention is passive, as it permits itself to be impressed by external objects and does not try to subdue them; at the same time it is action, because it searches for the objects without intending to make them subservient to inner satisfaction. The concept of will aims at isolating the individual egotistically from the objects outside by subduing them. Feeling is to be understood as either uniting pleasurably with those objects or repelling them no less egotistically, still connected with a basic tendency toward isolation and satisfaction of purely selfish interests. The understanding of attention, on the other hand, is to be found in its aim to absorb the outside world joyfully, to assimilate it spiritually, and to become merged with it altruistically. In the interpretation of the will, the outside world was confronted with the individual only as an object; feeling was understood as an assimilation of only a part of the object to the individual; attention, however, is to be conceived as totally subjectivistic, inasmuch as the individual wants to absorb the exterior entirely in his consciousness. To be sure, this concept in its purest form was impossible within a philosophy that, like that of antiquity, started from the idea that individuality constitutes the fundament of creation and the entire world falls into isolated organisms, necessarily confronting each other in egotism, isolation, and action. Attention in the art of Imperial Rome restricts itself, therefore, to expressing in a certain way the newly awakened interest of man in the world outside and especially in his fellowman, whereby the subordinating nature of the will and the underlying objectivity as related to the outside did not initially lose their power.[3] This, within the anthropocentric concept, could only be carried out by depriving the discriminating individual of his interest in the world around him and subjecting it to the dictates of a superhuman will. It became actuality in the Christian attitude, toward which at least since Hellenistic times the entire development was driving, characterized especially by a dualism between the isolating, self-centered individual will and the counteracting divine will, which demands of man the objective regard for the world outside him. In the visual arts of the Middle Ages, this dualism found an analogous expression from the 5th century A.D. (Vienna' Genesis),[4] especially in the typical attitude of figures that turn their bodies almost or wholly en face, toward the onlooker, while turning their eyes to the side where the [other] participants in the action are placed. This is even more exaggerated in some medieval figures, so that individual limbs seem to be moved inconsistently, as though out of joint, which, from a modern point of view, without regard to the specific stylistic intention, is usually explained as clumsiness. If one recalls that Classical antiquity had always given the eyes the same direction, and if one observes how the Middle Ages, in contrast thereto, took great pains to express a discrepancy in the two directions (of eyes and body), one can no longer deny that there are two fundamentally different tendencies in the artistic aims [Kunstwollen] involved.

At this moment of development, new peoples of the Indo-Germanic race entered history who up to that time, better than the Greeks and Romans, had preserved that original philosophy most clearly expressed, but also overemphasized, in the meaningful tat vam asi of the Indians. The early Christian thinking of the ancient Mediterranean peoples offered the Indo-Germanic tribes something akin to that

basic formula, and they adhered to it at first rather closely, at least on the outside; yet it was to be expected that in the course of development, they would make of it something totally different, namely, they let attentiveness appear not as the result of an objective force of law, but as having originated in the subjective urge of the individual. The difference between the concept of the Neo-Latin and that of the Germanic peoples (between whom the half-Latin Lombards and Franks played a mediating and therefore often creative role according to their degree of mixture and time of development) became quite apparent early in the Middle Ages, in the 10th century at the latest. The two roads decidedly separated, as far as was at all possible within the common Christian ideology, when in the 15th century the anthropocentric concept began to crumble, thereby paving the way for the emancipation of the individual, which in the old Christian tradition was guaranteed only through an objective norm. The next consequence of it was the relinquishing of that dualism and the reestablishing of the unity between isolating single will and combining attention. The different ways, however, in which that occurred in the North and in the South are characteristic of the relationship between the arts of both and enlightening for the entire development to follow.

During all of the Quattrocento, the Italians busied themselves in representing all parts of the individual body as following one willful impulse and in showing all figures of a story involved in one single action. If only the right hand was to be moved, all the other limbs had to assume the position that according to common experience harmonized best with that motion. This goal was reached only at the beginning of the 16th century but had been faced clearly a hundred years earlier. Will, action, and subordination evidently again dominate the basic attitude as in antiquity, and the Italians, in looking back, were not at all wrong during the 16th century when they labeled the past age as *Rinascimento* of ancient art. One thing only had been added: the subjective concept, especially revealed in the psychical attitude of the figure toward its surroundings. The antique figures never lost a certain objective character that could let them communicate in a lively way with one or the other neighbor, as it were, but never with the entire group. The more we watch antique figures in one pictorial composition, the more enigmatic becomes their psychical behavior regarding will, feeling, or attention. The figures of the Renaissance are conscious of the fact that within one pictorial unit they find themselves in mutual relationship. That means: an onlooker is presupposed, one who wants to see single figures in a picture united, and therefore everything has to be avoided that could disturb the impression of such unity. Because of this, the impact of the unifying mental functions of the figures—will, sentiment, and especially attention—exerts itself much more strongly in works of the Italian Renaissance than in those of antiquity. That is new, nonantique; however, the equality of the will with the closely related feeling and attention forms a bridge between the Italians of the Renaissance and the art of the ancients, whose true and direct heirs they had become. In the Italian Renaissance figure, more dispassionate feeling and more attentiveness are revealed than in any [figure] of antiquity. But the dignity of the self none denies; for, with regard to that, the ineradicable innate striving for grandeur in every Latin and the isolating impact of will power have drawn an unpassable borderline.

What the Nordic concept of the 15th century was, in contrast to this, we could derive from the insight given so far in the painting by Geertgen of Haarlem; and this impression is strengthened still more if we take a passing look at the participants in the burning. Behind the emperor, a

sizable entourage appears closely gathered, but nobody in it looks at the emperor or the fire, nor do these people face each other. They are neither connected with the main event nor subordinated, within the individual groups, to any single figure and its action. One senses the satisfaction with which the master has arranged these figures, and in not having been forced to bring them into direct relationship with the previously mentioned two persons near the emperor. Here we see the Dutchman firmly maintaining the medieval tradition because it was at the same time nationally inborn in him, while the Southerner was able to shake it off with one effort as a law forced upon him from the outside. One only has to compare it to any Italian painting of the time to recognize the profound difference: here, the figures are subordinated in partial groups and these in turn are integrated into the main action;[5] there, no outside connection between event and participants—utmost coordination. What we could above attribute to the stylistic requirements of portraiture in the twelve figures, we encounter here (in the entourage of the emperor) in a historical scene, notwithstanding certain heads that may have been painted from living models. It was therefore a general principle of early Dutch painting to avoid subordination and to isolate figures from one another outwardly through coordination. How awkward and forced appear most of the movements, because they are not carried off altogether by a single will impulse! Even the principal characteristic of medieval dualism, the difference between the directions of head and eyes, is not yet fully and exclusively overcome, as the main figure of Julian shows. In this respect, the contemporary Italian art seems to surpass by far that of the Netherlands. Yet, the weakness of the latter in this one respect was at the same time its strength. In deliberately suppressing the impulse of will, early Dutch art did not arrive at unity through subordination, to

be sure, but at a much deeper subjectivity of psychic expression. Again one has to compare these (Geertgen's) heads with, say, those by Ghirlandajo in order to recognize how [the latter's] figures, even when shown as passive spectators, present their fair existence with self-complacency and thirst for conquest, while the eyes of the Haarlem people are rather turned inward, gathering the world outside as in a mirror. Repeatedly (below and to the left of the Moor, seen from the back), the faces have received an almost dreamy expression through the cleverly shown indifference in their look (diverging direction of the eyes), leaving no doubt in the beholder that these persons do not concentrate on one special object, because then their eyes would be shown parallel. There is no trace of grandeur in these heads, including the emperor's. On the other hand, their miens express deep concern for the world outside, what we call, in one word, heart [Gemüt]. Such an expression, to be sure, is not appropriate for the villains, and in order to characterize them the master had to use drastic means, which explains the caricaturish looks, the animalistic, wide mouth, and the staring glance of the two entrusted with the execution of the imperial order. Attention, the most subjective of all psychical attitudes, is determined individually by a concrete object; it is of a rather general nature. Its foci lie scattered in all three dimensions, as the directions of the figures' eyes change constantly in a cunning manner, so that a fixed spot of attention cannot be established for any member of the retinue. The result is a selfless gaze, not interested in a special object. Any determinable aim of attention within the painting would undoubtedly have been felt by the master as action, utterance of the will, and weakening of the attentive attitude. True, the figures therefore appear dispersed in a manner that must have been unthinkable during objectively minded antiquity and incomprehensible to the Italians of the Renaissance.

But it corresponded perfectly to the Northern beholder, because he was much better prepared, and in a more specialized way, to comprehend all those figures in their mutual pictorial independence as a unit, just as they do it in the painting as "attentive" participants. In this picture it already becomes clear that there was a kind of art in the making, of which an advance in the direction of subjectivism was to be expected, leaving everything antique and Italian far behind.

The coordinating attention, instead of the expected subordinating action, that appeared to us so striking in the portrait group of the Johannites is also basically retained in the distinctly historical scene of the burning of the Baptist's bones. It can thus in no way be doubted that such a manner must have been especially akin to portraiture, which has to render the features as perfectly as possible while avoiding, if at all possible, every kind of action. This was the basis for the Netherlandish portrait by Jan van Eyck and his successors during the entire 15th century. All of these portraits reveal emotions instead of grandeur. The main accent is always placed solely upon the eyes, which look into the world with alertness and scrutiny but not with desire, while antiquity never gave them, as mirrors of the soul, preponderance over the other parts of the countenance. The Italian Renaissance partially followed antiquity therein by unifying the entire head and its details through graspable, exact delineation and by bringing it to the awareness of the viewer, with the eye and otherwise; but it also gave to the glance a special accent corresponding to a Christian and more subjectivistic art. Whoever compares such an Italian portrait with our Knights of St. John can no longer misapprehend the true character of Netherlandish portraiture. Admittedly a most typical example is the portrait of Cardinal Francesco Gonzaga by Mantegna, in the Camera degli Sposi in Mantua; with its captivating look, protruding eyeballs,

and lips shown in sensual tangibility, it makes the immediately impressed viewer totally oblivious of himself. In comparison, our Johannites appear unpretentious, yet full of inner life, their vision directed as much inwardly as outwardly in such a way that one remains unaware of the physical eye itself. As they look about, they can only be appreciated in their spiritual significance through a truly intimate contemplation by an observer who has enough time finally to discover himself. Some details of minor importance that frequently appear in the earliest single portraits point in the same direction, especially the showing of the hands, the foremost agents of action, which are obviously made to contrast to the inner life as revealed in the glance; they rest passively on a parapet, or they are folded in prayer, that is, in devotion, or, finally, they expose a ring, a carnation, or similar things, thereby also serving the expression of attention while the action in which they are engaged is, so to speak, halfway coming to a standstill, because the other person to whom the object is shown is missing from the painting.

A single portrait could still exist in the Italian concept, because the representation of the individual figure does not forcibly demand an action. On the other hand, a group portrait was almost impossible there, because as soon as several figures became united in one painting they had to be brought together by way of subordination. A group portrait of purely Dutch character never existed in Italy. Whatever appears similar originated in a limited region (Venice) and cannot be regarded as anything more than a preliminary step.

It now becomes clear why the group portrait could only have been possible in the Netherlands, and, may it be said right here, in those Dutch parts that at that time had remained almost totally untouched by Latin influences. Dutch painting asked even of the historical picture a lack of action if possible. So much more welcome to Dutch painting must have been a pic-

torial category that by its very nature not only neglected action but even had to avoid it, because every plot tends somehow to distort the human features and—the main reason—distracts the attention of the viewer from the personality, thereby weakening the effect of the portrayal. The inevitable conclusion is therefore that the group portrait had to become the most desirable, specifically national art work of the Dutch because no other category could bring such complete fulfillment of the typical artistic striving [Kunstwollen] of this people, as far as the rendering of the human figure is concerned. At the time of Geertgen, the group portrait, to be sure, was still tied up with historical cult imagery; the time, however, was no longer far when that became totally abandoned in order to be replaced fully by the group portrait of the profane (no longer church oriented) corporation.

After all this, the identity in the basic concept of the Johannite portrait group and the cremation scene can be established, yet the difference between the two should not be overlooked either. While the retinue of the emperor moves around to all sides and single figures show their profiles, even their backs (true, the Moor only) to the beholder, the Johannites are turned in three-quarter view to the right or left and are glancing in the same direction—except for the one already mentioned who gazes into the sarcophagus. This was undoubtedly done in order to present to the viewer the features of the person portrayed as perfectly and as clearly as possible, which would have been unnecessary in a story-telling picture. The outer portrait likeness calls for the objectively presented peculiarity of the figures, independent of the person viewing. That was already attempted in antiquity but totally ignored by the Middle Ages, which regarded the body as individually perishable compared to the truly existing objective, spirituality. After the 15th century, the body was again understood as an objective

entity, but in a subjective concept, and no longer in the antique sense, which tended to conceive the bodily phenomena as purely objective. The free, unhampered turn of the heads as shown in the entourage of Julian is more in line with our own experience, while the uniform bearing of the Johannites betrays a pattern, an objective rule, giving the impression of a posed picture. It follows that the group portrait was destined to preserve for Dutch painting, whose overemphasized emotionalism could have quickly led to extreme arbitrariness, an objective norm and with it the guarantee of a long, steady, and sound development.

We now have to take a look at the second element to which a work of art owes its effect, composition (in the widest sense, as form and color). The question is this: by what means has the unity of physical, sensuous appearance of the figures in Geertgen's painting been achieved? What causes us to comprehend the group of the Johannites on one side and the cremation scene on the other as a unit on the basis of mere pictorial appearance, aside from the already discussed psychical characterization of the corresponding figures? In this respect nothing positive, but something wanting, must strike the mainly Italian-trained art historian here: the subordination is missing. At the time when Geertgen's painting may have originated, subordination had already been developed into keen pyramidal compositions in Italy. Their element is the diagonal, in other words the combining line on the picture plane. Just this line is totally missing in our painting; where it could not be avoided, as in the detail of the executioners, it was treated as inconspicuously as possible. Most of the figures by far, including in part even the few who are really acting, retain a strictly vertical pose in order to stand side by side, without combining diagonals, as purely isolated and coordinated vertical axes. The integrating element that nonetheless makes them appear

as a unit again lies in the onlooking individual: in the pictorial concept it was called attention; in composition it is called space.

Art history distinguishes between two manifestations of three-dimensional space: cubic space, which clings to volumes, and intermediate space [Freiraum] between figures. An art such as that of antiquity, which regarded individual shapes as existing objectively, could not arrive at representing intermediate space. Only the Christian art that was emerging during Roman Imperial times emancipated intermediate space, and this was still in a rather shallow depth, between two figures, more on a flat surface [Ebene] than in infinite intermediate space [Freiraum]. Significantly, the physical bridge from figure to figure was built at the same time as that from man to man, which we called attentiveness in the Christian sense. Dualism also do we see returning here: the medieval figure appears projected onto the flat picture surface and therefore conceived not as space-filling but rather as standing in free space [im freien Raum]. This discrepancy is evident to the beholder. With the emancipation of the viewer in the 15th century, space follows attentiveness in becoming a special objective of the visual arts, and here again we see Italian and Nordic art following separate roads. The former strives mainly after the rendering of the spatial, cubic appearance of individual things (figures) in accordance with our subjective experience; hence its development of linear perspective, which adheres to shapes, and of symmetrical, triangular composition, which brings the objects on the picture plane together in a strikingly evident, real, and normal whole. Northern art, beginning with the brothers Van Eyck, strives mainly at the rendering of what is between the figures, that is, the free space, only insofar as it is betrayed on the figures, mainly through color; hence the cultivation of aerial perspective, of landscape, but also the adherence to vertical arrangements instead of a pyramidal

summary, in order not to let the togetherness on the picture plane get the upper hand. The Italians round out the figures in rhythmic, orderly lines to designate them as complete units; however, like all symmetry, this has its main effect on (the frontality of) the picture plane; the Dutch figures, on the other hand, are of commonplace, uneven contours that reveal to us no distinct purpose, thereby appearing more variable and moving more easily in free space.

The emancipation of intermediate space and the simultaneous avoidance of the pictorially unifying diagonals are to be seen in both described scenes of Geertgen's painting. In compositional unification there are also differences, as we have already observed in other respects. The Johannites, if we exclude those engaged in action, are arranged in rows behind one another, whereby they stand at equal distances, bordered on top by a horizontal line, which, true enough, seems to be pierced somewhat to the left of center by a projecting head; by this, the almost architectural rigidity of the rank and file is mitigated, but no integrating pyramidal effect of subordination is yet achieved. Nevertheless, an inclination toward retaining a normal, to a certain extent objective composition in the portrait group is undeniable, evidently originating in the same tendency toward a restful portrait effect as the already stated restraint in rendering the movements of the heads.

In contrast, the cremation scene does not offer any resonance of symmetry, not even in the form of an arrangement in equal rows. Again we have to distinguish between action and the retinue. The action appears to the modern onlooker undivided, through neither files nor triangular composition, but rather by the arrangement of the figures around a central event to which all refer. That means subordination; but it is not the emperor who exerts this influence but something nonhuman, elementary: the fire. Around it one can circum-

scribe a diagonally placed rectangle whose corners are formed by the executioner in the rear, the heavily cloaked attendant of the emperor, the stone in the foreground between the little dog and the outstretched foot of the kneeling executioner, and finally, by the tip of the latter's shovel. Here we come across a pictorial principle that was employed later in the 17th century by the greatest masters, above all, Rembrandt; only in our case, it is still the actual main feature, around which the action turns, while later a hole in the ground or a twig indicates the spatial volume above it, around which Rembrandt's beggars or Adrian van Ostade's musicians and dancers congregate.[6] Against this, the entourage of the emperor, which has to do without the unifying, symmetrical lines on the picture plane, remains also without the integrating, objective means of a spatial center. The observer sees how the figures recede gradually into space, and inasmuch as every spatial perception is subjective, the result is an impression of unity. Of course, to modern demands this spatial subjectivism is insufficient; but for Geertgen's

time, not only the relatively taller size of the figures in the foreground but also the contrasts between light and dark and their effect on spatial recession became progress of immense importance. The way in which the dark head of the Moor is profiled against the rock, together with the early attempts to make the borderlines fade out, prefigures later chiaroscuro painting, and, by the way, this is even more true of the dark monastery gate with the portcullis, to the upper right, which cuts into the broad daylight of the court behind.

Just in this lack of spatial composition in the arrangement of the retinue can one see that—similar to what we proved regarding the unifying medium of attentiveness—the outspoken tendency of the Dutch toward subjectivity needed a curb in order not to degenerate into sterile arbitrariness. We have already found this disciplined norm in the portrait group of the Johannites, and one might say that the Dutch group portrait exerted an objectivistic, and thereby retarding and conservative influence also on composition, but it was generally beneficial and regulating.

NOTES

1 In the introduction to this work, Riegl states that he regards the family portrait as nothing more than an enlarged portrait of an individual.—TRANS.

2 At least the leader of the Johannites in Geertgen's painting, the knight to the left in the lower group and to the right in the upper, has by now been identified; he is Commander Johann Willem Jansen (1484–1514). For this and other details supplementary to Riegl's discussion, see James E. Snyder, "The Early Haarlem School of Painting. II. Geertgen tot Sint Jans," *Art Bulletin* XLII (1960), pp. 125–6, and the literature cited there.—TRANS.

3 It is this emphasis on a certain more intimate kind of attention that distinguishes, for instance, the sacrificial processions of the Ara Pacis Augustae from the classic Panathenaic pageantry in which we see mainly the representation of action totally absorbing the mental element— a circumstance up to now not properly appreciated. By the same token, it was also Imperial Rome that imparted to the eye, as the foremost means of expressing attention, a formative rendering [*Ausbildung*] unheard of until that time and opening the way for all future, especially Christian, art. During the Roman Empire, art for the first time endeavored to deflect the direction of looking from the direction of the head, thereby giving to the former (that is, the underlying attention) a self-contained and autonomous importance, separate from the will (which governs all the other parts of the body).

4 An illuminated Greek manuscript now generally dated in the 6th century A.D.—TRANS.

5 The intrusion of action and subordination can be followed best in the history of the Santa (sic) Conversazione, which preserved the medieval attitude longest and most adamantly in the South.

6 In this connection, attention may be drawn to the strange foreshortening of the bent head of

the executioner in the rear who throws the bones into the fire. This foreshortening seems to have come in rather handy for the master, as he repeats it twice: in the already mentioned Johannite who gazes into the coffin, and in one of those who place the body of the Baptist into the sarcophagus. All perspective, that is, linear perspective as such, becomes space-indicating for the figure, wherefore the Italians gave it so much preference in developing it. The Netherlanders, on the other hand, had every reason to avoid it, which Geertgen did, too, with the one exception mentioned. This poses the question of what he wanted to express by it. It seems to me that he liked this motif because it reveals an inner life without showing the eyes in which the attentiveness of the other figures concentrates. Similarly, among the people of the retinue, the only Moor is represented with his head slightly turned to the side and with gesticulating fingers, and just this one figure shows us the back of his head. Dutch art of later times likes to present the heads of attentive figures drooping down, in order not only to eliminate the sensual impression of the eyeball, but also to preclude the effect of the glance, thereby letting us divine the inner life, so to speak, from the shadow above the eye sockets, which already comes close to modern subjectivism.

FORMAL CHANGE

3 Métamorphoses

HENRI FOCILLON

After having served for more than a decade at Lyon as professor at the university and director of the municipal museums, the French scholar Henri Focillon (1881–1943) was called in 1924 to the Sorbonne in Paris to succeed the renowned historian and iconographer of medieval art, Emile Mâle (1862–1954). In Paris, Focillon turned his attention from the study of engraving and 19th-century art to medieval art, which he approached not as an iconographer but essentially as a formalist, dealing with the genesis, evolution, and dissemination of formal conventions in the history of world art. His points of view are well exemplified by his best mature work, *L'Art des sculpteurs romans* (Paris, 1931), of which the remarkable chapter entitled "Métamorphoses" is presented here in a literal translation rendered by Marcel Röthlisberger especially for this anthology.

One of Focillon's major interests was the role of materials and techniques in the origin and development of forms. As the son of Victor Focillon, a well-known engraver, he learned to use and to love the tools in his father's studio, and this early, intimate experience with the artistic process was never lost on him. As early as 1919, a collection of his essays appeared entitled *Technique et sentiment,* in which the tools of the artistic process are regarded as "forces endowed with life" and "powers of magical suggestion." As did his contemporaries, Alois Riegl and Heinrich Wölfflin, Focillon focused on the nature of the genesis of art and the evolution of its forms, which he, too, regarded as an autonomous development. After deep and long study of these matters, he articulated his presuppositions and points of view in his major theoretical treatise, *Vie des formes* (Paris, 1934), which subsequently appeared in an excellent English translation by Charles B. Hogan and George Kubler in 1942 (2d Eng. ed., enl., New York, 1948). The opening passage of this treatise brings to mind the major thrust of his "Métamorphoses":

Whenever we attempt to interpret a work of art, we are at once confronted with problems that are as perplexing as they are contradictory. A work of art is an attempt to express something that is unique, it is an affirmation of something that is whole, complete, absolute. But it is likewise an integral part of a system of highly complex relationships. A work of art results from an altogether independent activity; it is the translation of a free and exalted dream. But flowing together within it the energies of many civilizations may be plainly discerned.

In addition to a long and impressive list of publications that comprises nearly four hundred books and papers (see *Bibliographie Henri Focillon,* comp. Louis Grodecki [New Haven, 1963]), Focillon's contribution is to be measured by his participation in a variety of causes. As a student he was active in social movements. After World War I he worked to promote the international educational efforts of the League of Nations. He was instru-

Translated by Marcel Röthlisberger from Henri Focillon, *L'Art des sculpteurs romans: Recherches sur l'histoire des formes* (Paris: Librairie Ernest Leroux, 1931), pp. 164–94. Reprinted with the permission of Presses Universitaires de France, Paris.

mental in the foundation of institutes in France, Roumania, and the United States. His lecture tours took him throughout Europe, the United States, and even Latin America. At the outbreak of World War II, he emigrated to this country and was invited to share a chair of art history at Yale University with the eminent French historian of medieval art and architecture, Marcel Aubert; he quickly attracted a host of young students in lectures and seminars. In the winter of 1940–41, he was invited to the Dumbarton Oaks Research Center for Byzantine Studies in Washington, D.C., as its first Research Scholar in Residence. During his few years in this country, his art history, eloquent speech, and universal humanity influenced many a scholar, student, and layman.

For a further insight into the accomplishment of Focillon, the reader is directed to his *Art of the West in the Middle Ages,* edited and introduced by Jean Bony (trans. Donald King, 2 vols. [London, 1963; Phaidon paperback]); the "Mélanges Henri Focillon," which appeared in *Gazette des Beaux Arts* XXVI, 6th ser. (1944); and the many writings listed in the *Bibliographie Henri Focillon.*

Eleventh- and 12th-century art is a rich repertory of forms that are seized by a marvelous instinct of life, yet are estranged from life. First, there are monsters, properly speaking, curious beasts that are at the same time plants, or composed of heterogeneous elements borrowed from different species, or even invented outright, as it would seem, according to the wandering caprice of the mind. Romanesque sculpture also shows human figures treated in the same manner, that is, composed of human and nonhuman elements. Finally— and this is no doubt the most interesting point—it presents an image of man with normal limbs, without foreign appendages, but elongated or shortened seemingly at random. It is well known how much this quest of beauty within "deformity" in the proper sense of the term, this *"formosa deformitas,"* roused the indignation of St. Bernard. He speaks of it with the eloquence of robust common sense in his *Apology to William of Saint-Thierry.* No doubt correctly do we see in him a reformative ascetic who needs the blank wall and the void in order to pray well, and we appreciate the elevated elegance of this austerity. But there is no question of taking him here as interpreter. This order of thoughts escapes him. It is an amusement to him and diverts from eternal truths. Far

from appearing to him as a law, he regards it as emerging from the disorder of imagination and from the debauchery of instincts. This magnificent dream of a Genesis continuously starting afresh shows in some way God at work in changeable matter. But the forms that He extracts from it, and which we take for rough and still convulsive sketches of chaos, are in reality predestinations.

We are ourselves tempted to interpret the oldest of these monstrous creations as a return to coarse forms. Speaking of the Atlas figure of an archaic capital of Auvergne, the scholar who has studied these questions with the most profound discernment, Louis Bréhier, uses the term "regressive convention."[1] To be sure, convention for any art, and especially for any decorative combination, is a convention. These touching, warped figures in which the effort is so apparent, these human animals sadly wearing a heavy burden of stone, are at the origin of a considerable work. If they seemingly turn backwards, it is not out of a passive obsolescence, it is not pure regression. We detect in them the beginnings of a construction of form.

I

In order to understand the principles in the 11th and 12th centuries, it is useful to

[1] Notes to this selection begin on page 153.

compare the characters of these fantastic creations in Asia and in Europe. This vast region of the human dream world deserves a systematic inquiry, it solicits everywhere the curiosity of the intellect. It touches upon the most intimate secrets of religious life, of which it gives us an expression of an esoteric character. It reveals psychological complexes that belong to the primitive history of man. It shows space and form treated with an audacity of combinations that the art of pure imitation never knew. The very term monster is repellent to reason and carries a pejorative note. But it would be wrong to take it as synonymous with frenzy and barbarity. In fact, it signifies, perhaps in the same way as the general ideas, the tools, and the machines, an endeavor of the "creature" to be itself in turn creative. If the monsters often betray the humble attitudes of spiritual life before the mystery of destiny, death, and the gods, they are also like symbols of the exchanges between all the forms of life. By linking the human being to the animal, by making man emerge from animality, by granting an organic appearance to the convulsions of nature and to the elementary forces, to the fluids even, they populate the universe with a new reign, with a rich series of intermediary lives.

But they differ widely according to environment and race. We immediately become aware of this if we think of the Far Eastern monster, the terminal point of our comparisons. In the art of Buddhist Asia, two contradictory forces are at work, one that accepts the image of man, one that dissolves it. Even before the expansion of Greco-Buddhism, the nudity of the Jaina saints may have reproduced some ancient Apollonian type from Ionia. In the first centuries of the Christian Era, nomadic workshops of Hellenistic sculptors imported to the kingdoms of northwestern India—heirs to the Greek tradition of the satrapies of Alexander—statues of the Mediterranean gods and of the Latin magistrates. But this energetic affirmation of the value of man and the beauty of his perishable flesh embodied quite inexactly the dream of the Sage and his detachment from everything. One sees the image of Buddha going to sleep, in its perfect form, as though it gathered itself and withdrew to the heart of matter in order to faint away and disappear forever. Precious reliquary, empty container. The great bronze statues of the 7th and 8th centuries preserve the purity of an almost Praxitelean form, like a resplendent sarcophagus closed upon nothingness.

But Buddhist thought contains a principle of dissolution of the human form that goes far beyond even this sleep. All life is merely a passage, all appearance is provisional, man is only instantaneous in the multiplicity of successive existences, the animal and the plant, too. They are accidents in space, faint ruffles of infinity. The doctrine and the imagination naturally led to exchanges and combinations. The tissue of all our lives until the distant Nirvana is made not of the identity of a body and a person, but of the essence and the appearance of all possible things. We are not separated from the grass, from the bird, since we have been it, or shall be it. Thus, inert matter is itself figure and physiognomy. The condition of all that exists expiates previous passions or is a reward for good deeds. In this way, we partake of the whole of nature; man, unstable or in brief equilibrium, is the beginning or prolongation.

Another force—the ancient animism that bestows a body, instincts, a will upon all the hidden forces—continues to act in a lower key with the coastal and insular people of the Pacific. To Buddha in eternal repose, enclosed in his sheath of humanity, it opposes the Dragon of eternal change. It is the whirl of the hurricane over the sea, of the storm, of the fog that lingers in the valleys and clings to the roughness of the rock, letting the crests appear as projections from a spine. While the Mesopotamian bull braces himself on his four paws

or crouches, unchangeable in his form, on the Han bronzes this monster makes vapors, is engendered by them, twists in a hundred ways, shimmering and changing, and undulates across the airs in order to devour the sun. Is it not the master and the inspiration of all the monsters brought forth by the astonishing graphic fantasy of China and Japan? It is there, perhaps, that the art of giving life to the impossible exercises itself with the greatest authority. This frightful creature, fitted with membranous wings, scales, horns, claws, and feelers, as nervously endowed for acting and combating as he is, is not activated as an automaton; as complex as he is, he does not seem to be made of detached pieces; he is a living entity, an abrupt and total apparition. The Far Eastern monster is a meteor and a thunderclap. It is the expansion, the indeterminate explosion, of a point in space. It is conditioned by nothing.

It finds its best expression not in bronze or stone, but in ink and brush. In the mist of water and smoke that impregnates the moist silk, it is a paraph, a backstroke, a sharp and rapid bite of the point. The astonishing fencing of the calligraphers maintains for it in this aquatic universe the concise, bizarre, yet nevertheless physiognomic character of the ideogram. This monster, originating from the ocean, still palpitates on the silk or paper, but there it already belongs to the alphabet. The imagination that engenders it is, as a matter of fact, perhaps more limited than one would at first think. It has no limit, nor rule, other than that of the matter that carries it and of the tool that suggests it. The absence of an exterior order reduces the vigor and originality of its experiences. It is a fugitive shadow in the trembling air.

At an earlier period, central Asia, Mesopotamia, and Iran offer other combinations, determined far more neatly and at first strongly linked with the wall through monumental or rupestrian sculpture. They do not err in vain in the atmosphere, they are not displayed by a single blow, fleeing and dying immediately thereupon. They are not the trace of the brush on fragile matter. They have the stability, the ponderability not merely of matter, but of the architectural organization. The eagle's wings with which the monstrous gods are purveyed do not prevent them from bearing upon the earth with their heavy sabots of quadrupeds, or, if they hover in the air, as did Ormazd, it is as though they were seated on some invisible throne. There is no greater contrast than the one opposing western Asia to the Asia of the Pacific, the land of the huntsmen and warriors to the land of rice fields and the archipelagoes of fishermen. Yet, the Mesopotamian arts have radiated as far as China, exercising on either side of their center of formation a fanlike influence; I have recalled it above, speaking of the Han. But, as E. F. Fenellosa has demonstrated, eastern Asia is no doubt the scene of a struggle between two currents, one coming from the Tigris and the Euphrates as well as from the highlands of Iran, the other from the whole of the Pacific, from the Bering Sea and the Aleutian Islands to New Zealand. On the one hand, the dragon and the great fliers with spread wings, the frigate birds, and on the other hand, the bull of Assyria, Zendic Persia, and Mithra.

In Khorsabad, on either side of the doors, the winged bull wears a human head crowned by a tiara and prolonged by a curled beard. We are no longer faced with an explosive meteor but with a very stable composition of easily identifiable elements. But its parts are so ingeniously linked that this monstrous combination seems admissible to us, natural, apt to live. The reason is that their stylistic and technical unity is formidable. At all times those [Assyrian] huntsmen have given to the human form the muscular touch, the rough framework of bones, ligaments, and nerves of the bestial form. The thighs, ankles, and arms of the kings victorious over the lions are not composed entirely of pieces of armor, as Heuzey said, but are

tied with the same protruding thongs as are the limbs and the bodies of their prey. Man and animal belong to the same reign and almost to the same species. Above the neck of a bull, a man's head may rise without disconcerting us, because it breathes a life of the same order. It is the fusion of the animal and the sculptor of animals.

Let us add immediately: the measure of space in these guardsmen of the doors is admirable. They are not narrowly defined by a milieu, but they are strongly determined by their function, which is to take possession of the walls on each side of a bay. They are symmetrical, they are facing us, and above all, they belong to the wall. The astonishing impression of vigor and unity that emerges from these monsters is due not only to the authority of the style that I have tried to define, but also to the possession of the wall. The impression is not less strong—perhaps it is even stronger—as we pass to the lion-griffins in colored, enameled bricks on the frieze of Susa. Above the bulging breast adorned with small curls, the head of the lion is surmounted by horns rolled up in a spiral. Its short and terrible wings, attached low, can permit it to fly, but it is far more terrestrial than aerial, and it bears down on the ground, where it moves with an even tramp. Lions, winged bulls, and dragons follow each other along the frieze in the same intervals and the same proportions.

The feroher, or Sassanian lion-peacock, may not originally have belonged to the monumental order. On the rupestrian reliefs it appears as though it were a decoration on fabric.[2] In a circular medallion, whose curve it embraces by bending its stomach and its tail, it is a typical example of a well-composed figure. Moreover, it seems in its very make-up a network of laces, an embroidery. The art of Achaemenian Persia gives the first examples of this evolution, which was one day going to reduce the organic form: among others, the lion assaulting a bull that decorates the staircase of the hall of Xerxes at Perse-

polis.[3] The bull, whose legs, one straight, another bent, lean rigidly against a flowered border of rosettes, seems to be embroidered with a broad lace of pearls along the spine, along the stomach, and at the joint of the shoulder. Monsters such as the feroher and diagrams such as the textile medallion allow for more supple combinations, for a more perfect success. Are we not, with the griffin decorating the costume of Chosroes II, already confronted with mature Romanesque art?

The Mediterranean peoples have invented with profusion. Egypt adored for a long time, under half-human form, the antique totems of the clans. It multiplied the image of the cynocephalous gods, of the gods with the head of a hawk, a jackal, or a bull. In the desert it erected lions with human heads dressed up as the Pharaoh. Its religious culture grants the animal an exceptional place. But in [Egyptian] art, man always tends to triumph, and he prevails indeed over the other elements of the monstrous combinations. Horus, Anubis, and Hathor remain normally, elegantly human in their entire bodies, from neck to foot. One is reminded of the masked personages of the fetishistic religions, who equip themselves on the days of the feasts with a wooden head imitating the totem. The animal-headed gods of ancient Egypt are perhaps masked fetishists. At any rate, the parts remain distinct, however well they are linked together. It is man who commands and defines the essential form. No doubt this does not apply to the sphinx: but it is a simple reversal of the proportions. The energy with which the Assyrian hunters bestialized man is lacking.

Is this not true also of Hellenic polytheism, prolific creator of monsters, inexhaustible narrator of fables? From Egypt it received the sphinx and the Minotaur, from Asia Minor the winged goddess, and the hundred-armed Briareus reminds us of the divinities of India. The funeral siren, which is not the maritime siren of Ulysses but a woman-headed bird, symbol of the

soul flying off, continues another siren, the human-headed Egyptian hawk, hieroglyph of the soul.[4] But Greek art has marked with its own stamp notable combinations of animal and man: the centaur, the satyr, and finally the Gorgon's head with a headdress made of knots of vipers. There again, it is admirable to see how, despite the skill of the joining and the likelihood and aptitude for life, a despotic idea of man imposes itself upon the organization of the whole. Is the centaur very different from an equestrian Lapith? The genius of another people might have been satisfied with another dosage of the amalgam. The sculptor of Khorsabad merely placed a man's head on a bull's neck, while the Greek artist has a complete torso with two arms emerging from the trunk of a horse. Not only do the parts of the man's body used by the inventor of the monster remain intact, but also the animality retreats. Only the satyr preserves, besides the paws, two small horns, a beard, and a he-goat's profile. But at the dusk of Hellenism, with the anthropomorphic evolution accomplished, the small Campanian bronzes show us the faun in a purely human image, which only preserves of its origin a short tail at the loins.

The history of the siren in Egypt and Greece is equally instructive. It, too, tends to rejoin man, to escape from the old totemistic form, to cast off the animal. Holleaux[5] early emphasized the *humanity* of the symbolic bird in the Egyptian statuettes of enameled terra cotta and in sarcophagus paintings, where it is seen in profile, ". . . walking with a gentle pace, stretching forward and lifting its human arms in a gesture of adoration. . . ." A terra-cotta statuette, and a marble statuette acquired in 1918 by the museum in Lyon, along with another terra cotta in the same museum, coming from the Artaud collection, give us in some way three stages of this development, of this progressive aspiration toward the human form. They have been studied from this point of view

in the charming and profound pages of Henri Lechat.[6]

At first a simple, woman-headed bird, the siren is soon fitted with two human arms. Since the Egyptians had thus represented their symbolic bird, the Greeks naturally profited immediately from the work already done. But while the artists of Egypt, having given the figurative sign of the soul sufficient means of action, and having assured it of its full value, considered their task accomplished, henceforth confining themselves to mechanical repetitions of their creation throughout centuries in thousands of examples, the Greeks, on the contrary, did not stop on the way; their aesthetic sense engages them to seek continuously how to modify or complete this type, which was originally a pure symbol and which is now a work of art. Thus, they shape for it a human breast; then, they continue, it is not merely the chest, it is the entire torso, it is the hips, the thighs, at least in their upper part, that are imitated from the body of a woman. And, since a human torso is not meant to trail on the ground, and since, besides, birds' claws could not carry it that way, they straighten the entire figure, raising it to a vertical stance: the tail, broadly displayed on the ground at the back, adds a solid reinforcement to the frail claws, and the two wings, more or less open, more or less extended, spread from top to bottom a foil from which the artist can draw varied effects.

To this last type belongs the marble statuette at Lyon: the breast, the abdomen, and the hips of the bird-woman are of an exquisite feeling of femininity. The charming monster offers now only a remote resemblance to what it had been a century and a half earlier. It dates from the 4th century B.C., a period when sirens became numerous in Attica.

Thus, in this vast field of the metamorphoses, where the poets and the mythographers do not tire of showing us how at the will of the gods the human being can be changed into an animal or a plant or can even be mingled with the elements, to rank among the constellations, an important place must be reserved for the reverse metamorphoses, which from a goat result

in the Aegipan, then in the completely manlike faun, and from the funeral bird result in the siren, more woman than bird. The Greek mind, contrarily to Circe, changes animals into human beings. For a long time it was to remain faithful to this choice! Even penetrated by Asiatic influences, even bearing the return impact of the Indian forms, it remains, at the twilight of its history, attached to the human norm and to the physiological likeness. In Egypt, from the Roman conquest to the Arab conquest, the taste of the Alexandrian bourgeoisie for elegant mythology continues to mingle the gods, the animals, the monsters, and the symbols of the elements on facades and in niches. As we study the iconographic repertory of the sculptures of Ahnas, dating from the 4th century A.D., we again find the loves of mortal women and divine animals—the rape of Europa by the bull, Leda and the swan, the lascivious plays of the Nereids and the Tritons, the birth of Venus from the waves of the sea, the metamorphosis of Daphne pursued by Apollo. Rather noteworthy is the study of this last theme in sculpture fragments in the Cairo Museum, which Monneret de Villard[7] linked with an ivory in the Ravenna Museum and a Coptic textile in the Musée Guimet [Paris]. Daphne transformed into a laurel—should we not expect to find in such an image, at the last hour of the twilight of Hellenism, the promise of these combinations with which Romanesque art so tightly intermingles the human form and the plant form in the capitals of the West? There is none of it. In the two fragments of Ahnas, the nude Daphne rises between two branches of laurel. In the one case, her arms are extended, in the other, her arms are bent and raised in the gesture of the *orans;* she seems to be holding the flexible branches with which she is to be united, but the metamorphosis does not take place, and Daphne remains entirely a woman. In the ivory in Ravenna and in the textile in the Musée Guimet, her feet and the lower part of her legs are hidden by the trunk of the laurel. The trunk divides into two branches, between which she rises with much grace, not as though she were to be united with it, but as though she emerged from it in order to be separated from it.

This respect for the human form at the very heart of the metamorphosis was not, however, always observed by Greek art. On the sculptures of Ahnas, in the niches where Venus and Daphne appear, one observes that the proportion of these two figures is arbitrary. They express a charming sensuality, but they are lovely dwarfs with heads too large; does perhaps an influence of the sculpture of India make itself felt here? Were this feature even more of an adaptation to the necessities of the place and the décor, it would have great importance for us. But one must above all remember that Alexandrian "genre sculpture," heir to an ancient Egyptian tradition, long-lived in the delta, loved caricature, the dwarfs, the Pygmies, the fellows with a grimacing head on a puny body. The hydrocephalous buffoons are of the same order as the teratological terra cottas of Asia Minor. These had, perhaps, in a certain number of cases, a medical character; but the study of deformities, of scoliosis, of all the varieties of rachitis, denotes a new curiosity that contradicts pure humanism. Besides, let us remember that statuettes [of dwarfs] such as those dug up at Mahdia [Tunisia] were, above all, comic fantasies. It is thought that the sunken vessel that carried them had despoiled them in Athens in the course of the 1st century B.C.; thus, Atticism itself knew these diminutives and these facetious monstrosities. These light trinkets are the burst of laughter of a fanciful mind that wants to amuse a tasteless bourgeoisie. We are at the antipode of the Roman genius.

The art of antiquity knew other monsters that were neither the mating of man with beings of another species nor the deformation of the normal type, but a

combination of elements borrowed from different animals: the winged horse Pegasus, the chimaera, lion, goat, and serpent all in one—in addition fitted with wings. At the end of the 5th or beginning of the 4th century, Thrasymedes of Paros decorated the throne of the statue of Asclepius in Epidaurus with reliefs representing various legends, among which is Bellerophon wrestling with the chimaera. The same subject is treated at the *heroon* of Tyrsa. It was from Asia that this beast of fable, as well as many others, reached Greece. In the struggle of the gods and the beneficent heroes against the monsters— Apollo and the Pythian serpent, Herakles and the Hydra with its ever-growing heads, Bellerophon and the chimaera—it is permissible to see a kind of symbol of the efforts of Hellenic anthropomorphism to humanize the animality of the ancient cults. Roman Imperial art, rich in elements borrowed from Hellenistic Asia, likewise accepted the old, legendary menagerie; it made knowledgeable use of it for the decoration of monuments; for proof, we only need think of the admirable frieze of griffins of the Temple of Antoninus and Faustina [Rome]. But fine examples of this kind cannot modify our conclusions regarding the disposition of the Greco-Roman mind to engender monsters: it remains humanistic above all.

As a rule, the type associating man with beast is governed by a principle of internal harmony that respects the human form, or rather tends to assimilate the beast with it; the evolution of the siren is characteristic. Normal man (or woman) is the aim and the model of these metamorphoses. Their value resides in the quality of the verisimilitude and of the anatomical norm; it is measured precisely by virtue of this verisimilitude. This notion of verisimilitude is utterly foreign to both the Eastern and the Roman mind, to the pen stroke of the calligraphers, and to the stroke of the chisel of the 12th-century sculptors. The Romanesque metamorphoses of man or animal must be studied not as a combination tending toward verisimilitude, but as an architectural composition.

II

I shall begin by discarding (not in order to eliminate them, but because they have, to my mind, only the value of *witnesses*) a certain number of types of importation. They are not the results of a creative elaboration; they present themselves as detached pieces, more or less agreeably encrusted into a whole, be they applied to a wall or to the surface of a capital, similar to a hunting trophy—for example, the griffins and stags in the exterior frieze of the bell tower porch at Saint-Martin d'Ainay, in Lyon, carved into juxtaposed blocks, the edge of which serves as a frame.[8] Many Arab elements of churches in the West belong to the same category and are apparently copied from the ivory caskets brought back from Spain or received as presents by the counts of Poitou. They are full of interest—we shall find them again—but they represent much less the result of an experience with the forms than an outside contribution—in a milieu, to be sure, that was likely to be interested in it and to understand it. But our research, while making allowance for borrowings of this kind, must be concerned with the manner in which the figure, in particular the human figure, modified in its equilibrium and its proportions, accomodates itself to the monumental plasticity of the Romanesque style and to the measure of the space that is imposed by the need for decoration in a given place.

What struck the most attentive observers is, first, the anomaly of the proportions. Louis Bréhier[9] notes the taste of the Burgundian and Languedocian sculptors for too-long bodies with too-small heads— for instance, the Christ at Vézelay, the angels surrounding the throne of God at Moissac, the two figures that decorate the jambs of the same portal, St. Peter and Isaiah, and the tubular angels of the Last

Judgment at Autun. "The limits of boldness," says Bréhier, "are reached on certain trumeaux of the portals of Languedoc. . . . The prophets of Beaulieu stretch all their muscles in a supreme effort to support the massive lintel." At Souillac, we have "a heaping of elongated figures in unlikely poses, an excessive Abraham whose arm is stopped by an angel descending from heaven in an absolutely vertical position, . . . an inextricable melee of human beings devoured by monsters. . . ." The final stage of the elongation is no doubt the figures of the portals of the transition, called statue-columns, of which the Royal Portals of Chartres offer us such beautiful examples.

Contrasting with this long type is the short type with big head, frequent in the Provencal and Lombard schools, and even more characteristic in the ateliers of Auvergne, where it is more squat than in the southeast. According to [Jean] Laran,[10] the relationship between head and body of the angels of Notre-Dame-du-Port is only 3 to 8; according to Bréhier, for the Auvergne capitals this relationship is generally 3 to 6. We thus have two races and, as it were, two humanities, both estranged from the normal—the one, mystical and violent, rising beyond measure to heaven, whence it descends occasionally in a blasting flight, capable of bending its long body in attitudes appearing most paradoxical, and also of staying rigidly in absolute immobility, to the point of espousing the form of, and playing the role of, the jambs; the other, terrestrial and squatty, recalling the dwarfs and the buffoons of Alexandrian sculpture and, above all, popular Gallo-Roman sculpture, and sadly carrying the weight of a too-big head on a skimpy body. Each of these two races has its area of geographic expansion, the one Burgundy and Aquitaine, the other Provence, Italy, and the Auvergne.

But this distribution is arbitrary. Burgundy offers very many examples of the short type with big head: the Apostles below the arcades of the lintel of Châteauneuf (Saône-et-Loire); those of the oldest lintel of Charlieu, and, also in Charlieu, on the relief of the cloister, the figures of the Annunciation; the Presentation in the Temple, at La Charité sur Loire; the lintel figures of Anzy-le-Duc (Saône-et-Loire), now in the Eucharistic Museum of Paray-le-Monial. Even more numerous are the examples offered by the Burgundian capitals: at Vézelay, to take only the most notable ones, the capital of the Winds, Daniel between the Lions, David and Nathan, Samson, the Golden Calf; at Saulieu, the Flight into Egypt, the scene of the *Noli me tangere*, and Balaam; at Moûtier-Saint-Jean, the capital representing Cain and Abel, now in the museum in Cambridge [Mass.], and others. They are, then, not chance encounters; it is almost a constant. The same is true of Aquitaine: at Toulouse, the beautiful lintel of Saint-Sernin, the corbels of the southern portal, the capitals of Daniel and of Christ in Glory; among those of the Daurade, David playing the harp; at Saint-Bertrand-de-Comminges, the lintel; the capitals of the abbey of La Sauve (Gironde) and of Saint-Martin at Brive, and others. The archivolt figures of Oloron-Sainte-Marie (Basses-Pyrénées), so characteristic, are dwarfs.

There can therefore be no question either of an ethnic determination or of workshop habits. We must look elsewhere for the *raison d'être* of these systematic deformations. More and more one tends to link them with the imitation of certain models, and from the doctrine of iconographic inspiration laid down by Emile Mâle, one has passed to that of stylistic limitation. Bréhier finds the elongated figures again in mural painting and in manuscripts. The walls of the churches were covered with paintings that were, incidentally, like the capitals and the other sculptural parts. The translation of those models into sculpture was rendered easy by the very style of the painted compositions: energetic contours and flat

tones. Numerous works show us the disproportionate shapes, the exaggerations of the "Aquitaine" type: the immense St. Michael of the cathedral of Le Puy, the Virtues that accompany the Last Judgment in the narthex of Brioude. But one may wonder why Auvergne, presenting in mural painting such beautiful types of long figures, remained in sculpture the preferred location of the short figures.

Bréhier also attributes importance to the manuscripts as sources of a style, not only as repertories of long figures, but also as compositional models. The rays extending from the hand of Christ to the heads of the Apostles, in the tympanum of Vézelay, recur in the representation of Pentecost as it appears in the Yates Thompson Missal in London [British Museum], the Vatican Gospel (ms. lat. 39), and the Cluny Lectionary in the Bibliothéque Nationale [Paris]. Likewise an idea of a painter would seem to be the Wedding at Cana on the tympanum of Charlieu, arranged in a hemicycle and seen in perspective. These suggestions, as well as the observations of the same author on the drapery folds, seem to remove us from our subject. But it appeared to me that I had to present the "imitative" theory as a whole, the parts of which hold together. Let me right now indicate that the rays of Pentecost, forming a sort of false pediment within the semicircular tympanum, and the curved table of the Wedding at Cana, repeating the outline of the archivolt, are part of those processes conceived by architects and sculptors who subordinate the sculpture to monumentality. It is neither pictorial nor picturesque.

The origin of the squat type is likewise reduced by the learned historian to the imitation of certain models, particularly Gallo-Roman sculpture. At the end of the empire, we find indeed, side by side with the copyists of the great statues, the appearance of a school of indigenous, rather mediocre sculptors and even of a popular art, as attested by funeral stelai bearing the image of the divinities of Roman Gaul. A good example of this thickset sculpture is provided by the Mercury of Lezoux, with the shoulders of a peasant, a big, hard head, and a miser's purse held in his hand. The affinities are close above all in the school of Auvergne: a capital of Mozat, stamped on each face with masks, may be a copy of a Gallo-Roman model in the museum at Reims. The ornamental ceramic medallions, of which several well-known workshops existed in Gaul, could also have lent suggestions to the cutters of images and to the sculptors of capitals. It remains true that the industrialized Hellenistic sculpture of the late periods cheaply multiplied trinkets representing dwarfs with enormous heads and the comic deformity of the monsters as shown in the jugglers. Popular art may have taken them up and may even have inspired the small, local divinities and the domestic Genii dear to the peoples of the earth in the remote districts. It is, though, not absolutely certain, and we must always reckon with survivals of ancient traditions.

It is a fact that the short type is not specifically of Auvergne or Lombardy, since we encounter it often in the churches of Burgundy and Aquitaine; on the other hand, the long type is found in Auvergne— for example, in the beautiful Apostle figure in the museum of Le Puy, coming from the Hôtel-Dieu of that town. Finally, as we have indicated, if the influence of the paintings were decisive, the importance and the interest of the elongated figures belonging to mural decorations of Auvergne would make it difficult to understand the predilection of Auvergne for the short type. In explaining the deformation of the human figure in the two directions, the influence of the models seems in reality as questionable as that of the specifically local or ethnic quality. It is to the study of the forms themselves, of the monumental rapport, and of the problem of position

that we must turn. We shall then understand why in the same building the long and the short type occur together.

Where are the figures of the elongated type placed? For the most part in the tympanum, the trumeau, and the jambs. Where are the figures of the short type placed? For the most part on the lintel and on the capitals. The reason for this is easy to see. Short of cutting and fragmenting them, which would be absurd in architecture where the decoration is closely linked to the function, the trumeau and the jambs can only accept long figures that rise in such a way as to occupy the available surface. It is true that the figures of the Provençal façades, those of the pillars of the cloister at Saint-Trophîme, are not long figures; but they present no link whatsoever with the dwarf type such as we have defined it above, and they cannot be classified in the same category. There exists a striking difference of proportion between the Provençal statues and the figures of the capitals of the same school. The image of the standing man in an upright frame, more or less associated with a function, tends necessarily toward the elongation of the type. The same applies to those placed in the tympana. This large, semicircular space could not be filled by dwarfs, unless it were split into compartments of one kind or another—for instance, reduced to a system of bands, as seen occasionally in the Romanesque period,[11] and as seen frequently in the Gothic period. If, on the other hand, the tympanum of the Pentecost at Vézelay is examined, one perceives a scaling of the proportions, which are in some sort changed as the figures approach the border of the archivolt, which in turn compresses them[12]—a measure underlined by the rays emanating from the open hands of Christ. The latter, in His mandorla, interrupts the course of the inner archivolt, and His head is placed into this notch. He is larger because He is Christ, but He is

also larger because He occupies the tallest axis. We have, for the rest, a proof of all this being planned in this way in the figures of the compartments of the inner archivolt, which form curvilinear rectangles: these figures are of normal proportions. As for the carved lintel figures, one cannot be mistaken about the elongation of their stature; but it is undeniable that the heads that are preserved are enormous. Finally, on either side of this admirable group and on the north and south portals, especially the latter (for the upper hemicycle of the north portal still follows the system), the short figures have big heads.

The same observations could be repeated for the tympanum of Autun. Unless large voids were maintained and few figures used—a solution that was generally to be adopted by the masters of the transitional period—it was necessary to elongate the figure of man according to the space he had to fill. This need for contact with the border is one of the essential rules of Romanesque art; we shall later see other and most singular consequences of this fact. At Autun, in order to avoid a threadlike elongation, the artist divided his tympanum into two zones, keeping the entire height for the central figure of Christ. But within the compartments, which are, moreover, scaled, the figures rise, rise to their borders, and seem a combination of tubes. As for the lintel, I admittedly still see long figures, but, as in Vézelay, their heads are of a disproportionate volume: they are not too small, they are rather large for these lean "nakednesses," and their volume is, by comparison, far more considerable than that of the heads on the slim shoulders of the tympanum figures.[13]

Is it possible to account for this? Characteristic examples of lintels (always chosen from the regions known for long figures) may perhaps permit an explanation: in Burgundy, those of Châteauneuf and Charlieu; in Languedoc, that of Mois-

sac. The first two show the Apostles lined up one by one under arcades. At Châteauneuf they are standing; they are seated at Charlieu. There can hardly be more typical examples of stocky figures. If we recall the lintel of Saint-Genis-des-Fontaines, we see that it is the arcade, here as well as there, that determines the volume of the head: the carved intervals around the figure are the same around the head as on either side of the shoulders and the hips. At Charlieu, where the arcade is wide open, an aureole further increases the size of the head. At Moissac, the case is a particular one: placed rather in the lowest register of the tympanum than on a lintel, the Elders of the Apocalypse are not dwarfs, but the proportion of the heads is normal as compared with the too-small heads of the tympanum, the sides of the portal, and the trumeau. Some are even too large, for example that of the elder with crossed legs, the fifth from the right. There is no vestige whatever of an arcade, for one cannot interpret in this way the undulated cloud that serves as the base for the upper part. Nor does anything remain of the old frontality: on the contrary, one sees in each of these statuettes a search for movement and variety. And despite everything, these figures belong to the same family as the Apostles under the arcades of the Burgundian lintels. The discussion is no longer possible in front of the lateral reliefs inscribed in long, horizontal bands—the Presentation in the Temple and the Flight into Egypt—where the figures are short in stature and the heads massive, while the contrary is the case in the vertical panels that accompany them, which carry representations of the Vices—Avarice and Luxury.

The canon [of proportions] of all these figures appears to us, therefore, determined not by the measure of man but by the measure of the space. We gain a further, very convincing proof of it by studying the tympanum of Conques. One recalls that the lintel comprises two compositions,

each placed under a sort of protecting double roof analogous in form to the so-called Auvergne-type lintel and furnished with diminishing arcades. Now the heads of all the personages placed underneath have the same volume, but the size of the bodies decreases with the height of the arcades. The last ones seem cut off at the knees; but the feet emerge from under the border of the robes, and we have in fact the complete body, though contracted and stocky; and the volume of each head, which is respected, seems arbitrarily enlarged.

The study of the capitals is even more instructive. It is there that the short type assumes its full authority, that we systematically find enormous masks surmounting doll-like bodies. It is quite evident that the long type could not find a place on the narrow corbeil without being bent into complicated attitudes. But why are there so many strange dwarfs appended there, while in other examples from the same period, the same region, neighboring workshops, and sometimes from the same church, the Romanesque sculptor would respect the proper proportions and convey to them a charming grace? The capitals of the Musée Ochier, at Cluny, display figures of the greatest elegance. The symbolic representation of the fourth note of the plain chant, for example, seems to belong to the art of the 13th century rather than to Romanesque art. We have seen how we have to interpret these lovely Cluniac figures; some are applied to the corbeil as though their task were to make us forget its structure. The big-headed figures, quite the contrary, reveal their secrets. I have cited the capital of the Winds at Vézelay: on the lateral right-hand face, the head of the symbolic figure has the place and importance of a rosette, and on the back face there are two of them, symmetrically combined. It is even more striking on the capital of Daniel in the same church, which is attributed to an artist from Cluny because

Daniel is represented in a mandorla, despite the immense difference of treatment, technique, and quality that makes us reject this attribution. A head on a Cluniac capital, in a plastered medallion, is normal; this one is huge. Placed directly below the abacus, framed by two volutes, it is an architectural element. On the capital showing Samson and the lion, the head plays the same role, similar to that of the nimbed head of the Virgin, slightly out of axis, in the Flight into Egypt in St-Andoche at Saulieu; likewise the *Noli me tangere*, the Balaam, and so forth. These huge heads, these powerful masks, mark the capital and have the image of the human being furnish its vigorous equilibrium. At Moissac, to cite one among many examples from Languedoc, on the capital of the Stoning of St. Stephen, the head of the saint is bigger than those of his tormentors, perhaps for hierarchic reasons, surely also because it is in the central medallion.

At the corners of the capital, these disproportionate volumes assume their most striking value and their greatest plastic authority: there they become corbel and consoles; they replace the volute underneath the abacus. The fact is notable in Auvergne—at Saint-Nectaire, at Mozat, and at Notre-Dame-du-Port; in this last church, on the capital in the ambulatory representing God and Adam after the Fall, the Visitation, the Annunciation to Zacharias, and the Angel and Joseph, we thus have monstrous caryatids of an astonishing vigor, short bodies that unfold into festive or terrible masks. What happens in Auvergne happens also in Burgundy and Aquitaine. In St-Martin, at Brive, on capitals of the type of the Arrest of Christ, the heads of the corner figures are one-third the total height of the bodies. On the capitals of Toulouse, carved according to the angular cutting of Moissac, the volute remains but the head placed below it has the proportion needed for it to act as console and point of support (Luxury, Expulsion from Paradise). At the Town Hall of Saint-Antonin, the human figure can not nestle entirely below the mask that terminates it, which measures more than half of what one sees of the body.

III

Thus, the elaboration of the giants and the dwarfs is due neither to pure caprice nor to a preference for certain types, nor to passive imitation; for the most part, Romanesque sculpture imitates only as far as it can adapt. We are at the peak of this severe liberty that imposes upon itself its own rule, and which would become servitude if it evaded it. The figures are engendered by it not for the life of the independent forms but for the requirements of a monumental order. The treatment of the overall proportions is merely a significant aspect of the system; there are many others, all of which can be reduced to principles of the same order. The parts perform similarly to the whole, and the whole can be decomposed. The limbs become elongated or atrophied. The arms stretch out in order to grasp the volutes or to reach across the knots of the interlace. The legs of several personages bend backwards and intertwine, thus forming figures, as they do on Irish crosses. The hand, as expressive as a face, unfolds enormously at the end of a slim strap. The human fauna of the capitals seems to transform itself before our eyes. The rule of these transformations must be sought only in the limits within which this drama is enacted. Thus the pacing of a prisoner draws on the pavement of his cell a hundred linear compositions, all of them inscribed in the square formed by the walls.

We have seen antique civilizations abolish the barriers that separate the species and create the bird-woman, the fish-woman, the human-bull. But by incorporating the existence of several beings within a single one, by having multiple lives pulsate inside a single body, the animal style had taken a dangerous step, destroying the principles of the unique in

order to recompose a complex unity. By joining and juxtaposing, all the varieties of fusion became possible for Romanesque art. It is no longer only the isolated being that serves as the subject of the experiences about irrational measures, but a singular duality made of two bodies that collide into each other and have one and the same head, or it is a single body to which two heads, two pairs of arms, and two pairs of legs are attached. In this way, the figures of the Asiatic medallions, displayed on either side of the altar of the blood ceremony or the altar of the fire ceremony come to meet and unite. The antithetical group becomes the synthetic group without losing its value as an antithesis. Defined not as interval but as a form in itself, the void separating the superposed figures was perforce destined to a powerful individual life, where other, opposed beings became fused.

Even after having been submitted to these frantic treatments, man, creation of God, made in His image, preserves certain identifiable traits of his humanity. The animal is an illimitable possibility. It can at once, be flying, swimming, and creeping; it can double, triple, devour itself ferociously, undulate as does the stem of a plant, be carved with moldings as is the base that it prolongs and to which it conveys an obscure physiognomy. To explain the Romanesque fauna by the Physiologus and the bestiaries is to limit it to a catalogue of borrowings. These old texts are less a source than an antecedent. Without them, Romanesque artists would have created their teratology.

But there exists in it a germ of destruction. On the day the armature gives in, the unemployed monsters will spread in profusion, destined to grow and to multiply at liberty. The fundamental antinomy that puts in opposition under all the forms, animate or not, the ornament and the architecture, will cause the latter to break under the useless and disorderly redundancy of the capricious figures. One can see it clearly in the countries where Romanesque art outlives itself, in Germany and in Italy.

In France, the architectural monster takes refuge in the upper parts. It brings about astonishing gargoyles, such as the beautiful dogs of the cathedral of Laon, with their paws bent back and their long, tubular bodies stiffened so well by the action. A Romanesque morphology endured for a fairly long time in winged figures of saurians, their necks carved with muscular wrinkles similar to moldings, and even in furious couples of the damned and of demons swung above the void, against a wall that they seem to push back with their heels in order to leap more vigorously, without ceasing to be marvelously adapted to their role of "throwers" [lanceurs]. But the absurd figure of St. Urbain at Troyes, a lovely vertical statuette placed horizontally, enabling water to flow from the vase, reveals what architectural sculpture lost to Gothic humanism.

Romanesque sculpture is first of all movement; even man himself, the long giant of the trumeaux, the jambs, and the tympana, moves with passionate ardor. Leaned against the lintel on these socles of immobility that the Twenty-Four Elders of the Apocalypse form for them, the Last Judgments stir throughout with movement. The angels, the elect, and the damned who bend their knees are joined by the flying figures, those who are falling, tumbling backwards, and, in the medallions, those forming the wheel. Romanesque art is not only the art of the monsters, it is also the art of the acrobats; besides the anomaly of form, there is the anomaly of gesture, as though the sculptor, respecting nature in a well-rendered body, wished nonetheless to impose upon it a sort of hidden frenzy and the audacity of his dreams. It is perhaps there that we shall see enforced with the greatest rectitude and authority the rules that have just been perceived.

NOTES

1 *L'homme dans la sculpture romane* (Paris, 1927), Pl. 3, p. 10.

2 Sarre, *L'art ancien de la Perse* (Paris, n.d.), pp. 94–5, compares a detail of the equestrian statue of Chosroes II, in the Tag i Bostan, and a Sassanian silk textile in the Victoria & Albert Museum. The feroher inscribed in a square is known to us from marble reliefs coming from Byzantium, preserved in the museum at Constantinople. Here, the tail of the peacock, still curved at the bottom, follows one of the sides. (*ibid.*, p. 102)

3 Sarre, *op. cit.*, p. 21.

4 For these connections with Egypt, see (Leon) Heuzey, Introduction to his *Catalogue des figurines antiques de terre cuite du Musée du Louvre* (Paris, 1882).

5 *Bulletin de correspondance hellénique* XII, (1888), p. 392.

6 "Sirènes," *Bibliothèque des musées de Lyon* (Lyon, 1919).

7 *La scultura ad Ahnas, note sull'origine dell'arte copta* (Milan, 1923), Figs. 38–41.

8 Deschamps, *op. cit.*, p. 65.

9 *Ibid.*, p. 18.

10 "Recherches sur les proportions dans la statuaire française du XIIe siècle," *Revue archéologique* IX (1907), pp. 436–59, XI (1908), pp. 331–59, XIV (1909), pp. 75–93, 216–49.

11 Tympanum of the church of St-Vincent at Mâcon.

12 See, above all, the last three Apostles on the left. The one closest to the border is restored by the border to the norm.

13 See also the beautiful lintel of Perrecey-les-Forges (Seine-et-Loire) and, in Montceaux-l'Etoile (Seine-et-Loire), the lower register of the tympanum, a sort of false lintel, and so forth.

PERIOD DISTINCTIONS

4 Principles of Art History

HEINRICH WÖLFFLIN

Born of a wealthy family near Zurich in 1864, Heinrich Wölfflin studied art history and philosophy at the universities of Munich, Berlin, and Basle, where his doctoral dissertation on Renaissance architecture was accepted in 1886, when he was 22. In 1893, he came to succeed his teacher Jacob Burckhardt (1818–97), the great historian and art historian of the Italian Renaissance, in the chair of art history at Basle. Soon after, he accepted the chair of art history at Berlin, which to this day many people regard as the pinnacle of a scholarly career. He retired from teaching in 1934 and died eleven years later.

Wölfflin's great persuasion and fame as a teacher and public lecturer were international. Overflow crowds of admirers were attracted to his public lectures and are reported to have been held spellbound. One of the techniques used in his lectures was the simultaneous projection of two lantern slides on a screen, a device he introduced to art history.

His most influential book was *Kunstgeschichtliche Grundbegriffe; das Problem der Stilentwicklung in der neueren Kunst,* "Fundamental Concepts of Art History," published in 1915. Its seventh edition was translated by M. D. Hottinger in 1932 as *Principles of Art History,* and the selection that is republished in this anthology is taken from that translation. These pages introduce Wölfflin's well-known fundamental concepts for dealing with the history of style. His avowed purpose as an art historian was to reduce the individual to the general—to the law. To remain simple at all times was the most important lesson he learned from his great teacher, Burckhardt. Wölfflin was convinced that seeing or beholding, like knowledge, has a universal meaning, and he thus formulated his concepts as universal forms of beholding. From an astute empirical observation of individual works of art—indeed works of great artistic significance—he conceived of his universal forms as schemata or polarities for describing the transformation of style. Specifically, his antithetical categories provide the art historian with analytical tools with which he can grasp and articulate fundamental stylistic distinctions between the Renaissance and the Baroque. As enormously influential as the book was, it received an avalanche of criticism that Wölfflin ignored until 1933, when he revised some of his views; but his recantation had little impact on art history (see his "Kunstgeschichtliche Grundbegriffe': Eine Revision," *Logos* XXII [1933], pp. 210–24; repr. in his *Gedanken zur Kunstgeschichte* [Basle, 1941], pp. 18–24).

While Wölfflin's *Kunstgeschichtliche Grundbegriffe* had a far-reaching influence on art history and criticism, as well as on the history of literature, musicology, and even economics, his finest book was *Die klassische Kunst: eine Einführung in die italienische Renaissance* (Munich, 1899 [*Classic Art; An Introduction to the Italian Renaissance,* trans. Peter and Linda Murray, New York, 1952]), published when he was only 35. Describing in masterly prose the salient formal features of individual paintings and sculp-

From Heinrich Wölfflin, *Principles of Art History,* trans. M. D. Hottinger (New York: Henry Holt & Co., 1932), pp. 13–17, 155–67 (reprinted by Dover Publications, Inc., 1950).

tures of the High Renaissance, it has been a source of inspiration for scholars and critics on both sides of the Atlantic and is widely used as a textbook in American colleges. The noted English formalist art critic Roger Fry (1866–1934) fell under its spell and assimilated some of its points of view (see Fry's *Cézanne: A Study of His Development* [London, 1927; Noonday paperback]). In this country, Renaissance art historian Sidney Freedberg of Harvard University seems to have continued and extensively refined Wölfflin's visually rooted approach (*Painting of the High Renaissance in Rome and Florence*, 2 vols. [Cambridge, Mass., 1961]).

Wölfflin himself was influenced at first by both Robert Vischer and his theories of empathy, and Konrad Fiedler (1841–95) and his aesthetic theories, and later by the views of his friend the German sculptor Adolf von Hildebrand (1847–1921), whose little pamphlet *The Problem of Form in Painting and Sculpture* (trans. Max Meyer and Robert Morris Ogden [New York, 1907; orig. pub. Strassburg, 1893]) is readily acknowledged by Wölfflin in his *Classic Art,* especially in the passages on the paintings of Raphael. Yet Wölfflin's method was at all times rooted in the keen observation of the formal qualities of individual works of art rather than in theoretical speculation, and it discloses the capacity to distinguish easily the relevant from the irrelevant, the masterpiece from the second-rate work. So intense was his artistic experience that he was fully able to convey clearly his points of view to his audience.

The Most General Representational Forms

This volume is occupied with the discussion of these universal forms of representation. It does not analyse the beauty of Leonardo but the element in which that beauty became manifest. It does not analyse the representation of nature according to its imitational content, and how, for instance, the naturalism of the sixteenth century may be distinguished from that of the seventeenth, but the mode of perception which lies at the root of the representative arts in the various centuries.

Let us try to sift out these basic forms in the domain of more modern art. We denote the series of periods with the names Early Renaissance, High Renaissance, and Baroque, names which mean little and must lead to misunderstanding in their application to south and north, but are hardly to be ousted now. Unfortunately, the symbolic analogy bud, bloom, decay, plays a secondary and misleading part. If there is in fact a qualitative difference between the fifteenth and sixteenth centuries, in the sense that the fifteenth had gradually to acquire by labour the insight into effects which was at the free disposal of the sixteenth, the (classic) art of the Cinquecento and the (baroque) art of the Seicento are equal in point of value. The word classic here denotes no judgment of value, for baroque has its classicism too. Baroque (or, let us say, modern art) is neither a rise nor a decline from classic, but a totally different art. The occidental development of modern times cannot simply be reduced to a curve with rise, height, and decline: it has two culminating points. We can turn our sympathy to one or to the other, but we must realise that that is an arbitrary judgment, just as it is an arbitrary judgment to say that the rose-bush lives its supreme moment in the formation of the flower, the apple-tree in that of the fruit.

For the sake of simplicity, we must speak of the sixteenth and seventeenth centuries as units of style, although these periods signify no homogeneous production, and, in particular, the features of the Seicento had begun to take shape long before the year 1600, just as, on the other hand, they long continued to affect the appearance of the eighteenth century. Our object is to compare type with type,

the finished with the finished. Of course, in the strictest sense of the word, there is nothing "finished": all historical material is subject to continual transformation; but we must make up our minds to establish the distinctions at a fruitful point, and there to let them speak as contrasts, if we are not to let the whole development slip through our fingers. The preliminary stages of the High Renaissance are not to be ignored, but they represent an archaic form of art, an art of primitives, for whom established pictorial form does not yet exist. But to expose the individual differences which lead from the style of the sixteenth century to that of the seventeenth must be left to a detailed historical survey which will, to tell the truth, only do justice to its task when it has the determining concepts at its disposal.

If we are not mistaken, the development can be reduced, as a provisional formulation, to the following five pairs of concepts:

(1) The development from the linear to the painterly,[1] i.e. the development of line as the path of vision and guide of the eye, and the gradual depreciation of line: in more general terms, the preception of the object by its tangible character— in outline and surfaces—on the one hand, and on the other, a perception which is by way of surrendering itself to the mere visual appearance and can abandon "tangible" design. In the former case the stress is laid on the limits of things; in the other the work tends to look limitless. Seeing by volumes and outlines isolates objects: for the painterly eye, they merge. In the one case interest lies more in the perception of individual material objects as solid, tangible bodies; in the other, in the apprehension of the world as a shifting semblance.

(2) The development from plan to recession:[2] Classic[3] art reduces the parts of a total form to a sequence of planes,

the baroque emphasises depth. Plane is the element of line, extension in one plane the form of the greatest explicitness: with the discounting of the contour comes the discounting of the plane, and the eye relates objects essentially in the direction of forwards and backwards. This is no qualitative difference: with a greater power of representing spatial depths, the innovation has nothing directly to do: it signifies rather a radically different mode of representation, just as "plane style" in our sense is not the style of primitive art, but makes its appearance only at the moment at which foreshortening and spatial illusion are completely mastered.

(3) The development from closed to open form.[4] Every work of art must be a finite whole, and it is a defect if we do not feel that it is self-contained, but the interpretation of this demand in the sixteenth and seventeenth centuries is so different that, in comparison with the loose form of the baroque, classic design may be taken as the form of closed composition. The relaxation of rules, the yielding of tectonic strength, or whatever name we may give to the process, does not merely signify an enhancement of interest, but is a new mode of representation consistently carried out, and hence this factor is to be adopted among the basic forms of representation.

(4) The development from multiplicity to unity.[5] In the system of a classic composition, the single parts, however firmly they may be rooted in the whole, maintain a certain independence. It is not the anarchy of primitive art: the part is conditioned by the whole, and yet does not cease to have its own life. For the spectator, that presupposes an articulation, a progress from part to part, which is a very different operation from perception as a whole, such as the seventeenth century applies and demands. In both sytles unity is the chief aim (in contrast to the pre-

[1] Notes to this selection begin on page 164.

classic period which did not yet understand the idea in its true sense), but in the one case unity is achieved by a harmony of free parts, in the other, by a union of parts in a single theme, or by the subordination, to one unconditioned dominant, of all other elements.

(5) The absolute and the relative clarity of the subject.[6] This is a contrast which at first borders on the contrast between linear and painterly. The representation of things as they are, taken singly and accessible to plastic feeling, and the representation of things as they look, seen as a whole, and rather by their non-plastic qualities. But it is a special feature of the classic age that it developed an ideal of perfect clarity which the fifteenth century only vaguely suspected, and which the seventeenth voluntarily sacrificed. Not that artistic form had become confused, for that always produces an unpleasing effect, but the explicitness of the subject is not longer the sole purpose of the presentment. Composition, light, and colour no longer merely serve to define form, but have their own life. There are cases in which absolute clarity has been partly abandoned merely to enhance effect, but "relative" clarity, as a great all-embracing mode of representation, first entered the history of art at the moment at which reality is beheld with an eye to other effects. Even here it is not a difference of quality if the baroque departed from the ideals of the age of Dürer and Raphael, but, as we have said, a different attitude to the world.

Imitation and Decoration

The representational forms here described are of such general significance that even widely divergent natures such as Terborch and Bernini can find room within one and the same type. The community of style in these two painters rests on what, for people of the seventeenth century, was a matter of course—certain basic conditions to which the impression of living form is

bound without a more special expressional value being attached to them.

They can be treated as forms of representation or forms of beholding: in these forms nature is seen, and in these forms art manifests its contents. But it is dangerous to speak only of certain "states of the eye" by which conception is determined: every artistic conception is, of its very nature, organised according to certain notions of pleasure. Hence our five pairs of concepts have an imitative and a decorative significance. Every kind of reproduction of nature moves within a definite decorative schema. Linear vision is permanently bound up with a certain idea of beauty and so is painterly vision. If an advanced type of art dissolves the line and replaces it by the restless mass, that happens not only in the interests of a new verisimilitude, but in the interests of a new beauty too. And in the same way we must say that representation in a plane type certainly corresponds to a certain stage of observation, but even here the schema has obviously a decorative side. The schema certainly yields nothing of itself, but it contains the possibility of developing beauties in the arrangement of planes which the recessional style no longer possesses and can no longer possess. And we can continue in the same way with the whole series.

But then, if these more general concepts also envisage a special type of beauty, do we not come back to the beginning, where style was conceived as the direct expression of temperament, be it the temperament of a time, of a people, or of an individual? And in that case, would not the only new factor be that the section was cut lower down, the phenomena, to a certain extent, reduced to a greater common denominator?

In speaking thus, we should fail to realise that the second terms of our pairs of concepts belong of their very nature to a different species, in so far as these concepts, in their transformations, obey an

inward necessity. They represent a rational psychological process. The transition from tangible, plastic, to purely visual, painterly perception follows a natural logic, and could not be reversed. Nor could the transition from tectonic to a-tectonic, from the rigid to the free conformity to law.

To use a parable. The stone, rolling down the mountain side, can assume quite different motions according to the gradient of the slope, the hardness or softness of the ground, etc., but all these possibilities are subject to one and the same law of gravity. So, in human psychology, there are certain developments which can be regarded as subject to natural law in the same way as physical growth. They can undergo the most manifold variations, they can be totally or partially checked, but, once the rolling has started, the operation of certain laws may be observed throughout.

Nobody is going to maintain that the "eye" passes through developments on its own account. Conditioned and conditioning, it always impinges on other spiritual spheres.[7] There is certainly no visual shema which, arising only from its own premises, could be imposed on the world as a stereotyped pattern. But although men have at all times seen what they wanted to see, that does not exclude the possibility that a law remains operative throughout all change. To determine this law would be a central problem, the central problem of a history of art.

Multiplicity and Unity

The principle of closed form of itself presumes the conception of the picture as a unity. Only when the sum of the forms is felt as one whole can this whole be thought as ordered by law, and it is then indifferent whether a tectonic middle is worked out or a freer order reigns.

This feeling for unity develops only gradually. There is not a definite moment in the history of art at which we could

say—now it has come: here too we must reckon with purely relative values.

A head is a total form which the Florentine Quattrocentists, like the early Dutch artists, felt as such—that is, as a whole. If, however, we take as comparison a head by Raphael or Quenten Massys, we feel we are confronted by another attitude, and if we seek to comprehend the contrast, it is ultimately the contrast of seeing in detail and seeing as a whole. Not that the former could mean that sorry accumulation of details over which the reiterated corrections of the art master try to help the pupil—such qualitative comparisons do not even come into consideration here—yet the fact remains that, in comparison with the classics of the sixteenth century, these old heads always preoccupy us more in the detail and seem to possess a lesser degree of coherence, while in the other case, in any detail, we at once become aware of the whole. We cannot see the eye without realising the larger form of the socket, the way it is set between forehead, nose, and cheekbone, and to the horizontal of the pair of eyes and of the mouth the vertical of the nose at once responds: the form has a power to awaken vision and to compel us to a united perception of the manifold which must affect even a dense spectator. He wakes up and suddenly feels quite a new fellow.

And the same difference obtains between a pictorial composition of the fifteenth and sixteenth centuries. In the former, the dispersed; in the latter, the unified: in the former, now the poverty of the isolated, now the inextricable confusion of the too much; in the latter, an organised whole, in which every part speaks for itself and is comprehensible, yet makes itself felt in its coherence with the whole as a member of a total form.

In establishing these differences between the classic and the pre-classic period, we first obtain the basis for our real subject. Yet here we at once feel the painful lack of distinguishing vocabulary:

at the very moment at which we name unity of composition as an essential feature of Cinquecento art, we have to say that it is precisely the epoch of Raphael which we wish to oppose as an age of multiplicity to later art and its tendency to unity. And this time we have no progress from the poorer to the richer form, but two different types which each represent an ultimate form. The sixteenth century is not discredited by the seventeenth, for it is not here a question of a qualitative difference but of something totally new.

A head by Rubens is not better, seen as a whole, than a head by Dürer or Massys, but that independent working-out of the separate parts is abolished which, in the latter case, makes the total form appear as a (relative) multiplicity. The Seicentists envisage a definite main motive, to which they subordinate everything else. No longer do the separate elements of the organism, conditioning each other and holding each other in harmony, take effect in the picture, but out of the whole, reduced to a unified stream, individual forms arise as the absolute dominants, yet in such a way that even these dominant forms signify for the eye nothing separable, nothing that could be isolated.

The relationship can be elucidated most satisfactorily in the composite sacred picture.

One of the richest motives of the biblical picture-cycle is the *Descent from the Cross*, an event which sets many hands in movement and contains powerful psychological contrasts. We have the classic version of the theme in Daniele da Volterra's picture in the Trinità dei Monti in Rome. This has always been admired for the way in which the figures are developed as absolutely independent parts, and yet so work together that each seems governed by the whole. That is precisely renaissance articulation. When later Rubens, as spokesman of the baroque, treats the same subject in an early work, the first point in which he departs from the classic type is the welding of the figures into a homogeneous mass, from which the individual figure can hardly be detached. He makes a mighty stream, reinforced by devices of lighting, pass slanting through the picture from the top. It sets in with the white cloth falling from the transverse beam; the body of Christ lies in the same course, and the movement pours into the bay of many figures which crowd round to receive the falling body. No longer, as in Daniele da Volterra, is the fainting Virgin a secondary centre of interest detached from the main event. She stands, and is completely absorbed, in the mass round the Cross. If we wish to denote the change in the other figures by a general expression, we can only say that each has abdicated part of its independence to the general interest. On principle, the baroque no longer reckons with a multiplicity of co-ordinate units, harmoniously interdependent, but with an absolute unity in which the individual part has lost its individual rights. But thereby the main motive is stressed with a hitherto unprecedented force.

It must not be objected that these are less differences of development than differences of national taste. Certainly, Italy has always had a preference for the clear component part, but the difference persists too in any comparison of the Italian Seicento with the Italian Cinquecento or in the comparison between Rembrandt and Dürer in the north. Although the northern imagination, as contrasted with Italy, aimed rather at the interweaving of the members, a *Deposition* by Dürer, compared with Rembrandt (Fig. 1),* provides the absolutely pronounced opposition of a composition with independent figures to a composition with dependent figures. Rembrandt focusses the story on the motive of two lights—a strong, steep one at the top left-hand corner, and a

* Illustrations accompanying this selection appear on page 469.

weak, horizontal one at the bottom right. With that, everything that matters is indicated. The corpse, only partially visible, is being let down, and is to be laid out on the winding-sheet lying on the ground. The "down" of the deposition is reduced to its briefest expression.

Thus there stand opposed the multiple unity of the sixteenth century and the unified unity of the seventeenth: in other words, the articulated system of forms of classic art and the (endless) flow of the baroque. And, as is evident from previous examples, two elements interact in this baroque unity—the cessation of the independent functioning of the individual forms and the development of a dominating total motive. This can be achieved plastically, as in Rubens, or by means of more painterly values, as in Rembrandt. The example of the *Deposition* is only characteristic of an isolated case: unity fulfils itself in many ways. There is a unity of colour as well as of lighting, and a unity of the composition of figures as of the conception of form in a single head or body.

That is the most interesting point: the decorative schema becomes a mode of apprehension of nature. It is not only that Rembrandt's pictures are built up on a different system from Dürer's, things are seen differently. Multiplicity and unity are, so to speak, vessels in which the content of reality is caught and takes form. We must not assume that just any decorative system was clapped over the world's eyes: matter plays its part too. People not only see differently, they see *different things*. But all the so-called imitation of nature has only an artistic significance when it is inspired by decorative instincts and produces in its turn decorative works. That the concept of a multiple beauty and of a unified beauty also exists, apart from any imitative content, is borne out by architecture.

The two types stand side by side as independent values, and it does not meet

the case if we conceive the later form only as an enhancement of the former. It goes without saying that baroque art was convinced that it had first found truth and that renaissance art had only been a preliminary form, but the historian judges otherwise. Nature can be interpreted in more than one way. And therefore it came about that it was just in the name of nature that, at the end of the eighteenth century, the baroque formula was ousted and again replaced by the classic.

The Principal Motives

The subject of this chapter, therefore, is the relation of the part to the whole— namely, that classic art achieves its unity by making the parts independent as free members, and that the baroque abolishes the uniform independence of the parts in favour of a more unified total motive. In the former case, co-ordination of the accents; in the latter, subordination.

All our previous categories have led up to this unity. The painterly is the deliverance of the forms from their isolation; the principle of recession is no other than the replacement of the sequence of separate planes by a uniform recessional movement, and a-tectonic taste dissolves the rigid structure of geometric relations into flux. We cannot avoid partly repeating familiar matter: the essential viewpoint of the consideration is all the same new.

It does not happen of itself and from the outset that the parts function as free members of an organism. Among the primitives, the impression is checked because the component parts either remain too dispersed or look confused and unclear. Only where the single detail seems a necessary part of the whole do we speak of organic articulation, and only where the component part, bound up in the whole, is still felt as an independently functioning member, has the notion of freedom and independence a sense. That is the classic system of forms of the sixteenth century,

and it makes no difference, as we have said, whether we understand by a whole a single head or a composite sacred picture.

Dürer's impressive woodcut of the *Virgin's Death* (Fig 2; 1510) outstrips all previous work in that the parts form a system in which each in its place appears determined by the whole and yet looks perfectly independent. The picture is an excellent example of a tectonic composition—the whole reduced to clear geometric oppositions—but, beside that, this relationship of (relative) co-ordination of independent values should always be regarded as something new. We call it the principle of multiple unity.

The baroque would have avoided or concealed the meeting of pure horizontals and verticals. We should no longer have the impression of an *articulated* whole: the component parts, whether the bed canopy or one of the apostles, would have been fused into a total movement dominating the picture. If we recall the example of Rembrandt's etching of the *Virgin's Death* (Fig. 3), we shall realise how very welcome to the baroque was the motive of the upward streaming clouds. The play of contrasts does not cease, but it keeps more hidden. The arrangement of obvious side-by-side and clear opposite is replaced by a single weft. Pure oppositions are broken. The finite, the isolable, disappear. From form to form, paths and bridges open over which the movement hastens on unchecked. But from such a stream, unified in the baroque sense, there arises here and there a motive so strongly stressed that it focusses the eye upon it as the lens does the light rays. Of this kind, in drawing, are those spots of most expressive form which, similarly to the culminating points of light and colour, of which we shall speak presently, fundamentally separate baroque from classic art. In classic art, even accentuation; in the baroque, one main effect. These motives which bear the main accent

are not pieces which could be broken out of the whole, but only the final surges of a general movement.

The characteristic examples of unified movement in the composite figure picture are given by Rubens. At all points, the transposition of the style of multiplicity and separation into the assembled and flowing with the suppression of independent separate values. The *Assumption* is not only a baroque work because Titian's classic system—the main figure opposed as vertical to the horizontal form of the group of the apostles—has been transformed into a general diagonal movement, but because the parts can no longer be isolated. The circle of light and angels which fills the centre of Titian's *Assunta* still re-echoes in Rubens, but it only receives an aesthetic sense in the context of the whole. However regrettable it is that copyists should offer Titian's central figure alone for sale, a certain possibility of doing so still exists: with Rubens, such an idea could present itself to nobody. In Titian's picture, the apostle motives to left and right mutually balance—the one looking up and the other with upstretched arms. In Rubens, only one side speaks, the other is, as far as content is concerned, reduced to insignificance, a suppression which makes the unilateral right-hand accent much more intense.

A second case—Rubens' *Bearing of the Cross* (Fig. 4), which has already been compared with Raphael's *Spasimo*. An example of the transposition of plane into recession, but also an example of the transposition of articulated multiplicity into unarticulated unity. In the *Spasimo*, the soldier, Christ, and the women—three separate, equally accented motives; in Rubens, the same, as regards subject matter, but the motives kneaded together, and foreground and background carried into each other in a uniform drift of movement, without caesura. Tree and mountain work together with the figures and the lighting completes the effect. Everything

is one. But out of the stream the wave rises here and there with surpassing force. Where the herculean soldier rams his shoulder under the cross, so much strength is concentrated that the balance of the picture might seem menaced—not the man as a separate motive, but the whole complex of form and light determines the effect—these are the characteristic nodal points of the new style.

To give unified movement, art need not necessarily have at its disposal plastic resources such as are contained in these compositions of Rubens. It needs no procession of moving human figures: unity can be enforced merely by lighting.

The sixteenth century also distinguishes between main and secondary light, but— we refer to the impression of a black and while plate such as Dürer's *Virgin's Death* —it is still an even weft which is created by the lights adhering to the plastic form. Pictures of the seventeenth century, on the other hand, readily cast their light on one point, or, at any rate, concentrate it in a few spots of highest light which then form an easily apprehended configuration between them. But that is only half the matter. The highest light or the highest lights of baroque art proceed from a general unification of the light-movement. Quite otherwise than previously, the lights and darks roll on in a common stream, and where the light swells to a final height, just there it emerges from the great total movement. This focussing on individual points is only a derivative of the primary tendency to unity, in contrast to which classic lighting will always be felt as multiple and separating.

It must be a pre-eminently baroque theme if, in a closed space, the light flows from one source only. Ostade's *Studio* (Fig. 5) gives a clear example of this. Yet the baroque character is not merely a question of subject: in his *St. Jerome* engraving, Dürer, as we know, drew quite different conclusions from a similar situation. But we will leave such special cases

out of the question and base our analysis on a plate with a less salient quality of lighting. Let us take Rembrandt's etching of *Christ Preaching* (Fig. 6).

The most striking visual fact here is that a whole mass of conglomerated highest light lies on the wall at Christ's feet. This dominating light stands in the closest relation to the other lights. It cannot be isolated as an individual thing, as is possible with Dürer, nor does it coincide with a plastic form: on the contrary, the light glides over the form, it plays with the objects. All the tectonic elements thereby become less obvious and the figures on the stage are, in the strangest way, dragged apart and reassembled as if not they but the light were the element of reality in the picture. A diagonal of light passes from the left foreground over the middle through the archway into the background, yet what meaning does such a statement have beside the subtle quiver of light and dark throughout the whole space, that rhythm by means of which Rembrandt, more than any other, imparts to his scenes a compelling unity of life?

Other unifying factors are, of course, at work here too. We disregard what does not belong to the subject. An essential reason why the story is presented with such impressive emphasis lies in the fact that the style also uses distinctness and indistinctness to intensify the effect, that it does not speak with uniform clearness at all points, but makes places of most speaking form emerge from a groundwork of mute or less speaking form.

The development of colour offers an analogous spectacle. In place of the "bright" colouring of the primitives with their juxtaposition of colour without systematic connection, there comes in the sixteenth [-century] selection and unity, that is, a harmony in which the colours mutually balance in pure oppositions. The system is perfectly obvious. Every colour plays its part with reference to the whole. We can feel how, like an indispensable

pillar, it bears and holds together the building. The principle may be developed with more or less consistency, the fact remains that the classic epoch, as an epoch of fundamentally multiple colouring, is very clearly to be distinguished from the following period with its aiming at tonal relations. Whenever we pass from the Cinquecentist room in a gallery to the baroque, the surprise we feel is that clear, obvious juxtaposition ceases and that colours seem to rest on a common ground in which they sometimes sink into almost complete monochrome, in which, however, if they stand out clearly, they remain mysteriously moored. We can, even in the sixteenth century, denote single artists as masters of tone and attribute to individual schools a generally tonal style; that does not hinder the fact that, even in such cases, the "painterly" century introduces an enhancement which should be distinguished by a word of its own.

Tonal monochrome is only a transitional form. Artists soon learned to use tonality and colour simultaneously, and in so doing, to intensify individual colours in such a way that, similarly to the highest lights, as spots of strongest colouring they radically reshape the whole physiognomy of painting in the seventeenth century. Instead of uniformly distributed colour, we now have the single spot of colour—it can be a chord of two or three colours— which unconditionally dominates the picture. The picture is, as we say, pitched in a definite hue. With that is connected a partial negation of colouring. Just as the drawing abandons uniform clearness, so it promotes the focussing of colour effect to make the pure colour proceed from the dullness of half or no colour. It breaks out, not as a thing which happens once, or can be isolated, but as one long prepared. The colourists of the seventeenth century handled this "becoming" of colour in various ways, but there is always this distinction from the classic system of coloured composition, that the classic age

to a certain extent builds with finished units, while in the baroque the. colour comes and goes and comes again, there louder, here lower, and the whole is not to be apprehended save through the idea of an all-pervading general movement. In this sense, the foreword to the great Berlin picture catalogue states that the mode of description of colour tried to adapt itself to the course of the development. "From the detailed notation of colour, there was a gradual transition to a description envisaging the whole of the colouristic impression."[8]

But it is a further consequence of baroque unity that a single colour can stand out as a solitary accent. The classic system does not know the possibility of casting an isolated red into the scene as Rembrandt does in his *Susanna* in Berlin. The complementary green is not absent, but works only softly, from the depths. Co-ordination and balance are no longer aimed at, the colour is meant to look solitary. We have the parallel in design: baroque art first found room for the interest of the solitary form—a tree, a tower, a human being.

And so, from the consideration of detail, we come back to the general principle. The theory of variable accents, which we have here developed, would be inconceivable unless art could show the same differences of type as regards content. A characteristic of the multiple unity of the sixteenth century is that the separate things in the picture are felt to be relatively equal in material value. The narrative certainly distinguishes between main and secondary figures. We can see—in contrast to the narration of the primitives —from far off where the crucial point of the event lies, but for all that, what have come into being are creations of that relative unity which to the baroque looked like multiplicity. All the accessory figures still have their own existence. The spectator will not forget the whole in the details, but the detail can be seen for itself. This

can be well demonstrated by Dirk Vellert's drawing (1524), showing the child Saul coming to the High Priest (Fig. 7). The man who created this work was not one of the pioneer spirits of the sixteenth century, but he was not a backward one either. On the contrary, the representation, articulated through and through, is purely classic in style. Yet every figure has its own centre of interest. The main motive certainly stands out, yet not so that the secondary figures find no room to live their own lives. The architectonic element too is so handled that it must claim some interest for itself. It is still classic art, and not to be confused with the scattered multiplicity of the primitives: everything has its clear relation to the whole, but how ruthlessly would an artist of the seventeenth century have cut down the scene to the points of vital interest! We do not speak of qualitative differences, but even the conception of the main motive lacks, for modern taste, the character of a real event.

The sixteenth century, even where it is quite unified, renders the situation broadly, the seventeenth concentrates it on the moment. But only in this way does the historical picture really speak. We make the same experience in the portrait. For Holbein, the cloak is as valuable as the man. The psychic situation is not timeless, yet cannot be understood as the fixation of a moment of freely flowing life.

Classic art does not know the notion of the momentary, the poignant, or of the climax in the most general sense: it has a leisurely, broad quality. And though its point of departure is absolutely the whole, it does not reckon with first impressions. The baroque conception has shifted in both directions.

NOTES

1 In the German, *das Lineare* and *das Malerische*. The term *malerisch*, here translated as "painterly," has no exact English equivalent. — ED.

2 In the German, *Fläche* and *Tiefe*. — ED.

3 *Klassisch*. The word "classic" throughout this book refers to the art of the High Renaissance. It implies, however, not only a historical phase of art, but a special mode of creation of which that art is an instance. — TRANS.

4 In the German, *Geschlossene Form* and *Offene Form* — what Wölfflin defined elsewhere in this book as *tektonisch* and *atektonisch*. — ED.

5 In the German, *Vielheit* and *Einheit*; later in this book, Wöfflin defines these terms as *vielheitliche Einheit* and *einheitliche Einheit*. — ED.

6 In the German, *Klarheit* and *Unklarheit*; in a later chapter of this book, these terms are further defined as *Unbedingte* and *bedingte Klarheit*. — ED.

7 In the German, *geistigen Sphären*. — ED.

8 Wilhelm von Bode, in *Königliche Museen zu Berlin, Die Gemäldegalerie des Kaiser-Friedrich-Museums*, 2 vols., ed. Hans Posse, (Berlin, 1909–11), I:v. — ED.

DOCUMENTARY STUDIES IN ARCHITECTURAL HISTORY

5 S. Maria della Salute:
Scenographic Architecture and the Venetian Baroque

RUDOLF WITTKOWER

Modern scholarship in Italian Baroque art is virtually synonymous with the name of Rudolf Wittkower, whose interest and many published contributions have stimulated his colleagues and especially younger scholars to pursue the same field of research, often the ideas first put forward by him. Born in Berlin in 1901, Wittkower studied art history at the universities of Munich and Berlin and received his doctorate at Berlin in 1923. He served as an assistant and research fellow at the Biblioteca Hertziana in Rome from 1923 to 1933 and lectured at Cologne University in 1932–33. He joined the staff of the Warburg Institute in London in 1934, and in 1946, the faculty of the University of London, where he was Durning-Lawrence Professor in the History of Art from 1949 to 1956. During his tenure in London he served as coeditor of the *Journal of the Warburg and Courtauld Institutes* (1937–56), one of the leading international periodicals in humanistic studies. He came to the United States in 1956 to join the faculty of the Department of Art History and Archaeology of Columbia University, and during the twelve years he served as the chairman of that department (1956–68) he built it into one of America's leading schools for art historical studies. At the time of this writing, he serves jointly as Avalon Professor in the Humanities at Columbia University and Kress Foundation Professor in Residence at the National Gallery of Art in Washington, D.C.

The writings of Rudolf Wittkower reveal a scholar of wide humanistic learning and interests. They deal with the *oeuvres* of such artists as Michelangelo, Palladio, Carlo Rainaldi, Nicolas Poussin, and Gian Lorenzo Bernini, and with important aspects of the works and writings of Alberti, Raphael, El Greco, Inigo Jones, Domenichino, Piranesi, and Le Corbusier. This perspicacious scholar has investigated problems of proportion and perspective in Renaissance, Mannerist, and Baroque art, the migration and interpretation of symbols, the Mediterranean sources of British art (with Fritz Saxl in 1948), the idea of individualism in art and artists (in the *Journal of the History of Ideas* XXII [1961], pp. 291–302, and in his *Born Under Saturn: The Character and Conduct of Artists; A Documented History from Antiquity to the French Revolution,* with Margot Wittkower [London, 1963]), the theories of imitation, eclecticism, and genius in the 18th century (in *Aspects of the Eighteenth Century,* ed. Earl Wasserman [Baltimore, 1965], pp. 143–61), the politics of the administration of Russian museums, "The Significance of the University Museum in the Second Half of the Twentieth Century" (in *Art Journal* XXVII [1967/68], pp. 176–79), the modern restoration of Italian buildings, and a brief historical evaluation of art history as a discipline (in *Winterthur Seminar on Museum Operation and Connoisseurship,* 1959 [Winterthur, Del., 1961], pp. 55–69). At the age of 30, he coauthored with Heinrich Brauer a searching analysis of the drawings of Bernini and his studio (*Die Zeichnungen des Gianlorenzo Bernini,* 2 vols. [Berlin, 1931]). His monograph of Bernini (London, 1955; 2d ed., 1966) is a standard work, his *Art and Architecture in Italy, 1600–1750* (Harmondsworth, Eng. and Baltimore, 1958; 2d ed., 1965) a masterly survey that is widely

Reprinted from *Saggi e memorie di storia dell'arte* III (1963), pp. 31–54

used both as a college textbook and as a reference work. Equally erudite and creative is his *Architectural Principles in the Age of Humanism* (London, 1949), the theme of which is the "meaning of classical trends of thought for those architects of the Renaissance who had close ties with humanist circles." This work perhaps above all others by Wittkower demonstrates his indebtedness to the tradition of thought of the German art and cultural historian Aby Warburg. (For Wittkower's publications to 1966, see *Essays Presented to Rudolf Wittkower on His Sixty-Fifth Birthday*, ed. Douglas Fraser et al, 2 vols. [London, 1967]).

A zealous worker and prolific writer, Wittkower has freely shared his erudition and ideas with colleagues and students alike. His impact on modern scholarship in the arts has been keenly felt throughout the Western world. Before he came to this country, the British Broadcasting Corporation acknowledged that his many writings did so much "to elucidate British art and architecture to the British" (Nikolaus Pevsner, "An Un-English Activity? Reflections on Not Teaching Art History," *The Listener*, October 30, 1952, p. 716).

The following paper by Wittkower on the Church of S. Maria della Salute in Venice, designed by the Venetian Baroque architect Longhena, is an exemplary demonstration of how a scrupulous examination and interpretation of a building and all the historical data pertaining to it can result in an illuminating evaluation of the architect's conceptual approach to his art. After carefully sifting through a mass of documents concerned with the commission and construction of the church and investigating the indebtedness of Longhena to architectural tradition, Wittkower interprets the iconography of the building and the architect's way of proceeding, especially the mathematical, optical, and coloristic principles he unified and integrated in what Wittkower terms his "scenographic architecture."

It is the purpose of this paper to discuss Longhena's conceptual approach to architecture. What were his guiding ideas when planning his masterpiece, S. Maria della Salute? What is the historical place of this church in the wider panorama of Italian seventeenth-century architecture? To what extent did Longhena take up and develop north Italian and in particular Palladian ideas; how far does his specific interpretation of architecture depend on precedence? I propose to clarify these points through a closer analysis of the church than has hitherto been devoted to it. This programme cannot be carried out without a good deal of philological research into the material relating to the planning of S. Maria della Salute. But I do not intend to give a full history of the construction, of the vicissitudes presented by the site or of the decoration.[1] We shall not lose sight of our primary purpose, namely to discover Longhena's method of procedure, by which he arrived, in my view, at a true 'scenographic architecture.'

The Chronology of Events

The circumstances of the commission are well known. The documents, published by Giannantonio Moschini,[2] are however incomplete and not arranged in chronological order. Other authors, among them V. Piva,[3] supplemented Moschini's material, but no serious attempt has yet been made to evaluate the documents. It is for this reason that we shall begin by charting the events in their sequence of time.

1. In 1630 the population of Venice was decimated by a frightful plague. A few months after its beginning, on 22 October 1630, the Doge and Senate decided to erect

[1] Notes to this selection begin on page 186.

as an *ex voto* a church dedicated to the Virgin and to call it S. Maria della Salute, which has the double meaning of Health and Salvation. According to the document recording this decision, it was resolved that the cost of the church should not be more than 50,000 ducats; further, that three senators should be chosen for the purpose of selecting an appropriate site and recommending a project.[4]

2. The commission of three—Simone Contarini, Pietro Bondulmier and Zuanne Marco Molin—choose the present site; this is confirmed by a decree of the Senate, dated 23 November 1630 (Corner, p. 75, verbatim; Piva, p. 31).

3. 3 December 1630: It is decreed that the church of SS. Trinità, standing close to the selected area next to the Seminary of the Somaschi (which had to be demolished), is to survive (Fig. 2).* (Corner, p. 76, verbatim; Piva, p. 31).

4. 2 January 1631: It is resolved to begin clearing the area of the Seminary[5] (Corner, p. 77, verbatim; Piva, p. 31 f.).

5. 18 January: It is resolved to order the wood necessary for the new foundations (Moschini, p. 6; Piva, p. 33).

6. 1 February: It is resolved to lay the foundation stone of the new church on 25 March, the day of the Annunciation, which is also the legendary day of the foundation of Venice;[6] it is expected that a model will have been chosen before that date (Corner, p. 77 f.; Piva, p. 33).

7. 1 April: The laying of the foundation stone took place a week after the appointed day, on 1 April (Moschini, p. 22; Piva, p. 33 f.). On this occasion medals were put into the foundations with the inscription UNDE ORIGO INDE SALUS—in terse words referring to the origin of Venice under the Virgin's tutelage and to the physical and spirtual health guaranteed by her patronage. The same inscription was later placed in the centre of the pavement of the 'Rotonda.'

8. Beginning of April: At an earlier date (probably in December 1630) a competition had been arranged. Eleven projects were submitted, and at the beginning of April the commission chose two for closer consideration: that by Longhena and one for which Antonio Fracao and Zambattista Rubertini were jointly responsible (Moschini, p. 7; Piva, p. 35). The latter's share, however, seems to have been inconsiderable. From then on Fracao conducted his affairs alone. He was the son of Francesco Smeraldi,[7] who, as architect of the Palladian façade of S. Pietro in Castello (1594–6), commanded considerable authority.

9. 13 April: Longhena submits a memorandum consisting of twelve different points, evidently explanatory notes to accompany his model[8] (Moschini, pp. 11–13).

10. 15 April: Antonio Fracao hands in a memorandum (Moschini, p. 14 f.).

11. After 15 April: Meanwhile it must have transpired that the commission favoured Longhena's project in preference to Fracao's and Rubertini's. Fracao, therefore, wrote a second memorandum reaffirming the advantages of his design which followed by and large the pattern of Palladio's Redentore. But the main purpose of the new memorandum was by a subtle device to insinuate that Longhena's project was in many ways unsatisfactory. Fracao added a centrally planned project to his memorandum in order to demonstrate that this form of design was unsuitable for the purpose. It is likely that this project was the work of a few days, drawn in a hurry with the sole aim of combating Longhena (Moschini, p. 55 ff. [verbatim], without date, but obviously dateable shortly after 15 April).

12. 26 April: Faced with an increasingly difficult situation the Senate must have found it advisable to broaden the original committee of three: two new names— Girolamo Cornaro and Paolo Morosini—

* Illustrations accompanying this selection appear on pages 470 to 475.

were added to it as "aggiunti alla Fab-
brica." (Casoni,[9] p. 35; Piva, p. 35).

13. 21 May: The committee decided to
call upon eight experts to make sworn
statements mainly about the security of
Longhena's dome. Four of them voiced
some criticism of his design and a fifth in-
sisted energetically on radical alterations
(Moschini, pp. 19–22).

14. 13 June: It seems that the committee
was unable to come to a final decision. On
13 June they appeared before the Senate
with a long and well balanced report. The
Senate resolved to decide by ballot
whether Longhena's or Fracao's model
should be chosen for execution. Fortu-
nately the senators had sufficient wisdom
and taste to cast their votes in favour of
Longhena's project (Moschini, pp. 7–11;
Piva, p. 36 f.).[10]

15. After 13 June: Even after the formal
decision had been taken, Fracao once more
assailed his successful opponent. Now in
desperation, he seems to have gone over to
a frontal attack. Fracao's new memoran-
dum is not with the rest of the documents
in the Archivio di Stato and may be lost,
but its character can be deduced from
Longhena's answer, a lengthy memoran-
ium in which he refutes point by point
Fracao's criticism. In the beginning Long-
hena refers to the false statements made
by his adversary regarding "la formazione
del già accettato mio modello." This formu-
lation makes it possible to date this episode
soon after 13 June without any reasonable
doubt. Longhena also mentions that eight
new experts were prepared to make sworn
statements to the effect that Fracao's ob-
jections were baseless (Moschini, p. 17 ff.).

16. 6 September: The laying of the foun-
dations of Longhena's structure has begun
(Casoni, p. 37; Piva, pp. 40, 47).

17. 9 November 1633: The foundations
were finished on 8 November 1633. On the
following day building above ground level
was started (Piva, p. 47).

It is well known that the completion of
the church dragged on for a very long time.

But for the purpose of the present paper
the documentation can stop here. We now
have to evaluate what the documents tell
us.

The Stipulation of The Competition

In its report of 13 June 1631 (14)[11] the com-
mittee summarized the conditions which
had to be observed by the competing archi-
tects. Three specific points were made,
namely (i) that from the entrance of the
church it should be possible to embrace
the whole ample space of the building un-
obstructed, (ii) that there should be an
even distribution of bright light through-
out the church, and (iii) that the high altar
should dominate the view from the en-
trance, while the other altars should come
into full view as one proceeds in the direc-
tion of the high altar. To these main condi-
tions, others, no less essential but of a
more general nature, were added: the new
building had to harmonize with the site
and had to make a grand impression, in
spite of the fact that sufficient ground had
to be left for the erection of the monastery
and that the expense should be kept within
reasonable limits.

The committee followed the time-hon-
oured and perfectly justifiable practice of
squeezing the last ounce out of the compet-
ing architects. No wonder that only two of
the eleven projects which had been sub-
mitted[12] were worth considering: Long-
hena's centrally planned church for which
the report had words of high praise, and
Fracao's and Rubertini's longitudinal de-
sign which, according to the jury, recom-
mended itself by good distribution, good
lighting and spaciousness. The first ques-
tion that arises concerns the nature of
Longhena's model. Did he submit a design
corresponding to the one that was even-
tually built? The documents supply a clear
answer.

Longhena's Model

Before we let the documents speak, it is
worth enquiring whether a pictorial repre-

sentation of Longhena's model survives. We have noted that on the foundation day medals were sunk into the foundations. They show on the obverse the Virgin hovering on clouds over the Piazzetta S. Marco and on the reverse the Doge Nicolò Contarini (who died a day after the event, on 2 April) kneeling before the new church.[13] Desirous of beginning the church at the earliest possible moment, Doge and Senate agreed to the laying of the foundation stone two-and-a-half months before Longhena's project was accepted (7 and 14). It is therefore evident that the elevation represented on the medals cannot be related to any of the competing projects, which came up for criticism only after the foundation day (8). Consequently the medals illustrate an ideal project. Nor is the model of the church carried by angels in Padovanino's *Virgin on Clouds* connected with Longhena. Painted in 1631, the work (now in the large sacristy) was placed on the high altar as a provisional arrangement. Padovanino himself was one of the eleven competitors, and one would, therefore, surmise that he painted his own model. But he certainly did not represent his final model, the plan of which was hexagonal, based on the interpretation of two equilateral triangles.[14]

By contrast, the model in Bernardino Prudenti's picture (Fig. 6), painted to celebrate the cessation of the plague, has documentary value. The official celebration was fixed for 28 November 1631, and on this occasion Prudenti's work was exhibited in the Piazza S. Marco.[15] In spite of its large size, it must have been painted in great haste, as a cursory examination reveals. In any case, since the model here appears to be close to Longhena's executed design the picture cannot have been started before the second half of June 1631. But it was not until September that the mortality began to drop very considerably, and it is therefore not unlikely that the painting was commissioned after this period. The inference seems inescapable

that Prudenti copied in his picture Longhena's model of June 1631. Historical facts, however, do not always correspond to simple logic. We happen to have an eyewitness report according to which the picture was finished in four days[16]—in other words, it was probably painted late in November. Over five months had gone by since the Senate had chosen Longhena's model, so the model shown by Prudenti may well represent a project different from the one accepted on 13 June.

As we shall see, this last assumption is confirmed by certain clues contained in Longhena's memorandum of 13 April (9). This memorandum is a most remarkable document and requires closest attention. Longhena tells us that he had worked on his project for months,[17] and this, incidentally, makes it likely that the beginning of the competition dates back to December 1630. Some time early in the new year he had been asked to submit a model;[18] it is this model to which his memorandum of 13 April refers. Next to a detailed description Longhena supplies in the document all the important measurements of his projected building. By implication, reduced in scale these were the measurements shown in the model. A comparison between the measurements quoted by him and those of the execution will, therefore, allow us to draw definite conclusions as to the appearance of the model submitted on 13 April and accepted on 13 June. For clarity's sake a table giving the projected and the executed dimensions may follow (Figs. 4, 5, 12).[19]

The data supply sufficient evidence to prove that Longhena's model was similar but not identical to the execution. The difference of 6 to 8 feet in the over-all width (a) presents the first problem. Since the diameter of the Rotonda (b), the depth of the chapels (d), and presumably also the width of the pillars (5 feet)[35] and of the outside walls (2 feet) tally, the difference of 6 feet (or, in actual fact, of about 1½ feet more)[36] between the model and the execu-

tion must result from the design of a narrower ambulatory in the model stage. This conclusion would seem entirely convincing: if we presume that Longhena had planned the ambulatory 12 instead of 15 feet wide (e), the discrepancy in the overall width is resolved.

But such a simple solution contradicts the facts, for it can be shown without any shadow of doubt that Longhena had incorporated an ambulatory 15 feet in width into his model. There is, however, good reason to assume that his pre-model designs to which he referred in the memorandum of 13 April[37] had a 12-foot ambulatory. It will be noticed that the width of the ambulatory (e) is the only important measure that he left unmentioned in the memorandum accompanying his model, and this may be

interpreted as an indication that he did not want to draw attention to the widening of the ambulatory in the model. As we shall see, he may have had very good reasons to keep silent on this point. The hypothesis of a discrepancy between the designs and the model is supported by the fact that some of the experts in their memorandum of 21 May (13; Moschini, p. 21) clearly imply that the ambulatory was planned 15 feet wide, while the final report of the committee of 13 June (14) mentions the width as *ca.* 12 feet.[38] This contradiction can only be resolved if we suppose that the experts and the committee had different evidence before them. But the words "piedi dodici incirca" used in the report also indicate that the committee was somewhat puzzled and probably not unaware of the altera-

	MODEL Finished 13 April 1631, accepted 13 June 1631 Feet are always Venetian feet[20]	EXECUTION	
		Diedo	Santamaria
a. Whole width of the 'Rotonda' including the walls of the chapels	118 feet	ca. 126 feet	44 m.[21]
b. Diameter of the Rotonda (mentioned in Longhena's second memorandum after 13 June)	60 feet	60 feet	20.30 m. (?)[22]
c. Width of the chapels between the pilasters	19 feet	18.4 feet	6.50 m.[23]
d. Depth of the chapels, from the balustrade to the back wall	10 feet	10 (11) feet	3.80 m.[24]
e. Width of the ambulatory	no figure given	15 feet	5.25 m.[25]
f. Entire length of the church including the walls	188 feet	188 feet	ca. 65.30 m.[26]
g. Presbytery (from the steps leading into it to the columns of the high altar	37 feet	43 feet	ca. 15.20 m.[27]
h. Presbytery, width within the walls	60 feet	80 feet	27.60 m.[28]
i. Depth of high altar space	no figure given	10 feet	3 m.–3.40 m.[29]
k. Choir, length within the walls	26 feet	20.5–21 feet	ca. 7 m.[30]
l. Choir, width	30 feet	ca. 38.9 feet	ca. 13.5 m.[31]
m. Central portal, height	32 feet	ca. 37 feet	12.55 m.[32]
n. Central portal, width	15 feet	ca. 14.5 feet	5.25 m.[33]
o. Steps leading up to the level of the church	13 steps		16 steps
p. Steps leading up to the high altar	6–8 steps		4 steps[34]

tion. It may be assumed that in his memorandum Longhena mentioned the over-all width of 118 feet (a), as originally planned in the drawings, although it no longer applied to the model, because it was contrary to his interests to admit an increase in the over-all width of the church. I shall later demonstrate that Longhena's decision to enlarge the width of the ambulatory was concerned with one of the most hotly debated aspects of his project. As a result of the present discussion it can be stated that in the model the Rotonda and ambulatory must have corresponded to the execution.

But the design of the presbytery and the choir differed. The figures given by Longhena prove that, compared with the execution, the model showed a presbytery of considerably less depth and width (g, h) as well as a longer and narrower choir (k, l).[39] A welcome control is at hand in the way these different units fit into the general design of the model. Since Longhena supplied the over-all length of the church in the model stage (f, 188 feet)— a length equal to that of the present building—the sum of the individual measurements must add up to 188 feet. It now becomes clear (as is demonstrated in footnote 40) that such correspondence depends on the assumption that in the model the ambulatory was 15 feet wide.[40] This is at variance with the over-all width given by Longhena (a), and confirms our hypothesis that he made the latter statement with his tongue in his cheek. If this premise is accepted the model chosen by the Senate for execution can be reconstructed with a high degree of certainty (Fig. 5). The presbytery and the choir were less differentiated as regards size than they are in the execution. If a small dome was planned over the presbytery—and there is no reason for doubting it—it would have been no match for the dome of the Rotonda and would have played a less important part for the silhouette of the exterior than the present second dome. The Rotonda of the model, in other words, was considerably more dominant than that of the execution.

Briefly, the relationship of the Rotonda to the presbytery in the model stage was still close to such older structures as Sanmicheli's Madonna di Campagna or even the Bramantesque S. Maria di Canepanova at Pavia (Fig. 13).

The model in Prudenti's picture proves that Longhena's change of design must have taken place before mid-November 1631. Since the original model was ready on 13 April and still valid on 13 June, the day of its acceptance, Longhena must have worked out the revision during the intervening five months. At this period his attention was focused on the enlargement of the presbytery. This made a reduction of the length of the choir necessary, for he had to keep within the over-all limits of the site at his disposal. After its enlargement the presbytery offered a much more striking silhouette holding its own next to the dome of the Rotonda (Figs. 7, 19). But other reasons, too, must have prevailed upon Longhena to change the model. The final plan (Fig. 4) exhibits an intrinsic beauty and logic still lacking in the model stage: now both the presbytery and the choir have their longer axes along the transverse line, and the gradual reduction in size from the Rotonda to the presbytery and the choir immediately strikes the eye as intimately related and harmonious even in the black and white of the ground plan. In fact, it was the change of design that enabled Longhena to achieve a simple progression of ratios from one unit to the next[41]—a problem, as we shall see, to which he must have devoted a good deal of careful thought. We may sum up that the final design was the result of a slow development and growth. It is not unlikely that he found this solution between September and November 1631, at a time when the foundations were built (16, 17), many months after the completion of the model.

The Plan of the Rotonda

The main portion of Longhena's project— the octagon which is always called 'Ro-

tonda' in the documents—presents a baffling problem. A centrally planned building with ambulatory is rather rare in Renaissance and post-Renaissance architecture. Well known from late antiquity (S. Costanza, Rome), the type recurs not infrequently in medieval, particularly Byzantine baptistries and churches. S. Vitale at Ravenna immediately comes to mind. It seems fairly evident, why octagons (or, for that matter, any centrally planned building) with ambulatory were almost excluded from Renaissance planning, for it is the ambulatory that renders it impossible to produce a design with entirely regular sub-units. If an architect with Longhena's classicizing leanings accepted this shortcoming (for such it must have appeared to him), he had important reasons for it. These reasons clearly overrode every other consideration. But before throwing light on them some characteristic features of his design must be described.

The success of the plan depended on the shape given to the pillars of the octagon. Had he chosen the obvious solution of trapezoid pillars determined by the radii from the centre, he could not have avoided alternating large and small trapezoid units in the ambulatory, trapezoid chapels and acute angles at the meeting points of the chapel walls and the octagon outside (Fig. 8). Although feasible in cases of circular design,[42] this solution was evidently not appropriate to an octagon. Longhena found a way out of this predicament by designing trapezoid pillars without relating their sides to the centre of the octagon radially: he made the sides of two consecutive pillars parallel to each other. To be sure, this was not a new idea. Following Byzantine tradition, the architect of S. Vitale at Ravenna had done the same. But in order to be able to repeat the octagonal shape of the interior also outside, he returned in the ambulatory to a radial design resulting in large trapezoid sub-units and a complex system of vaulting (Fig. 11). This was not acceptable to an architect reared in the Renaissance tradition. Longhena had to be consistent throughout, and it is precisely the parallelism of the sides of adjoining pillars, logically carried over into the ambulatory, that enabled him to give the visually important units of the ambulatory as well as the chapels regular geometrical shapes (Fig. 9). Owing to this procedure the irregularly shaped sections of the ambulatory behind the pillars and between any two chapels are reduced to insignificance.

This is, however, not the full story, for Longhena also incorporated radial relationships in his design. The radii not only determine, as one would expect, the angles of the octagon and the broken faces of the pillars, but also the bases of the columns inside the octagon (Fig. 10). Thus within the compound design of each pillar the geometrical loci of the sides of the pillar and of the base of the column differ. Analytical enquiry then leads to an important result: while it is the openings between the pillars, and not their sides, that correspond across the octagon, the opposite is true regarding the bases of the columns; here it is solid form, and not open space, that corresponds. Longhena's handling of the pillar and column motif was new and ingenious. This will be realized when its effect is interpreted in terms of optical impact. Seen from the centre of the octagon the units of pillar and column reveal their dual function: while the sides of the pillars are space-limiting, the columns with their bases are space-absorbing.

Instead of a further verbal exposition I refer to Figs. 15, 33: the columns push forward into the central space, and as one is more or less consciously aware of their radial arrangement, they suggest rotation or, better, they support the enclosed centralized character of the octagon; the small orders of the piers, by contrast, face sideways, carry the arches of the octagon, and link up with the corresponding order of the chapels. We begin to see what fascinated Longhena in the plan with ambulatory.

Criticism of the Model

Longhena's model contained features which his contemporaries could not accept unchallenged. Current criticism found expression in the memoranda submitted by the experts (13). The statements of the brothers Comin were most explicit. They explained that the opening between two pillars of the octagon as well as the entrance to each chapel is "at least 18 feet"[43] and the width of the ambulatory only 15 feet. The arches inside the ambulatory would therefore have to be lower than those between the pillars (Fig. 12). They could not agree to this and regarded it as necessary to increase the width of the ambulatory by 3 feet so that the arches encompassing each ambulatory unit could be made equally high. Such treatment was, according to them, not only a requirement of correct design, but also a technical necessity because, they maintained, the ambulatory as planned by Longhena would not give sufficient support to the dome. Moreover, for reasons of proportion they advocated that externally the ambulatory should be raised at least 5 feet. Other experts summarily agreed with these stipulations.

The over-all width of Longhena's design was just, and only just, inside the permissible limits (Fig. 2). By incorporating the experts' recommendations the area of the Rotonda would have to be enlarged, and this was not possible because the building would have come too close to the church of SS. Trinità and would also have encroached on the site reserved for the monastery. The impasse seemed almost insoluble. The brothers Comin made a clear statement to that effect. And the expert Pietro Zambon opined laconically that the arches of the ambulatory were disporportionate in relation to those of the octagon, but that the restriction of the narrow site did not allow the present limits to be exceeded. Girolamo Oti, finally, repeated the same criticism and held that the replanning of the entire Rotonda was unavoidable.[44]

These views are reflected in a passage of the final report of the committee (14), where the whole argument is reiterated with reference to the experts' opinions. The deadlock created by the supposed necessity of enlarging the area of the Rotonda and the impossibility of doing so, is summarized in one lapidary sentence: "a manifest defect (of Longhena's model), unsurmountable, known to one and all, affirmed by experts, a defect which we felt we had to bring to the attention of the Senate as of most urgent importance."[45]

All this was, of course, very much on Longhena's mind. It now becomes clear why he mentioned in his memorandum (9) the width of the Rotonda of the pre-model designs instead of the increased width of the model stage. By incorrectly quoting 118 feet rather than 124 feet as the greatest width of his model he hoped to avoid discussion of this critical point. In addition, the greatest width of Fracao's project was 120 feet (Moschini, p. 16), and Longhena must have felt it necessary to score against his competitor in this matter of vital importance. We have come to the conclusion that between his first set of designs and his model Longhena widened the ambulatory from 12 to 15 feet. This was not a concession to criticism, for the experts pounced upon him long after the change had been made. Once he had made up his mind that he had found the right solution he was prepared to defend it tooth and nail, even at the risk of having his project rejected.

In the end Longhena carried his point. He was a better technician than the experts, for his ambulatory remained 15 feet wide, and the church stands as firm as a rock. Nor was he unduly worried by the offence against uniformity in the height of the arches in the sub-units of the ambulatory. He adjusted the arches inside the ambulatory by stilting them slightly, but their apex is about 60 cm. lower than that of the arches of the octagon. He must have been convinced that this irregularity would remain unnoticed because the arches of the

ambulatory belong to an optically neutralized area. This has proved so true that Diedo's section, which shows the octagon and ambulatory arches as of equal height, has always been accepted as correct.[46] Only recently have the real facts been revealed by Santamaria's measured drawings, published in *L'Architettura*, 1955 (Fig. 12).

As regards the exterior Longhena had no intention of yielding to the expert's recommendation. An increase of the height of the ambulatory wall would have had serious repercussions on the carefully balanced internal design. Moreover, he had many other reasons for keeping the ambulatory wall low. On the other hand, the magnificent scrolls optically form part of the body of the church, which seems, therefore, higher than it really is (Figs. 7, 42).

The criticism of the experts was focused on the discrepancy in the height of the ambulatory arches. The points they made may seem to us somewhat spurious; we may feel that the argument was taking place in the thin and unrealistic atmosphere of academic finesse. But this would be misjudging the situation. After all, the criticism came from men well versed in the practice rather than in the theory of architecture. These experts had certain standards with which they had grown up and which they regarded as unimpeachable. The tradition of Renaissance aesthetics was part of their intellectual equipment, and to them it was, therefore, an article of faith, almost a law of nature, that a spatial unit must be encompassed by arches of equal height. Longhena, on the other hand, introduced new optical standards, and it is these, that made it possible for him to transcend the limitations of the earlier approach. Yet he was far from throwing tradition overboard.

Traditional Aspects of Longhena's Design

In his two memoranda Longhena himself proudly points out the novelty of his design (9, 15), and his view is echoed in the final report of the committee (14). Nevertheless

his grammar of forms is firmly based on precedent. In a hundred direct and indirect ways S. Maria della Salute shows links with Palladio's architecture. Such features as the high pedestals of the columns, the breaking of the entablature above them, and the combination of the small Corinthian and the large Composite order derive from S. Giorgio Maggiore (Figs. 16, 17). Moreover, although it is less obvious, the attentive student cannot fail to discover the impact of a distinct older group of buildings. A number of Bramantesque Lombard churches, for which S. Maria di Canepanova at Pavia (begun 1492?; Fig. 13) may serve as an example, are designed as octagons with columns on high pedestals in the re-entrant angles. The similarity to S. Maria della Salute is evident. These churches also have as a rule the high drum with the two round-headed windows to each wall section — a clear indication that Longhena knew this class of works.[47] But instead of continuing the columns of the octagon into the architecture of the drum — the rule in Bramante's circle — Longhena placed large wooden figures of Prophets above the projecting entablature of the columns (Fig. 18, 31). He therefore strengthened the impression that each column with its figure is a unit in its own right; at the same time, the coherent sequence of these 'monuments on columns' supports the self-contained, centralized character of the octagon. It may be mentioned at once that the addition of an almost independent centralized presbytery to the centrally planned main body of the church is common in the North of Italy,[48] again, the closest parallels to S. Maria della Salute will be found in Bramante's circle (Fig. 13).

Among the Palladian detail used by Longhena the segmental window with mullions deserves mention. Palladio first incorporated this type of window, derived from Roman thermae, into ecclesiastical architecture in S. Giorgio Maggiore and Il Redentore (Fig. 29). He found the type eminently suitable because it supported and repeated the form of the arches, so that he was able

to avoid introducing a new shape for the lights into an otherwise homogeneous design. The same applies to Longhena's chapel windows: within the logic of his design it was absolutely indispensable to give the windows the form of the arches of the chapels (Fig. 33).

Palladio's influence on Longhena is so obvious that it needs no further elaboration. We shall see that it can also be traced in the architectural motifs of the presbytery, the high altar zone, and choir as well as in important aspects of the exterior. Moreover, even on far more fundamental matters Longhena turned to Palladio for guidance. He owed to Palladio his basic, conceptual approach to architecture, and this is a point which we shall later discuss in some detail.

It seems hardly possible to reconcile with our analysis the view, often expressed, that the design of the Rotonda was dependent on the famous woodcut in Colonna's *Hypnerotomachia*, first published in 1499, which shows a section through a centrally planned building with ambulatory (Fig. 14). Although slight affinities between the woodcut and S. Maria della Salute cannot be denied, the romantic idea that the former supplied the basis for the planning of a real structure must be abandoned once and for all. To regard Longhena's project—as has been done—as a literal plagiarism from the Quattrocento source,[49] is only proof of the blinding effect of preconceived notions. Yet one motif Longhena may possibly have owed to the graphic representation: the figures above the columns. There is, incidentally, no reason to doubt that the *Hypnerotomachia*, well known to every Venetian, had a certain impact on the direction of his thought.[50] For the actual planning, however, he turned, as we have seen, to Byzantine and Bramantesque ideas and wedded them to the Palladian tradition.

The Rotonda as Symbolic Architecture

When he decided on a centrally planned design, Longhena was, of course, guided by a great variety of considerations. He had to reconcile the spatial limitations dictated by the restricted site at his disposal (Figs. 1, 2) with the request for monumentality, and his choice of a centralized plan was not independent of this aspect. He knew that a centralized church looks larger than it is, and this was also observed by the members of the committee who mentioned in his favour (14): "ricerca spaziosità e larghezza per goderla non meno al di dentro che a fuori, eguaglianza di parti, principalmente grandezza, più che ordinaria." The urban setting, too, almost required a centralized solution. It was most appropriate to crown the tip of the island between the Canal della Giudecca and the Canal Grande, near the point where the two merge into the broad Canale di S. Marco, with a compact building and a widely visible, high dome (Figs. 1, 19, 20). In addition, chance had given this exposed setting a particular significance, for the new church was to rise in the centre of a semi-circle with San Marco and Palladio's S. Giorgio Maggiore and Il Redentore at about equal distances on the periphery (Fig. 3). Although we cannot prove it, it seems more than likely that Longhena was fully aware of the fact that only a centrally planned church would establish an ideal relationship to the arc of these great churches. Whether he was conscious of it or not, this intangible harmonizing of the design with the monumental buildings in the vicinity testifies to the susceptibility of a master who had his ear close to the heartbeat of his city. By introducing the conception of the centre, the radii, and the periphery of the circle Longhena superimposed on the varied and picturesque sky-line of Venice the kind of urban order that was in line of descent from the town-planning ideas of the Renaissance—but the scale and extensive sweep of his scheme has a truly Baroque quality.

No practical, utilitarian or technical considerations could possibly have dictated Longhena's choice of a centralized project. But the artistic reasons, just stated, would

seem amply to justify his decision. The centralized design, therefore, has the quality of a powerful symbol in so far as it must be regarded as the formal sublimation of a visionary responsiveness to the *spiritus loci*. This is, however, only one side of the story, for Longhena felt the need of suggesting a distinct literary concept by the specific form of his design. The centrally planned church was the symbol of a sublime mystery for him. He expressed it himself with these words in his first report (9): "The mystery contained in the dedication of this church to the Blessed Virgin made me think, with what little talent God has bestowed on me, of building the church in *forma rotonda*, i.e. in the shape of a crown."[51]

The crown alludes to the Queen of Heaven whose help was implored in the Venetian litany which was recited during the processions at the time of plagues.[52] And the Virgin as Queen of Heaven appears twice in the building, first over the pediment of the main entrance (Figs. 21, 42), elevated above the host of angels,[53] and a second time on the high altar under an enormous crown hanging from the vaulting (Fig. 24). Longhena's own words seem to suggest that he also thought of the crown of stars of which the twelfth chapter of *Revelation* speaks: "a woman clothed with the sun, and the moon under her feet, and upon her head a crown of twelve stars." Indeed, the Queen of Heaven over the altar is an Immacolata; in addition, the large figure of the *Immacolata* with the crown of stars raised high above the dome (Fig. 21) proves without a shadow of doubt that at some time during the construction the passage from *Revelation* had unequalled authority. The iconographical programme contains, moreover, a further important reference to the *Immacolata*: the Apostles, who were always thought of as the Virgin's companions[54] and, since St. Augustine, were symbolically identified with the twelve stars of her crown. Characteristically, they appear as large figures on the scrolls of the exterior.[55] Longhena's image of the crown takes on a

new dimension, for it does not seem idle speculation to interpret his words more literally than we are nowadays inclined to do and compare the figures with the points above the rim of the Virgin's crown. Inside the Rotonda, corresponding to the Apostles, over life-size figures of Prophets are placed before the re-entrant angles of the drum, below the area where the octagon is transformed into the round of the dome (Figs. 18, 31). Like the sibyls in the spandrels of the entrance (Fig. 42), it was they who by their prophecies foreshadowed the coming of the reign of Grace.[56] Thus the pointed contrast between the bizarre scroll-brackets — the realm of the Apostles — and the calm silhouette of the dome of Heaven is taken up inside as a contrast between the octagonal drum — the realm of the Prophets — and the divine roundness of the domical vault. The mystery of which Longhena speaks finds its human-made echo in the perfect symmetry of the 'crown-shaped' church,[57] and even the choice and distribution of the decoration plays a part in illuminating the symbolism expressed by the structure itself.

Longhena's symbolic interpretation of the Rotonda looks back to, and is superimposed on, a very old tradition. Already at an early period the Virgin was glorified as the Queen of Heaven and the protector of the whole universe, owing to the accretion of ideas around her burial, assumption, and coronation.[58] The martyrium erected over her tomb, the heaven in which she is received, the crown of the heavenly Queen and the crown of stars of the *Immacolata*, the roundness of the universe over which she presides — all these inter-related concepts played their part in determining the centralized planning of so many sanctuaries and churches dedicated to the Virgin. The Italian Renaissance was particularly responsive to this symbolism, since Renaissance architects were attuned to the 'divine harmony' which they found expressed by the perfect geometry of centrally planned churches with dominating domes.[59] Buildings such as

S. Maria della Consolazione at Todi, S. Maria di Canepanova at Pavia, the Madonna di Campagna near Verona and many others immediately come to mind. The Incoronata at Lodi retains in the name the reference to the crown. Like all these older churches, Longhena's design was deeply rooted in ancient religious symbolism. Moreover, he fully harmonized artistic considerations with the demands of the iconographic tradition.

Presbytery and Choir

Our discussion so far has been mainly focused on the Rotonda. A closer inspection of the presbytery and choir is now necessary. A few steps separate the Rotonda from the presbytery. This domed area with apsidal endings in the transverse axis is only loosely connected with the octagon—a manner of combining isolated spaces known from Roman antiquity. [60] Adopted at an early date in northern Italy, the type—as we have seen—served Longhena as model. But in an important respect Longhena's solution departs from similar spatial groupings of the Renaissance (Fig. 13). Instead of maintaining the homogeneity of wall treatment in the main and subsidiary units, neither the form nor the articulation of his presbytery has much in common with the Rotonda, as a cursory glance at the section (Fig. 12) demonstrates.

The giant pilasters of the apses are the principal motif in the presbytery (Fig. 22). Between them are two tiers of windows, the lower ones in the shape of the so-called Venetian window, the upper ones rectangular and framed by columned aediculae. There is nothing in the Rotonda to prepare for this arrangement. [61] But Longhena took his cue from Palladio [62] who in Il Redentore had performed a similar change of system between the nave and the centralized domed unit (Figs. 23, 29). In spite of the evident similarities, however, the break does not appear as radical as that carried out by Longhena. The comparison between the two sections speaks for itself and makes further

analysis superfluous. Only one point requires special comment. In Il Redentore all the horizontal divisions are carried over from the nave into the domed area; in S. Maria della Salute, on the other hand, there are in this respect significant discrepancies between the Rotonda and the presbytery. The high common base of the pilasters does, in fact, rise to the height of the pedestals of the columns in the octagon; but the Venetian windows of the presbytery begin and, consequently, end at a higher level than the ambulatory windows; the broad string-course between the two tiers tallies only at the upper edge with the cima (top profile) of the entablature of the small order in the Rotonda; the pilasters of the presbytery are slightly longer than the columns of the octagon; [63] and the main entablature lies about 50 cm. above that of the octagon. When looking at the section (Fig. 12), it is this lack of elementary unification between the two spaces that one registers long before analysing its cause. It would not have been difficult for Longhena to avoid such inconsistencies. They are, of course, deliberate and must, therefore, have a special reason for which we shall try to account in a later context.

The rectangular choir is separated from the presbytery by a broad arch resting on pairs of free-standing columns; [64] between them stands the large high altar crowned by Le Cort's sculptured group of the Queen of Heaven with the personification of Venice in devotional attitude kneeling at her feet, while Venice's counterpart, the gruesome allegory of the Plague, takes to flight (Fig. 24). The whole area of the high altar and choir is raised one step above the level of the presbytery. [65] Once again, the articulation changes inside the choir: two small orders of pilasters are placed one above the other. [66] And once again, the horizontal divisions in the presbytery and the choir do not entirely correspond. The string-course is carried over from one unit to the next, but in the choir the base is higher than in the presbytery, and the windows of the upper tier

are on a higher level than those of the presbytery.

Pairs of columns framing the high altar, and functioning as a screen through which the choir is seen, were used by Palladio in S. Giorgio Maggiore for the first time (Fig. 25). In spite of important changes, Longhena had recourse to this solution. In the choir of S. Giorgio Maggiore Palladio switched to a small-scale system, and this is precisely what Longhena did in S. Maria della Salute. And as in S. Giorgio Maggiore, the beholder views an entirely new type of articulation behind the area of the high altar.

In making such changes from unit to unit Palladio as well as Longhena were, of course, guided by the rational consideration that rooms with different functions and of different shape and size require different architectural treatments, whereby they are given their specific and autonomous character. One may be tempted to conclude that Longhena not only used retrogressive Palladian detail, but also grouped together isolated spatial units in an additive Renaissance-like manner. This, however, would be a serious misinterpretation of his intentions. It is a misinterpretation from which the older pragmatic history of art knew no escape.

The Mathematical Concept

Longhena employed, in fact, a dual method of unification and integration: an objective-mathematical and a subjective-optical one. Both procedures will have to be investigated in turn. It is they and their relationship to each other that supply the key to Longhena's ideas. To begin with his objective-mathematical approach, it is hardly necessary to emphasize that his method of establishing arithmetical ratios throughout the entire building is derived from the Renaissance conception of proportion. He worked mainly with the ratios of small integers, and it may at once be said that his specific procedure reveals a thorough and intelligent study of Palladio's work, on a level that leads deep below the surface of patent influences and straight-forward borrowings of motifs.

Fortunately, we have Longhena's own quotations of measurements as a guide to the system of proportion underlying his model of S. Maria della Salute. As we have seen, not all the figures given by him were incorporated into the final design. But the measurements of his model are sufficiently illuminating to allow us to draw certain conclusions regarding the ratios he was aiming at. The key is contained in five notations of our table (b, d, h, l, n); they show that in the model the size of the diameter of the Rotonda (without ambulatory)—60 feet—was repeated in the width of the presbytery, halved in the width of the choir (30 feet), quartered in the width of the central portal (15 feet), and divided by six in the depth of the chapels (10 feet). If one regards the width of the piers of the Rotonda as the module (5 feet),[67] the following simple series results: 5 (piers)—10 (chapels)—15 (entrance and ambulatory) —30 (choir)—60 (Rotonda and presbytery).

It is clear now that within this system of continuous ratios there was no room for an ambulatory of 12 feet width,[68] and it is reasonable to assume that in the model Longhena enlarged the width of the ambulatory not only for spatial and structural reasons, but also on grounds of proportional symmetry and coherence. Similary, after the stage of the model, the change of the presbytery and the choir seems to have resulted as much from a maturing of Longhena's architectural conception as from the desire to integrate the entire structure fully into an unbroken series of arithmetical ratios. In the model neither the 37 feet of the presbytery (g) nor the 26 feet of the choir (k) have a place in the simple progression discussed above. These unsatisfactory figures must be regarded as the by-product of the integrated widths h and l. One would expect Longhena to have striven for bringing the length as well as the width of presbytery and choir in line with his series of continued ratios.

His final result is as ingenious as it is simple. First it should be noted that the over-all width of the church is related to its over-all length (a : f) as 1 : 1½. This was not the case as long as he planned an over-all width of 118 feet. The final measurements of the domed spaces are 60 (Rotonda) and 40 feet (presbytery),[69] and the length of the choir is 20 feet; in other words, the relation between these three spaces follows the decreasing progression of 3 : 2 : 1. A similar coordination of ratios he achieved along the transverse axes. The series runs: 120 feet (measured across the whole Rotonda from chapel wall to chapel wall),[70] 80 feet (presbytery), and 40 feet (choir).[71] Once again, we find a decreasing progression of 3 : 2 : 1, and the first series to the second is related as 1 : 2 (Fig. 26).

One is on less firm ground as regards the ratios intended for the height of the structure, since Longhena himself supplied no figures. But it is a reasonable hypothesis that he applied a similar system of proportions to the vertical dimensions. This view is supported by the fact that the interior of the Rotonda is about 120 feet high,[72] corresponding to the entire interior width, while according to Santamaria's inscribed measurement the whole exterior height from the street level to the top of the Immacolata is 64 m. (182.4 feet) and is, therefore, close to the entire outside length (f). Moreover, the height of the arcades of the octagon corresponds to the height of the dome, and the whole area between the arcades and the dome repeats the same measurement. Thus the interior height is built up of three times 40 feet,[73] but units of 30 and 60 feet are also significant.[74] The most important large unit outside seems to be once again 40 feet (Fig. 36). The height from the level of the entrance to the entablature of the giant order and from there to the top of the entablature above the drum is twice 40 feet,[75] and the same measure recurs in the height from the foot of the scrolls to the top of the attic and from there to the foot of the lantern.

The same unit appears also in the elevation of the presbytery, first, in the height from the floor to the entablature above the giant order and, secondly, in the combined height of drum and dome. This analysis could easily be carried considerably further,[76] but I am well aware of the danger of deception presented by a pair of dividers in the hands of the historian. Enough has been said to show that a unifying system of arithmetic ratios informs the whole structure in all three dimensions. I have confined myself to the demonstration in detail of the all-pervading logic of the system of proportion in the plan, where Longhena's own measurements can be used as a guide.

My analysis shows—I trust—that he endeavoured to bring a variety of exigencies into line with what he regarded as a harmonic mathematical development of his design. This was for him a pre-condition of successful planning. Still heeding Alberti's recommendation and warning that a building dedicated to God did not permit of the slightest liberty in proportion, Longhena must have regarded an immanent mathematical structure as a *sine qua non*. And for an architect who had studied Palladio so closely, it was the musical ratios of the small integers[77] that attuned the building to universal harmony.

The Optical Concept

The second method of unification which Longhena employed, attunes the beholder to the optical relationships suggested by the handling of the design. A detailed description of his procedure will show clearly the extent to which he transcended the procedure of the Renaissance. On entering the church, the spectator sees in his field of vision the columns and arch framing the high altar, and it is essential to note that, looking straight ahead, his view of the altar is not interfered with by any distracting features (Figs. 27, 34). Thus the beholder's attention is immediately directed to the spiritual centre of the church; its

importance is emphasized by the framing function of a contracting series of arches, one behind the other, from the arch of the octagon to those of the ambulatory and of the altar and, concluding the vista, to the arched wall of the choir. Originally, this wall contained the apogee of the composition. Before it was blocked up, the central window, opening to the south,[78] shed an aureole of light around the head of the Virgin on the altar.

So, in spite of the carefully calculated centralization of the octagon and in spite of the autonomy of spatial entities, unification is achieved in terms of a scenic progression. More thoroughly than the selection committee could ever have expected, Longhena had complied with the demand that the high altar should dominate the view from the entrance.

Only when the optical factor is taken into consideration can the meaning of Longhena's design be fully understood. Whichever way one looks from the centre of the Rotonda, entirely homogeneous perspective views open (Figs. 15, 33): an arch of the octagon, an arch of a chapel and of the mullioned window appear set one into the other, and even each altar pediment consists of a segment with the same curve. From the ideal standpoint in the centre the trapezoid sectors behind the pillars are completely invisible; Longhena evidently knew what he was doing when he refused to respond to criticism.

The question which we have been asking throughout this study, why Longhena clung so stubbornly to a design with ambulatory, despite the criticism and the overwhelming difficulties it created, can now be answered. His passionate interest in determining the beholder's field of vision was surely one of the major factors which made him concentrate on his problematical project instead of choosing one of the more traditional centrally planned designs common since the Renaissance.[79] It cannot be emphasized too strongly that no other type of plan allows only carefully integrated

views to be seen; it is the plan with ambulatory that prevents the eye from wandering off and making conquests of its own.

In his first memorandum (9), Longhena himself pointed out that one can enjoy the full view of all the chapels and altars from the centre of the church.[80] In a precise and unexpected sense he thus fulfilled the stipulation that the altars should come into view as one walks into the church. Indeed, they are all visible from the same point from where no other distracting views are possible—apart from that toward the high altar. One may argue that the uniform 'pictures' here described are not effective unless the beholder takes up certain pre-selected standpoints. This does not invalidate our conclusions: Longhena's own words prove that he had such fixed viewpoints in mind, and they recommend themselves to the sensitive spectator by the character of the design.

Once again, for his method of optical unification Longhena followed Palladio's lead. In Palladio's Redentore the hall-like nave and the centralized domed area— objectively entirely separate entities— form an optical unit for the view from the entrance (Fig. 28).[81] The visual lines which I have drawn on the plan show that from the entrance the beholder sees a half-column coupled with a pilaster at the far end of the crossing—a precise repetition of the motif that closes the nave (Fig. 30). Walking along the central axis, one perceives more and more of the farther supports of the dome, until, from the centre of the nave, one sees a grouping of half-columns and niches very similar to the bays at the end of the nave. That such an optical rapport was new and unusual, may be exemplified by reference to the most important and most progressive Roman structure, the Gesù. Here the unification of the nave and the domed area is accomplished by the repetition of the same order of giant pilasters around the entire building, without any of Palladio's scenic effects. The comparison demonstrates all the more

clearly to what an extent Longhena was indebted to Palladio's principle of optical unification of separate spaces. But S. Maria della Salute shows that the disciple went far beyond the master in the application of this method.

It is often said that Baroque architecture owes a great deal to the contemporary stage. This assertion requires considerable modification when applied to Roman Full Baroque buildings. Short of divesting the term of any precise meaning, it is difficult to detect scenographic concepts in such a church as Borromini's S. Carlo alle Quattro Fontane, begun in 1634, three years after S. Maria della Salute. It can easily be demonstrated that S. Carlino was conceived in terms of a sophisticated arrangement of interlocking rhythms, which determine the poignancy of the unified spatial impression. Once the implications of this procedure have been understood, a generalization seems inescapable: on the whole, the architects of the Roman Baroque aim at dynamic spatial effects, and their structures are, therefore, intrinsically non-scenic. With Longhena, it is quite another matter: in the case of S. Maria della Salute the relation to the stage is real and specific. Here scenery appears behind scenery like wings on a stage. Instead of inviting the eye—as the Roman Baroque architects did—to glide along the walls and savour a spatial continuum, Longhena constantly determines the vistas across entire spaces.

It is also reminiscent of the stage that in S. Maria della Salute the floor rises with the perspective, first at the transition from the octagon to the presbytery and then at the junction of the presbytery and the high altar.[82] By contrast, in none of the Roman Baroque churches is the continuity of the floor space interrupted by steps.[83] In contrast also to Roman churches, and even to those of Palladio, in the different units salient features such as entablatures and windows are not on the same level; as we have noted, they

lie higher from space to space. It is such diversions from objective alignments that guarantee the impression of optical continuity. A study of the exterior makes this particularly obvious (Figs. 7, 12). The cornice separating the drum and dome of the presbytery is 1 m. above the cornice which crowns the drum of the Rotonda, with the result that, from a distance, there seems to be continuity from one cornice to the next.

All the observations of this section make it apparent that the judicious grouping of almost self-contained Renaissance-like units rather than the Roman concept of dynamic unification was the pre-condition for a strictly scenographic architecture. This also explains why the architecture of the Late Baroque (which may be said roughly to begin with Carlo Fontana), in spite or just because of its classicizing tendencies, was essentially a scenographic style.

Taking Palladio's architectural principles as his starting point, Longhena evolved an alternative to the Roman Baroque. His Venetian Baroque was, in fact, the only high-class alternative Italy had to offer. It is hard to resist the temptation of seeing, on a different plane, a renewal of the contrast between Venice and Rome, Titian and Michelangelo. But just as this old contrast between colore and disegno cannot simply be stated in terms of freedom versus law, illusion versus truth, optical refinement versus representational honesty, irrationality versus intellectual sobriety, so Longhena's architecture should not simply be interpreted as arbitrary, 'painterly' and 'picturesque', as has been done from Selvatico to the recent monograph by Semenzato.[84]

Without going further into the semantic problem, I would claim that the term 'scenographic' rather than 'picturesque' helps to define Longhena's intentions. In its specific stylistic sense, the term 'picturesque' should be reserved for a late eighteenth-century trend, the pro-

moters of which stood for asymmetry in theory and practice and were violently opposed to all Renaissance values.[85] In contrast to this purely sensorial style, Longhena's scenographic approach to architecture implies a precisely construed relationship between the object to be viewed and the viewer; space is organized with reference to him in such a way that from the right standpoint he always perceives coherent perspective images. Longhena, therefore, drew the logical consequences of the Renaissance conception of space and its corollary, central perspective.[86]

But for Longhena this subjective, scenographic space would have lacked the quality of finality, were it not anchored in, and superimposed on, an objective mathematical space ordered according to absolute ratios and existing in its own right, independent of the beholder. It is this interweaving of the objective mathematical and the subjective optical concepts that gives the planning of S. Maria della Salute its singular character and makes the church one of the most important buildings of the entire seventeenth century. And nobody can deny that it needed a master of rare ability to be stimulated by the strictly defined requirements into conceiving a design with flawless absolute proportions beneath the scenographic surface.

Although Longhena's problem was to a certain extent still that of Brunelleschi, he had moved far from the position of the founder of modern architecture. To Brunelleschi central perspective was the intellectual vehicle for perceiving metrical harmony and order in space.[87] The metrical organization of his structures and the perception of their harmonic mathematical quality may be likened to two sides of a coin. In Longhena's case this unity was broken. The ratios of the series 5, 10, 15, 20, 40, 60, 80, 100, 120, on which his design is based, have little, if any, bearing on the perspective images

revealed to the beholder inside the church. If I talk of the interweaving of the mathematical and optical concepts, it should be understood, therefore, that I mean the process of thought informing Longhena's design rather than the duality between the hidden metrical scheme and the obvious perspective effect.

A recognition of this duality invites a further reflection. It appears now that little would be said about a structure like S. Maria della Salute by only noting certain proportional relationships. All too often enquiry breaks off at that stage. But proportion as such is rarely meaningful. Our question should be: proportion for what purpose and in what context? I have attempted to supply an answer.

The Colouristic Concept

A study of Longhena's sophisticated handling of colour will throw more light on the relationship of mathematical to optical devices in the church. The whole interior is conceived in terms of the contrast between grey stone and whitewashed areas. Once again, the method was derived from Palladio. But it is well known that it was neither Palladio's invention nor speciality. It had, in fact, a mediaeval pedigree, was taken up and systematized by Brunelleschi, and, after him, resorted to by most architects who in one way or another took their cue from the Florentine Renaissance. The architects of the Roman Baroque avoided this method of differentiation, the isolating effect of which would have interfered with the dynamic rhythms of their buildings. Thus, in a very important respect Longhena was tied, via Palladio, to the tradition of the Florentine Renaissance.

It is even more important to notice where he departed from Florentine usage. Tuscan architects were consistent in applying grey stone to the structural parts and whitewash to the rest. Longhena abandoned this logical procedure. For him colour was an optical device, which

enabled him to support or suppress elements of the design, thereby directing the beholder's vision. The grey stone columns of the octagon rise before the whitewashed pilaster shafts of the piers, and this gives emphasis to the homogeneous 'reading of the eight columns (Figs. 15, 16, 33). On the other hand, the pilasters of the piers and the orders of the ambulatory and the chapels form a visual unit not only because of their equal height but also by virtue of their whiteness. Thus the colouristic treatment helps to isolate the octagon from the radiating spaces and, in addition, supports the impression of scenographic entity of the latter. Yet the position is somewhat more complicated, for the capitals, entablatures, and arches of the small orders are of the same dark grey stone as the columns of the Rotonda;[88] and so is the lower part of all the shafts of the small orders to the height of the pedestals of the large columns. It is these dark stone features that re-establish a tangible link between the radiating spaces and the enclosed space of the octagon.

In S. Giorgio Maggiore Palladio had placed the half-columns of grey stone against whitewashed pilasters,[88a] whereby he pulled the nave together as a rhythmically divided unit and contrasted its longitudinal direction with the transverse direction of the aisles and chapels (Fig. 17); among other things he also made the lower part of the pilaster shafts of stone. Longhena's acceptance of this not entirely agreeable device—which incidentally was also dictated by obvious practical reasons —shows to what extent he relied on the older master. But he went far beyond his model and experimented with infinitely more complex colour arrangements.

The colouristic handling of the drum and dome is a case in point (Figs. 18, 31). In the past, purists attacked Longhena for having placed above the Composite order of the columns of the octagon a Doric order of pilasters along the walls

of the drum.[89] Yet these pilasters are not meant to be a structural and logical continuation of the columns; this is indicated not only by the function of the columns as bearers of 'monuments,' by the intense break between the body of the church and the drum caused by the gallery, and by the flatness of the pilasters, but, above all, by their warm beige colour which contrasts with the cool grey of the columns.[90] The beige pilasters rise before window surrounds—arches resting on pilasters—of grey stone, so that the colour relationship between the columns and the pilasters in the octagon is very nearly reversed in the drum. By virtue of their colour the window surrounds establish an unexpected link with the body of the church; unexpected, because the grey stone pilasters of the drum correspond to the whitewashed pilasters of the pillars below. The reversals in the colour scheme show that Longhena wanted to treat the drum as an area existing in its own right. He, therefore, did not hesitate to introduce another 'licence': he also placed pilasters above the voids of the octagon—an unforgivable sin against the letter and the spirit of classical precepts.[91] The round vault of the dome, boldly placed upon the octagonal drum, is structurally again conceived as an isolated unit, but optically drum and dome belong together owing to the sixteen beige-coloured, band-like ribs which continue, also colouristically, the hexadecagonal articulation of the drum.[92] Finally, with the eight columns of the lantern Longhena returned to the number of supports in the lowest tier— thus resolving the contrast between the octagonal and hexadecagonal dispositions.

Colour reversals more telling than those in the Rotonda are to be found in the presbytery (Fig. 22). Here the shafts of the giant pilasters are whitewashed and what remains of the walls between the pilasters is grey stone. In other words, the entire colour scheme of the octagon

has been reversed. This subjective play with colour was for Longhena primarily a means of supporting the autonomous character of adjoining spaces. In terms of visual experience, such colour reversals present the beholder with a whole range of new sensations, for one might almost say that the plastic solids (grey areas) and the flat fillings (white areas) have exchanged places. No further comment is needed to illuminate the essential contrast between the Florentine colouristic procedure which sustains a coherent metrical system and Longhena's which operates with large optical fields.[92a]

A word should be added about the light. Strong contrasts of dark and brightly lit areas as a means of dramatizing architecture belong to the repertory of the Roman Baroque. Longhena's S. Maria della Salute, however, is anything but dramatic. He worked with an evenly distributed bright light using, in the wake of Renaissance procedure, individual sources of light for each spatial unit; even the trapezoid sectors of the ambulatory have their own windows. Since studied light effects would have interfered with the clear perception of scenographic views and, implicitly, of unified or contrasting colour areas, he had to make no concessions in complying with the request of even distribution of bright light throughout the entire church. Thus Longhena's approach to colour and light supplements each other. The upshot of all this is that his specific use of colour, rare or even unique at the time,[93] further obscured the mathematical harmonic structure of the design, while supporting the perception of 'pictures' defined by optical laws.

The Exterior

It remains to investigate to what extent scenographic principles apply to the exterior of S. Maria della Salute. Without losing sight of our main quest, some observations about the exterior may find a place here. In designing the church, Long-

hena had to take into consideration the different requirements concerning the far and the near view. This old problem of monumental building needed closest attention since the church was to rise in one of the most exposed and busiest parts of the city. The high dome and the rich silhouette were intended for the view from afar. Technical wizardry was needed to make this dome possible. Even from a fair distance the beholder cannot avoid noticing the 'functional' quality of the design (Figs. 1, 7, 19). The scroll-brackets take the place of Gothic buttresses, and their thrust is conducted further, along the projecting side walls of the chapels. In this way Longhena created an extremely lucid system of abutments to the dome.

It has been maintained that this design closely followed Labacco's engravings of 1558[94] after Antonio da Sangallo's project for S. Giovanni de' Fiorentini in Rome[95] (Figs. 35, 36, 43). A sober study reveals, however, that this opinion cannot be accepted without considerable reservation. In Labacco's plan the walls of the chapels which serve as abutments to the dome are placed entirely inside the containing circular wall of the church. His design is essentially a 'wall structure' with an uninterrupted sequence of subsidiary units. Longhena's church, by contrast, is a rhythmically arranged 'skeleton structure' where the static problem is solved by way of an intricate system of pillars and arches.[96] In Labacco's project neither the dome itself and its relation to the drum nor even the triumphal arch motif of the façade show more than the vaguest analogies with S. Maria della Salute. On the other hand, one will not hesitate to agree that Longhena seems to have been attracted by the uncommon motif of the large scrolls. But while Labacco's engraving shows the traditional S-shaped scrolls and giant figures placed before them, Longhena entirely transformed the scroll-brackets, crowning them with the figures as stabilizing weights. It is the

bulging circles of the bracket ends with their decorative spirals (Fig. 32) that introduce the luxuriant note into an otherwise austere design.

The dome of S. Maria della Salute has an outer and an inner vault, the outer one consisting of lead over wood, in keeping with the Venetian tradition (Figs. 12, 21). The use of double shells for domical structures had, of course, a long pedigree: it was an ingenious Byzantine device, revived in the Renaissance, of making an effective external silhouette possible. By treating the outer shell as a separate vault, only connected with the inner shell by a system of wooden supports, Longhena departed from central Italian technique as practiced from Brunelleschi's dome to Michelangelo's and beyond, and returned to the structural method of San Marco. But he accepted the 'false' inner lantern, placed between the two shells and therefore not visible from outside — a type which was not rare after the dome of S. Spirito in Florence and which even Michelangelo incorporated into his model of the dome of St. Peter's. Longhena's external lantern, an airy structure, designed for the far view, has at its base a simplified version of the scrolls on which are perched Scamozzesque obelisks instead of the figures. Continuity of design is further emphasized by the repetition of similar scroll-brackets at the lantern of the subsidiary dome as well as by the corresponding small domes over both lanterns and their echo in the two domes crowning the towers (Figs. 20, 41).

The most striking motif of Longhena's main dome is the transformation — inside and outside — of the octagonal drum into the round. Outside, this resulted in the hiatus between drum and dome for which Michelangelo's very different dome of St. Peter's established a precedent. If the design of the principal dome ingeniously blends a variety of stimuli from Byzantine, Renaissance and post-Renaissance sources, the subsidiary dome with its stilted form over a simple cylindrical drum is in direct line of descent from Byzantine-Venetian models. Palladio himself had followed this tradition and in the Redentore had placed a Byzantine dome between two round belfries (Fig. 40). It is this grouping that Longhena accepted for the south end of the Salute[97] (Fig. 39). In spite of such acceptance of the local tradition, it remains a fact that never before had the silhouette of a church been so varied and never before had such entirely different types of domes been combined into a unified 'picture'.[98] One can hardly doubt that for the panoramic view Longhena deliberately brought into play perspective effects[99] (Figs. 1, 7, 19) — but not scenographic principles of the kind discussed in this paper.

Quite different problems are posed by the near view which had to be designed for the approach from the Canal Grande (Fig. 42). The area in front of the church is necessarily shallow, and it was, therefore, a wise decision to make the body of the church as low as possible and, moreover, to emphasize the relationship to the human scale in the subsidiary fronts. It was also an imperative requirement to create, for the view from the Canal Grande, a rich and diversified façade of which the two conspicuous chapel fronts right and left of the main entrance had to make part. Longhena treated them elaborately like small church façades in their own right (Fig. 37); they are, in fact, clever adaptations from Palladio's small Chiesa delle Zitelle (Fig. 38). The entire tripartite front may be compared to an altarpiece with two wings, with a decisive emphasis on the central portion (Fig. 36). We notice that once again Longhena applied the principle of treating each part as an isolated unit; nevertheless some important horizontal divisions tally, and the small order of the chapel fronts is carried over into the large triumphal arch motif of the main entrance.

It is the centre motif that sets the seal

on the entire composition. The central arch with the framing columns corresponds to the interior arches of the octagon and the width of the side bays to that of the bays in the presbytery. In addition, the small order conforms with the one inside, and the niches for statues in two tiers echo the two rows of windows in the presbytery. The façade, therefore, combines the principal motifs of the octagon and presbytery: the theme is given before one enters the church.

There is even more to this integration of outside and inside. Clearly, the façade is devised in analogy to a *frons scenae*, to which the platform over the staircase forms the proscenium. A contemporary engraving shows the central door thrown wide open.[100] It is then that the consecutive sequence of arches inside the church, contained by the triumphal arch of the *frons scenae*, conjures up a proper stage setting. It is then, too, that the triumphal concept is thrown into full relief, for encompassed by arches—projections, as it were, of the triumphal arch of the front—appears the Queen of Heaven above the altar like a distant vision.

When talking of a *frons scenae* in connection with the façade of S. Maria della Salute, I am not thinking of the contemporary Baroque theatre which, after Aleotti's Teatro Farnese at Parma (erected between 1618 and 1628), always shows a wide open proscenium arch. Longhena's architectural *frons scenae* with the perspective appearing through the central opening points to an older prototype, namely Palladio's Teatro Olimpico (Fig. 44). One can hardly doubt that this building had an important formative influence on Longhena's design. It is the conceptual analogy rather than the similarity of detail that proves the point.

As a rule, architects of the Renaissance designed their church façades as isolated structures without organic relationship to the interiors behind them; this resulted from the Renaissance practice of interpreting each problem on its own merits. Most Roman Baroque architects, on the other hand, endeavoured to interpret exterior and interior as an organic whole. In consequence, Baroque church façades in Rome differ widely among themselves. They have at least one characteristic in common—that they are in a variety of ways linked with their respective interiors by dynamic devices. This is as true of Cortona's SS. Martina e Luca and Borromini's S. Carlino as of Bernini's S. Andrea al Quirinale, where patently the façade reverses the inside movement and design.

Longhena, too, interpreted the relationship of inside and outside in organic terms. In his case, however, the integration is derived from perspective contrivances borrowed from the stage. Though both should be termed Baroque, the Roman and the Venetian approach are worlds apart.

It seems to us that S. Maria della Salute is the most distinguished scenographic structure of the seventeenth century—at once a pioneering work and a culmination. Imbued with Palladio's ideas, but carrying them a decisive step further, Longhena made an important contribution to European architecture. In the last decades of the seventeenth century a remarkable volte-face can be observed in Italy: in their search for new values many architects turned from Rome to Venice and embraced Longhena's scenographic concepts. It was then that S. Maria della Salute came into its own. The aftermath can be found not only in Italy but also in countries as far apart as Spain, Poland and England.[101]

NOTES
1 The fullest collection of historical material concerning S. Maria della Salute appeared in Vittorio Piva, *Il tempio della Salute eretto per voto de la repubblica veneta*, Venice, 1930.

Some of the conclusions of the present paper were first published in *Journal of the Society of Architectural Historians* XVI (1957), pp. 3–10.

2 *La chiesa e il seminario di S. Maria della Salute*, Venice, 1842.

3 See note 1. Some documents appeared first in Flaminio Corner, *Ecclesiae venetae antiquis monumentis . . .* VII–VIII, Venice, 1749, pp. 74–6.

4 Venice, Archivio di Stato, Senato terra, filza 22 October 1630. Verbatim in Corner, *op. cit.,* p. 74f. and Piva, *op. cit.,* p. 29.

5 For the history of SS. Trinità and the Seminary, see Piva, pp. 13 ff., 73 ff.

6 See, e.g., Marco Antonio Sabellico, *Le Historie Vinitiane*, Venice, 1544, fol. 5v; H. Kretschmayr, *Geschichte von Venedig*, Gotha, 1905, I, p. 19 f., with references to chronicles.

7 In his 'inventario dei beni' compiled on 1 August 1648 after his death he is mentioned as "Antonio quandam Francesco Smeraldi, detto Fracao" (Arch. di Stato, Petizione 361, n. 29).

8 In the beginning of the memorandum Longhena mentions that at an earlier date he had handed in measured drawings of his project, whereupon he had been asked to make "un modello di rilievo sopra esse Piante. Io prontamente con ogni diligenza e studio il fabbricai. . . ." He concludes the memorandum with the words: "Il tutto mi obbligo prontamente mostrare nel mio modello e pianta presentati."

9 See Giovanni Casoni, *La peste di Venezia nel MDCXXX origine della erezione del Tempio a S. Maria della Salute*, Venice, 1830, p. 35.

10 Neither Moschini nor Piva published the result of the ballot. Longhena's project received 66 votes and Fracao's 39; see Arch. di Stato, Senato I, R.o 105, Terra 1631, fol. 222v.

11 Arab numbers in brackets always refer to the documents mentioned in the previous section.

12 Among the other competitors were probably the Florentine Gherardo Silvani and the Venetians Matteo Ingoli, Bortolo Belli and the painter Padovanino. See G. Dalla Santa, *Il pittore Alessandro Varotari e un suo disegno per la chiesa della Salute di Venezia* (Nozze Lampertico-Feriani), Vicenza, 1904.

13 Reproduced in Casoni, *op. cit.,* frontispiece, and Piva, p. 34.

14 See Dalla Santa, *op. cit.,* p. 13 ff.

15 See Casoni, p. 37 ff. and Piva, p. 97.

16 Casoni, p. 40.

17 ". . . mi sono posto, già mesi, a fare Pianta, Profili e Facciata in disegno. . . ."

18 See note 8.

19 There is no full agreement as to the measurements of the execution. Discrepancies are partly due to the fact that different authors measured the same parts between different points.

Old measured drawings are in *Le fabbriche più cospicue di Venezia*, Venice, 1820, II, plates 111–14; on these all later reproductions were based until recently. New edition of the same work with the title: L. Cicognara, A. Diedo, G. A. Selva, *Le fabbriche e i monumenti cospicui di Venezia*, Venice, 1858, II, pp. 113–18, plates 213–16, with additional notes by Francesco Zanotto. The text to the chapter on S. Maria della Salute is by A. Diedo (henceforth quoted as 'Diedo').

New measured drawings made under Bruno Zevi's guidance by Carlo Santamaria were published in *L'Architettura* I (1955), pp. 53–7 (henceforth quoted as 'Santamaria'). I am greatly indebted to Professor Zevi for having put the original measured drawings at my disposal.

I checked up certain measurements inside the church. In addition I am under a great obligation to Signor Cattaruzza of the Ufficio Tecnico of the Fondazione Cini for having also verified the measurements of the evaluation. He confirmed the correctness of Santamaria's work, but noted occasional errors in the figures inscribed in the drawings, a fact that had puzzled me before.

Finally, it should be mentioned that Piva *(op. cit.)* gives the principal measurements in his text without revealing his source for them.

I should like to put on record my gratefulness to the Fondazione Cini not only for the services of Signor Cattaruzza, but also for a number of new photographs which were spe-

cially taken for me and for the efficient and unfailing assistance given me by the staff of that admirable Institution.

20 Not only in my table but whenever mentioned in my text 'feet' are Venetian feet. One English foot equals 0.877 Venetian feet, i. e. the Venetian foot is *ca.* 13 inches. 2.85 Venetian feet = 1 m.

21 Santamaria's 44 m. are 125.40 feet. According to Santamaria the greatest width (including the base outside) is 45.40 m., according to Piva 45.50 m.

 As will be shown below the ideal measurements aimed at by Longhena are 124 feet (43.50 m.).

22 60 feet are 21 m. This is also the measurement given by J. Durm, *Die Baukunst der Renaissance,* Leipzig, 1914, fig. 863. Santamaria's measurements are not quite consistent.

23 According to Longhena himself (9) and the report of the commission (14): 19 feet; according to one of the experts (13): "18 in luce almeno." Diedo's and Santamaria's measurements agree. The latter's 6.50 m. = 18.5 feet.

24 According to Diedo: 10 feet from the balustrade to the pilasters of the wall and 11 feet to the wall itself. My own measurement is 3.65 m. = 10.5 feet. Santamaria's 3.80 m = 10.8 feet.

25 Diedo's and Santamaria's figures are in agreement.

26 188 feet = 65.9 m.

27 43 feet = 15 m. It is to be noted that in Santamaria's plan the steps are wrongly placed. The first step is flush with the half-columns (as shown in Santamaria's section) and not with the pilasters under the arch.

28 80 feet = 28 m. Piva's measure is 27.75 m.

29 In Diedo's plan clearly 10 feet = 3.5 m. In Santamaria's section: 3 m. (section through the arch), but in the plan at the level of the base of the columns at least 3.40 m.

30 According to Diedo 20.5 feet to the pilasters of the back wall and 21 feet to the wall itself. Santamaria's *ca.* 7 m. are almost precisely 20 feet. Piva's measurement: 6.60 m.; my own: 6.80 m.

31 Diedo and Santamaria almost agree. The latter's 13.5 m. = 38.5 feet. Confirmed by my own measurement.

32 Santamaria's 12.55 = 35.75 feet seems to be correct.

33 5.25 m. = 15 feet.

34 The level of the high altar area—separated from the presbytery by the Communion rails— is raised one step above the level of the presbytery. This step appears in the correct position in Santamaria's plan, but is wrongly drawn in his section. Three further steps lead up to the high altar.

 In the choir the level of the high altar is maintained, so that the floor of the choir is one step above that of the presbytery.

35 Measured at the bottom of the double pilaster shafts, according to Santamaria 1.85 m. = 5.27 feet.

36 See note 21.

37 See note 8.

38 Moschini, p. 9: ". . . mentre colla sola distanza che si trova presentemente di piedi dodici incirca esso corridore non si stima a sufficienza fianchegiata. . . ."

39 A comparison of the figures under g and k makes it evident that between the stage of the model and that of the execution Longhena added 6 feet to the presbytery and took 6 feet off the length of the choir.

40 The detailed measurements of the model taken along the central axis were: 12 (wall and entrance, corresponding to the chapels), 15 (ambulatory), 5 (pillar), 60 (Rotonda), 5 (pillar), 15 (ambulatory), 37 (presbytery), 10 (high altar area), 26 (choir). The sum is 185 feet to which should be added about 2 feet for the wall of the choir. This brings us within one foot (or 35 cm.) of the over-all measurement of 188 feet given by Longhena—but only if he planned the ambulatory 15 and not 12 feet wide.

41 See above, p. 178.

42 A common procedure in medieval rotundas with ambulatory. Among late examples Carlo Fontana's Jesuit church at Loyola, Spain, is particularly interesting because Fontana knew the Salute but did not accept the system employed in that church.

43 "18 in luce almeno"; see note 23.

44 "Mi oppongo alla Rotonda, bisogna alterarla. Si è esteso nei difetti espressi dai Comini della sproporzione dei volti tra gl'intercolumnii e i corridori; onde si converrebbe alterare tutto il corpo della Chiesa da chi volesse allargare i corridori, come si perderia il terreno per il Monastero, e si perderia il confine alla fondamenta, et sic juravit."

45 "difetto patente, isuperabile, conosciuto da tutti e affermato, dopo che dalla perizia di alcuni è stato raccordato, che conoscemmo di dover portare puntualmente alla notizia delle EE. VV. come punto essenzialissimo."

46 J. Durm (op. cit., fig. 863), too, who seems to have taken measurements in the building, incorporated into his section this and other mistakes made by Diedo.

47 This was first noticed by Dohme in Jahrbuch der Preussischen Kunstsammlungen III, 1882, p. 127.

 One must not exclude the possibility that the Venetian double-arched window, familiar from such palaces as Corner-Spinelli, Vendramin-Calergi, and the Scuola di S. Rocco may have influenced Longhena's choice. But before Longhena no such windows are to be found in Venice in the drum of a dome.

48 This type of plan was the North Italian contribution to the old problem of axial direction in centralized churches (see R. Wittkower in Art Bulletin XIX, 1937, p. 263 and Architectural Principles in the Age of Humanism, New York, 1965, pp. 11, 99 f). By placing the high altar into an architecturally isolated presbytery, axial ambiguity was reduced, for the centralized character of the congregational room was preserved without abandoning emphasis on the high altar.

49 See Lorenzo Santi, Ricordo di Fra Francesco Colonna e ragionamento sull'estetica architettonica, Venice, 1837, who was the first to claim Longhena's dependence on the Hypnerotomachia. See also P. Selvatico, Sulla architettura e sulla scultura in Venezia. Venice, 1847, p. 415.

50 The kind of influence which the Hypnerotomachia may have had on architectural thought was admirably demonstrated by E. Gombrich in Journal of the Warburg and Courtauld Institutes XIV, 1951, p. 119 ff.

51 "Avendo essa Chiesa mistero nella sua dedicazione, essendo dedicata alla B.V., mi parve per quella poca virtù che Dio benedetto mi ha prestato, di farla in forma rotonda, essendo in forma di corona, per essere dedicata a essa Vergine. . . ."

52 S. Beissel, Geschichte der Verehrung Marias im 16. und 17. Jahrhundert, Freiburg, 1910, p. 478 f.

53 Figures of angels are placed on the balustrade over the entrance, at both sides of the Virgin, as well as on top of the chapel fronts.

54 L'Abbé Auber, Histoire e théorie du symbolisme religieux, Paris, 1871, II, p. 225.

55 The figures are so much corroded and mutilated that it is virtually impossible to name them. But their number leaves hardly any doubt that the Apostles are represented.

56 Inscriptions make it possible to identify the figures of the Prophets. Apart from the four main prophets—Isaiah, Jeremiah, Ezechiel, and Daniel—three minor Prophets, Simeon, Hosea, Baruch, and, in addition, David are represented. The reasons for this choice are not obvious and would require further investigation.

 The rest of the decoration is not of absorbing iconographic interest. The main features may be mentioned briefly. Façade: left niches: St. Mark, St. Matthew; right niches: St. Luke, St. John. On the scrolls left and right of the Virgin: Moses and David.

 Subsidiary fronts: left of centre: in the niches: Courage, St. Michael, Justice; above the pediment: Eve. Right of centre: in the niches: Prudence, St. George, Temperance; above the pediment: Judith. Thus these two subsidiary fronts have a uniform programme: two antitypes of the Virgin, the two Archangels and the four Cardinal Virtues.

Presbytery: in the spandrels of the arch above the high altar: St. John and St. Mark; opposite: St. Matthew and St. Luke. In the niches left and right of the high altar: SS. Peter and Paul.

Chapels of the ambulatory: on the altars, with one exception (second left, Liberi's St. Anthony of Padua), pictures illustrating the life of the Virgin: Birth of the Virgin, Presentation in the Temple, and Assumption by Luca Giordano; Annunciation by Liberi; Descent of the Holy Spirit by Titian.

57 The close alliance between the crown and centralized buildings in contemporary thought finds welcome support in Domenichino's *Madonna of the Rosary* (Pinacoteca, Bologna; 1617–25), where the angel holding the crown appears next to one with a small round temple, both resting on clouds close to the Virgin. For the identification of the rosary with the crown of stars, see Beissel, *op. cit.,* p. 44.

58 R. Krautheimer, "Sancta Maria Rotunda," in *Arte del primo millennio. Atti del Convegno di Pavia,* 1950, pp. 21–7, discussed this problem at length and has shown that the roundness of churches dedicated to the Virgin was originally the result of their being derived from the martyrium erected over the tomb of the Virgin.

59 See R. Wittkower, *Architectural Principles, op. cit.,* p. 1 ff.

60 See, among others, the sequences of differently shaped domed spaces in Roman thermae.

61 With the exception of the Venetian window-type altars of the centre chapels; see Fig. 15.

62 First observed by Diedo who called the presbytery "felicissima imitazione di quanto pratico il Palladio nella Chiesa del Redentore."

63 In addition, their diameter is *ca.* 90 cm. as against the Rotonda columns' *ca.* 95 cm.

64 The colourful marble shafts—the only architectural members of precious material in the church—stem from the Roman theatre at Pola. Longhena obviously adjusted their height for his purpose.

65 See note 34.

66 Originally the three arches visible in Figure 24 opened in windows; they were blocked when the organ was built in. Professor Nicola Ivanoff informs me "che nel '700 vi è stato inserito l'organo bloccando le finestre, in modo che non è più, come era in origine, la parte più luminosa della chiesa."

67 Longhena does not mention the size of the pillars. It seems almost certain that they were executed as planned in the model stage. Measured at the base of the pilaster shafts their size appears to be slightly over 5 feet; see note 35. The diameter of the columns may possibly have been Longhena's module, but it seems to be slightly too large, namely 2.6 feet (95 cm.) instead of 2.5 feet.

68 It is possible that the ambulatory of 12 feet survived from an earlier plan to which the series 10, 12, 18 might well have belonged. In this plan the main measures of the ambulatory would have been related as 12 : 18. The present ratio is 15 : 18½ (see note 23). The latter figure (opening of the arches into the octagon) is the only major measurement that does not fit into the series of the execution, but the distance from column shaft to column shaft in the octagon is 20 feet.

69 The 43 feet of the length of the presbytery (g) are the measure taken from the steps on, as we have noted. The measure from the far end of the pilasters at the entry into the presbytery to the columns of the high altar—i.e. the presbytery proper—is exactly 40 feet.

70 It appears now that the intended over-all measure must have been 124 feet (120 plus 4 feet for the walls); see above, note 21.

71 The width of the choir falls short of the ideal measurement by 40 to 50 cm. (see *l* and note 31). The reason cannot be determined without further investigation. However, the difference between the actual and the ideal measurement does not seem large enough to voice doubt as to Longhena's intentions.

72 Diedo's, Piva's, and Santamaria's measurements differ considerably. Diedo committed the error, always repeated until it was corrected by Santamaria, of drawing the inner vault of the dome semi-spherically. In Santamaria's section the sum of the single measurements is

at variance with the corresponding over-all notation (mainly owing to the wrong inscription 8.92 m. for the height of the drum). The entire interior height to the ring of the lantern is given by Santamaria as 41.70 m. (118.8 feet) and by Piva as 42.20 m. (120 feet). Diedo mentions in his text: "tutta l'altezza dal pavimento alla sommità equivale a due larghezze dell'ottagono" (i.e. twice 60 feet). The measurement taken for me by Signor Cattaruzza is 42.57 m. (121.3 feet).

73 To be exact, according to Santamaria: 13.80 m., 13.90 m. and 13.70 m. = 41.40 m. (instead of the inscribed over-all measure 41.70 m.) or 39.3, 39.6, 39 feet.

74 The height from the pavement to the top of the figures in the octagon is 21.65 m. according to Santamaria (21 m. = 60 feet); the height of the dome and inner lantern is also 60 feet; the height of the drum, measured from the top of the balustrade is exactly 30 feet.

75 Santamaria's inscribed measurement '29 m.' (82.65 feet), shown in our Figure 12, refers to the height from the pavement to the top of the interior balustrade under the dome. The top of the outside entablature lies about 2 feet lower, i.e. the whole height is 80 feet.

76 According to Signor Cattaruzza's measurements it is 16.13 m. to the top of the entablature above the giant pilasters. Since the entablature is 2.20 m. high, the entire height without the entablature is 16.13 — 2.20 m. = 13.97 m. (14 m. = 40 feet).

The computing of Santamaria's figures for drum and dome results in 13.90 m. The radius of the dome is 20 feet (that of the large dome is 30 feet); its centre lies 1.50 m. above the entablature of the drum, and the full circle drawn from this centre touches, of course, the lower edge of the balustrade of the drum.

The radius of the semi-vaults of the apses seems to be 15 feet and the height of the giant pilasters 30 feet.

77 R. Wittkower, *Architectural Principles, op. cit.*, p. 101 ff.

78 See note 66.

79 Longhena also thought that the ambulatory plan had practical advantages for the smooth functioning of the service and religious ceremonies. He wrote (9): "tra la nave grande di essa Chiesa ed esse cappelle vi sarà sito per poterci andare intorno colle processioni nel tempo delle feste principali senza impedimento del popolo che si troverà nel mezzo della Chiesa, e delle Messe che vi saranno agli altari." Such later authors as Selvatico and Zanotto thoroughly disagreed. In any case, it seems unlikely that these were primary considerations in determining the choice of the ambulatory plan.

80 Moschini, p. 13: "ed essendo nel mezzo del Cupola grande, cioè nel mezzo di essa Chiesa si godranno benissimo tutte le cappelle e gli altari."

81 Wittkower, *op. cit.*, p. 97 ff.

82 The breaking up of the uniform floor space by steps is to be found, of course, in Palladio's churches. But the tradition went further back; see, e.g., Codussi's S. Michele all'Isola. Moreover, examples in the rest of northern Italy are not rare, e.g. S. Fedele in Milan.

83 With the exception of the step of the Communion rail.

84 *L'architettura di Baldassare Longhena*, Padua, 1954, p. 18.

85 C. Hussey, *The Picturesque*, London, 1924; N. Pevsner, "The Genesis of the Picturesque," *Architectural Review*, vol. 96, 1944.

86 It is perhaps not out of place to compare Longhena's approach to space with that of seventeenth-century perspective theory and practice. The spectator can, of course, take up any position inside the church; he is free to move about, but the views appearing in his field of vision may be distorted—just as Padre Pozzo's illusionism collapses when seen from a wrong standpoint.

87 Further to Brunelleschi's 'perspective' conception of architecture, Wittkower, "Brunelleschi and 'Proportion in Perspective,'" *Journal of the Warburg and Courtauld Institutes* XVI, 1953, p. 275 ff.; G. C. Argan. *Brunelleschi*, Mondadori, 1955; C. Brandi, *Arcadio—Eliante*, Milan, 1956, p. 155 ff.

88 In the illustrations the capitals look darker, but this is due to the effect of shadows.

88a During a recent restoration the pilasters have also been painted grey.

89 See Antonio Visentini, *Osservazioni che servono di continuazione al trattato di Teofilo Gallacini sopra gli errori degli architetti*, Venice, 1771, pp. 68, 69; see also Diedo's text. Selvatico, *op. cit.*, p. 414, defended Longhena against the purists.

90 In S. Giorgio Maggiore Palladio also worked with two colours, the grey stone colour and a yellowish hue which he used for arches and windows and for the arches of the crossing and the architectural parts of the drum.

91 See the criticism by Diedo, Selvatico and Francesco Zanotto (in the 1858 edition of *Le fabbriche e i monumenti cospicui di Venezia*, II, p. 113 ff.).

92 The ribs are set off against white bands which form the lateral frames of the coffers. These white bands reverse the grey of the window surrounds in the drum and return to the white of the pilasters in the body of the church.

92a The use of colour at the exterior would deserve a special discussion. I only want to mention that the tripartite façade, the scrolls, and the entablature and balustrade over the drum form a 'pictorial' unit by virtue of the use of white stone and are set off against the grey plaster of the drum itself and of the chapel walls of the rotonda further back.

93 It is worth while studying the use of colour in later Venetian churches such as the Gesuati, the Gesuiti and S. Geremia. Nowhere will similar complexities be found.

94 Labacco, *Libro di architettura*, 1558, fols. 24, 25. See G. Fiocco in Thieme-Becker, *s. v.* Longhena.

95 See W. Lotz in *Römisches Jahrbuch für Kunstgeschichte* VII, p. 22 f.

96 The weight of the dome rests on the free-standing pillars; the scrolls rest on the arches of the ambulatory.

97 But for the form of the towers he returned to the square design traditional in Venice.

98 The comparison of Figures 39 and 40 makes it evident that the assumption of a direct influence of the Santo at Padua on Longhena (Semenzato, p. 20) is unjustified.

99 See also p. 180 above.

100 Illustrated in Piva, *op. cit.*, p. 53.

101 Carlo Fontana's Jesuit church at Loyola (above, note 42) is unthinkable without the Salute. Gibbs' Ratcliffe Camera at Oxford is a late descendent of the Salute, via Fontana's work at Loyola. The church of St. Mary at Gostyn (Poland) built by Pompeo Ferrari *ca.* 1725 is almost a straight copy of the Salute (ill. in Zbigniew Dmochowski, *The Architecture of Poland*, London, 1956, pp. 262, 263).

Vanvitelli's Caserta with the octagonal vestibules with ambulatories spells a last great triumph for Longhena's principles.

ICONOGRAPHY AND ICONOLOGY

6 Jan van Eyck's 'Arnolfini' Portrait

ERWIN PANOFSKY

The assets of American art history were increased and transformed for the better by the arrival of a group of exiles from Nazi Germany in the early 1930s. One member of that group was Erwin Panofsky, the most renowned art historian of our times in the Western world. Born in Hanover in 1892, Panofsky grew up in Berlin and received an excellent education at the Joachimsthalsches Gymnasium, whose curriculum (as in American high schools today) did not include the history of art. This subject he discovered in 1910 during his first semester as a student of law at the University of Freiburg. A year later he became a student of that remarkable historian of medieval sculpture and painting, Adolf Goldschmidt (1863–1944), and produced a prize-winning essay on the art theory of Albrecht Dürer. He received his doctorate, written on the same subject, from another pioneering medievalist, Wilhelm Vöge (1868–1952), at Freiburg in 1914 when he was 22. He was successively *privatdozent* (very roughly equivalent to assistant professor with tenure, receiving fees paid by students but no remuneration from the institution) and professor at the newly founded University of Hamburg from 1921 until 1933. In Hamburg, he developed a close friendship with the noted German art and cultural historian Aby Warburg (1866–1929), as well as with the eminent Neo-Kantian philosopher and historian Ernst Cassirer (1874–1945), both of whom gave new and exciting dimensions to Panofsky's intellectual thought. In 1931, he was invited to hold a lectureship at New York University, and two years later, dismissed from his chair at Hamburg, he moved permanently to this country, in what he characterized as his "Expulsion into Paradise." He taught at New York University from 1931 to 1935 and at Princeton in 1934–35; in the latter year he joined the faculty of the Institute for Advanced Study, which had given refuge to Albert Einstein and other noted scientists. In subsequent years, he frequently conducted graduate seminars at New York University and Princeton. When he retired from the Institute in 1962, he became the first Samuel F. B. Morse Professor of the Literature of the Arts of Design at New York University, a post he occupied until his death on March 14, 1968.

Before emigrating to this country, Panofsky focused on the art of Albrecht Dürer and related iconographical problems, such as perspective, the theory of human proportions, and the Classical tradition in Western medieval and Renaissance art. But even during the early years of his career, he was more than a mere iconographer, whose traditional interests were the description and identification of subject matter of representational images. From the outset, Panofsky investigated the problem of the links between images and thought, between modes of artistic creation and philosophies, or what he termed iconology, "iconography in a deeper sense." He retained these interests after moving to the United States, though his attitudes toward them broadened. In this country, he was afforded the opportunity to deliver frequent public lectures, which resulted in magisterial monographs he might not have written, or which might not have had such scope and character, had he remained in Germany: *Studies in Iconology; Humanistic Themes in the*

Reprinted with permission of Mrs. Panofsky from *Burlington Magazine* LXIV (1934), pp. 117–27.

Art of the Renaissance (New York, 1939), *Albrecht Dürer*, 2 vols. (Princeton, 1943), *Early Netherlandish Painting, its Origins and Character*, 2 vols. (Cambridge, Mass., 1953) and *Renaissance and Renascences in Western Art* (Stockholm, 1960). Moreover, in America he became fascinated by cinema, on which he published several papers. It is probably fair to say that America influenced Panofsky as much as he influenced American scholarship in the arts—and even literature and musicology!

Notwithstanding his extraordinary knowledge of art, literature, and philosophy, and his command of many languages, Classical and modern, Panofsky was a warm and witty scholar who loved to teach and who encouraged his students to dissent from his views. He wrote of the ideal student-professor relationship as "the joyful and instructive experience which comes from a common venture into the unexplored." His presence in the seminar room or lecture hall inspired rather than intimidated those present. Students left his seminars not only equipped to publish important papers, but also with a joyful love for art and literature. Regrettably, Panofsky never taught undergraduates.

The following paper of 1934 on the Arnolfini double portrait by Jan van Eyck was Panofsky's first publication in early Netherlandish art, an interest he was to continue and expand into his magisterial *Early Netherlandish Painting* of 1953. This paper, which may be characterized as a "major minor classic," exemplifies Panofsky's iconological method at work. Since 1934, a few scholars have emended but no one has invalidated the interpretation by Panofsky of this well-known painting.

For the bibliography of this extraordinary humanist, see his *Aufsätze zu Grundfragen der Kunstwissenschaft*, edited and compiled by Hariolf Oberer and Egon Verheyen (Berlin, 1964), which lists some 155 books and papers, and for his personality see his own words in "Three Decades of Art History in the United States," published conveniently in his *Meaning in the Visual Arts* (Garden City, N.Y., 1955; Doubleday Anchor Book). (For an evaluation of his accomplishment and personality, see H. W. Janson [a former student], in *American Philosophical Society Year Book 1969* [Philadelphia, 1970], pp. 151–60.) Two major monographs of a definite iconographic bent that Panofsky published during his last years are: *Tomb Sculpture: Four Lectures on its Changing Aspects from Ancient Egypt to Bernini*, ed. H. W. Janson (New York, 1964), and the posthumous *Problems in Titian, Mostly Iconographic* (New York, 1969); see also his paper "Erasmus and the Visual Arts," in *Journal of the Warburg and Courtauld Institutes* XXXII (1969), pp. 200–27.

For about three quarters of a century Jan van Eyck's full-length portrait of a newly married couple (or, to speak more exactly, a man and a woman represented in the act of contracting matrimony)[1] has been almost unanimously acknowledged to be the portrait of *Giovanni Arnolfini*, a native of Lucca, who settled at Bruges before 1421 and later attained the rank of a "Conseiller du Duc de Bourgogne" and "Général des Finances en Normandie," and his wife *Jeanne de Cename* (or, in Italian, Cenami) whose father, Guillaume de Cename, also came from Lucca, but lived in Paris from the beginning of the fifteenth century until his death.[2] But owing to certain circumstances which require some investigation, this identification has been disputed from time to time.

The "orthodox theory" is based on the assumption that the London portrait (Fig. 1)* is identical with a picture acquired by Don Diego de Guevara, a Spanish grandee, and presented by him to Margaret of Austria, Governor of the Netherlands, by whom it was bequeathed to her successor,

[1] Notes to this selection begin on page 201.

*Illustrations accompanying this selection appear on page 476.

Queen Mary of Hungary. This picture is mentioned in two inventories of Lady Margaret's Collection (one made in 1516, the other in 1523), which give the name of the gentleman portrayed as "Hernoul le fin" and "Arnoult fin" respectively, as well as in the inventory of Queen Mary's property made after her death in 1558.[3] From this we must conclude that she brought it with her to Spain when she left the Netherlands in 1555, and in 1789 it is still mentioned among the works of art adorning the palace of Charles III, at Madrid.[4] As for the London portrait, we only know that it was discovered at Brussels in 1815 by an English Major-General called Hay and subsequently taken to England where it was purchased by the National Gallery in 1842.

As the subject-matter of the picture described in the inventories (a man and a woman standing in a room and joining hands) is absolutely unique in northern fifteenth-century panel-painting, its identity with the London portrait seems to be fairly well established; moreover, considering that the picture formerly belonging to the Hapsburg princesses disappeared after 1789, and the London portrait appeared in 1815, it seems safe to assume that the latter is identical with the former and was carried off during the Napoleonic wars. In addition, the London portrait corresponds to the descriptions in several respects, particularly the date (1434) and the mirror reflecting the couple from behind.[5]

There are only two circumstances which periodically give rise to discussion and recently led Monsieur Louis Dimier[6] to the conclusion that the picture in the National Gallery cannot be identical with the picture mentioned in the inventories: firstly, the enigmatical inscription on the London portrait: "Johannes de Eyck fuit hic"; secondly, the fact that, in Carel Vermander's biography of Jan van Eyck (published in 1604), the "Hapsburg picture" is descirbed in the following manner: ". . . in een Tafereelken twee Conterfeytsels van Oly-Verwe, van een Man en een Vrouwe,

die malcander de rechter handt gaven als in Houwelijck vergaderende, en *worden ghetrouwt van Fides, die se t'samengaf.*"[7] Translated into English, the passage reads: "On a small panel two portraits in oils, of a man and woman taking each other by the right hand, [note that, in reality, the man grasps the woman's right hand with his *left:*] as if they were contracting a marriage; and *they were married by Fides who joined them to each other.*"

From this Monsieur Dimier infers that the "Hapsburg picture" not only showed a bridal pair as in the London panel, but also a *Personification of Faith* who fulfilled the same office as, for instance, the priest in the versions of the Sposalizio, and he confirms this conclusion by quoting Joachim von Sandrart who, in 1675, qualifies Vermander's description by adding the statement that "Fides" appeared as an actual female ("Frau Fides" as the German version puts it): "Par quoddam novorum coniugum, quos *muliebri habitu adstans* desponsare videbatur Fides."[8]

Now, Monsieur Dimier is perfectly right in pointing out that Vermander's "Fides" cannot possibly be identified (as was conjectured by some scholars)[9] with the little griffin terrier or Bolognese dog seen in the foreground of the London picture. For although a dog occurs fairly often as an attribute or symbol of Faith,[10] the Flemish word "tesamengeven" is a technical term equivalent to what "desponsare" or "copulare" means in Latin—a term denoting the action of the person entitled to hand over the bride to the bridegroom. Thus it is beyond doubt that not only Sandrart, but also Vermander actually meant to say that the couple portrayed in the "Hapsburg picture" were united by a *human figure embodying Faith.* The only question is whether or not Vermander is reliable. And this question must be answered in the negative.

Apart from the fact that a description as thorough as that in Queen Mary's inventory where even the mirror is mentioned

would hardly omit a full-size figure, we must inquire from whom Vermander gleaned his information about a picture which, as mentioned above, he had never seen. Now it is a well-known fact (although entirely disregarded by Monsieur Dimier) that Vermander's statements as to the van Eycks are mostly derived from Marcus van Vaernewyck's "Spieghel der Nederlant-scher Audtheyt" published in 1569, and (as "Historie van Belgis") in 1574. This was also the case with Vermander's description of the "Hapsburg picture," which is proved by the fact that he repeats Vaernewyck's absurd tale that Queen Mary had acquired the picture from a barber whom she had remunerated with an appointment worth a hundred florins a year—a tale which Sandrart took over from Vermander as credulously as the latter had taken it over from Vaernewyck. Thus Vaernewyck is the ultimate source from which both Vermander and Sandrart obtained their information, and his description of the "Hapsburg picture" reads as follows: "een cleen tafereelkin . . . waerin gheschildert was/een trauwinghe van eenen man ende vrauwe/*die van Fides ghetraut worden*,"[11] that is in English: "a small panel on which was depicted the wedding of a man and a woman *who were married by Fides*."

It is self-evident that Vermander's description is nothing but an amplification of this text, and we can easily see that he amplified it rather at haphazard. Since he was familiar with the usual form of a wedding ceremony, he ventured the statement that the two people took each other by the *right* hand (whereas, in the London portrait, the man proffers his *left*); and since, in his opinion, Vaernewyck's sentence "die van Fides ghetraut worden" (who were married by Fides) was lacking in precision he *arbitrarily added the adjectival clause* "*die se t'samengaf*" (who joined them to each other). So this adjectival clause, so much emphasized by Monsieur Dimier, turns out to be a mere invention of Vermander's.

But what did Vaernewyck mean by his mysterious sentence? In my opinion he meant nothing at all, but simply repeated (or rather translated) information which in all probability puzzled him as much as his translation puzzles his readers. We should not forget that Vaernewyck had not seen the picture either, for it had been brought to Spain by Queen Mary, and it is a significant fact that, in his earlier writings, he does not mention it at all.[12] Thus his description must be based on information gleaned from an unknown source, most probably a letter from Spain; and when we retranslate his sentence into Latin (using the passage of Sandrart as a model) we can easily understand how the confusion arose. This hypothetical text might have read; "Tabella, in qua depicta erant sponsalia viri cuiusdam et feminae *qui desponsari videbantur per fidem*," and a sentence like this would have been an absolutely correct description of the London picture. Only, it could easily give rise to a misinterpretation because, to an uninitiated mind, the expression "per fidem" might easily suggest a personification—while, in reality, it was a *law-term*.

According to Catholic dogma, marriage is a sacrament which is immediately accomplished by the mutual consent of the persons to be married when this consent is expressed by words and actions: "Actus exteriores et verba exprimentia consensum *directe faciunt* nexum quendam qui est sacramentum matrimonii," as Thomas Aquinas puts it.[13] Even after the Council of Trent had prescribed the presence of two or three witnesses and the co-operation of a priest, the latter is not held to dispense the "sacramental grace" as is the case in the baptism of a child or the ordination of a priest, but is regarded as a mere "testis qualificatus" whose co-operation has a mere formal value: ". sacerdotis benedictio non requiritur in matrimonio quasi de materia sacramenti." Thus, even now, the sacerdotal benediction and the presence of witnesses does not affect

the sacramental validity of marriage, but is only required for its formal legalization. Before the Council of Trent, however, even this principle was not yet acknowledged. Although the Church did its very best to caution the Faithful against marrying secretly, there was no proper "impedimentum clandestinitatis" until 1563; that is to say, two people could contract a perfectly valid and legitimate marriage whenever and wherever they liked, without any witness and independently of an ecclesiastical rite, provided that the essential condition of a "mutual consent expressed by words and actions" had been fulfilled. Consequently in those days the formal procedure of a wedding scarcely differed from that of a betrothal and both these ceremonies could be called by the same name "sponsalia," with the only difference that a marriage was called "sponsalia de praesenti" while a betrothal was called "sponsalia de futuro."

Now, what were those "words and actions" required for a legitimate marriage? Firstly: an appropriate formula solemnly pronounced by the bride as well as by the bridegroom, which the latter confirmed by raising his hand. Secondly: the tradition of a pledge ("arrha"), generally a ring placed on the finger of the bride. Thirdly, which was most important: the "joining of hands" which had always formed an integral part of Jewish marriage-ceremonies as well as those of Greece and Rome ("dextrarum iunctio") (Fig. 2). Since all these "words and actions" (comprehensively depicted in the London portrait) fundamentally meant nothing but a solemn promise of Faith, not only the whole procedure was called by a term derived from "Treue" in the Germanic languages ("Trauung" in German, "Trouwinghe" in Dutch and Flemish, whereby originally "Trouwinghe" could mean both "sponsalia de praesenti" and "sponsalia de futuro"), but also the various parts of the ceremony were called by expressions emphasizing their relation to Faith. The forearm raised

in confirmation of the matrimonial oath was called "Fides levata";[14] the wedding-ring is called "la fede" in Italy up to our own times; and the "dextrarum iunctio" was called "fides manualis" or even "fides" without further connotation,[15] because it was held to be the essential feature of the ritual. Also in heraldry a pair of joined hands is simply called "une Foi."[16]

Thus in medieval Latin the word "fides" could be used as a synonym of "Marital oath," more particularly "dextrarum iunctio." Consequently Jan van Eyck's London portrait could not be described more briefly or more appropriately than by calling it the representation of a couple "qui desponsari videbantur per fidem," that is to say: "who were contracting their marriage by a marital oath, more particularly by joining hands."

It is both amusing and instructive to observe how, in the writings of sixteenth- and seventeenth-century biographers, this abstract law term gradually developed into a living, though allegorical, female figure. Vaernewyck opened the way to the misinterpretation by inserting the Latin word "fides" into his Flemish text and writing it with a capital F, but shrank from any further explanation. Vermander emphasized the personality of this rather enigmatical "Fides" by adding the adjectival clause "who joined them to each other," and finally Sandrart explicitly asserted that she was present as an actual woman, "habitu muliebri adstans." It is not difficult to understand the mental processes of those humanistic authors. To the contemporaries of Cesare Ripa, personifications and allegories were more familiar than to others, and they had in their minds all those Roman sarcophagi where the people to be married are united by a "Juno pronuba" (Fig. 2). But the case should be a lesson to us not to attempt to use literary sources for the interpretation of pictures, before we have interpreted the literary sources themselves.

To the modern mind it seems almost in-

conceivable that, up to the Council of Trent, the Catholic Church could acknowledge a marriage contracted in the absence of any priest or witness. Still this seeming laxity logically follows from the orthodox conception of matrimony—a conception according to which the binding force of a sacrament fulfilled by a spiritual "coniunctio animarum" did not depend upon any accessory circumstances. On the other hand, it is obvious that the lack of any legal or ecclesiastical evidence was bound to lead to the most serious inconveniences and could cause actual tragedies. Medieval literature and papers dealing with law-suits are full of cases, partly tragic, partly rather burlesque, in which the validity of a marriage could be neither proved nor disproved for want of reliable witnesses,[17] so that people who honestly believed themselves to be married found out that they were not, and vice versa. The most preposterous things could happen when the depositions of the people concerned contradicted each other as they often did; for example, in the case of a young lady who was to become the mother of no less illustrious a person than Willibald Pirckheimer. This young lady was originally on fairly intimate terms with a young patrician of Nürnberg, called Sigmund Stromer, but wanted to get rid of him when she had made the acquaintance of Dr. Hans Pirckheimer. Now the unfortunate lover asserted that she was his legitimate wife, owing to the fact that they had secretly performed the ceremony of "joining hands"; but this was exactly what she denied. So the bishop of Bamberg, to whom the case was submitted, could not but decide that the marriage was not proved, and she was allowed to become the mother of Willibald Pirckheimer while poor Stromer remained a bachelor all his life.[18]

Now, this state of affairs perfectly explains the curious inscription on the London portrait: "Johannes de Eyck fuit hic. 1434." In Monsieur Dimier's opinion, this sentence which, according to the rules of Latin grammar, cannot but mean "Jan van Eyck has been here," would make no sense if it was not translated by "this was Jan van Eyck," thereby proving that the persons portrayed were the artist and his wife. Setting aside the grammatical problem, Monsieur Dimier's interpretation (which, by the way, was suggested by several other scholars, but was emphatically opposed by Mr. Salomon Reinach some fourteen years ago)[19] is contradicted by the simple fact that a child of Jan van Eyck had been baptized before the 30th of June, 1434. Thus, discarding suspicions which must be regarded as groundless by the fact that this child was held over the font by Pierre de Beffremont in the name of the Duke of Burgundy,[20] we must assume that Jan van Eyck and his wife were married in the autumn of 1433 at the very latest, so that they cannot be identical with the bridal pair represented in the London picture. Furthermore, the phrase "Jan van Eyck was here" makes perfectly good sense when we consider the legal situation as described in the preceding paragraphs. Since the two people portrayed were married merely "per fidem" the portrait meant no less than a "pictorial marriage certificate" in which the statement that "Jan van Eyck had been there" had the same importance and implied the same legal consequences as an "affidavit" deposed by a witness at a modern registrar's office.

Thus there is no reason whatever to doubt the identity of the London portrait with the panel mentioned in the inventories: we can safely adopt the "orthodox theory" according to which the two people portrayed are Giovanni Arnolfini and Jeanne de Cename,[21] all the more so because the circumstances of their marriage are peculiarly consistent with the unusual conception of the "artistic marriage certificate." Both of them had absolutely no relatives at Bruges (Arnolfini being an only child whose property finally went to a nephew of his wife, and Jeanne de Ce-

name's family living in Paris),[22] so that we can understand the original idea of a picture which was a memorial portrait and a document at the same time, and in which a well-known gentleman-painter signed his name both as artist and as witness.

Dr. Max J. Friedländer (who, by the way, already divined the meaning of the inscription without investigating the matter)[23] rightly points out that the Arnolfini portrait is almost a miracle of composition: "In it a problem has been solved which no fifteenth-century painter was destined to take up again: two persons standing side by side, and portrayed full length within a richly furnished room a glorious document of the sovereign power of genius."[24] In fact, to find an analogous composition in northern painting, we must go forward to Holbein's *Ambassadors.* However, taking into consideration the fact that the London picture is both a portrait of two individual persons and a representation of a sacramental rite, we can explain its compositional scheme by comparing it not only with specimens of portrait-painting, but also with representations of marriage ceremonies to be found, for example, in the Bibles Moralisées[25] or, even more à propos, in a French Psalter (Fig. 3) of about 1323 (Munich, cod. gall. 16, fol. 35).[26] In it, the marriage of David and Michal, the daughter of Saul, is represented in a very similar way as that of Giovanni Arnolfini and Jeanne de Cename, only the bride does not act of her own accord, but is given away by her father who is accompanied by a courtier and carries a glove as a symbol of his tutelary authority.

Apart from this difference, the two scenes resemble each other in that the ceremony takes place in absence of a priest and is accomplished by raising the forearm and joining hands, "fide levata" and "per fidem manualem." Thus the precocious apparition of a full-length double portrait can be explained by Jan van Eyck's adopting a compositional scheme not uncommon in the iconography of marriage pictures. But this adoption of a traditional scheme means anything but a lack of "originality." When the Arnolfini portrait is compared with the fourteenth-century miniature, we are struck by the amount of tender personal feeling with which the artist has invested the conventional gesture and, on the other hand, by the solemn rigidity of the figures, particularly that of the bridegroom. Van Eyck took the liberty of joining the *right hand* of the *bride* with the *left* of the *bridegroom,* contrary to ritual and contrary, also, to all the other representations of a marriage ceremony. He endeavoured to avoid the overlapping of the right arm as well as the *contrapposto* movement automatically caused by the "dextrarum iunctio" in the true sense of the term (see Fig. 2). Thus he contrived to build up the group symmetrically and to subdue the actual movement in such a way that the "fides levata" gesture of the bridegroom seems to be invested with the confident humility of a pious prayer. In fact the position of Arnolfini's right arm would make a perfect attitude of prayer if the other arm moved with a corresponding gesture. There is something statuesque about these two figures, and I cannot help feeling that the whole arrangement is, to some extent, reminiscent of those slab-tombs which show the full-length figures of a man and a woman in similar attitudes, and where the woman is usually made to stand upon a dog, here indubitably used as a symbol of marital faith (Fig. 4).[27] It would be an attractive idea to explain the peculiarly hieratic character of the Eyckian composition by an influence of those quiet devout portrayals of the deceased, such as may be seen on innumerable monuments of that period; all the more so because the inherent connexion between the incunabula of early Flemish painting and sculpture is proved by many an instance.

In the London picture, however, these statuesque figures are placed in an interior suffused with a dim though coloured light, which shows up the peculiar tactual

values of such materials as brass, velvet, wood and fur, so that they appear interwoven with each other within a homogeneous chiaroscuro atmosphere. Small wonder then that the Arnolfini portrait has always been praised as a masterpiece of "realistic" interior, or even genre, painting. But the question arises whether the patient enthusiasm bestowed upon this marvellous interior anticipates the modern principle of "l'art pour l'art," so to speak, or is still rooted to some extent in the medieval tendency of investing visible objects with an allegorical or symbolical meaning.

First of all we must bear in mind that what Mr. Weale simply calls "a Flemish interior" is by no means an ordinary living room, but a "Nuptial Chamber" in the strict sense of the term, that is to say, a room hallowed by sacramental associations and which even used to be consecrated by a special "Benedictio thalami."[28] This is proved by the fact that in the beautiful chandelier hanging from the ceiling, only one candle is burning. For since this candle cannot possibly serve for practical purposes (in view of the fact that the room is flooded with daylight), it must needs bear upon the marriage ceremony. In fact a burning candle—symbol of the all seeing wisdom of God—not only was and often is, required for the ceremony of taking an oath in general,[29] but also had a special reference to weddings. The "marriage candle"—a substitute for the classical "taeda" which had been so essential a feature of Greek and Roman marriage ceremonies that the word became synonymous with "wedding"—was either carried to church before the bridal procession, or solemnly given to the bride by the bridegroom, or lit in the home of the newly married couple; we even know of a custom according to which the friends of the couple called on them in the evening "et petierunt Candelam per sponsum et sponsam . . . sibi dari."[30] Thus we learn from the one burning candle that the "Flemish interior" is to be interpreted as a "thalamus," to speak in medieval terms, and we comprehend at once its unusual features. It is not by chance that the scene takes place in a bedroom instead of a sitting-room (this applies also to a considerable number of fifteenth- and sixteenth-century Annunciations in which the interior is characterized as the "Thalamus Virginis," as a liturgical text puts it), nor is it by accident that the back of the armchair standing by the bed is crowned by a carved wooden figure of St. Margaret triumphing over the Dragon, for this Saint was especially invoked by women in expectation of a child;[31] thus the small sculpture is connected with the bride in the same way as the burning candle is connected with the bridegroom.

Now the significance of these motives is an attributive, rather than a symbolical one, inasmuch as they actually "belong" to a Nuptial Chamber and to a marriage ceremony in the same way that a club belongs to Hercules or a knife to St. Bartholomew. Still, the very fact that these significant attributes are not emphasized as what they actually are, but are disguised, so to speak, as ordinary pieces of furniture (while, on the other hand, the general arrangement of the various objects has something solemn about it, placed as they are according to the rules of symmetry and in correct relationship with the statuesque figures) impresses the beholder with a kind of mystery and makes him inclined to suspect a hidden significance in all and every object, even when they are not immediately connected with the sacramental performance. And this applied in a much higher degree to the medieval spectator who was wont to conceive the whole of the visible world as a symbol. To him, the little griffin terrier as well as the candle were familiar as typical symbols of Faith,[32] and even the patterns of white wood so conspicuously placed in the foreground of the picture would probably impress him

with a feeling of sacredness: "Loose thy shoe from off thy foot, for the place whereon thou standest is holy." [Ed. trans.]

Now, I would not dare to assert that the observer is expected to realize such notions consciously. On the contrary, the supreme charm of the picture—and this applies to the creations of Jan van Eyck in general—is essentially based on the fact that the spectator is not irritated by a mass of complicated hieroglyphs, but is allowed to abandon himself to the quiet fascination of what I might call a *transfigured reality.* Jan van Eyck's landscapes and interiors are built up in such a way that what is possibly meant to be a mere realistic motive can, at the same time, be conceived as a symbol, or, to put it another way, his attributes and symbols are chosen and placed in such a way that what is possibly meant to express an allegorical meaning, at the same time perfectly "fits" into a landscape or an interior apparently taken from life. In this respect the Arnolfini portrait is entirely analogous to Jan van Eyck's religious paintings, such as the marvellous *Virgin of Lucca* where many a symbol of virginity (the "living waters," the candlestick,

the glass carafe and even the "throne of Solomon")[33] is "disguised" in a similar way; or the image of *St. Barbara* whose tower (characterized by the three windows alluding to the Holy Trinity) has been transformed into what seems to be a realistic Gothic church in course of erection;[34] but, thanks to the formal symmetry of the composition, this building impresses us as even more "symbolical" than if the tower had been attached to the figure in the usual form of an attribute.

Thus our question whether or not the still life-like accessories in our picture are invested with a symbolical meaning turns out to be no true alternative. In it, as in the other works by Jan van Eyck, medieval symbolism and modern realism are so perfectly reconciled that the former has become inherent in the latter. The symbolical significance is neither abolished nor does it contradict the naturalistic tendencies; it is so completely absorbed by reality, that reality itself gives rise to a flow of preternatural associations, the direction of which is secretly determined by the vital forces of medieval iconography.[35]

NOTES

1 W. H. James Weale: "Hubert and John van Eyck," 1908 ("Weale: I"), p. 69 et seq.; W. H. James Weale, and M. W. Brockwell: "The van Eycks and their Art," 1912 ("Weale: II"), p. 114 et seq. Both with bibliography.

2 For the Cename family and the personality of Giovanni Arnolfini cf. L. Mirot, "Etudes Lucquoises," Bibl. de l'Ecole des Chartes, XCI, 1930, p. 100, et seq., especially p. 114.

3 These inventories are reprinted in Weale: I, p. 70 and Weale II, p. 114. In Weale: II a third inventory of Lady Margaret's Collection, made in 1524 is also quoted. This is said to contain a similar description of the picture. As for Queen Mary's inventory, cf. R. Beer: "Jahrb. d. Kunstslgn. d. Allerh. Kaiserh.," XII, 1891, p. CLVIII, Nr. 85.

4 K. Justi: "Zeitschrift für bildende Kunst," XXII, 1887: "Otra pintura vara de alto y tres quartos de ancho; Hombre y muger agarrados de las manos. Juan de Encina, Imbentor de la pintura al oleo."

5 The fact that the picture is called a large one in the inventories (while, in reality, it is not larger than 0.845 by 0.624 cm.) is no obstacle. Mr. Weale is obviously right in pointing out that "large" and "small" are relative terms, and that the panel is set down as "large" in comparison with those preceding it in the inventory of 1516. In addition a picture which was "small" for a late sixteenth-century writer like Vermander, was "large" when judged by the standards of about 1400. As for the inventory of 1555/58 it is obviously based on an earlier one.

6 "Revue de l'Art," XXXVI, 1932, p. 187, et seq. and also November, 1932. Monsieur Dimier's

statements were already contradicted, though not properly disproved, by Mr. M. Jirmounsky, "Gazette des Beaux-Arts," LXXIV, 1932, p. 423, and also December, 1932.

7 Carel Vermander: "Het Leven der doorluchtighe Nederlandtsche en Hooghduytsche Schilders, ed. H. Floerke": 1906, I, p. 44.

8 Joachim von Sandrart: Acad. Germ., 1683, p. 203. In the German edition (Teutsche Akademie, 1675, ed. R. Peltzer: 1926, p. 55) the passage reads as follows: "Ein Mann und Weibsbild, so sich durch Darreichung der rechten Hand verheurathen und von der *darbey stehenden Frau Fides* vermählet werden."

9 See, for instance, Weale: "Notes sur les van Eyck," 1861, p. 26, et seq., and Floerke, p. 408.

10 Cf. Barbier de Montault: "Traité d'Iconographie Chrétienne," 1890, p. 196 or Cesare Ripa: "Iconologia," s.v. "Fedeltà." In the "Repertorium Morale," by Petrus Berchorius (middle of the fourteenth century, printed Nürnberg, 1489) the dog is interpreted as "vir fidelis" (s.v. "canis").

11 Weale: I, p. LXXXV. In the "Historie van Belgis" of 1574 the passage is to be found on fol. 119 verso.

12 Cf. Weale: I, p. LXXVI, et seq.

13 As for the theory of matrimony in Catholic theology, see Wetzer und Welte: "Kirchenlexikon," s.v. "Ehe," "Eheverlöbnis," "Ehehindernis." Also F. Cabrol and H. Leclercq: "Dictionnaire d'Archéologie Chrétienne et de Liturgie," s.v. "Marriage"; same authors: "Dictionnaire de Théologie Catholique," s.v. "Marriage" (very thorough).

14 Du Cange:"Glossarium mediae et infimae latinitatis," s.v. "Fides."

15 Cabrol-Leclercq: "Dict. d'Archéol. Chrét.," l.c., col. 1895, Du Cange, l.c.

16 Didron: "Annales Archéologiques," XX, 1860, p. 245. Cf. also Andrea Alciati's famous "Emblemata," No. IX ("Fidei symbolum").

17 Plenty of Literature in Cabrol-Leclercq, "Dict. de Théol. Cath.," l.c., col. 2223.

18 E. Reicke: "Willibald Pirckheimer," 1930, p. 10, et seq.

19 Sal. Reinach: "Bulletin archéologique du Comité des travaux historiques et scientifiques," 1918, p. 85.

20 Weale: I, p. XL; Weale: II, p. XXXVI.

21 As for the apparent family likeness between Jeanne de Cename and the wife of Jan van Eyck as portrayed by her husband in the famous picture of 1439 (a family likeness from which Monsieur Dimier concludes that the two portraits represent the same person, while Mr. Weale rather believes Jeanne de Cename to be the sister of Margaret van Eyck), we must bear in mind that in Jan van Eyck's pictures the women are much less "individualized" than the men, adapted as they are to a typical ideal of loveliness. As far as we can learn from documents, Jeanne de Céname had only one sister named "Acarde" (Mirot: l.c., p. 107 and stemma p. 168).

22 Mirot: l.c., p. 114.

23 "Die Altniederländische Malerei," I, 1924, p. 18.

24 "Van Eyck bis Breughel," second edition, 1921, p. 18.

25 Laborde: "Les Bibles Moralisées," 1911, pl. 86 and 154.

26 Published by Hans Fehr: "Das Recht im Bilde," 1923, fig. 191.

27 This type of medieval slab-tomb is the result of an interesting process which can be observed in a good many instances. The Bible is full of what we may call, "involuntary descriptions" of ancient oriental images, such as, for instance, the scape-goat tied to the Holy Tree as recently discovered in the Royal tombs of Ur which was the model of Abraham's ram caught in the bush, or the Babylonian astral divinity resuscitated as the "apocalyptic woman." Now the thirteenth verse of the 90th Psalm says "super aspidem et basiliscum ambulabis et conculcabis leonem et draconem," thus describing the Babylonian type of a god or hero triumphing over an animal or a couple of animals (a type which also gave rise to the representations of St. Michael fighting the Dragon, the Virtues conquering Evil and so forth). We can observe how this motive which originally was used exclusively for the representations of Christ was gradually transferred to the Virgin, the Saints and finally to the slab-tombs, such as the monu-

ment of Bishop Siegfried von Epstein in Mainz Cathedral or that of Heinrich von Sayn in the Germanisches Museum, Nuremberg. From this we must conclude that the animals forming the "foot-rest" of the knights and princes portrayed on great medieval slab-tombs were originally no attributes denoting the praiseworthy qualities of the deceased, but symbols of Evil conquered by the immortal soul. Later on, however, the Lion which originally was meant to be the "leo conculcatus" described in the 90th Psalm was interpreted as a symbol of Fortitude, and when the statues of a married couple were to be placed on the same monument (so that the woman, too, had to be provided with an animal) she was usually made to stand upon a Dog, conceived as a symbol of Marital Faith (cf. note 10).

28 Cf. Ildefons Herweghen: "Germanische Rechtssymbolik in der römischen Liturgie" (Deutschrechtliche Beiträge VIII, 4), 1913, p. 312, et seq.

29 "Jurare super Candelam," "Testimonium in Cereo." Cf. Wetzer-Welte, l.c., s.v. "Eid" and Jac. Grimm: "Deutsche Rechtsaltertümer," fourth edition, 1899, II, p. 546.

30 Du Cange: l.c., s.v. "Candela." Cf. Wetzer-Welte: l.c., s.v. "Hochzeit" and "Brautkerze."

31 Weale: I, p. 20 and Weale: II, p. 17. This belief has even led some scholars to suppose that St. Margaret is to be regarded as a substitute for the classical Lucina (F. Soleil: "La vierge Marguérite substituée à la Lucine antique," 1885).

32 With regard to the dog, cf. notes 10 and 27; with regard to the candle, see Didron: l.c., p. 206, et seq., and plate facing p. 237. Also E. Mâle: "L'Art religieux de la fin du moyen-âge en France," second edition, 1922, p. 334, and Ripa: l.c., s.v. "Fede Cattolica," where the motive is explained by a passage of St. Augustin which says "Caecitas est infidelitas et illuminatio fides." Needless to say that "Fides" could always mean both "True Belief" and "Faithfulness," especially of wife and husband. Fides conceived as a theological virtue explicitly prescribes "serva fidem coniugum" (Didron: l.c., p. 244).

33 As for the "aquae viventes" cf. W. Molsdorf: "Führer durch den symbol. und typol. Bilderkreis," 1920, nr. 795. The comparison of the Virgin with a "candelabrum" is to be found in the "Speculum Humanae Salvationis" (quoted by E. Beitz: "Grünewalds Isenheimer Menschwerdungsbild und seine Quellen," 1924, p. 25); in Berchorius' "Repertorium morale" the "candelabrum" is adduced as a symbol of Virtue and, quite logically, as "basis fidei," because the candle itself stands for Faith as mentioned in the preceeding note). As for the carafe, which also occurs in Grünewald's Isenheim altar, cf. Beitz: l.c., p. 47.

34 This is the reason why the picture was sometimes described as St. Agnes (Weale: I, p. 89; Weale: II, p. 129).

35 Thus, it is not surprising that a little dog, very similar to that in the Arnolfini portrait, occurred also in the famous picture of a naked woman taking her bath described by Bartholomaeus Facius and apparently analogous to a painting which was formerly in the collection of Cornelius van der Geest (Weale: I, p. 175, et seq., Weale: II, p. 196, et seq.), where the motive has obviously nothing to do with marital Faith. Iconographical symbols, especially in medieval art, are almost always "ambivalent" (the snake can mean Evil as well as Prudence, and golden sandals can be an attribute of Luxury as well as Magnanimity, cf. Panofsky, Münchner Jahrbuch der Bild. Kunst, N.F., IX, 1932, p. 285, et seq. Thus, the equation Dog-Faith does not preclude the equation Dog-Animality, as shown on the reverse of the well-known Constantinemedal, where a little dog characterizes the personification of Nature in contradistinction to Grace. Consequently the griffin terrier "fits" into the bathroom picture as well as into the Arnolfini portrait, whether we regard it as a "symbol" or as a mere "genre-motif." When this article was in print, K. von Tolnai published a paper (Münchner Jahrbuch, l.c., p. 320 et seq.) in which, I am glad to say, the problem of symbolism in Early Flemish art is approached in a similar way.

7 The Survival of Mythological Representations in Early Christian and Byzantine Art and Their Impact on Christian Iconography

KURT WEITZMANN

Distinguished scholarship in Byzantine art is synonymous with the name of Kurt Weitzmann, who has made an enormous contribution to this field of study and especially to the study of ivory carving, illuminated manuscripts, and icon painting. Weitzmann was born at Klein Almerode, Germany, in 1904 and attended the universities of Münster, Würzburg, and Vienna, where he studied with Julius von Schlosser and, for a brief time, with Josef Strzygowski. On Von Schlosser's advice he went to Berlin to study with Adolph Goldschmidt, then the world's foremost authority on medieval sculpture and painting. He submitted his doctoral dissertation on 10th-century Byzantine ivory caskets to Goldschmidt in 1930, and with him coauthored the fundamental corpus of Byzantine ivories (Byzantinischen Elfenbeinskulpturen des X. bis XIII. Jahrhunderts, 2 vols. [Berlin, 1930–34]). From 1931 to 1934, he served as a member of the German Archaeological Institute in Berlin and published a number of papers. In 1935, his monograph on 9th- and 10th-century Byzantine illuminated manuscripts appeared, a standard work to this day (Die byzantinische Buchmalerei des IX. und X. Jahrhunderts [Berlin]). By that year he had been invited to join the faculty of the Institute for Advanced Study in Princeton, and a decade later he became professor of art history at Princeton University, a position he has occupied ever since. He has also taught at Yale and the universities of Alexandria and Bonn.

Weitzmann travels widely and frequently. In the 1930s, he began a series of photographic expeditions to Mount Athos to study its collection of manuscripts, and in 1956 he made the first of many visits to the monastery of St. Catherine on Mount Sinai to study its Byzantine mosaics, manuscripts, and collection of over 2,000 icon paintings (of the last he is preparing for publication a monumental corpus). Since he settled in Princeton, he has written a number of important books on this and other topics related to Byzantine monuments: Illustrations in Roll and Codex, A Study of the Origin and Method of Text Illustration (Princeton, 1947; 2d ed., 1970), which puts forth his carefully reasoned methodology for the study of the origin and development of textual illustration; The Joshua Roll (Princeton, 1948); The Fresco Cycle of S. Maria di Castelseprio (Princeton, 1951); Greek Mythology in Byzantine Art (Princeton, 1951); Ancient Book Illumination (Cambridge, Mass; 1959); Geistige Grundlagen und Wesen der Makedonischen Renaissance (Cologne and Opladen, 1963), a study that summarizes some 25 years of his research on the art and culture of late 9th- and 10th-century Byzantium; Aus den Bibliotheken des Athos (Hamburg, 1963); Frühe Ikonen (Vienna, 1965 [Icons: From South Eastern Europe and Sinai, trans. R.E. Wolf, London, 1968]); and, with George H. Forsyth, Monastery of Saint Catherine at Mount Sinai: The Church and Fortress of Justinian, 2 vols. (Ann Arbor, Mich., 1971). He has also written scores of learned papers on a variety of topics that have appeared in widely scattered journals; some of these papers are being collected and edited for publication in 1971 by Herbert L. Kessler, one of his students.

A zealous scholar who is compassionate and open-minded, Weitzmann may be characterized in a number of ways. He is first an unusually talented connoisseur of Byzantine and Western medieval art. He has the capacity for hard and prolonged concentration on the individual work of art. Having studied so many original works during his annual

Reprinted from Dumbarton Oaks Papers XIV (1960), pp. 43–68.

travels, he has developed a visual memory that is a storehouse of information. Moreover, he has at his disposal, in a suite of offices, seminar rooms, and library of rare books on Byzantine art in the Department of Art and Archaeology at Princeton, a huge collection of photographs taken during his years of study abroad. (To take a seminar with him as a graduate student in these surroundings is indeed a memorable experience.)

Secondly, one of Weitzmann's major contributions has been in the field of textual illustration, in which he has focused on the nature, origins, and development of the relation of picture to text in ancient, Early Christian, Byzantine, and even Islamic manuscripts. Pictorial representations of the Book of Genesis have been of special interest to him and some of his students (see his "Observations on the Cotton Genesis Fragments," in *Late Classical and Mediaeval Studies in Honor of Albert Mathias Friend, Jr.* [Princeton, 1955], pp. 112–31). His simple, yet ingenious method for establishing the archetype and recensions of individual manuscripts is spelled out in lucid detail in his *Roll and Codex* (Princeton, 1947), and its application to such important problems as the illustration of the Byzantine psalter can be seen at work in a number of his books and papers (for example, "The Psalter Vatopedi 761: Its Place in the Aristocratic Psalter Recension," *Journal of the Walters Art Gallery X* [1947], pp. 20–51). More historical than methodological is his "Book Illustration of the 4th Century: Tradition and Innovation," in *Akten des VII. Internationalen Kongresses für christliche Archäologie, Trier 5–11 September 1965* (Studi di Antichita Cristiana, vol. XXVII [Vatican City and Berlin, 1969]), pp. 257–81. His findings have broadened our knowledge and deepened our understanding of the sources for the illustration of the Old and New Testaments (see especially his "Die Illustration der Septuaginta," *Münchner Jahrbuch der bildenden Kunst,* 3d ser. III/IV [1952/53], pp. 96–120), as well as Islamic manuscripts ("The Greek Sources of Islamic Scientific Illustrations," *Archaeologica Orientalia. In memoriam Ernst Herzfeld,* ed. George C. Miles [New York, 1952], pp. 244–66).

Thirdly, these interests in the origins and methods of textual illustrations have led him to an extensive study of the Classical tradition, one of the salient characteristics of Byzantine art specifically, and of Western art generally. As pointed out in my Introduction, the Classical tradition has been a major interest in modern art history (both Goldschmidt and Von Schlosser were vitally concerned with it). To illustrate this aspect of art history in our day the following paper by Weitzmann has therefore been included in this book. Compare also the papers by Richard Krautheimer and Erwin Panofsky.

In his *Chronographia* (VI, 61) Michael Psellos tells the following story of the Emperor Constantine IX. One day the Emperor appeared in the hippodrome with his mistress Skleraina. A courtier, marvelling at her beauty, exclaimed: "It were no shame . . . that man should fight for such as she," drawing a quotation from the third book of the *Iliad* which alludes to Helen of Troy.[1] It is not so much the fact that there happened to live in the eleventh century a courtier who knew his Homer by heart, which is worth noting, but that he could count on his fellow courtiers to recognize the quotation. The knowledge of Homer and other classics of ancient Greece had never completely died out in Byzantium, although there were times, primarily during the period of iconoclasm, when minds were so preoccupied with theological issues that the classics were permitted to collect dust. This, however, was swept off as soon as iconoclasm was over and the newly established Bardas University appointed the grammarian Cometas as Homeric critic. "Great souled Homer,

[1] Notes to this selection begin on page 223.

Cometas having found thy books utterly aged, made them younger; for, having scraped off their old age, he exhibited them in new brilliancy to those of the learned who have understanding." So reads an epigram of the Palatine Anthology (XV, 37).[2] The undercurrent of an uninterrupted, classical tradition in literature and the arts, and the limited change of language were some of the reasons why Michael Psellos' story sounds so credible. We have sufficient evidence that epic poems, dramas, mythological handbooks and other products of classical literature were still appreciated in the Middle and Late Byzantine periods, and that in cases where they had survived with illustrations these, too, appealed to the Byzantine public and the artist who desired to copy them.[3]

Likewise in the Latin West we find an undercurrent of the classical tradition which, just as in Byzantium, is at times a trickle and then again grows into a broader stream, particularly in those periods which have variously been called renaissances, renascences, *renovationes,* or simply revivals.[4] Yet, in the West the classical tradition of mythological writings and their pictorial representations was not as direct and immediate as in Byzantium. In Latin literature the chief means of transmission was not so much the classical texts themselves, but rather the writings of Macrobius, Martianus Capella, and Fulgentius, i.e. the fifth- and sixth-century authors who had reinterpreted the classical myths in an allegorical and moralizing manner. Of course, a certain estrangement from classical form and content was inevitable even in Byzantine literature and art, but here the interpenetration of the pagan and the Christian realms took place, on the whole, on a higher intellectual level.

Instead of reconstructing historically the process of continuation, adaptation, and transformation of mythological representations in Byzantine art, I propose to deal with the subject in a more systematic manner. I should like to show a kind of morpho-logical process of transformation from classical into Christian art and to point out as many facets of this problem as the pictorial evidence permits. In trying to do so I have included in my demonstration several objects of the rich Dumbarton Oaks Collection in the hope that such a discussion will contribute to a better understanding of their stylistic and iconographic position in the history of Byzantine art.

I. Continuation and Weakening of the Classical Tradition

No other object could afford more striking evidence of a continued appreciation of the classical literary and artistic tradition than an illustrated Homer. In the Ambrosian Library in Milan there is a well-known fragment, cod. F. 205 inf., consisting of fifty-six miniatures of an illustrated *Iliad,* part of a manuscript which originally must have contained more than 200 miniatures. To execute such a comprehensive cycle with all its intricate iconographical details requires familiarity with the text on the part of the illustrator, even if he is only a copyist, and presupposes a public that is still interested in it. As long as the Milan *Iliad* was considered to be an Italian work of the third century, as proposed in the facsimile publication of Ceriani and Ratti,[5] it raised no problems with regard to the cultural environment in which it was supposed to have been produced, but since Bianchi Bandinelli in his recent monograph[6] has conclusively proved its origin to have been in the period of well-settled Christianity, it must now be regarded as a key monument of the classical survival in the Early Christian period. The less important problem that remains is whether the manuscript can still be dated in the second half of the fifth or in the beginning of the sixth century, and whether it originated in Alexandria, where the illustration of Greek literary texts on a large scale had apparently started in the Hellenistic period, or in Constantinople where, from the fifth century on, the survival of the classi-

cal heritage was strongest.[7] In any event the Milan *Iliad* is the product of a period in which Biblical illustrations had already become predominant.

Typical of the kind of illustration that had already existed in papyrus rolls, where the figures were lined up in a single plane,[8] is the one depicting Ares before Zeus enthroned in Olympus (Fig. 1).*[9] There are slight discrepancies with the text: Ares had been wounded in the belly, not on his right hand as the miniature seems to suggest, and when he appeared before Zeus, Hera and Athena had not yet returned. The latter error resulted most likely from a conflation of two scenes which originally had been consecutive. But copying illustrators have always taken such liberties.

Subjects of the Trojan epic poems, not of Homer's *Iliad* alone, continued to appeal to the erudite Byzantine of the Christian era. To have recognized the awarding of the weapons of Achilles on a Byzantine silver plate, now in the Hermitage in Leningrad, presupposed a thorough knowledge of the Trojan saga (Fig. 2).[10] According to the *Little Iliad* of Lesches of Mytilene it was due to the contrivance of Athena that the weapons were awarded to Odysseus, and this is obviously the version underlying the representation on the silver plate which shows Athena in the center, Odysseus at the right, and Ajax at the left. We owe to Matzulewitsch the proof for dating this plate in the sixth or seventh century, his evidence being drawn from comparisons with other silver plates that have datable stamps. He clearly analyzed the persistence of the classical style as well as some stylistic misunderstandings that are due to the relatively late date of the plate, but he showed little concern for the iconography where several incongruities must be pointed out.

In a representation of the Greco-Roman period would Athena, who had influenced the decision in favor of Odysseus, ever

have been shown seated on the throne in the judgment hall of the Achaeans? An Etruscan urn, found in Ostia (Fig. 3),[11] shows, in the same scene, the judgment throne occupied by an older man who is either Nestor or Agamemnon, while Odysseus is already laying his hands on the weapons of Achilles and Ajax is angrily taking his leave. In a Greco-Roman work of art, wherever a god or a goddess is involved in a terrestrial event, he or she appears — invisible to most — standing, or hovering behind or alongside the person protected by the deity. In having Athena take the place of an Achaean commander-in-chief, the Byzantine artist may well have been inspired by a figure of a divine emperor enthroned, for which there was a special tradition in silver plates, as exemplified by the well-known Theodosius missorium in Madrid.[12] Here we have the first signs of a mediaeval concept creeping into a classical scene from the Trojan War.

In the silver plate from Leningrad Athena speaks to Ajax, while, according to the story, she should turn to Odysseus whom she favors. Moreover, does Ajax here look like a man going mad and about to commit suicide as indeed he does on the Etruscan urn? How can the pose and gesture of Odysseus, which previous observers have thought strange, be explained? Nothing really seems to fit the story and yet there can be little doubt that its identification is correct, for there is the supporting evidence of Achilles' weapons in the segment below the feet. The whole composition looks like a pasticcio for which the artist took the figures from another context which, if we are not mistaken, can be identified.

The posture of Odysseus is that of a man who is beckoning and sneaking up on someone. Both acts, though strange in this context, are fully explained in a scene on the neck of a Roman silver oenochoe from Berthouville in the Cabinet des Médailles

*Illustrations accompanying this selection appear on pages 477 to 482.

in Paris (Fig. 4).[13] There Odysseus, who has been lying in wait for Dolon, cunningly beckons to him to come closer, only in order to kill him (*Il.* X, 338 ff.). Thus we conclude that the Byzantine silversmith used as a model an *Iliad* cycle which included the Dolon episode. Moreover he seems also to have excerpted the other two figures from an *Iliad* scene. The very miniature of the Milan *Iliad* already described (Fig. 1) shows Athena seated beside Zeus and lifting her hand in a gesture of speech just as she does in the silver plate, but in this case she addresses Ares instead of Ajax. Yet this very Ares who stands rather calmly, with the spear in his left hand, might well have served as a model for our Ajax, and a slight lowering of the extended right arm was all that was needed to have him point at Achilles' weapons.[14] Such a mixture of figure types from different scenes, though usually from the same iconographical realm, is by no means an innovation of Byzantine art, but occurs also in Greco-Roman art and is quite frequent in Pompeian wall paintings.

This detailed analysis of a pasticcio holds also the key to the understanding of a Byzantine silver plate of the fifth to seventh century which is in the Dumbarton Oaks Collection (Fig. 5).[15] It represents an Amazon on a galloping horse, attacking a lion with a spear. Behind her an archer, clearly characterized as a Trojan by his Phyrygian cap, draws his bow. This combination of Amazon and Trojan warrior leads us again into the iconographic realm of the Trojan saga: The *Aethiopis* of Arctinus began, as we know from Proclus' Chrestomathy, with the Amazons joining the Trojans as confederates and fighting on their side.

However, the Amazon and the Trojan are not fighting Achaeans; they are hunting, and both are aiming at a leaping lion, after having already killed a leopard. The classical sources are concerned, almost exclusively, with the warlike activities of the Amazons who fought against Theseus, Heracles, and finally the Achaeans, and

mention their hunting only in passing. Diodorus Siculus says merely (II, 46, 1) that Hippolyte, their queen, exercised the maidens in the hunting of wild animals and drilled them daily in the arts of war. This easily explains why, in classical art proper, the warrior-Amazon is extremely popular, while her representation as a hunter, if I am not mistaken, does not occur before the late classical period, after the ties of epic iconography had begun to slacken and decorative hunting scenes, in which heroes participated, had become a popular motif. One of the few earlier examples of Amazons hunting is preserved among the Antioch mosaics of about the middle of the fourth century (Fig. 6).[16] It shows an Amazon riding a rearing horse and aiming her spear at a lion, a representation similar to that on the silver plate. She is, however, associated with members of her own tribe: a second Amazon holds a protective umbrella over the first who is presumably the queen, while a third, of whom only a small part is preserved, aims her arrow at the same wounded lion.

Thus this silver plate turns out to be just another pasticcio, the figures of which, however, are taken not only from different scenes, but also, in contrast to those on the Leningrad plate, from different realms: the Trojan saga and the hunt. It would seem that, from the point of view of iconographic coherence, we are here one step further removed from the classical source. Nevertheless, the individual types are just as classical and, in design, just as assured and elegant, and maintain a high level of craftsmanship. The formal vocabulary is essentially the same as in works of classical art proper, whereas in contemporary religious art quite a different set of formal conventions had already developed.

II. Revival and Disintegration

The primary concern of classical art was the understanding of the organic structure of the human body. This goal remained more or less valid for Byzantine art in gen-

eral, even when, in Christian subjects, a more dematerialized figure style had developed. What wavered at various periods of Byzantine culture was the willingness either to outlaw or to tolerate the depiction of subjects of classical mythology concurrently with the study of classical literature. There was, as mentioned in the introductory remarks, a great intensification of classical studies after the end of iconoclasm, and, as far as the arts were concerned, this was focussed on the illustrations of classical texts which were copied with renewed vigor in the *scriptoria* of the capital, patronized by emperors and patriarchs alike.[17]

There is, for instance, in a tenth-century manuscript of the *Theriaka* of Nicander in the Bibliothèque Nationale in Paris, cod. suppl. grec. 247, a miniature based on a Gigantomachy (Fig. 7)[18] which in form and content is remarkably close to a Greco-Roman prototype. It depicts the giants recoiling under the attack of the gods who themselves are not shown. This abbreviation, however, is not necessarily due to the Byzantine miniaturist since it can already be found in a floor mosaic from Piazza Armerina in Sicily which dates from the turn of the third to the fourth century (Fig. 8).[19] The comparison between miniature and mosaic is particularly instructive, since they both show similar types, like the one at the lower right seen from the back, but the miniature, in contrast to the mosaic, is composed by making use of overlappings and foreshortenings which create a real sense of depth. In this respect it is more classical than the mosaic, and this means that the tenth-century miniaturist must have copied, directly or indirectly, a model that was earlier than the mosaic of Piazza Armerina. What is most noteworthy is not so much the fluency and elegance of the design and brush technique, but the awareness on the part of the illustrator of the precise meaning of the picture, since it had not formed part of the original Nicander illustration. Guided only by an allusion in the pharmaceutical text which speaks of malicious spiders, creeping worms, serpents, and other injurious animals emerging from the blood of the Titans, the illustrator must have remembered a scene of a Gigantomachy from an illustrated text that described the battle more fully, in all probability a mythological handbook, and most likely the *Bibliotheke* of Apollodorus, by far the most popular text of its kind in mediaeval Byzantium.[20]

The comparison of the mosaic and the miniature is very revealing from still another point of view. The former is placed in a semi-circular niche which can, of course, be explained formally as an architectural encroachment. However, in a representation of the Gigantomachy on a fragmentary, red-figured crater in Naples[21] the semicircular line above the fighting and defeated giants indicates the vault of heaven that separates the giants from the gods beyond this line. Now it will be noticed that in the Nicander miniature the five recoiling giants at the bottom and in the center conform most closely to the mosaic and reflect most clearly the Hellenistic tradition of fighting giants, while the giants at the top look rather like swimming or drowning figures that have no parallels in an ancient Gigantomachy. It seems quite conceivable, therefore, that the model of the miniature possessed only the recoiling giants under a semicircular arch of heaven and that the other giants were added by the miniaturist from another context.

Yet it must be admitted that the revival of mythological subject matter in the ninth and tenth centuries had its limited effect on Byzantine art in general. Only within a circle of erudite Byzantine humanists who moved in the atmosphere of the patriarchal and imperial palaces were miniatures like the Gigantomachy produced and fully appreciated. They were not without influence upon other media, but as soon as they had lost their physical association with the explanatory text, their proper meaning was

quickly lost and only a sense for the classical form remained.

There is in the treasury of San Marco in Venice a unique piece of rare beauty: a cup of ruby glass with enamel painting which belongs to the tenth or eleventh century (Fig. 9).[22] Its seven roundels are filled with figures of gods and heroes, and one contains a scene we believe to have derived from a representation of Oedipus and the Sphinx, an identification which is based on the pensive posture of the warrior and the gesture of speech of the winged creature that obviously poses the riddle. It is, however, more than questionable whether the enamel painter still had a clear comprehension of the proper meaning of this group. It almost seems as if he were not even really interested in it, but that he was satisfied with decoratively filling the roundels with a pleasing design of figures that had a classical flavor. For one thing, no classical illustrator would have changed the lion part of the Sphinx into an entirely human body, thus turning her, knowingly or unknowingly, into an angel. In this transformation the Byzantine artist may have been helped by a model such as the lamp of the Roman period in the Benachi Collection in Alexandria (Fig. 10),[23] where not only the head of the Sphinx, but a large part of her body is rendered in human form, and where, for lack of space, she is shown in a more upright position than is usual. The depiction of the Sphinx seated on an architectural support instead of in a rocky landscape must not, however, be taken as a mediaeval misunderstanding, since it had already been done in a Roman fresco from Hermopolis where the support resembles and is apparently derived from a theater prop,[24] and long before then on a red-figured cylix in the Museo Gregoriano in Rome,[25] where the support, in even closer agreement with the glass bowl, is a column. Moreover, the same vase-picture, unlike the lamp but like the glass, shows Oedipus in a seated position. Only the substitution of the rock by a throne, unsuitable to the setting of the episode on Mount Phicium, is clearly a mediaeval error.

Early Byzantine silver had already shown a weakening of the classical content, although figures like Athena, Ajax, and Odysseus in the Leningrad plate and the Amazon and the Trojan warrior in the Dumbarton Oaks plate were still clearly identifiable. But now, in the Middle Byzantine period, this individual identity seems, at times, not only lost, but intentionally sacrificed. This is particularly true for a whole group of ivory caskets which, because of the ornament used in their frames, are usually called rosette caskets and probably served as jewel boxes for noble ladies.[26] A very good specimen, from the turn of the tenth to the eleventh century, in Dumbarton Oaks (Fig. 11)[27] has, on its back, three plaques with human figures which, though iconographically unrelated to each other, were brought together for decorative purposes. A putto in the center, holding an unidentifiable object which was quite likely misunderstood by the copist, is flanked by a fully dressed archer and a nude bearded warrior with shield and sword. The latter seems to belong to a group of big bellied warriors from a Dionysiac battle.[28] It will be noted that both warriors are designed, with their short, chubby legs, to resemble the putto in the center. Obviously, on this and other caskets, the artist tried to turn all figures, whether gods or heroes, into putti, and in doing so created a uniform classical type and achieved a decorative unity. This "putticizing," if it may be permitted to coin such a word, carried with it the abandonment of the sensuous quality of the classical nude and its transference to a sphere of unreality, whereby it became more readily acceptable to a basically Christian culture.

III. The Impact of Mediaeval Form

In the process of copying scenes of classical mythology in a mediaeval surrounding, de-sensualizing was only one aspect. In a

culture which increasingly denied corporeal values this device was often considered insufficient, and artists began to dress nude figures while keeping intact the arrangement and meaning of compositions. This process had already begun in late classical art at a time when Christianity could hardly have been held responsible for this change of taste.

There is, in the so-called House of Menander in Antioch, a mosaic emblema representing Apollo's pursuit of Daphne (Fig. 12).[29] In contradistinction to Pompeian frescoes and other classical monuments, where Daphne is depicted nude or at least seminude, she appears in the mosaic fully dressed in a tunic that is fastened at both shoulders. Even more interesting is Apollo who is clad in a violet-reddish mantle, fastened over the right shoulder, that is clearly the imperial purple chlamys. Instead of the laurel wreath, he wears, set against a grey nimbus, the pearl diadem, similar to the one that became fashionable under the emperors of the Constantinian dynasty. This, apparently, is an early attempt to replace the timeless garment of a god or hero with contemporary dress. Here begins a trend not only to humanize the gods—this Homer had already done—but to historicize them. In Roman imperial times emperors were made divine, but now gods became emperors.

Each phase of the Middle Ages adjusts the dress of the pagan gods to the fashion of its day. In an eleventh-century miniature of Pseudo-Nonnus' commentary to the homilies of Gregory of Nazianzus, in the Patriarchal Library of Jerusalem, cod. Taphou 14, the Birth of Dionysus (Fig. 13)[30] is depicted in three consecutive phases, beginning with Zeus taking the half-grown embryo out of the womb of the dying Semele, then sewing it into his thigh, and finally delivering it himself. Like Apollo in the Antioch mosaic, Zeus, as a Byzantine emperor, wears a crown, but now it is the jewel-studded crown of the Middle Byzantine type instead of the pearl

diadem, and the gold embroidered tunic instead of the chlamys. The artist has shown restraint by not putting the heavy loros over the tunic which would hardly have been fitting at the moment when the Zeus-emperor has taken upon himself the obligation of a midwife. Moreover the three scenes are placed in a surrounding of conventional Byzantine furniture and architecture. Even so, the poses and gestures of Zeus and Semele have changed so little that their classical prototypes can still be traced.[31]

IV. The Impact of Christian Iconography

Whereas in the last two instances mediaeval *form* was imposed upon mythological representations, there exist also cases in which Christian *content* had infiltrated mythological scenes.

One of a pair of Early Byzantine silver plates in the Dumbarton Oaks Collection (Fig. 14)[32] illustrates a story in which a youth in heroic nakedness is reading a letter and, at the same time, turning away from a woman who is trying to detain him. An attempted seduction, a resisting youth, and, as an important detail, a love letter in the form of a diptych are features that best fit the Hippolytus myth, and the seducing woman, therefore, is none other than Phaedra. Although the text of Euripides (v. 601 ff.), on which practically all extant representations of this myth are based,[33] does not mention such a letter, it is a familiar attribute in classical monuments, as may be seen on a Roman sarcophagus in Girgenti (Fig. 15)[34] where Hippolytus looks at the diptych in his raised left hand without, however, giving the impression of nearsightedness, as he does on the silver plate.

Yet, there is one feature that is irreconcilable with the Euripidean text, namely, Phaedra's grasping of Hippolytus' mantle. In the drama as well as in all other representations the hero does not meet Phaedra alone, but in the presence of the nurse who must have delivered the letter. In Euripides

the nurse does touch the hero's garment, in order to attract the attention of Hippolytus who (verse 606) rebukes her: "Hence with thine hand! Touch not my vesture thou." And, indeed, on the Girgenti sarcophagus the nurse touches Hippolytus' spear with her right hand and his chlamys with her left. In all likelihood the Byzantine silversmith was forced to abbreviate a fuller three-figure composition, and, in omitting the nurse, he had Phaedra touch the garment of Hippolytus. In doing so the meaning of the gesture was changed: what, in the case of the nurse, was meant to be a gesture of supplication then became one of seduction.

There is still another incongruity in the silver relief that likewise seems to have resulted from lack of space. Phaedra is leaning on a pedestal, a pose which seems a little too relaxed for a person at a high pitch of emotional strain. Such pedestals are theater props as can be seen in a second-century Antioch mosaic that depicts Phaedra, the nurse, and an angry Hippolytus (Fig. 16).[35] Here it supports a statuette of Aphrodite, the goddess whom Hippolytus had offended, and beside it stands Phaedra with her right arm raised and playing nervously with the edge of her veil. By moving the pedestal and Phaedra closer together one can readily see how the former could become the support for Phaedra's arm.

Coming back to the all-important motif of the grasping of the mantle; was the Byzantine silversmith the first to invent this motif as a means of portraying a seduction? There exists a Late Roman floor mosaic from Porcareccia, now in the Vatican Museum (Fig. 17),[36] that depicts among its twenty-four panels of scenes from the theater one in which the grasping of the mantle is the central motif, and on account of this an identification with Phaedra and Hippolytus has been proposed. But the comparatively short hair of the mask on the left and the longer hair of the one on the right suggest that the seducer is a male and the seduced a female and that, there-

fore, the mosaic can only be regarded as a formal, but not as an iconographic, prototype of the scene on the silver plate. While the Phaedra story is by no means the only one in Greek mythology in which a woman tries to seduce a resisting young hero, I cannot recall any representation in classical antiquity in which the artist has portrayed a woman in the seductive act of grasping a garment; on the other hand it is a common device for depicting the more aggressive male.

At the same time the most famous precedent for the grasping of the mantle of a chaste, resisting youth is found not in classical mythology, but in the Biblical story of Joseph and Potiphar's wife. In every picture-recension of the Book of Genesis an illustration of this episode must include this motif since it is explicitly described in the Bible text. For instance, in the thirteenth-century mosaic in the narthex of San Marco (Fig. 18),[37] which harks back to the so-called Cotton Genesis[38] of, as we believe, Alexandrian origin,[39] we see Potiphar's wife pursuing Joseph out of the door of her bedchamber and snatching his mantle which hangs loosely over his shoulder. Indeed, it seems more than likely that the Byzantine silversmith was stimulated by such an illustration from the Book of Genesis. After all, the sixth century, which is the approximate date of the silver plate, was a flourishing period of narrative Bible illustrations, as the Vienna and the Cotton Genesis testify, and it seems only natural that in a predominantly Christian culture they should have exerted a reverse influence upon representations of Greek mythology. What makes this case interesting is that the artist not only took over an isolated iconographical motif, but must have been aware of a parallelism in the meaning of the two scenes, both of which implied not only a seduction but a refusal on the part of a chaste youth.

In another example that illustrates an episode from the popular story of the infancy of Achilles, the influence of Christian content and mediaeval form can be dem-

onstrated simultaneously. A seventh- or eighth-century bronze plate in the museum of Cairo has, among its several infancy scenes which closely follow the classical tradition, one that shows a significant deviation from it. Illustrating the bringing of the boy Achilles to Chiron for his education (Fig. 19),[40] it shows Thetis pushing the little boy in front of her towards the centaur. In all earlier representations of this scene, including a circular marble relief of the fourth century, likewise of Egyptian origin, in the Museo Capitolino in Rome (Fig. 20),[41] Thetis holds the nude babe in her arms when she hands him over to Chiron, his future teacher.[42] Moreover, in the Cairo plate Thetis is nimbed, and this suggests that the changes in the composition were made under the influence of a Biblical scene.[43]

In an eleventh-century Book of Kings in the Vatican Library, cod. gr. 333,[44] whose comprehensive miniature cycle is descended from a very early archetype,[45] there is a scene in which the child Samuel is brought by his mother Hannah into the temple to Eli the priest (Fig. 21). The composition is very much the same, with the half-grown boy being gently pushed forward. A parallel such as this would also explain the fact that the boy Achilles is clothed, as opposed to the subsequent scenes of the Cairo plate where, in agreement with the classical tradition, he is nude. Thus it appears that the metal worker was influenced by a Biblical illustration only for the group of the mother and the child and in none of the other scenes on the Cairo plate. Once more the parallelism is not merely formal; the artist must have been aware of the similarity of content: in both cases a boy is given to a respected educator to be raised outside the parents' home.

V. Mediaeval Creations

With a comparatively rich heritage of mythological scenes available, the instances in which Byzantine artists set out to illustrate a mythological event entirely in the spirit and form of their own times, and without the use of classical models, are rather rare. A few such instances from the ninth century are known,[46] but the renaissance of the tenth century seems to have prevented a further development in this direction, and most such attempts date from the Late Byzantine period. Even then they were unusual.

In Hellenistic-Roman times the most frequently illustrated text had undoubtedly been the *Iliad*, and it is hardly an accident that the only illustrated manuscript of a Greek epic poem known today is the well-known *Iliad* fragment in Milan (Fig. 1). The fact that in the eleventh or twelfth century short minuscule inscriptions were added to the illustrations clearly shows that these were still highly appreciated at that period. At the same time the famous *Iliad* manuscript in the Marciana in Venice, cod. gr. 454, one of Cardinal Bessarion's prize possessions, that was written in the first half of the tenth century in a beautiful minuscule,[47] has no pictures, and it seems safe to suppose that its model, too, had none, since, otherwise, they would have been copied or provisions would at least have been made for their inclusion. In about the fifteenth century a few pages that had been lost were repaired and apparently at that time a few miniatures of a rather crude style were added at the very beginning of the codex. One of these marginal scenes (Fig. 22) depicts the pleading of Chryses, the Trojan priest, before an enthroned Agamemnon who is dressed like a Byzantine emperor and wears a high crown. Chryses offers Apollo's wreath and a staff of gold, not, as the text suggests, one upon the other, but separately, and the staff is the imperial labarum like the one which Agamemnon also holds as a sign of his imperial rank. Thoroughly Byzantine, too, is the second scene in which Chryses, after having been repudiated, prays in the temple of Apollo Smintheus. Here Chryses is a Christian priest, with a censer, standing before a ciborium which encloses a stereotype idol on a pedestal.

How removed these scenes are from classical representations of this episode may be demonstrated by comparing them with the Iliac tablets of the first century. In a plaque in the Cabinet des Médailles in Paris (Fig. 23)[48] Chryses bends his knees and touches the knees of the enthroned Agamemnon, as a sign of supplication, while the ransom is unloaded; and in the subsequent scene, as may be seen in the tablet of the Museo Capitolino (Fig. 24),[49] the priest offers a libation on an altar that stands in front of a templum in antis. The inspiration of the Late Byzantine illustrator obviously did not come from an illustrated *Iliad* but from a Chronicle like that of the fourteenth-century John Scylitzes manuscript in Madrid.[50] Artistically these attempts are not too successful compared with those of the Latin West where from the twelfth century on the rendering of mythological scenes in mediaeval form became widespread and artistically is often quite imaginative.[51]

VI. Transformation of Mythological into Christian Scenes

Of even greater consequence, perhaps, than the mere persistence of mythological representations within a Christian culture is the influence they exercised on the formation of Biblical iconography. It is well known that the earliest illustrators of the Old Testament, either Hellenized Jews or Christians, relied on the formal vocabulary of Greco-Roman art, having no pictorial tradition of their own. Formalistic art history has put its main emphasis on the tracing of types with identical poses and gestures in Christian and classical art. But since Hellenistic art had reached the point where it mastered the rendering of the human body from every aspect, physically and psychologically, and thus could and did represent it in every possible pose, it was more or less a foregone conclusion that for each figure in a Biblical scene a classical counterpart could be found. However, what scholarship has begun only

gradually to realize is that the first illustrators of the Bible must have roamed through extensive classical picture cycles, searching not only for suitable figure types, but for whole compositions which were appropriate from the formal point of view and had similar meanings as well. In other words, the first Biblical illustrators had a good knowledge of the illustrated Greek classics and remembered where related episodes with similar actions could be found. We have already discussed a case of reversed borrowing in connection with the scene of Phaedra's attempted seduction which was changed under the influence of the Biblical story of Potiphar's wife (Fig. 14). However, such cases remained rare, while the primary influence of mythological representations upon Christian scenes was not only widespread, but formed the basis without which the creation of Biblical picture cycles on a vast scale would have been impossible.

Unfortunately, this process cannot be fully reconstructed, since the chief medium in which the transformation of mythological into Biblical scenes took place was book illumination, and illustrated classical texts in their original form of papyrus rolls are completely lost save for a few fragments.[52] Scholarship, therefore, must rely chiefly on the equally scarce reflections in other media and on a few mediaeval manuscripts. So it is very fortunate that we can cite at least one instance of a Biblical miniature derived from a mythological illustration in a papyrus roll which has become known only very recently.

In an eleventh-century Octateuch in the Vatican Library, cod. gr. 747, there is a representation of Samson's fight with the lion (Fig. 25),[53] illustrating the phrase of the fourteenth chapter of Judges which reads: "Samson crushed the lion as he would have crushed a kid of the goats." The miniature shows the hero strangling the lion by pressing its head under his armpit, an act which is not quite in agreement with the Greek συνέτριψεν, the word used

in the Septuagint. What induced the Bible illustrator to depict the lion fight in this particular manner?—In our opinion, a model that depicted Heracles fighting the lion of Nemea.

In a third-century papyrus from Oxyrhynchus (Fig. 26)[54] which contains a fragment of a Heracles poem with three scenes, all of which relate to Heracles' first adventure, the lion fight is depicted in the very same manner as Samson's fight. But in the case of Heracles there was a motivation for illustrating this particular method of killing since Diodorus Siculus (IV, ii, 3–4) explicitly states that the Nemean lion "required the compulsion of the human hand for his subduing," and that Heracles "winding his arms around the beast's neck choked it to death." This case demonstrates clearly that in the process of such an adaptation the mythological composition loses, to some extent, its precise relationship to the text after it has been introduced into the story of the Bible. This raises an important methodological question. Quite often students of iconography, when they meet discrepancies between a Biblical illustration and the Bible text, look for some other literary source to explain such discrepancies, while in many cases, we believe, these are caused by an unaltered adaptation of a compositional scheme. A second example will make this point even clearer.

In the Landesmuseum in Trier there is a fifth-century ivory pyxis which on one side represents the sacrifice of Isaac (Fig. 27).[55] Abraham has just drawn the dagger in order to cut the throat of Isaac whose head he holds with his left hand. Large parts of the figure of Isaac are, unfortunately, destroyed, but enough is left to make the original pose quite apparent. He had obviously tried to run away and had sunk to his knee, when Abraham caught him and prevented his escape. This situation is clearly in contradiction to the meaning of the text of Genesis (22:9), according to which Isaac, quite submissive, should be on the altar, not beside it, as in the ivory. It would, however, be wrong in our opinion to look for another textual version of this Biblical story. The deviation can be more easily explained by the use of a classical model and, once more, we may expect this to be a mythological scene with a similar meaning.

There is in the *Telephus* of Euripides a highly dramatic scene in which Telephus, being pursued by the Greek chieftains, snatches the child Orestes. While he tries to reach the safety of the altar he threatens to kill the boy if harm should be done to him. This moment is depicted on an Etruscan urn, in the Museo Archeologico in Florence (Fig. 28),[56] where Telephus steps forward like Abraham and, although his right hand is lost, there can be no doubt that it held the dagger which he aimed at the neck of the boy Orestes. In spite of minor adjustments made by the Bible illustrator to adapt his model to the passage in Genesis, the similarity is close enough to suggest this particular Euripidean scene as his ultimate source. To this formal agreement may be added an ideological common denominator: in each case the sacrifice of an innocent boy is attempted but at the last moment prevented—in the mythological scene by the prevailing of reason and in the Biblical by divine intervention.

There is sufficient evidence to conclude that, except for the poems of the epic cycle, the dramas of Euripides were the most frequently illustrated classics in the Hellenistic-Roman period, and therefore it would not be surprising to find them widely used as a source for Biblical illustrations. There is, if I am not mistaken, a reflection of even the "theater style" in the very large head of Abraham: the mouth is broad and open and the eyes vacant as in a mask, and one gets the distinct impression that the ivory carver had in front of him a scene not in the "epic-heroic style" like that of the Etruscan urn, but in the "theatrical style" so common in Roman monuments, though he seems to have tried

to avoid the appearance of a mask.[57] The results gained from the analysis of the Trier pyxis call for a closer scrutiny of this particular group of Early Christian monuments of which I should like to cite another example.

Among the treasures of the Dumbarton Oaks Collection there is a sixth-century ivory pyxis (Fig. 29)[58] which, like almost every other member of this group, possesses some unique features. Moses is represented receiving the law in a composition whose peculiarities will stand out more clearly if we compare it with that of a contemporary ivory pyxis in the Hermitage in Leningrad (Fig. 30)[59] which conforms to the more normal iconography. Here Moses, face averted, receives, with veiled hands, the tablets from the hand of God, while an Israelite looks on with his hand raised in a gesture of astonishment and in a receding pose as if recoiling from the awe-inspiring apparition. In the Dumbarton Oaks pyxis Moses is represented in a similar pose, climbing the mountain in order to receive the law, which is in the shape of a scroll rather than a tablet. These are variants within the Biblical iconography. But then there is, behind Moses, an Israelite who has thrown himself to the ground in a frantic mood, thrusting his arms about with wild and uncontrolled gestures. We do not know of any other representation of this scene in Early Christian or later art which includes this frantic onlooker; nor is there any hint in the Septuagint text that would provide an explanation. The alternatives can only be: is this figure based on another textual source, perhaps a Targum, a Midrash, or an apocryphal passage, or has it slipped in from a classical model? Both alternatives are possible. Moreover, behind the figure just described stand two more onlookers who raise their hands in gestures of astonishment, though they do so quietly and almost without emotion. Each one holds in his veiled left hand a staff that is meaningless for an onlooking Israelite. Its incised

spiral pattern is typical of the scepter in the hand of a theater king,[60] as may be seen in a fragment of a sarcophagus in the Louvre (Fig. 31).[61] This indicates that we are dealing here once more with the impact of a theatrical scene upon a Biblical one, and suggests that the dramatic figure in the foreground also stems from the same source, presumably a tragedy scene.

Yet, unlike the Trier pyxis for which we proposed as its model a scene from the Euripidean *Telephus*, we have not been able to find a parallel among the theater scenes that have come down to us from the Roman period. It is essential to realize that of Euripides alone, the most frequently illustrated ancient dramatist, all of the nineteen preserved plays, in addition to most of the other fifty-five which we know only through fragments and quotations, had rich narrative cycles. For these there must have existed hundreds of miniatures of which only a few have survived through copies in other media. Consequently one should not be surprised that in many cases, where the influence of a theater scene is visible, the exact model cannot be traced. Thus, where the pictorial evidence is lacking one can only try to interpret the scene from literary remains. Since, as stated above, Euripides was the most frequently illustrated dramatic text, it is reasonable to consult him first. What comes to our mind is the story of Odysseus feigning madness in order to escape participating in the Trojan war when some of the Achaeans came to Ithaca to win him over. Presumably this episode was told in the prologue of Euripides' *Palamedes*, a tragedy with which no pictorial representations have been connected so far. To interpret the gesticulation of the kneeling figure as an act of madness seems quite appropriate, and two onlooking Achaean kings would form a suitable background to this. Admittedly this explanation must remain in the realm of hypothesis, all the more so since it is difficult to suggest a common denominator with the Moses scene, but it points perhaps

in the direction in which the solution of the enigma of the Dumbarton Oaks pyxis will have to be sought.

The process of transforming mythological scenes into Biblical ones started, of course, centuries before these pyxides were made and coincided with the very beginning of the illustration of the Septuagint which, on the basis of its reflection in the frescoes of the Dura synagogue, can be assumed to have taken place in Greco-Jewish art.[62] When, centuries later, the New Testament was illustrated for the first time, this must have been done under conditions very similar to those that produced the Old Testament cycles, that is, at a time when Homer and Euripides were still the chief illustrated classics to be consulted and used by the artists. To demonstrate this point I may be permitted to choose an example from Western art which seems particularly instructive.

A ninth-century Gospelbook in the Statsbibliothek in Munich, cod. lat. 23631 (Fig. 32), written in gold on purple, has a few miniatures which have variously been considered as products of the sixth century,[63] or as copies, contemporary with the text, made in the ninth century on the basis of Early Christian models[64] and even as tenth-century Ottonian works.[65] While the Carolingian origin seems to us the most plausible one, it suffices for our purpose to note that compositionally they are Early Christian inventions. One of them depicts in cross-form the Massacre of the Innocents, with many strange features that find no explanation in Matthew's terse account (2:16): "Herod slew all the children that were in Bethlehem." Normally this scene is represented by soldiers who kill the infants with swords and spears, but in the Munich miniature a very specific type is used which also occurs elsewhere in Early Christian monuments:[66] a soldier is smashing an infant by hurling it over his head, and the miniaturist emphasizes this motif by depicting it twice. Moreover, another slain infant is shown falling head first through

the air as if it had been hurled from a wall or rampart. A famous story from the Trojan war tells of the killing of an infant in this particular manner. The *Little Iliad* of Lesches of Mytilene, according to the scholia to Lycophron's *Alexandria,* contained an episode in which Neoptolemus snatched Andromeda's son, the little Astyanax, "from the bosom of his rich-haired nurse and seized him by the foot and cast him from a tower."[67] An illustration of this story occurs in blackfigured vases,[68] and we assume that some later copy of the Hellenistic-Roman period was used as a model by the Gospel illustrator.

The connection between scenes from the Trojan war and the Massacre of the Innocents is not confined to this one motif. At the bottom of the miniature a soldier is dragging away a kneeling woman by her hair; his sword is sheathed, and there is no infant for him to kill. Neither feature quite fits the story of the Massacre, but both can be fully explained in an episode from the Trojan war. In the Iliac tablet of the Museo Capitolino (Fig. 33)[69] the center of which is occupied by a complex composition of the *Iliupersis* of Stesichorus, one sees in the middle of the top row the temple of Athena and, in front of it, Ajax dragging away Cassandra who kneels on the steps of the temple.

The *Iliupersis* explains still another motif not called for in the story of the Massacre of the Innocents, but necessary to a depiction of the Sack of Troy, namely, the prominently displayed altar. In the epic scene it is at the altar of Zeus Herkeios that Priam is slain, and in the Iliac tablet it occupies, quite properly, the very center of the city. Beissel[70] wondered about this altar in the miniature and connected it with a hymn of the Feast of the Holy Innocents which mentions an altar. But its round form indicates that it is pagan, not Christian. Once more, the similarity between the pagan and Christian illustration is not confined to mere formal adaptations, but extends to an ideological parallelism

that reveals the learnedness of the Christian illustrator. In both cases a massacre took place in order to kill the offspring of a whole nation, yet one infant was destined to be saved: Ascanius in the Trojan story and Christ according to Matthew's Gospel.

VII. Renewed Impact of Mythological upon Christian Scenes

In the course of repeated copying, the classical elements, particularly those that were in conflict with the Biblical text, were either gradually eliminated or adjusted to the Christian content, thereby losing some of their original characteristics. After iconoclasm, however, and during the Macedonian renaissance we see a new infiltration of mythological representations into Christian iconography which can best be observed in the New Testament cycle, since at this period the main artistic energies were centered on the illustration of Gospel events at the expense of the Old Testament. The most striking case is the introduction of a new Christ type into the Anastasis, a Christ who, instead of approaching Adam, drags him out of Hell like Heracles dragging Cerberus out of the Lower World.[71] I should like to demonstrate that this was not an isolated case, and that the best examples of this renewed impact of classical models on New Testament subjects are to be found not in the narrative cycle of Christ's life, but more specifically in the representations of the great feasts which in the Middle Byzantine period had assumed especial prominence.

In the feast cycle the Anastasis is followed by the Ascension of which the most classical rendering I know is on the lid of a tenth-century ivory casket in Stuttgart (Fig. 34).[72] Whereas the enthroned Christ carried to heaven by angels is traditional, there are here, among the apostles, several types which had not existed in earlier Ascension scenes. This will become clear by comparing the ivory to a typical Early Byzantine Ascension like that on an icon from Mount

Sinai (Fig. 35)[73] which is closely related to the representations of the Ascension on the Monza phials,[74] the lid of the Sancta Sanctorum reliquary box,[75] and others. In the ivory the apostles are, first of all, more widely distributed than on the icon, and those of the rear plane are raised on a kind of dais reminiscent of a stage setting. While some apostles, like those pointing upwards to the ascending Christ, are traditional and can be found in the Sinai icon, others have no analogy in any early Ascension picture; for instance, the apostle in the middle of the lower right who excitedly turns around to his neighbor in order to strike up a conversation. There is a similar type, to the left of the Virgin, who addresses another apostle whose pose is even more unusual. Seen from the back, he is turning in an almost dancing motion, as if he were making a pirouette. The formal elegance of this pose is contrary to the hieratic concept that pervades all pre-iconoclastic Ascension pictures, and can only be explained by the influence of the Macedonian renaissance. It has been noticed that the style of this ivory is closely related to, though not quite the same as, that of the "Malerische Gruppe" of Byzantine ivories which, in addition to plaques with religious subjects, produced the classicizing rosette caskets. It is on these caskets that one finds dancing Maenads and other figures from the Bacchic repertory who resemble so closely the dancing apostle.[76] Yet on most of these caskets the Maenads are already more or less "putticized" (p. 210), whereas on a late-classical fifth- or sixth-century pyxis in the museum of Zurich (Fig. 36)[77] a Maenad is still depicted in the more slender proportions of the Ascension apostle.

Even more incongruous for an Ascension is the equally emotional and dramatic apostle, close to the Virgin, who buries his head in his hand. Probably the artist wanted to convey the idea that the apostle is shielding his eyes against the light of the

heavenly apparition—a gesture which would seem to be more suitable for a Metamorphosis, although no Transfiguration scene is known to me in which an apostle makes just this gesture. In the classical repertory of gestures this pose expresses brooding, a mood hardly proper for an apostle watching the Ascension of Christ. It is a most fitting pose, however, for Agamemnon, brooding and turning aside when Iphigenia passes him on her way to where her sacrifice and subsequent carrying-off are to take place. In this very pose Agamemnon is seen on an ancient marble altar in the Uffizi in Florence, the so-called Ara of Cleomenes (Fig. 37).[78] Is it too farfetched to assume an influence by this particular figure from a Euripidean tragedy upon a mid-Byzantine Ascension? Not if we realize that this very composition of Iphigenia's sacrifice, of which Agamemnon was normally a part, was copied on a tenth-century Byzantine ivory casket, now in the Victoria and Albert Museum in London.[79] True, Agamemnon himself was omitted from the scene on the ivory plaque, but it is more than likely that he existed in the Byzantine miniature which, in our opinion, must be considered a common model for both the casket and our Ascension ivory.

The Stuttgart relief thus reveals itself as a classicized Ascension for which the renaissance artist employed types from heterogeneous realms of classical iconography. Apparently he was satisfied with a merely formal adaptation, having had difficulty in finding an entire scene of similar meaning in classical art. In general it seems that in this period of the renewed impact of classical upon Middle Byzantine art the formal aspect began to play an increasingly important role because copyists no longer had an unlimited wealth of classical models at their disposal or the knowledge of mythological subject matter at their fingertips.

Although the Christological feast cycle, as mentioned before, shows within the religious iconography of the Macedonian renaissance the most distinctive examples of a renewed influence of mythological elements, other iconographical realms were also affected by this classicizing trend. A tenth-century ivory plaque in the Berlin Museum, depicting the Forty Martyrs of Sebaste about to freeze to death in the icy water (Fig. 38),[80] may be chosen as an example from the hagiographical realm. The martyrs, and especially those in the front row, are represented in poses of extreme emotional stress, either with their heads drooping in utter dejection or looking up to the enthroned Christ who appears in heaven worshipped by angels.

As in the case of the contemporary Ascension ivory in Stuttgart, the peculiar quality of this renaissance creation stands out most clearly when confronted with a pre-iconoclastic representation of the same subject. A fragmentary fresco in Sta. Maria Antiqua in Rome (Fig. 39)[81] shows the Forty Martyrs lined up frontally with very little variation in poses, all of them raising their hands in orant gestures and revealing no sense of pain, in agreement with the more hieratic, unemotional style of the Early Byzantine period. This forms the strongest possible contrast to the agile bodies in the ivory plaque which are seen from all sides, leaning backward and forward, and gesticulating wildly in all directions. The relief belongs to the same Constantinopolitan atelier that manufactured the classicizing rosette caskets filled with "putticized" figures from ancient mythology; consequently the carver of the Forty Martyrs plaque must have had access to the same repertory of mythological scenes.

It has already been noted by Otto Demus[82] that the Apparition of Christ in heaven, which does not exist in the early fresco, was taken from a composition of the Ascension of Christ like that of the Stuttgart ivory, and this applies also to some of the martyrs, who raise their arms

towards Christ just as do some of the apostles in the Ascension picture. At the same time, not all of the agitated martyrs can be derived from a composition of the Ascension, and this is true particularly of the most classical ones. One must, therefore, search the classical repertory for a scene in which nude figures are depicted in violent postures, recoiling under the impact of an invisible force. The subject which immediately comes to our mind is the battle of the giants against the gods as represented in the tenth-century Nicander miniature in Paris (Fig. 7). One may, for example, compare the martyr at the extreme lower right, in the three-quarter pose seen from the back, who throws up his left arm, with the giant in the lower center of the miniature. The dejected martyrs in the front row who hold one arm under the chin and the other before the breast, not only show a similar formal conception, but express the same sentiment as that of the central giant in the mosaic of Piazza Armerina (Fig. 8). It is, of course, to be expected of a Byzantine artist of the tenth century that, in spite of a very good understanding of the organic structure of the human body, he would object to the muscular exuberance of the giants and make his martyrs more slender and thereby more ascetic and ethereal.

There are other types among the Forty Martyrs who do not fit the formula of a recoiling giant, yet are very classical in appearance and must therefore have been derived from another iconographical realm. Among the various classical types and models involved I should like to point out only one more that is particularly striking, and revealing of the mentality of a Middle Byzantine artist. In the second row close to the center is a group consisting of an older, bearded martyr who turns to one side and tenderly places his left arm around the neck of a youth. If one can forget for a moment the context and define the sentiment conveyed by this group, one would describe it as one of affection, inti-

macy, with even a trait of importunity. There was a famous group in classical antiquity, existing in more than twenty replicas, which embodied just this sentiment and apparently stimulated the Byzantine artist to incorporate it in the composition of the Forty Martyrs, and which, as is generally agreed today, represented Pan instructing Daphnis in the playing of the syrinx.[83] The replica in the museum of Naples (Fig. 40)[84] is particularly close as far as the pose and the profile head of the obtrusive Pan are concerned. Daphnis is turning his head away, but this is by no means the rule in this group, and in another replica in the Museo Nazionale in Rome[85] the charmed youth turns his head towards Pan, thus showing a response not basically different from that of our youthful martyr. In spite of these similarities, it must not necessarily be assumed that the model of the ivory carver was actually a sculptured group; indeed, for an ivory of the "Malerische Gruppe" one would think first of all of a painted model. Actually, a rather badly preserved fresco from Herculaneum[86] depicts a variant of the Pan-Daphnis group, in which Marsyas and Olympus are represented in very much the same poses conveying the same meaning, and it is entirely possible that the model of the ivory carver represented Marsyas and Olympus rather than Pan and Daphnis. The Gigantomachy and the erotic group of music-teaching are indeed heterogeneous realms out of which the Christian artist chose his models for martyrs shivering and freezing to death in an icy lake.

Classical mythology and the forms in which it had crystallized had ever-revitalizing power in Byzantine art. After the classical features had somewhat worn off in the centuries following the Macedonian renaissance they reappear with renewed vigor in the Palaeologan period, as may be seen in one of the finest creations of this period, a fourteenth-century portable mosaic icon of the Forty Martyrs in the Dumbarton Oaks Collection (Fig. 41).[87]

Otto Demus has clearly demonstrated that in its classicizing features it is akin to the ivory just discussed and yet sufficiently different to exclude a direct descent. The attitudes of the martyrs are here again more restrained, thus more closely approximating the Early Byzantine ideal of dignified behavior. At the same time the faces are much more individualized and expressive and, in this respect, more classical than the lively and yet uniform heads in the ivory. It will be noted that in the Dumbarton Oaks icon there are new types of martyrs that exist neither in the early fresco in Rome nor in the Berlin ivory, as, for instance, the second from the right in the front row who, in despair, holds his right hand close to his forehead. This type appears once more in the Gigantomachy of Piazza Armerina in the upper left corner (Fig. 8). Admittedly such a pose could also be found in other classical works, but the fact that so many gestures can be traced to this specific context, and that a copy of the Gigantomachy is known to have existed in tenth-century Byzantine painting, make the connection between these two scenes plausible from both the artistic and the historical points of view. One gets the impression that the ivory and the mosaic hark back to two different, though related, archetypes, and that whereas the model for the ivory was a creation of the Macedonian renaissance, the Dumbarton Oaks mosaic reflects the mind of an artist who tried to revitalize and, at the same time, to retain the more hieratic, Early Christian composition, infusing into it only a limited number of classical poses.

However, in both cases the influence of a Gigantomachy upon a martyrdom scene is not confined to an agreement of the poses of a few figures, since both events concern a group of men who, one by one, are meeting a slow death, without being able to escape or to offer effective opposition, and we presume that the Byzantine artists who designed a classicized version of the Forty Martyrs were well aware of this

similarity of content and meaning as well as of form.

VIII. Combination of Mythological and Christian Elements

A free attitude with regard to the classical heritage is shown by those Byzantine artists who dared to place undisguised classical and Christian elements side by side, thus striving for a harmony between two cultures which at an earlier stage had sometimes been antagonistic towards each other. After the end of iconoclasm, when classical culture was no longer a living force, imperial court and patriarchal palace alike made classical learning a subject of humanistic endeavor, not only to be tolerated but to be cultivated insofar as it did not endanger the Christian foundation of Byzantine civilization.

One of the most successful examples of such a synthesis is the title miniature of the well-known Psalter manuscript in Paris, cod. gr. 139, which, as we believe, dates from the tenth century. David, playing the harp in the midst of his flock, forms the nucleus of the composition (Fig. 42).[88] and he is surrounded by a wealth of classical motifs of which the most prominent is the personification of Melody who leans on his shoulder despite his apparent indifference to her. The closest parallel to this personification is Io, as she appears in several frescoes in Pompeii, seated on a rock and watched over by Argus; the representation most closely allied to our miniature being that from the Macellum (Fig. 43).[89] Hugo Buchthal,[90] while admitting the close similarity of the two females, nevertheless objected to the idea that the illustrator of the Psalter derived Io from a composition like that of the Macellum fresco; David and Melody appeared to him to be so much a group composition that he postulated a classical prototype depicting a pair of lovers seated together on a rock. These

two seemingly contradictory opinons can, we believe, be reconciled since an Antioch mosaic has come to light which represents just such a couple: a woman, who is clearly our Io-type, is seated on a rock with a shepherd who puts his arm around her (Fig. 44).[91] For this and other reasons it has even been proposed that the mosaic represents Io and Argus, but such an identification meets with difficulties. First of all the shepherd is clad in an embroidered tunic and wears a Phrygian cap, attributes unsuitable to Argus. Moreover, the function of Argus is to guard Io carefully in order to prevent her escape, and nowhere in antiquity is he known to have been her lover. Another identification which has been proposed is that of Paris and Oenone, and this seems to us to be the correct one. The royal garment and the Phrygian cap fit the scion of Priam, and the syrinx is likewise a proper attribute of the nymph, as can be seen in a Roman relief from the Ludovisi collection in the Museo delle Terme in Rome.[92] Thus it seems that the mosaicist of Antioch used Io as the model for Oenone, his only modification being the addition of the syrinx. Such a composition, then, might well have been before the eyes of the Byzantine illuminator, although it must have shown the loving couple in a richer landscape setting than that of the mosaic, that is, with more grazing animals surrounding the royal shepherd. Whether or not this hypothetical model showed Oenone holding the syrinx which the Byzantine artist then omitted, is difficult to determine. Even if not, however, we would expect the classical Paris and Oenone group to have included some indication of the nymph's association with music, since this was quite likely the reason why the artist of the Psalter selected this type as a personification of Melody. Another reason why the Byzantine copyist chose this particular model may have been the presence in it of a royal shepherd in embroidered robes whom he equated with David in spite of the fact that he refrained from classicizing David in this fashion, but continued to use the traditional Biblical type. This group of David and Melody, whom one could hardly call lovers, was surrounded by the copyist with other figures of mythological origin and with a rich landscape setting that must have appealed to the patron of this lavish manuscript, who may well have been none other than the emperor himself.

It must be pointed out that the mythological representations in Early Christian and Byzantine art, to which the first part of this paper is devoted, were never very numerous, even during the periods of conscious revivals. Byzantine art, in all the phases of its long history, was dominated by religious subject matter, based on the Old and New Testaments and on stories from the lives of the saints or from homiletic literature. Next in importance was the imperial realm which had its own widespread iconography, whereas the classical realm remained the concern of a small class of intellectuals having a humanistic outlook.

What, in the last analysis, is even more significant than the mere survival of mythological representations is their influence upon the formation of Christian iconography, not only in its incipient stage, but during the periods of revival as well, as I have tried to demonstrate by a few examples. In most cases where such an influence could be traced it became evident that the Byzantine artist had approached his problem intellectually and had proved himself to be well acquainted with the classical past as to both form and content. Consequently it should be the task of the historian to reconstruct this process of penetration of classical iconography into Christian iconography, not only by tracing individual types with regard to their artistic form, but by searching for whole compositions which fitted corresponding Christian scenes, and by uncovering, as far as the evidence permits, the reasons for their selection. The Byzantines, like their forebears of ancient Greece, were never satis-

fied with a play of forms alone, but, stimu-
lated by an innate rationalism, endowed
forms with life by associating them with
a meaningful content. The change from

Olympian religion to Christianity did not
alter this basic attitude towards art. After
all, the Byzantines were Greeks.

NOTES

1 N. H. Baynes, *The Hellenistic Civilization and East Rome* (The James Bryce Memorial Lecture, Oxford, 1946), p. 40.

2 Ed. W. R. Paton, *The Greek Anthology* (Loeb Class.), V (1926), pp. 142–3.

3 K. Weitzmann, "Das Klassische Erbe in der Kunst Konstantinopels," *Alte und Neue Kunst*, III (1954), p. 41ff.

4 A. Goldschmidt, "Das Nachleben der antiken Formen im Mittelalter," *Vorträge der Bibliothek Warburg*, I, 1921–22 (Leipzig-Berlin, 1923), p. 40ff.; E. Panofsky and F. Saxl, "Classical Mythology in Mediaeval Art," *Metropolitan Museum Studies*, IV (1932–33), p. 228 ff.; J. Adhémar, *Influences antiques dans l'art du moyen âge français* (London, 1939); J. Seznec, *La survivance des dieux antiques* (London, 1940); E. Panofsky, "Renaissance and Renascences," *Kenyon Review* (1944), p. 201 ff.; H. von Einem, "Die Monumentalplastik des Mittelalters und ihr Verhältnis zur Antike," *Antike und Abendland*, III (1948), p. 120 ff.; R. Hamann-MacLean, "Antikenstudium in der Kunst des Mittelalters," *Marburger Jahrb. für Kunstwissenschaft*, XV (1949–50), p. 157 ff.

5 A. M. Ceriani and A. Ratti, *Homeri Iliadis Pictae Fragmenta Ambrosiana* (Milan, 1905).

6 R. Bianchi Bandinelli, *Hellenistic-Byzantine Miniatures of the Iliad (Ilias Ambrosiana)* (Olten, 1955). Previous bibliography on p. 169.

7 See the author's review of Bianchi Bandinelli, *Gnomon*, 29 (1957), p. 606 ff.

8 For the system of illustration in ancient rolls see K. Weitzmann, *Illustrations in Roll and Codex. A Study of the Origin and Method of Text Illustration* (Princeton, 1947), p. 42 ff. and *passim*; figs. 32–34.

9 Pict. XXIII, illustrating Il. V, 868 ff.

10 L. Matzulewitsch, *Byzantinische Antike* (Berlin, 1929), p. 54 ff. and pl. 35.

11 C. Meyer, *Ann. dell' Inst.*, VIII (1836), p. 22 ff.; *Mon. Ined.*, II (1835), pl. XXI.

12 R. Delbrueck, *Die Consulardiptychen und Verwandte Denkmäler* (Berlin, 1929), p. 235 ff., no. 62 and plate.

13 E. Babelon, *Le Trésor d'Argenterie de Berthouville* (Paris, 1916), p. 86 and pls. VII–VIII.

14 The shepherd in the upper right corner who appears from behind a groundline remains unexplained. He holds a pedum and makes a gesture of astonishment, seemingly because of the unjust verdict of Athena. He obviously does not come from another *Iliad* scene, but may be explained as Actaeon expressing astonishment over the beauty of Artemis bathing (cf. the Roman sarcophagus in the Louvre — C. Robert, *Die Antiken Sarkophag-Reliefs*, III, pt. I [Berlin, 1897], p. 3 and pl. I); K. Weitzmann, "The Origin of the Threnos," *De artibus opuscula XL: Essays in Honor of Erwin Panofsky* [2 vols., ed. Millard Meiss, New York; 1961, pp. 476–90].

15 Catalogue, exhibition *The Dark Ages* (Worcester, Mass., 1937), p. 34, note 72 with figure (here described as from Asia Minor. Parthian. A.D. I–II cent.): *Handbook of the Dumbarton Oaks Collection* (Washington, D.C., 1955), p. 54, no. 125 and figure on p. 59.

16 *Antioch-on-the-Orontes, II, The Excavations 1933–36* (Princeton, 1938), p. 182 and pl. 28, no. 39; D. Levi, *Antioch Mosaic Pavements*, I (Princeton, 1947), p. 282; II, pl. LXIVb.

17 K. Weitzmann, *Greek Mythology in Byzantine Art* (Princeton, 1951).

18 H. Omont, *Miniatures des plus anciens manuscrits grecs de la Bibliothèque Nationale du VIe au XIVe siècle*, 2nd ed. (Paris, 1929), p. 40 and pl. LXVIII, no 2.

19 A. V. Gentili, "I Mosaici della Villa Romana del Casale di Piazza Armerina," *Boll. d'Arte*, XXXVII (1952), p. 35 and pl. I a; B. Pace, *I Mosaici di Piazza Armerina* (Rome, 1955), p. 47 and fig. on p. 49.

20 K. Weitzmann, "Klassisches Erbe," p. 54 ff. and pl. VIII, 15–16. About the *Bibliotheke* as a source of Middle Byzantine miniatures see the author's *Greek Mythology*, p. 78 ff. and *passim*.

21 A. von Salis, "Die Gigantomachie am Schilde der Athena Parthenos," *Jahrb. d. Inst.*, 55 (1940), pp. 92, 112 and figs. 1–2.

22 C. J. Lamm, *Mittelalterliche Gläser und Steinschnittarbeiten aus dem Nahen Osten*, I (Berlin, 1930), p. 107; II, pl. 34, no. I (giving older bibliography).

23 I am much obliged to Mr. Lucas Benachi, the owner of the lamp, for kindly supplying me with the photograph and for permission to publish it. A publication of Mr. Benachi's collection of terracottas is being prepared by Prof. Kenneth R. Rowe of Leeds University.

24 Sami Gabra, *Annales du service des antiquités de l'Egypte*, XXXII (1932). The fresco is now in the Egyptian Museum in Cairo. *Idem, Rapport sur les fouilles d'Hermoupolis ouest (Touna el-Gebel)* (Cairo, 1941), p. 98 ff. and pl. XLVI.

25 P. Hartwig, *Die Griechischen Meisterschalen* (Stuttgart—Berlin, 1893), p. 664 ff. and pl. LXXIII.

26 A. Goldschimdt and K. Weitzmann, *Die Byzantinischen Elfenbeinskulpturen des X–XIII Jahrhunderts*, I (Berlin, 1930); K. Weitzmann, *Greek Mythology*, p. 152 ff. and pls. XLVI-LX.

27 Goldschmidt-Weitzmann, *op. cit.*, II (Berlin, 1934), p. 82, no. 236 and pls. LXXVI-LXXVII .

28 For similar figures see K. Weitzmann, *Greek Mythology*, p. 182 and pl. LVIII, nos. 242–244.

29 *Antioch-on-the-Orontes, III, The Excavations 1937–1939* (Princeton, 1941), p. 190, no. 136 and pl. 65; Levi, *Antioch Mos. Pav.*, I, p. 211; II, pl. XLVII b.

30 K. Weitzmann, *Greek Mythology*, p. 46 ff. and pl. XVI, no. 52.

31 As, e.g. Roman sarcophagi, Robert, *op. cit.*, pls. XVI, no. 54 and XVII, no. 55, and a lost fresco from the Domus Aurea, *ibidem*, pl. XVII, no. 56.

32 *Handbook, D. O. Coll.*, p. 54, no. 127 and figures on pp. 60–61.

33 L. Séchan, *Etudes sur la tragédie grecque* (Paris, 1926), p. 323 ff.; Robert, *Sarkophag-Reliefs*, III, 2 (Berlin, 1904), p. 169 ff. and pl. XLIV ff.; K. Weitzmann, "Euripides Scenes in Byzantine Art," *Hesperia*, XVIII (1949), p. 162 ff. and pls. 29, 15–30, 22.

34 Robert, *op. cit.*, III, 2, p. 178, no. 152 and pl. XLVII.

35 K. Weitzmann, *Antioch-on-the-Orontes*, III, p. 233, no. 140 B and pl. 67; Levi, *Antioch Mos. Pav.*, I, p. 71; II, pl. XI b.

36 A. L. Millin, *Description d'une mosaique antique du Musée Pio-Clementin à Rome, représentant des scènes de tragédies* (Paris, 1829); B. Nogara, *I mosaici antichi conservati nei Palazzi Pontifici del Vaticano e del Laterano* (Milan, 1910), p. 27 ff. and pls. LVI-LXVI; M. Bieber, *History of the Greek and Roman Theater* (Princeton, 1939), p. 404 ff. and fig. 530.

37 F. Ongania, *La Basilica di San Marco in Venezia* (Venice, 1880–1893), pl. XIX, no 4; S. Bettini, *Mosaici antichi di San Marco a Venezia* (Bergamo, 1944), pls. LXXXI-LXXXII.

38 J. J. Tikkanen, "Die Genesismosaiken von S. Marco in Venedig und ihr Verhältnis zu den Miniaturen der Cottonbibel," *Acta Societatis Scientiarum Fennicae*, 17 (Helsingfors, 1889).

39 K. Weitzmann, "Observations on the Cotton Genesis Fragments,'" *Late Classical and Mediaeval Studies in Honor of A. M. Friend, Jr.* (Princeton, 1955), p. 112 ff.

40 J. Strzygowski, *Koptische Kunst, Catalogue général du musée du Caire* (Vienna, 1904), p. 257 and pl. XXVI.

41 H. Stuart Jones, *Catalogue of the Sculptures of the Museo Capitolino* (Oxford, 1912), p. 45 and pl. 9.

42 K. Weitzmann, *Greek Mythology*, p. 165 f. and pl. LII, no. 209.

43 *Idem, Ancient Book Illumination* (Martin Classical Lectures, XVI) (Cambridge, Mass., 1959), p. 57 and pl. XXX, 66.

44 J. Lassus, "Les miniatures byzantines du Livre des Rois," *Mélanges d'archéologie et d'histoire*, XLV (1928), p. 38 ff.

45 K. Weitzmann, "The Psalter Vatopedi 761," *Journal Walters Art Gallery*, X (1947), p. 38ff.; *idem*, "Die Illustration der Septuaginta," *Münchner Jahrbuch der Bildenden Kunst*, III—IV (1952–53), p. 105ff.

46 Notably in the manuscript of the Homilies of Gregory of Nazianzus in Milan, Ambros. Lib. cod. E. 49 inf. (A. Grabar, *Les miniatures du Grégoire de Nazianze de l'Ambrosienne* [Paris, 1943]). Most typical is the illustration with Chronos wielding an enormous axe against a segment of sky, depicting in this naive manner the castration of Uranos (K. Weitzmann, *Greek Mythology*, p. 90 and pl. XXVIII, no. 98).

47 D. Comparetti, *Homeri Ilias cum scholiis, Codex Venetus A, Marcianus 454* (Leiden, 1901 [facsim.]).

48 O. Jahn, *Griechische Bilderchroniken* (Bonn, 1873), p. 4, 10, no. 2 and pl. III C; K. Weitzmann, *Roll and Codex*, p. 39 and fig. 30.

49 Jahn, *op. cit.*, p. 2, 10, no. 3 and pl. I (top frieze); K. Weitzmann, *op. cit.*, p. 39 and fig. 31.

50 Biblioteca Nacional cod. 5–3 N-2. G. Millet, *La Collection Chrétienne et Byzantine des Hautes Etudes* (1903), p. 26, nos. 369–375; p. 54, no. C 869–1277; G. Schlumberger, *L'épopée byzantine*, II and III (Paris, 1900–1905), *passim*; etc.

51 E. Panofsky and F. Saxl, *loc. cit.* Most recently J. Weitzmann-Fiedler, "Romanische Bronzeschalen mit mythologischen Darstellungen," *Zeitschrift für Kunstwissenschaft*, X (1956), p. 109ff.; XI (1956), p. Iff.

52 Concerning illustrations on papyrus see K. Weitzmann, *Roll and Codex*, p 47ff. and figs. 35–43; R. Bianchi Bandinelli, "Schemi iconografici nelle miniature dell'Iliade Ambrosiana," *Rend. Accad. Naz. Lincei. Cl. Scienze mor., stor. e filol.*, ser. VIII, vol. VI (1952), p. 430, note I; *idem, Hellenistic-Byzantine Miniatures of the Iliad* (Olten, 1955), p. 27 and *passim*; Weitzmann, *Ancient Book Illumination*, p. 5ff. and *passim* and figs. 1, 2, 10, 11, 37, 59, 72, 107, 117, 135, 136.

53 K. Weitzmann, *The Joshua Roll* (Princeton, 1948), pp. 6, 31ff.

54 K. Weitzmann in: *The Oxyrhynchus Papyri*, XXII (Oxford, 1954), p. 85, no. 2331 and pl. XI; *idem*, "Narration in Ancient Art," *Amer. Jour. Arch.*, LXI (1957), p. 84 and pl. 33, no. I; *idem, Ancient Book Illumination*, p. 53 and fig. 59.

55 W. F. Volbach, *Elfenbeinarbeiten der Spätantike und des Frühen Mittelalters* (Mainz, 1952), p. 77, no. 162 and pl. 53; G. Bovini and L. B. Ottolenghi, *Catalogo della Mostra degli Avori*, 2nd ed. (Ravenna, 1956), p. 45, no. 33 and figs. 47–50.

56 E. Brunn, *I Rilievi delle Urne Etrusche*, I (Rome, 1870), p. 34 and pl. XXVIII, no. 6; K. Weitzmann, *Roll and Codex*, p. 175 and fig. 175, where it is compared with a miniature of the sacrifice of Isaac in the well-known Gregory manuscript in Paris, cod. gr. 510 (*ibid.*, fig. 173).

57 For the distinction between the "theater style" and the "epic-heroic" style see Weitzmann, *Ancient Book Illumination*, p. 73ff.

58 Volbach, *Elfenbeinarbeiten*, p. 79, no. 168 and pl. 54; *Handbook, D. O. Coll.*, p. 104, no. 227 and figure on p. 117.

59 Volbach, *op. cit.*, p. 86, no. 190 and pl. 57.

60 The fact that it is held by a king in this fashion excludes its interpretation as a *skytale*, which one would expect to find only in the hands of a messenger (See Th. Birt, *Die Buchrolle in der Kunst* [Leipzig, 1907], p. 271ff.).

61 From the Campana collection.

62 E. R. Goodenough, *Jewish Symbols in the Greco-Roman Period*, I (New York, 1953), p. 3ff., and in subsequent vols.; C. H. Kraeling, *The Synagogue, The Excavations at Dura-Europos. Final Report VIII, Part I* (New Haven, 1956), p. 398ff.; K. Weitzmann, "Illustr. der Septuaginta," p. 116ff. and figs 24–26; *idem*, "Narration in Ancient Art," p. 89ff. and pl. 36, nos. 14–17; C. O. Nordström, "Some Jewish Legends in Byzantine Art," *Byzantion*, XXV–XXVII (1955–57), p. 487ff.

63 St. Beissel, *Geschichte der Evangelienbücher* (Freiburg, 1906), p. 84ff. and fig. 19.

64 A. Boinet, *La miniature carolingienne* (Paris, 1913), pls. I–II; W. Koehler "Die Denkmäler der Karolingischen Kunst in Belgien," *Belgische Kunstdenkmäler*, I (Munich, 1923), p. 4.

65 A. Boeckler, "Bildvorlagen der Reichenau," *Zeitschrift für Kunstgeschichte*, XII (1949), p. 13 (here still wavering between a Carolingian and Ottonian origin); *idem, Ars Sacra, Kunst des frühen Mittelalters* (Exhib., Munich, 1950), p. 28, no. 58.

66 E. B. Smith, *Early Christian Iconography* (Princeton, 1918), p. 62ff. Whether his "smashing type" is "Provençal" in origin as he suggests may be doubted.

67 Hesiod, *The Homeric Hymns and Homerica*, ed. H. G. Evelyn-White (Loeb Class., 1936), pp. 518–9.

68 J. Overbeck, *Die Bildwerke zum Thebischen und Troischen Heldenkreis* (Stuttgart, 1857), pl. XXV, no. 22.

69 Jahn, *Bilderchroniken*, p.33, no. 66 and pl. I.

70 Cf. note 63.

71 K. Weitzmann, "Das Evangelion im Skevophylakion zu Lawra," *Seminarium Kondakovianum,* VIII (1936), p. 88 and pl. II, no. I; pl. IV, no. 3.

72 Goldschmidt-Weitzmann, *Byzant. Elfenbeinskulpt.,* II, p. 30, no. 24 and pl. VII, 24 a.

73 G. and M. Sotiriou, *Icones du Mont Sinai,* Plates (Athens, 1956), pls. 10–11; *idem,* Text (1958), p. 25.

74 A. Grabar, *Ampoules de Terre Sainte* (Paris, 1958), p. 17 and pl. III.

75 H. Grisar, *Die Römische Kapelle Sancta Sanctorum und ihr Schatz* (Freiburg, 1908), p. 113ff. and fig. 59; C. R. Morey, "The Painted Panel from the Sancta Sanctorum," *Festschrift Paul Clemen* (Düsseldorf, 1926), p. 151ff.

76 Golschmidt-Weitzmann, *op. cit.,* I, pl. IX, 21 a; K. Weitzmann, *Greek Mythology,* p. 180 and pl. LVII, no. 232.

77 Volbach, *Elfenbeinarbeiten,* p. 53, no. 98 and pl. 29; Bovini-Ottolenghi, *Catal. Mostra Avori,* p. 51, no. 42 and figs. 67–70.

78 E. Löwy, "Der Schluss der Iphigenie in Aulis," *Jahresh. d. Österr. Arch. Inst.,* XXIV (1929), pl. 1 and figs. 2, 10–13; K. Weitzmann, "Euripides Scenes," p. 180 and pls. 27, 9–28, II.

79 Goldschmidt-Weitzmann, *op. cit.,* I, pl. IX, 21 b; K. Weitzmann, "Euripides Scenes," p. 177 and pl. 27, 7; *idem, Greek Mythology,* p. 169 and pl. LIV, no. 214.

80 Goldschmidt-Weitzmann, *op. cit.,* II, p. 27, no. 10 and pl. III, 10.

81 J. Wilpert, *Die Römischen Mosaiken und Malereien,* II (Freiburg, 1916), p. 722ff., and IV, pl. 199.

82 O. Demus, "An unknown mosaic Icon of the Palaeologan Epoch," *Byzantina-Metabyzantina,* I (1946), p. 108.

83 This group was called to my attention by Prof. P. von Blanckenhagen whom I wish to thank for this and other valuable suggestions made when discussing this paper.

84 W. Klein, "Studien zum Antiken Rokoko," *Jahresh. d. Österr. Arch. Inst.,* XIX–XX (1919), p. 260ff. and fig. 178; L. Laurenzi, "Problemi della scultura ellenistica," *Riv. dell'Ist. d' Arch. e Storia dell' Arte,* VIII (1940), p. 36 and fig. 9.

85 M. Bieber, *The Sculpture of the Hellenistic Age* (New York, 1955), p. 147 and fig. 628.

86 P. Herrmann, *Denkmäler der Malerei des Altertums* (Munich, 1904–31), p. 110, fig. 29 and pl. 87.

87 Demus, *op. cit.; Handbook, D. O. Coll.,* p. 147, no. 290 and figure on p. 151.

88 Omont, *Miniatures,* p. 6 and pl. I.

89 Herrmann, *Denkmäler Mal.,* p. 67 and pl. 53; K. Weitzmann, "Der Pariser Psalter ms. grec. 139 und die Mittelbyzantinische Renaissance," *Jahrb. für Kunstwissenschaft* (1929), p. 178 ff. and pl. I, fig. 2.

90 H. Buchthal, *The Miniatures of the Paris Psalter* (London, 1938), p. 13ff. and pl. 1.

91 *Antioch-on-the-Orontes, III,* p. 189, no. 135 E and pl. 64; Levi, *Antioch Mos. Pav.,* I, p. 210; II, pl. XLVI a.

92 Robert, *Sarcophag Reliefs,* II, p. 17, with fig.

8 The Dome of Heaven

KARL LEHMANN [1]

The son of a professor of law at the University of Rostock, Germany, Karl Lehmann (1894–1960) studied Classical archaeology and civilization at the universities of Tübingen, Göttingen, Munich, and Berlin, and in 1922 received his doctorate from the University of Berlin, where he was a student of the Classical archaeologist Ferdinand Noack (1865–1931). By this time he had published half a dozen papers and had served during World War I as interpreter to the Turkish naval command at Istanbul, where, in addition to devising secret codes, he was able to undertake research and travel in Asia Minor. After receiving his Ph.D., he became a member of the German Archaeological Institute at Athens and Rome and taught at the universities of Berlin and Heidelberg. In 1929, he was appointed to the chair of Classical archaeology and the directorship of the museum at the University of Münster. In 1933, he left Germany because of Hitler and went to Italy, and in 1935 he joined the faculty of the Institute of Fine Arts of New York University as professor of ancient art and archaeology. From 1938 until his death in 1960, he conducted excavations of the Sanctuary of Great Gods at Samothrace under the auspices of the Institute of Fine Arts, in collaboration with the American School of Classical Studies at Athens. So ingenious were his excavations and so rich his findings that he was created a Knight Commander of the Royal Greek Order of the Phoenix in 1951.

Lehmann's impressive bibliography, conveniently listed in *Essays in Memory of Karl Lehmann,* ed. Lucy Freeman Sandler (New York, 1964), points to a scholar passionately interested not only in the entire field of Classical art and civilization but also in the problem of the survival or revival of antiquity in Western art, as well as the history of ideas. When only 32 years old, he published the fundamental two-volume monograph on the Column of Trajan in Rome (Berlin and Leipzig, 1926), and when 33, an indispensable three-volume study of monumental bronze statues of antiquity (Berlin and Leipzig, 1927). He also wrote books on the ancient ports of the Mediterranean (Leipzig, 1923), Pompeian architecture (Berlin and Leipzig, 1936), the archaeological significance of the letters of Pliny the Younger (Florence, 1936), Dionysiac sarcophagi (Baltimore, 1942), and even Thomas Jefferson (New York, 1947), as well as a plethora of papers dealing with, among other subjects, the ancient Greek theater (1927 and 1928), a remarkable interpretation of the meaning of the Arch of Titus (1934), the *Imagines,* or descriptions of paintings, by the Elder Philostratus (in *Art Bulletin* XXIII [1941], pp. 16–44), and the mausoleum of Santa Costanza (1955), as well as the brilliant paper "The Dome of Heaven" (1945), republished here, which traces the evolution of the dome and its decoration from antiquity to the beginning of the modern era (cf. Alexander C. Soper, "The 'Dome of Heaven' in Asia," *Art Bulletin* XXIX [1947], pp. 225–48). These contributions to humanistic studies reveal an exceptionally creative archaeologist and art historian of profound and universal learning, graced with the utmost respect for fact and impeccable scholarship. At the Institute of Fine Arts, this inspired and inspiring teacher and lecturer attracted a large number of students, many of whom are now young scholars in their own right making important contributions to Classical archaeology and ancient art history.

[1] Notes to this selection begin on page 257.
Reprinted with the permission of Mrs. Lehmann from *Art Bulletin* XXVII (1945), pp. 1–27.

Lehmann taught his students not to pursue a single methodology, perpetuate a "school of thought," or construct theories, but to examine rigorously historical data and stylistic phenomena and to interpret them imaginatively in accordance with an uncompromising integrity of scholarship. Frederick Hartt wrote:

The doctrine and the influence of Karl Lehmann transcended the immediate limits of his courses and his writings. In his lectures he presented in brilliant detail the complex drama of interacting forces that characterized the artistic civilizations of ancient Greece and Rome. Yet from this kaleidoscopic spectacle there emerged imperceptible in the mind and memory of the student a sense of the enduring structure of classical humanistic values on which subsequent cultural achievements have largely been based. [*Essays in Memory of Karl Lehmann,* ed. Lucy Freeman Sandler, New York, 1964, p. 114]

"*Haec, Auguste, tamen, quae vertice sidera pulsat, par domus est caelo sed minor est domino.*

Martial, *Epigr.*, VIII, 36, 11–12.

" 'Ο δὲ οὐρανός μοι Θρόνος, ἡ δὲ γῆ ὑποπόδιον τῶν πόδων μου λέγει Κύριος Παντοκράτωρ."

Inscription surrounding the bust of Christ in the dome of the Palatine Chapel, Palermo.

One of the fundamental artistic expressions of Christian thought and emotion is the vision of heaven depicted in painting or mosaic on domes, apsidal half-domes, and related vaulted forms. It is the culminating theme of the theological decoration of religious buildings from the beginnings of ecclesiastical art in the age of Constantine the Great throughout the entire development of Byzantine art. It survives in numerous varieties in the Western religious art of mediaeval, Renaissance, and Baroque periods. Michelangelo's ceiling in the Sistine Chapel and many ingenious contemporary and later ceiling decorations transfer this Early Christian and Byzantine scheme into the world of modern speculation and emotion; as Milton likewise achieved the great transposition of mediaeval cosmology into modern thought.[2] Though the idea of interpreting the ceiling as the sky may be the result of a general and not unnatural association and though it also found expression outside the sphere of Western art,[3] the specific forms and the systematic approach of Christian monumental art far transcend such general associations. In all their specialized varieties and applications, the Early Christian patterns of heaven on vaults and ceilings are united by a common systematic, centralized and organized approach, an approach which is cosmic in the triple sense of the Greek meaning of this term: it combines decorative ideals of formal beauty with an order of speculative reasoning and the concept of a permanently established world.

The problem of the origin of these schemes is of the utmost importance in view of their preëminence in Christian monumental art and of their intimate connection with the development of the architectural form of the dome which ultimately became their ideal field of crystallization. In spite of the fact that this is obviously so, no serious effort seems to have been made to clarify the question whether this vision of heaven is a new and unprecedented expression of Christian faith or whether, in its specific forms, it is an offshoot and descendant of pre-Christian pagan types.[4] Inasmuch as the latter is true of almost every other fundamental feature of Christian monumental art, one might a priori assume a similar relationship in this instance. It is the purpose of the following discussion to establish and clarify the antique background of the Christian vision of heaven in the dome and to discuss some problems of the iconography, decorative system, development, and symbolism of domed construction in antique and late antique art.

Let us begin with a superficial formal comparison of two examples of Christian and pagan ceiling decoration widely separated in chronology, function and spirit. The eastern dome of San Marco in Venice,[5] an outstanding work of late Byzantine art based on a long and unbroken tradition handed down from Early Christian times, may serve as a starting point (Fig. 1).* In the center, a bust of the Savior emerges from the starry sphere of heaven which is framed by an iris border. Around it and above the windows, on the symbolically celestial golden ground, appear the saintly figures of the Virgin and prophets. Floral motifs fill the spaces between the windows, whose frames and arches are decorated with additional floral and starry ornaments. In the four pendentives the symbols of the Evangelists with outstretched wings emerge from the clouds of the lower atmosphere; the clouds rest upon floral forms which fill the lower corners. As the Latin inscription explains, the Evangelists are entrusted with conveying the meaning of otherwise obscure divine truth to the mortal world below: they support by written tradition the truth which was forecast by the prophets represented above, and which manifests itself in the summit with the presence of the Cosmokrator in the celestial orb.[6]

At first sight a comparison of this great and elaborate theological picture with an Italian ceiling which is 1700 years older will undoubtedly seem fantastic and far-fetched to the reader. We may nevertheless ask his indulgence, so that it may serve as a point of departure. A single square coffer in the center of a flat, rock-hewn ceiling in the rear chamber of an archaic Etruscan tomb, the Tomb of the Monkey in Chiusi (early fifth century B.C.), shows an unusual painted decoration (Fig. 2): in each of the four corners a diagonally placed Siren supports the rounded central motif.[7] This is a disk painted red[8] and dec-

orated with a green foliate pattern. It is framed by a double border, of which the outer edge is scalloped. At first the analogy between the two monuments seems to be purely formal and restricted to the combination of a central dominating circle and diagonal winged corner supports. Even so, we may face here the beginning and end of the formal development of a pattern. But this formal analogy becomes more substantial if one investigates the meaning of the motif in the Etruscan tomb painting. In this connection, the editor of the fresco mentioned the funereal significance of the Sirens, as the soul-birds of Greek and Etruscan art. But that relationship is not sufficient to explain their subordinate rôle as supports of a great round central motif. The carpet-like motif with its fringed border is a kind of baldachin which the Sirens carry. It is a canopy, rendered in the plane projection of archaic art. In view of our preliminary comparison, we may suggest that it is the canopy of heaven.[9] Such a suggestion, however, would remain hazardous unless we could prove three facts: first, that in early Etruscan art the Sirens were connected with the celestial sphere; second, that Sirens and related winged figures continued to be used in a similar diagonal position as the supports of a central celestial representation on ceilings; third, that the canopy as a symbol of heaven was also a common central element in the decoration of ancient ceilings.

In reality, all three of these facts can be illustrated by extant monuments. A few of them may be presented in this initial stage of our investigation in order to clarify the direction to be followed later. As to the celestial affiliation of the Sirens, we possess an extremely interesting Etruscan artifact which is considerably earlier than our fresco, a heavily decorated gold bracelet from Tarquinia (Fig. 4).[10] Its astrological and apotropaic character is obvious. At one end we see the sun-disk with a

* Illustrations accompanying this selection appear on pages 483 to 492.

rayed star in the center and beneath it a crescent moon. Its center is supported by two laterally seated bearded male demons. Nearer the center of the bracelet the crescent moon appears again several times, and its curve is each time filled with a Siren of exactly the same type as we have seen on the painted ceiling. Within the context of Etruscan astrological speculation which was derived from Mesopotamia, it is not surprising to find demons of Eastern origin associated with the heavenly bodies. We need not pursue this line further. It suffices to state that the Sirens were known in archaic Etruria as heavenly demons of astrological character. Whence and how this idea was included in the realm of funereal speculations[11] is not our concern. But it may be noted that not only the type of sun-disk on the bracelet, but also the demons supporting it and the figure in the moon are of oriental origin: the leaf pattern with a center of concave arches which decorates the central circle on the ceiling was also derived from Near Eastern tradition. Together with definite star forms, it occurs in Assyrian art in the embroidered decoration of the garment of the heavenly god Marduk.[12]

Our second requirement was to prove the persistence of Sirens or similar winged figures as diagonal corner supports in representations of the sphere of heaven. Here we are able to point to a lucid discussion of the ceiling decoration of the southern adytum of Bel in his temple in Palmyra (Fig. 3).[13] This decoration can be dated about the beginning of our era. Thus it stands halfway between our Etruscan painting and the great age of Early Christian art. It shows a central square field filled by a circle. The circular center is hollowed out from the monolith to form a flat dome. This dome is filled with a carpet-like geometrical pattern of relief fields which show the busts of the seven planets; the central one, Bel-Jupiter, dominates the composition as does the bust of the Panto-

krator in Venice, with subordinate heavenly figures radiating from him. The ruling heavenly bodies in the dome are framed by the circle of the zodiac on the outer fringe of heaven. Finally, the four corners of the heavenly circle are supported by diagonally placed Sirens. L. Curtius, who thought this element was unique, pointed out its relationship to Plato's vision of the music of the heavenly spheres produced by the Sirens (Pol. x, 114, 2; 616 A f.) and to a Pythagorean background.[14] It is evident that the originally Eastern idea of the Sirens as heavenly demons influenced the representations of the ceilings in Chiusi and Palmyra before and after Plato, as it also inspired Plato's own vision. But it is also significant that many centuries later, in the same church of San Marco, where we saw a cupola with supporting symbols of the Evangelists, their images appear in another mosaic (over the entrance door), accompanied by an inscription which attests their succession to the Platonic musicians of the spheres: "*Ecclesiae Christi / vigiles sunt quattuor isti, / quorum dulce melos / sonat et movet unique caelos.*"[15]

We may now move another step forward and glance at a lost ceiling decoration (probably in stucco) from the Villa of Hadrian (Fig. 5).[16] Chronologically it stands halfway between the ceiling of Palmyra and the age of Constantine. In the center of the vault, the globe of the firmament with the stars and the belt of the zodiac may be taken as the forerunner of the heavenly sphere in the center of the cupola of San Marco and numerous earlier Byzantine examples. This sphere has a strange curved fringe, which reminds us of the outer edge of the canopy of heaven in the fresco from Chiusi. It is supported by four dancing children, who circle in rhythmical musical movements.[17] This theme occupies the center of what is clearly a tent-like *velum* or canopy, with concave edges between

eight projecting corners. The surface of this carpet is, so to speak, embroidered with an inner square from the corners of which another carpet-like form with four concave sides emerges. Every space of this carpet is filled with scrolls and figures which we may leave aside for the moment. What matters to us at this point is the fact that the four corners of the big central carpet are diagonally supported by "grottesque" structures; they arise from acanthus motifs filling the lower corners, like those of the pendentives of San Marco. These supporting tabernacles are flanked by two herms of Pan, the great god of nature. Between these herms "Giants" terminating in snakes, or earth-bound creatures, support a central floral "candelabrum" beneath a floral arch. From this arch the four actual corner supports of the central canopy emerge. They are four winged female demons, and if they are not actually our Sirens, they are at least closely related to them in form and meaning. Undoubtedly, these demons are successors of the Sirens supporting the corners of the carpet or the dome of heaven which we saw in the ceilings of Chiusi and Palmyra. Leaving other elements aside for the time being, we may call attention to the fact that other radial figures of the celestial world appear between floral decorations near the outer fringe of the ceiling, like the saintly figures of the cupola of San Marco. They are a chorus of eight dancing maidens, most likely Horae (of the Hours). Alternating with them we see four divine figures: Jupiter, Mars, Venus and (probably) Leda-Luna[18] the four planets who command time and destiny and whose images we met in busts around the time-less and eternal Bel-Jupiter in the Palmyra ceiling.

These general comparisons between monuments of four such different periods as the early Etruscan, the early Imperial, the middle Imperial, and the Byzantine, may justify our attempt to clarify the pagan background of the Christian vision of the Dome of Heaven.

I

The image of heaven which we discuss here is comprehensive in character; it exceeds ornamental allusion to the sky. It is therefore unnecessary to discuss the possible truth of old theories that all ceiling decorations are ultimately based on such allusions, or to assemble the evidence for starry decorations of Greek coffered ceilings and their later descendants, or to appreciate the degree to which these ornaments, from the Mycenaean cupola tombs on, reveal an awareness of their ultimate implication. Our concern is with the origin and development of a symbolism of heaven on the ceiling, which is expanded to an actual cosmological image, whether it be rationally descriptive, emotionally visionary, or both. Such a vision may occupy part of a ceiling or its entirety. It may be coherent and "exact" or it may be loosely dispersed within a decorative system. It may be confined to one or more elements which are emphasized; or it may aim at "completeness." It can and does select figures of divinities and demons which rule the world, or symbols of heavenly bodies, or a mixture of both. It may use illusionistic images or it may appeal to the reasonable process of "reading" the meaning of abstract symbols; or it may combine both these approaches. In any case, the Christian vision of heaven on the ceiling is based on the practice of decorating ceilings with figured painting, or later, in stucco, stone relief, or mosaic.

Evidence for this practice is entirely lacking in Greece in the earlier periods. The prevailing use of the structural coffered ceiling in monumental Greek architecture was not favorable to it. On the other hand, there is a valuable piece of information in Pliny's account of the history of painting. He says that Pausias was the first to paint flat ceilings and that before his time it was not customary to have

painted decorative vaults (xxxv, 124).[19] This information, pointing as it does to a coherent tradition of Greek painted ceiling decoration from the beginning of the Hellenistic age, corresponds to what we know of the monuments. The earliest example of a painted figure on a Greek ceiling is found in a tomb in Southern Russia about the end of the fourth century B.C.[20] It shows a bust of Demeter or Kore in a coffer against a background of blue sky, as if it were an opening in the roof. The position in the center of the ceiling, the use of a bust and of the sky motif, all reveal the origin of many later antique pagan and Christian visions in Greek art of the time of Alexander the Great (Fig. 6). On the other hand, the previously discussed ceiling of the Tomb of the Monkey in Chiusi (Fig. 2) shows that such a practice was already known in Etruria one hundred and fifty years before the initial Greek attempts to use the ceiling for this purpose. The fact that the decoration of coffers with divine heads also occurs in later Etruscan relief ceilings[21] suggests that the relatively late Greek usage may have been derived from Etruria via Southern Italy. But at the present stage of our knowledge any such explanation is hazardous. We also do not know how often figured ceiling decoration was used during the Hellenistic age either in the Greek East or in the Italo-Greek West. For the time being, the evidence from tombs[22] in both regions is not sufficient; evidence from houses and monumental buildings is entirely lacking. It is also impossible to decide whether either of the two schemes of the pre-Roman period is the result of earlier Eastern prototypes. But the representation of a bust[23] and the more comprehensive appearance of the round heavens (Figs. 6, 2) are two basic forms, developed separately in the pre-Imperial World.

We have already observed a synthesis of these two forms in the early Imperial ceiling from Palmyra (Fig. 3). Here, the round canopy of heaven supported by corner Sirens has been filled with busts which are inserted in the coffers. These divine busts represent the planets, and in their entirety they indicate one great sphere of heaven with a Pantokrator-leader in the center. This very expansion of the bust motif not only creates a new and durable type, but it has an astrological, "scientific" nature. The astrological inspiration is further emphasized by the zodiacal frame for this carpet of the planets. Later we shall discuss the literary evidence for the background of this new astrological image of the sky in Republican Rome.[24] Fortunately, we possess a precious document for another, possibly slightly earlier variety than the ceiling from Palmyra. This is the famous pre-Neronian relief ceiling from the cella of the temple in Dendera (Fig. 7).[25] Though this ceiling contains a detailed description of heaven which combines Egyptian with Babylonian and Hellenistic Greek symbols, and though its formal language is Neo-Egyptian, it has no relation to Egyptian tradition. Its comprehensive and scientific astrological approach and its formal arrangement vary. The former is intimately related to the Hellenistic-Roman astronomical and astrological description of planispheres in books and on stones;[26] the type of the canopy of heaven supported by four diagonal corner figures is derived from the old tradition, exemplified in the Tomb of the Monkey. Here, the corner supports are four women. Between the corner supports four kneeling demons lend their assistance. It should also be noted that this scheme includes the representation of the signs of the zodiac as well as those of the Dodekaoros, or stars of the Hours.[27] The comprehensive picture of the Dendera ceiling is richer and more detailed than that from Palmyra. This is primarily the result of a more elaborate description of astral phenomena, in addition to an increase in the number of supporting elements. The emphasis rests upon the "scientific" description which has been fitted

into an available symbolical pattern. On another Egyptian ceiling from a tomb in Athribis,[28] also of Roman date, we see the exclusively descriptive use of scattered star symbols, without relation to another scheme. Hence the ceiling of Dendera is a mixture of an astrological map with the old ceiling symbol of the round heavens supported by diagonal corner figures. The Palmyra ceiling, on the other hand, reveals a synthesis of three originally separate traditions, in its combination of the rounded form of the sky with heavenly figures and the astronomical description. This synthesis is later modified and elaborated in various directions.

L. Curtius has already compared a later mosaic floor from Zaghouan in Tunisia (Fig. 9) with the Palmyra ceiling.[29] As he has stated, a persistent interrelationship exists between ceilings and floor decorations. In most cases, we see projected upon floors the schemes which were originally developed on ceilings. Sometimes, and as early as the first century B.C., we meet a direct representation of a ceiling on a floor,[30] as if it were reflected in a mirror. We shall meet further examples of this relationship, which adds important evidence to that derived from the scantily preserved ancient ceilings and vaults. In the case of the mosaic from Zaghouan, the connection with a ceiling of the Palmyra type is evident. We find the same arrangement of the busts of the planets, with the exception of Saturn, who here replaces Jupiter the Pantokrator. We also find the outer frame of the zodiac. But here it has been assimilated to the coffer scheme of decoration: the systematic description of the planisphere type has been sacrificed to the tendency of individual representation in framed units. A third ring of panels with animals has been inserted between the zodiac and the planets. As Curtius has pointed out, they are the sacred animals of the six outer planets. Yet we may conclude that their presence in this place is derived from the plani-

sphere representation of the various animals of the Dodekaoros which we met in the ceiling from Dendera, and which occurs in other planispheres at the same place.[31] In other words, this floor reflects a ceiling based on two traditions: the coffered ceiling with busts, and the astronomical description. It lacks the third compound, the comprehensive symbol of the round heavens. In this case, the coffer-bust type has imposed its law on the arrangement of all the descriptive astronomical elements, and as it were, it has dissected and subordinated them.

These observations may help us to understand the peculiar character of a grandiose floor mosaic from a villa in the Alban Hills. In view of its style it can be dated about the middle of the first century A.D. (Fig. 8).[32] It clearly reflects a ceiling decoration of the basic type of the round sky supported by four diagonal corner figures, in this case nude dancing boys. The circle is a richly framed carpet. Its inner ring shows the globes of the sun and moon with interspersed stars on a blue ground. The sun and moon are repeated in various phases,[33] positions and degrees of visibility. Framed by these moving and changing heavenly bodies of astronomical description, the bust of Minerva appears on a purple ground in the inner round disk which is to be interpreted as the ethereal sphere. She is here the Pantokrator, the supreme essence. Her nature as ruler of the sky is indicated by her stormy appearance and windswept aegis. Though the type is basically a combination of the same three roots which were already combined in the Palmyra ceiling, several themes are new and remarkably important for future development. In the first place, the element of time has been introduced everywhere: it manifests itself in the dancing and rotating figures of the corner supports as well as in the descriptive succession of the phases of sun and moon, and it culminates in the stormy image of the goddess. Secondly, the Pantokrator is here not a

well established heavenly body like Jupiter or Saturn. Because of a peculiar speculative revelation, another deity has here been appointed to the supreme rôle, as will happen later to Christ. It is evident that this substitution reflects a new religious unrest and search for all-powerful divinities: precisely in the case of Minerva, it manifests itself in the next generation in her exaggerated worship by Domitian. This unrest relates to the dynamic artistic experience which created the fourth Pompeian style with its miraculous visionary appearance of flying figures on walls, in unexpected openings, and on ceilings. Flying figures occur on ceilings as early as the Julio-Claudian age, as in the stucco reliefs of the basilica near Porta Maggiore.[34] The motif of the illusionistic opening in the ceiling appears in the center of the vault of the Arch of the Sergii in Pola, where an eagle carries a snake to heaven.[35] We see the increasing intensity of such illusionistic visions in several ceilings of the Golden House of Nero to which we shall return later.[36] And this development culminates in the *Apotheosis of Titus* in an illusionistic opening of the vault, where he appears as a new star and is obliquely carried up to heaven.[37] With this background in mind we can understand the character of the Vatican mosaic.

Since the ceiling decorations of this period in painting, stucco, and mosaic are lost, with few exceptions, this floor is of great importance. It marks considerable progress in the direction of late antique artistic experience. Additional evidence for celestial cupola decoration in this age will be submitted later. Unfortunately, it does not help us to trace the typological and artistic development in detail. But we do possess in faithful eighteenth-century reproductions two celestial ceilings, probably in stucco, from the Villa of Hadrian.[38] We may trust the usually reliable etcher Ponce, to whom we owe these etchings, for he can hardly have been aware of the importance of what he reproduced. These two ceilings illustrate the culmination of the development which we have traced, toward a fusion of the symbolical elements of heaven with astrological description and the representation of divinities. They are, also, the most comprehensive documents of celestial speculation known to us from ancient art. Strangely enough, they do not seem to have been analyzed or discussed by modern scholars.

The main features of one of these ceilings (Fig. 5) have already been mentioned. We see a mixture of the three traditions: the carpet of heaven with its diagonal supports; the appearance of heavenly divinities; and astrologically descriptive elements. But all these are elaborated in a playful way, in repetitions and insertions and in the "grottesque" manner of the preceding fourth style with its mixture of abstract ornament and visionary illusion. For the first time the central globe with stars appears on a ceiling as an illusionistic body. It is supported by the same four youthful dancers whom we met in the Vatican mosaic. This central motif thus represents a mixture of the tradition of the round heavens with diagonal corner supports and the astronomical description— this time in the form of a globe instead of a planisphere—of which the fringed edge, however, reveals its derivation from the old canopy (cf. Fig. 2). The richly embroidered carpet around it has the form of an octagon with concave sides. Its scrollwork and figures of putti and heraldic goats may be purely decorative. This is less likely for the four female figures in mandorla frames; they clearly appear in four different degrees of clothing ranging from nudity to complete dress. Evidently they allude to the changing seasons. The diagonal corner supports with their combination of the herms of Pan the great god of nature, with the giants of the earth below and the celestial Sirens above have already been discussed. The fact that the supports pierce the airy space is indicated by birds and hanging garlands. The cof-

fered ceiling has been reduced to a remnant in an outer frame through which the appearance of the cosmic structure is seen. Above it, eight dancing girls move in a chorus united by garlands connecting them with the celestial carpet. Between them sit four figures—not simply busts—of the planetary gods Jupiter, Mars, Venus and Luna.[39]

In the second ceiling (Fig. 10) we see a similar mixture of an even more comprehensive and systematic character.[40] The central motif is the heavenly circle with diagonal corner supports in a large square. The circle is filled with Jupiter or Sol as the Pantokrator on a quadriga. The corner supports seem to be the herms of Pan encountered in the preceding ceiling. Around this central motif and separated from it are the twelve signs of the zodiac, as in the mosaic from Zaghouan, broken up into individual units in remnants of coffer fields, three in each corner. This division seems to be related to the appearance of four winged angel-like figures who blow trumpets and stand on globes. Ponce has included even the detail that the globes differ in size: this evidently symbolizes the changing phases of the sun[41] and it seems clear that we have here four seasonal divinities or personifications, who separate the quarters of the year, each of which is characterized by three signs of the zodiac. The small fields in the inner square are filled with eight oval and rectangular panels; each bears the picture of an animal. These animals constitute an unusual group: one recognizes a snake, a bug, a mouse and a bird in the outer circle. They seem to be the scattered remnants of a cycle of the Dodekaoros.[42] The inner animals may refer to other stars. An outer frame around the large square includes floral patterns, griffins and tigers, which may be purely decorative or may allude to a connection between Bacchic creeds and astral religion.[43] The twelve nude dancing maidens tempt us to recognize the twelve hours of the day.[44]

These two ceilings reveal several points, intellectual as well as formal, which are generally important to the development of our theme. In respect to content they show a systematic fusion of religious figures and cosmological speculation in a predominantly astrological sense. The sphere of heaven and the Pantokrator are the central figures of these symphonic visions of a universe which, in various subordinate astral and mythological figures, alludes to the eternal creative power of nature and to ever moving time. Artistic speculation could move in various directions from this point: it could expand into a kind of astronomical calendar or astrological horoscope, or into a representation of the religious order of the world of time and space as governed by heavenly persons and expressed in their sacred hierarchy. Both developments actually took place in the late antique world, and, together with revivals of the earlier simpler and more unified types, their tendencies define the variety of later formulae. A comparison of these two ceilings with earlier tradition reveals a tendency toward centralization in two sharply contrasting schemes: in the first ceiling (Fig. 5) this centralization has been achieved by an emphasis on the diagonal supporting elements which produces a simple star pattern; the second ceiling shows a basically concentric scheme in which the diagonals are suppressed and instead, the distribution of figures and ornamental units emphasizes a central cross parallel to the sides. These varieties of an increasing centralization are of course part of a general decorative development which cannot be discussed here. But inasmuch as these tendencies are connected with the ideological trend discussed above, it should be noted that the phase which we meet here, complicated as it is, opens the way in various directions: either toward an increasing emphasis on the cross-pattern, be it diagonal or vertical-horizontal, or toward a pattern of radiating figures or decorative

units, or, finally, toward a combination of concentric rings. These tendencies are recognizable in changing combinations with ever increasing centralization during the later second and third centuries A.D., as we know from the history of catacomb and pagan tomb ceilings. The debased style of most sepulchral decorations of that age, and particularly of the catacomb paintings, makes their evidence for general stylistic development less reliable than the conclusions drawn from them by modern writers would in most cases suggest. In the opinion of this writer, the representation of saintly figures and eschatological legends alluding to heavenly redemption, in connection with the prevailing use of the pattern with the circle in the center and diagonal figures, is primarily related to the long line of celestial representations on ceilings of which only a limited number of monumental examples is preserved. We shall later see certain connections between details of catacomb ceilings and this tradition. Like the similar loose reflections of celestial ceilings in pagan tombs of the period, they point to the catacomb paintings as vague adaptations of that general idea to Christian eschatological ideology, in the sphere of the popular symbolism of hymns and prayers. In that sense, the numerous catacomb ceilings are forerunners of the Christian heavenly ceilings of ecclesiastical art which, from the fourth century on, continue the pagan tradition of celestial ceiling decoration.

Although no monumental ceiling decorations with the representation of heaven are preserved from Rome after Hadrian's Villa, we nevertheless have evidence for their existence. The most important document is the narrative of Dio Cassius pertaining to a part of the imperial palaces on the Palatine: ". . . he [Septimius Severus] knew that he was not to return [from Great Britain]. He knew this above all from the stars under which he had been born. In fact, he had paintings of the stars made on the ceilings of the halls in the palace in which he used to give judgment. They were arranged in a way to be seen by everybody, with the exception of that section [of the sky] which, as [astrologers] express it, 'observed the hour,' when he first emerged to light; for this [section of the sky] he had represented in a different manner in relief on both sides [of his throne]."[45] It is certain from this somewhat obscure text that Severus had representations of the sky on the vaults, probably at the apsidal ends in the basilicas where his tribunals stood. These representations were either in fresco or in mosaic. This fact is of great importance since it indicates that not only the celestial decoration of vaults in general, but also the specific vision of heaven in the vault of an apse, which we later find in Early Christian churches, had been developed by this time, that is, about 200 A.D. Beyond that, the text does not enable us to say whether the sky was represented with astronomical symbols or whether it included illusionistic elements or divine figures. The direct transition from the pagan custom to the Christian interpretation of the ceiling as heaven within the same sphere of imperial palace decoration is documented by the famous passage in Eusebius referring to the decoration of a ceiling in the palace of Constantine the Great with a cross as the symbol of Christian religion.[46] It is hardly necessary to remind the reader of the continued use of the cross symbol in the center of ceiling decorations in Early Christian and Byzantine art, and of its intimate relationship to a starry ground, sphere or other celestial surroundings (Fig. 11).[47] But it is interesting to note at this point that in Christian art the cross does not appear in this place simply as the symbol of Christ, the source of light, the dominating heavenly body. According to literary evidence, it is also connected with the cosmic structure as an astronomical center with its four branches indicating the points of the compass.[48] As late as the eleventh

century A.D., the distinctions of color in the sections of heaven divided by the arms of the cross monogram reflect the changing phases of time (Fig. 12).[49] We have seen before how such an emphasis on the rotation of time was prepared by earlier Roman celestial ceilings.

From the second century on, there is evidence for the increasing preoccupation of monumental decorative art with the cyclic movement of time in the growing number of calendar representations on mosaic floors.[50] In the round form, their connection with and derivation from this tradition of heavenly images on the ceiling are very likely.[51] And it is here that we can see the first clear evidence of a radiating pattern. Unfortunately, in what seems to be the earliest example of this scheme, a late second-century mosaic floor from Antioch (Fig. 13), the central bust of a celestial ruler is no longer preserved.[52] The twelve months are grouped around it in radial units, while the outer spandrels are filled with busts of the Seasons. In addition to its progressively centralizing tendencies, the division into compartments, one for each month, may have been inspired by the earlier (Fig. 3) arrangement of celestial bodies in coffer compartments. Many interesting relationships are to be found here. In a second-century mosaic floor from the Rhineland, we see the zodiac frame around a heavenly representation of Helios (Fig. 14).[53] But the single signs of the zodiac are no longer united in a ring, as they were in Dendera and Palmyra (Figs. 7, 3). They are separated into single compartments[54] as we found them in the later mosaic from Zaghouan (Fig. 9) and in a ceiling from Hadrian's Villa (Fig. 10), where they were inserted into coffers as individual units. The late antique development from the mosaic in Bingen (Fig. 14) to a fully radiating scheme of the kind already familiar in the *calendarium* floor from Antioch (Fig. 13) is reflected in the mosaic of the Synagogue in Beth Alpha (Fig. 15),[55] which again shows Helios

framed by the zodiac. It seems likely that the mosaic from Antioch and other similar representations, as well as these heavenly floor mosaics, more or less reflect ceiling decorations. This connection is further borne out by another mosaic floor, this time from Gaul, which as far as I can judge from the style, may well belong to the second century A.D. (Fig. 16).[56] It shows the sphere of heaven in the central disk, in a fashion very similar to the representation in the center of one of the ceilings from Hadrian's Villa (Fig. 5). This starry globe appears again in the center of the Early Christian dome of San Prisco in Capua (Fig. 17).[57] Around it, on the mosaic floor, we see the seven planets in separate compartments, as if they were the "houses" of astrological speculation. While this floor undoubtedly reflects a heavenly ceiling, another mosaic, in this instance of the third century A.D. and from Hippone in Algeria (Fig. 18), gives evidence of the relationship between floor representations of the annual cycle and ceiling decoration.[58] Here, a representation of Annus(?) holding the zodiac[59] appears in a circle in the center of a canopy with concave edges: the outer circle shows personifications of the four Seasons in diagonal single compartments. The formal pattern has analogies not only in some catacomb ceilings[60] but also in an ornamental stone ceiling of earlier origin in Palmyra.[61]

Scanty and indirect as the evidence for the development of late Roman visions of heaven on ceilings often is, it suffices to show that an unbroken continuity existed between antique and Christian monuments of this kind. It also indicates an increasing preoccupation with a well established cosmic order, a certain tendency toward systematic illustration of that comprehensive order, and a formally correlated centralization. If the derivation of the Christian vision of heaven from an unbroken and ever growing stream of pagan tradition is obvious, the connection is further borne out by the persistence and reorganization

of specific elements of classical tradition. Two major features, the very two which formed the starting point of our observations, deserve particular attention: they are the motif of the canopy of heaven, and the character of the supporting figures.

II

Our investigation began with a general comparison of two widely separated examples of heavenly representation: the ceiling of an archaic tomb in Chiusi (Fig. 2) and one of the domes of San Marco (Fig. 1). This comparison first considered the general analogy of the round symbol of heaven with its winged corner supports. Returning once more to these two monuments, we may now stress a far-reaching difference: the Etruscan ceiling shows a simple carpet of red, symbolizing light, with a floral ornament of symbolical character and a fringed edge of little semicircles.[62] The cupola of San Marco shows an infinitely more complicated system: the floral elements are limited to the outer fringe; the red ground has been supplanted by the gleaming and visionary late antique gold; heaven is filled with figures; and in its center we see, as it were, another carpet, the firmament with stars from which the bust of the Pantokrator emerges, framed by a rainbow border.[63] We have seen how, in the Roman period, the actual representation of the sphere of heaven with stars, heavenly figures, and busts entered and expanded the simple earlier symbolism. In the course of this development, it would seem, the old carpet symbol was definitely abandoned for new narrative forms. But even here the rainbow frame of the sphere of heaven with its alternatingly folded sections still retains the idea of a canopy. If we now look at another late Byzantine monument, a vault in the inner narthex of Kahrie Djami in Constantinople,[64] we meet another and, at first sight, rather bewildering analogy to the ceiling from Chiusi (Fig. 19): within

the context of this picture, the vault shows a circular canopy with several concentric borders in the sky. In its center, the very motif of the Chiusi ceiling with four leaves sprouting from a square of stems with concave sides recurs after more than 1800 years. But the form is more complicated: the leafy star is applied to a larger square with concave sides, and this pattern is silhouetted against a curious shell-like inner canopy, the projecting points of which touch the innermost of the three concentric outer textile borders. By a happy coincidence, in the midst of the long road leading from one monument to the other, we are again able to show a tangible connection between them. In a mosaic floor of the third century A.D. in Trier (Fig. 20),[65] we meet the system of the central canopy of Kahrie Djami already fully developed with only slight modifications in details. It is obvious that these coincidences imply a long and continued development of the canopy motif. The two mediaeval examples which we have compared with their initial background constitute two divergent results of that evolution: one tending toward visualized figurative representation, in which the carpet character has almost been forgotten; the other toward rich embroidered decoration which obliterates the meaning of the original simple symbolism. Two factors alien to the representation of heaven on ceilings have influenced this development: the more or less illusionistic representation of canopies on ceilings, in general, and the actual use of canopies symbolizing heaven in temporary structures.[66]

Leaving aside the question whether any of the earlier Etruscan painted tomb ceilings actually represented the roofs of tents, we have evidence for the illusionistic imitation of canopies in painted ceilings as early as the Hellenistic age. In a tomb of the Aufudshi necropolis in Alexandria (Fig. 21),[67] the ceiling is painted with an imitation of an open pergola covered by a carpet having a central red

square and several borders. It is interesting to read that the central border zone showed busts, certainly of gods, in coffer-like fields, while the outer border had a frieze of figures. In the very center there was a circle, and in the circle a wheel-like ornament was preserved. This ornament is evidently a star: it occurs again, about seven centuries later, among a great variety of star patterns in an interesting Early Christian mosaic (Fig. 22).[68] Here the four rivers of Paradise emerge from the center of heaven through the starry sky. The Aufudshi ceiling thus represents an awning decorated in the center with the heavenly sphere which appears as a flat circle, and with busts of divinities inserted into imitations of the coffers of a ceiling. In other words, the carpet which is shown spread over the lattice-work of the pergola has absorbed elements of actual ceiling decoration—an interesting example of reciprocal influence. Further cases of the imitation of canopies on the ceilings of Hellenistic tombs have been discussed by R. Pagenstecher.[69] They are found in such widely distant regions as Southern Italy, Alexandria, and Southern Russia. It may be safely assumed though evidence is lacking, that similar motifs were used in private houses and palaces of the period. Thus far we possess only one imperial example of the representation of a large carpet covering the entire room over a central beam, from Hadrian's Villa in Tivoli.[70] The custom is important, inasmuch as it may easily have contributed ornamental embroidery motifs to the representations of the canopy of heaven. It may also have facilitated the expansion of loosely associated embroidery motifs into the general realm of ceiling decoration.

More important for our discussion is the actual use of heavenly symbols on temporarily erected canopies. This custom goes far back in antiquity; became widespread during the Hellenistic and Roman ages; and almost certainly survived in the temporary canopies erected over the altar in the earlier periods of the Christian church.[71] The earliest document of this practice from the Greek world is the famous description in Euripides' Ion (1141 f.). Here, a temporary tent structure for the festival was covered by a carpet richly embroidered with pictures of the stars. In Hellenistic time, the custom of using such heavenly carpets was so common that the actual term for canopies was uraniscus.[72] Their form was usually rectangular to conform to the shape of the structures. But an extremely interesting late gloss leads back into the oriental world and refers to circular awnings symbolizing heaven, such as we have already seen reflected in the Tomb of the Monkey (Fig. 2), and in the majority of later heavenly awnings in ceiling decoration: "Heaven . . . The Persians also [used the term] for the royal tents and courts whose round awnings they called Heavens."[73] In the Roman Imperial age the custom of decorating temporary awnings with heavenly representations is also documented. Nero used such a velum in the amphitheater: "The carpets which were spread out through the air, in order to protect [the spectators] from the sun, were of purple color, and in their center in embroidery Nero appeared driving a chariot, while around him golden stars spread their light."[74] Nero was represented here as the Sun-God in his chariot at the center of the starry heaven. We have already seen such quadrigas in various representations on ceilings or their reflections.[75] The ground color of heaven was a purple which Pliny,[76] speaking of the same performance, calls "the color of heaven." We may remind the reader of the use of red to symbolize heavenly light, which appeared on the canopy ceiling from Chiusi, in Aufudshi, in the Vatican mosaic (purple, Fig. 8) and in still later survivals.[77] The only direct representation of such a heavenly awning and one which gives evidence of the widespread and common popular use of such embroideries as early as the late Roman Republic, is the well-known relief

with a funeral procession from Aquila (Fig. 23).[78] The whole surface of the awning, with the typical running spiral border, is covered with stars among which the crescent of the moon emerges.

This common use of the outspread awning, under the inspiration of illusionistic visions, led toward an enrichment of the canopy of heaven with imaginative patterns. The simple projection of the heavenly sphere on a circular disk, as we first find it in the tomb of Chiusi and, afterwards, in some of the monuments discussed in the first section, survives in many instances as a vague heavenly symbol. If one looks at the many Roman mosaic floors and the limited number of Hellenistic and pre-Hellenistic forerunners, one finds that the dominant central circle is not so common as one might suspect for reasons of pure decorative convenience. It remains rather exceptional. And in most cases, circular fields are filled with flying or heavenly figures which reflect their ultimate celestial symbolism. The same is true of the use of circular fields during and after the early Imperial period. On the other hand, simple circular centers decorated with ornaments or figural representations of heaven persist in the center of Christian vaults. The constant recurrence of painted central circles on catacomb ceilings is part of this development. A later Christian example in El Bagaouat (Fig. 24),[79] showing a cupola with the concentrically decorated round carpet, may illustrate the survival of the aboriginal type still found in several central disk-shaped decorations with starry patterns in various cupolas of San Marco in Venice.[80] We also saw this circle penetrated by representations of heavenly bodies, and interpreted as a sphere seen in space, in the Roman Imperial age (Figs. 5, 16). Those two elaborations as well as their mixture and superimposition define the character of many Christian monuments in an almost complete loss of the carpet motif.

But from an early period, we meet a different development which also continues in Christian art. This is based on the pseudo-illusionistic representation of a canopy spread out in the center of ceilings or of other supposed openings. In this variety, the points where the tent-like *velum* is fastened to the edges of the opening are marked by projecting angles between concave sides. We cannot define the exact moment when this innovation was made. But we do possess an isolated example of the representation of such a decoration in the apparently wooden cupola of a tholus on an Etruscan mirror of the third century B.C. (Fig. 26).[81] Again, we are led back to Etruria and its tradition in the further development of a motif whose simple prototype first occurred there. It is a fully developed and constant feature in the age of Nero, the period of the fourth Pompeian style, and it agrees with the playful and pseudo-illusionistic tendencies of that style. In most cases, the supposed form of the canopy is circular and it appears with eight projecting angles between concave sides.[82] A recently discovered ceiling from Pompeii (Fig. 25)[83] illustrates the idea extremely well. As if it were a large carpet, the central square is supported by diagonal "candelabra" in which we find the familiar Sirens. In the outer centers of the four sides appear "tabernacles" covered by *uranisci*. Within this framework, an inner square is illusionistically opened. In its corners, four snake-bodied "Giants" support a flowery ring. Birds are perched on this ring to indicate the airy space of the vision, and at eight points the projecting corners of a windblown canopy are fastened. This canopy is embroidered with a divine group of two enamored planets: Mars and Venus. We possess a precious record in old drawings of a cupola decoration (Fig. 27)[84] from the Golden House of Nero (or the nearby Thermae of Titus), where the eight-cornered carpet occurs. Here, the awning is richly embroidered with alternating figural scenes and, at the projecting points, "grottesque" panels with

supporting figurines appear; but they have been transferred into the surface of the canopy. The central circle shows Jupiter on clouds. The motif of the eight-cornered canopy occurs in pagan tombs of the later Roman period as well as in the Christian catacombs. It still survives in one of the central ornaments of the mosaic cupolas from San Marco.[85] But as early as the Flavian period we also meet an increasing number of projecting points and concave sides.[86] In another vault from the Golden House there is a twelve-cornered carpet which has a vision of Bacchus in the central disk. In an outer dodecagonal border we see alternating support-elements of a floral character no longer related to the corners, and figured scenes (Fig. 28).[87] The latter show hanging canopies seen in profile over the figures, a motif which illustrates the artist's consciousness of the meaning of the canopy. This is particularly interesting, because a later and fuller development of such radially independent canopies is found in the cupola decoration of San Giovanni in Fonte in Naples,[88] where rich canopies hang down over the biblical scenes in the radial fields around the blue central circle of heaven. In the circle the monogram of Christ has displaced the pagan divinities (Fig. 30). In a ceiling from Hadrian's Villa (Fig. 29),[89] we even find sixteen projecting corners and a pleasant decorative embroidery in corresponding radiating fields surrounding a central vision of Hercules and Bacchus. It is against this background that we can understand the fan-like patterns in various pagan and Christian monuments which we have discussed before (Figs. 5, 18, 19, 20).

Grandiose later domes were conditioned by this tradition. The cupola decoration of Santa Costanza (Fig. 31),[90] with its mixture of Christian and Bacchic elements, illustrates the passing of this type of decoration into the mediaeval world. The canopy of heaven with twelve projecting corners is spread out in the dome over an illusionistic picture of the earth and sea.

The corners are fastened to caryatids who also support an upper row of similar figures and these in turn carry a second twelve-cornered awning in a central disk. The mixture of supports on and below the awning and the duplication of awnings and supporting figures recall the system of the ceiling from Pompeii (Fig. 25); the application of pictured panels to the radial sections of the canopy, and the twelve rays remind us of the ceilings from the Golden House (Figs. 27, 28). Finally, there is a much later and equally important instance, at the end of the mediaeval period, in the dome of the Baptistery at Florence (Fig. 32).[91] Although the simple circle of heaven with radial fields is supported in the Tribuna by kneeling figures (Fig. 41), in the center of the main dome a richly embroidered golden carpet appears. It has sixteen projecting edges and the concave sides of the now familiar Roman type. Whether this is the result of direct and unbroken tradition or a symptom of a proto-Renaissance revival, I cannot say. But later, when the Renaissance artists elaborated the theme on the basis of a new direct approach to nature, they were still fully aware of the original meaning of a motif which by that time seemed to have become an abstract decorative formula of crystallized ornamentation. A good example is the ceiling of the Sala Ducale in the Vatican (Fig. 33; 1559–1565),[92] where the canopy is suspended over a hexagonal opening beneath which angels carry the coat of arms of the ruling pope to heaven. The starry canopy in the vault-center occurs even later still, as in a Zuccheri ceiling of the Lateran (Fig. 34).[93] As often happens, these cases display the way in which the new and vital Renaissance approach to reality discontinued the true classical formal tradition, which had been retained in crystallized schemes from the Roman through the mediaeval ages.

We must return once more to the Roman form of the canopy of heaven in the center of vaults in order to appreciate a branch

from this root which grew to considerable importance in Christian ecclesiastical mosaics. The stucco decoration in the apse of the caldarium in the thermae near the Forum in Pompeii (Fig. 35)[94] shows a semicircle above the circular window. In this semicircle we see an illusionistic opening with a canopy of the previously discussed type fastened to its edge. In the same period, in the mosaic decoration of a fountain in Herculaneum (Fig. 36),[95] we find a representation of an apse vault situated over a shrine filled with a richly embroidered half-canopy of our type. This transfer of the rounded canopy of heaven to apsidal niches in the reduced form of a half-canopy is logical. We have another extremely interesting document for this process in a painted apse decoration from the Golden House (Fig. 37).[96] Here, however, the richly embroidered canopy emerges from the waves. In its center it bears images of Venus Marina and two Amores. Looking closely at it one notices that the upper edge is bent forward like a shell. It obviously expresses the old idea of Venus emerging from the sea in a shell. The same theme appears with illusionistic rendering in the mosaic decoration of the same period on apsidal fountains in Pompeii.[97] But it is also evident that two originally different motifs, the shell and the embroidered canopy of heaven, once used to fill the semicircle of apses, have been formally and symbolically fused in the representation from the Golden House. The canopy is essential enough for us to call this type the canopy with a shell border.[98] The important thing is that from the Early Christian period on, this Roman type of apsidal canopy occurs in the apsidal decoration of Christian basilicas in both varieties, with or without shell elements at the edges. Owing to the basic derivation of the Early Christian—Byzantine mosaic decoration of the canopy of heaven from such ancient models, this element is distinct from the pure shell motif which frequently occurs in sculpture, and, less often, in

mosaic representations of buildings.[99] For example, the canopy of the supreme heaven, hanging in the uppermost part of the apse, with the hand of God emerging through it, occurs in the apse mosaic of Old St. Peter's (Fig. 38).[100] In addition to the simple embroidered canopy, the canopy with shell edges derived from the type of the Venus canopy of the Domus Aurea is used, too, as in the thirteenth century in Santa Maria Maggiore (Fig. 39).[101]

From the fact that this symbol is represented throughout mediaeval art with clarity, suspended above the physical heaven and connected with the hand of God or the cross, we may conclude that the survivals of the full canopy motif in the center of vaults and domes, which otherwise might easily be interpreted as purely decorative elements, were also consciously used as symbols of the highest heaven.

III

Next in importance to the vision of the center of heaven in the decoration of Christian vaults and domes, however that vision is defined, are figures which surround, if they do not actually support, the heavenly representation or its central element. Usually they are four in number and arranged in a vertical or diagonal cross pattern. Our investigation started with a comparison between one such type, the Sirens, and its obvious continuation in the use and meaning of the symbols of the evangelists in corresponding places in Christian art. Typologically, of course, the actual appearance of the evangelists has other origins. Apart from the previous examples showing Sirens in antiquity as diagonal supporting elements of heaven or its canopy (Figs. 2, 3, 5), a few other instances of the kind[102] may be passed over here, together with the use of the symbols of the evangelists (Fig. 1) for a similar purpose in the four corners of a vault or around its central element, which occurs from the Early Christian period on.[103] But, in addition to the interesting inscrip-

tion from San Marco in Venice which explains the evangelists as cosmic musicians, and thus as successors to the Sirens,[104] we have a precious document bearing upon this relationship. This is an Ottonian miniature in which, in a strange hierarchic combination of antique mythology and Scripture, four Sirens support the symbols of the evangelists around the representation of Christ in the Tree of Life (Fig. 40).[105]

Closely related to the Siren type, though possibly of different meaning and connected with the motif of the winged Horae,[106] is the female divinity or demon emerging as a half figure or bust from a floral root. Whatever the original meaning of the motif and its various applications,[107] in the early Imperial age it was used in the decoration of heavenly vaults for corner supports. We have already met such figures in the cupola from the Golden House (Fig. 27), where they appear above the Giants within the radiating ornamentation of the canopy of heaven. In the same building they also appear with diagonal "Victories" in the outer corners of a vault of which the chief motif is a twelve-cornered canopy.[108] It is interesting to note that the use of such a figure as an actual "caryatid" occurs in Etruscan funeral art. I refer to one side of the central pillar of the Tomba del Tifone in Tarquinia which dates from the third century B.C. While the three other sides (Fig. 48) have ceiling supports of a different kind, the fourth shows a female figure terminating in foliage.[109] On the other hand, wingless "caryatids" emerging from chalices support the outer edge of the heavenly canopy in the cupola of Santa Costanza (Fig. 31) in the initial period of Christian monumental art. They are flanked by heraldic feline animals in continuation of the old type of the Lady of the Animals.[110] The second and upper row of supports of the supreme heaven in the center of the canopy is formed by images of triple Hecate,[111] the all-powerful divinity of earth and heaven in late antique speculation and superstition. In the light of our earlier observation,[112] it is not surprising to find a late echo of this type of floral winged half-figures,[113] in the crowning elements of "grottesque" candelabra supporting the periphery of the central disk of the Lamb in the Scarsella vault of the Baptistery in Florence (Fig. 41).[114] Other figures to be discussed later support the larger outer circle of this heavenly canopy.

Also intimately related to the figures emerging from chalices are the supports of heaven, sometimes winged, commonly known as "Victories." As early as the Golden House of Nero[115] such draped winged female figures appear in the traditional position of diagonal supports of the canopy of heaven. In a lost vault, possibly from the same place, and preserved in old drawings (Fig. 42),[116] we find these figures hovering over disks containing the busts of the four Seasons and supporting the corners of a canopy. Such figures occur again in the well-known stucco ceiling from the Via Latina of the second century A.D.[117] It is evident that these supporting figures on ceilings are the forerunners of the angels occurring in similar positions and having a similar function and meaning in the decoration of Christian vaults and cupolas, whether they are simply winged demons (Fig. 44)[118] or the orientalized type of Seraphim.[119] Although the angels in the vault of the Archbishop's Chapel in Ravenna stand solidly on green mountains, they hover on globes in the vault of the presbytery of San Vitale (Fig. 45)[120] in Torcello,[121] and in Santa Prassede in Rome.[122] We have already met this type of the "Victory" on a globe in the same position and function in a vault from Hadrian's Villa (Fig. 10) and we commented upon a curious detail of that representation: the different size of the globes representing different phases of the annual cycle.[123] It is an amazing document of the continuity of both form and spirit between Roman Imperial and Byzantine art that a similar indication of cyclic changes recurs in the

vault of San Vitale (Fig. 45). As good reproductions clearly reveal, the globes are distinguished in each case by larger and smaller areas of light representing various astronomical phases, a convention which occurs elsewhere in Byzantine art.[124] Thus the master of the San Vitale mosaic, while imbuing the pagan type with a Christian meaning, retained the pagan connotation of the changing cycle of time. The coördination of Christianized winged demons, called angels, with the various energies of nature and the elements occurs in the same period in the cupola decoration described by John of Gaza (Fig. 63), and it is also documented by literary evidence.[125] These associations are further borne out by the motif—unique among ancient ceilings—of the "Victories" blowing trumpets in Hadrian's Villa (Fig. 10). Angelic trumpeters occur much later in a vault in Civate[126] and the "evangelicae quattuor tubae" have left their traces in Carolingian art.[127] It is evident that this is another Christian element derived from ancient decorative symbolism. What was the original meaning of the heavenly winged musicians who hover on globes and support the higher regions of the universe, over which Jupiter rules as Pantokrator? If their musical activity relates them to the Sirens, their global supports emphasize cosmic service, and the changing phases of these spheres indicate their relationship to the phases of the year. Who are they and who are all their winged sisters on ceilings? Are they figures symbolizing time, like the winged Horae, the hours which are described as preceding and succeeding dawn in John of Gaza's cupola (Fig. 63)? We were also tempted to recognize such personifications in the wingless girls who dance around the images of planetary gods in another ceiling from Hadrian's Villa (Fig. 5).[128]

However this may be, the occurrence of the four Seasons as actual supports of heaven or alluding to that function by their position in heavenly ceilings is well substantiated. Their types are various and they are also connected in various ways with other spheres of art. We have already met them as standing full figures in a ceiling from Hadrian's Villa (Fig. 5), where they appear in mandorlas on the canopy of heaven around the central field in which the starry globe is visible. They occur in diagonal positions in several other Roman vaults and in their reflections on mosaic floors.[129] Under the circumstances, the question arises whether the four diagonal heavenly women supporting the planisphere of the Dendera ceiling (Fig. 7) are simply Egyptianized Seasons, too. Like the planets the Seasons are occasionally represented as seated figures in a ceiling from Hadrian's Villa.[130] They were seen thus seated, though as a compact group in the Byzantine cupola described by John of Gaza (Fig. 63).[131] Their appearance as busts in the corners of ceilings is more common (Fig. 42).[132] It may be noted that the connection of this type of corner bust with systematic representations of heaven is documented by late survivals in manuscripts, where a planisphere is surrounded by four corner busts of Seasons.[133]

In view of the many other connections, it is notable that this naturalistic element of the annual cycle of the year, with its relationship to the world of experience, was eliminated from monumental Christian vaults and domes. As far as I know, there exists but one early survival, in the hidden allusion to seasonal changes in the composition of the crown surrounding the divine Lamb in the center of the vault of the Lateran Chapel (Fig. 46).[134] This crown is composed of four different sections (each with its center in the diagonal) whose elements reflect the flora of the four seasons. On the other hand, the ceiling is interesting in comparison with a Roman mosaic floor of the second century A.D. which may well reflect the decoration of a pagan vault (Fig. 47).[135] This mosaic shows Diana Ephesia as celestial Pantokrator in a crown

"of life" with the eagle of Jupiter hovering over her head. The differentiation of the four diagonal corner trees as sprouting, fully developed, wind-swept, and barren, evidently symbolizes the seasonal changes of the eternally moving cosmos.[136] In a vault at San Prisco in Capua these trees were supplanted by the eternal palm trees of Paradise.[137] In other ways also, as in the well-known general symbolism of floral elements, Christian art reflects the idea of permanent and eternal life. The vault of the Lateran Chapel is a good example of the Christian elaboration of this theme; it adapts the floral diagonal corner supports of the canopy of heaven to this new meaning. The use of these floral motifs in ancient ceilings as well as in Christian vaults is so common and so widespread, and their association with heavenly ideas is so evident from the examples offered in our illustrations, that a further discussion of other instances is not necessary.

Returning to the varieties of supporting figures in ancient ceilings, we notice with some surprise the absence of the normal forms of standing female caryatids or male telamones as supports of heaven.[138] The telamones occur but once, at Ostia, in a third-century A.D. mosaic floor (Fig. 43) which seems to reflect a ceiling decoration.[139] This connection is indicated by the capitals on which the diagonal supporting figures stand. Such capitals occur again a thousand years later, beneath supporting figures in the decoration of the vault of the Scarsella in the Baptistery in Florence (Fig. 41) which preserves so many remnants of antique tradition. On the other hand, the central motif of the city wall sustained by these telamones—whatever its meaning here[140]—appears to be a forerunner of Christian representations of the heavenly city in vaults (e.g., Fig. 51). Atlas supporting the heavenly globe, a not uncommon theme of ancient art, does not occur: the individual effort of this purely mythological figure could not easily be included in the speculative and decorative

system of these ceilings.[141] Only later do we meet Atlas, in the strange and descriptively organized decoration of the cupola in Gaza (Fig. 63). Here he is aided by two intellectual personifications of Virtue and Wisdom, and he is relieved of his original universal function and carries only the sun. Instead of traditional telamones, we find unorthodox supporting males such as the herms of Pan, in two ceilings from the Villa of Hadrian (Figs. 5, 10). They allude to the power of the elementary god of nature and his alleged universality.[142] Brute element that he was, he could not, of course, be christianized. The same is true of the diagonal youthful dancers whom we met in the mosaic in the Vatican (Fig. 8; compare also Fig. 5) and whose meaning escapes us so far,[143] though there are counterparts to them in a ceiling from Pompeii.[144] A third type, evidently of common use and old tradition, which again leads back to Etruscan funeral art, is that of the demon whose body terminates in two snakes. On the central pillar of the Tomba del Tifone (Fig. 48) of the third century B.C.,[145] winged underworld demons of terrible aspect support the ceiling with raised arms. These underworld monsters as such could not find their way into heavenly representations; neither could their cousin, the Etrusco-Roman god Summanus, whose images showed the same monstrous type.[146] The snake monster which appears as a diagonal corner support in several ceilings is rather to be identified with the Giants of Greek mythology whose iconography, undoubtedly, also inspired those other creatures. The idea of an earthbound anchor of the heavenly structure is expressed by the insertion of such figures in the diagonal candelabra of one of the vaults from Hadrian's Villa (Fig. 5), while in the cupola decoration from the Golden House, such giants occur in radiating elements of the canopy, which higher up, include the floral goddess (Fig. 27). In a third ceiling, this time from a tomb in Rome,[147] each of the outer corners of a canopy is

filled with a diagonal heraldic group of two such monsters with entwined snake bodies, and again they are winged. In the Pompeii ceiling reproduced in Figure 25, the four columns supporting the central ring to which the canopy is fastened are stylized architectural forms based on this type. An interesting reflection of this genre is found in a funeral mosaic from Algeria (Fig. 49),[148] in which four diagonal giants support the heavenly circle containing an allegory of the release of the soul by the divine physician. J. Carcopino has commented on the relationship of such demons to the spheres of the planets and the stars and to such acolytes of heaven as the Cherubim.[149]

All these male demons who were not susceptible of Christian reinterpretation were, it seems, eliminated by Early Christian art. In the catacomb ceilings, the traditional diagonal corner spaces of supporting elements are commonly occupied by figures of orantes who, with their raised arms and frontal position, naturally offered themselves as the successors to the antique figures (Fig. 50).[150] But some tradition must have survived in monumental art,[151] because we have two strange late reflections of it in thirteenth-century vaults from Austria. In the church of Windischmatrei in the Tyrol (Fig. 51), the central disk with the image of Christ is supported by the four symbols of the evangelists emerging from the towers of the celestial city where the twelve apostles dwell; in the four corners, four young men appear with raised arms as supports of this intermediate sphere.[152] They are characterized as the four elements, and it is notable that Water is lent the attributes of the constellation Aquarius (jar and fish), a clear indication of a background in astrological ceiling decoration. We may recall the fact, for example, that the four dancing youths, who also raise their arms to support the disk of the pagan Pantokrator Minerva in the Vatican mosaic (Fig. 8) may well be stars.[153] The second example

is a vault of St. John in Pürgg (Styria, Fig. 52).[154] Here, the heavenly canopy shows the traditional disk of the Agnus Dei surrounded by the four evangelists. Its corners are supported by four male half-figures with raised arms who appear to emerge from mountains, earthbound, like the giants.[155] In this case, it is likely that the four earthly figures who support the Christian theological structure of heaven were meant to represent the gentes, the nations mentioned as heralds of Christian faith in an inscription surrounding the central disk.[156]

One more type should be mentioned which occurs in late and sporadic versions of mediaeval ceilings in Tuscany. It is the kneeling figure. This type of kneeling carriers of heavenly symbols ultimately goes back to old Near Eastern iconography.[157] It may be that the eight kneeling demons in the ceiling from Dendera (Fig. 7), who add their strength to that of the four women in the corners, are derived from such sources and are Egyptianized along with the rest of the representation. Though kneeling supporting figures in general are not uncommon in Roman art and though this type, too, was adopted by Atlas supporting the sphere of heaven,[158] such kneeling supports did not become a common feature of heavenly ceilings in the Roman age. Among the numerous examples of such ceilings which we have discussed, they do not occur. Their sudden reappearance in the late mediaeval age in Tuscany is, therefore, somewhat bewildering. In a cross vault of San Pietro in Civate,[159] the four rivers of Paradise appear as kneeling figures (Fig. 53). In view of the fact that we have already seen late antique reflections of a ceiling with a representation of heaven in which the naturalistically represented rivers of Paradise occupy the place usually allotted to diagonal supports (Fig. 22),[160] and in view of the well-known appearance of the rivers of Paradise in apse mosaics in churches, it may be that this type of kneeling river of

Paradise on vaults has an old tradition and is actually connected with the Dendera demons. The second example is that of four youthful men who kneel on Corinthian capitals[161] and support the canopy of heaven in the Scarsella of the Baptistery in Florence (Fig. 41).[162] Their meaning is obscure, but within the context of the structure they may be related to the *nationes* of St. John in Pürgg (Fig. 52), though they are of a different type. It is worthy of note that all these revivals of early motifs, like those we found in San Marco in Venice, belong roughly to the same late mediaeval age.

One more supporting element remains to be discussed. It leads us back into the lofty realm of winged creatures. This is the support in the form of a heavenly bird. In antique ceilings, it is invariably an eagle. It appears in a diagonal position in the four outer corners of a vault from the Palatine beneath allegories of the Seasons,[163] and a thunderbolt designates it as the eagle of the sky-god Jupiter. In the same age, four eagles with globes over their heads support four of the eight sides of a central canopy in a fourth style vault from Pompeii (Fig. 54).[164] Later, at the beginning of the third century A.D., we find eagles in relief on globes, serving as actual supports in the pendentives of the dome in the Janus quadrifrons of Septimius Severus in Leptis (Fig. 55).[165] The widespread use of the motif in late antiquity is documented by one of the chamber tombs of El Bagaouat in Egypt (Fig. 56).[166] The cupola with an oculus in the summit is decorated with a scale pattern and framed by a crown. Again in the pendentives, the outspread wings of four eagles perched on spheres support the dome. That Byzantine imperial architecture actually used such supports in tabernacle structures can be concluded from one of the miniatures of the famous Gregory codex in Paris (Fig. 57).[167] The emperor Theodosius is shown outside his throne tabernacle. Its column capitals are surmounted by eagles perched on globes: they are cosmic[168] as well as imperial symbols. They support the four corners of a dome of exactly the same type which we have in El Bagaouat. The Christian church, of course, had no use for the religious or profane pagan symbol of the eagle in its vaults. Occasionally, however, the type of the bird on the sphere does occur: a peacock (which appeared earlier with a similar function in the pagan tomb of the Aurelii, though without a sphere),[169] supplants the eagle, but it preserves the connection with the globe (Fig. 45).[170]

IV

Throughout Christian art, the heavenly visions are found in cupolas or other types of centralized vaults or in the reduced half-domes of apses. On the other hand, most of the antique decorations discussed in the preceding sections are preserved on flat ceilings or barrel vaults. Among them, however, are some cupola decorations (Figs. 3, 27, 55, 56). Moreover, a strong centralization based on a radial or concentric pattern and the grouping of symbolical elements around a central circular motif connects with this realm almost all the other decorations, whether ceilings (Figs. 5, 7, 10, 25, 28, 29, 42, 54) or reflections of ceilings on mosaic floors (Figs. 8, 9, 13, 14, 16, 18, 20). A round central field frequently appears, with its frame often imitating an opening. These oculi are a common feature of Roman cupolas, as in the Pantheon (Fig. 61). Very often we find the canopy spread out over such an oculus, which belongs structurally to the cupola type rather than to that of the non-centralized vaults. In view of all these facts, and of the lack of preserved ancient cupola decorations, it is natural to assume that in the ancient world domes were the leading monuments in the development of the vision of heaven, as they were later in the Christian world, and that the other types of ceilings rather loosely reflected and adapted the cupola decorations. Such a development would constitute but one symbolic and decorative expression of the

well-known progressive centralization of Roman architecture, which was interwoven with the growing importance of vaulted construction. This explanation is enhanced by the chronological parallelism between the expansion of the theme of heavenly vision on vaults and the growth of domed construction. In both realms, there are only forerunners in the pre-Imperial time (Figs. 2, 6, 21); a few instances from the beginning of the Imperial age (Figs. 3, 7); and a notable increase in the Neronian-Flavian period (Figs. 8, 25, 27–29, 42, 54) and the second century A.D. (Figs. 5, 9, 10, 13, 14, 16, 18, 47). Finally, scanty as the remains of Roman cupola decorations may be, they are supplemented by certain literary sources, both antique and post-antique, which enable us to understand more clearly the origin, meaning, and development of this type of decoration in domes.

In fact, the earliest document of an astronomical ceiling decoration which we possess is a literary source of extreme importance. This is the famous description of an aviary which Varro gives in his book on agriculture (4, 5, 9).[171] It dates from the same period in which Antigonus of Cyrrhestus erected the Tower of the Winds in Athens.[172] This astronomical, mechanical clock is covered with a flat monolithic dome, once probably decorated with paintings. Varro's description is a strange escapade into the realm of luxury in which he himself indulged in contrast to the avowed task of his book to lead his fellow Romans back to the good old simplicity of the Roman farmer's life. Certain details of interpretation may be debated. But fortunately, the basic features of the tholus he describes are unmistakable. Varro's tholus is a circular pavilion with an outer row of stone and an inner row of wooden columns. Between these two colonnades are the screened cages of the birds. The inner circle frames an artificial pond with a little island in its center. In the dome of the tholus which was a

wooden construction supported by the inner ring of wooden columns, two stars, Lucifer by day, and Hesperus by night, circle about the lower edge by some kind of mechanism. In the center of the dome, the pole of heaven, undoubtedly moved by an outer weathervane, indicates the direction of the wind by pointing with a hand toward one of the eight winds. Clearly, the winds were represented in the upper section of the dome, and here Varro refers to the analogy of the Horologium in Athens, where they appear in relief panels beneath the roof on the outside of the octagon.[173] The existence of the eight winds and the twelve or twenty-four sections through which the two stars moved during the hours of day and night, indicate a radial arrangement for the decorative framework. Whether this cupola was hemispherical or flat, Varro does not say. In order to appreciate its meaning beyond the application of technical devices to indicate weather and time, or as a horologium, we must keep in mind the implications of the whole structure: the water with its island, the birds behind which the trees of the forests appear through the outer open columns, and above, the canopy of heaven in which a mysterious power moves the stars and winds in space and time. Varro's tholus contains a curious blend of cosmic speculation (which here as well as later found interesting expression in the Roman Villa); interest in astrology,[174] which was strong in Roman society of this period; and the farmer's practical sense for the observation of weather and time. The fact that the cupola is of wood, and that no trace of such large-sized dome construction is left, calls our attention to the possibility of wooden domes in earlier antique buildings. Whether any of the round Greek structures which we know from monuments and literary sources had wooden domes is unknown. The problem has been much debated.[175] That wooden domes were used in Etruria from archaic times on is evident from their reproduction in rockcut Etrus-

can tombs.[176] Such domes continued to be built in Etruria in Hellenistic (Fig. 26) and, elsewhere, in early Imperial times. They appear in several Pompeian wall paintings from the third style and later (Fig. 58),[177] with either a painted reproduction of the sky in the upper part of the dome, or with the sky visible through its central opening. Such wooden domes allowed for a wide span, and their great importance in Early Christian and Islamic architecture of the East has been discussed by Creswell.[178] We shall return several times to their rôle in the development of the vision of heaven. To what extent they were used in Greece and Rome; whether they were decorated with celestial representations in the earlier periods; and if so, of what kind—in other words, how broad the background of Varro's aviary was—are questions which cannot be answered on the basis of our present knowledge. But from his own references to the aviaries in other villas of his time, one would assume that Varro's structure reproduced a fully developed type.

These large wooden domes of cosmic character cannot have failed to inspire both the development of stone cupolas and their decoration in early Imperial times. It is this age which introduced large stone domes exceeding in size and ambition the small cupolas that had previously existed, especially in Egypt and the Near East.[179] In the development, both of domed construction of monumental size in Roman architecture, as well as of vaulted construction in general, the Roman thermae played a leading part. The domes of bathing halls of the second and first centuries B.C. in Pompeii are still small. In one case the later decoration of a dome is the blue sky with ornamental stars (Fig. 59). The case is a forerunner of the long development in Early Christian vaults, which in itself is evidence of the widespread use of this scheme. It may well date back to the Roman Republic.

The first large dome which we know is to be found in the hall of a thermae building of the Augustan age, the so-called Temple of Mercury in Baiae (Fig. 60).[180] Though it has completely lost its decoration, so that we are unable to say whether it was celestial, it is of considerable importance to our discussion. The type with an open circular "eye" in the center and four additional diagonally arranged, and in this case, square skylights, is analogous to the scheme of a number of celestial ceilings mentioned and illustrated in the preceding sections. The cupola decoration from the Golden House (Fig. 27), in which four diagonal skylights interrupt the decorative system, differs from the dome of Baiae only insofar as the pictorial celestial vision replaces the oculus. On the other hand, the influence of this type of cupola and its celestial decoration on other vaults is clearly visible in a vault from the Palatine (Fig. 62)[181] which may be even earlier. In this vault a central celestial canopy around an "eye" in which Luna appears riding over the heavens, is combined with four diagonal minor canopies. Spreading the celestial canopy over a cupola skylight clearly inspired such decorative arrangements; and it is clear that a long line of celestial and loosely related Roman ceiling decorations (Fig. 54)[182] is rooted in such domes. It is obvious, too, that even in Baiae the cupola could easily have been decorated with a canopy surrounding the open central skylight, as many centuries later such a scheme was still retained in the Baptistery in Florence (Fig. 32). With the exception, therefore, of the central picture, the complete scheme of the dome from the Golden House (Fig. 27) can be applied to that of the Temple of Mercury (Fig. 60). These connections show the great impact of monumentalized dome construction on the celestial decoration of vaults. They further suggest that this theme was developed in the cupolas of early Imperial Rome.

In the East, at the same time, we find the flat early Roman dome of Palmyra with its canopy of heaven (Fig. 3). Its structural

type is different, however, and its playful form with the center blown upward, as it were, is analogous to the flat segment of early Roman pseudo-cupolas in Alexandrian tombs.[183] It will be noted that the ceiling from Dendera (Fig. 7), though flat, reflects the same constructive type, the two lateral bands being decorated with the zig-zag symbol of water. The type is also reflected in later celestial ceilings from the Golden House (Fig. 28) and Tivoli (Fig. 29).

The Golden House of Nero, which has retained so many visions of heaven on its ceilings, also marks an important development in the use of monumental cupola construction. In the section still preserved, which is only a small though significant portion on the lower periphery of the once enormous complex, there is a vast octagonal domed hall with a skylight in the center.[184] Unfortunately, no fragment of the dome decoration has been preserved. Considering the fact that literary sources indicate the beginning of the common practice of decorating vaults with mosaic in this age and that this art is reflected in the fountain mosaics from Pompeii,[185] the lack of preservation of such mosaics from Roman thermae and villas is particularly deplorable. The most famous feature of the Golden House was the great circular dining hall which turned around "like the world."[186] It may well be that it was this outstanding feature of the building, and its gilded roof, which gave rise to the name, Domus Aurea. Indeed, we know of a curious and surely related repetition of the name Golden House in a later Islamic palace thus termed because of its gilded dome.[187] And it is also in the Islamic world that we find an explanation of the manner in which such a dome revolved; in the basement, horses were harnessed to ropes, and as they circled, the dome rotated.[188] Such a structure, of course, had to be wooden, and this material as well as the mechanical movement relates Nero's dining hall to Varro's aviary. A curious passage in Seneca (ep. 90, 15) throws further

light on the nature of this mechanism; he mentions a dining room so cleverly constructed "with a ceiling of movable panels that it presents one appearance after another, the roof changing as often as the courses."[189] It is evident that Seneca describes a mechanism in which both the framework and the panelling above it move, apparently in opposite directions; this was clearly a device to increase the effect of motion. That he alludes to Nero's dining hall is very likely. It is also clear that the changing aspects of this cosmic dome revealed heavenly bodies and that it constituted a kind of planetarium. Martial may well refer to this structure of the Neronian palace, still extant in his period, when he mentions a tholus as an imperial dining hall (epigr. II, 59, 2). In another passage he refers to the stars and to the pole over Domitian's head (7, 56). This fantastic structure, in which the Lord of the Oecumene feasted with his guests in the center of the cosmos, just as he appeared on his canopy as the sun god amidst the stars of heaven,[190] is a successor and expansion of Varro's tholus in idea, construction, and decoration. In addition, it combines the cosmic speculation of learned men of philhellenic Roman republican society with the religious-political symbolism of the Roman empire. And it is this tradition which later continues in the appearance of the Christian Kosmokrator in the heavenly dome or in the throne-hall of Chosroes.

In this connection, an extremely interesting passage from Philostratus' *Life of Apollonius of Tyana* should be mentioned. On the occasion of the philosopher's visit to Babylon, he describes a palatial hall as follows, "He reports that he also saw a hall, the ceiling of which was constructed in the form of a dome, like the heavens, covered with sapphire stone—this stone being intensely blue and of the color of the sky—and in the heights are the images of the gods in whom they believe and they appear golden as if it were from the

ether."[191] Whether or not Philostratus found precisely this description in the alleged documents of Apollonius; whether or not he elaborated a suggestion; whether or not Apollonius had really seen such a structure in the Parthian empire about 100 A.D., and whether or not the report has other sources, fantastically exaggerated, we cannot decide. In any case the text is a document for the existence of a mosaic cupola with representations of Eastern astral gods in the upper regions of the blue sky. It is also interesting to note that this hall was used by the king for giving judgment, as Philostratus remarks; a use which relates it again to Rome, with the astrological ceiling of Septimius Severus in his basilica on the Palatine.[192]

Next in chronological order follow the Hadrianic Pantheon, the character of which has been much debated.[193] While some scholars interpret it as a kind of shrine of the planets, others are sceptical about such an explanation. In view of the development traced here, the scale seems to go down in favor of an astrological interpretation of the whole structure. However that may be, we possess an unequivocal document for the interpretation of the cupola of this famous building as a symbol of heaven. Dio Cassius (*Hist.*, LIII, 27) discusses the name Pantheon as follows, "It is called thus possibly because it included images of many gods in its statues, amongst them those of Ares and Aphrodite; but I believe that the reason is the similarity of its cupola-form to the heavens." It has been said that Dio's idea was suggested by a starry decoration of the coffers of the dome, which is probable, though by no means documented. But the important fact is that the coffer decoration stops some distance below the skylight (Fig. 61),[194] and this fact has led some modern restorers to suggest the presence of a canopy or shell-like element in this area. Again we cannot say what actually existed at this point. But that this place was occupied by a symbolical or figural representation of celestial character in painting or mosaic or stucco is indicated by the very system as well as by Dio's interpretation.

In this period of Hadrian and the elaborate celestial ceiling decorations in his villa (Figs. 5, 10, 29), documented evidence for the dome of heaven in pre-Constantinian art ends. The lack of literary sources is complete. It is part of the deplorably poor tradition about history and buildings in the second and third centuries of our era. It should be kept in mind, however, that the sources and monuments discussed here are the only sources whatsoever which refer to the decoration of large domes even in the early Imperial age: without exception, they point to the celestial character of these structures.

From Constantine on, we meet the long series of visions of heaven on domes and vaults, some instances of which we have discussed and included in our illustrations (Figs. 1, 7, 11, 12, 19, 30, 31, 32, 41, 44, 45, 46, 51, 52, 53). The root of this tradition, which we established generally in the realm of a long and increasing symbolism of heaven on ancient ceilings, is evidently in a more specific sense to be found in the decoration of domes in the Roman Imperial period. The decoration also survived in non-ecclesiastical domes of the Byzantine and Islamic world, which likewise can be rightly appreciated only against this tradition.[195] One of the later examples is the cupola decoration of a tomb in El Bagaouat (Fig. 56) which probably dates from the fifth century A.D. It shows the canopy of heaven decorated with an aegis pattern and with eagles on spheres[196] as corner supports alluding to the celestial rule of the sky. The connection between this decoration and the appearance of the throne-tabernacle of the Byzantine emperor (Fig. 57) has been pointed out before. In a tomb structure, evidently of pagan tradition, the association of an apotheosis canopy (Fig. 23) with the symbolism of imperial glorification continues a traditional fusion

and exchange between these two realms. We possess another interesting Byzantine document in the description of the Bath of Oecumenius. It displayed a zodiac frigidarium and the apparent representation of the planets in seven different niches. The Seasons were shown in four other halls.[197] Likely as it may seem, we cannot be sure that these representations were on ceilings. They could have been floor mosaics, inasmuch as the motif of the zodiac floor is also widespread and traditional (Fig. 14).[198]

The most remarkable document of a dome of heaven outside the ecclesiastical sphere is John of Gaza's long description of a cupola decoration in painting or mosaic in a bath in Gaza or Antioch probably written in the sixth century.[199] Because of the poetic nature of the source G. Krahmer's reconstruction (Fig. 63) gives only a vague idea of the representations and their approximate distribution in the dome. The lack of decorative arrangement is hardly satisfactory and it seems quite possible that the system was much more highly organized within an ornamental framework, which the poet did not mention since it was of no intellectual interest. A strange array of astronomical elements such as the sun and moon, the globe of earth, and Orthros, also includes Phosphorus and Hesperus, the only stars of Varro's tholus. The cruciform symbol of Christian tradition, which had already figured as the leading star in Constantine's palace, occupies the highest place.[200] The pagan gods and even the planets have been eliminated. Only the elements of time and space and the forces of nature are kept: Aion, Dawn, the Seasons,[201] the Hours,[202] Anatole and Nyx symbolize movement in time; Oceanus,[203] Thalassa, Ge, Europe, Asia, and Ouranus illustrate cosmic space; the Winds,[204] Storms, Rains, Lightning, Thunder, and the Rainbow[205] appear as the elementary forces of nature. The Phoenix[206] refers to life's eternal renewal, while Wisdom and Virtue are cou-

pled with the bodily strength of Atlas in supporting the sun globe of light which is both physical and intellectual. At the height, near the cross, an allegorical group of Cosmos triumphing over Physis and crowned by the supreme Ether resumes the underlying ideology. In this intellectual combination of various elements of descriptive astronomy, religious vision, and abstract symbolism, we re-encounter that fusion of three different trends which had existed and entered into various combinations ever since the early Imperial age. However, the fusion of pagan tradition and Christian faith in a realm of lofty intellectual speculation, as well as the extent and comprehensiveness of the illustration of the cosmic structure, is new. New also is the introduction of moral-philosophical allegory. All these are expressions of the systematic Byzantine mind. But the basic idea of this vision of an intellectualized and spiritualized heaven on the dome, like that of many of its individual elements, is clearly rooted in a now aging antique tradition.[207]

Two more monuments illustrate the Islamic branch which grew from the late antique root of heavenly domes. They deserve a brief discussion here. The earlier one is the description of the "Throne of Chosroes" which is found in both Arabic and Western mediaeval sources. In several respects these sources are rather vague, and at first sight they seem to contradict each other. The two scholars[208] who discussed them at length in recent years, have reached widely divergent conclusions. E. Herzfeld, who first collected the sources,[209] believed that two heterogeneous elements were fused in the descriptions. He assumed that the actual core of reality underlying them was a mechanical clock with astrological elements, and that the fabulous idea of a king's jeweled throne had been confused with these accounts. F. Saxl,[210] on the other hand, recognized elements of a regal throne and baldachin decorated with celestial figures.

But he concluded that in the sources, the vague idea of such a structure was developed from apocalyptic visions into fabulous narratives about something which never existed. Neither author considered the connection with the long and well established tradition which is the subject of our discussion. Within the framework of this tradition, every single element of the descriptions receives its explanation, however fairy-tale-like its garb and however much it may stress the luxurious and miraculous. The sources are unanimous in reporting a domed structure in a palace.[211] It is decorated in blue (lapis lazuli) and gold.[212] The representation includes: stars,[213] the zodiac,[214] the planets,[215] sun and moon,[216] astrapai,[217] kings,[218] among them Chosroes,[219] and subordinate figures of "angels."[220] The Byzantine sources limit themselves to a description of this dome, but Islamic writers and Ado of Vienna quite clearly distinguish the throne from the hall in which it stands. The throne is decorated with gilded and jeweled brocades.[221] Each of four tapestries shows the picture of a Season.[222] These items are all well-known in our tradition, for we have traced the decoration of cupolas with heavenly representations of astronomical character from the early Imperial age. Such decoration appeared in Imperial palaces. The horoscope character of the image of heaven in connection with the throne of the ruler was developed by the time of Septimius Severus,[223] the representation of the ruler himself among the stars took form as early as the period of Nero.[224] In fact, there is not a single part of the representations mentioned which does not occur in Roman or Byzantine ceilings. The dome of heaven over the jeweled throne of the ruler appears in the representation of Theodosius in the Paris Gregory (Fig. 57). A later artist, probably using some earlier iconographic tradition, pictured the Throne of Chosroes in a similar fashion (Fig. 64);[225] he, too, represented the structure as an open monopteros in order to make the throne visible, although in reality it was evidently an interior throne hall. In view of all these circumstances, and of the fact that in the cupola of Quseir Amra an early Islamic dome of heaven is actually preserved (Fig. 65), it is surprising to witness the reluctance of modern scholars to accept these descriptions at face value. The reason may be the presence of another item which looms particularly large in the Western sources. But it is also confirmed by one of the two Islamic writers. We are told that the dome revolved, causing a terrifying noise like thunder,[226] and that drops of a liquid "like rain" came down from the dome.[227] It is no wonder that modern writers have been sceptical of such a seemingly fantastic story. But the fact is that this rotation of the heavenly dome had its actual forerunner in the famous dining hall of Nero's Golden House which is beyond suspicion of being a literary fantasy, inasmuch as it was seen and described by contemporary writers. As it is, the elaborate description of the mechanism of the Throne of Chosroes given by Ado throws light on the way in which these wooden domes, Nero's as well as Chosroes', were moved. He says that horses moved around in a basement, and by means of a rope mechanism, dragged the structure into its revolving movement.[228] In view of this connection between the throne hall of Chosroes and the dining hall of Nero, it is interesting to see that even the seemingly fabulous feature of liquid sprayed from the dome like rain by means of hidden pipes,[229] has its antecedent in the same Roman tradition. Suetonius reports that in the Golden House perfumes were sprayed on the dinner guests from holes in the ceiling, and he may well refer to the circular dining hall.[230] This, again, reveals the tradition of such customs as well as the actual existence of the throne hall of Chosroes.

We have already mentioned the most completely preserved astronomical cupola decoration, that found in the caldarium of

the early Islamic palatial bath in Quseir Amra (Fig. 65).[231] It is a purely descriptive representation. Deprived of visionary and symbolical features, it constitutes a purely "scientific" use of the already long established, continuous tradition of domes of heaven. The idea of decorating the cupolas of baths with the bodies of heaven continued long after in the Islamic world.[232]

In this learned early mediaeval atmosphere, in which the astrological tradition of the antique age continued both in the Islamic and in the Western world, we find the representation in manuscripts of an astronomical observatory: it has the form of a domed monopteros with ten columns. Within, a columnar support carries a globe of heaven adorned with the zodiac and capable of being turned around on a handle (Fig. 66).[233] Though the copyists of two ninth-century manuscripts which repeat the same earlier model misunderstood the space relationship between the structure and the globe beneath its dome, the scheme of this observatory is evident.[234] Many centuries earlier we find the same type of structure included in the decorative patterns of a Pompeian wall in the playful manner of the third style (Fig. 67).[235] Here, the heavenly sphere and its network, a common feature of ancient globes,[236] is supported by a "candelabrum" within a circular building having a roof in the form of a cone with a concave contour. The inner ceiling is decorated with a canopy of heaven and its concave edges frame a central disk, as is so often the case. The connection of the picture with actual observatory structures is further indicated by the console-shaped decorations on the roof, which occur centuries earlier in a real structure, the Lysikrates monument, and later, in Byzantine book illustration.[237] In the fresco, the consoles support griffins, which are animals of solar significance. This type of observatory structure adds a last interesting "scientific" note to the long series of monuments of celestial speculation.

The modern planetarium, in the age of technical civilization and popular instruction, seems to lack connection with these antique and mediaeval observatories. Yet, it may be appropriate in this respect to refer to a curious scheme conceived by Thomas Jefferson for the astronomical instruction of the University of Virginia.[238] "The concave ceiling of the Rotunda is proposed to be painted sky-blue, and spangled with gilt stars in their position and magnitude copied exactly from any selected hemisphere of our latitude." This suggestion is followed in his notebook by elaborate instructions for the building of a movable seat in which the operator, seated on a saddle at the end of an oak sapling, can be transported to any point of the concave ceiling in order to adjust the stars to their appropriate positions. The scheme of this dome, which was deliberately imitated from the Pantheon,[239] might also have been suggested to Jefferson by a recollection of Varro's Tholus with its moving stars.[240] However that may be, it is again the result of the meeting of an antique architectural form, inherently symbolical in character, with a scientific spirit, belonging in this case to our own world.

Looking back on this sequence of domes of heaven and on their reflections in other ceilings and pavements in Roman and postantique art, we note the fact that they are limited to three functional environments: villas and palaces, baths, and rather infrequently, tombs. This seems quite appropriate from the point of view of the coördination of intellectual factors and the functions of buildings: cosmic speculation and the fashionable astrological interest of Roman society were centered in private life in the villas; and in public life in the lecture halls of the Roman and Byzantine thermae, which succeeded the Greek gymnasia. The growing religious interest in astrological creeds and the related astral glorification of the emperor and the deceased explain the use of such domes in palaces and tombs. But there is another side to this

question. Within the Roman world, domed constructions are limited almost without exception to the three environments of thermae, villas and palaces, and tombs. The Pantheon, as part of the Thermae of Agrippa, was no exception, whatever its religious character may have been. And, as is well known, the limitation of the dome to memorial edifices, which were connected with the realm of the tombs, and to baptisteries, which are related to the baths, continued during the early Christian period until the fusion of the dome with the Christian basilica had been achieved. The tradition of circular tomb structures, often covered in the early period with pseudo-vaulted domes—regardless of whether or not any heavenly symbolism was originally involved—reaches far back into the prehistoric past. In Italy, it was a continuous tradition. A round form for bathrooms was known in Greece.[241] It was recommended by Vitruvius and often used for caldaria. The circular dining hall of Roman palatial residences may also have its origin in the Greek tradition of circular buildings.

In each case, therefore, the development of cupola construction can be understood as a result of such traditions of functional types of round buildings combined with the need for fireproof construction, which was particularly pressing in villas and thermae, and with the general development of vaulted construction from the late Republic on. It is questionable, however, whether sizable wooden domes like those of Varro's aviary and Nero's dining hall can be understood as a result merely of this process. The former edifice antedates any large sized dome of which we have knowledge. These structures are not substitutes for solid domed buildings. They are pioneers which prepare the way for large domed construction in durable materials. The same is true for the development of Early Christian and Islamic domes, at least in the East, where Roman vaulted construction had been used only sporad-

ically during the Empire. It seems, rather, that the desire to have great domed halls preceded and promoted technical progress in their construction. And in view of the fact that wherever we know something about their decoration, it points to celestial symbolism, we may ask whether the latter was not at least one important factor in the development of dome construction. We may also call the reader's attention to the fact that the early occurrence of the round symbol of the canopy of heaven on ceilings (Fig. 2), although it belongs to a type of symbolic decoration which tangibly inspired the later decoration of vaults and domes, precedes by a long time any permanent domed structure of large size. Furthermore, in the earliest preserved examples of flat domes, as in the Tower of the Winds in Athens (an astronomical building) and the ceiling from Palmyra with its astrological decoration, we see a purely decorative and not a constructive use of the dome motif. All these facts point to the considerable importance of celestial symbolism in the Roman development of domed construction. On the other hand, we may also ask whether the bold introduction of domes—invariably decorated with heavenly visions—in the Christian basilica is merely a problem of construction and space rendering, as proposed in evolutionary theories of the history of architecture. At least one driving force may have been the firmly established symbolism of the dome as a celestial hemisphere.

However that may be, certain types of construction exist in ancient central plan buildings which require more specific attention in connection with the observations presented in this paper. The earliest of these types is the concave conical roof. It was known in the time of Alexander the Great in the monument of Lysikrates in Athens, and shortly afterwards, in the Arsinoeion in Samothrace.[242] It seems to have been a widespread Hellenistic form and it occurs not infrequently in Pompeian

paintings (Fig. 67). Sagging downward in outline, it is clearly derived from the idea of a tent or canopy. To illustrate this relationship we may refer to the actual appearance of such canopies in Roman representations (Fig. 28). Though one might suspect a connection not only with canopies in general, but also with the symbolism of the celestial canopy[243] which we saw so widely used on ceilings, it is not yet possible to establish any evidence for such a connection. In any case, this form of roof, which in a tomb in Termessos[244] is combined with a flat ceiling, is not compatible with actual domed construction. It belongs to a preceding age. But it is in exactly this respect that its relationship to the canopy is interesting, since within the framework of domed construction, another type, the melon cupola, originated in Imperial architecture.[245] Its form is characterized by the outward curving of single sections of the dome, either all of them, or half of them in alternation with the precisely spherical sections. As far as we can see, the scheme first occurs in the Hadrianic age, though it too may have earlier antecedents in the first century A.D. Its relation to the wind-blown canopy with curved edges and radial units (Figs. 5, 10, 25, 26, 27, 28, 29, 35, 42, 54, 62) is evident.[246] It is transferred from the decorative symbolism of the canopy of heaven to actual structural and plastic form. It survives in the Byzantine cupolas of SS. Sergius and Bacchus and the Kahrie Djami, as well as in Early Islamic art.[247] Its explicit explanation seems to be furnished by a Byzantine writer referring to a Roman structure in Gaza, "its center was a blown up cupola extended into the heights."[248]

In both the pagan and Christian worlds, the manifold visions of the dome of heaven, with their symbolism in canopies, figures, and structural forms, with the projections of heaven on ceilings, often coupled with an actual or supposed opening in the sky, all reflect the basic experience of man in visualizing the physical as well as the transcendental celestial realm. It is evidently because of this ever increasing tradition of heavenly visions on ceilings that coelum became a common term for roof or ceiling in late antique speech.[249] It is not common usage in earlier antiquity. The term caelum occurs only once in classical Latin in this sense. Vitruvius casually speaks about the suspension of a stucco vault under a roof. He may well refer to a flat cupola (VII, 3, 3). The use of the term hemispherium for cupola, which continues later on, also appears in Vitruvius (V. 10, 5). This term, though it may originally have been merely descriptive of the form of a dome, suggests an analogy with the cosmic structure of the heavens.[250] According to the writers of the Middle Roman Empire whom Servius used (Ad Verg., Aen., 1,505), the roof of central plan buildings was called testudo in allusion to its external appearance; and the roof was built to resemble the heavens ("ut simulacro coeli imaginem reddat"). This was the intellectual background parallel to the monumental tradition from which Byzantine writers derived their conception of the domical vision of heaven. Thus, Mesarites describes the central dome in the Church of the Holy Apostles in Constantinople, ". . . the other central hall emerges and its direction is towards heaven. It seems to me that it calls towards it the heavenly God-Man, to come down, and through it, as it were from heaven, to look down, again, on all the sons of men. . . . I say, indeed, one can see him . . . emerging from his navel through the canopy in the summit of the sphere. . . . This sphere of the hall is truly celestial, inasmuch as within it the sun of justice is erected, the light beyond light, the Lord of Light, Christ."[251] The vision of a directing spirit of the world, the source of physical, moral, and spiritual light, in the image of the Pantokrator on the celestial dome is here the source of faith and revelation. The downward movement of the heavenly Savior toward the sons of men is a new and Christian activation of

the ancient contemplative and speculative visualization of gods, stars, elements of nature, and cosmic energies. In art, this Byzantine revelation found its most explicit expression in the representation of Pentecost in dome mosaics (Fig. 68).[252] There the rays of the light of inspiration shoot down in radiating lines from the throne erected in the center of the ethereal canopy of heaven. The idea that this revelation should be communicated from heaven through a domed structure is illustrated in naïve form in a Carolingian miniature (Fig. 69).[253]

NOTES

1 For many suggestions and extensive help, I am indebted to my wife, Phyllis L. Williams. I also wish to express my gratitude for valuable information to Walter Allen, Jr., Herbert Bloch, Phyllis Bober, Ilse Falk, Ernst Herzfeld, Nancy S. Holsten, Richard Krautheimer, Doro Levi, Charles R. Morey, Richard Offner, Elizabeth Riefstahl, Guido Schoenberger, and Bluma Trell.

2 For Italian Renaissance and Baroque ceilings, see A. Colasanti, *Volte e soffitti italiani*, Milan, 1915.

3 For Egyptian ceiling decoration, which generally prefers all over textile motifs, see G. Jequier, *Décoration égyptienne*, Paris, n.d.; but often, in naturalistic illusion, it interprets the ceiling as a starry heaven: *Idem, Manuel d'archéologie égyptienne*, Paris, 1924, p. 292; cf. G. Maspero, *L'archéologie égyptienne*, 2nd ed., Paris, n.d., p. 88. The Egyptian symbolism of heaven (H. Schaefer, *Aegyptische und heutige Kunst*, Berlin, 1928, pp. 93f.) represented as a woman bending over the world is entirely different from the later Western tradition. On the other hand, systematic representations of astronomical heavens occur in Egypt only in the Roman period. See above, pp. 232–33.

4 See, for example, G. Wilpert's chapter "Behandlung des Firmaments in der römischen Kunst," in *Mosaiken und Malereien*, Freiburg, 1917, I, pp. 53 f., dealing exclusively with Christian materials. In the modern discussion of individual monuments or of more comprehensive character, some of which are quoted below, nearly all the antique works of art and literary sources discussed here have been neglected. The idea of a lack of continuity between antique and Christian decoration is typically expressed by E. Müntz, *Revue des deux mondes*, July, 1882, pp. 162 f: On the other hand, some useful general observations on the lines of this study have been made by C. Cecchelli, *Architettura ed arti decorative*, II, 1922, pp. 3 f. A few, somewhat confused observations about corner figures are found in W. de Grueneisen, *Les caractéristiques de l'art copte*, Florence, 1922, pp. 71 f.; also C. Ricci, *Monumenti*, V. p. 45. Most writers on Early Christian and Byzantine art ignore the issue completely.

5 For the mosaics of San Marco, see O. Demus, *Die Mosaiken von S. Marco, 1100–1300*, Vienna, 1935. The central medallion, though not preserved in its original state, is a restoration of the 13th century (pp. 23, 86, note 21).

6 For similar ideas in Carolingian art, see W. Weisbach, *Gaz. d. B. A.*, LXXXI, 1939, pp. 137 f.

7 R. Bianchi-Bandinelli, in *Monumenti della pittura antica*, ser. 1, *Clusium*, fasc. I, Rome, 1937, pp. 6 f., fig. 8.

8 The red color may well be symbolical of light. E. Wunderlich, *Die Bedeutung der roten Farbe*, Giessen, 1925, pp. 96 f. In the first cupola of the narthex of San Marco, in the scene of the separation of light from darkness, the globe of light is still intensely red, and that of darkness is blue-green: A. Gayet, *L'art byzantin*, I, Paris, 1901, pl. 22. In Byzantine art the stars sometimes express the source of emanating light, a red center: *ibid.*, II, pl. 19. In the well known *Prayer of Isaiah* in the Paris Psalter the scarf of Night is blue with white stars, and the heavenly sphere from which God's hand issues is light red: H. Omont, *Miniatures des plus anciens manuscrits grecs*, Paris, 1929, pl. 12 bis. See also below, p. 261, note 77.

9 For this motif, see the learned work of R. Eisler, *Weltenmantel und Himmelszelt*, Munich, 1910, 2 vols. (which, however, is bewilderingly lacking in knowledge of the monuments and sources discussed here: see particularly the false generalizations, II, p. 613), and below, pp. 238 f.

10 *Monumenti dell'Ist.*, 1854, pl. 32, no. 2, fig. 1; G. Karo, *Le oreficerie di Vetulonia* (*Studie materiali di archeologia*, vol. 2), 1902, p. 68, fig. 74; H. Mühlestein, *Die Kunst der Etrusker*,

Berlin, 1925, pp. 197 f., with bibl. (without recognizing the Sirens as such), figs. 88 f. For astrological bracelets, see H. Gressmann, *Die hellenistische Gestirnsreligion*, Leipzig, 1925, p. 21.

11 A Siren leads the chariot of apotheosis to the other world on an Etruscan ring: Roscher, *Ausf. Lexic. der griech. u röm. Mythologie*, 1909–15, IV, p. 613 fig. 5 on p. 611.

12 See the well-known Marduk seal (9th cent. B.C.): R. Eisler, *op. cit.*, p. 60, fig. 6; E. Unger, *Babylon*, Berlin, 1930, p. 210. Can this use of floral motifs possibly be connected with the idea of the astral trees on top of the cosmic mountain? See O. Jeremias, in Roscher, *op. cit.*, IV, pp. 1492 f.; Ps. Calisthenes, *Alexander*, ch. 3.

13 L. Curtius, *Röm. Mitt.*, L, 1935, pp. 348 f., with bibl. For the ceiling of the southern adytum which also has a flat cupola in the center (not indicated by Dr. Schulze in Th. Wiegand, *Palmyra*, Berlin, 1932, pl. 83), see K. A. Creswell, *Early Muslim Architecture*, Oxford, I, 1932, pp. 138 f., fig. 87. The meander instead of the zodiac frame of this cupola points to another decoration. But from Cresswell's photograph it would seem likely to be a kind of canopy (see also Schulze, *op. cit.*, pl. 71).

14 *Op. cit.*, pp. 352 f. Bianchi-Bandinelli (*op. cit.*) was certainly right in rejecting any direct connection between the Etruscan use and the Platonic idea which would revive the ghost of "orphism." But such a motif cannot be purely decorative.

15 Gayet, *op. cit.*, I, p. 21.

16 N. Ponce, *Arabesques antiques des bains de Livia et de la Villa Adrienne*, Paris, 1789, pl. 5. See above, p. 234 f. and note 38 below.

17 They are probably stars: compare Fig. 8, p. 246 above, and note 153.

18 See above, p. 235, and note 39.

19 K. Jex-Blake and E. Seller, *The Elder Pliny's Chapters on the History of Art*, London, 1896, pp. 150 f.; E. Pfuhl, *Malerei und Zeichnung der Griechen*, Munich, 1923, II, pp. 731 f.; K. v. Lorentz, in Thieme-Becker, *Künstlerlexicon*, s.v. Pausias; A. Reinach, *Recueil Millet*, Paris, 1921, pp. 256 f. and pp. 30 f., note 9.

20 M. Rostovtzeff, *Ancient Decorative Wall Paintings in Southern Russia* (Russian), St. Petersburg, 1914, pls. 7 (fig. 2), 8. I see no reason whatsoever to relate Aristoph., *Wasps*, 1215 and Diphilos, *Comic. Graec. fragm.*, ed. Meinecke, p. 1082, note 2, 1–2, to a figured decoration on a ceiling.

21 Rostovtzeff, *op. cit.*, pl. 9, figs. 5–6.

22 The most important painted ceilings aside from those in Etruria and Southern Russia are the few early Hellenistic examples from Alexandria: R. Pagenstecher, *Nekropolis*, Leipzig, 1919, pp. 168 f.

23 A coffered ceiling with relief busts, one in each coffer, is known from the pronaos of the Serapeion in Miletos (3rd century A D.): Th. Wiegand, *Miletos*, I, 7, Berlin, 1924, pp. 97 f. For Pompeii see: J. Overbeck and A. Mau, *Pompeii*, 4th ed., Leipzig, 1884, p. 349. Phyllis Williams definitely discards the old theory that some coffer-like slabs with relief busts from the decoration of the New Temple in Samothrace (last discussion: F. Chapouthier, *Les Dioscures au service d'une déesse*, Paris, 1935, pp. 177 f.) belong to a ceiling. Whether the relief from Khirbet Tannur showing a bust of Atargatis as a celestial goddess, with a crescent symbol on the ground, and a zodiac frame, belongs to a ceiling (or to a pediment), I am unable to say. In the former instance, it would represent a reduced form of the Palmyra type. In any case, it was inspired by a similar ceiling. See Nelson Glueck, *The Other Side of the Jordan*, New Haven, 1940, p. 192, fig. 122, and *A.J.A.*, XLV, 1941, p. 339, fig. 2.

24 See above, p. 238 f.

25 W. Gundel, *Dekane und Dekansternbilder* (*Studien der Bibl. Warburg*, 19), Hamburg, 1936, pl. II, p. 182; F. Boll, *Sphaera*, Leipzig, 1903, pp. 159 f.; idem, *Sternglaube und Sterndeutung*, Leipzig, 1926, pl. I, fig. 2; C. Ricci, *op. cit.*, fig. 15.

26 Gundel, *op. cit.*; Boll, *Sphaera*, pp. 9 f., 295 f., 303 f., pls.; Roscher, *op. cit.*, IV, p. 1492. For astrological manuscripts, see F. Saxl, *Sitz. Ber. Heidelb. Akad. Phil.-Hist. Kl.*, 1925/6, fasc. 2.

27 For Dodekaoros: Roscher, *loc. cit.*; Boll, *Sphaera*, pp. 295 f.

28 W. Flinders Petrie, *Athribis*, London, 1908, pls. 26 f.
29 *Op. cit.*, pp. 349 f., fig. 2; *Déscription de l'Afrique du Nord, Cat. du Musée Alaoui* (Gauckler and La Blanchère), Paris, 1897, pl. I, no. 10.
30 L. Curtius, *op. cit.*; C. R. Morey, *Early Christian Art*, Princeton, 1942, pp. 31 f. See a mosaic from Terano with the representation of a coffered ceiling on the floor (1st cent. B.C.), *Mem. Am. Ac. Rome*, VIII, 1930, frontispiece. A mosaic in Piacenza shows a particularly interesting example of the representation of a dome with a cornice on which birds are perched around a central opening: through this opening the constellation of the lyre appears in the sky: *ibid.*, p. 110, pl. 39, fig. 2.
31 See above, note 27.
32 B. Nogara, *I Musaici antichi nei Palazzi Pontifici*, Milan, 1910, pl. 53; C. Cecchelli, *op. cit.*, pp. 49 f. W. de Grueneisen, *op. cit.*, pl. 3, fig. 5; C. Ricci, *op. cit.*, fig. 16. From Villa Rufinella, Tusculum. Outer spandrels modern. One might be tempted to recognize a "shield" as the round forms of ancient mosaic floors are often called. But the relationship to the corner figures leaves no doubt in this case, in spite of the fact that shields with representations of heaven have their own long history: O. Brendel, *Antike*, XII, 1936, pp. 272 f.
33 Compare pp. 235, 243 f., and Figs. 10 and 45.
34 See for general discussion and bibl. J. Carcopino, *Etudes romaines*, I, Paris, 1925.
35 *Bull. commun.*, LXII, 1934, pp. 115 f.
36 Above, pp. 240, 242, 243. See also note 207.
37 *Bull. commun., loc. cit.*
38 Ponce, *op. cit.*, pls. 5, 9; P. Gusman, *La villa impériale de Tibur*, Paris, 1904, pp. 234 f.; figs. 344, 346. K. Ronczewski, *Gewölbeschmuck im römischen Altertum*, Berlin, 1903, pp. 22 f., questioned whether the dome of Ponce's drawings belonged to Hadrian's Villa. The only recent writer on this subject, F. Wirth, *Röm. Mitt.*, XLIV, 1929, pp. 125 f. (also *Römische Wandmalerei*, Berlin, 1934, pp. 74 f.) has rejected these drawings as not belonging to Hadrian's Villa without any sensible reason. The basis for this is the fact that the complicated patterns of these ceilings do not fit his oversimplified theory of Hadrianic style as his theory, in turn, would not fit the upright ruins of such complicated structures as the Piazza d'Oro and the Little Palace there. This theory which is a crude transfer to Roman art of the antithetic categories of H. Wölfflin, eliminates everything which does not fit into the scheme. Wirth's statement that the decorations mentioned in old writers (with the exception of those drawn by Ponce or Bartoli, who, to be sure, was somewhat less reliable) are still recognizable (*Röm. Mitt., loc. cit.*, p. 125) is contradicted (though this has been skillfully camouflaged) by the evidence which he himself gives. The fact is that, of the five places where Piranesi indicates stucco ceilings, only one entire ceiling, and a fraction of a second are now preserved. One of these was also drawn by Ponce (*op. cit.*, p. 141). The destruction of numerous decorations between Piranesi and Ponce, on the one hand, and Penna (1831), on the other, is certain. Because a circle is allegedly not classicistic, Wirth (*Wandmalerei*, p. 76) declares that there were no circle patterns in Tivoli. As he nevertheless finds one himself, he attributes it to later restoration! His statements about the development of vaulted construction are so obviously wrong that they do not require discussion.
39 Jupiter, Mars, and Venus are easily recognizable. The fourth figure (between Mars and Venus), a half nude woman with her left arm raised while a bird approaches from her right, can hardly be any other than Leda as the Moon Goddess. Ponce, not clearly recognizing the bird, made it a peacock, which, as Juno's bird, would be incompatible with the nudity of the figure.
40 Ponce, *op. cit.*, pl. 9; Gusman, *op. cit.*, p. 235, fig. 346.
41 See K. Lehmann-Hartleben and E. Olsen, *Dionysiac Sarcophagi in Baltimore*, Baltimore, 1942, pp. 48 f. Compare also pp. 233 and 243, and Figs. 8 and 45.
42 See note 27.
43 See above, note 41.
44 The four horae-seasons and the horae-hours occur in one and the same heavenly painting centuries later in the cupola of the Bath in Gaza: see above, p. 252, and Fig. 63.

45 E. Maass, *Die Tagesgötter*, Berlin, 1902, pp. 143 f.; Gundel, *op. cit.*, p. 182. The translation above and the resulting interpretation differ from that of Maass and Cary (Loeb ed.). They translate the last sentence: "for this portion he had not depicted in the same way in both rooms." The Greek text is: "τοῦτο γ ὰρ οὑτὸαὑτὸ ἐκατὲρωθι ἐνετύπωσεν." The verb used differs from ἐνέγραψεν which is used before for ceiling decoration, and it points to a different technique, relief, instead of painting. In addition, a difference of place is indicated by the contrast between that part which people could see, and that which is "excepted" from the view of the spectators facing the tribunals. A change in the representation of that section of the sky would not have made it "invisible" to them.

46 *Vita Constantini*, 3, 49. The cross was a *crux gemmata* on gold ground in the dominating central unit of a coffered ceiling, possibly a dome. M. Sulzberger, *Byzantium*, II, 1925, p. 418, however, thinks that this was an actual object, i.e. a labarum, an interpretation which the text does not allow.

47 P. Friedländer, *Johannes von Gaza und Paulus Silentarius*, Leipsiz, 1910, p. 188; A. Muñoz, *L'arte*, XI, 1908, p. 441; G. Krahmer, *De Tabula Mundi ab Joanne Gazaeo descripta*, Diss., Halle, 1920, p. 57. For the vault in Albenga (Fig. 11) and related motifs, see Morey, *op. cit.*, pp. 145, 273 with bibl.

48 G. Krahmer, *op. cit.*, p. 3.

49 Th. Schmit, *Die Koimesiskirche von Nikaia*, Berlin, 1927, pl. 28.

50 See J. Ch. Webster, *The Labors of the Months*, Princeton, 1938. For the calendar element in cupola decoration, see below, pp. 242 f. The relationship of the calendar picture to astrological representation is common: Petronus, *Cena Trim.*, 30. Here, as well as in an incised calendar from the region of the Golden House, the planets are combined with the calendar. In the Golden House, they appear as busts over a circle with a central rosette and the radial fields of the zodiac (compare Figs. 3, 9, 15, 16): K. W. Kubitscheck, *Grundriss der antiken Zeitrechnung*, Munich, 1928, p. 30 with bibl.

51 For the calendar significance of the Early Christian mosaics in the dome of St. George in Saloniki, see Morey, *op. cit.*, p. 143.

52 Webster, *op. cit.*, p. 119, pl. 2; *Antioch on the Orontes*, II, Princeton, 1938, pl. 52, no. 71 Panel E. The bearded bust in the center may be Saturn, Jupiter, or Annus.

53 F. Quilling, *Westdeutsche Zeitschrift*, XX, 1901, pp. 114 f., pl. 3.

54 Compare also the relief from Khirbet el Tannur, above, note 23.

55 E. L. Sukenik, *The Ancient Synagogue of Beth Alpha*, Jerusalem, 1932, pp. 35 f., pls. 10 f. (also for the similar mosaic of the Naaran synagogue); *idem, Ancient Synagogues in Palestine and Greece*, London, 1934, pp. 28 f.; R. Wischnitzer-Bernstein, *Gestalten und Symbole der jüdischen Kunst*, Berlin, 1935, pp. 127 f. G. M. Hanfmann, *Latomus*, III, 1939, p. 112. For mediaeval zodiac mosaic floors, see P. Clemen, *Romanische Monumentalmalerei in den Rheinlanden* Düsseldorf, 1916, p. 167. For astrological manuscripts, F. Boll. *Sternglaube*, p. 8, fig. 15.

56 *Inventaire des mosaiques, Gaule*, 203, Paris, 1909–11. For the sphere of heaven with crossed rings, see O. Brendel, *Röm. Mitt.*, LI, 1936, pp. 55 f. A developed scheme with radial fields around a central section occurs in several catacomb paintings of the 3rd century: Wilpert, *op. cit.*, pls. 55, 96.

57 *Architettura ed arti decorative*, II, 1922, p. 18. Here the sphere is only partially visible and over it hangs a canopy. Cecchelli, *op. cit.*, p. 14, not knowing the antecedents, was unable to make sense out of this and suspected the 17th-century draughtsman of misinterpretation.

58 *Inventaire des mosaiques, Algérie*, 41.

59 Compare for this motif, Alda Levi, *La patera di Parabiagio*, Rome, 1935, pls. 1–5, pp. 8 f; G. Calza, *La necropoli del porto di Roma*, Rome, 1940, pp. 183 f., fig. 92. Dr. Doro Levi tells me that with others he is inclined to interpret the figure not as Annus but as Aion and that he will submit evidence for that interpretation in a forthcoming study.

60 Wilpert, *op. cit.*, pl. 72.

61 Th. Wiegand, *Palmyra*, Berlin, 1932, pl. 44 (upper right figure).

62 The question arises whether the motif is derived from oriental prototypes: on a stele of Gudea (*Mon. Piot*, XII, 1909, pl. I) an enormous disk with similar projections on the periphery is supported by two flanking demons. Heuzey's (*ibid.*, p. 12) explanation as a chariot wheel is less convincing than that of those who "rêveront d'un emblème solaire." This fringed edge later left its traces, in many cases in arches or garlands surrounding the periphery of the celestial circle; see our Figs. 5, 10, 29, 31, 39, 42, 46, 50. See also the central veil of the Tomb of Hermes (*Not. sc.*, 1923, pl. 14; Wirth, *Wandmalerei*, pl. 50; Tomb of the Nasonii: *Jahrb. arch. Inst.*, XXV, 1910, Beilage 2). On the other hand, the curious arched fields with the planets' children in the Brindisi planisphere (above, note 25) may be derived from this edge with its little arches.

63 Compare a rainbow border in the mosaic of Casaranello (Wilpert, *Mosaiken*, pl. 108) and Iris supporting the rainbow in the cupola decoration described by John of Gaza: above, p. 252, and Fig. 63.

64 Th. Schmit, *Kahrie Djami* (in Russian, 1924), Munich, 1906, pl. 24.

65 *Germania Romana*, 2nd ed., II, pl. 8, fig. 2.

66 See V. Chapot, in Daremberg and Saglio, *Dictionnaire*, Paris, 1897–1917, *s.v. velum*, pp. 676 f.; G. Rodenwaldt, "Cortinae," *Nachrichten der Göttinger Gesellschaft der Wissenschaften, Phil.-hist. Kl.*, 1925, pp. 37 f.

67 M. Rostovtzeff, *op. cit.*, pl. 25, fig. 2; R. Pagenstecher, *Nekropolis*, Leipzig, 1918, p. 181, fig. 111. See in general, *ibid.*, pp. 173 f.

68 From Die; *Inventaire des mosaiques, Gaule*, 131. For connections with ceilings, compare the decoration of a vault of the church of the monastery in Gurk (13th cent.) in W. Borrmann, *Aufnahmen mittelalterlicher Wand- und Deckenmalereien in Deutschland*, Berlin, 1897/8.

69 *Loc. cit.* For Southern Russia, M. Rostovtzeff, *op. cit.*, pl. 14.

70 F. Wirth, *op. cit.*, p. 69, fig. 30.

71 For these, see bibl., below, note 248.

72 K. F. Boetticher, *Tektonik der Hellenen*, 2nd ed., Berlin, 1874, I, pp. 259 f.; F. Studniczka, *Das Symposion des Ptolemaios IV*, Leipzig, 1915, pp. 27, 49 f.

73 Hesych, *s.v.* οὐρανόζ. Πέρσαι δὲ τάζ Βασιλείουζ σκηνάζ καὶ αὐλάζ, ὧν τὰ καλύμματα κυκλοτερῆ οὐρανούζ (ἐκάλουν).

74 Dio Cass., *Hist.* LXIII, 2.

75 Compare Figs. 10, 14, 15. The motif of the sun-chariot already occurs in the carpet used by Ion for the ceiling of his tent; see above.

76 *Nat. Hist.*, XIX, 6, "Vela colore coeli stellata . . ."

77 P. 229 and note 8, and for red carpets over the compluvia of Roman houses, Ovid, *Met.*, X, 595; Chapot, *loc. cit.*

78 Photo Deutsches archaeol. Inst. Rom., neg. 1930, 516. See R. Pagenstecher, *loc. cit.*; E. Strong, *Apotheosis and After-life*, London, 1915, pp. 175 f., pl. 23.

79 W. de Bock, *Matériaux pour servir à l'archéologie de l'Egypte chrétienne*, St. Petersburg, 1901, pl. 15; W. de Grueneisen, *op. cit.*, pl. 21.

80 Gayet, *op. cit.*, I, pls. 22, 23 D.

81 E. Gerhard, *Etruskische Spiegel*, IV, Berlin, 1867, p. 106, pl. 355; M. Bratschkova, *Bull. Inst. arch. Bulgare*, XXI, 1938, p. 23, fig. 9, p. 122, no. 885. The artist clearly intended to represent the interior of a building with columns supporting a dome. Sections of the walls are visible at the two sides. See above, p. 249, note 176. What Gerhard interpreted as triglyphs are the ends of beams which support the flat ceiling over the ambulatory. The roof which is not seen in the picture would presumably be conical.

82 Examples, aside from those mentioned above in the text: Pompeii, Stabian Baths (alternating with circular fields), Ronczewski, *op. cit.*, pl. 25; Pompeii, arch of tomb, *ibid.*, p. 32, fig. 19; Palatine, A. Cameron, *The Baths of the Romans*, London, 1782, pl. 58; Golden House, *ibid.*, pl. 64, Ponce, *Description des bains de Titus*, Paris, 1786, pl. 57; Tomb of Hermes, above, note 59; our Figs. 5, 25, 27, 35, 54, 62. Six corners, Tomb of the Pancratii, *Memoirs Am. Ac. Rome*, IV, 1924, pls. 25 f., San Sebastiano, *ibid.*, pls. 28 f. Interestingly enough, one such ceil-

ing of the early 2nd century A.D. is known from Alexandria: Pagenstecher, *op. cit.*, pp. 193 f., fig. 112. The more reduced square with only four corners is rare: *Pap. Brit. Sch. Rome*, VII, 1914, pl. 16, p. 32, n. 15, our Fig. 42; Golden House (oblong, with only two concave edges), Ponce, *Description*, pls. 18, 24. A somewhat hybrid adaptation also occurs in the Golden House (Cameron, *op. cit.*, pl. 62) and later in the Tomb of the Nasonii (above, note 62). The motif is confounded with the similarly edged aegis in the mosaic floor. Nogara, *op. cit.*, pl. 15 (2nd cent. A.D.).

83 *Not. sc.*, 1934, p. 329, pl. 12.

84 Bartoli, Appendix to *Picturae antiquae*, Rome, 1791, pl. 6; Cameron, *op. cit.*, pl. 59; Ronczewski, *op. cit.*, p. 35, fig. 22; A. B. Cook, *Zeus*, III, Cambridge, 1940, p. 39, pl. 5.

85 Demus, *op. cit.*, fig. 28; Gayet, *op. cit.*, I, pl. 23. See also T. Ebersolt, *Mon. Piot*, XIII, 1906, pl. 57.

86 Whether the strange rayed symbol (of the sun?) on the stucco ceiling of the house near the Villa Farnesina (Ronczewski, *op. cit.*, pls. 10, 11; E. L. Wadsworth, *Mem. Am. Ac. Rome*, IV, 1924, pp. 23 f.) has any connection with this type, I cannot say. Heavenly elements evidently form the main subject of this ceiling too: E. Petersen, *Röm. Mitt.*, X, 1895, p. 67; Ronczewski, *op. cit.*, p. 27. J. Lessing and A. Mau, *Wand- und Deckenschmuck eines römischen Hauses*, Berlin, 1891, pls. 13 f.

87 Bartoli, Appendix, *op. cit.*, pl. 2; Cameron, *op. cit.*, pl. 65; Ronczewski, *op. cit.*, p. 12, fig. 8. Similar: Cameron, *op. cit.*, pl. 60.

88 Wilpert, *op. cit.*, pls. 29 f. A similar motif in a catacomb painting of the 4th century, idem, *Roma sotterranea*, Rome, 1903, pl. 210.

89 Ponce, *op. cit.*, 1786, pl. 2; Gusman, *op. cit.*, p. 236, fig. 352.

90 Morey, *op. cit.*, pp. 142 f., with bibl.

91 E. W. Anthony, *A History of Mosaics*, Boston, 1935, pls. 61, 62; M. E. Isabelle, *Les édifices circulaires et les dômes*, Paris, 1855, pl. 52. For chronology see R. v. Marle, *The Development of the Italian Schools of Painting*, I, The Hague, 1923, pp. 265 f. (with incorrect description). For the motif, see also the center of the vault in Anagni: P. Toesca, *Affreschi decorativi in Italia*, Milan, 1917, pl. 22.

92 Colasanti, *op. cit.*, pl. 59.

93 *Ibid.*, pl. 101.

94 Ronczewski, *op. cit.*, pl. 26. This part of the decoration almost certainly belongs to a late fourth style restoration.

95 House of Mosaic Triclinium. Photo Alinari 43125.

96 Ponce, *Description*, pls. 7, 8. Photo Alinari 27097 shows the apse in its entirety with what is preserved of the painting. Compare also the quarter sections of such canopies in the lateral fields, above, Fig. 28. According to Mazois, *Les ruines de Pompéi*, III, Paris, 1836, pl. 48, fig. 3 (see Niccolini, *Case e monumenti di Pompei, III, Terme presso l'arco della Fortuna*, pl. 2), the niches of the frigidarium in the Forum Baths had similarly hybrid "shells" with embroidered sea monsters.

97 Herrmann and Bruckmann, *Denkmäler der Malerei des Altertums*, Text, I, Munich, 1904, p. 257, fig. 77; M. Bratschkova, *op. cit.*, pp. 11, 84, fig. 4.

98 For this fusion, see Bratschkova, *op. cit.*, pp. 30 f., 55, 81 f., with more examples and a full discussion of the later development.

99 See, for the material, *ibid.*, pp. 44 f., 70 f., 86 f. In the discussion these motifs have not been sufficiently distinguished.

100 Wilpert, *Mosaiken*, I, p. 362, fig. 114. For other examples of the simple canopy: Lateran, Baptistery (4th cent.), *ibid.*, pl. 1; Forum Claudium, É. Bertaux, *L'art dans l'Italie méridionale*, Paris, 1904, I, pl. 13; Santa Maria in Trastevere (12th cent.), A. Agazzi, *Il mosaico in Italia*, Milan, 1926, fig. 22.

101 Wilpert, *op. cit.*, I, pls. 121–122. For other examples of the canopy with shell edge: Ravenna, San Apollinare Nuovo, *ibid.*, pls. 100, 2; Santa Francesca Romana, Parenzo, Gayet, *op. cit.*, II, pl. 15; San Clemente, Wilpert, *op. cit.*, pls. 117 f. (with candelabra supports of the projections, cf. our Figs. 27, 29).

102 (a) Pompeii, Fig. 54; (b) Domus Aurea: Cameron, *op. cit.*, pl. 60 (small Sirens perched on the picture panels of the center of each side and giving additional support to the central canopy); (c)? Domus Aurea: on the diagonal supports of the central circle of the Volta Dorata, according to the less reliable reproduction by Minni (Ponce), *Jahrb. arch. Inst.*, XXVIII, 1913, p. 169, fig. 15; (d) Villa of Hadrian: Ponce, *op. cit.*, pl. 10 (in the diagonal foliated supports).

103 Examples: (a) Naples, San Giovanni in Fonte, Fig. 30; (b) Ravenna, Mausoleum of Galla Placidia: in corners of vault, best ill. *Boll. d'arte*, VIII, 1914, fig. 55, opp. p. 142, C. Ricci, *op. cit.*, I, pl. 1A; (c) *ibid.*, Palace Chapel: between the corner supports, fig. 44; (d) Palermo, Martorana: A. Colasanti, *L'arte bisantina in Italia*, Milan, 1914, pl. 32 (in the squinches of the cupola), like a; (e) Windischmatrei: Fig. 51, supporting the central disk; (f) Pürgg: Fig. 52; (g) Civate: P. Toesca, *La pittura e la miniatura nella Lombardia*, Milan, 1912, pp. 107 f. (around a disk with the monogram of Christ). For evangelists supporting the celestial sphere in manuscripts, see W. Weisbach, *G.B.A.*, LXXXI, 1939, p. 136.

104 Above, p. 230.

105 Munich, Cod. Lat. 4454, G. Leidinger, *Miniaturen und Handschriften der Bayerischen Staatsbibliothek*, VI, Munich, n.d., pl. 13, pp. 27f.; Weisbach, *op. cit.*, p. 140, fig. 5, p. 144. I see no reason to connect these Sirens with the rivers of Paradise. The poem mentioning them does not refer to other elements of the picture such as Sun, Moon, Oceanus, Caelus. Although it refers to the symbols of the evangelists and their association with those rivers, which is otherwise documented, it does not aim at interpreting all the details of the picture. For rivers of Paradise, see above, p. 246.

106 See above, pp. 244 f.

107 See E. Jastrow, *A.J.A.*, XLVI, 1942, p. 119.

108 Cameron, *op. cit.*, pl. 60; compare above, p. 241 note 87. Compare the similar position of such (unwinged) figures in a mosaic: *Inv. des mos., Gaule*, 301, and also, possibly, the supports of the central disk with Pegasos in the Tomb of the Nasonii: *Jahrb. arch. Inst.*, XXV, 1910 Beilage 2.

109 G. Dennis, *Cities and Cemeteries of Etruria Maritima*, 3rd ed., I, London, 1883, p. 448.

110 See above, note 107.

111 C. Cecchelli, *op. cit.*, p. 62.

112 Above, p. 241.

113 In this case, however, they seem to be male. The artist who designed these mosaics must have had a model, all the details of which he did not understand. This would account for the change of sex. The dependence on such a model is indicated by the strange position of the wings growing from the elbows.

114 Anthony, *op. cit.*, pl. 60.

115 Cameron, *op. cit.*, pl. 60 (over winged busts emerging from chalices, above, note 108, and between Sirens, above, note 102). A lost Roman ceiling from a tomb in Alexandria should possibly be included too: R. Pagenstecher, *op. cit.*, pp. 181 f.

116 *Pap. Brit. Sch. Rome*, VII, 1914, pl. 16, p. 32, no. 15.

117 Wadsworth, *op. cit.*, pls. 25 f. Here in each case six of them support the lateral carpets which are decorated with mythological scenes and grouped around a central field with a canopy with a celestial picture. In the outer corners of the entire cross-vault allegories of the four seasons appear.

118 Ravenna, Archbishop's Chapel: Wilpert, *Mosaiken*, pl. 91; Galassi, *op. cit.*, pl. 64; Ricci, *Monumenti*, V, pl. 41; Morey, *op. cit.*, fig. 169, p. 276, *Ibid.*, and p. 29, Professor Morey connects these angels with the Victories holding *clipei* over their heads from the well-known tomb in Palmyra and from Dura (not an oriental, but a common Roman type: see F. Staehelin, *Die Schweiz in römischer Zeit*, 2nd ed., Basel, 1931, p. 212, fig. 46). This type is, of course, related in a general way. However, the use of four such supports in Christian vaults is undoubtedly directly derived from similar Roman ceilings. Other examples in the pendentives of the Pentecost cupola in Venice, Fig. 68, and flying, in the central dome there: Demus, *op. cit.*, fig. 12. This type occurs in reduced form in the cupola of the Martorana in Palermo,

above, note 103. Kneeling angels supporting the disk with the bust of Christ between corner medallions with the symbols of the evangelists: M. Nugent, *Affreschi del trecento nella Cripta di S. Francesco ad Posina*, Bergamo, 1933, pls. 90 f. At least one such angel supporting a sphere (according to Friedländer's reconstruction, *op. cit.*, pp. 195 f., which, in this part, seems to me to be preferable to that of Krahmer) occurred in the cupola decoration described by John of Gaza. Again, the chorus of angels in the arcades over which the awning of the cupola of the Baptistery in Florence (Fig. 32) is suspended is derived from this old tradition. See also for the motif: J. Ebersolt, *Mon. Piot*, XIII, 1906, p. 38, fig. 3, note 1, pls. 26–27; Anagni: P. Toesca, *op. cit.*, pl. 22.

119 Constantinople, Hag. Sophia, pendentives of the dome; Kiew, vault of Hag. Sophia; Venice, San Marco, cupola of the Creation.

120 For the best illustrations in which the above mentioned detail can be distinguished: Galassi, *op. cit.*, pls. 73 f. Compare also A. Blanchet, *La mosaïque*, Paris, 1928, pl. 13. For restorations: C. Ricci, *op. cit.*, VI, 1935, pl. 46. Two of the spheres are preserved in their original state and show the difference in the lighted areas. The two others (those at the sides of the Lamb) are antique restorations. Two of the corner globes are also preserved in the original state. A third one is partly ancient, partly restored in antiquity. Only one is modern. This is sufficient to show that the differentiation belongs to the original state.

121 Galassi, *op. cit.*, pl. 115; A. Agazzi, *Il mosaico in Italia*, Milan, 1926, fig. 4.

122 A. Colasanti, *L'arte bisantina in Italia*, Milan, 1912, pl. 95.

123 Above, p. 235, note 41.

124 Compare the *Creation of the Firmament* in Monreale: D. Gravina, *Il duomo di Monreale*, Palermo, 1859, pl. 15 C.

125 G. Krahmer, *op. cit.*, p. 4.

126 R. v. Marle, *op. cit.*, I, p. 224.

127 Weisbach, *op. cit.*, pp. 131 f., 136.

128 See above, pp. 230, 235. Dancers on pedestals occur between the supporting diagonal Sirens (above, note 102) in another vault from Hadrian's Villa (Ponce, *op. cit.*, pl. 10), in which the central carpet shows the four seated Seasons around a rosette.

129 Ceilings: Palatine, Cameron, *op. cit.*, pl. 57; Via Latina, above, note 117. Mosaic floors: La Chebla, *Inv. des mos.*, *Tunisie*, 86; Hippone, Fig. 18.

130 Ponce, *op. cit.*, pl. 10, see above, note 128. Four seated Seasons occur in the outer spandrels of the calendar mosaic from Carthage, see above, note 50.

131 G. M. Hanfmann, *loc. cit.*

132 Other examples: (a) Golden House, in the spandrels of an inner carpet with the representation of Hercules and Bacchus: Cameron, *op. cit.*, pl. 62; above, note 82; (b) Tomb, 2nd cent. A.D.: Bartoli, *Pitture*, pl. 14, with interesting connections: the central circle is characterized as the opening of a dome from which four diagonal crowns are suspended and the edge of which has preserved a remnant of the fringed outline (above, p. 238, note 62); (c) Ostia, tomb: G. Calza, *Necropoli*, pl. 1, figs. 66 f. Although most of the other pagan elaborations are absent in the catacomb ceilings, this less conspicuous element has been retained in some of them: for example, Wilpert, *Roma sotterranea*, pl. 100.—Reflections on mosaic floors: Calendar mosaic from Antioch, Fig. 13; Phaeton mosaic, *Mon. Piot*, XXI, 1913, pl. 9.

133 Boll, *Sternglaube*, pl. 8, fig. 15. It may also be recalled at this point that masks of the four winds occasionally fulfill a similar function on ceilings: (a) Pompeii, Ronczewski, *Gewölbeschmuck*, pl. 29; (b) Hadrian's Villa, Fig. 29; (c) Tomb of Via Latina, above, notes 117, 129 (in the corners of the central field). This type, too, recurs in astronomical illustration, this time in the famous Bianchini marble planisphere: Boll, *op. cit.*, pl. 15, fig. 28.

134 Wilpert, *Mosaiken*, pls. 86 f.

135 Blake, *Mem. Am. Ac. Rome*, XIII, 1936, pl. 41, fig. 4.

136 Another reflection of a celestial ceiling with a star in the center of the round canopy and diagonal corner-trees occurs in a mosaic floor from Gaul: *Inv. des mos.*, *Gaule*, 291.

137 C. Cecchelli, *Architettura*, p. 55.

138 Vitruvius, *De arch.*, VI, 7, 6.

139 The mosaic is found in a thermal hall of the so-called "magazzini republicani": described by G. Calza, *Ostia, Guida*, Milan, n.d., pp. 88 f.; *idem*, 2nd ed., pp. 91 f., fig. 29. Illustrated: *idem, The Excavations at Ostia*, Milan, n.d., fig. 4; *idem, Ostia (Itinerari dei musei)*, Rome, n.d., p. 19, fig. 5. For the date (2nd half of 3rd cent. A.D.), see H. Bloch, "Bolli laterizi," *Bull. com.*, LXVI, 1938, p. 279.

140 The motif of the city wall in mosaic floors has its own long history: R. Herbig, *Germania*, 1925, pp. 138 f.; M. Blake, *Mem. Am. Ac. Rome*, VIII, 1930, pp. 73 f., 106; *ibid.*, XIII, 1936, p. 189. In this case, however, the floor reflects a vertical succession from the edge toward the center: marine divinities and swimmers form the outer frieze; chariots on land follow; the city supported by figures over columns is clearly in the air. I have no explanation to offer.

141 See, however, below, note 207.

142 It is this connection with the universe, of course, and not a purely "poetical" reason which motivated his presence in the mechanical clock described by Procopius of Gaza: H. Diels, *Abhandl. Akad. Berl., Phil.-hist. kl.*, 1917, p. 15.

143 See above, p. 246, note 153.

144 Ronczewski, *op. cit.*, pl. 29 (diagonally placed in the four corners to which the central canopy is fastened by candelabra). A mosaic from a tomb of the 2nd cent. A.D. (Bartoli, *Sepolcri*, Rome, 1765, pl. 18) shows four dancers with flutes, two of them wearing pointed caps, moving in acanthus foliage around a central motif which looks as if it had included a globe which Bartoli misunderstood: compare, for this mosaic, H. Goldman, *A.J.A.*, XLVII, 1943, p. 28.

145 E. Q. Giglioli, *L'arte etrusca*, Milan, 1935, pls. 388, fig. 4, 389, figs. 1–2, p. 72, with bibl. For the fourth side, see above, p. 243.

146 L. Curtius, *Röm. Mitt.*, XLIX, 1934, pp. 233 f.

147 Reproduced from Bartoli in Ronczewski, *op. cit.*, p. 38, fig. 24.

148 *Musée d'Alger (Description de l'Afrique du Nord, 21)*, Paris, 1928, pp. 83 f., pl. 13, fig. 2. Compare also the diagonal supporting giants in a slightly earlier mosaic floor from Great Britain, whose pattern is intimately related to ceiling decorations although its representations are of different character: Ph. Morgan, *Romano-British Mosaic Pavements*, London, 1886, pl. opp. p. 136.

149 *Rev. arch.*, I, 1922, p. 263, note 2.

150 Examples: Wilpert, *Roma sotterranea*, pls. 61, no. 1, 72, 75, 96, 203, 210.

151 In the oratorium of Santa Croce (5th cent. A.D.), four wingless young men supported the central disk with a cross according to Sangallo's drawing: Cecchelli, *op. cit.*, p. 51. A Florentine miniature, to which Richard Offner has kindly called my attention, shows a central Kosmokrator with the sun and moon in a circle from which the four major winds radiate, while twelve minor winds are seen in the spandrel-like corners: P. d'Ancona, *La miniatura fiorentina*, Florence, 1914, I, p. 5. Though the four main figures radiate outward, they have retained the posture of the raised arms typical of supporting figures. The whole layout indicates that a vault served as the ultimate model. For the rose of winds in illuminated manuscripts, compare also: *Boll. della R. Soc. Geografica it.*, XLVII, 1910, pp. 269 f. An interesting mediaeval mosaic floor in Turin connected with the same tradition of cosmic vaults shows four different stages of destiny around a circle with Fortuna on a central canopy. This circle is surrounded by medallions with animal groups. The outer frame shows Oceanus with islands. In the four spandrels are twelve medallions of winds, one major and two minor in each: *Boll. d'arte*, IV, 1910, pp. 4 f.

152 Borrmann, *Aufnahmen . . . Deckenmalerei*, II.

153 See above, pp. 230, 233, 245, notes 17, 144.

154 Borrmann, *op. cit.*, II, 7. Graus, *Mitteil. d. k.k. Central-Commission*, Vienna, XXVIII, 1902, pp. 78 f.

155 The color allows no clear decision whether the figures emerge from mountains, or, as has been suggested to me, from clouds, or from water (compare E. Kitzinger, *Early Medieval Art in the British Museum*, London, 1940, pl. 48). It seems possible that this type was inspired by the well-known type of the Birth of Mithras: for this see F. Saxl, *Mithras*, Berlin, 1931, pp. 73 f., compare pp. 82 f. To my knowledge, no Mithraic ceiling decoration has been preserved,

but it seems quite likely that images like that of the monument from Igel (H. Dragendorff and F. Krueger, *Das Grabmal von Igel*, Trier, 1924, pl. 8) and the Mithraeum of Dieburg (F. Behn, *Das Mithrasheiligtum zu Dieburg*, Berlin, 1928, pl. 2) were inspired by ceiling decorations representing the particular heaven of this religion.

156 Borrmann, *loc. cit.*: "*naciones agni praecones I. Xro. dant.*"
157 See, for example, for Achaemenid seals: A. U. Pope, *Survey of Persian Art*, Oxford, 1938, IV, pls. 123 f.
158 G. Thiele, *Antike Himmelsbilder*, Berlin, 1898, pp. 1 f.
159 P. Toesca, *op. cit.*, pp. 107 f., fig. 74. It is noteworthy that in a corresponding vault the evangelists occupy the same place; see above, note 103.
160 See above, p. 239, note 68. For rivers of Paradise and their relationship to heaven, see Weisbach, *Gaz. B.A.*, LXXXI, 1939, p. 148. Personified rivers, eight in number, two of which recline in each spandrel, occur in an interesting 3rd-century mosaic from Great Britain (Morgan, *op. cit.*, pl. opp. p. 74), which may well reflect a ceiling. Unfortunately, the representation of the central disk is lost: it included some supreme person to whom Orpheus with the animals is subordinate in the surrounding circle.
161 Compare notes 139 f., p. 245, Fig. 43.
162 See above, p. 243, note 113.
163 Cameron, *op. cit.*, pl. 57, see above, note 129.
164 Niccolini, *Case e monumenti*, II, 2, *Descrizione generale*, pl. 57; P. Gusman, *Pompéi*, Paris, 1899, p. 313; *idem*, *Mural Decorations of Pompeii*, Paris, 1924, pl. 23; Ronczewski, *op. cit.*, pls. 27, 28.
165 R. Bartoccini, *Africa italiana*, IV, 1931, pp. 48 f., figs. 16–17. I owe this information to Phyllis Bober. The rather obscure remarks of Bartoccini about the construction of the dome seem to point to a canopy form. The eagle repeatedly occurs combined with star motifs on stone lintels in Syria: *Syria*, XIV, 1933, p. 254, fig. 2; D. Krencker and W. Zschietzschmann, *Römische Tempel in Syrien*, Berlin, 1938, *passim*.
166 W. de Bock, *Matériaux pour servir à l'archéologie de l'Egypte chrétienne*, St. Petersburg, 1901, pp. 19 f., fig. 81.
167 Paris, Bibl. Nat., Ms. Gr. 510, fol. 239. H. Omont, *Miniatures des plus anciens manuscrits grecs*, Paris, 1929, pl. 14; J. Braun, *Der christliche Altar*, II, Munich, 1924, p. 192.
168 In the framework of astrological speculation, eagles occur, too, in the mechanical clock in Gaza (see note 142).
169 *Monum. ant. Linc.*, XXVIII, 1922, pl. 14, p. 338, fig. 21.
170 See above, p. 243, note 120.
171 For bibl. see: Daremberg and Saglio, *op. cit.*, *s.v. Villa*, p. 886; Cato-Varro, ed. G. Keil, II, p. 245; M. L. Gothein, *Geschichte der Gartenkunst*, I, Jena, 1914, pp. 120 f.
172 For bibl. see W. Judeich, *Topographie von Athen*, 2nd ed., Munich, 1931, pp. 374 f.
173 Thomas Jefferson, who may rightly be suspected of having read Varro's *De re rustica*, may have borrowed the idea for a mechanical version of this contraption in Monticello: "In the ceiling of the east portico is a compass of a diameter of two feet, connected with a weathervane on the roof. Here also is a clock face of the same dimensions over the door . . . he could tell the hour or the direction of the wind without leaving his chair" (P. Wilsted, *Jefferson and Monticello*, New York, 1921, p. 107; see also Fiske Kimball, *Thomas Jefferson, Architect and Builder*, Richmond, 1931, pl. 8). Attention may also be called to two of his sketches for observation towers. One shows a rounded tholus with a cloister vault in the upper story, while the other (after Stuart-Revett) follows the model of the Tower of the Winds in its octagonal form. Both culminate in a finial with a weathervane on a sphere: Fiske Kimball, *Thomas Jefferson, Architect*, Boston, 1916, figs. 38–39. See also above, p. 254.
174 See F. Boll, *Sternglaube*, pp. 100 f.; G. Kroll, *Die Kultur der Ciceronischen Zeit*, Leipzig, 1933, II, p. 14, with bibl.
175 For the alleged wooden domes of Greek tholoi, see: G. Kabbadias, *Mélanges Nicole*, Geneva, 1905, p. 611; H. Pomtow, *Klio*, XII, 1912, pp. 216 f.; H. Thiersch, *Zeitschrift für Geschichte der Architektur*, II, 1909, pp. 33 f. See, however, the critical remarks of J. Charbonneaux, *Fouilles de Delphes*, II, 4, fasc. 2, pp. 9 f., and *B.C.H.*, XLIX, 1925, pp. 158 f.

176 I refer to a group of archaic Etruscan tomb ceilings in which earlier critics (*Annali*, 1832, pp. 265 f.) have rightly recognized a "demi-voûte sphérique." See also J. Martha, *L'art étrusque*, Paris, 1889, pp. 154 f., figs. 122 f. Compare further for this type: Canina, *Etruria maritima*, I, Rome, 1846, pl. 68; Dennis, *Cities and Cemeteries*, I, pp. 274, 448; *Monumenti dell'Ist.*, I, 1829, pl. 41. The most recent and comprehensive discussion of the type is found in A. Ackerstroem, *Studien über die etruskischen Kammergräber*, Lund, 1934, pp. 26, 68, 88. Mr. Ackerstroem denies the interpretation as a wooden dome and recognizes instead the imitation of the hipped roof of a house with two apsidal ends. There are several grave objections to be raised against this theory: (a) No such house-type is known from Italy; (b) The "fan-shaped" decoration is invariably restricted to the entrance hall of the tomb and not found in the rear sections; (c) The ground plan is rectangular and the roof construction with concentric circles of horizontal rafters clearly indicates a dome above a square, a type which occurs with rudimentary pendentives even in stone constructions in later Etruscan tombs (Ackerstroem, *op. cit.*, pp. 134, 144, 153 f.); (d) As Ackerstroem's photographic illustration (fig. 6) shows particularly well, the idea of a hall with a rounded dome which, just beyond the center, is cut off by the door wall of the inner chamber, is clearly expressed by the continuing radiation of the rafters beyond the central shield in the summit. This type of wooden construction in which the upper ends of curved vertical ribs are fastened to a circular disk beneath them, explains the curious passage of Servius, *Ad. Verg., Aen.* IX, 40: "tholus proprie est veluti scutum breve quod in medio tecto est, in quo trabes coeunt." See also the central disk in the canopy of our Fig. 26. One of these early tombs in Vulci was called after its discovery "Tomba del Sole e della Luna." Ackerstroem and F. Messerschmidt, *Nekropolen von Vulci, Jahrb. arch. Inst.*, Erg. Heft, XII, 1930, p. 25, note 1, derive the name from the "fan-shaped ceiling." But this would account for only one of the two heavenly bodies attached to the tomb by this name. It seems to me that the name must have referred, like the names of the majority of Etruscan tombs, to some element of the painted decoration which soon after disappeared, as was usually the case. Could sun and moon have been painted on the disk in the center of the vault? In view of what we have seen before, this does not seem impossible.

177 (a) Fig. 58, House of Caecilius Jucundus: E. Presuhn, *Pompéi*, Leipzig, 1878, I, pl. 5; V. Steeger, *The Most Beautiful Walls of Pompeii*, Rome, 1877, pl. 5; P. Gusman, *Pompéi*, pl. 10; idem, *Mural Decorations*, pl. 11; Cook, *Zeus*, III, 1, pp. 443 f. The cupola is clearly wooden and of brown color. (b) Villa of Diomedes: Niccolini, *op. cit.*, II, 1, pl. 4, with open skylight. (c) Stabian Baths, fourth style: *ibid.*, I, 2, pl. 4, with red circular disk in center.

178 Creswell, *Early Muslim Architecture*, I, pp. 42 f., 83 f.

179 In the discussion of the development of domed construction, wooden domes are generally neglected. See, for example, R. Delbrück's otherwise very useful survey in *Hellenistische Bauten in Latium*, II, Strassburg, 1912, pp. 78 f. Neither does H. Thompson, in his fine monograph on the Tholos in Athens (*Hesperia*, Suppl., IV, 1940, pp. 42 f.), consider the possibility of a wooden dome for the later stage of that building, a solution entirely compatible with the evidence he submits. The best discussions of the development of domes are those by Creswell, *op. cit.*, pp. 304 f. (also: *Burl. Mag.*, XXVI, 1915, pp. 146 f.). See also O. Reuther, in *Survey of Persian Art*, Oxford, 1938, I, pp. 501 f. However old the construction of small domes in Egypt and the Near East may be, and however many technical contributions the latter regions may have made, the essential fact in the development of Western, Byzantine and Islamic architecture is the monumentalization of dome construction in Roman Imperial architecture, which set an entirely new standard. No large dome structures were built in the East before this influence was received.

180 A. Maiuri, *I campi Flegrei*, Rome, 1934, pp. 66 f. For a similar thermal hall near Pisa, with an oculus and eight additional skylights around it, see Cameron, *op. cit.*, p. 48 (p. 51 of the French text). The vault has ribs, which indicates that the building was not earlier than the 2nd century A.D.

181 Cameron, *op. cit.*, pl. 58.

182 Golden House, Volta Dorata: above, note 102; the purely formal analysis of the pattern of this vault by F. Saxl, *Wiener Jahrbuch f. Kunstgesch.*, II, 1922, p. 92, does not consider this connection and shows the danger of approaching such problems purely from the point of view of

"abstract" pattern. Golden House, Ponce, *Description*, pl. 57; Cameron, *op. cit.*, pl. 57. Tomb of Hermes, above, note 62. A loose adaptation is found in the tomb no. 2 Corsini (Bartoli, *Sepolcri*, pl. 6). In another ceiling from the Golden House (Cameron, *op. cit.*, pl. 64), a central canopy, framing an "eye" with a flying figure, is surrounded by eight circular minor "eyes" like those of the thermal hall near Pisa, mentioned in note 180.

183 *Bull. Soc. Arch. Alex.*, III, 1900, pls. 4, 6. See also Delbrück, *loc. cit.*

184 It has a cloister-vault buttressed by an interesting group of radial "chapels" with barrel vaults. G. Lugli, *The Classical Monuments of Rome*, Rome, n.d., p. 191, fig. 45, room 84, p. 194.

185 *Boll. d'arte*, VIII, 1914, pp. 273 f. Of particular interest is the Fontana degli Scienziati (p. 274) which shows a niche with a half canopy, and, on the upper walls around it, the perspective design of a section of a dome with decoration.

186 Sueton., *Nero*, 31: "cenationes laqueatae tabulis eburneis versatilibus, uti flores, fistulatis, ut unguamenta desuper spargerentur; praecipua cenationum rotunda, quae perpetuo diebus ac noctibus vice mundi circumageretur."

187 Creswell, *op. cit.*, p. 87.

188 See above, p. 253

189 In the text, I have given the translation of R. M. Gummere, *Seneca* (Loeb Class. Library), who correctly relates the passage in note 6 to Nero's dining hall. I have preferred, however, to translate "facies" by "appearance" instead of "pattern."

190 See above, p. 239

191 I, 25. See R. Eisler, *op. cit.* (note 9), II, p. 614; Cook, *Zeus*, I, 1914, pp. 262 f.; F. Saxl, *Wiener Jahrb*, II, p. 111. For the wheels suspended from this dome, see G. M. Nelson, *A.J.A.*, XLIV, 1940, pp. 449 f., as well as for interesting connections with the Sirens and the music of the spheres.

192 Above, pp. 236 f.

193 For bibl. see: Platner and Ashby, *A Topographical Dictionary of Ancient Rome*, Oxford, 1929, pp. 382 f. For arguments against Mommsen's theory of the Temple of the Planets, E. Maass, *Die Tagesgötter*, Berlin, 1902, pp. 287 f.; O. Weinreich, *Sitz. Ber. Heidelberg. Ak., Phil. Hist. Kl.*, 1913, 5, p. 72. For this theory: F. Boll, *Sternglaube*, p. 27; Cook, *op. cit.*, III, 1940, pp. 353, 441 f.

194 Ronczewski, *op. cit.*, pl. 3. He stresses (p. 6) the point that in construction the use of coffers to the upper edge would have advantageously reduced the weight of the top part, and he suggests (p. 10) painting in this upper section. See also G. Rivoira, *Roman Architecture*, Oxford, 1925, p. 125, fig. 140.

195 It may be noted that the common occurrence of celestial motifs on Syrian lintels (above, note 165) gives evidence of the general use of such decoration throughout the Empire.

196 Above, p. 247, note 166.

197 Kodinos, *Top.*, 18; Richter, *Quellen der byzantinischen Kunstgeschichte*, II, Leipzig, 1897, p. 256.

198 See above, pp. 233, 237 f; notes 53–55.

199 P. Friedländer, *op. cit.*; G. Krahmer, *op. cit.* The first to recognize the decoration as belonging to a dome was A. Trendelenburg, *Jahrb, arch. Inst.*, XXVII, 1912, Anzeiger, pp. 47 f. See Krahmer, *op. cit.*, p. 56. Compare above, p. 244; notes 47, 63, 125. For details, see also: G. Downey, *Antioch-on-the-Orontes*, II, Princeton, 1938, pp. 205 f., with further bibl.; G. M. Hanfmann, *Latomus*, III, 1939, pp. 111 f.

200 See above, p. 236, note 46. The scepticism of Downey, *op. cit.*, pp. 212 f. (cf. Hanfmann, *op. cit.*, p. 112) about the Christian character of this cross seems to me unjustified. I fail also to see why the relatively limited number of Christian motifs in the decoration of a non-eccesiastical structure of this period should lead to the conclusion that the work was "pagan" or based upon a pre-Christian model.

201 See above, pp. 243 f.

202 See above, pp. 231 f., 232, 235, 243 f.

203 Note the analogy with the Oceanus river along the lower edge of the cupola of Santa Cos-
 tanza, Fig. 31, and below, note 207.
204 Compare above, note 151.
205 Compare above, p. 238, note 63.
206 Compare above, p. 247, note 168.
207 Aside from the analogies found in earlier monuments and already noted, there is a curious
 description of a ceiling in a palace by Valerius Flaccus, *Argonautica*, V, 410 f.: ". . . tale
 iubar per tecta micat. stat ferreus Atlans Oceano genibusque tumens infringitur unda; at
 media per terga senis rapit ipsa nitentes altus equos curvoque diem subtexit Olympo;
 pone rota breviore soror densaeque sequuntur Pliades et matidis rorantes crinibus ignes."
 The presence of the Sun-god ascending over and behind Atlas in his chariot; of Oceanus;
 the Moon-goddess on her chariot; the Pleiades and Hyades—all connect this description
 with that given by John of Gaza five centuries later. On the other hand, the emphasis on
 the curve of the sky (curvo Olympo) points to the decoration of a dome or vault, and it may
 well be that the poet was inspired by some part of the Domus Aurea.
208 E. Herzfeld, *Jahrb. d. preuss. Kunstsammlungen*, XLI, 1920, 1, pp. 103 f.; F. Saxl, *Jahrb. für
 Kunstgeschichte*, II, 1923, pp. 102 f.
209 *Op. cit.*
210 *Op. cit.*
211 The sources are published in the articles referred to in note 208 and need no repetition here.
 For the domed structure: Al Tha'álibi, Firdausi, Cedrenus, Gregorius Monachus. Ado, prob-
 ably by error of translation, calls the structure a "tower."
212 Al Tha'álibi.
213 *Idem*, Firdausi, Cedrenus, Ado.
214 Al Tha'álibi, Firdausi.
215 *Idem.*
216 Cedrenus, Ado, Nikephoros. Ado mentions the detail that the sun appears in the classical
 form of a charioteer.
217 Nikephoros. Compare the group of Bronte and Astrape in the Gaza dome, Fig. 63.
218 Al Tha'álibi.
219 Cedrenus, Nikephoros.
220 *Idem.* Believed by Gundel, *op. cit.*, p. 182, to be the Decani.
221 Al Tha'álibi, Firdausi.
222 Al Tha'álibi. According to Firdausi, the seven planets and historical personalities were also
 on these tapestries.
223 See above, pp. 236 f.
224 See above, p. 239.
225 Flemish gobelin in Saragossa, Saxl, *op. cit.*, p. 108, fig. 75.
226 Al Tha'álibi, Cedrenus, Ado, Nikephoros, Tzetzes.
227 Cedrenus, Ado, Nikephoros, Tzetzes.
228 See above, p. 250.
229 ". . . atque per occultas fistulas aquae meatus adducunt, ut quasi deus fluvium desuper
 videretur infundere: et dum subterraneo specu equis in circuitu contendentibus circumacta
 turris fabricata [i.e. wooden] moveri videbatur. quasi quodam modo rugitum tonituri invecta
 possibilitatem artificis mentiebatur."
230 See above, p. 249, note 181.
231 Creswell, *op. cit.*, I, pp. 253 f., with bibl.; F. Saxl and A. Beer, *ibid.*, pp. 289 f. The photo re-
 produced here is from the collection of the late Professor R. Meyer-Riefstahl.
232 See, for example, Ch. Texier, *Byzantine Architecture*, London, 1864, pl. 57.
233 G. Thiele, *Himmelsbilder*, p. 43, fig. 7.
234 In this connection, it is interesting that F. Saxl, *op. cit.*, note 224, has shown that the repre-
 sentation of the dome of Quseir Amra used a convex sphere, i.e., a globe as its model.
235 W. Zahn, *Ornamente aller klassischer Kunstepochen*, Berlin, 1849, pl. 31.

236 O. Brendel, *Röm. Mitt.*, LI, 1936, p. 16.

237 I refer to the Paris Psalter (139), fol. 3a.: H. Omont, *Miniatures*, pl. 3; C. R. Morey, *Medieval Art*, New York, 1942, fig. 39. Behind Samuel anointing David, the monopteros has a vault with aegis decoration (compare Fig. 56), and on its roof between the above mentioned consoles is the heavenly sphere decorated with a disk bearing the bust of the sun. A similar structure with a sphere of light between consoles on the roof appears in Cod. Vat. Gr. I, p. 11r. (Bratschkova, *op. cit.* [note 81], p. 28, fig. 13, pp. 52, 127, no. 973a, with confused argument; this is clearly a permanent structure like the others in the picture and not a "baldachino"; the inner dome is not decorated with a shell with "Schloss oben," but, of course, with a hemispherical pattern of the canopy variety; that these structures are "Hellenistic" is by no means certain). See also *ibid.*, p. 52, fig. 37.

238 P. A. Bruce, *History of the University of Virginia 1819–1919*, New York, 1920, I, p. 270 (from Jefferson's notebook).

239 Jefferson read Dio Cassius. See above, p. 251.

240 See above, note 173.

241 Rivoira, *op. cit.*, pp. 35 f.

242 *A.J.A.*, XLIV, 1940, p. 338. I noted an apparently Hellenistic Etruscan example in the Museum of Villa Giulia, Room VIII, case 3, in a clay model of a nymphaeum which has a grotta-stone frame around the arched door and, on the opposite side, a projecting water reservoir of the type found in the Tower of the Winds.

243 See above, pp. 238 f.

244 St. Lanckorónski, *Städte Pamphyliens und Pisidiens*. II, Vienna. 1892, pl. 17.

245 Examples: Rivoira, *op. cit.*, pp. 130 f.; K. Lehmann-Hartleben and J. Lindros, *Opuscula archaeologica*, I, 1935, pp. 197 f. Tor de Schiavi is one of these domed structures and not merely an apse. It makes no sense to call its decoration a shell and there is certainly no "Schloss" above (Bratschkova, *op. cit.*, pp. 44 f., fig. 31, p. 71, no. 59).

246 If the lines of such cupola interiors be projected on a plane various patterns of the canopy type emerge, like those occurring in our decorations. The dome of the Tempio di Siepe (Rivoira, *op. cit.*, fig. 152) shows a combination of an eight sided canopy with a central circle and four smaller "eyes" similar to Fig. 27. A strange bell-shaped variety occurs in the vault of an early Imperial tomb in Pompeii (third style) and shows a decoration with stars and a central disk: Mazois, *Ruines de Pompéi*, I, Paris, 1824, pl. 28, fig. 5; pl. 29, fig. 5.

247 See Creswell, *op cit.*, II, 1940, *passim*.

248 Marcus Diaconus, ed. Bonn, p. 62, 5 f.; see H. Grégoire, in Creswell, *op. cit.*, I, p. 84: "Τὸ δὲ μέσον αὐτοῦ ἦν ἀναφυσητὸν κιβώριον καὶ ἀνατεταμένον εἰς ὕΨος." For the later church use of the term *ciborium*, see J. Braun, *op. cit.*, II, pp. 185 f. It was originally a craftsman's term describing the form of a "cup," and it corresponds here in its meaning to the Latin *cupola* used in antiquity in North African inscriptions for vaulted tombs (*Thesaurus linguae Latinae*, *s.v.*). For further connection of the altar ciborium with the canopy of heaven, see the Vision of Isaac, Braun, *op. cit.*, pp. 194 f. The terms καταπέτασμα and παραπέτασμα which also occur in Byzantine Greek for such structures, both refer, of course, to their character as canopies, which A. Heisenberg, *Grabeskirche und Apostelkirche*, Leipzig, 1908, I, p. 119 and II, p. 81, failed to recognize in a rather confused discussion. Unfortunately, no Early Christian ciborium has preserved its ceiling.

249 For bibl. see Wilpert, *Mosaiken*, I, p. 55.

250 I may recall at this point the great astronomical and astrological interest on the part of professional architects which is evident in Vitruvius' long discussion, *De arch.*, IX, 1 f.

251 Heisenberg, *op. cit.*, II, pp. 28 f.

252 Fig. 64, Venice, San Marco: Demus, *S. Marco*, fig. 2. Compare Hosios Lukas: E. Diez and O. Demus, *Byzantine Mosaics in Greece*, Cambridge, Mass., 1931, color pl. 5, p. 15, fig. 7; and, for the iconographic tradition: J. Baumstarck, *Oriens Christianus*, IV, 1904, pp. 123 f., 140 f.

253 Paris, Bibl. Nat., Lat. 1428, Sacramentary of Drogo: A. Bonnet, *La miniature carolingienne*, Paris, 1913, pl. 88.

PART III
EXTRINSIC PERSPECTIVES

ART HISTORY AND PSYCHOLOGY

Psychology of Perception and Artistic Tradition

9 Light, Form and Texture in Fifteenth-century Painting

E. H. GOMBRICH

As deeply interested in psychology and psychoanalysis and the perceptual aspects of artistic tradition as in the more established genres of art historical writing, Ernst H. Gombrich has made a substantial contribution toward a deeper understanding of both the visual arts from antiquity to the present day and the history of styles. Born in Vienna in 1909, the son of a lawyer and a pianist, Gombrich attended the lectures of Heinrich Wölfflin in Berlin (1930), of the psychologist Wolfgang Köhler, of the Classical archaeologist Emanuel Loewy, and of the art historian Julius von Schlosser at the University of Vienna, where his doctoral dissertation, "Giulio Romano as an Architect," was accepted in 1933. In 1936, he moved permanently to London and became a research assistant at the Warburg Institute. Today he serves as director of that internationally renowned institute. Since 1950 he has been an editor of the *Journal of the Warburg and Courtauld Institutes.* He has taught at Oxford, Cambridge, and Harvard universities, and since 1959 has been professor of the history of the Classical tradition at the University of London. He has lectured widely and been awarded a number of honorary degrees.

Gombrich's interests span many disciplines, not only art history but also psychology and psychoanalysis, the film, and modern mass communication. His important papers are numerous and deal with Carolingian ivories (in *Jahrbuch der kunsthistorischen Sammlungen in Wien,* n.s. VII [1933], pp. 1–14), "Achievement in Mediaeval Art" (1937), "The Early Medici as Patrons of Art" (1960), "Botticelli's Mythologies" (*Journal of the Warburg and Courtauld Institutes* VIII [1945], pp. 7–60), "*Icones Symbolicae:* The Visual Image in Neo-Platonic Thought" (*ibid.,* XI [1948], pp. 163–92), "Leonardo's Method of Working out Compositions" (1952), Giulio Romano (1934, 1935, 1950), "Moment and Movement in Art" (*Journal of the Warburg and Courtauld Institutes* XXVII [1964], pp. 293–306), "Reynolds' Theory and Practice of Imitation" (1942), caricature (with Ernst Kris, 1938 and 1940), Freud's aesthetics (in *Encounter* XXVI [1966], pp. 30–40), the "Debate on Primitivism in Ancient Rhetoric" (1966), and "Bosch's 'Garden of Earthly Delights': a Progress Report" (*Journal of the Warburg and Courtauld Institutes* XXXII [1969], pp. 162–70). Many of these as well as other papers by Gombrich have been collected and republished in his *Meditations on a Hobby Horse, and Other Essays on the Theory of Art* (London, 1963) and in his *Norm and Form: Studies in the Art of the Renaissance* (London, 1966).

By far his most revolutionary and provocative contribution is *Art and Illusion: A Study in the Psychology of Pictorial Representation* (New York, c. 1961; Bollingen paperback),

Reprinted from *Journal of the Royal Society of Arts* CXII (October 1964), pp. 826–49.

perhaps the most important addition to the historiography of art since Erwin Panofsky's *Studies in Iconology* of 1939. In his well written and widely read *Story of Art* (London, 1950), Gombrich sketched the development of representation from Classical times to the Postimpressionist era and proposed, as Aby Warburg had many years earlier, that no artist can "paint what he sees" and discard all conventions. In a much publicized essay, "Meditations on a Hobby Horse or the Roots of Artistic Form" (in *Aspects of Form; A Symposium on Form in Nature and Art*, ed. Lancelot Law Whyte [New York, 1951; Indiana paperback]; repub. in his *Meditations on a Hobby Horse*), he examines the history of representational art in the light of hypotheses and findings of studies in the psychology of perception, maintaining that all art is "image making . . . rooted in the creation of substitutes," that "an image is not an imitation of an object's external form but an imitation of certain privileged or relevant aspects . . . [of] certain privileged motifs in our world to which we respond. . . ." These ideas were elaborated and refined in his *Art and Illusion*, which was initially delivered as the A. W. Mellon Lectures in the Fine Arts in Washington, D.C., in 1956. A closely written book whose point of departure is the psychology of perception, *Art and Illusion* contends persuasively that the history of representational art is created by a specific tradition of reinterpreted images, by memory-guided responses that are conditioned by the artists' experience in the world. Changes in this tradition of images, Gombrich argues, occur when the artist checks past schema against nature, modifying and refining them in accord with his perception. Thus the origin of the work of art is to be found in an experience of other works of art rather than nature or "reality," and the story of art can be explained by this theory of making and matching. (Artists checking out books on past masters from public and university libraries is a sight familiar to art historians.)

Some perceptual aspects of the problems raised by *Art and Illusion*—problems that have caused or should perhaps cause the art historian to rethink his basic premises and theoretical presuppositions about the development of styles, one of his major interests— have been elaborated by Gombrich in his "Visual Discovery through Art" (*Arts Magazine* XL [November 1965], pp. 17–28). In his "Light, Form and Texture in Fifteenth-century Painting" (1964), which appears below, some of the methodology set forth in *Art and Illusion* is applied to specific examples of Flemish and Italian painting. The formal differences between these works, Gombrich writes, are to be accounted for rather by modifications made by the masters of the traditions of light and texture, than by the direct observation of natural phenomena, as is generally assumed by contemporary art historians. For other papers by Gombrich pertaining to these issues, see "The Renaissance Conception of Artistic Progress and its Consequences" (available in *Norm and Form*), "The Use of Art for the Study of Symbols" (*American Psychologist* XX [1965], pp. 34–50), "The Leaven of Criticism in Renaissance Art" (in *Art, Science, and History in the Renaissance*, ed. Charles S. Singleton [Baltimore, 1967], pp. 3–42), and especially the outstanding paper "From the Revival of Letters to the Reform of the Arts: Niccolò Niccoli and Filippo Brunelleschi" (in *Essays Presented to Rudolf Wittkower on His Sixty-Fifth Birthday*, ed. Douglas Fraser et al, 2 vols. [London, 1967], II, pp. 71–82).

His short paper entitled "Style" (in *International Encyclopedia of the Social Sciences*, vol. XV [1968], pp. 352–61) serves to supplement Meyer Schapiro's widely quoted essay on the same subject (orig. pub. in *Anthropology Today*, ed. A. L. Kroeber [Chicago, 1953; University of Chicago paperback], pp. 287–311; repr. in *Aesthetics Today*, ed. Morris Philipson [Cleveland and New York, 1961; Meridian Book], pp. 81–113) as well as James S. Ackerman's "Style" (in James S. Ackerman and Rhys Carpenter, *Art and Archaeology* [Englewood Cliffs, N.J., 1963], pp. 164–86). Gombrich examines the development of 19th-

and 20-century cultural history (*Kulturgeschichte* and *Kulturwissenschaft*) in a lecture, *In Search of Cultural History: The Philip Maurice Deneke Lecture 1967* (Oxford, 1969), and finds that it is enormously indebted to Georg Friedrich Hegel's metaphysical notion of the "Spirit of the Age." Especially new here is his interpretation of the widely influential writings of the Swiss historian and art historian Jacob Burckhardt (1818–97), which are said to have a Hegelian framework. (An apparently related paper, "The Logic of Vanity Fair; Alternatives to Historicism in the Study of Fashion, Style and Taste," will appear in *The Philosophy of K. R. Popper* [*The Library of Living Philosophers,* ed. P. A. Schilpp]).

The way light falls on a body reveals its form. The way the body's surface reflects the light reveals its texture. Any tyro in art who has learnt the elements of drawing is aware of this distinction. He has learnt how to model form in light and shade and he has learnt how to indicate the reflections and highlights that impart the impression of glossiness or moisture.

An old-fashioned textbook of line drawing[1] explains this difference by means of two top hats (Fig. 1).* The surface of the matt variety reveals the direction from which the light comes. It is brightest where the light falls nearest to a right angle, darkest on the opposite side. This, of course, is an objective state of affairs which depends only on the position of the object in relation to the light source. Clearly the matter is different with the shiny silk hat; the highlights you see are reflections of the light source, they are composed of little mirror images distorted by the curvature of the tissue, and the place where we see such highlights does not only depend on the position of the light source in relation to the object, but also on our own position. Strictly speaking we do not even see the highlight in the same place with both eyes. Like all mirror images these reflections appear to lie somewhat behind the reflecting surface which often gives their sheen a strangely hovering and elusive quality. The distinction to which I wanted to draw your attention was, of course, known to that great explorer of visual reality, Leonardo da Vinci. He calls it the difference between light and lustre, *lume e lustro*. Nothing fascinated Leonardo more than the subtle gradations from light to shade which can be observed when an opaque sphere is placed near a window. Several of his scientific drawings indicate the different gradations of light, the shape of the cast shadow and of what Leonardo called the "derived" shadows.[2] Another diagram in Leonardo's notes illustrates the observation: "Of the highest lights (de' colmi de lumi) which turn and move as the eye moves which sees the object. Here 'a' represents the source of light and the zone 'b' 'c' the illuminated part of the sphere. If you stand at 'd' the highlight or lustre will appear at 'c' and the nearer you come to 'a' the more will the highlight move to 'n' (Fig. 2)."[3]

As there is no telling where these wandering highlights will settle and break up the even gradations of light, it follows that *lustro* is sometimes the enemy of *lume*. Indeed in extreme cases, let us say on a polished sphere, the reflection will totally swallow up the shadows; texture will impede the perception of form.

Vital as is this distinction and commonplace as it must be to painters who are interested in natural appearances, art historians have not to my knowledge paid a great deal of attention to these various manifestations of light. And yet it is obvious that what used to be called the various schools of painting divided their attention

[1] Notes to this selection appear on page 284.
* Illustrations accompanying this selection appear on pages 493 to 495.

in very different ways. This becomes particularly clear in the fifteenth century that witnessed the conquest of appearances north and south of the Alps. Here, as everybody knows, the Florentines triumphed in the representation of form, the northerners in the rendering of texture. Take two altar paintings of the Virgin and Child with Saints painted within the same decade: the first in Bruges, the second in Florence. No illustration can hope to convey that miracle of subtlety, Jan van Eyck's *Madonna with the Canon van der Paele* of 1436 in the Bruges Museum[4] (Fig. 3), but even an inadequate image gives some idea of the range and richness of van Eyck's rendering of texture. The sparkle of the jewels on the hem of the Virgin's garments, the polish of the armour of Saint George, the stiff brocade of St. Donatian's vestments, the soft carpet with its woolly texture, the feel of the leaded glass and of the shiny marble columns—one could go on almost for ever enumerating these magic evocations of any kind of substance and surface by means of Jan van Eyck's miraculous and mysterious technique. In a sense it is true to say that it is all done with mirrors, for Jan van Eyck is supremely aware of the fact that reflections are mirror images. Standing in front of the original you can actually see the reflections of the red cloak of the Virgin at various points of the armour of Saint George and we are aware of the fact that if we were to move the reflection and the sparkle would change and scintillate. It is a commonplace of art history that compared with this miraculous fidelity in the rendering of surfaces, the rendering of forms in space is less secure in van Eyck. He is not in possession of the art of perspective construction, and so the floor seems slightly to slope and the spatial relationships between the figures and the building are not completely convincing.

We become aware of this difference when we look at the painting done in Florence some five years later, Domenico

Veneziano's *Madonna and Child with Saints* in the Uffizi (Fig. 4).[5] In this masterpiece the figures stand clearly and firmly on the patterned floor, which is constructed according to the rules of projective geometry. We feel that solidity of form which Berenson described as tactile values. You are aware, of course, that this impression of solidity and spatial clarity does not only depend on the linear construction of the picture but even more on the treatment of light. Not only is every form consistently modelled in light and shade, we see the sunlight streaming into the open courtyard and imparting on to the whole scene that feeling of radiant serenity which is a characteristic of that great artist, the master of Piero della Francesca. Remember that the light Domenico Veneziano represents is an objective state of affairs. If we imagine our standpoint to shift, the overlap of the columns would change but the light would not. It is *lume*, not *lustro*. The difference of emphasis becomes perhaps particularly clear at points of the greatest similarity; compare the way Domenico paints the head of the Bishop with his mitre and that of Jan van Eyck. To use the chilling language of photographers, you might say that the one is matt, the other glossy. Of course, this difference extends to the actual surface of the painting. Domenico's tempera technique is evident in the Uffizi panel, despite Vasari's gruesome thriller according to which Domenico was murdered by Castagno because he held the secret of oil painting. We are less sure than Vasari was that the secret of van Eyck's technique depends mainly on the use of oil, but clearly the surface of van Eyck's painting, with its layers of transparent glazes, suggests something of the fattiness of oil which he undoubtedly used.

And yet it seems to me that the contrast in techniques is here less important than the contrast in emphasis on light or lustre. It is this attention to the appearance of solid forms modelled in light which gives

the Florentine painting that sculptural quality. When we come from Jan van Eyck, who so convincingly conveys the softness of the child's body and the sheen of the Madonna's hair, Domenico's group looks indeed almost like the rendering of a sculpture made of solid inert material.

Given the vital importance for this impression of texture of a study of reflections, of highlights, it is surprising, as I said, that no historian of art seems to have devoted a monographic study to the development of this effect. Here as elsewhere the question of space seems almost to monopolize the attention of the great pioneers of stylistic analysis, and the only book specifically devoted to the history of light in painting, Schöne's *Über das Licht in der Malerei*[6] is so much concerned with the metaphysics of divine radiance that the author is too dazzled to pay much attention to these mundane lights. Yet it would be unfair to be too severe on that author. For the question: "When was the first highlight painted and *lume* distinguished from *lustro?*" is more easily asked than answered. Even so I have found it not a useless question to ask. In fact, my lecture will not have been in vain if I have sent you on a wild goose chase to the National Gallery hunting for the first highlight. I suppose the first thing you will notice on such an expedition is the way painters before the fifteenth century managed to evade the problem. For wherever you come across the representation of an object that should really shine and sparkle in the painting, a piece of jewellery or a golden chalice, you are as likely as not confronted with real gold paint or even the imitation of a jewel in coloured paste. The Wilton Diptych, whatever its exact date or school, is a characteristic instance of that procedure that was current in the generation before van Eyck, the period of the International Gothic Style.[7] For all its splendour it has no *rendering* of the sheen of gold. It has real shining gold. But during the 1430s, the time that is when van Eyck's

and Domenico's Madonnas were taking shape, Leone Battista Alberti explicitly censured this convenient practice. In his *Treatise on Painting* of 1435 he criticized artists who used much gold in the paintings, believing, as he says, that this would impart majesty to their work. As the perfect humanist he avoided Christian examples and wrote that "Even if someone were to represent Dido as Vergil describes her, with her golden quiver . . . her golden girdle and the golden trappings of her horse, I would not want him to use gold, since it contributes to the admiration and praise of the artist if he imitates the sparkle of gold with colour" (Book III).[8]

It will not take you long to discover in any Gallery that this trick of imitation must indeed have been a novelty in Alberti's time. Before his period artists both north and south of the Alps universally preferred the short cut of using real sparkling gold and silver to the imitation of their sparkle in paint. But this particular evasion, after all, need not deter us from continuing our search for the first rendering of lustre, for it is not only polished metal that reveals its texture through reflection but also cloth, for instance.

And yet the more closely you study Trecento paintings the more you may be baffled for an answer. Take that treasure of the National Gallery, the *Healing of the Blind* by Duccio from the Siena *Maestà* (Fig. 5). It is clear that Duccio handled the treatment of light with assurance. Mark in particular the way the windows are illuminated from the side and the precise gradations of white in the buildings clarifying their shape and position. The draped bodies of the figures are also modelled with assurance, and even the blind man's stick shows an illuminated and a shaded side. But are these modifications of the draperies to be seen as lustre? The answer depends on our interpretation of what we have in front of us. Indeed the more insistently we ask the more we feel that Duccio would not have wanted us to interpret

his tonal effects in such a precise way. No more, in fact, than he would have wanted us to ask how far and how tall the buildings in the background are, or whether the Apostles standing farther back are taller or standing on higher ground. We are told, and rightly so, that in medieval art such questions must not be asked, because this tradition operates with conceptual or conventional symbols which tell the sacred story without direct reference to visual reality. And yet this is a slightly deceptive answer. For in a sense, as I have tried to argue elsewhere,[9] all art operates with conceptual or conventional symbols, though the character and amount of information these symbols are able to convey may differ radically. From this point of view medieval art happens to be a highly complex case, for it grew out of the naturalistic conventions of ancient art which it put to a novel use. It was in the illusionistic art of antiquity that the methods of suggesting light and reflection were developed, and the distinction of *lumen* and *splendor* is explicitly mentioned by Pliny in this context.[10] Having announced a lecture on fifteenth-century painting I must be careful at this point not to be caught in an infinite regress, beyond convincing you that here as elsewhere the Renaissance was indeed a Renaissance, the rediscovery of potentialities in the classical tradition that had lain dormant during the Middle Ages. Not that the distinction between *lumen* and *splendor* is always quite clear in those works of ancient painting that have come down to us, but the more subtle of the still lifes from Pompeii and Herculaneum and of the mummy portraits from El-Faiyum and Hawara of the first centuries A.D. (Fig. 6)[11] show distinct highlights on glass, grapes, gold and pearls. The portraits usually also show a highlight on the tip of the nose that was to become conventional in medieval art. I remember noticing, by the way, that discussion of this point tends to bring

out the powder compacts of my female listeners. But whether they want it or not, the human face can and does show *lustro*, particularly in the intense *lume* of the south.

It is this precise differentiation which is lost in the traditions of medieval art. In a way, of course, this loss is less surprising than the persistence with which medieval styles held fast to the effects of tonal painting as such. You find it in many of the most schematic and conventionalized styles of the West, and the convention is frequently revitalized by contacts with Byzantium, where the link with ancient painting is of course closest. The exact transformations, however, by which a naturalistic idiom became transformed into the hieratic style of the Icon still await analysis. In the Washington *Madonna* (Fig. 7), which Berenson attributed to Byzantium around 1200, light is stylized into gold.[12] On the throne we can call it *lume*, for we see the incidence of the light on the sunk panelling—though no consistency is aimed at. The golden lines along the folds might stand for lustre, for they give us the impression of a precious material shot with gold, but we soon notice that it is not only pedantic but illicit to worry our heads over this distinction since there are no cues which would allow us to tell what the painter intended. If that is true in the East it is all the more obvious in the provincialized versions of the *Maniera Greca* that we find in Italy (Fig. 8).[13] Even here jewels receive their conventional white spot which was once a highlight, though it no longer affects us as sparkle.

If confirmation were needed that the medieval tradition had lost a precise awareness of our distinction it could be found in both those late codifications, *The Painter's Handbook* of Mount Athos and Cennino Cennini's *Libro dell'Arte*.[14] This latter one is particularly interesting as it was written near the very threshold of the New Age, possibly only a few years

before Alberti's Treatise and Jan van Eyck's *Madonna*. I must introduce you to this method in some detail, for it exemplifies the rôle which schematic conventions play in the traditions of paintings. In my book on *Art and Illusion* I have tried to condense this conviction in the formula that making comes before matching. It is with the making of images that Cennini is concerned, and there is no clear distinction in his mind between recipes for the grinding and mixing of pigments and prescriptions for the painting of folds.

Having decided, he says (Chapter LXXI), whether the drapery is to be in white, yellow, green, red or any other hue, the painter must take three dishes to represent the three gradations of tone.[15] If he decides for red, for instance, he must put into the first dish cinnabrese with a little white, well mixed with water. In another dish he should mix a lighter red by using much more white. Having established these extremes he can always find the required mean by mixing the two in his middle dish. He then begins laying in the darkest parts with the darkest of the three tones, taking care not to go beyond the middle of the thickness of the figure.[16] (I take this to mean that the figures are on the whole envisaged to be lit from in front and to recede into the shade.) Then you lay in the middle tone from one dark tract to the next, blending them well in. Then comes the third and lightest of the tones with which you colour the protruding parts (*il rilievo*), arranging the folds with good design, feeling and practice. Having gone over these several times in order to blend them well, take another dish with a colour that is lighter even than the lightest of the three and pick out and whiten the ridges of the folds. Then take pure white and pick out perfectly all the places which protrude. And finally, take pure cinnabrese and go through the darkest parts and some of the outlines. Watching this work, Cennini adds rather disarmingly, you will understand it rather better than reading this. Note that he says watching it being done, he does not say looking at real drapery. Making comes before matching.

For though the result is certainly convincing, there is very little reference to natural appearances in this method. In this respect, by the way, the excellent translation of Cennini's Handbook by Daniel Thompson is a little misleading. For Thompson always makes Cennini say "put on lights" where the original merely speaks of *biancheggiare*, whitening. The lights sound as if Cennini had thought of reflections, but his expression *bianchetto* which marks the utmost relief is much more neutral. Clearly in all Cennini's precepts, whether for drawings, fresco or tempera the implication is that ridges in lit areas should be marked with white—it is the procedure we still call heightening with white, and which belonged to the technique of drawing on tinted paper also recommended by Cennini.[17] Even the term highlight may still carry with it some of the implication not only of the highest, that is the brightest light, but also of the relief it tends to give; so much at least is suggested by the French word *rehauts*.

There is some reason in optics for this identification, for highlights do indeed tend to settle on ridges and protrusions of lit objects. For since highlights are reflections of the source of light, the sun, the sky, a window or a lamp, any curved surface that acts like a convex mirror will be more likely to catch this reflection since the whole of the surrounding will be reflected much as in the side mirror of a motorcar. The steeper the curvature, the smaller and more concentrated will this mirror image be, the more irregular the surface, the less will it be recognizable. If you want to extend your hunt for highlights beyond the National Gallery to your backgarden, study, kitchen, pantry or wherever else you happen to look, you will also notice that highlights are not only

more likely to settle on such edges and protrusions but that they also remain there more tenaciously for equally good geometrical reasons. A flat polished surface acts like any flat mirror—we see the shifting as quickly as we see change in our surrounding. But in the convex mirror the displacement is as reduced in size, and hence in speed, as is the whole of the reflected area. Hence we scarcely notice the shifting of the highlights in these exposed positions—the eyeball or the tip of the nose can thus be described accurately, though scarcely poetically, as one of those reducing mirrors which are most likely to receive the image of a lightsource from somewhere and to retain it faithfully wherever we turn.

The rule of thumb recorded in Cennini, therefore, and confirmed by the practice of painters and draughtsmen to mark the *rilievuzzi* by *bianchetti*, will certainly achieve its aim of giving the impression of relief. It does so precisely because we have good reason on grounds of probability to interpret a strongly illuminated part as a protrusion. But a moment's reflection—in both meanings of the term—will show us that this guess can also lead us astray, for in the visible world it is not only convexities which thus catch the image of a light. The concave sides of a bowl or sphere also act like a mirror when polished; though functioning like magnifying mirrors they will of course invert the image of a distant lightsource if we, too, stand beyond the distance of the mirror's focal length.

There is quite a gap, in other words, between the simplified convention and the variety of possibilities realized in the visible world. But the most striking omission in Cennini is of course the absence of any trace of awareness that different materials should receive more or less white linings on the ridges according to their tendency of reflecting or absorbing light. Cennini's silence about texture in this context is all the more telling as he does have advice to offer elsewhere to painters who may want to imitate the texture of velvet, wool or silk exactly. His method here is briefly to imitate these textures directly on the wall or panel just as gold brocade in his time is still imitated with a surface of stencilled gold. If the painter wants to achieve the exact appearance of a lining or dress that really looks like a woollen cloth, Cennini advises him to roughen up the surface of the wall with a wooden block to give it the appearance of woollen texture (Chapter CXL). The idea is the same as with the imitation of gold—you try to copy or duplicate the actual texture and material character of the stuff rather than its characteristic reaction to light.

Knowing, as we do, Jan van Eyck's astonishing success with this latter method, Cennini's advice inevitably strikes us as rather naïve. Yet his concern with real texture is clearly a sign that the medieval tradition was breaking up and that he meant what he said when, in a famous passage, he speaks of the triumphal arch of drawing from nature, a guide that is superior to all exemplars (Chapter XXVIII).

In fact I oversimplified matters a little when I represented Cennini as a source for our knowledge of medieval conventionalism. It is true that his advice on painting draperies and his remarks on the distribution of tones are generally in accord with procedures that can be traced back through the centuries and possibly as far as classical antiquity. But there are passages where the conventional term *bianchetti*, whitenesses, gives way to the term *lumi*, lights, and there is that astonishing chapter in which the artist is advised to pay heed to the fall of light and the position of the windows in a given chapel where he works. "You must," he writes, "grasp and follow it with the required understanding, for else your work would show no relief whatever and would turn out a crude thing of little skill." (Chapter VIII.)

It was of course Cennini's special pride that the skill and method he taught was

the tradition he had received in direct line of succession from none other than Giotto, the master of the master of Cennini's master Agnolo Gaddi. "It was Giotto who transferred the art of painting from Greek into Latin and made it new." How much we would all give to be able to ask Cennini what exactly he meant by this remark ("Giotto rimuto l'arte del dipignere di grecho in latino, e ridusse al moderno"). Unfortunately there is only one other passage where Cennini comes back to Giotto's achievement and the procedures he started and that, too, is not easy to interpret. It seems, however, that it has a direct bearing on our subject, for Cennini here contrasts Giotto's methods of modelling a head in fresco with two other traditions he considers inferior. Basically, I think, the contrast is one between crude and slapdash methods and the care and finish demanded by Giotto's heirs. What all methods he discusses have in common is the preliminary work in sinopia of which we now know several examples revealed to us by the restorers. The face is first roughed out with a soft brush whereby the painter must remember to divide it into three equal parts, the forehead, the nose and the chin. Then one must proceed to shade the face under the chin and the nose and on the side where it is to be darker with liquid terre verte. Some masters continue now with the lights, or rather the whites, searching out the highest points and reliefs of the face one by one. It is only when the whole modelling in light and shade is completed that they superimpose a transparent layer of flesh tint in water colour. Only a few of the reliefs remain then to be picked out in white. This, says Cennini, is a good method. Much better in any case than first to lay in the flesh colour and then put in the shades with verdaccio and touch it all up with white, which is done by those who know little of the craft.

But Giotto's tradition which Cennini had learnt in twelve years of apprenticeship demands infinitely more care. Start colouring the underpainting by indicating the lips and the cheeks in red, and then use three shades of flesh colour in three dishes, as many in fact as for the modelling of any drapery, start with the lightest one, then paint the half tones and then seek out the deepest shadows with the darkest tone but take care that the terre verte underneath still tells at the extremes. Go over it all several times softening the transitions from one flesh tone to the other as nature shows it. It is only after this careful modelling that the last touches are applied with a sharp minever brush, the white of the eyes and the tip of the nose in pure white, the outlines of the eyes, the nostrils and the openings of the ear in black, some dark red, for instance, between the lips, and all is done except the hair for which there are still special procedures (Chapter LXVII).

It is clear, I think, that in this procedure and tradition the emphasis is on modelling, on modelling moreover from light to shade, for this is the sequence in which the three flesh tones are applied. It is surely not fanciful to connect this procedure with that impression of solidity we all associate with Giotto and his tradition (Fig. 9). For in this careful tonal method with its meticulous application and blending of three flesh tones the conventional lights are devalued in their function. The method condemned by Cennini depended largely on the darks and lights superimposed on the uniform flesh tone to indicate form; in what he described as Giotto's way these accents become subordinate to the establishment of structure from the very beginning. I believe that the visual evidence supports this interpretation. What Vasari called the Greek manner—including the paintings we attribute to Cimabue or Duccio—still relied much more on the effects of undifferentiated lights which you can see in the head of an angel attributed to Cimabue in Assisi (Fig. 10). Any visitor to the Uffizi must be struck by the incomparable clarity and majesty of Giotto's *Ognisanti Madonna* (Fig. 11) that is enhanced

by the absence of those fussy lights which can be seen on any well-preserved panel of the *Maniera Greca*. As always, there is both gain and loss in this revolution. Compare the head of the Christ Child from Duccio's *Madonna Rucellai* (Fig. 11), with its charming highlight on the tip of the nose, with Giotto's heavy modelling and smooth transitions into the shadows so well described by Cennini. It is clear from these and other details how far Giotto had moved away from the Byzantine convention of painting light and had concentrated on the function of light as a revealer of form. It is not for nothing that it was Giotto who apparently painted the first monumental grisailles in the Arena Chapel imitating sculpture.

It was with this method of modelling in large, clearly lit planes that Giotto "transferred the art of painting from Greek into Latin and made it new." We can study the effect of his innovation in the Florentine tradition of the Trecento, and I recommend to you here the many details of Florentine frescoes which have recently become available in excellent new photographs in the Phaidon edition of Berenson's lists,[18] which show the concentration of form rather than texture. It fits in well with this interpretation that the Sienese tradition remains relatively unaffected by Giotto's reform and rather continues developing that detailed attention to minor articulations that is consistent with individual strokes of white—witness the details from a fresco in Siena by Ambrogio Lorenzetti available in Miss Borsook's invaluable book on the *Mural Painters of Tuscany*.[19]

Which of these two methods is more realistic? You realize that this is not really an answerable question. For each tradition develops an idiom, or (to use modern jargon) a code in which certain features of reality can be recorded or coded. But once the attention of the artist and of his public has become focused on this possibility of suggesting reality the painter will watch out for those effects he can best express

in his system. That mnemonic formula that making comes before matching is meant to remind you that such schematic methods as Cennini had learned from Giotto's tradition were not so much based on observation as that they led to fresh observations. I believe, for instance, that it was this emphasis on modelling in firm planes that necessitated increasing attention on the imagined fall of light and the effect of tonal gradations.

In a fresco in Santa Croce dating from about 1390 by Agnolo Gaddi, in whose workshop Cennini was trained for twelve years, the figure of St. Mark is conceived in a unified light which is indicated by contrasting planes.[20] Once these effects were noticed and studied the way was open for a genius such as Masaccio to use these contrasts for the suggestion of sunlight (Fig. 13). In one sense this involved the sacrifice of Giotto's method of smooth transitions, and yet it is hard to see how this realistic innovation could have emerged directly out of the conventions of the *Maniera Greca*. For Masaccio knows how contrasts in areas create the impression of strong light and shade. It was this discovery also that enabled him to include in his scenes from the Life of St. Peter the miracle of the Saint healing cripples with the shadow of his body.[21]

It is surely no accident that Masaccio's methods of clarifying the position of forms in unified illumination coincide with the first application of scientific perspective, the clarification of spatial relationships by geometrical means. It was Masaccio, of course, who completed that effect of sculptural solidity and firmness that we still associate with the central tradition of Tuscan art from Giotto to Michelangelo. Its glory remains the clarification of structure, not of texture, for the flickering highlights that shift with our position have no place in this objectivized world.

There exists perhaps an indirect confirmation of my hypothesis that this achievement rested on a supreme act of concentra-

tion that involved the elimination of disturbing *bianchetti*. I find it in that memorable passage of Alberti's *Della Pittura* where the treatment of light and colour is discussed. For Alberti no less than for Cennini white and black serve the all-important purpose of creating the impression of relief. To achieve this purpose, we learn, the painter must always balance the whites against darks. He suggests in fact that the painter should proceed in a gradual process of adjustment, always adding a little white here and a little black there and watch the form acquiring relief.[22] The best illustration I found of this method comes in [the] Predella by Fra Angelico painted in Rome in 1437, two years after Alberti's treatise (Fig. 14). Notice the curiously artificial effect of this procedure despite Alberti's mistaken idea that it is based on a study of nature. In nature, of course, not every object shows us its illuminated and its shadowed side. But to Alberti this idea of an exact balance is so important that he even suggests marking the pivot or dividing line with a very faint brush stroke to aid in these calculations. It is clear that this procedure excludes the medieval convention of marking the ridges with white. Giotto's reform is carried to its logical conclusion.

It is quite consistent, therefore, that Alberti inveighs against an excessive use of white no less than he censures the use of real gold. Modifying a remark Vitruvius makes about minium, he says that he wishes white pigments were as expensive to buy as the most precious jewels, for then painters would use them sparingly. The passage is doubly important for us for it is here that Alberti explicitly refers to the problem of highlights and reflections. He knows—and he may have been the first to know this—that the painter's gamut of relationships can never match the range of light intensities that can occur in nature. He must scale them down. The painter must remember—he writes—never to paint any surface so white that it could

not be whiter still. Even if you dressed your figures in the most shining white you would have to stop short very far from utmost whiteness. For the painter will find that he has nothing but white with which to render the extreme lustre of the most polished sword and nothing but black to show the utter darkness of night. The power of a correct juxtaposition of black and white can be seen where vessels appear to be of silver, gold or glass and seem to shine, though they are only painted (Book II).

The passage remains admirable despite the fact that Alberti here slightly mixes up two different things, that of light intensities and that of reflections. It was an understandable confusion, for the brightest flash of a polished sword would indeed be a mirror image of the sun and would thus come close to its intensity. But we also see texture and the sparkle of gold on a darkish day when the highlights may be darker than the painter's most intense light. It is indeed *only* what Alberti calls the correct juxtaposition of black and white, the gradients or steps between the tones, that results in this impression of sparkle.

Even so Alberti was right that the painter will have more scope for light-effects the darker he keeps the general tone of the picture. He must sacrifice his enjoyment of bright colours if he is to suggest brightness. The development of painting from Leonardo to Caravaggio and Rembrandt has tended to confirm this analysis.

Was Alberti aided in his astonishing diagnosis by acquaintance with Flemish paintings? He had been north of the Alps between 1428 and 1431, at the very time the new art took shape there, in fact he probably knew it before he returned to Florence from his family's exile. But this is guesswork, and not very important in my present context. What matters is that in the period that was my starting point, the period of Domenico Veneziano and Jan van

Eyck, the problem of white and of light was the subject of this searching discussion.

Giotto had started to reduce the conventional whites of the *Maniera Greca* which broke up and disturbed the clarity of structure that could only be achieved by balanced modelling in light and shade. You will have guessed by now that what 'I want to suggest here as my hypothesis is precisely that this reform had never affected the tradition of Northern painting to the same degree, and that it was therefore easier for the north to rediscover the potentiality of these conventional whites to give the effect of reflections.

I realize that this hypothesis must look redundant to those who see the Renaissance both north and south of the Alps exclusively in terms of a break with the past and a fresh discovery of nature. The historian so minded will be less interested in the chain of traditions. For him Jan van Eyck painted highlights because he observed them, just as Masaccio painted clear forms modelled in light because he knew how to use his eyes. But in a sense the very difference between Masaccio and Jan van Eyck would suffice to put this explanation out of court. What we observe in nature depends on our interest and on our attention. To the Florentine painters the criss-cross of flitting reflections on the surface of things appeared like a random noise which they disregarded in their search for form. Some artists in the north who also looked at nature became fascinated by the unexpected power of these lights to reveal and suggest texture. I am not, alas, a specialist in Gothic painting, but some of the stages in the rise of the new realism have by now been so well mapped out by those who are,[23] that we know roughly in what territory to look for the first signs of the new skill. Looking at the paintings of the so-called International Gothic style around 1400 we find that the realism of minute details does not yet imply a clear awareness of *lustro*, but we also observe that with all its Italian, especially Sienese and North Italian, motives this idiom still embodies the ambiguities of the medieval tradition that favoured the picking out of bright ridges and luminous points in gold or white. Study the panels of Bohemian masters from the last decades of the fourteenth century[24] or of Meister Francke of Hamburg from the early fifteenth[25] and note their use of the scattered conventional lights on narrow folds, on hair and on the tip of the nose; pursue these tell-tale details into the Burgundian *ambiente*[26] of Melchior Broederlam, and the contrasts between these refinements of an old tradition and the methods practised in contemporary Tuscany will become apparent. The rendering of *splendor* as practised in antiquity lies dormant but ready to be revived. In the *Scenes from the Life of the Virgin* (Fig. 15)[27] painted in the Northern Netherlands around 1400 these white ridges on the drapery, on still life objects and particularly on the organ pipes can be interpreted like real highlights, but there is no consistency yet in the distinction between light and lustre.

Even so, I hope these few examples may illustrate what I have in mind when I say that the new interest in illusionist effects may have led to the discovery that these lights could be made to suggest sparkle and texture, provided, as Alberti knew, they are sparingly used. For the real discovery of Flemish illusionism is not completed with the new use of these *bianchetti*. It lies in the introduction of a new differentiation, a new gamut that is superimposed on the traditional gamut of tonal gradation. It is the gamut of textures from sparkling jewels to matt velvet that can be expressed by the distribution of lights. Again this magic makes use of a psychological fact of no mean importance. In grasping a system of notation, be it of a language, of a game or of an art, we become alert to what are called distinctive features—it is their presence or absence that matters. One convincing highlight

placed correctly on a pearl or jewel or on the pupil of an eye will also, by force of contrast, help to impart on to the surrounding surfaces the effect of a matt, absorbent texture. It is likely that van Eyck found this method in the making when he set out on his career. It is certainly adumbrated in the work of the so-called Master of Flémalle who is probably identical with Robert Campin.

There is more of Giottesque modelling than of real sparkle in the *Madonna of the Firescreen* in the National Gallery,[28] but the subtle lights are placed on such strategic points as on the jewels of the Virgin's garment, the eyes of the Christ Child and on the drop of milk that comes out of the Virgin's breast.

But the full potentiality of *lustro* to reveal not only sparkle but sheen is a discovery that will always remain connected with the art of the van Eycks. This conviction, however, need not deter the historian from exploring the links of van Eyck's technique not only with that of Robert Campin or the brothers Limbourg but with the earlier traditions. The way Jan van Eyck picks out the lights on the Bishop's vestment of brocade[29] can perhaps be seen as an infinite refinement of those networks of gold that were conventional in Byzantine art. These networks could be seen as light, as reflection or as that elusive and fascinating effect of shot silk that also gained its place in the repertory of painting, requiring the most careful grading of transitions through hatching or stippling. Nobody, to my knowledge, has yet analysed in any detail how Jan van Eyck combined these effects with those of lustre. Maybe art historians shied away from this task because the admiration of illusionistic effects is considered a hallmark of the untutored and philistine. Maybe also they overrated the explanatory force of a phrase such as "the meticulous observation of nature." One would like to see a more technical analysis of the making as well as the matching. What one can even see on any large enough reproduction is the way Jan van Eyck systematically increases the density and brightness of the highlights on the gold threads to conform with the sheen of reflections. It is certainly more easily said than done, but up to a point the trick was picked up by most Flemish artists of the fifteenth century.

I hope that in thus stressing the importance of the systematic modification and refinement of traditions I have not given you the impression that I underrate the importance of the observation of nature in this give and take. Nothing could be farther from my intention. If it were, countless details in Netherlandish paintings would quickly refute me. But if looking alone would suffice to observe and to paint, the discoveries of the *Fiaminghi* would not have made such an impression on the Italians, who surely knew how to use their eyes. We know what a stir was created in Florence by the arrival of the Portinari Altar by Hugo van der Goes (Fig. 16). Among those who admired its rendering of natural effects there was also the greatest observer of them all, Leonardo da Vinci (Fig. 17), who strove in his formative period to overcome the sculptural neutrality of his native idiom and make his art a mirror of *lume* and of *lustro*, giving each effect its due by following Alberti's advice of lowering the key[30] and thus tuning the great instrument of painting afresh for the recording of further aspects.

It is true that the variety of styles confirms the idea that nature can be described in many different languages, but it happens to be wrong to infer from this premise that any of these different descriptions can not be either good or bad, true or false. We art historians are perhaps guilty here in having concentrated so long on the morphology of different styles and visual idioms without seriously probing their descriptive potentialities in matching the visible world.

NOTES

1 Edmund J. Sullivan, *Line*, London, 1922, p. 122

2 Jean Paul Richter, *The Literary Works of Leonardo da Vinci*, London, 1939, Vol. I, Plates III–VI.

3 Richter, ed. cit., No. 133 (Bibliothèque Nationale 2038, 32a); for parallel passages see Leonardo da Vinci, *Treatise on Painting*, ed. A. Philip McMahon, Princeton, 1956, pp. 260–63.

4 For good reproductions (including 26 details) cf. A. Janssens de Bisthoven and R. A. Parmentier, *Le Musée Communal de Bruges (Les Primitifs Flamands, Fasc. 1–4)*, Antwerp, 1951; also Ludwig Baldass, *Van Eyck*, London, 1956.

5 For two details (and a colour plate of one predella) cf. Bernard Berenson, *The Italian Painters of the Renaissance*, London, 1952.

6 Berlin, 1954.

7 For a colour plate cf. Philip Hendy, *The National Gallery, London*, London, 1955, p. 67. The patch on the knob of the flagstaff that might be interpreted as a highlight is due to damage.

8 Leone Battista Alberti, *Kleinere kunsttheoretische Schriften*, ed. H. Janitschek, Vienna, 1877, p. 139.

9 *Art and Illusion*, New York and London, 1960.

10 *Naturalis Historia*, XXXV, 29; cf. A. Rumpf, "Classical and Post Classical Greek Painting," *Journal of Hellenic Studies*, LXVI/VIII, 1947/8, p. 14.

11 Charles Sterling, *Still Life Painting*, London, 1959; A. F. Shore, *Portrait Painting from Roman Egypt*, London, 1962 (both with colour plates).

12 For a colourplate cf. Huntington Cairns and John Walker, *Masterpieces of Painting from the National Gallery of Art*, Washington, D.C., 1944, p. 14.

13 Cf. Carlo Raghianti, *Pittura del Dugento a Firenze* (Sele Arte), Florence, n.d., with a colour plate from which our illustration is taken.

14 Edition and translation by Daniel V. Thompson, New Haven, 1932, 1933.

15 For illustrations of trecento frescoes (including colour plates) cf. Ugo Procacci, *Sinopie e Affreschi*, Milan, 1961.

16 Cf. for instance Parri Spinelli's fresco of the Crucifixion, Bernard Berenson, *Italian Pictures of the Renaissance, Florentine School*, London, 1963, Fig. 428.

17 For examples of this technique cf. A. F. Popham and Philip Pouncey, *Italian Drawings in the Department of Prints and Drawings in the British Museum, The Fourteenth and Fifteenth Century*, London, 1950. No. 273 (Tuscan about 1430) etc.

18 Berenson, *Italian Pictures of the Renaissance, Florentine School*, e.g., Figs. 155, 156, 158 (Maso); 196, 197 (Nardo di Cione).

19 London, 1960, Figs. 24 and 25.

20 Berenson, op. cit., Fig. 348.

21 Berenson, op. cit., Fig. 586.

22 Janitschek, ed. cit., pp. 133–5.

23 Erwin Panofsky, *Early Netherlandish Painting*, Cambridge, Mass., 1953.

24 Antonín Matejcek and Jaroslav Pesina, *Czech Gothic Painting*, Prague, 1950.

25 Bella Martens, *Meister Francke*, Hamburg, 1929.

26 Grete Ring, *A Century of French Painting*, London, 1949.

27 Another scene is illustrated in Panofsky, op. cit., Fig. 112.

28 For a colour plate see Philip Hendy, op. cit., Pl. 69.

29 For a detail in original size see the volume of *Les Primitifs Flamands* quoted above under note 4.

30 For a perceptive discussion of Leonardo's aims cf. G. Vasari, *Vite* (ed. Milanesi), IV, Florence, 1879, p. 26.

Psychoanalysis

10 A Psychotic Artist of the Middle Ages

ERNST KRIS

Ernst Kris (1900–57) gained international distinction in two fields, the history of art and psychoanalysis. Born and raised in Vienna, he was able to participate, even before becoming an undergraduate, in the seminars of Julius von Schlosser (1866–1938), an astonishingly learned art historian and humanist, at the University of Vienna. Having aroused the keen interest of Von Schlosser, Kris became the first student to submit a doctoral dissertation to him (in 1922), which was published as "Der Stil rustique" in the *Jahrbuch der kunsthistorischen Sammlungen in Wien*, n.s. I (1926), among the most outstanding studies of the 20th century. He then entered the Austrian state service by becoming a custodian of the Kunsthistorisches Museum, the Austrian State Museum for Art, in Vienna. There he earned renown as a connoisseur of medieval goldwork (see his *Goldschmiedearbeiten des Mittelalters, der Renaissance und des Barock* [Vienna, 1932]) and as the author of the standard work on Renaissance cameos and intaglios: before the appearance of the former book, he had collaborated with F. Eichler to compile the museum's catalogue of its well-known collection of cameos and intaglios (pub. 1927). As a consequence he was called upon to catalogue a similar collection at the Metropolitan Museum of Art in New York City. In 1934, he coauthored with the noted Austrian art historian Otto Kurz an important study of the role of tradition in biographies of artists (*Die Legende vom Künstler; ein geschichtlicher Versuch* [Vienna, 1934]).

During these years Kris met Sigmund Freud (1856–1939), the founder of psychoanalysis, and in consequence Kris himself became a psychoanalyst years later. In 1927, the Austrian Institute of Psycho-Analysis invited him to become an associate member, and in the late 1930s Freud entrusted him, jointly with Dr. Robert Waelder, with the editorship of the international journal *Imago, Zeitschrift für die Anwendung der Psychoanalyse auf die Natur- und Geisteswissenschaften*. After Hitler's invasion of Austria, Kris settled in London, where he edited the first volumes of the London edition of Freud's collected works (*Gesammelte Werke*, 17 vols. [London 1940–50]) as well as *Internationale Zeitschrift für Psychoanalyse und Imago*. (Later he would write an important introduction to Freud's *Origins of Psycho-Analysis* [London, 1954].) At the outbreak of World War II, the British Broadcasting Corporation was instrumental in having him appointed director of the Research Project on Totalitarian Communications in Wartime.

The year after Freud died, Kris emigrated to the United States; here he became a leading exponent of modern ego psychology, which originated in the work of the psychoanalyst Heinz Hartmann and the later thought of Freud himself. After the end of the war, the Harvard Medical School appointed Kris its first Hanns Sachs Lecturer of Psychoanalysis. He was subsequently appointed clinical professor at the Child Study Center of the School of Medicine at Yale University, where he carried out a team project dealing with behavioristic studies of child development. He died in 1957, before the project could be completed.

The following paper by Kris, "A Psychotic Artist of the Middle Ages," is reprinted from his *Psychoanalytic Explorations in Art* (New York, c. 1952), a valuable source book con-

Reprinted from Ernst Kris, *Psychoanalytic Explorations in Art* (New York: International Universities Press, Inc., 1952), pp. 118–27.

taining papers based on more than 25 years of careful research in the psychology of art and clinical psychoanalysis as well as the history of art. In this book Kris asks some fundamental questions suggested by the study of art and artistic creation: "What are those things . . . which . . . tend to be endowed with the specific aura which the word ART conveys? What must the men have been like who made these things, and what did their work mean to themselves and to their public?" (*ibid.*, p. 13). Searching for, and depending on, minute observation while never losing sight of the whole comprising the parts, Kris strives to develop a valid methodology for further investigation, and to formulate research hypotheses in a cautious manner. As E. H. Gombrich has characterized his work, "Kris abhorred the oversimplifications of the confident vulgarizers." (With Gombrich, Kris wrote a little book on caricature in 1940.) Approaching his field of inquiry from surface phenomena rather than pure speculation, Kris investigated incisively and patiently the circumstances under which the phenomena came to be observed and tried to establish something of their origins and functions. It would seem that his approach to modern ego psychology was rooted in his training as a connoisseur of goldwork and carved gems, a valuable lesson first learned from Julius von Schlosser. The art historian can derive a great deal from the deep insights and cautiously formulated hypotheses of Kris, who has made a major contribution to our understanding of psychoanalytic ego psychology, hence the nature of artistic creation.

The case to be presented here in comparative detail offers several unique features. . . . It is hoped that this case will attract the interest of other investigators, who might try to view the productivity of the insane in the framework of comparative psychiatry, i.e., linked to the study of culture and personality.

Opicinus de Canistris, an Italian cleric (1296 to about 1350), is known as the author of two tracts and a volume with extraordinarily large drawings and an abundance of written commentary. His sole claim to distinction lies in the peculiarities which this volume reveals. He was eminent neither as a theologian, a writer, a painter, nor did he play any relevant part in political affairs or in the intellectual and artistic life of his time. His very identity was established only because of a combination of fortuitous circumstances and the acumen of recent historians. Only because of his illness can we offer something more than the skeleton of data recorded in the archives. On one of a series of enormous sheets of drawings, most of which are filled with only partly meaningful annota-

tions, he recorded in some detail his life history, of which we first present a summary.[1]

Opicinus was born into a world sharply torn by political and spiritual strife. The secular power of the Church, divided in itself, was waning, and for the first time in history the Popes had been driven into exile from Rome. His great contemporaries, Dante, Giotto, and later Petrarch, had opened new horizons for mankind. In Opicinus' life we find only external and minor reflections of this grandiose social change. He was born in Pavia, and by the age of ten was destined for a career in the Church. From the age of fourteen on, he found pleasure in drawing. For economic reasons he had to interrupt his studies and worked for a while as a toll collector on a bridge. He had returned to school, aged sixteen or seventeen, for a short time when he had the opportunity of attending some classes in medicine. Forced by the deterioration of family finances to earn his livelihood, he became for a while a tutor in a wealthy family. When Opicinus was nineteen years of age, Pavia

[1] Notes to this selection appear on page 292.

came under the suzerainty of a new family, and he and his people emigrated to Genoa, where he once more worked as school teacher. In order to increase his earnings, he learned to illustrate manuscripts—a skill particularly important before the invention of print. The content of the theological treatise he adorned attracted his attention, and when, in 1318, he could return to Pavia with his mother and siblings—his father had died shortly before— he continued at first his work as an artisan but soon obtained, without having been ordained, the position of chaplain at the cathedral. Supported by one of the curates, he could continue his theological studies and reach ordination. The ceremony had to take place outside of Pavia, because the town had been excommunicated for some time—one of the reasons which restricted the scope of his sacerdotal functions and which seem to have rendered his clerical career arduous. He embarked first on literary work, none of which is preserved. He was soon subject to attacks by opponents in local politics and hard-pressed by creditors, in spite of the fact that, aged twenty-seven, he had been able to obtain a small parsonage in town. He left Pavia but continued to write, living in various places in Northern Italy. In 1329, aged thirty-three, he appeared at the Papal Court in Avignon, where at the time clerics without attachment tended to assemble. His first job was the illustration of a manuscript, after which he lived on alimonies. He soon wrote a political tract on the relationship of the Holy See to the Empire, in the hope of attracting the Pope's attention, and then obtained a clerk's position in one of the divisions of the Papal Chancery, which he retained till his death. But before he could assume this position, and during his early time of tenure, he was investigated and had to stand trial for reasons unknown. The trial exhausted him physically and depleted his meager resources.

During this period of trial or shortly after

its conclusion, in the spring of 1334, aged thirty-eight, Opicinus fell ill. He described the onset of illness as sudden and mentioned that he had been unconscious for ten days. During this illness a dream occurred:

I was in Venice, a town I had known only from descriptions. When I opened my eyes I felt as if I had awoken from eternal sleep and was born anew. I had forgotten everything and could not recall how the world outside looked.

He recorded that he had had a vision in June: "In the presence of a servant who could testify to it," he saw a vase in the clouds. In his weird annotations, the vase plays a considerable role since by a play on the double meanings of the word *canistra* it is linked to his own name. "I was," he writes later, "at the time mute, paralyzed in my right hand and had lost in a miraculous way a large part of my memory for affairs of learnings."[2]

We note that the loss of "memory" is described as *"miraculous"*; similarly the (alleged) impairment of the right hand was later seen as an asset: it *miraculously* enabled him to draw and write what he considered his great and inspired work. We are not informed how long the speech disturbance persisted.

Up to this point one is inclined to consider the illness as a cerebral process and might think of an inflammatory or vascular basis. However, it seems that the symptoms described might have been either part of a psychotic process, or that subsequently a mental condition developed, which, though rich in hysterical features, bears unmistakably the imprint of a psychosis. We arrive at this conclusion for a variety of reasons. Before we discuss them in detail, we have to point to some of the psychological dynamics which we can infer in Opicinus' experience. There is in his autobiographical notes evidence of a deep attachment to his mother; when she died shortly after the onset of his illness,

his reaction was strong. We also learn that in order to stay close to her he decided not to join one of the religious orders. The death of his father and, shortly before it, that of one of his brothers is simply mentioned. His sisters seem to have played a more relevant part in his life; he is, for instance, concerned with finding a place for one of them in a suitable convent. Moreover, the earliest of his self-accusations concerns sexual play with a sister at the age of eight. The very fact that such an event should be recorded in the life history of a medieval cleric is symptomatic; the very existence of a biographical record of the kind is considered to be without contemporary parallel. While it is a record without ideological implications, it is not a simple statement of facts. The account of events and experiences is interwoven with self-accusations and self-exposure, which, according to the views of experts, is only marginally related to contemporary literary patterns. Thus, one might be inclined to consider it as "acceptable" when Opicinus mentions that before the age of twenty he submitted to carnal temptations, but the scarcely veiled references to masturbatory activity are without analogy in contemporary documents; references of this kind are without any doubt to be viewed as an expression of the dynamics of an individual conflict.

We are familiar with the fact that the stringency of cultural patterns seems to weaken, the closer we come in a personal document to the individual's central psychological conflicts, a fact noted and discussed by Kluckhohn (1945) in relation to anthropological data. Opicinus de Canistris' personal notes seem to be, if not the only, at any rate the most outstanding example of a similar deviation from medieval tradition. In many instances he remains vague: thus, when he refers to personal difficulties during his early theological studies, and in his self-accusatory fury quotes instances of his lack of understanding of this or that of the current

theological concepts. But he goes further; he gives reasons for what was, at least initially, a disturbance of concentration during his theological studies, mentions persisting blasphemous thoughts during religious service, and the irresistible impulse to outbreaks of laughter while celebrating mass. These were not symptoms of his youth. Immediately before the outbreak of his illness, the obsessional-compulsive soul-searching seems to have reached a peak. During the early years in Avignon his scrupulosity is such that in spite of absolution he refrains from exercising sacerdotal functions and seems to have requested absolution ever anew.[3]

Scrupulosity, one might be tempted to assume, is typical of a medieval cleric, a part of his training, and to refer to it might be part of literary tradition; the experts, however, assure us that nowhere in this tradition is there to be found a model for such behavior as that displayed by Opicinus: As Salomon puts it, he feels that sin is with him, is reality, that there is no redemption, and he does not expose his sinfulness as moral example. He does so because of reasons for which the familiar cultural patterns offer no rationalization, perhaps with the intention of barring future vices by loud acclaim.

We should at this point remind ourselves that the record in which these autobiographical statements are contained and this obsessional symptomatology is deployed was written during what we consider his psychotic period, of which the acute illness was part or during which it was initiated. We left Opicinus in June of 1334, two months after the onset of illness, paralyzed in the right hand, with impairment of speech ("mute") and of *memoria literalis*. According to his record the following dream occurred somewhat later: He saw

. . . the Virgin with the Child on her lap, sadly seated on earth. She gave me back instead of the literary learning, which since my youth had

been wasted, the spirit in reduplicated strength.

Salomon points out that similar formulations in which comparatively "external" intellectual capacities are contrasted to spiritual force occur frequently in writings of contemporary mystics, which otherwise show no resemblance to Opicinus' mentality.

The extent and nature of the change produced by his illness can only be appreciated if we turn to subsequent events. Early in 1335 he retired temporarily from his job because of the weakness of his right hand. But this very hand proved, in his own words, miraculously strong when he was not required to draft documents for the Chancery of the Holy See, but was engaged in the work which at the time occupied his imagination. This work is preserved as a collection of twenty-seven enormous drawings on parchment, varying in height between 70 and 97 cm. and averaging in width 50 cm. The vast majority of them—and only with these are we concerned—were produced between February 1335 and June 1336 with that right hand "which produced these images without human assistance." They follow no definite or even detectable plan, and no clear ideological tendency which would connect them has been established. According to Heimann, the art historian collaborating with Salomon, almost all of the drawings have been started with some circle into which human figures were later inserted or on which they were superimposed. All have the character of some monumental scheme, layout, or architectural design. Two of these drawings are here reproduced to convey a general impression (see Figs. 1 and 2).[4*]

It is clearly impossible to attempt an enumeration of the content of the whole or even of a part of one of the drawings. We mention only a few details of Figure 1:

In the center there is the Virgin surrounded by smaller figures. Around this central panel we find forty concentric circles, each corresponding to one year of the author's age and each carrying 366 letters for the days of the year, ingeniously subdivided by diameters into groups of seven, with Easter being specially indicated for each year. This is the "system" into which the author has inscribed the record of his life; what did not find its proper place here was distributed in the corners or elsewhere. In the axes of the ring system, we find the four evangelists and what are intended as four self-portraits.

A wealth of details is not visible on our reproduction: Thus the background of the innermost circle is formed by a map of the Mediterranean, the African coast, and the Peloponnesian peninsula, with other parts of the coastline visible. The Virgin's head is by inscription designated as the priest; other designations are distributed over other parts of her body. The inscription in large letters on the Virgin's mantle, however, refers to Italy: On the map the outline of Italy would be visible at this point if the Virgin were removed. Similarly, the fact that her feet are designated as "husband" and "wife" respectively seems to refer to the nearby statement concerning the author's legitimate birth, on the innermost of the forty surrounding circles.

At first one might be tempted to see in this configuration evidence of medievalism; one feels vaguely reminded of glass paintings in cathedrals, with which Opicinus naturally was familiar. But medieval art has nothing similar to offer.

When Salomon, the learned editor of the codex, first approached his task he was, as he puts it, for some time tempted to put the volume aside as a "merely pathological product" not deserving the historian's attention. But under the impact of the consideration that even in pathological pro-

*Illustrations accompanying this selection appear on page 496.

ductions "there might be some material that advances historical insight," he did not drop his investigation. Salomon and his collaborators have devoted infinite labors to tracing whatever connections the historian can establish between Opicinus' work and contemporary knowledge or models. They have drawn attention to a vast array of influences to which he was exposed, to many sources from which he drew the vast store of information which is contained in his written comment. And we shall try to show that some of Opicinus' search for information seems to be connected with the inferred content of his delusions. The delusional character of his productions reveals itself by a large number of traits. As far as the written material is concerned, there is no doctrine or view expounded, and relations to contemporary knowledge are limited to details. There are, however, a number of "themes" to be detected, such as the predominance of damnation. It threatens Opicinus, the sinner in past and future, and also threatens the world around him. Side by side with despair stand thoughts of advancement, of high ecclesiastic honors. However, such ambitions are in turn portent of evil; the small parsonage in Pavia would still offer the most adequate protection; it could replace the world and the whole church to him. At times, while he writes, ambition grows into thoughts of grandeur, and at least in one instance he designates what he has written as "the most recent and eternal evangelium," which should be approved by the Pope and recited in all churches.

Thoughts and expression of this kind are not met with in Opicinus' previous writings, neither in the tract we have mentioned nor in a minute and very accurate description of his home town, both of which fall into common literary categories of the time in Italy. In his annotations, the writings after the "illness," Salomon finds a man who wanders on dark paths, of a kind onto which he might have never ventured before. Not only has the sinister gained the upper hand and the factual receded, but it is noted by Salomon, who admired here and there the vigor of an isolated figure of speech, that the thought is of a disjuncted character; the writer, he says, is constantly forced to ward off the onslaught of associations—a good many clang associations among them—and while he heaps arguments upon each other, he ever again loses the thread. The rapid, and at times incoherent, change of images lends to Opicinus' writings an affinity with the discourse of the prophets, and while he obviously was familiar with their style, the prophetic attitude reoriginates, as it were, afresh out of the tenor of his messages; their content, however, frequently cannot be established. Salomon often finds himself unable to translate the author's simple Latin, in which there seems to be little rhetorical refinement. We are, quite obviously, at the border of verbigeration and at times beyond it. It fits into this pattern that hidden meanings abound which can be unraveled only rarely.

Similarly, when Opicinus comments directly on the "meanings" of his drawings, he refers to many overdeterminations, heaping associations upon associations.

The analysis of the drawings themselves led the art historian Heimann to analogous conclusions: Opicinus uses patterns familiar from contemporary art, and all the technical aspects of his drawings, for instance the way in which he renders the human figure, can be related to current contemporary practices. In the details he uses there is little originality and certainly no increase of expression and no innovation; however, there is no evidence of deterioration. But the entire setup, the total composition, is deviant. Heimann uses examples to illustrate this: On some drawings we find a towering figure holding a circle or arena, like a shield in front of the body, so that only feet and fingertips are visible. While this may still be an acceptable pattern of medieval representational art, in

many instances the figures, and not the geometrical schemata they carry, include other smaller figures. Even this has its analogies, but not in the same manner: Some justification is generally found in the posture of the including figure. Opicinus seems to use the "inside" in the way one uses a diagram; contemporaries, on the other hand, used a mantle to make the inclusion of small figures into bigger ones plausible: Under her mantle the Virgin protects her flock. No similar justifying device occurs with Opicinus: the inclusion of small in big figures serves to express a view of dependent interrelation, ultimately linked, I believe, to fantasies concerning the inside of the body. We have no way of establishing their content in detail. The direction, however, is suggested if we mention two sources of contemporary imagery with which Opicinus proves to be familiar and which he copies in his drawings. There is first the medieval map which he draws repeatedly—and we have every reason to assume that the link between "the earth" as a whole and the Virgin whose figure it surrounds is one familiar from widespread symbolism: The interest in maps would be linked to delusional inquiries into the human and particularly into the female body. The second source to which we refer supports this view. Opicinus was familiar with medical manuscripts, and some of the details rendered in his drawings copy fetal positions illustrated in these treatises. In a particularly obscure passage in his text he refers to the caesarean operation.[5]

There is one tendency in his drawings which deserves our particular attention: the frequency with which one line serves several functions, with which one shape transgresses upon another. The elaboration of the coastlines of the maps into human shapes can serve as a case in point; it is a transmutation to which, we presume, certain thought contents were attached. While these thoughts remain unknown, we may tentatively assume that there might be some relation to creation and decomposition of the body. At the same time, the play with shapes and the play with words are characteristics of the breakthrough of the primary process and part of the typical symptomatology of schizophrenic production.

In summarizing, we may now attempt to review the course of Opicinus' illness: We cannot believe that the paralysis of the right hand can have been of organic nature when we realize the sheer enormity of the task which he performed. The very physical effort of the minute and detailed drawings, of the small and yet highly legible writing, eliminates the idea of a physical impairment. We rather assume the literal truth of what he says: The hand could function only to execute what a miraculous force told him to do.

In a similar sense, the loss of *memoria literalis* can be understood. To draft documents had become impossible; to write tracts or treatises was no longer his task. But a wealth of words was at his disposal when he wanted to convey a message, reveal his own life, view his relation to the Virgin who controlled it, or comment on the plans of the world, the Church, and the hierarchies he drew.

The assumption that they are plans is, it seems, well warranted by their appearance, by the strange mixture of geometry and life, by the symbolism and depiction which they contain—by their emptiness and neatness.

Their resemblance to the products of schizophrenics of our own period hardly needs to be emphasized. We find here and there a comparable interaction between intactness of comment and privatization of expression; in both the function of communication has miscarried.

The similarity with products of other schizophrenics is not less evident. The idea of creating or organizing a world and the fear of its destruction seem to connect Opicinus' effort with that of many schizophrenics of our own day. Even the formal

appearance and the occasional break-through of a *horror vacui* are similar. The difference rests in the intact part of the personality. However great this difference may be, we are struck by the similarity that exists when the particular mecha-nisms of schizophrenic production are at work, in spite of the fact that the medieval environment seemed to offer pathways of discharge not equally available later and least of all in our own culture.[6]

We therefore tentatively conclude that Opicinus' life after the illness, if an inde-pendent illness existed, was determined by a schizophrenic process; the obses-sional-compulsive symptomatology of his earlier years had apparently acted as a defensive barrier.[7] With the outbreak of the schizophrenic process a creative spell was initiated, in which no other activity but that devoted to the great project could be executed. There are, naturally, many uncertainties in the way of a similar set of assumptions, but since we have gained insight into many similarities between Opicinus' work and that of schizophrenics of our own time, it seems permissible to assume that his urge to create, like that of others, was a protection against the fantasy of its total destruction: The theme of damnation would be an attenuation of this delusion.[8]

Opicinus shares many traits with the other trained creators we have discussed; in his work as in theirs, no understanding of the full, intended "meaning" is possible without a detailed and intimate familiarity with the content of the delusional system.

NOTES

1 We rely in what follows on Salomon's admirable edition (1936). In many points the psychiatric approach suggests a different evaluation of details; however, it seemed advisable not to venture too far in this direction, lest the crucial question be obscured of what is "culture" and what "deviation."

2 The Latin original says *memoria literalis*. We shall subsequently comment on the probable meaning of this expression.

3 Opicinus quotes in detail the limitations to which his functions as a priest had been subjected. While Salomon tends to attribute these limitations to the fact that, while a priest in Pavia, the town was under interdict, I tend to disagree and am inclined to connect the passage with the thought: "I was at all times cautious to exercise as little sacerdotal power as possible, sinner I was and am."

4 Salomon, Plates XIV and XXII.

5 For a somewhat similar significance of fantasies concerning the inside of the female body see Chapter 5 [of *Psychoanalytic Explorations in Art*—W.E.K.]. See also some of the schizophrenic drawings recently described by Chatterji (1951, particularly p. 39) [N.N. Chatterji, "Schizo-phrenic Drawing," *Samiksa* V, 1951—W.E.K.] who interprets drawings by Indian patients as expressing the fantasy "of going to the mother's womb and the desire of coming out of it."

6 See Freud [*The Psychopathology of Everyday Life*, trans. A. A. Brill, New York, 1914—W.E.K.]; Hartmann, Kris, and Loewenstein ["Some Psychoanalytic Comments on Culture and Personal-ity," in *Psychoanalysis and Culture*, ed. G. B. Wilbur and W. Muensterberger, New York, 1951 —W.E.K.].

7 There is the possibility that in the years between 1325–1328, about which he is strangely silent in his record, a previous process had occurred.

8 The question how Opicinus' condition was viewed by his contemporaries, i.e., the question to what extent his behavior was considered as psychotic, remains unfortunately undecided. Fol-lowing suggestions by Tatlock ["Geoffrey of Monmouth's *Vita Morlini*," in *Speculum* XVIII, 1943—W.E.K.] one might well assume that awareness of pathology existed; see also Zilboorg [*A History of Medical Psychology*, New York, 1941—W.E.K.].

ART HISTORY, SOCIETY, AND CULTURE

Context of Artistic Patronage

11 Art and Freedom in Quattrocento Florence

FREDERICK HARTT

The author of many important papers and monographs on Italian artists of the 15th and 16th centuries, the American scholar Frederick Hartt enjoys a reputation as a leading international specialist in the visual arts of the Italian Renaissance. Born in Boston in 1914, Hartt received his education at Columbia University, Princeton, and the Institute of Fine Arts of New York University. The inspired teaching of the eminent art historian and critic Meyer Schapiro introduced him to the aims, methods, and satisfactions of the discipline, and thereafter he pursued a course of graduate studies under such internationally renowned art historians as Walter Friedlaender, Millard Meiss, Richard Offner, and Erwin Panofsky. His graduate work was interrupted by World War II, in which he served in the USAAF in Italy from 1942 to 1946, receiving the Bronze Star and, from the Italian Government, the Knight's Cross, Crown of Italy. For his work protecting the monuments and fine arts in Italy during the war he was made an honorary citizen of Florence (see his *Florentine Art under Fire* [Princeton, 1949]). The United States Government sent him to Florence after the devastating floods of 1966 to assess the damage to works of art and to organize the initial phase of American assistance. The following year, he completed a lecture tour in the United States to raise money for the Committee to Rescue Italian Art (CRIA). In 1967, he became McIntire Professor of the History of Art at the University of Virginia, where he currently teaches.

The war interrupted Hartt's research for his doctoral dissertation, "Giulio Romano and the Palazzo del Tè," which he submitted to New York University in 1950. It was subsequently expanded and revised in a two-volume work entitled *Giulio Romano* (New Haven, Conn., 1958), the major monograph on this 16th-century master. In what may be termed a contextual approach to the *oeuvre* of the artist, Hartt collects and evaluates biography and original source material as well as documentary and stylistic evidence, presents cogently reasoned attributions to the hand of the master, and interprets the meaning of the works. In other studies, Hartt has dealt with the early works of Andrea del Castagno (in *Art Bulletin* XLI [1959] pp. 159–81, 225–36), Mantegna's *Madonna of the Rocks* (in *Gazette des Beaux Arts* XL, 6th ser. [1952], pp. 329-42), and, with Gino Corti and Clarence Kennedy, *The Chapel of the Cardinal of Portugal, 1434–1459, at San Miniato in Florence* (Philadelphia, 1964). The artistic genius of Michelangelo especially has engaged his interests since his master's thesis of 1937, with stimulating iconographic interpretations of the Sistine Chapel ceiling ("*Lignum Vitae in Medio Paradisi,* The Stanza d'Eliodoro and the Sistine Ceiling," *Art Bulletin* XXXII [1950], pp. 115–45, 181–218) and of "The Meaning of Michelangelo's Medici Chapel" (in *Essays in Honor of Georg Swarzenski* [Chicago, 1951]), as well as a recent series of books on the master's paintings, sculptures,

Reprinted from *Essays in Memory of Karl Lehmann*, ed. Lucy Freeman Sandler (New York: Institute of Fine Arts, New York University, 1964), pp. 114–31.

and drawings (1965 ff.). His work on the Medici Chapel has led him to a consideration of aspects of the problem of Mannerist art ("Power and the Individual in Mannerist Art," in *Acts of the Twentieth International Congress of the History of Art,* vol. II [1963], pp. 222–38). The theme of *Love in Baroque Art* (New York, 1964) has also been dealt with. Hartt's most recent work is a monumental *History of Italian Renaissance Art: Painting, Sculpture, Architecture* (New York, 1969).

Among his outstanding contributions to the discipline is his "Art and Freedom in Quattrocento Florence" (in *Essays in Memory of Karl Lehmann,* ed. Lucy Freeman Sandler [New York, 1964]), which appears below. Here Hartt gives an account of the relation of artists and patrons specifically, and artists and their society generally, in the early Italian Renaissance. Stimulated by the recent work of the historian Hans Baron, *The Crisis of the Early Italian Renaissance: Civic Humanism and Republican Liberty in an Age of Classicism and Tyranny* (Princeton, 1955), he tries to explain the great formative changes that occurred in the art of Florence in the first three decades of the 15th century by reference to contemporary political, economic, and social crises that confronted the entire population of the city. He finds that the concern of these Florentine artists over the fate of their society is "reflected and paralleled in the content and style" of their works of art. It is especially the guilds of the city that are held to have played a leading role in the emergence of the fundamentally new style of the visual arts called Renaissance.

Of all the problems that confront the historian of art, perhaps the most interesting and certainly the most baffling is that of accounting for stylistic change. Not gradual change (which proceeds from a multiplicity of factors beginning with the independent aesthetic and technical discoveries of the artists themselves, and acquires the momentum inherent in any human activity of research and invention, collective or individual), so much as the sudden revolution which transforms almost overnight the style of a cultural center or of a group of artists or even of a single artist beyond recognition. The great formative changes in the history of art have frequently been of this cataclysmic nature.[1]

Ernst Gombrich has dealt severely with certain typical views which attempted to find a solution to the problem of stylistic development before the proper questions had been asked.[2] He has shown how explanations of stylistic change in terms of the inherent possibilities and limitations of techniques gave way to interpretations appealing to such mysterious entities as *Zeitgeist* or *Kunstwollen;* he might well have mentioned the pseudo-Darwinian thinking that still underlies much of the teaching and writing about the history of art, more frequently than we like to believe. Who among us has never caught himself tracing an evolutionary relationship between a series of chronologically arranged works of art, even though the accidents of time may unsystematically have deprived him of many of the monuments, perhaps the crucial ones, for the completion of such a series? While contemplating Gombrich's discussion of the exploded Hegelian myth of history, we would also do well to assess the widespread if not always self-conscious tendency among art historians to superimpose on the diverse phenomena of the history of art the rhythm of the pendulum swing between opposites apparent in the Hegelian pattern of thesis, antithesis and synthesis. And, as we examine our collective historiographic conscience, we might take note of the Marxist and pseudo-Marxist attempts to read, sometimes perceptively but more often with self-defeat-

ing rigidity,[3] the economic doctrines of Karl Marx into the still mysterious creative desires of humanity.

Among all the objections that might prompt us to reevaluate any one of these modes of interpreting stylistic change, there is one which applies to them all: their determinism. Through much of the theorizing on the history of art, whatever the philosophical commitments of the theorizer, runs a persistent if not always easily discernible thread—the assumption that artistic change obeys laws which can be discovered and formulated. Few will deny that the artist, like anyone else, is affected by the styles of his immediate predecessors and contemporaries in one way or another, and therefore that continuity of tradition plays an important role in the development of style. Nor would many be willing to disregard the formative influences of the society in which the artist lives. But no period in Western art is a stylistic monolith. Frequently the variety of conflicting styles and tendencies in a single period eludes explanation by any deterministic theory.[4] The artist, at any rate ever since Egypt, is an individual, and like other individuals he is confronted from time to time with distressing choices which involve not only his outward economic self and social allegiance but his essence as an artist and a human being. As likely as not the crises in which the artist is successively involved differ in intensity but not in kind from those which face in one way or another all the individuals in the social group to which he belongs. If the work of art is indeed, in the last analysis, a sensory symbol of human experience, then many of the unpredictable developments in the sphere of style, which we examine under the name of the history of art, may well depend upon the artist's decisions in such crises.

Like other human beings, the artist does not always decide wisely. Sometimes he retreats, and then this retreat is perpetuated in a style of disturbing neurotic intensity, e.g. the art of the so-called Mannerist crisis and its forebears among the anticlassic styles of the mid-Trecento and mid-Quattrocento.[5] But when he faces, absorbs and synthesizes external reality, his decisions are likely to produce one of the enduring, normative styles of Western mankind, such as the first Gothic style or the Italian High Renaissance.[6] The present study is an attempt to examine one of these classic styles, unpredictable in origin and meteoric in development—the early Florentine Renaissance—in terms of the continued crisis which in the first three decades of the Quattrocento confronted the entire population of Florence, including the artists, with a series of difficult and fundamental decisions, on whose outcome depends to a surprising degree the whole subsequent development of Renaissance and post-Renaissance art and culture.

As a complete, illustrative example of the first Renaissance style we may well consider the fresco of the *Trinity* (Fig. 1)* painted in all probability in 1427 by Masaccio for unknown donors (possibly members of the Lenzi family) before a now-vanished altar in the left side-aisle of Sta. Maria Novella in Florence. The familiar elements of Renaissance art are visible in a highly developed state: an architectural setting derived from the forms of Roman architecture, a space convincingly constructed according to the principles of one-point perspective, human figures projected in the round, proportioned as in real life, and characterized with scrupulous fidelity to everyday human types. Above all, the fresco exhibits a certain lofty grandeur of mood deriving not only from the beauty of the architecture and the dignity of the figures but from the harmony and clarity of the composition, and especially of the idea behind the composition, transcending

* Illustrations accompanying this selection appear on pages 497 to 498.

in every essential respect any previous representation of this difficult and exalted subject.[7]

Below the painted steps recent research has discovered a beautifully painted skeleton lying on a tomb, apostrophizing the spectator with the following grim if not unusual epitaph: IO · FV · GA · QVEL · CHE · VOI SETE · E · QVEL CHIISONVOI · ANCO · SARETE On a step above the body and outside the painted Brunelleschian architecture the donor and his wife kneel in prayer, apparently for the repose of the soul of a relative whose skeleton lies below. Within the architecture, the Virgin on one side, St. John on the other, intercede below the sacrificed Saviour, Whose cross is held by God the Father, while between the heads of Father and Son floats the Dove of the Holy Spirit. While the praying donors and the interceding saints form a pyramid ascending to the triune God, the descending perspective lines of the vault converge upon the center of the step on which the donors kneel, directly below the symbolic Golgotha from which Adam's skull is absent (as if the departed Lenzi had replaced it) and directly behind the altar on which the miracle of the Mass re-enacts the sacrifice of Christ for the salvation of souls. The central idea of Catholic liturgy could scarcely have been expressed with greater vigor, simplicity, human directness or geometrical precision. One is reminded of the saying of the Florentine humanist Giannozzo Manetti that the truths of Christianity are as clear and indisputable as the axioms of mathematics.[8]

But by common consent, the earliest fully Renaissance work of art seems not to have been a painting but a statue, the St. Mark (Fig. 2) carved in marble by Donatello for the niche of the Arte dei Linaiuoli e Rigattieri on the exterior of the grain exchange of Orsanmichele in Florence, between 1411 and 1413,[9] ten years or so before the newly discovered earliest work of Masaccio.[10] Although the surrounding niche was carried out by the minor masters Perfetto di Giovanni and Albizo di Pietro still working in a florid Gothic tradition, it emphasizes by contrast the revolutionary nature of Donatello's statue. The dignity and intensity of the characterization, the forcefulness of the pose and glance, the sense of the three-dimensional structure of the body under the drapery masses, all proclaim this statue as a direct ancestor of the powerful figures of Masaccio. H. W. Janson has written that this statue "is in all essentials without a source. An achievement of the highest originality, it represents what might almost be called a 'mutation' among works of art."[11]

But what of painting meanwhile, surely the leading art in the Florentine Trecento? One may look in vain for a painting datable in the second decade of the fifteenth century which shows a glimmer of the new style. The Florentine pictorial botteghe were numerous and active, turning out fantastic quantities of panels and frescoes in a number of personal styles, often highly accomplished and sometimes of the greatest beauty, all generally comprised under the loose category of the late Gothic. Gherardo Starnina, Lorenzo Monaco, Niccolò di Pietro Gerini and Lorenzo di Niccolò, Mariotto di Nardo, Francesco d'Antonio, Rossello di Jacopo Franchi, the Master of the Bambino Vispo, the Master of 1417, the young Giovanni dal Ponte, Bicci di Lorenzo, continue working as if Donatello had never created the St. Mark. Traditional or visionary architectural settings, Giottesque or fantastic landscape backgrounds, Trecentesque or International Gothic figures and drapery, constitute the repertory of these busy and frequently prosperous practitioners who were not to be deflected from their course until the arrival of Gentile da Fabriano in Florence in 1421 and the first revelations of Masaccio soon thereafter. But when these two formidable revolutionaries had disappeared from the Florentine stage, few of the older artists still alive showed any

real recognition of the new possibilities open to the art of painting, and systematically exploited by the sculptors.[12] Not until the first dated works of Fra Angelico, Fra Filippo, and Paolo Uccello in the 1430's does painting begin to occupy in earnest the position Gentile and Masaccio had conquered for it, and not until the middle of the century were the last defenders of the late Gothic subdued in Florence.

The sudden mutation, as Janson puts it, that brought forth Donatello's St. Mark is no harder to understand than the astonishing discrepancy between the nature, aims and values of sculpture and painting in the early Quattrocento, a divergence about which no deterministic theory can inform us. In trying to account for this extraordinary split I became conscious of a guilelessly simple fact: all the surviving paintings of the 1420's in Florence were altarpieces and frescoes for the interiors of churches or of chapels within churches, or else street tabernacles, and all were intended for the aesthetic enhancement of worship or the provocation of solitary prayer and meditation. All the statues, and there was a host of them, were destined for the exteriors of two churches of predominantly civic character, and all were addressed to the imagination of the man in the street. Some, in fact, were placed hardly above the street level. To put it simply, in the second decade of the Quattrocento, Florentine painting was characteristically other-wordly, even mystical, dominated by the churches and even the monasteries (Lorenzo Monaco, the leading master, was a monk in the important Camaldolite monastery of Sta. Maria degli Angeli), while contemporary sculpture was increasingly humanistic and naturalistic, dominated by the guilds or by committees chosen by and responsible to the guilds. Between 1399 and 1427 no less than thirty-two over-lifesize male figures made their appearance in the center of Florence, eighteen on the Cathedral and fourteen at Orsanmichele,

representing the work not only of the great masters Donatello and Ghiberti, and somewhat lesser artists such as Nanni di Banco and Nanni di Bartolo, but relatively standardized practitioners like Niccolò di Pietro Lamberti and Bernardo Ciuffagni.[13]

The saints at Orsanmichele and the prophets and evangelists at the Duomo share a surprising degree of emotional intensity, resulting in expressions which range from the deeper inner reflection of Ghiberti's St. Matthew (Fig. 3) to the violent excitement of Donatello's St. Mark (Fig. 4), with his disordered locks, rolling eyes, quivering features and writhing beard. The poses vary from the classic balance of Ghiberti and Nanni di Banco, reminiscent of Greek and Roman philosopher portraits (Fig. 5), to the extreme turbulence of Donatello's prophets from the Cathedral campanile. But in each case the ideal person is depicted less as a static monument to sanctity, with uncommunicative features in the manner of Gothic cathedral sculpture, than as subject to a psychic state provoked partly by what he perceives in the outer world, partly by his inner contemplation of himself. These saints and prophets seem aware of opposition from without, against which they must summon up the full resources of their personalities. Sometimes they show confidence in their strength, sometimes alarm at the suspicion of their inadequacy, but always their reactions to the world they confront betray a profound realization of the conflicting forces among which they must struggle to maintain an equilibrium. The fact that these unprecedented characterizations owe their existence to their role as protectors and defenders of the guilds suggests a brief reconsideration of the familiar features of the Florentine state.

At the opening of the fifteenth century, Florence was an artisan republic exclusively controlled by the guilds. There were seven major guilds and a constantly varying number of minor ones, some of whom—

the so-called *arti mediane* or median guilds—were eventually admitted on sufferance to the major group.[14] Through the Guelph party, the only legal party in Florence, traditionally but by no means consistently the supporter of the Papacy, the guilds controlled the government of the republic.[15] The great humanistic scholars and writers of the early Quattrocento were guild members and so, by no means incidentally, were all the artists. The painters belonged to the guild of physicians and pharmacists,[16] the sculptors, insofar as they were metalworkers, to the guild of silk merchants; both were counted among the all-powerful major guilds. Sculptors who began and continued as stonecutters were relegated to the secondary guild of the masters of stone and wood.

In a series of brilliant studies, summed up and expanded in an indispensable book,[17] Professor Hans Baron has shown in detail how this guild republic, long vigorously maintained through the passing dictatorships, famines, pestilences, financial crashes and revolts of the Trecento, had found itself around the year 1400 engaged in a life and death struggle with a wholly different polity which threatened to engulf it—the fast-growing, militant duchy of Milan. Florentine writers, Baron has shown, spare no words to express their hatred of the Milanese tyranny (whose people are not "citizens but subjects born in subjection")[18] nor their fear of conquest and consequent loss of liberty. By intrigue and threat quite as often as by actual force, the first Duke of Milan, Giangaleazzo Visconti, had absorbed almost all of northern Italy save for the republic of Venice, and had even surrounded Florence to the south controlling the road to Rome, his overlordship being acknowledged by Siena and Perugia, while his control over Lucca and Pisa cut off Florence from the sea and threatened to strangle her trade. The historic liberties of the Florentine people seemed to be doomed. In Baron's words, "From then on the Florentine Republic,

protected no longer by membership in any league except for her alliance with Bologna, and enjoying that protection only as long as Bologna could avoid surrender, was left alone to confront one of those challenges of history in which a nation, facing eclipse or regeneration, has to prove its worth in a fight for survival."[19]

At this very moment, Baron pointed out, an apologist for the Duke, the humanist Saviozzo da Siena, compared Giangaleazzo to Caesar encamped on the Rubicon before his march to Rome, and prayed for the success of the enterprise in the name of every true Italian, while deprecating the "detestable seed, enemy of quietude and peacefulness which they call liberty."[20] Poised on the edge of the precipice, Florence was saved by a wholly unexpected event. In the hot summer of 1402 the plague, that faithful companion of Renaissance armies, swept through Lombardy and on September 3 carried off Giangaleazzo himself at the Florentine frontier. In a matter of months the jerry-built Milanese empire had collapsed and Florence again found herself at the head of a league of city-republics in defense of liberty.

His death had been, so people believed, heralded by the appearance of a comet.[21] The Florentines in their joy repeated verses from Psalm 124. 7–8:

. . . the snare is broken, and we are escaped. Our help is in the name of the Lord, who made heaven and earth.[22]

But, divine intervention or no, the Florentines had been ready for the battle. As Scipione Ammirato puts it, "This, at the end of twelve years, which now with suspect peace, now with dubious truce, now with open war had tormented the Florentine Republic, was the end of Gio. Galeazzo Visconti first Duke of Milan, most powerful prince, who had no impediment to the occupation of Italy greater than the Florentines: whence

both then and later it was noted with great wonder, how against such forces could resist a single people without a seaport, without discipline of war, not helped by the ruggedness of mountains, nor by the width of rivers, but only by the industry of men and the readiness of money."[23] In the words of the great Chancellor of later date, Lionardo Bruni, "What greater thing could this commonwealth accomplish, or in what better way prove that the *virtus* of her forebears was still alive, than by her own efforts and resources to liberate the whole of Italy from the threat of servitude?"[24] And it is indeed *virtus*, which might be defined not so much as virtue but as the kind of courage, resolution, character in short, that makes a man a man, which flashes from the eyes of these statues of marble and bronze. In Gregorio Dati's history of Florence, written soon after 1406, we read that "to be conquered and become subject, this never seemed to the Florentines to be a possibility, for their minds are so alien and adverse to such an idea that they could not bring themselves to accept it in any of their thoughts . . . a heart that is free and sure of itself never fails to bring it about that some way and remedy is found."[25]

But in only a few years a new menace appeared, from the south this time, in the person of King Ladislaus of Naples. Burning to become a new Caesar, Ladislaus received the submission of papal Rome and all of Umbria in 1408 and in 1409 took Cortona, on the borders of the Florentine state. In 1413 he sacked Rome and stood master of central and southern Italy, poised in 1414 for the attempt to surround Florence to the north, and supported incidentally by the same insidious voices who had prepared the propaganda for Giangaleazzo.[26] To these the aged Niccolò da Uzzano answered "that for the protection of our liberty we must shoulder anything,"[27] and the Flor-

entines in the early summer of 1414 refused any compromise with the tyrant. And then, as before, Florence was saved by a portentous occurrence, accompanied this time by earthquakes. In August, struck by a violent fever and raving that Florence should be destroyed, Ladislaus died in Naples. His empire collapsed, and his sister and successor, Giovanna, instantly sent envoys to make peace with the Florentines.[28] Oddly enough, Ammirato records no feeling on the part of the Florentines that they had again profited by divine intervention.

Florence then embarked upon a period of unexampled prosperity. During the ensuing peace, Poggio Bracciolini found the city "full of every opulence and the citizens universally most abundant with money,"[29] and Cavalcanti wrote, "Our city was on the height of worldly power and its citizens with their sails filled with proud fortune."[30] And then it started all over again. Defeated in the north and defeated in the south by the intervention of sudden death, the menace of absolutism sprang up anew in the north, in the person of Filippo Maria Visconti,[31] who followed in the steps of his ambitious father, Giangaleazzo. The non-aggression pact signed by the Florentines in 1420, apprehensive over their prosperity and disregarding the advice of Niccolò da Uzzano and Gino Capponi, was all Filippo Maria needed to absorb Genoa on the one hand and Brescia on the other. When in 1423 he seized Forlì, on the borders of the Florentine Republic, the time had come to act. The Florentines prepared for war, and although the Pope tried to mediate, they sent defiant messages to both Rome and Milan.

Then, alas, ensued a succession of military disasters, culminating in the fantastic rout of the Florentine forces at Zagonara in July 1424, and the destruction of a whole army at Valdilamone in February 1425. Despite universal dismay in Florence, the Republic pulled itself to-

gether and faced the threat of invasion. Antonio di Meglio, the herald of the Republic, wrote inflammatory verses. "Still we are Florentines, free Tuscans, Italy's image and light. Let there arise that rightful scorn which always in the past emerged among us when the time was ripe; do not wait any longer, for in procrastination lies the real danger."[32]

The tremendous challenge before the Florentines and their response in terms of *virtus* to the danger threatening their *libertas* goes far to illuminate the new content we have observed in the race of heroes that populate the center of the city. The fourteen (originally thirteen) niches at Orsanmichele had been assigned to the various guilds since 1339, with only two statues completed before 1400. But immediately after the collapse of Giangaleazzo in 1402 began the march of the statues. In 1406 the council of the Republic quickened the pace by giving the guilds ten years to fulfill their obligations at Orsanmichele.[33] After a lapse of nearly two generations the statues were suddenly recognized as a civic responsibility. Work went on through the war with Ladislaus, the ensuing peace, and into the thick of the second Visconti crisis. In fact, after the long series was nearly done in 1425, the very year of the worst Florentine defeat, the powerful wool manufacturers' guild, the *Arte della Lana*, seems to have considered its Trecento statue of St. Stephen lamentably out of date, and commissioned Ghiberti to replace it with a more modern one in bronze at about ten times the cost of marble.[34] And from 1416 to 1427 the same guild, which had charge of all work for the Cathedral of Florence, commissioned from Donatello and Nanni di Bartolo the great series of prophet statues for the Campanile.[35] Right through the three crises the ancient guild of *Calimala*, the dealers and refiners of imported cloth, once but no longer more powerful than the *Arte della Lana*, fi-

nanced Ghiberti's great doors for the Baptistery. This even though in 1427 the immense cost of the warfare, which had emptied the Florentine treasury and devastated its banking system, had necessitated as we shall see new and radically altered forms of taxation. In this imposing series of sculptured images, unprecedented in any of the Italian cities since antiquity, paralleled outside of Italy only by the vast sculptural programs of the Gothic cathedrals of France, England and Germany, the new classic style makes its appearance, mingled at first in Ghiberti with strong Gothic elements, but forthright from the start in Donatello and Nanni di Banco in its commitment to a new conception of the freedom and dignity of the human person.

However seductive, contentions concerning the relations between stylistic development and political history are notoriously difficult to demonstrate beyond a certain point. Luckily, however, we possess several examples in which the character of specific works, involving notable stylistic innovations, seems bound up with events involving the cherished *libertas*. In 1401, with Giangaleazzo breathing down their necks, the officials of the committee for the Baptistery of the guild of *Calimala* proclaimed a competition for the enormous and extremely expensive second set of doors for the Baptistery, to be executed in gilded bronze. Not until 1402, perhaps not until after the death of Giangaleazzo in September, and possibly even in March 1403 (our style), was the competition judged and Ghiberti declared the winner.[36] But the figures to be included were doubtless laid down by *Calimala*, and the story is therefore told in more or less the same way by both the principal contestants. The fact that the deliverance of Isaac from death by divine intervention was chosen out of all possible Old Testament subjects seems worthy of note. In both Ghiberti's and Brunelleschi's reliefs the

knife is about to be plunged into Isaac's throat when the angel appears. Of course the sacrifice of Isaac traditionally prefigures that of Christ, but the desired salvation of the state from mortal danger is by no means impossible as a secondary meaning. In Ghiberti's relief the feeling of unexpected deliverance is marked and especially touching, in the joyous upward glance of the kneeling youth (Fig. 6). One might note how, in Gregorio Dati's history of the events of the war with Galeazzo, written as we have seen only four years later the hand of God is constantly discovered intervening for the Republic.[37]

In Donatello's graceful, still Gothic marble David of 1408-9, designed for one of the buttresses of the Duomo (Fig. 7), the connection between a triumphant Scriptural victor and the contemporary political scene is reinforced by three separate factors, an iconographic attribute, an exact inscription, and a noteworthy historical event. The youthful champion of the chosen people stands, staring out into space, above the severed head of the defeated tyrant. Due to Janson's enquiries,[38] the wreath about David's brow has been identified by Mr. Maurice L. Shapiro as amaranth, a purplish plant whose name in Greek means "non-fading." It was considered the fitting crown for the undying memory of heroes, and was therefore used by Thetis to cover the grave of Achilles. The amaranthine crown is held out in the New Testament as the ultimate reward of the faithful.[39] Now the statue once bore in Latin the following inscription, "To those who bravely fight for the fatherland the gods will lend aid even against the most terrible foes."[40] In other words, with divine aid a child has put to flight the potent enemy of the people of God. The relevance of the statue to Florence and its political and military situation is especially marked because there are no statues of the youthful, victorious

David (as distinguished from the adult King) before this time, and from this time on they are legion.[41]

Lest anything be lacking to reinforce its significance, in 1416, two years after the overthrow of Ladislaus—our second Goliath—the Signoria demanded the statue urgently and without delay from the Arte della Lana, so that it could be set up in Palazzo Vecchio in the council halls of the Republic, where it stood for many years. Interestingly enough the same thing happened in Florence almost a century later when the David of Michelangelo, also intended for a buttress of the cathedral in 1502, was set up after its completion in 1504 in front of the Palazzo Vecchio itself, as a kind of symbol of the embattled Republic under Piero Soderini, then engaged in the last and tragic phase of its struggle for survival against tyranny. By no means accidentally, Michelangelo's David is not only one of the most noble but also one of the last works of art in Florence to embody that classical notion of human dignity and completeness whose origin in Renaissance art we are considering here.

But Donatello's marble David is by all accounts not a fully Renaissance work, nor, incidentally, does the blank physiognomy of the entranced victor betray any traces of the deep antinomy of shifting emotional states that darkens the faces of the saints of Orsanmichele or the prophets of the Campanile. What shall we say of the St. George of 1415-16?[42] In spite of the obstreperously Gothic niche (probably, as Janson contends, not planned by Donatello), this is a Renaissance statue in the completeness of its individuality, the forthrightness of its stance, the magnificence of its forms (Fig. 8). The warrior saint stands supporting his great shield and looking out on a hostile world with the supreme bravery of a man born a coward. Despite all that Vasari, under fashionable Michelangelesque influence, had to say about its

"vivacità fieramente terribile," this is a reflective, gentle face, with delicate nose, pinched, nervous brows, sensuous mouth, even a weak chin. Yet with divine guidance he has put on the whole armor of the spirit and summons up all his inner forces to confront the enemy. In this work Donatello's analysis of spiritual duality, of the inner battles of the mind, has reached an even greater stage of development than in his St. Mark.[43] As in Castagno's St. Theodore, so deeply influenced by Donatello, the Christian Psychomachia is translated "from the language of traditional symbols into that of individual experience."[44]

We do not, of course, see the work as originally intended. Janson has shown that the right hand originally held a sword or a lance (the former would seem more probable, considering that the saint is shown on foot and that a lance would have jutted unreasonably into the street) and that the head probably wore a helmet,[45] understandably, considering that the figure was done for the guild of the Corazzai or armorers. But how did such a modest guild, not even counted among the Arti Mediane, possess itself of a fine niche at Orsanmichele? In the absence of specific knowledge, I suspect that after the close of the second war for the survival of the Republic, the stock of the armorers in political circles had gone sharply up. In any event, we note that only after King Ladislaus had appeared on the borders of Tuscany in 1408 does the definitive change take place between the late Gothic and the early Renaissance in Florence. From 1410–12 the still medieval masters Bernardo Ciuffagni and Niccolò di Pietro Lamberti find themselves replaced at Orsanmichele by Donatello, Ghiberti, and Nanni di Banco, the founders of the new style.[46] In 1409, in fact, Lamberti is willing to accept the rather humiliating assignment of procuring the marble at Carrara for the St.

Mark to be executed by the still youthful Donatello.[47]

In these new works part of the forces of the self are directed outward toward a world of obstacles and dangers, the other part inward, assessing with deep anxiety the resources of individual character—like divisions within the Florentine Republic itself, acutely conscious of the threat to its liberties, and quite as deeply of its own inadequacy to meet the challenge. Bitterly had Domenico da Prato cried that Florence's deepest sorrow was caused not by the enemy from without but by the poison in the hearts of her own sons. No new Brutus would arise among a people who knew only the maxim, "Let us make money and we shall have honor."[48] But Rinaldo de' Gianfigliazzi was to say, after the rout of Zagonara, "It is in adversity that men who want to live a free life are put to the test; in times of good fortune everybody can behave properly,"[49] and Niccolò da Uzzano, "Virtue reveals itself in adversity; when things go smoothly anybody can conduct himself well. Liberty is to be valued higher than life. The spirit cannot be broken unless one wills it so."[50] These searching estimates of the resources of human character differ profoundly from the still medieval longing for divine deliverance in 1402.

From an historical point of view, perhaps the most extraordinary aspect of Donatello's St. George is not the statue itself so much as the relief on its base (Fig. 9). On a grim terrace of rocks, with the opening of a cave on one side and a delicate arcade on the other, St. George on a rearing horse plunges his spear into the dragon's breast, while the captive princess folds her hands in prayer. If the St. George statue can stand as a symbol of the Republic at war, this relief may count as an allegorical reenactment of the battle. But the relief is executed in a style the like of which had

not been attempted since the first century of our era. The figures, landscape elements and buildings are not, as in medieval reliefs—and still in early Ghiberti and the neighboring reliefs of Nanni di Banco at Orsanmichele—set forth almost in the round against a uniformly flat and inert background slab. Rather they are projected, as it were, *into* the surface of the marble to varying degrees of depth corresponding, not to the actual shapes of the represented objects, but to the play of light across bumps and hollows. Donatello is thus enabled to suggest, by the manipulation of tone, steady recession into depth, distant hills, trees, clouds, a building in perspective, and an all-over play of atmosphere. He was aided, of course, by the position of the relief in a never-changing diffused light on the north side of Orsanmichele, and the effects he obtained were undoubtedly much more delicate before the marble had been corroded by exposure to five and a half centuries of rain and wind.

While Janson is correct in pointing out that the building is not accurately constructed according to the rules of one-point perspective,[51] it certainly represents the closest approach to such perspective construction before the days of Masaccio. But, even more important, Donatello has grasped in this relief the essential idea on which not only one-point perspective but every other important principle of Renaissance and later art was to be based up to and including nineteenth century Impressionism— namely, that the represented object has no autonomous existence, ideal, tangible or both, for the artist, who is bound to represent it only as it appears to one pair of eyes at a single moment, from a single point of view and under a single set of atmospheric and luminous conditions. The supremacy of the individual implied in this concept is by far the most startling aspect of Donatello's early pro-

duction. In fact, the basic optical revolution of Renaissance art may be said to have first taken place in the mind of this young man as he contemplated the fine marble slab specially procured from the Opera del Duomo for this relief for the north side of Orsanmichele in February 1417—even a few months earlier if, as seems to me inescapable, the subtle and unprecedented luminary and atmospheric effects carried out with such success in marble were first prepared for in a clay model in which experimentation would have been easier and failure quickly remedied. Regardless of the fact that the analogous optical achievements of the Van Eycks could only have been accessible to the Italians at a much later date, even the earliest reasonable dating for the Hand G miniatures of the Turin-Milan Hours leaves this enormous intellectual conquest securely in the hands of Donatello.[52]

There is a peculiar propriety in the fact that this new conception of the supremacy of the individual should make its first appearance in a work of art celebrating the heroic encount of a single armed knight against the forces of evil at a moment when the Florentine republic had just won so striking a battle for individual freedom. Baron notes that, "as late as 1413, the psychological interpretation of freedom as the spark struck by equality in competition seems to have been still absent from the mental armory of Leonardo Bruni,"[53] so soon to become the greatest apologist for freedom. Yet only a year later he began the first volume of his history of the Florentine people in which, referring to the ancient Etruscan city-states under Roman domination, he said, "For it is Nature's gift to mortals that, where the path to greatness and honor is open men easily raise themselves up to a higher plane, where they are deprived of this hope, they grow idle and lose their strength."[54] In 1427

the general of the Florentine forces, Nanni degli Strozzi, was killed in combat against Filippo Maria Visconti. Bruni was asked to write a eulogy in his honor. Shortly thereafter Bruni became Chancellor of the Florentine Republic, and not until 1428 was he able to finish the work, which he modeled on Thucydides' account of Pericles' oration for the first Athenian citizens to fall in the Peloponnesian war. The secret of Florentine greatness, according to the Chancellor at this moment, lay in the fact that "Equal liberty exists for all . . . , the hope of winning public honors and ascending is the same for all, provided they possess industry and natural gifts, and live a serious minded and respected way of life; for our commonwealth requires virtus and probitas in its citizens."

But this is not all. Florence, Bruni says, is the great home of writing in the vernacular, the volgare, and her Italian speech is the model for the peninsula. At the same time it is Florence alone who has called back the forgotten knowledge of antiquity. "Who, if not our Commonwealth, has brought to recognition, revived and rescued from ruin the Latin letters, which previously had been abject, prostrate and almost dead? . . . Indeed even the knowledge of the Greek letters, which for more than seven hundred years had fallen into disuse in Italy, has been recalled and brought back by our Commonwealth with the result that we have become able to see face to face, and no longer through the veil of absurd translations the greatest philosophers and admirable orators and all those other men distinguished by their learning."[55]

And now let us return to the statues of Orsanmichele. These are the saints of God, chosen to do His work, to carry His banner or His sword.[56] They are also the guardians of the guilds in the maintenance of the Republic, and its spiritual defenders in the battle for the survival of free institutions. As such, they partake

of the virtus and the probitas which were the ideal of the Florentine citizen and the dignity and reflectiveness of the classical philosopher orator or writer.[57] In them becomes explicit the awareness of the historian concerned with the perpetuation of all that is most noble in man. Not only do their cloaks begin to assume the folds of Roman togas, but as soon as the vocabulary of classical architecture is again available, the saints appear in niches framed by Roman orders, as in Donatello's St. Louis of Toulouse done for the Parte Guelfa in 1423 (Fig. 10).

It is doubtless this new equation of citizen-hero-philosopher-saint that sustains Masaccio in setting forth with such grandeur the formidable apostles of the Brancacci Chapel, classic exponents of the dignity of the volgare, and exemplars of the corporeal massiveness and ample fold structure of Donatello and Nanni di Banco. But what is the meaning of the rarely treated subject of the Tribute Money (Matthew 17. 24–27), given such unusual prominence among the frescoes of the Brancacci Chapel (Fig. 11), equated with the most exalted apostolic acts of baptism, preaching and healing?

By 1425 the immense burden of the war had emptied the Florentine treasury and the Florentine economic scene was darkened by a rapid succession of bank failures. A new form of taxation was essential in order to support the war, and in 1427 the Signoría adopted the Catasto, the first attempt at an equitable form of taxation in modern history, and in some respects the ancestor of modern income and personal property tax systems—complete with declaration, exemptions and deductions.[58] But the Signoría did not come to this measure without a fight. In fact the first proposals for the Catasto were made by Rinaldo degli Albizzi on February 19, 1425, and repeated again and again throughout that grim spring. It is in this very spring and summer that I have dated, on a combination of stylistic

and documentary evidence, the *Tribute Money* of Masaccio as well as the neighboring scenes in the Brancacci series.[59] Although Baron makes surprisingly little out of this fact, the Pope himself, successor of St. Peter, resided temporarily in Florence just before the opening of the final war against Filippo Maria Visconti, from 1419–21, on his way to take possession of the papal throne as the first ruler of a Papacy reunited after more than a century of exile and schism.

The *Tribute Money* not only announces taxation as a civic duty divinely revealed but reinforces the traditional Guelph policy of Florence as the Florentine ambassadors were doing at that moment to the Pope newly reestablished in Rome. "To eternity we will persist to preserve our liberty, which is dearer to us than life. And to that effect we will not spare our substance, our sons and our brothers, but put forth without reserve our lives and likewise our souls."[60] The doctrine of divine approval of taxation for the purpose of defense, embodied in Masaccio's *Tribute Money*, persisted in the interpretation of this very passage from Matthew as late as the 1450's when St. Antonine of Florence set down his immense universal history, the *Opus Chronicorum.*[61] Confronted with the dilemma of apparent submission to earthly authority on the part of Him Who is subject to no one, Antonine rationalizes the situation by the following quotation from the Gloss: "not as a sign of subjection does the Church give tribute to kings . . . for the Church is not subject to them, but as a subsidy and occasion for defence, therefore it should not be given to them if they do not defend."

Only in the light of the tragic necessity of Florence in 1425 can we understand this monumental rendition of what might otherwise seem a trivial occurrence in the narration of the Gospels. Masaccio has set the solemn group in the midst of the Florentine countryside, with the range of the Pratomagno in the background, and all the atmospheric effects he had learned from Donatello's eight-years-earlier *St. George* relief now greatly expanded and enriched. He has animated the features of the apostles with the earnestness and excitement of the Florentines themselves, confronted with the awesome task of finding the means of preserving their Republic and its threatened liberties, and receiving from supernal authority the new solution and the mission to proceed with it.

Turning to the adjacent wall of the Brancacci Chapel, we find still another fresco dealing with taxation, representing at once the equable distribution of its benefits to the community and the punishment meted out to those who will not share in time of common need (Fig. 12). The apostles under Peter are distributing alms to men, women and children, while in the foreground (now so badly damaged as to be easily overlooked) lies the body of Ananias, who held back a part of the price of a farm, and was struck down by God at Peter's feet (Acts 4. 34–37; 5. 1–6). I know of no more eloquent visual sermon on the benefits of taxation or the dangers of evasion. The setting is not specified in the Scriptural account, but Masaccio has placed the scene in an ordinary village in the country surrounding Florence and peopled it with pure *volgare* types, including St. Peter himself.

The moving picture of the little Republic standing alone on the edge of the abyss might tempt one to all sorts of parallels. But this was neither the Battle of Britain nor yet Valley Forge. Despite Bruni's proud boast, all classes in Florence were not free. The fate of the oppressed wool carders who tried in 1378 to effect an entry into the guild system and were mercilessly crushed is eloquent testimony to the exclusiveness of the all-powerful guilds and the essentially oligarchic nature of the Florentine state. Perhaps the Florentine situation in the

1420's might better be compared with that of the Athenians at Thermopylae or at Salamis. Both Florentine and Athenian societies were controlled by mercantile classes which enjoyed internal liberties unprecedented in their eras, however little they were willing to extend these same liberties to the classes on whose labors their commercial prosperity rested; both societies were driven to extreme measures to raise from their essentially non-military citizenry the forces necessary for the repulsion of better armed and organized autocracies. What is most important for us as art historians is that ancient Athens and Quattrocento Florence, so threatened and so triumphant, were the matrices of the two most completely humanistic revolutionary styles in the history of art. And, as a corollary, the art of their enemies presents a totally opposed spectacle of individual absorption in the general scheme, material luxury, efficient, mechanical regularity of organization and uniformity of detail. For the art of Milan and Naples was Gothic and remained so until the second, Albertian phase of the early Renaissance provided Roman Imperial forms to celebrate the ambitions of mid and late Quattrocento dynasts in both centers. Outside of Florence, the first Renaissance style of the great sculptors and Masaccio is accepted, among major Italian centers, only in Venice, the Florentine ally in the struggles against monarchic absorption. In Florence the early Renaissance is a republican style; its more rigid Albertian phase is never universally welcomed, and Alberti and Piero can develop their full potentialities only in centers of princely rule. The Florentine Renaissance is sapped from within by late Quattrocento tyranny reflected in the "Gothic" art of Botticelli; revived heroically in the second Republic in the defiant masterpieces of Leonardo and Michelangelo for the seat of republican government, the Renaissance is corroded under the Medici dukes in the nightmare art of the Mannerist crisis, and supplanted altogether under the principate by the neo-Gothic Maniera which becomes in the Cinquecento the normative style of the European courts.

It would be satisfying to record that the Florentines won their struggle against Milanese tyranny. Actually nobody won. Unlike his predecessors, Filippo Maria Visconti did not just die. The battle seesawed on for years, but at least the Florentines did not lose and by virtue of the alliance with Venice were able to preserve for a while their cherished independence. The struggle eventually shifted, as struggles have a way of doing, into other levels with other participants and other principles. The decisive, eventually victorious threat to Florentine freedom arose, as Domenico da Prato had foreseen, not from external threats but from inner weaknesses. In the end it was not foreign but domestic tyrants who undermined the liberties of the Republic in the name of stability.

The solution of every crisis in human affairs leads inevitably to a new crisis. Locked in the bonds of time and his own mortality, man can cope with perils from within and from without only through clear-eyed recognition. Eventually the Florentines lost their liberties through not having recognized in time the subtle threat of the Medici. But their finest hour, to quote Winston Churchill, had still been faced, and in the civic art of the first Florentine Renaissance we have the enduring embodiment of their decision.

We know far too little as yet about the relation between artist and patron in the early Renaissance to pronounce any dogmas, but in this instance it is clear that artists and patrons were intimately allied. The artists, themselves guild members, must have been as concerned as any other Florentines over the fate of their

society, as deeply committed to its continuance,[62] as aware of its limitations and dangers, and as influential in the growth of its ideals, all of which are reflected and paralleled in the content and style of the first great artistic achievements of the early Renaissance. To return to Masaccio's *Trinity*, we behold in the naturalism of these citizens and their rough, human dignity the *probitas* and *virtus* which the Republic exalts; in the classic architecture that enframes them a fitting reference to enobling antiquity and the universal spread of humanistic ideals; in the resignation of the sacrificed Christ to Whose mercy they appeal the ideal of Stoic behavior under adversity; in the simple articulation of the structure leading from man to God, their confidence in the righteousness of their cause and their belief that God helps those who help themselves; in their control over form and space and design the firmness of their moral and intellectual victory over the enemy and over the inner man.[63]

But I am well aware that the foregoing arguments can do no more than hint at the depth and complexity of the factors involved in the appearance of the early Renaissance style in Florence. In the last analysis such matters are as elusive and as mysterious as the nature of creativity or the origins of man's will to resist.

NOTES

1 The aesthetic and psychological perceptions embodied in the present study, and the consequent hypothesis concerning the nature of the early Quattrocento artistic revolution, were first tentatively proposed in my courses at Washington University in the winter of 1955–56. Almost immediately thereafter I read, at the suggestion of Professor Richard Krautheimer, the epoch-making volumes (*The Crisis of the Early Italian Renaissance*, Princeton, 1955), in which Hans Baron provided what seemed to me the long-missing historical motivation not only for the Florentine artistic revolution but even for the time-lag between sculpture and painting. My indebtedness to Dr. Baron's inexhaustible and decisive study goes well beyond the numerous passages from his material quoted here.

 The nucleus of the present article was published in "The Earliest Works of Andrea del Castagno," *The Art Bulletin*, XLI, 1959, p. 170, n. 33. Lectures on the subject were presented in 1957 at the City Art Museum of St. Louis, in 1958 at Yale University (as the first in a series entitled *Three Crises in Renaissance Art*), and in 1960 at the National Gallery of Art in Washington.

 Quite independently, without knowledge of these lectures or the Castagno article, Mr. Truman H. Brackett came to many of the same conclusions on the basis of Baron's book, and presented them in a remarkable paper at the University of Pennsylvania, completed in the spring of 1960.

2 In his inaugural lecture as Professor at the Slade School, published under the title "Art and Scholarship," *College Art Journal*, XVII, 1958, pp. 342–56. Meyer Schapiro's brief article "Style," published in *Anthropology Today*, ed. Kroeber, University of Chicago Press, 1953, is by far the most comprehensive and penetrating historical survey of the whole problem of the theory of style and its relation to the general requirements of sociological, anthropological and psychological studies. The crucial importance of this article to our discipline recommends its republication in a form more immediately accessible to students of the history of art.

3 Although Schapiro (*op. cit.*, p. 311) indicates the value of considering stylistic change in the light of changing and conflicting social and economic allegiances, he notes that "Marxist writing on the subject has suffered from schematic and premature formulations and from crude judgments imposed by loyalty to a political line." Schapiro's strictures could well be applied to the most ambitious Marxist attempt to interpret Florentine style, Frederick Antal's *Florentine Painting and Its Social Background*, London, 1947. This work has, in fact, been subjected to a delicate and searching review by Millard Meiss (*The Art Bulletin*, XXXI, 1949, pp. 143–150) in which the consequences of doctrinal rigidity in the distortion of frequently valuable

evidence are carefully analyzed. There is little to add to Meiss's evaluation save my own feeling that Antal never presents a convincing motivation for the very social changes he considers so important to the development of style. In his book various classes, and divisions and subdivisions of classes (frequently arbitrary and confusing as Meiss has shown) are constantly rising to power, losing power, rising again like elevators, but without any apparent reason. Wars are scarcely mentioned, crises overlooked. Trecento and Quattrocento history becomes a shadow-play between splinter-groups which willy-nilly drag the artist with them.

4 Often noted, but never better stated than by Schapiro, *op. cit.*, p. 294. The supposedly wide divergence between the contemporary styles of Gentile and of Masaccio in Florence serves Antal as the springboard for his plunge (*op. cit.*, pp. 1–3). Yet his emergence from the problem is especially disappointing when he points out himself (p. 311) that Gentile's patron, Palla Strozzi, was the father-in-law of Felice Brancacci, and, therefore, presumably the two artists shared patronage of the same social category, which rather defeats the author's basic contentions. Never in his treatment of Gentile do we find the slightest mention of the painter's prolonged stay in Venice (only the commission in the Ducal Palace is cited) or of his relation to Venetian late Gothic taste, or of the style of Lorenzo Veneziano without whose morphology of drapery and facial types the early work of Gentile is incomprehensible. Nor does Antal give any account of the gradual Florentinization so apparent in Gentile's style between the Strozzi and Quaratesi altarpieces, and especially evident in the Orvieto fresco.

5 The anticlassic style of the mid-Trecento was analyzed and its sources convincingly traced in Millard Meiss's basic study, *Painting in Florence and Siena after the Black Death*, Princeton, 1951. I have attempted a briefer treatment of the relation of content and history to the style of the Mannerist crisis in "The Meaning of Michelangelo's Medici Chapel," *Essays in Honor of Georg Swarzenski*, Chicago, 1951, pp. 145–155, and in "Power and the Individual in Mannerist Art," in *The Renaissance and Mannerism* (Acts of the Twentieth International Congress of the History of Art, II) Princeton, 1963, pp. 222–238. The presuppositions of the foregoing works would appear to be comprised by Schapiro's category of historians who "find in the content of the work of art the sources of its style" (*op. cit.*, pp. 304–5) and thus be subject to the objections he rightly points out, raised by periods which show a discrepancy between content and style, or by those which embody a wide variety of disparate ideas and purposes in much the same artistic forms. But even in such cases, I would contend, the origin of the specific forms can be traced back to symbolic necessities in the sphere of experience, however much conventional acceptance of these forms may cause them to be repeated without reference to their original meaning. Cases in point might be the rote repetition of Orcagnesque motives by artists of the later Trecento not directly affected by the crisis that Meiss has shown influenced Orcagna so deeply, or even the later compositions of Pontormo in which his own forms, so brilliantly original and so moving around 1520, are recapitulated without justification in a period which had already turned in another direction. Schapiro has himself demonstrated a difference in quality between secular Gothic buildings and the cathedrals for which the Gothic style was invented.

6 Overwhelmingly documented by Erwin Panofsky in the case of the first Gothic style (*Abbot Suger on the Abbey Church of St.-Denis and its Art Treasures*, Princeton, 1946). In addition to certain inaccuracies not relevant to the present argument, my own "Lignum Vitae in Medio Paradisi, the Stanza d'Eliodoro and the Sistine Ceiling," *The Art Bulletin*, XXXII, 1950, pp. 115–145, 181–218, suffers from two major omissions. In my attempt to set forth the role of Julius II in the formation of the ideology of the Roman High Renaissance, I neglected the Florentine republican phase of the High Renaissance, and have attempted to supply this omission in the article cited in note 5 above. Furthermore, the megalomaniac element in High Renaissance style remains to be interpreted. It seems particularly significant that the new concept of a titanic race operating in a superhuman arena arises among states pervaded by the general recognition of their real impotence and eventual doom. J. R. Hale ("War and Public Opinion in Renaissance Italy," *Italian Renaissance Studies Edited by E. F. Jacob*, London, 1950, pp. 94–122) has produced a wealth of texts to show that after the disasters of the Taro in 1494 and especially Fornovo in 1495 Italians felt not only that peace and prosperity had fled but that

the small and disunited Italian states were powerless to repel the invading armies of the increasingly centralized European monarchies. The grandiosity of the High Renaissance in both Florence and Rome may well have represented a symbolic response, on the plane of fantasy, to crises that, despite the most desperate efforts, neither the Florentine Republic nor the Papacy was powerful enough to solve in reality. This very sense of impending and inevitable tragedy lends to the High Renaissance art of both centers at once a dreamlike unreality, as compared to the less pretentious and more realistic Quattrocento, and a profound suggestiveness for all later periods haunted by the dichotomy between human aspirations and human transiency.

7 Mariotto di Nardo's panel at Impruneta (Antal, *op. cit.*, fig. 151) is typical of the usual Italian formula. The present study was completed and sent to press before the appearance of the excellent article by Ursula Schlegel, "Observations on Masaccio's Trinity Fresco in Santa Maria Novella," *The Art Bulletin*, XLV, 1963, pp. 29–33. While many of the author's solutions are convincing, and have required revisions in my text, the date on the grave slab of Domenico Lenzi between the altar and the fresco is *1426*, a year completely absorbed by Masaccio's work on the Pisa altarpiece. Both in this respect and with regard to the Gonfaloniere's costume worn by the donor (Lorenzo Lenzi was Gonfaloniere in 1425) the fresco may well be commemorative.

8 Ludwig Pastor, *A History of the Popes*, ed. London, 1910, I, p. 40, quoting a reference in Burckhardt which I have not as yet been able to locate. A serious study of the art-historical importance of Manetti's ideas has yet to be attempted.

9 The evidence is ably analyzed by H. W. Janson, *The Sculpture of Donatello*, Princeton, 1957, II, pp. 17ff.

10 The Cascia di Reggello altarpiece, dated 1422; see Luciano Berti, "Masaccio 1422," *Commentari*, XII, 1961, pp. 84–107.

11 *Op. cit.*, II, p. 19.

12 I would like to repeat here the acknowledgment of my indebtedness to Professor Richard Krautheimer for the notion of the continued stimulus of sculpture on painting in the early Quattrocento (see *Castagno*, note 33). Antal, *op. cit.*, p. 305, noted that "at the beginning of the century upper-bourgeois rationalism was most strikingly expressed in religious sculpture, both statues and reliefs, whereas its full expression in painting came somewhat later," without ever telling us why. He has noted (p. 332) the infiltration of some Masaccesque elements into the style of Francesco d'Antonio in the 1429 organ shutters for Orsanmichele. He might have added the somewhat stronger influence of Masaccio in the Grenoble altarpiece by this same master, and the numerous allusions to Masaccio in the work of Giovanni dal Ponte, adduced in part by Salmi, *Masaccio*, Paris, 1935, fig. CCII.

13 The list includes the *St. Luke*, by Nanni di Banco, the *St. Matthew* by Bernardo Ciuffagni, the *St. Mark* by Niccolò di Pietro Lamberti, and the *St. John* by Donatello, all for the facade of the Duomo; the *Isaiah* by Nanni di Banco, the marble *David* and the lost *Joshua* by Donatello, the *King David*, *Joshua* ("Poggio Bracciolini") and *Isaiah* by Ciuffagni, all for the main fabric of the Duomo; the beardless and bearded prophets, *Zuccone*, *Jeremiah* and *Abraham* by Donatello, the *John the Baptist* and *Abdia* by Nanni di Bartolo called il Rosso and the prophet by Giuliano da Poggibonsi, all for the Campanile; and finally the *St. Peter* by Ciuffagni, the *St. James* by Lamberti, the *St. John the Baptist*, *St. Matthew* and *St. Stephen* by Ghiberti, the *St. Matthew*, *St. George* and *St. Louis of Toulouse* by Donatello and the *Quattro Santi Coronati*, *St. Eligius* and *St. Philip* by Nanni di Banco, all for Orsanmichele.

14 Antal, *op. cit.* pp. 16ff., provides a very able introduction to the intricate and shifting structure of the guilds. Of particular importance is his insistence that from 1251 onwards the ". . . guilds had become fighting organizations in the fullest sense of the word." This is one of the most useful and objective sections of the entire book.

15 Despite the characteristically restrictive and oppressive role of the *Parte Guelfa* traced by Antal, Baron (*op. cit.*, I, p. 15) cites a surprising redefinition of the *Parte Guelfa* by Leonardo Bruni in 1420 when its Statute was being revised: "If you consider the community of the Guelphs from the religious point of view, you will find it connected with the Roman Church,

if from the human point of view, with Liberty—Liberty without which no republic can exist, and without which the wisest men have held, one should not live." For recent bibliography, see *ibid.*, II, pp. 445–446, notes 8 and 9.

16 For the Statutes of the *Arte dei Medici e Speziali*, see C. Forilli, "I dipintori a Firenze nell' Arte dei medici, speziali e merciai," *Archivio storico italiano*, II, 1920, pp. 6–74.

17 Baron (*op. cit.*) has demonstrated full awareness of the importance of his new emphasis for the cultural history of the Renaissance, and in several places invites the application of his ideas to the interpretation of the new art of the Quattrocento, e.g., I, p. 29, "On the other hand, the factor which produced a sudden and incisive change in the art of the first two or three decades of the Quattrocento was the emergence of a new ideal of man, together with the discovery of the laws of anatomy, optics and perspective, knowledge of which was needed to express that ideal and could largely be gained in the school of antiquity," and, p. 174, "those who recall Donatello's *St. George* of 1416—the first book of Bruni's *Historiae Florentini Populi* had been written the year before—will be certain that even the arts did not remain entirely untouched by the political climate of the time of the Florentine-Milanese struggle."

18 Baron, *op. cit.*, I, p. 145, quoting from Gregorio Dati, *L'Istoria di Firenze dal 1380 al 1405*, ed. L. Pratesi, Norcia, 1904, p. 14 (supplemented by comparisons with ed. G. Manni, Florence, 1735, p. 5).

19 Baron, *op. cit.*, I, p. 27.

20 *Ibid.*, I, p. 29, quoting from A. D'Ancona, "Il concetto dell'unità politica nei poeti italiani," *Studi di critica e storia letteraria*, I, 1912, p. 41.

21 Scipione Ammirato, *Istorie fiorentine*, Florence, 1647, II, p. 889.

22 *Ibid.*, II, p. 893.

23 *Loc. cit.*

24 Baron, *op. cit.*, p. 186, quoting Lionardo Bruni, *Laudatio*, L, fol. 150v–152r.

25 Baron, *op, cit.*, I, p. 159, quoting Dati, *op. cit.*, ed. Pratesi, p. 74 and Manni, p. 70.

26 Baron, *op. cit.*, I, p. 320.

27 *Ibid.*, p. 322.

28 Ammirato, *op. cit.*, II, p. 971.

29 Ugo Procacci, "Sulla cronologia delle opere di Masaccio e di Masolino tra il 1425 e il 1428," *Rivista d'Arte*, XXVIII, 1953, p. 12, quoting *Istorie di M. Poggio fiiorentino tradotta di latino in volgare da Jacopo suo figliuolo*, Florence, 1598, p. 135.

30 Procacci, *op. cit.*, p. 12, quoting Giovanni Cavalcanti, *Istorie fiorentine*, Florence, 1838–39; ed. di Pino, Milan, 1944.

31 Eloquently characterized by E. M. Jacob, *op. cit.*, p. 26, as "living in a sort of artistic Kremlin with agents watching everybody. . . ."

32 Baron, *op. cit.*, I, p. 336, quoting messer Antonio di Matteo di Meglio (called Antonio di Palagio), "Rimolatino per lo quale conforta Firenze dopo la rotta di Zagonara," in Guasti, *Commissioni di Rinaldo degli Albizzi*, II, pp. 78–80.

33 Richard Krautheimer, *Lorenzo Ghiberti*, Princeton, 1956, pp. 71–72. This was, of course, one of the innumerable unmet Renaissance deadlines, but it gives an index of the urgency of the need for the statues.

34 *Ibid.*, p. 93.

35 The evidence is summarized and analyzed by Janson, *op. cit.*, II, pp. 33–35.

36 Krautheimer, *op. cit.*, p. 41.

37 Baron, *op. cit.*, I, p. 144.

38 Janson, *op. cit.*, II, p. 6.

39 Janson, *op. cit.*, II, p. 7.

40 *Ibid.*, p. 4.

41 There is, however, Taddeo Gaddi's fresco of the 1330's in the Baroncelli Chapel at S. Croce (Janson, *op. cit.*, II, p. 6). A partial list of the later Davids would include Donatello's bronze, Castagno's shield in Washington, the Martelli *David* by Bernardo Rossellino in the same gallery (for the attribution, see my "New Light on the Rossellino Family," *Burlington Magazine*,

CII, 1961, pp. 387–92), Pollaiuolo's little panel in Berlin, and Verrocchio's bronze, not to speak of Michelangelo's colossal marble statue and his lost bronze.

42 I follow Janson's dating, *op. cit.*, II, pp. 28ff.

43 Vividly stated by Janson, *op. cit.*, II, p. 29.

44 If I may be permitted a self-quotation; *Castagno*, p. 233.

45 Janson, *op. cit.*, II, pp. 26ff.

46 This radical change was noted by Krautheimer, *op. cit.*, p. 72.

47 Janson, *op. cit.*, II, p. 17.

48 Baron, *op. cit.*, I, p. 336, quoting "Risposta di Ser Domenico al prefato Messer Antonio, in vice della Città di Firenze," Guasti, *op. cit.*, p. 81.

49 Baron, *op. cit.*, I, p. 338, quoting *Commissioni di Rinaldo degli Albizzi per il Comune di Firenze del MCCCLXCIX al MCCCCXXXIII*, ed. C. Guasti, Florence, 1867–1873, II, pp. 145–9.

50 Baron, *loc. cit.*

51 Janson, *op. cit.*, II, p. 31.

52 The Hand G miniatures, if by Jan van Eyck, would date between 1422 and 1424 according to the closely reasoned account in Erwin Panofsky, *Early Netherlandish Painting*, Cambridge (Massachusetts), 1953, I, pp. 232–46, but esp. p. 245. If I understand correctly, the recent, still unpublished, researches of Miss Dorothy Miner tend to confirm this dating. A University of Pennsylvania student, whom I have since been unable to identify, pointed out to me the important fact that Donatello's optical predilections are evident as early as the marble *David*, not to speak of the *St. Mark*, in the handling of projections and hollows. The formal repertory of Donatello's relief betrays no hint of northern influence, but seems to derive from the landscape forms current in Florence at the end of the Trecento, especially in the workshop and following of Agnolo Gaddi.

53 Baron, *op. cit.*, p. 367.

54 *Ibid.*, p. 368, quoting Leonardo Bruni, *Historiarum Florentini Populi Libri XII*, ed. Santini, p. 36.

55 Baron, *op. cit.*, I, pp. 352 and 364, quoting Lionardo Bruni, *Laudatio*, ed. Baluzius, pp. 3–4.

56 God the Father appears in the gable of Donatello's *St. George* and in the gables above all three of Nanni's statues for Orsanmichele, blessing the saints below.

57 For the classical sources of the *St. Matthew*, see Krautheimer, *op. cit.*, p. 342.

58 The most valuable recent treatment of the history of the *Catasto*, rich in new material, is to be found in Ugo Procacci's study cited in note 29 above.

59 For reasons to which I alluded in *Castagno*, p. 163, n. 16, but which are not ready for publication.

60 Procacci, *op. cit.*, p. 15, quoting *Commissioni*, II, p. 332.

61 St. Antonine of Florence, *Opus Chronicorum*, Lyon, 1589, I, p. 220.

62 Frequently the artists appear as designers of weapons and systems of defense and offense, as Brunelleschi against Lucca, Leonardo against Pisa, Michelangelo against the Medici.

63 As E. F. Jacob pointed out (cf. note 6, *Italian Renaissance Studies Edited by E. F. Jacob*, p. 47), "A great civilization is not built upon magnificence alone. Self-denial, forethought and forebearing are needed, qualities which historians are not always ready to concede to the makers of the Italian Renaissance." He continues to quote Leonardo (*The Notebooks of Leonardo da Vinci*, ed. Edward McCurdy, London, 1956, I, p. 87), "You can have neither a greater nor a less dominion than that over yourself."

Theological Context

12 Religious Expression in American Architecture

DONALD DREW EGBERT

With the assistance of Charles W. Moore*

An enthusiastic teacher, a scholar with impeccable professional standards, and a master of literary craft, Donald Drew Egbert, Jr. is a leading authority on modern architecture, American art and civilization, and the relation of socialism to the arts. Born in Norwalk, Connecticut in 1902, Egbert studied architecture before becoming an art historian, receiving his Master of Fine Arts degree from Princeton University in 1927. He has taught at that university since 1929, and in 1968 was appointed to a chair of art history as Howard Crosby Butler Professor of Architecture.

Having studied art history with Charles Rufus Morey, Albert M. Friend, Jr., and other members of the "Princeton school" of the history of art and archaeology, Egbert turned his early scholarly attention to medieval art and especially to ivory carving. In his early papers, he attempted to ascertain the dating and provenance of some 35 "North Italian Gothic Ivories in the Museo Cristiano of the Vatican Library" (*Art Studies* VII [1929], pp. 169–206) and some "Baroque Ivories in the Museo Cristiano of the Vatican Library" (*ibid.,* VIII [1931], pp. 33–45). For his illuminating study *The Tickhill Psalter and Related Manuscripts* (New York, 1940) he was awarded the Haskins Medal of the Mediaeval Academy of America in 1943. Four years later he wrote a monograph on the portraits owned by Princeton University (*Princeton Portraits* [Princeton, 1947]). During these early years of his career, Egbert also remained vitally interested in modern architecture, which had become a new branch of accepted art historical research only at the time of the Great Depression; one of the first such architectural studies was Henry Russell Hitchcock's *Modern Architecture* (New York, 1929), which was perceptively and searchingly reviewed by Egbert in the *Art Bulletin* XII (1930), pp. 98–9. Egbert himself wrote a paper on "The Education of the Modern Architect" for *The Octagon: Journal of the American Institute of Architects* XIII (1941), pp. 4–12. In 1942, Princeton University founded its American civilization program for undergraduate instruction, and Egbert both contributed to this program as a teacher and was deeply influenced by its substance and scope in his later thought and scholarship. In an incisively written paper of 1944, he dealt with "Foreign Influences in American Art" (pub. in *Foreign Influences in American Life,* ed. David F. Bowers [Princeton, 1944], pp. 99–125; Princeton paperback). In one of his most profound studies, he examines in considerable detail the various theories that have been operative in the thought of American architects, hence influential in the creation of their individual works and the development of their *oeuvres* ("The Idea of Organic Expression and American Architecture," in *Evolutionary Thought in America,* ed. Stow Persons [New Haven, 1950], pp. 356–96; reissued in 1956 and again in 1968). In a later work on "Religious Expression in American Architecture" (Princeton, 1961), reprinted here, Egbert

*This essay was in large part written by Professor Moore from a recorded lecture by Professor Egbert, and then jointly revised.

Religious Perspectives in American Culture, ed. James Ward Smith and A. Leland Jamison, Vol. II in *Religion in American Life,* No. 5, Princeton Studies in American Civilization (copyright © 1961 by Princeton University Press) "Religious Expression in American Architecture" by Donald Drew Egbert, with the assistance of Charles W. Moore. Reprinted by permission of Princeton University Press.

seeks "to show how the architecture of American churches, meeting houses, and synagogues has tended to exemplify, in highly tangible form, important aspects of prevailing American religious beliefs and practices" from the 17th and early 18th centuries to the present day.

These were significant contributions toward an understanding of the history of American art and architecture in the light of its functional and cultural background. Egbert's work in this area led him to study social radicalism as it has affected the spatial arts in America, Western Europe, and behind the Iron Curtain. In 1952 he coedited, with Stow Persons, and coauthored for the American Civilization Program of Princeton University the monumental work *Socialism and American Life* (which was nominated for a Pulitzer Prize). The long, concluding chapter of the first of these two volumes was subsequently revised and expanded by Egbert in his *Socialism and American Art in the Light of European Utopianism, Marxism, and Anarchism* (Princeton, 1967; Princeton University paperback). Egbert has examined some relevant aspects of this topic in a number of recent articles: "Politics and the Arts in Communist Bulgaria," *Slavic Review* XXVI (1967), pp. 204–16; "English Art Critics and Modern Social Radicalism," *Journal of Aesthetics and Art Criticism* XXVI (1967), pp. 29–46; and "The Idea of 'Avant-garde' in Art and Politics," *American Historical Review* LXXIII (1967), pp. 339–66. These and other of his papers have recently been compiled for presentation by his former graduate students as a token of esteem and appreciation on the occasion of his retirement from the faculty of Princeton University (*On Arts in Society: Selections from the Periodical Writings of Donald Drew Egbert,* ed. Alan Gowans [Victoria, British Columbia, 1970]). His major contribution on the interdependence of the visual arts, social history, and the history of ideas, and indeed his most towering achievement, is *Social Radicalism and the Arts, Western Europe: A Cultural History from the French Revolution to 1968* (New York, 1970). It is studies such as this which demonstrate that, contrary to current trends in scholarship, the history of art need not be divorced from other branches of humanistic learning. Treating complicated matters clearly and simply, this objective study shows that the interpretation of art history in the light of social history and ideas can be free of the dogmatic strait jacket in which Marxist art history and criticism is imprisoned (compare the paper by Frederick Antal on page 339 of this anthology). Moreover, it can be said that Egbert is an example of an American-educated art historian whose intellectual thought not only has broadened and matured in significant respects during his career, but is also characterized by an openmindedness and a meaningful multiplicity of points of view that are the hallmark of the best art history of our times.

Winston Churchill once declared, "We shape our dwellings, and afterwards our dwellings shape us."[1] It is true that he was referring, not to dwellings of the spirit but to a specific secular edifice, the recently bombed-out House of Commons, which he insisted must be reconstructed exactly as it had been before the bombing in order that its architectural arrangement might continue to foster the British parliamentary system. Nevertheless, his statement has meaning for other kinds of buildings, including religious buildings. For temples, churches, meeting houses and synagogues, if architecturally adequate, all reflect in some way and to some degree religious beliefs of their specific denomination or sect. These buildings, in turn, may also affect the very nature of the religious services held in them, so that an individual architect or a prevailing architectural style may actually foster a new interpretation of some of the doctrines and beliefs of the given religious group.

[1] Notes to this selection appear on page 338.

The purpose of this essay, then, is to seek to show how the architecture of American churches, meeting houses, and synagogues has tended to exemplify, in highly tangible form, important aspects of prevailing American religious beliefs and practices. To begin, we must go back to the original forms of Christian church architecture, as they evolved during the first centuries of Christianity. At the risk of oversimplification one can say that there are two chief types. The first of these is the basilical type—essentially a long rectangle, usually divided along the long axis into three aisles, with the chief door in the center of one short end, and at the other end a sanctuary. The sanctuary is often in an apse (a kind of large niche) projecting from the end of the building. Sometimes there are transepts extending out from the long sides of the rectangle, producing a Latin cross plan. Beginning relatively early in the Middle Ages, there were frequently towers (the bell tower was a Benedictine addition that originated in the eighth or ninth century). By the very nature of the basilical plan, attention is focused down the long axis of the structure, at the end of which lies the sanctuary in which the axis culminates.

The second traditional Christian church type has a plan in which attention is focused into the center of the building—even though often the sanctuary is not located at this point. This central type may be circular or polygonal, or it may have a Greek cross plan, that is, one with four equal arms.

Early Protestant churches in Europe often continued these traditional plan types, especially the basilical type with bell tower. The traditional basilica particularly tended to persist where a state Protestant church took over existing Catholic buildings, as was done, for example, by the Anglican church in England, or by the Lutheran church in north Germany and Scandinavia. The continuation of a traditional type was likely to occur, too, where the

reaction against the Catholic liturgy and hierarchy was relatively weak, again as in the case of the Anglican church in England. Moreover, the traditional type customarily survived wherever the church edifice was looked upon as a holy building, as the house of God.

Some Protestant groups, however, especially those who—in sharply rejecting hierarchical religious government—were religiously on the far left, added a new kind of church building, the meeting house, to the traditional types mentioned above. Most meeting houses, as their name implies, were derived from the house (with perhaps some influence also from simple, aisleless, rectangular medieval churches), although, as we shall see, there was one important meeting house type that apparently did not stem at all from domestic architecture. As one might expect, meeting houses were most likely to occur where dissenting Protestant groups were frowned upon by the state church, as was the case, for example, in seventeenth-century England, except during the Civil War and the Commonwealth or after the Toleration Act of 1689. As one might expect, also, some type of meeting house was generally found wherever the reaction against the old liturgy and hierarchy was particularly strong. Emphasis was placed then on the priesthood of all believers, on preaching, or—usually—on both. And the meeting house was most likely to be found wherever the building was not regarded as a holy place, but as suitable for all group meetings, secular as well as religious. This was to be the case, of course, in New England, where the town meeting was held in the same edifice that was used for religious services.

Thus meeting houses were built especially by dissenting groups made up of religiously left-wing Protestants. All of these groups emphasized a preaching space, a simple rectangular or, more rarely, polygonal room; and as might be expected, the emphasis was on simplicity,

whether from fear of popery, or from fear of persecution, or both. For even more than other Protestants, these groups emphasized what is known as the Protestant plain style.[2]

Such is the general background of the chief types of religious architecture to be found in the American colonies during the seventeenth and early eighteenth centuries. As regards the churches of the Spanish colonies, suffice it to say that they were essentially provincial versions of the traditional basilicas of the mother country. In the other colonies, however, there was more variety—in some the traditional church types prevailed; in others, the meeting house types were dominant; while in still others, both were to be found side by side—variations depending on the particular colony and the denominations or sects that prevailed there. The basilical type, for instance, was especially to be found in colonies where the Anglicans were strong, and in colonies where Lutheranism was important.

The beginnings of Anglicanism, it will be recalled, lay in the refusal of the English church under Henry VIII to acknowledge the Pope's supremacy over any other bishop: Henry VIII's promulgation in 1534 of his Act of Supremacy followed the Pope's refusal to grant him a divorce from his wife, Catherine of Aragon, so he could marry Anne Boleyn. As a result, when the Anglican church broke with Rome, it simply took over existing buildings. However, under Henry VIII's successors, especially Edward VI and Queen Elizabeth, an increasingly Protestant tendency developed: under Elizabeth's government were promulgated the Thirty-nine Articles which showed strong Calvinistic and Lutheran influences. During this period, the parish church type of the Middle Ages continued to be built in England, although the type was somewhat modified to contain a more Protestant service.[3]

In the American colonies of Virginia and South Carolina, where the Anglican church was established by law, the basilical type also prevailed. The church building believed to be the oldest in this country is St. Luke's Church near Smithfield, Virginia (Fig. 1),* apparently built in 1632. Typically English, this is an Anglican parish church of the medieval type, only slightly modified by Protestantism and by Renaissance classicism. The layout of the building, with its tower at the center of the façade, is of a sort frequently encountered in English parish churches of the medieval period. The Gothic tracery in the windows, the little Gothic pinnacles still surviving on the edges of the gables (particularly the rear gable), Gothic buttresses, all are parts of what remains essentially a medieval parish church, but with some new and more classical elements beginning to assert themselves under a fashion then developing in England. Over the door is a triangular pediment, more or less classical, and on the corners of the tower are quoins, both probably somewhat later in date than the body of the building. The look of a medieval parish church is even more pronounced on the interior (Fig. 2) —the Gothic tracery shows in the sanctuary window, and the structure of the roof is exposed in the medieval fashion, rather than concealed as customary later under the influence of the Renaissance and post-Renaissance. The church has a choir screen, also Gothic in spirit but classical in detail: this, with the exposed roof structure, has very recently been restored. Notice that in this church the altar occupies a place of major importance. As a consequence, the pulpit is placed off to one side, although it is nonetheless in a very important position, given prominence by the Protestant emphasis on preaching.

* Illustrations accompanying this selection appear on pages 499 to 510.

Like Anglican churches, the Lutheran examples of the colonial period also tended to adhere to the basilical type. German Lutherans began to come into the colonies in the late seventeenth century; like the Anglicans, they claimed that their church was catholic and not sectarian, although the colonial American Lutheran leaders, such as Muhlenberg, were in close touch with pietistic left-wing Protestants in Germany. As a consequence, one could expect the architecture of the early Lutheran churches of the Pennsylvania German country to be based on a basilical plan, but with considerable emphasis on the ultra-simplicity characteristic of the architecture of left-wing Protestant groups. One of the most famous examples of the period is Muhlenberg's own church at Trappe, Pennsylvania, known as the Augustus Lutheran Church, built in 1743 (Figs. 3 and 4). The type is basilical, but the church is very simple. Its towerless exterior is not wholly unlike a meeting house; nevertheless it is not a meeting house type because the main door is in the short side and the sanctuary is located at the end of the long axis opposite the main entrance. The interior (Fig. 5) shows the simplicity of the church; the pulpit, as at St. Luke's, is placed off the axis of the church, and the sanctuary is then reserved for communion. A gallery, built to allow more people to get closer to hear the services, underlines the importance of preaching in Protestant churches.

In considerable contrast to the basilical church are the meeting houses, two chief varieties of which occur in the American colonies. These two types—built by those colonial groups regarded in England as dissenters—are quite similar on the inside but different on the exterior, and overlap confusingly. Among the dissenting groups who made use of them, the Calvinists figured with particular importance, and in the American colonies included, of course, the Congregationalists of New England, the Dutch Reformed of New Netherlands

(later New York and New Jersey), the Presbyterians in New Jersey and the Piedmont, the German Reformed of Pennsylvania, and the Huguenots of South Carolina and New York.

The first type of Calvinist meeting house to be discussed was often employed by the Congregationalists and also by some Dutch Reformed congregations. The only example of its type remaining from the more than 200 meeting houses known to have been built in New England in the seventeenth century is the famous Old Ship Meeting House at Hingham, Massachusetts (Figs. 6 and 7). This, the second meeting house at Hingham, was built by Congregationalists in 1681 but successively enlarged in 1730 and 1755, so that it is only partly a seventeenth-century meeting house. One might note here that since the New England meeting house served for town meetings as well as for religious services, it became the prototype for many early American town halls—including those of the Western Reserve which was settled by Congregationalists from New England.

Even in its present form, the Old Ship Meeting House shows various survivals from medieval architecture,[4] and in this respect is not unlike most other seventeenth-century colonial buildings, including St. Luke's Church in Virginia. The high pyramidal roof, for instance, reflects medieval antecedents in its steepness, although a Renaissance type of cupola has been placed on the deck at the top of the pyramid.

The earliest meeting house in Connecticut, built in Hartford in 1636, was of the same type except that the high pyramidal roof came to a point, so that the deck and cupola, essentially Renaissance features, were lacking. Other meeting houses had the roof deck, but not the cupola and bell, and in such cases the congregations were usually called together by a drummer standing on the deck.[5] The New Haven meeting house of 1639 already had a cupola, but New Haven was established by

relatively wealthy and aristocratic found-
ers whose architecture, therefore, was
more likely to be up-to-date in style.

On the interior of all these early meeting
houses, the structure was exposed in the
medieval fashion: its resemblance to the
timberwork of a ship gave the Old Ship
Meeting House in Hingham its name. In
plan these New England buildings were
rectangular, but with reduced emphasis
on a long axis; in fact the main entrance at
Hingham is on the long side of the building,
with the pulpit placed directly opposite
the entrance door. On the short axis, it is
true, there is a side entrance, but the main
axis runs the other way from that of the
basilical plan, and the building itself is
more nearly a square. Thus, in its interior,
which is typical of meeting houses of early
type, attention is focused on the pulpit,
placed on the long side of the room. Also
typically, the men were separated from
the women, who sat on the right while the
men sat on the left. The earliest seats were
simply crude benches; as the desire for
comfort increased backs were placed on
the benches; and then, with increasing
wealth, box pews were put in for the aris-
tocracy.

In summary, what was the character of
the meeting house as seen here? First,
great emphasis was placed on simplicity
in the architecture, harmonizing with the
primitive simplicity of the service, as these
Protestant groups sought to reestablish
the simple purity of early Christian ser-
vices. Secondly, emphasis was placed on
the direct connection of the individual
worshiper with God, through God's word,
for God was regarded as incarnate in the
Bible. The belief in the priesthood of all
believers, though strong, was less empha-
sized than among the Quakers, for ex-
ample, because in Congregationalist New
England, the Word was interpreted by the
minister as the spiritual shepherd of the
flock, whereas the Quakers, on the con-
trary, have had no clergy until quite re-
cently. Yet for Congregationalist and

Quaker alike, as for most other Protestant
groups, the individual does not approach
God through a priestly hierarchy as in
Roman Catholicism. The New England
meeting house, far from being a place for
the celebration of the Mass, is a preaching
house, designed for hearing the word of
God expounded. Galleries are included if
necessary so that all the congregation can
hear, but they are not ordinarily present in
the meeting house because the New En-
gland town, and the congregation that
made up the population of the town, were
restricted in size. As soon as the town
grew so big that it became difficult for the
members of the congregation to get into
meeting, another town was established.
Not only was the meeting house small
in scale, but into its simplicity nothing was
allowed to intrude which might distract
from the direct connection of the individ-
ual member of the congregation with the
word of God: no crosses, no images, no al-
tar with the relics of the saints. A pulpit
placed close to a communion table marked
what was regarded as a return to the spirit
and usages of primitive, and true, Chris-
tianity.

What is the origin of the Hingham type
of meeting house, characterized by a rela-
tively square plan, by an entrance and
pulpit on the longer sides, and by a roof of
more or less pyramidal shape usually with
a deck on top and often a cupola for a bell?
It is difficult to say. Interestingly enough,
England contains no early meeting houses
of exactly this type. It becomes useful,
therefore, to interrupt our consideration
of this Congregationalist type of building
to examine two examples which illustrate
the kind of meeting houses used by Con-
gregationalists and similar groups in Eng-
land, so as to see how they differ from the
Hingham Meeting House. The first of these
examples is at Horningsham in Wiltshire
(Fig. 8). It was built in 1566, and is the old-
est Congregational chapel in England (the
meeting places of English dissenters are
called chapels), although it was originally

erected for a group of Scottish Presbyterian masons who were working on a great house, "Longleat," nearby. This meeting house is clearly different from that at Hingham; on the exterior it resembles much more closely a simple house. This could be expected, since the Separatist movement in England, except under the Commonwealth in the middle of the seventeenth century, had to remain to a considerable degree underground, until the expulsion of the Catholic James II by William III of Orange in the Glorious Revolution of 1688 was followed the next year by William's Toleration Act, which gave greater freedom of worship to the dissenters in England.

Yet even when the dissenters had been briefly dominant in England in the mid-seventeenth century, such meeting houses as were built had exteriors of the house type, and so did not resemble the New England meeting houses of the kind found at Hingham. This can be seen in our second English example (Figs. 9 and 10), which was built during the Civil War shortly before the establishment of the Commonwealth. It is a Congregational chapel at Walpole in Suffolk. The original building, constructed in 1647 in the midst of the Civil War, was enlarged about 1690; and the peculiar double gable probably resulted from the enlargement. It has been suggested that this meeting house may originally have been formed by joining two cottages together side by side. Whether or not this is the case, the Walpole meeting house was erected at a time when the Congregationalists who built it were at least locally dominant, yet the exterior of the building is still of the simple house type so characteristic, also, of earlier and later meeting houses in England and so different from the typical New England Congregational meeting houses of the period. The interior, however, is quite similar to that at Hingham, though with galleries and with a flat ceiling covering the upper part of the timbers of the roof.

We are left still with the problem of the origin of the Hingham type of meeting house. Some authorities have suggested that influences from Holland largely determined its form. It indeed seems likely that the Hingham type originated at least partly under Dutch influence, and that it is a modified form of Dutch Reformed, or Dutch Calvinist, church building.[6] The Congregationalists could, of course, have received this Dutch influence while the Pilgrim Fathers were in Holland before embarking for New England. Certainly, similar pyramidal roofs are to be found in Dutch Calvinist churches. One example, the Dutch Reformed Church built in Albany, New York (Fig. 11) in 1715, and seen here in a view of 1805, seems to be of much the same type as the Old Ship Meeting House at Hingham; and the Huguenots in New York had an early meeting house of a similar kind which likewise resembled the Hingham meeting house except in the absence of the balustraded roof deck. However, it should be noted that by no means all of the Dutch Reformed churches were of this relatively square type: many of them were octagonal, such as the church in Bergen, New Jersey, built in 1680 (Fig. 12), or that erected in New Brunswick in 1767.

Obvious prototypes for this octagonal form, at least, existed in Dutch Reformed churches in Holland. An example at Willemstad, Holland—erected in 1586 (Fig. 13) and the oldest Dutch Protestant church built as such—is a clear forerunner of the octagonal church in Bergen. The ancestry of the Willemstad church form lies in the traditional central type of Christian church, adapted to the Protestant service by the Dutch Reformed Church, the state church in Holland. Again a state church had taken over a traditional type, in this case the central type, one especially adapted to the Calvinistic emphasis on preaching. The source of the form, for the Dutch, may actually have been from French émigrés who were Huguenots. It is possible that the octagonal shape came from a design by the Italian architect

Serlio for a "temple" in classic style, first published in 1547 at Paris. On the other hand, ever since the early Middle Ages there had existed not far away at Aachen, in the Rhineland, the palace chapel of Charlemagne, which is polygonal, and which suggests that the form used at Willemstad may have been a local regional type. The roof at Willemstad, an octagonal pyramid surmounted by a Renaissance cupola, is not unlike that at Hingham. If it is necessary to account for the shift from building polygonal churches to building rectangular ones, an answer might be that it is easier to roof a rectangular structure. It may be tentatively suggested, then, that the New England meeting house of the Hingham type originated, at least partly, in Holland, and that the polygonal form became rectangular—as also in the Dutch Reformed church at Albany—for greater simplicity of framing and roofing. One might add here that the interior of the church at Willemstad (Fig. 14) shows the characteristic Protestant simplicity, with the pulpit directly opposite the door and the church arranged for easy hearing.

Since the New England meeting house, such as that at Hingham, also served for town meeting, the possibility should be mentioned that this kind of meeting house may reflect the influence of a town hall type (much as later—in reverse—the town halls of the Western Reserve were to reflect the influence of New England meeting houses). For example, a typical English town hall at Abingdon in Berkshire (Fig. 15), built in 1677 and including an open market, has a similar squarish shape, with high roof, cupola, and roof deck.[7] It is true that this generally squarish type of building, which thus appears both in some meeting houses and in some town halls, seems to be characteristic of many types of English and Dutch buildings of the seventeenth century. The Governor's Palace at Williamsburg, for instance—which of course is neither a meeting house nor a town hall—has the same general type of composition, one that in its compact clarity of form probably reflects the increasing influence of the Renaissance and post-Renaissance from Italy, whatever the specific sources of the type may be.

Unlike the Congregationalists in New England and the Dutch Reformed in New York, the other Calvinist groups in the American colonies, particularly the Presbyterians, were especially likely to use the house type of meeting house. And this was also true of such extreme left-wing sects as the Quakers and the Baptists. In other words, the more ultra-Protestant the group, the more likely would be its use of the house type found in England. It must be remembered that meeting houses of this kind presumably originated partly in an effort to avoid attracting undue attention in places where dissent was forbidden or frowned upon, much as is the case in Roman Catholic Spain today. The early meetings of dissenting congregations were thought of, too, as parallels to early Christian meetings, which had often taken place in private houses. Thus there were special reasons for such religiously radical groups as the Quakers and the Baptists to have a building that looked like a house. Although the house type is usually somewhat less square, more elongated than the Congregational meeting house of the Hingham variety, the form differs sharply from the basilical type in that the entrance is on the longer side, and this side is ordinarily placed parallel to the street in front of the building.

A famous Quaker example in England itself, the Quaker Meeting House at Jordans, in Buckinghamshire, built in 1688 (Fig. 16), is fairly early and very typical. Because of its close association with the Penn family, this is of particular interest to American Quakers. Turning to American examples: at Stony Brook, near Princeton, New Jersey, is a charming little Quaker meeting house (Fig. 17) built in 1760, which likewise obviously resembles a private house. (The porch seen in the illustra-

tion was added later.) The interior of this, as of many other Quaker meeting houses, is not large enough to allow for a very descriptive photograph; therefore a relatively late and relatively large example, the meeting house at 4th and Green Streets, Philadelphia, is shown (Fig. 18). This was built in 1812, and is a characteristic Quaker meeting house in that it does not have a pulpit, because—as mentioned above—the Quakers until recently have had no ministers. Instead, a group of elders sat in a row facing the rest of the congregation, and, like other members, prayed or preached whenever individually moved to do so by the spirit, the Inner Light. This Quaker meeting house has galleries, because it serves a large city congregation.

An interesting left-wing Baptist example is the Elder Ballou meeting house at Cumberland, Rhode Island (Fig. 19), which was built about 1740 for a group of unorthodox Baptists known as Free-Will Baptists, and is clearly of the house type. On the interior, it would differ from a Quaker meeting house especially in having a pulpit.

There are exceptions to be noted to the general statement that the Anglicans used a church type with tower and steeple, while dissenters used some kind of meeting house. One exception was this: in the colonial regions where dissent from Anglicanism was dominant, even Anglicans at times felt it necessary to adopt a local meeting house type. This can be seen in St. Paul's Church in Wickford, Rhode Island (Fig. 20), an Anglican church built in 1707 in Narragansett, and moved to Wickford in 1800. (The famous Dean Berkeley preached in it in 1729.) Even though this is an Anglican, or Episcopal, church, it is basically a house type of meeting house, and as such has its long side parallel to the street. On the interior, the pulpit is placed on a long side opposite the main door as in the meeting houses. Although the plan (Fig. 21) does show elements of the basilical type in having a sec-

ondary entrance on a short side with the altar opposite it on the other short side, no axis leads from one to the other as it would in a true basilica.

It should be noted, also, that even in colonies where Anglicanism was the established religion, as in South Carolina, local functional considerations might modify the standard basilical scheme. Country churches, for instance, might omit the towers and steeples when they were in areas where the plantations were so widely separated that a bell could not be heard, for there a belfry would be relatively useless. Thus the church of St. James at Goose Creek, South Carolina (Figs. 22, 23, and 24), built in 1711 in plantation country, has no bell tower, although its entrance is on the short side and it has a long axis leading to the sanctuary, as in a typical basilical plan. Here, however, in a period when Anglicanism still tended to reflect some relatively strong Calvinistic influences, the pulpit is placed on the axis, and the communion table a little to one side though still within the sanctuary. At this time, even Anglican churches such as this one were still likely to demonstrate a kind of Protestant simplicity, reinforced at St. James's by the fact that this is a small country church.

As the eighteenth century wore on, however, not only did Anglican churches become less severely Protestant, but under the leadership of Anglicanism the basilica type tended to replace the meeting house type for practically all American religious groups with the notable exception of the Quakers. Moreover architectural fashion greatly aided the eventual triumph of the basilica type: the increasing use of classic forms, for stylistic reasons, acted in the basilica's favor, because increasing classicism meant greater admiration for the classic temple form. And in the classic temple the entrance was customarily placed on a short side of the building, which, with its pedimented gable, was the

side of the building likely to be located—
in Roman classic fashion—toward the
street. The use of classical forms, in short,
greatly encouraged placing a long axis
perpendicular to the street, as in the basil-
ical type.

The classic temple composition, which
came from the revival of classic architec-
ture in the Renaissance and post-Renais-
sance, had been introduced into Anglican
church architecture in England by a great
seventeenth-century architect, Inigo Jones,
on the east façade of St. Paul's, Covent
Garden, in London. The use of various clas-
sical elements was to become customary
in Anglican architecture after they had
been widely, and freely, employed by Sir
Christopher Wren, and especially by
Wren's great eighteenth-century succes-
sor, James Gibbs.

The transformation of Anglican church
building in England at the hands of Sir
Christopher Wren and James Gibbs is
worth our further attention because of its
profound effect on American architecture.
Wren, who was born in 1632, lived well
into the eighteenth century: he died in
1723. It was, however, soon after the great
fire of London in 1666 that he had built
a great number of churches in London, and
had given a new expression to the Angli-
can church. Basically Gothic tower and
steeple forms were usually retained at the
entrance end of the long axis as in so many
English medieval parish churches, but
now were treated with superimposed clas-
sical colonnettes and other decoration,
apparently in part under the influence
of the towers of some Dutch Protestant
churches. Wren used many varieties of
both basilical and central plans, but the
basilical type, with the pulpit somewhat
off the axis, tended to become dominant
under the widening classicism of the eigh-
teenth century, especially in the form
popularized after Wren by James Gibbs
(1682–1754), who had studied in Italy.
It was Gibbs whose influence on colonial

builders was most direct, largely through
the widely popular book that he had pub-
lished in 1728 entitled A Book of Archi-
tecture. A typical example of Gibbs's work
is the Church of St. Martin-in-the-Fields in
London, built 1721–1726. The exterior
view (Fig. 25) shows a basilica-type church
whose tower, instead of rising from the
ground as Wren's ordinarily did, visually
rests on the roof so as not to interfere with
the classic pediment and portico on the
front of the church. For reasons of archi-
tectural composition, it is obviously essen-
tial to place a pedimented and porticoed
edifice of this kind with its short side to
the street, as the Anglican church for a
long time had often done for other reasons.
The interior of the church is not unlike
many of Wren's, except that there is a
greater degree of elaboration in the chan-
cel, which is given further architectural
emphasis in plan (Fig. 26) as well as detail.
This tendency toward more elaborate arch-
itecture was destined to increase as reac-
tion set in among Anglicans against the
Calvinistic simplicity which had so often
prevailed in the seventeenth century. Nev-
ertheless, some emphasis on preaching con-
tinued, as the galleries here demonstrate,
although the pulpit, unlike the arrange-
ment in St. James's at Goose Creek, is off
to one side while the sanctuary is reserved
for the altar. The position of the pulpit
placed to the side of the sanctuary indicates
that Calvinist influence is not so strong
even as it had been in South Carolina,
when St. James's at Goose Creek was built.

An eighteenth-century Anglican church
in the American colonies, which may be
compared with Gibbs's St. Martin-in-the-
Fields, is Christ Church in Philadelphia,
built between 1727 and 1754 (Figs. 27, 28,
and 29). The interior is not so very differ-
ent from that of St. Martin-in-the-Fields,
but, as could be expected, is simpler and
more provincial. Yet for a colonial church
of its time, it shows a most unusual degree
of elaboration in the chancel end. For this

was a church in a big city, the church of wealthy and fashionable people, who, like most wealthy colonials everywhere, were seeking to keep up to date with the latest architectural fashions in the mother country; moreover, at this time it was fashionable for cultivated gentlemen to design buildings in collaboration with experienced craftsmen, and this was the case with Christ Church. Here also, as at St. Martin-in-the-Fields, the pulpit is set off to one side with the altar placed on the axis. The exterior, although lagging behind St. Martin's in having a Wren-type projecting tower, and therefore no portico at the entrance end, otherwise shows the increasing elaboration which had become possible in the colonies as they grew richer —especially in Philadelphia, the most populous city. It shows, too, the increasing prevalence of classical forms even on the sanctuary end of the church. In this case, a classical pediment, although on the end opposite the entrance, nonetheless suggests the long axis of the basilical plan. This is the type of building, then, which was eventually to prevail even for most non-Anglican religious edifices. For in competition with the Anglicans, who had become increasingly fashionable even in non-Anglican colonies largely because Anglicanism was the official religion of the mother country, non-Anglicans gradually found it necessary to adopt the tower and steeple. As classicism increased, they also adopted the pediment with, often, a front portico, which, in accordance with the classic principles of composition of the Renaissance and post-Renaissance, meant —as we have noted in English churches— that the tower would no longer be carried down to the ground in front of the church, like so many of Wren's towers, but would spring from the main roof as in Gibbs's St. Martin-in-the-Fields.

Thus, in seeking to compete with the Anglicans, and to be up-to-date in style, the Calvinists and most other dissenting groups not only took over the tower and steeple, but eventually, also, often combined these with a portico as well as a pediment. At first the dissenting groups merely placed the tower and steeple on the short, or minor, side of a house type of meeting house—the tower and steeple meant that the Hingham variety of meeting house, with pyramidal roof and cupola, had to be abandoned. Now an entrance in the tower could serve for reaching stairs to the galleries, even though the main entrance was still on the long side. Eventually, however, the whole basilical plan was adopted, and, in still later examples, was often combined with a classical entrance portico. It might be noted here that only after the desire for a classic effect had become very strong was the whole edifice likely to be painted white: the pre-Revolutionary churches and meeting houses were generally far more colorful than is usually realized today. For example, New Haven had a meeting house which, when rebuilt in 1764, became known from the color of its paint as the Blue Meeting House, while another Connecticut meeting house, this one at Pomfret, was described in 1762 as painted a deep orange, with doors and bottom boards chocolate, and only a few relatively minor details painted white.

Probably the first Calvinistic example of a meeting house constructed with a tower and steeple placed on the short side of a house-type meeting house was the Second Congregational Meeting House in Boston, known as the New Brick Meeting House, which was built in 1721 and destroyed in 1884. A famous example still standing of such a meeting house with tower and steeple is the Old South Church in Boston, built in 1730 (Fig. 30). Actually, this is a Congregational meeting house of the house type with which a tower and spire have been combined. The design was unquestionably influenced by Christ Church in Boston, the Old North Church, built by the Anglicans seven years before, in 1723. Because the Old South Church (notice it is now called church; the name meeting

house was eventually replaced) had a corner location, two entrances could each be almost equally important. In the meeting house tradition, the main entrance for the congregation was placed on the long side, while the tower entrance now could lead directly to stairways serving the galleries.

A famous Jewish synagogue dating from the colonial period shows many of the same general tendencies that we have seen in Christian architecture of the time. This is the Touro Synagogue in Newport, Rhode Island, designed by a Gentile, the well-known architect Peter Harrison, and built in 1763 for a Sephardic congregation. In being without a tower and simple in other respects, its exterior is not unlike that of a meeting house; yet at the same time the building was not uninfluenced by the trend away from the meeting house toward the basilica type. The synagogue's strict orientation in accordance with specifically Jewish doctrine places it at an angle to the street, and the entrance is though a modest one-story portico (Fig. 31). The plan (Fig. 32) indicates, however, that the still rather squarish building nonetheless has a quite strong longitudinal axis, with the entrance at one end and the Ark at the other, the reading platform being placed midway along the axis. Even the gallery, supported on twelve columns in the Jewish tradition, contributes to this basilical arrangement. A view of the interior (Fig. 33) shows the richness and delicacy of the detail, which is apparently original except that the Ark was remodeled early in the nineteenth century. One might note here that, as Touro Synagogue already indicates, Jewish religious architecture in America has, on the whole, been subject to the same general stylistic influences as Christian architecture.[8]

Nearly half a century had to pass after the building of the Old South Church before a Puritan church was erected which not only had a tower and steeple like Old South, but an entire basilical plan. This was the Brattle Street Church in Boston, erected in 1772–1773, just before the outbreak of the American Revolution. The main entrance here was at the tower, which was placed at the end of the long axis, with the communion table and the pulpit at the other end in the basilical way. The fact should now be added that in the years following many old meeting houses were to be brought more or less up-to-date by simply adding a tower and spire to them; this was done, for instance, to the meeting house at Cohasset, Massachusetts.

A Presbyterian church that somewhat similarly reflects the tendency away from the meeting house toward a more basilical type is the Old Tennent Church, built in 1731 but enlarged in 1751, at Tennent, New Jersey, near Freehold (Fig. 34), which has a rudimentary steeple on the short side of what is otherwise a meeting house. However, such little steeples were to be found on some Presbyterian meeting houses in Scotland, and so may indicate a Scottish, rather than an Anglican, influence on the Old Tennent Church, the original name of which was Old Scots Meeting House. Notice that the entrances here are still on the long side, as in a meeting house, and that originally there were two, while the pulpit is located in the center of the opposite long side.

The same general development away from a meeting house type toward the basilical plan with tower and steeple took place in the meeting houses of practically all left-wing Protestant sects. Even the Quakers, who have customarily continued to build the traditional type of meeting house, in relatively recent times have built a few with tower and steeple, especially in the Middle West.

The addition of tower and steeple to the meeting house also became customary in Baptist buildings. The First Baptist Meeting House at Providence, Rhode Island (Fig. 35), erected in 1775, said to be the oldest orthodox Baptist church edifice that

still stands in this country, was built with a tower and spire which were directly copied from Gibbs's *A Book of Architecture*, from an alternate design made by Gibbs for St. Martin-in-the-Fields in London (Fig. 36). Yet this Baptist building is still called a meeting house, and it preserves a meeting house type of plan in being squarish, with the main entrance on the long side. The pulpit, however, is placed opposite the tower, and thus in the position it would have in a basilical plan; and the style of the whole interior, too, bears a great resemblance to such famous Anglican churches by Gibbs as St. Martin-in-the-Fields.

Thus, as such examples as the Old South Church in Boston or the First Baptist Meeting House in Providence so clearly show, even before the Revolution the Anglican church type was winning out among non-Anglican denominations and sects, particularly among the wealthy and fashionable congregations of the larger cities. And during the same years, not only were the latest architectural modes of the mother country being increasingly adopted, but at the same time Anglicanism was becoming increasingly fashionable even in regions, such as New England, where formerly it had hardly existed at all or had played a very secondary role. It is true that in the Revolution most of the American Anglicans, especially in the cities, remained loyal to the mother country, and thus were Tories—with the result that Anglicanism (or Episcopalianism, as it was called after the Revolution) was for many years hard hit in the United States. Nevertheless, the shift to the basilical plan with tower and steeple on the front that the influence of the Anglicans had so largely instigated among other American religious groups continued rapidly. Soon the meeting house type was no longer being built except by the Quakers and a few other religiously left-wing groups such as the Shakers. For we shall see that important architectural influences in addition to those coming from

Anglicanism strongly encouraged church, rather than meeting house, types.

In various ways, then, the Revolution constituted a kind of architectural boundary or watershed. When it ended, various currents already endemic but secondary in American life were to become much more pronounced. For one thing, the American tendencies toward individualism and anti-traditionalism became much stronger, and helped to encourage the eclecticism in architecture that for a variety of reasons was now developing throughout the Western world. The term eclecticism comes from a Greek verb meaning to choose or pick out, and simply refers to choosing whatever style or styles of present or past may be desired, and even to combining various styles in a single building. The process is, as it were, an expression of architectural *laissez faire*—each individual freely selects the architectural elements and forms that he wishes.

A second current of growing importance for American religious architecture after the Revolution was revivalism. It is true that revivalism, with its emphasis on evangelical Christianity, had begun before the Revolution, especially in the Great Awakening of 1740 which was particularly fostered by an evangelistic tour made by the Reverend George Whitefield, friend of the Wesleys. Like Whitefeld, John Wesley, the chief founder of Methodism, regarded himself as an Anglican. However, the evangelicism of the Methodists and their tendency toward revivalism eventually led to their departure from the Anglican church. In 1784, almost immediately after the Revolution, Methodism was officially established in this country, with the result that the Methodists—along with the Baptists—had a profound influence on the spread of revivalism, especially in the back-country and on the frontier.

A glance at the background of English Methodism should include reference to George Whitefield's Tabernacle in St. Luke's Parish, London, built in 1753 (Fig.

37). The name Tabernacle clearly implies the influence of the Old Testament on Christianity. The architectural form itself places an emphasis on revivalistic preaching by providing a preaching room not unlike that of the New England Congregational meeting houses, although on a far larger scale and with huge galleries. In contrast to the small meeting houses of New England, this tabernacle held 4,000 people. And where most earlier New England preaching had been based on a primarily intellectual approach to a theologically trained congregation, Whitefield's preaching was intended to have an emotional appeal. Moreover, this appeal was not restricted here to a congregation made up merely of the population of a small village, but was directed to great masses of people from all over a great city. In this case, then, the emphasis was more on the common man, and on arousing him emotionally, not only by means of emotional preaching but also by the wholehearted congregational singing of revival hymns, rather than of Psalms alone, which is so stressed by Methodists to this day.

Another building important for the background of Methodism in England was Wesley's City Road Chapel in London (Fig. 38), built in 1778. This tabernacle, now also destroyed, likewise was a kind of simplified meeting house for preaching. Although this too was a squarish building, it did have a long axis running away from the entrance somewhat more like a basilica. Interestingly enough, however, this chapel was originally subsidiary to, though separate from, a neighboring Anglican church where the sacraments were administered, while the chapel itself was used simply for a preaching house. In spite of the shape of this building, Wesley once said that he preferred to preach in octagonal structures. He was probably influenced in this by a well-known Presbyterian octagonal meeting house at Norwich, England, which had apparently been inspired by octagonal churches in Holland, so that here again

the influence of Dutch Protestant architecture seems to have affected the architecture of an English Protestant group. Furthermore, in accordance with Wesley's preference, many later British Methodist chapels were octagonal: a typical example is that built about 1830 at Mawgan-in-Meneage, in Cornwall (Fig. 39). The simplicity characteristic of the buildings of left-wing Protestants is also evident here, although some of the details show a prevailing architectural fashion of the time, for Gothic Revival touches, such as tracery in the windows, are present.

While in the early nineteenth century revivalism, with its need for a centralized space for preaching and hymn singing, fostered the popularity of the central type of plan, this was by no means the only reason for the type's popularity. Even more important was the fact that this peak of revivalism happened to coincide with the rise to fashion of an architectural style which particularly lent itself to producing such a centralized space. This style was the Roman Revival. And the particular Roman prototype that now especially encouraged central type churches was the great circular temple in Rome known as the Pantheon, erected under Hadrian in the second century A.D. In addition to the Methodists, many of the other American Protestant denominations and sects had their own specific requirements which in some way especially encouraged them to make use of Roman Revival architecture. This was true, for example, of the Baptists. Like the Methodists, they too could make good use of a centralized temple form for revivalistic preaching. However, there was another reason why this type of building was especially suited to the needs of Baptists, as can be seen in an old view of the Sansom Street Baptist Church in Philadelphia (Fig. 40), designed by Robert Mills in 1808–1809. For this kind of building was well fitted to housing and emphasizing the baptismal pool which the Baptists require in accordance with their belief in the

baptism, not of children, but of adults old enough to realize the significance of the rite, and by total immersion.

This central type, which as here could be covered with a dome more or less like that of the Roman Pantheon, could serve still other tendencies in American religion. Inasmuch as it possessed a clear rational shape, for instance, it could be attractive to groups like the Unitarians who, far from being revivalists, were strongly rationalistic, and so at an opposite pole of Protestantism. An example is the Octagon Unitarian Church of Philadelphia (Fig. 41), designed in 1813 by the same Robert Mills, in which much the same architectural form was used as in the Sansom Street Baptist Church but for a religion rationalistic rather than enthusiastic, though nonetheless a religion in which preaching is important. Thus in this case the revival of classic architecture went hand in hand with intellectualism and rational simplicity, a third powerful tendency within American religion of the period.

This intellectualism grew out of the eighteenth-century rationalism of the Enlightenment which itself had helped to encourage the revival of Roman and, later, Greek classical forms as an expression of a rational spirit in architecture. Yet these forms, if they were accurately archaeological, could produce many other connotations and associations—some of them far from purely rational. They could symbolize, for one thing, the republican spirit by creating a romantic association with the republics of ancient Rome and Greece, an association which lent a special importance to the classic revivals in the new American republic. Their luster in this respect was even further enhanced for Americans in the 1820's and later because of American sympathy for the modern Greeks who had revolted against the tyranny of the Turks to achieve their own independence in the romantic aura which attended the death of Byron in Greece. For many Americans, the Greek and Roman forms also effectively connoted the primitive virtues and rational simplicity of classic man, as a more natural man than his modern counterpart. This harmonized, of course, rather with the views of Rousseau and of his followers than with Christian belief, but nonetheless had an indirect effect even on religious architecture.

Largely as a result of such Classic Revival fashion, paradoxically a fashion peculiarly suited both to the emotional spirit of evangelical revivalism and to the new rationalism, many religious buildings once more lacked towers and steeples simply because classical temples lacked them. And this Revival imitated not only the form of circular temples, such as the Pantheon, but also that of rectangular temples, Greek as well as Roman. The rectangular form, with its especially clear and easily comprehensible shape, in particular lent itself to the expression of the religious values of the more rationalistic nonconformist groups, Unitarian or Calvinistic. However, the imitation of the rectangular classic temple form meant that the main entrance would have to be placed on the short side beneath the pedimented gable, as it had been in the temples themselves; and to be truly classic there could be no tower or steeple. This was the case with the present building of the First Presbyterian Church at Princeton (Fig. 42), which was designed and built in 1836–1837 by a local architect, and is clearly inspired by a classic temple even though with a facade apparently more or less based on a widely known design made and published by the American architect, Asher Benjamin. This Princeton church stands on the site of two earlier edifices, both of which had burned, and the first of which was a meeting house of the house type, with its main entrance in the long side opposite the pulpit. In both earlier buildings the long sides were parallel to the street. It was especially the prevalence of classic fashion at the time when the present church was erected, then, that produced a major compositional

change. Yet the severely rational form of the present temple-like edifice could also serve here as a clear expression of the rationalistic and anti-revivalistic old school Calvinism for which Princeton had come to stand in the nineteenth century. This was a kind of Calvinism in sharp contrast to the Whitefieldian revivalism that the eighteenth-century builders of the original meeting house on this site (and also the founders of Princeton College, which used that meeting house for its Sabbath services and graduating exercises) had once so whole-heartedly accepted.

Even more rationalistic than old school Calvinism, of course, was Unitarianism, whose growth in New England could directly parallel the spread of classical revivalism in architecture. Much later, the Christian Scientists, too, were to use for their mother church in Boston a domical structure not unlike some Renaissance versions of the Pantheon. Even though today the Christian Scientists have no one standard type for their churches, nevertheless the rationally clear form of their building in Boston does seem harmonious with their belief that mind is a fundamental principle of the universe. This doctrine is seemingly also reflected in the fact that they have in their churches no pulpit. In place of the minister there are two readers, one of whom reads from the Bible, the other from the writings of their founder, Mary Baker Eddy. It may be significant that, like Unitarianism, Christian Science was partly an outgrowth from rational Calvinism, and that Mrs. Eddy's own parents were Congregationalists.

The existence side by side in American life, and especially in American Protestantism, of such widely different tendencies as extreme individualism, emotional revivalism, and intellectualism could only be expected ultimately to give rise to a reaction against such confusion—to emphasis on strong central church organization and hierarchy, traditionalism, and an elaborate liturgy. As could be expected,

also, this kind of reaction developed especially among groups that had always been more likely to emphasize hierarchy and a richly liturgical service. It therefore was led by Roman Catholics and by Anglo-Catholics. And the architectural style to which both of these groups turned as the best expression of their needs was the Gothic Revival (which, however, like the Classic Revival, was by no means restricted solely to church architecture).

The Gothic Revival, like the Classic Revival also, was encouraged by the romantic love for the remote in space and time; and this, among other things, could encourage a belief that the past was superior to the present—more natural, less spoiled by the development of civilization. In religious architecture this could stimulate a preference for some earlier style regarded as being closer to the original—therefore purer—doctrines of the particular religious group. Both the Roman Catholics and the Anglo-Catholics eventually emphasized a revival of the Gothic style for their church buildings because it was a style that preceded the Renaissance and the Reformation, which for them had sullied the stream of pure Christian doctrine.

Significantly, what is usually called the first Gothic Revival church design in the United States was made for Roman Catholics in Maryland, the only British colony originally settled by Catholics. It was a design prepared in 1805 by the architect Benjamin Latrobe for the Roman Catholic Cathedral at Baltimore (Fig. 43). However, in this design Latrobe—who had recently come from abroad with a most up-to-date Continental and British training in architecture—was ahead of his time. Offered as an alternative solution, this Gothic design was rejected in favor of one in a Roman Classic style clearly inspired by the Pantheon in Rome (Figs. 44 and 45).[9] But although Latrobe's alternative Gothic design was rejected, only a year later Roman Catholics in Baltimore were to build a Gothic Revival chapel for St. Mary's Semi-

nary, designed by the architect Maximilien Godefroy, who had recently arrived from France (Fig. 46). Thereafter, the Gothic Revival, which exponents could regard as exemplifying a revival of the spirit of St. Thomas Aquinas, was to be used with increasing frequency for Catholic churches, as it has been almost to the present. Perhaps the best known example of a Gothic Revival Catholic church in this country is St. Patrick's Cathedral in New York, designed by the architect James Renwick and built between 1850 and 1879 (Fig. 47).

Like the Roman Catholics, and partly under their influence, the Anglo-Catholics —or High Church Episcopalians—reacted against individualism, emotional revivalism, and the over-intellectualism of the Enlightenment, and likewise embraced the Gothic Revival. Anglo-Catholicism really began in England in 1833 with the foundation of what became known as the Oxford Movement. This was led especially by John Henry Newman, who wrote its first tract, but who eventually became a convert to Roman Catholicism and finally was made a Cardinal. A little church built for Newman at Littlemore (Figs. 48 and 49), not far from Oxford, in 1835–1836 is, significantly, in the Gothic Revival style. Its close resemblance to an English parish church of the Middle Ages indicates that the spirit of actual Gothic architecture has been very well understood by the Gothic Revival designer.

The first American publication devoted wholly to Gothic architecture appeared in 1836, three years after the Oxford Movement began in England. This was an *Essay on Gothic Architecture*, written by John Henry Hopkins, the Episcopal bishop of Vermont. While it is true that Episcopal churches with Gothic Revival details had been built before this time, now many Episcopal churches were to be designed in a well-understood Gothic style. The vogue for Gothic Revival church architecture gained particular impetus with the completion of Trinity Church in New York

(Fig. 50), which was designed by the architect Richard Upjohn, and built between 1839 and 1846. Upjohn was a devoted and persuasive follower of the High Church movement. As such, he finally succeeded in winning the building committee over not only to having a Gothic church, but a Gothic church with a deep and elaborate chancel. However, he was unable to persuade the vestry of the need for a cross at the top of the steeple—the vestry preferred a weathervane as less redolent of popery. According to a story which has come down in the Upjohn family, Upjohn then secretly put a cross in place on the steeple just before the scaffolding was taken down. With the scaffolding gone, the vestry was reluctant to pay to have it put up all over again; and so the cross is there to this day. The interior (Fig. 51) of the church, as well as its exterior, shows an extensive knowledge and understanding of Gothic architecture. The Gothic detail is highly elaborated, especially in the chancel, where the pulpit's location to one side also helps to indicate the reaction against earlier Calvinist influence on Episcopalianism. Upjohn's own influence extended to country areas with a book, *Upjohn's Rural Architecture,* which was published in 1852, and contained designs for wooden "carpenter" Gothic churches (Fig. 52) of a kind that Upjohn had begun to design about 1845. Innumerable rural churches, especially for Episcopal congregations, were built from the designs in his book by carpenters who, however, usually altered the design somewhat to meet local conditions (Fig. 53).

At the height of the popularity of Gothic Revival, a Romanesque Revival was also flourishing in the United States. The original Romanesque style had preceded the Gothic in western Europe, and—being nearer in time to Roman architecture— tended to retain such Roman characteristics as the rounded arch and a considerable massiveness. In the mid-nineteenth century, the Romanesque Revival was also

sometimes called Byzantine (from that style found in the eastern Mediterranean contemporary with the actual Romanesque in western Europe), or sometimes Lombard (from the variety of Romanesque which had occurred in north Italy). However, the role of this Romanesque-Byzantine-Lombard style in the general medieval revival of the nineteenth century was a secondary one until, with the advent of one great architect in the second half of the century, it became immensely popular. This architect was Henry Hobson Richardson. The most famous and most influential example of Richardsonian Romanesque is Trinity Episcopal Church in Boston (Fig. 54), built between 1873 and 1877. Although this building is called Romanesque, it is actually a kind of Victorian free eclecticism in which elements of some diversity are welded by a superlatively skillful architect into one composition. For Richardson's inspiration derived from a variety of sources: the tower was inspired by that of a Spanish Romanesque cathedral; the ornament comes largely from a French Romanesque style, that of the region of central France called Auvergne; while other elements are borrowed from the Romanesque school of Provence. Nor was Richardson inspired only by the Romanesque: on parts of Trinity Church, some Gothic tracery can be found, as well as Gothic colonnettes and ornament. Only an architect of Richardson's immense ability could transform this variety of sources into a personal style which in many ways transcended his models.

Trinity Church in Boston is Low Church. The fact that some earlier Low Church Episcopalian churches—such as St. George's, Stuyvesant Square, in New York —also used a kind of Romanesque style, may indicate a tendency among Low Church Episcopalians to wish to employ a medieval style other than the Gothic Revival in order to distinguish themselves from High Church Episcopalianism. Indeed, their own revival of an earlier medi-

eval style may even have been regarded by them as a revival of a "purer" architecture.

In addition to his characteristically massive stone architecture, so well illustrated by Trinity Church, Richardson also developed a shingle style which likewise had a profound influence, and which was used for many small churches of various denominations by some of his numerous imitators. In his stone and shingle architecture alike, Richardson increasingly gave a direct and natural expression to each specific material. In other words, unlike the average architect of the Victorian period who so often loved to make things look like what they were not, Richardson took expressive advantage of inherent characteristics of the particular material. In this respect, and also in often emphasizing the fundamental geometric forms of his buildings, Richardson was a direct forerunner of major twentieth-century tendencies in architecture.

After his early death in the middle 1880's, however, his style continued to be imitated by lesser architects unable to achieve such creative results, with the consequence that the tendency in Episcopal churches soon was to return to a Gothic Revival style now directly based on the careful use of "good" medieval models. The practitioners of this kind of eclecticism usually did not seek either to copy an original model in full detail, or to develop a very free version of "modern" Gothic as the Victorians had done largely under the influence of John Ruskin. Instead, they devoted painstaking care to evoking the spirit of the actual Gothic of the Middle Ages, and did so with an emphasis on good craftsmanship which often reflected the influence of the artistic beliefs of William Morris, and at times of his social beliefs as well.

The first example in the United States of a Gothic Revival building carefully based on the spirit of good models in this way is said to have been the chapel of a great Episcopalian private school, St. Paul's

School at Concord, New Hampshire, designed by an imported English architect named Henry Vaughan, and mostly built in 1888. Other architects, many of them likewise devoted Episcopalians, took over this style: the American architect, Ralph Adams Cram, was notable among these. Cram, who was born in 1863 and died in 1942, was the son of a Unitarian minister; but Unitarianism never satisfied him and he became a convert to Anglo-Catholicism. As a member of the firm of Cram, Goodhue and Ferguson, he developed a large practice, becoming especially known as a highly fashionable church architect, not only for Episcopal churches but for those of other fashionable forms of relatively right-wing Protestantism. Ons of his most famous works is the Episcopal Cathedral of St. John the Divine, which had been begun by other architects in a Richardsonian Romanesque style. Cram took it over, revising it as far as possible into a Gothic building. An example by Cram that shows how right-wing Protestant congregations who were not Episcopalians might take over this style, is the East Liberty Presbyterian Church in Pittsburgh (Figs. 55 and 56), commissioned by a member of the wealthy Mellon family as a Mellon memorial church and completed about 1935. Of this Cram said in his autobiography: ". . . it is a simple fact that in half an hour, by the addition of a Crucifix and six candles on the Communion table, the church could be prepared for a pontifical High Mass either of the Roman or the Anglican Rite."[10] And privately Cram said much the same of the Princeton University Chapel, completed in 1928. (The fact that in 1907 Cram had become supervising architect of Princeton University—so long a great Presbyterian stronghold even though it has always been technically nonsectarian—is significant for the period.)

Many of those who have disagreed with the point of view represented by Cram have objected to the Gothic Revival in this country on the ground that it is not a national American style, and therefore is necessarily a false expression of American tradition. Nonetheless, various upholders of the Medieval Revival have long sought to glorify it as a national style. To cite a famous secular example—in 1847 Robert Dale Owen, son of the great utopian socialist, Robert Owen, had become the chairman of the building committee for the Smithsonian Institution in Washington. As such he wrote a book telling in detail how his committee had selected a kind of late Romanesque-early Gothic style for the Smithsonian Institution as the best expression of a truly national American style.[11]

Thus we turn to the question of nationalism, which in religious architecture has been most likely to encourage, not the Gothic Revival, but a revival of what is regarded as American colonial style. The revival of the colonial began especially after the Centennial Exposition at Philadelphia in 1876, which of course took its name from the fact that it celebrated a century of American independence. At that exposition one of the buildings was supposed to represent a colonial log cabin (although we now know that the original settlers in New England customarily did not live in log cabins); and in it were displayed such examples of colonial furniture as the cradle of Peregrine White, the first white child born in New England, and the desk of John Alden.

Largely out of the Centennial Exposition, then, grew the colonial revival. Yet many of the favorite old examples imitated in the colonial revival actually were works of the federal period, and so did not date from pre-Revolutionary, and therefore colonial, times. As might be expected, it is a revival particularly popular for churches of those Protestant groups, such as the Congregationalists, whose days of greatest influence had been in the colonial period. A beautiful example of the type of Congregational church which was imitated in this supposedly colonial revival is the church at Lyme, Connecticut (Fig. 57).

As this was built in 1815–1817, it dates well into the republic, and thus is not colonial at all; yet it is this style that many if not most Americans like to think of as being typically colonial. The church at Lyme has been copied several times in the twentieth century, usually for Congregational churches such as those at Williamstown, Massachusetts, and Norwalk, Connecticut. Interestingly enough, however, the Congregational church at Lyme was also imitated in the private chapel of the late Roman Catholic Cardinal Mundelein, built at his seat near Chicago. In this case, the architecture apparently reflected a desire, conscious or unconscious, to have the Roman Catholic church accepted as traditionally American, in order to meet the criticism of those non-Catholics who—for example, in the Hoover-Smith campaign of 1928—have held that simultaneous allegiance to the United States and the Pope is impossible.

Another tendency that must now be mentioned as affecting church architecture, particularly Protestant church architecture, ever since the eighteenth century, is the humanitarianism on which the whole Social Gospel movement has been based. It is true that some of the seeds of that movement had long been present in the left-wing Protestant emphasis on the common man, but it was brought to flower by the romantic humanitarianism of the late eighteenth and nineteenth centuries, and was especially fostered by Ruskin's social doctrines. The effect of humanitarianism and the Social Gospel on religious architecture can especially be seen in the increasing tendency for the church edifice and related buildings, particularly of Protestant groups, to develop into a social and educational center. This tendency really began with the Sunday school movement, founded by Robert Raikes in 1780 with Wesley's approval, which originated as an effort to get working-class children off the streets on Sunday, and thus originally involved secular as well as religious educa-

tion. In view of its outgrowth from Methodism, it is worth mentioning that the Sunday school was later given special importance by an American Methodist bishop, John Heyl Vincent, whose friend, Louis Miller, a Methodist Sunday school superintendent, invented what was known as the Akron plan. This took its name from its demonstration in the Methodist church in Akron, Ohio, built in 1868, and was strongly supported by Bishop Vincent. His motto was "Togetherness and Separateness," and the basic concept of the Akron plan was to have all the members of a Sunday school gather together in one large room for joint activities, then at a signal to break up into separate groups in small classrooms divided from the big room by folding doors. As part of the element of togetherness, singing was stressed, as is usual in Methodism. Adopted by many other Protestant groups, only about 1910 did the Akron plan tend to be abandoned in favor of the departmentalized Sunday school and large parish house. One might add here that the Akron plan had connections with the widely popular Chautauqua movement, of which Louis Miller and Bishop Vincent were two of the founders. The headquarters of the movement grew out of a center for training Sunday school teachers founded in 1871, and were established at Fair Point on Lake Chautauqua three years later.

Today, of course, the elaborate kind of parish house which, with the decline of the Akron plan, became so popular, often occupies an area far larger than that of the church itself. As everyone knows, its layout is often very complex, with spaces for men's groups, women's societies, boy scouts, bowling alleys, basketball courts, and the like. A good example to illustrate this complexity is a plan of the early 1940's for the First Presbyterian church of North Hollywood, California. Here the total plan (Fig. 58) is so elaborate (even including in the Sunday school area a "Jinks Court," presumably for high jinks) that on paper

it is difficult to find the church proper. Notice, also, that in the church building itself, there is a large and elaborate chancel, even though this is a Presbyterian church. As in the period before the Revolution, the influence of Episcopalianism has tended to lead other Protestant groups toward a more elaborate service—again partly, perhaps, because of the fashionableness of Episcopalianism in American society.

When the North Hollywood Presbyterian Church was finally built in 1945 on a different plan, it was in a Spanish style. Yet only fifteen years later it was being altered to a style described by the minister as "contemporary."

This suggests another tendency which since the eighteenth century has increasingly affected much church architecture: an emphasis on progress and modernism. In the nineteenth century when the Gothic Revival was the dominant style for Roman Catholic churches, so also did Popes Pius IX and Leo XIII attack liberalism and modernism. Meanwhile, within the various Protestant denominations and sects there was going on a constant struggle between belief in tradition as good and belief in progress as good. Naturally enough, those liberalistic groups which—under the influence both of scientific and technological progress and of a romantic optimism—have upheld the idea of progress, were more likely than religiously conservative groups to make early use of "modern" architectural forms with little or no reminiscence of the past. However, today the problem is not so simple; and we shall find that some of the most traditionalistic and also some of the most fundamentalist groups have likewise made much use of modern architecture. This paradox we must now try to account for.

Unity Temple, or Church, at Oak Park, Illinois, designed and built by Frank Lloyd Wright in 1905–1906 (Figs. 59, 60, 61), exemplifies a church built by a religiously radical Protestant group subscribing to an optimistic liberal theology in which belief in secular progress is implicit. The building itself was highly radical and progressive for its time in being built of poured concrete, a new material here frankly expressed with no reminiscence of historical style. Significantly, the congregation that built Unity Temple—of which Wright's family had long been members— had originally been Unitarian but had largely become Universalist. In so doing, they had accepted not only Unitarian rationalism but the basic Universalist—and non-Calvinist—doctrine that because of God's love for man, the probability exists that all will be saved, an optimistic liberal theology which had first come to America in 1770. In this building rationalism has combined with theological optimism to encourage a progressive spirit in architecture, and therefore a building was achieved in a technique and style extraordinarily modern for its time. Not only is this true of the materials, the structure, and the architectural form, but of the plan as well (Fig. 60); for Unity Temple was the first church to have the entrance not directly on the street, but opening off a terrace between the church and the parish house so that it might serve them both. This plan has exerted a very wide influence, not only on churches of many different denominations—including Bernard Maybeck's unique Christian Science Church (1912) at Berkeley, California—but also on many synagogues. The interior of Unity Temple (Fig. 61) shows not merely a lack of historical reminiscence but a deliberate avoidance of it. Nevertheless, the building is still in the Protestant tradition of a preaching room, in which, since the eighteenth century, the singing of hymns has also been important.

Over thirty-five years after Frank Lloyd Wright designed Unity Temple, he was to design a Unitarian meeting house in Madison, Wisconsin (Fig. 62). Looking at this from the exterior of the sanctuary, we can see why Wright has called it "the church

in the attitude of prayer," for the treatment has the spirit of hands placed together in supplication. In this symbolic way the architect has conveyed the idea of religious edifice, yet has avoided imitating churches of the past. The interior of the building, however (Fig. 63), which again suggests the Protestant preaching room, shows how Frank Lloyd Wright in his recent churches and chapels often liked to have natural daylight behind the pulpit, and even in some cases to have the congregation look out through a window behind the pulpit into nature. This could suggest the Christian view that nature is good because created by God and because it is the earthly dwelling of man. But in being carried so far, this actually is a reflection of that kind of romantic pantheism which is often implicit in Wright's buildings or in such statements by him as "Buildings like trees are brothers to the man, buildings trees and man are all out of the ground into the light."[12] Nevertheless, it will be noted that in this building Wright—unlike many other modern architects who have used the same device—has distinguished the architectural space of the interior from the natural space out of doors by means of horizontal bars placed across the great windows behind the pulpit.

Wright's son, Lloyd Wright, has gone much further than his father toward a kind of romantic pantheism in the Wayfarers' Chapel that he designed in Palos Verdes, California, in 1951 (Fig. 64). Since the photograph used for illustration was taken, trees have grown up around the glass walls, still further erasing any division between architectural space and natural space outside. Moreover, the laminated-wood framework, largely for structural efficiency, has shapes which not only recall Gothic arches but are themselves not unlike forms in nature—in this case the trunks and arching branches of trees— so that this building illustrates almost literally the elder Wright's statement quoted above that "Buildings like trees are

brothers to the man." It is probably significant that the Wayfarers' Chapel is a Swedenborgian church, for the mystical side of Emanuel Swedenborg was not unaffected by that Neo-Platonism with pantheistic overtones which so largely gave life to romantic pantheism. Thus Swedenborg himself spoke of "God as the spiritual sun from which proceeds the sun of the natural world; because the world of nature and spirit, while distinct, are intimately related." Lloyd Wright's chapel reflects this intimate relationship between nature and spirit, rather than a distinction between them.

As already mentioned, among the more radical Protestant groups not only the groups of liberal, optimistic, "progressive" theology, but some groups of fundamentalist theology, were led to use highly modern architectural forms. A case in point is the Tabernacle Church of Christ at Columbus, Indiana (Fig. 65), designed in 1940 by Eliel and Eero Saarinen. The members of the Churches of Christ are Campbellite fundamentalists as distinguished from the Disciples of Christ, the Campbellite liberals. The Churches of Christ believe that "where the Scriptures speak we speak, where the Scriptures are silent we are silent," so that they subscribe to a fundamentalist Bible Christianity. It is significant that the church is called "Tabernacle," and that the building committee of the congregation declared, "We attach much importance to our effort to preach and practice primitive Christianity and nothing else. . . ."[13] Primitive Christianity is the clue here: the return to primitive Christianity clearly implies a break with all intervening traditions, including intervening architectural traditions. Thus the bald, cubistic simplicity of the stripped-down forms of much modern architecture can be used, as here, to express a kind of "primitive" simplicity, with the result that the general effect is not unlike that of an Early Christian church. Note, however, that the romantic pantheism characteristic of so

many modern architects, including Eliel Saarinen, is here seen in the inclusion of growing nature on the interior (Fig. 66) in the form of actual foliage that grows over the screen at the sanctuary end.

Turning from the more radical Protestant groups today toward Protestant groups with more traditional theology: as one might expect they are especially likely to retain a traditional plan and some associations also with a traditional style, even if, for some reason, they use architectural forms that are otherwise highly modern. This may be illustrated by a Lutheran Church at Portland, Oregon, built by the architect Pietro Belluschi in 1950 (Figs. 67 and 68). Here, although the structure is modern insofar as the architect has used roof supports made of laminated wood and has replaced windows by glass block, nevertheless by means of his laminated-wood supports in the shape of arches he has suggested the pointed arches of Gothic architecture, and by means of the glass block scattered through the walls he has achieved an effect not entirely unlike that of Gothic stained glass even though color is not actually used here. And then, of course, the cross on the sanctuary wall further connotes church, while the plan is that of a traditional basilica.

In recent years the Roman Catholics, too, have not hesitated to build many modern churches under the influence of what is known as the Liturgical Movement. In part stimulated by the Gothic Revival, this developed in Germany particularly after World War I, and its major doctrine is that the Church is the local incarnation of the Body of Christ, and so must carry on His redemptive work. It therefore sees the need for impact on a secularized society, not primarily by means of large-scale organized religion, but through small communities of engaged Christians who at various levels take on themselves the task of representing Christ to our secularized society, as well as of representing that society to God in the eucharist. In architecture, then, the Liturgical Movement has given rise to a kind of small church so designed that each person can see and hear, and thus better participate in the Mass. It has also led to the saying of the Mass in people's houses, and thus often to the minimizing of churches altogether. As the Liturgical Movement is itself a modern movement, it has fostered the use of modern forms in Roman Catholic architecture, especially as the traditional long-aisled Gothic and Gothic Revival church plan could not give the kind of space desired. Nevertheless, for so strongly traditional a religion as Roman Catholicism it was only to be expected that even ultra-modern churches would retain associations with traditional Catholic architectural forms. The combination of a basically traditional Catholic spirit in the arts with a truly modern treatment has been especially fostered by the magazine *Liturgical Arts*, founded in 1931, the influence of which has even affected Protestant religious architecture.

Both the influence of the Liturgical Movement and continuing associations with tradition are well illustrated by such a modern Roman Catholic church as the Church of the Resurrection in St. Louis, Missouri, designed by Murphy and Mackey in 1954 (Fig. 69). In its use of modern forms and structure to produce a space so designed that all can see and hear the Mass, this clearly reflects the influence of the Liturgical Movement. Although in these respects this church is a thoroughly modern one, nevertheless there are reminiscences here of past styles closely associated with Catholicism. The effect is still largely that of the traditional basilica plan with a long axis culminating in the sanctuary. The windows high up in the side walls recall the clerestories of Gothic churches, while the oculus that focuses light directly and dramatically upon the altar is a device that recalls similar lighting in various baroque churches of the Catholic Counter-Reformation.

The Catholic Liturgical Movement—itself not wholly unaffected by certain developments within Protestantism—has spread into many Protestant groups in various countries, especially affecting numerous Anglicans, Episcopalians, and Lutherans, but also some Calvinists, particularly in Scotland and France.[14] In American architecture, an Episcopalian example that apparently reflects the influence of the movement is the Church of St. Clement at Alexandria, Virginia, designed by J. S. Saunders in 1949 (Fig. 70), and built so that the service at the altar can be clearly seen and heard from three sides. This ultramodern church has no windows, and the artificial light is so handled as to enhance the focus on the altar and on the cross that rises from it, on the pulpit and prayer desk, and on the font, while also creating a sense of mystery and awe (Fig. 71). Interestingly enough, St. Clement's, Alexandria, is somewhat Low Church. One would gather that its emphasis on having each member of the congregation equally able to see and spiritually participate in the service, consciously or unconsciously reflects a kind of democratic approach to religion which contrasts with the more hierarchical and conservative point of view of High Church Episcopalians even if they abandon the Gothic Revival, as the more advanced High Church circles have been doing. And it is an approach which, if adopted by Calvinists, could foster a return to a kind of meeting house plan.[15]

At St. Clement's, apart from the cross on the altar and the atmosphere of awe created by the lighting, there is almost nothing that traditionally bespeaks "church." And this leads us to a dilemma that commonly faces those modern architects who would hold that a building cannot be good architecture unless it is wholly of its own time, and who therefore are likely to reject traditional forms and traditional symbolism to such a degree that they have great difficulty in achieving a suitable religious expression. It is said that the great German-American architect, Walter Gropius, refused to accept commissions to design churches because the problem was foreign to his talents and sympathies as a modern architect. Few critics have felt that Mies van der Rohe—Gropius' equally noted friend and former colleague in Germany—adequately expressed the spirit of Episcopalianism in the Chapel of St. Saviour that he built for Illinois Institute of Technology in 1952 (Fig. 72). Apart from the simple cross on the sanctuary wall, Mies' concern with modern materials and with the modern forms which stem so largely from that modern movement in painting and sculpture known as cubism, resulted in too completely eliminating the traditional forms and symbols by which the Episcopalian tradition can most directly be expressed.

One particularly difficult kind of problem involving suitable expression for religious buildings became especially acute in World War II. This was the problem of designing chapels for American troops which could be used equally for Catholic, Protestant, and Jewish services. Despite the enormous difficulties that this requirement imposes on a designer, following the war various non-denominational educational institutions have similarly sought to have their chapels designed in a style that could somehow convey the spirit of religion to members of all the chief religious groups in America. An example of this is the chapel designed by Eero Saarinen for the Massachusetts Institute of Technology (Figs. 73 and 74), and built in 1955. We know that the architect consciously sought to express a general image of religious content, non-sectarian by nature; and he made clear to the sculptor for the interior, Harry Bertoia, that he too must respect the non-denominational character of the building. Interestingly enough, Bertoia has told[16] how this restriction led him to design the sanctuary screen as he did. First of all, as he said, "All [specific] images had to be forgotten." In his mind, instead, were

vague forms of the primordial cosmos; and he noted that "What was actually evolved . . . was closest to my ideas of the stars." In sum, he sought to achieve a religious effect without recourse to any customary religious symbols, which inevitably tend to connote some specific religion. Therefore, in a most generalized way, he designed his screen to connote the stars and the cosmos as expressive of the handiwork of a God Who transcends earthbound man, and therefore transcends any specific religious group.

As the exterior of this chapel especially shows, however, it is not without faint reminiscences of past styles of religious architecture. The general form, with its heavy walls and round arches, has something in common with Romanesque churches. The spire, made by the modern sculptor, Theodore Roszak, nonetheless recalls the *flèche* of a Gothic cathedral, while the light reflected into the interior from the surrounding pool produces an effect of flickering light and color that suggests an otherworldliness by a kind of dematerialization of the natural world in somewhat the same way as does the stained glass of Gothic architecture.

In contrast to M.I.T., some other educational institutions have sought to solve the problem of suitable religious expression in architecture by deliberately rejecting the non-denominational chapel in favor of separate chapels for the major religious groups. Thus for Brandeis University in Waltham, Massachusetts, the architectural firm of Harrison and Abramovitz erected in 1954–1956 three chapels—respectively Jewish, Protestant, and Catholic —to form an Interfaith Center (Fig. 75). Significantly, unlike the Protestant and Jewish chapels which have windows behind the sanctuary looking directly out into nature in the manner popularized by Frank Lloyd Wright, the Catholic chapel does not, but instead has a definitely enclosed sanctuary. For modern Catholic church architecture has in general rejected the other solution, with its pantheistic overtones, which has become a cliché of modern religious architecture among non-Catholics.

From this rapid survey of American religious architecture since the seventeenth century, what general conclusions can be drawn? For one thing, the fact emerges that any successful religious building must express qualities which are in harmony with the doctrines of the group for whom it is built. Indeed, the finest religious edifices by their qualities in some way enhance and develop the expression of those doctrines, whether through the interpretation given to them by a great individual architect or through new expressive means made possible by developments in architectural style.

Our chronological study has indicated a further fact: that even for the groups with the longest and most orthodox traditions, religious expression in architecture has never remained unchanged for any length of time. Thus the styles of the buildings of even the most conservative Catholics and Episcopalians demonstrate almost constant change, while nearly all the other American denominations and sects have by this time completely abandoned their original architectural expression—derived from, or at least affected by, some form of meeting house—in favor of some other kind of building.

This also can be said: twentieth-century architecture has placed especially strong emphasis on the expression of the physical function of the religious building, so that solutions have been sought which will be particularly well suited physically to seeing, hearing, and participating in the service. Consequently, in recent years there has been a concentration on functional directness and simplicity which in some respects recalls the spirit of the early meeting houses. Paradoxically, however, this new simplicity and functionalism— far from distinguishing the left-wing Prot-

estants, for whom so many of the meeting houses were built, from more completely orthodox denominations—have been almost simultaneously fostered by some liberal Protestant groups, by some fundamentalist Protestants, and even by Roman Catholics under the influence of the Liturgical Movement as it spread from Germany after World War I.

Another tendency characteristic of twentieth-century religious architecture places the modern architect on the horns of a dilemma. On the one hand, the architectural spirit of this century has emphasized progress in the use of new materials and techniques, and of new and therefore untraditional forms. It is not easy to employ these untraditional materials and forms so as to express traditional religious values. Therefore, in the effort to overcome this limitation on the expression of religious content, the modern architect has felt the need to retain some historical reminiscences by making use of at least some qualities and accessories that for Christians have traditionally connoted "church." These accessories (bell tower, cross, and the like), which have mostly been borrowed from the Episcopalians or the Roman Catholics, often have a tendency—in the face of a modern desire for simple, clear, unadorned "abstract" forms—to be mere stripped-down parodies of their historic selves, so that the modern architect has also felt the need to avoid them about as strongly as he has felt the need to use them. But even when he has made use of them, his approach has been sharply different from the eclecticism of the architects of the nineteenth century. For their kind of eclecticism sought the expression of religious values by imitating specific styles of the past regarded as particularly evocative of a whole set of such values—whether those implicit in the Romanesque, the Gothic, the "colonial," or some other style. Such historical eclecticism has now largely vanished in favor of a non-historical kind which has

rejected the styles of the past, but has followed closely behind such individual innovators of forms as Frank Lloyd Wright, Eliel Saarinen, or even Mies van der Rohe. The work of any of these men, or of the other leaders of modern architecture, cannot, by its very nature, be particularly rich in forms with specific traditional religious connotations. The church architect, therefore, faced with this dilemma, finds himself adopting even for left-wing Protestant sects, readily comprehensible symbols, such as the cross or a modern version of stained glass, which were once anathema to most Protestant groups as being expressions of "popery."

An example in point is the First Presbyterian Church at Stamford, Connecticut (Fig. 76), completed in 1958 by Wallace Harrison of the firm of Harrison and Abramovitz. On the interior, this shows an imaginative use of techniques and materials, notably pre-cast concrete, that are clearly of the twentieth century, as well as a kind of dynamic architectural expressionism that first appeared in works by German expressionists of the 1920's. At the same time, however, in order to express "church" to the beholder, there are obvious reminiscences of the Gothic style in the plan, the structural forms, the large cross, and especially in the atmosphere created by a kind of modern stained glass actually made at Chartres—forms and qualities that any Presbyterian of the seventeenth or eighteenth century would surely have denounced as "popery." It is true that the exterior does not recall the Gothic, but, as so many who have written about this church have pointed out, its vaguely fish-like form recalls the fish symbol of the Early Christians, which originated chiefly from the fact that the five Greek letters which express the word "fish" form an anagram of the name of Jesus Christ. While it is also true that the early Presbyterians, like other Protestants, in many ways sought to return to the doctrines of early Christianity, this kind of

symbolism, applied to architecture, again would surely have been frowned upon by them.

Therefore, with perhaps the exception of the Roman Catholics for whom traditional values are so particularly important, religious groups today are unlikely to express architecturally their own *specific* traditional beliefs and values. However, it should now be noted that this architectural situation does find its counterpart in the ecumenical tendencies which are so strong today within American Protestantism, at least, and which have led and are leading to so many mergers among Protestant groups in the twentieth century. For that matter, even among the Roman Catholics, the strong influence of the Liturgical Movement since World War I reflects certain socio-religious values not so directly expressed in earlier Catholic architecture.

Thus even under present-day conditions, different as they are from those of earlier periods in American religious history, we still see interactions between architectural expression on the one hand and religious situations on the other. In other words, today, as earlier in American history, Winston Churchill's dictum that "We shape our dwellings, and afterwards our dwellings shape us" continues to have meaning not only for the kind of secular architecture to which he was immediately referring, but also—and especially—for the dwellings of the spirit.

NOTES

1 Speech of October 28, 1944.
2 See Anthony Garvan, "The Protestant Plain Style before 1630," *Journal of the Society of Architectural Historians*, Vol. 9, no. 3, October 1950, pp. 5–13.
3 See George W. O. Addleshaw and Frederick Etchells, *The Architectural Setting of Anglican Worship*, London, 1948, one of the few first-rate books on the relation of religious architecture to religious doctrine.
4 A conjectural restoration drawing to show the original design of the exterior of this meeting house is published in Marian C. Donnelly, "New England Meetinghouses in the Seventeenth Century," *Old-Time New England*, Vol. 7, no. 4, April–June 1957, p. 87.
5 A more medieval kind of roof also sometimes used on this squarish type of meeting house was the cross-gable, or four-gable, roof.
6 The problem is complicated by the fact that there is a Presbyterian church at Burntisland, Fife, in Scotland, built in 1592, which has a square plan, pyramidal roof, and belfry (finished in 1749)—though here the belfry is a tower that rests on four piers in the center of the church. Interestingly enough, local tradition has it that this church was copied from the Noorderkerk at Amsterdam, which, however, is some thirty years later in date. See George Hay, *The Architecture of Scottish Post-Reformation Churches*, Oxford, 1957, pp. 32–34.
7 Donnelly, p. 95, draws a somewhat similar parallel with a market hall at Amersham, Buckinghamshire.
8 This has been made clear by Rachel Wischnitzer in her excellent book, *Synagogue Architecture in the United States: History and Interpretation*, Philadelphia, 1955.
9 In execution, Latrobe's design for the cupolas and portico was somewhat modified.
10 Ralph Adams Cram, *My Life in Architecture*, Boston, 1936, p. 255.
11 Robert Dale Owen, *Hints on Public Architecture*, New York, 1849.
12 Frank Lloyd Wright, *Modern Architecture*, Princeton, 1931, front fly-leaf.
13 *Architectural Forum*, Vol. 77, October 1942, p. 36.
14 See Alfred R. Shands, *The Liturgical Movement and the Local Church*, London, 1959.
15 See the proposed design for Calvin Presbyterian Church, Long Lake, Minn., published in *Progressive Architecture*, Vol. 40, Part 1, January 1959, p. 134. This has a rectangular plan with the pulpit placed against the middle of a long wall, opposite the entrance.
16 In *The Graham Foundation's First Year: 1957*, mimeographed; Chicago, 1957, p. 26.

13 Reflections on Classicism and Romanticism

FREDERICK ANTAL

Frederick Antal earned an international reputation as an art historian who emphasized the relation of class to style in accordance with Marxist thought. Born in Budapest in 1887, he studied art history first with Heinrich Wölfflin and then with Max Dvorák at the University of Vienna, where he received his doctorate in 1914. After completing his education, Antal returned to Budapest, where he served as a member of the staff of the Museum of Fine Arts. In his native city he developed a close friendship with Georg Lukács (born 1885), the internationally renowned Hungarian communist aesthetician and critic who became minister of education in the communist government of Bela Kun in 1919 (and again in 1956 under Imre Nagy at the time of the Hungarian Revolution). When Bela Kun's government was defeated by a counter-revolutionary government in 1919, Antal, a Marxist, decided to leave Budapest. He went first to Vienna and then to Berlin, where he resided until Hitler came to power in 1933. He then moved to London, where he lived until his death in 1954.

Antal's dissertation topic, "Classicism, Romanticism and Realism in French Painting from the Middle of the Eighteenth Century to Géricault," became the subject of a series of five articles that were entitled "Reflections on Classicism and Romanticism" and published in the English periodical *Burlington Magazine* between 1935 and 1941 (repub. in Antal's posthumous book, *Classicism and Romanticism, with Other Studies in Art History* [New York, 1966]). The fundamentally Marxist point of view of these articles patently rejected the formalist approach of his own earlier studies. In an important study of 1928 on "The Problem of Mannerism in the Netherlands" (translated into English in his *Classicism and Romanticism*), his indebtedness to the formalist approach of his first great teacher, Wölfflin, is readily apparent. Such an approach is also evident in his other early papers: for instance, "Gedanker zur Entwicklung der Trecento- und Quattrocento-malerei in Siena und Florenz," *Jahrbuch für Kunstwissenschaft* II (1924/25), pp. 207 ff.; and "Studien zur Gotik im Quattrocento," *Jahrbuch der preussischen Kunstsammlungen* XLVI (1925), pp. 3–32. By 1935, however, a marked departure from this point of view had taken place: now he began to maintain that works of art are determined by political, economic, and social factors. Thus he could describe such paintings as Jacques Louis David's *Oath of the Horatii* as "the most characteristic and striking expression of the outlook of the bourgeoisie on the eve of the [French] Revolution." His interpretation set Western European and American art history on its ear, even though he had failed to provide sufficient historical evidence to support his point of view.

From this time until his death in 1954, Antal was systematic if not rigid in his application of social determinism to art history. In his masterly, though provocative, monograph *Florentine Painting and Its Social Background; The Bourgeois Republic before Cosimo de' Medici's Advent to Power: Fourteenth and Early Fifteenth Centuries* (London, 1948), Antal returned to the subject of an earlier paper (1924/25) in which he had traced two stylistic trends in Trecento and early Quattrocento painting, the one rational, the

Chapter 1 of *Classicism and Romanticism* by Frederick Antal, © 1966 by Evelyn Antal, Basic Books, Inc., Publishers, New York. Reprinted by permission of Basic Books, Inc., Routledge & Kegan Paul Ltd., London, and Burlington Magazine.

other irrational (a dichotomy of styles so characteristic of early 20th-century German and Viennese art history). The significant change in Florentine painting from about 1300 to 1434 is closely related to the attitudes of the classes in contemporary Florentine society. Thus the rational style of a Giotto or a Masaccio is explained by the emergence of a progressive upper middle class, and the emotional, sentimental, dramatic, and mystical style of some of their contemporaries, to the conservative upper middle class and the lower middle class. Moreover, the ideas of these classes were the immediate causes of the new emerging art. For Antal, the fact that a class accepted an art is proof that the class generated it. In this manner he tries to demonstrate his thesis that "we can understand the origins and nature of co-existent styles only if we study the various sections of society, reconstruct their philosophies and thence penetrate to their art." In his book, the link between art and society is subject matter, hence the iconography of Florentine painting is closely examined—the first such iconographic study of this art. By investigating iconography against the backdrop of political, economic, and social events of the time as well as literature and science, philosophical thought, and religious sentiment (and by so doing revealing his indebtedness to the thought of Max Dvořák, Aby Warburg, and others), he raises questions of fundamental importance for an understanding of Florentine art. While persuasively written, the book has been harshly criticized for its misunderstanding of original documentary material, for its oversimplification of certain facts and its selectivity of evidence, even for its alleged failure to present a convincing motivation for the very social changes Antal considers so vital to the development of Florentine painting (see the paper by Frederick Hartt on page 293, as well as the searching reviews of Antal's book by Theodor E. Mommsen, in *Journal of the History of Ideas* XI [1950], pp. 369–79, and by Millard Meiss, in *Art Bulletin* XXXI [1949], pp. 143–50 and in his *Painting in Florence and Siena After the Black Death* [Princeton, 1951]). Yet this adverse criticism has failed to invalidate the Marxist approach. Free from schematic and premature formulations, a number of art historians have succeeded in relating the formal development of styles to social history and attitudes (see the Introduction to this book).

When he died in 1954, Antal had prepared monographs on Fuseli and on Hogarth, which were published posthumously: *Fuseli Studies* (London, 1956) and *Hogarth and His Place in European Art* (London, 1962). He introduces his study on Hogarth by stating that, the criticism of his *Florentine Painting* notwithstanding, "I have associated Hogarth's art throughout with its social background as intimately as I did Florentine art, and here too I have used the themes to link the outlook on life with the style of the works" (p. xix). Until the end he remained convinced of the Marxist conception of the work of art as "a creative experience fused in the crucible of life."

Few conceptions in the terminology of art-history are as vague and indefinite as those of classicism and romanticism. At the same time the methods adopted by modern art-historians to overcome this difficulty clearly reveal the limitations of the purely formal criteria generally applied by them. Thus, a subdivision of the wide and vague stylistic groups of classicism and romanticism has recently been attempted in which the work of certain more limited groups of artists, or even of single artists, is char-acterized by certain formally more precise terms taken from earlier periods of art. A German writer has described the various styles of French painting during this period —the late eighteenth and early nineteenth century—as follows: the pure "classicism" of David is followed by the "proto-baroque" style of Prud'hon and Gros; Ingres' style is "romantic late classicism, i.e., classicism with gothic and manneristic tendencies"; that of Géricault "early baroque with realistic tendencies"; and

that of Delacroix "romantic high baroque."[1] Another art-historian has analysed and classified the German painters of the same period: thus Mengs is called an "early classicist" by this authority; Fuseli (whose work in this country makes him of special interest to English readers) an "early gothicist"; the Füger-Carstens group "high classicists"; another group (Runge, Friedrich) "high gothicists"; and the Nazarene School (Overbeck, Cornelius, etc.) "late gothicists."[2]

From the formal point of view, all these connotations are certainly correct. Nor can there be any objection in principle to the use of terms applicable to the style of earlier, to describe that of later, periods. Certain terms exist in style analysis, and it is reasonable to use them for purposes of formal classification. These various definitions, however, do not take us far towards an understanding of the period analysed. Is it really sufficient for the purpose of historical explanation simply to devise a nomenclature for changes of style, to describe the formal criteria of these changes, or to discover formal similarities between the styles of different periods? To state that not only Rubens, but also Delacroix, is baroque is not to explain romanticism. The questions to be answered are surely these: Why are the styles of the eighteenth and nineteenth centuries similar to those of the sixteenth and seventeenth centuries? Why are the artists working about the year 1800 gothic-manneristic, classicistic, protobaroque, high baroque? What is the reality behind these similarities, behind these formal criteria of style? What is the meaning of the conception of style in its totality?

In defining a style I believe that contemporary art-historians frequently devote too much attention to the formal elements of art at the expense of its content. Only too often they overlook the fact that both form and content make up a style. If we take sufficient account of content we realize at once that styles do not exist in a vacuum, as appears to be assumed in purely formal art-history. Moreover, it is the content of art which clearly shows its connection with the outlook of the different social groups for whom it was created, and this outlook in its turn is not something abstract; ultimately it is determined by very concrete social and political factors. If, therefore, we wish to undertand a style in its totality, we must trace its connection with the society in which it has its roots.

Once we have realized the character of this relationship, we shall no longer exaggerate the significance of formal similarities between the styles of different periods to the extent of using them for purposes of definition. We shall recognize the existence of these similarities, search out their true causes and thus reduce them to their proper significance. Since the same social and political conditions, the same social structure, never recur in different historical periods; since any similarity can only apply to certain aspects of the conditions found; any resemblance between the art of such periods can only be partial. It is true that such similarities can be of considerable importance, if, as is often the case, the structure of the societies in question and their general outlook are fundamentally related to one another. But equally often the "similarity" in style has a very different significance: under greatly changed social and political conditions it may express the outlook of a social group different from that of the earlier period. It is one of the most interesting problems in art-history to explore in this way the basic causes of stylistic similarities and apparent relationships, to show why a certain older style exerts an important influence on a later style in the development of art. The explanation follows quite naturally, almost automatically, when we clearly grasp the changes in the social structure,

[1] Notes to this selection appear on page 348.

in the appropriate ideologies and in the styles corresponding to them.

What is the reality behind the terms "classicism" and "romanticism" at the end of the eighteenth and the beginning of the nineteenth century?

Let us begin with France and trace the development of French art from its own roots. Where foreign influences—primarily English ones—are important, I shall simply mention the fact. The true causes of such influences—why at a certain historical moment a certain foreign style could exert an influence—will be fully comprehensible only after a study of the development of these other countries and a discussion of the significance of the style in question in terms of its own basic causes. Even in this sketch of the French development, however, I can do no more within the framework of these articles than present the results of my investigation; there is no space to support my conclusions in detail.

I shall discuss first the picture which is generally regarded as the classicistic one *par excellence* of French eighteenth-century art: David's *Oath of the Horatii* (1784) (Fig. 1). What significance attaches to the appearance at that moment of a pictorial representation of a heroic scene closely related in its general theme to Corneille's tragedy? What is the significance of a picture so simple and compact in its composition, a picture in which the principal figures are placed soberly side by side, dressed in ancient Roman costume, a picture painted with such severe objectivity? What explains its wildly enthusiastic reception at a time when Fragonard was still painting his sumptuous and whirling rococo pictures, based on the Rubens-Watteau tradition?

It is not necessary to give a detailed account of the well-known political and ideological situation in France at this period. The rising middle class proclaimed

new political ideals: democracy and patriotism. It had a new conception of morality: civic virtue and heroism. The pattern of these ideals, as elaborated most effectively by Montesquieu and Voltaire, Rousseau and Diderot, was provided by ancient history. This complex of middle-class ideals immediately enables us to comprehend David's picture. Yet it was painted for the Ministry of Fine Arts? Again, there is no mystery. The Court of Louis XV, even more so that of Louis XVI, was anxious to make some concessions to the new spirit of the middle class and to assume the appearance of enlightened absolutism. It was a reflection of this compromising, yet inconsistent and therefore fundamentally hopeless policy, that the Royal administration should yearly have commissioned, through the Ministry of Fine Arts, pictures with subjects drawn from ancient history, preferably having a moral tendency. The whole tendency of David's painting, however, its exaltation of patriotism and civic virtue in all its austerity, the puritanical economy of its composition, was radically directed against his own patrons. Its overwhelming success, indeed its very existence, was determined by the strong feeling of opposition then prevailing against the demoralized Court and its corrupt government.

This picture is the most characteristic and striking expression of the outlook of the bourgeoisie on the eve of the Revolution. It is rigid, simple, sober, objective, in a word, puritanically rational. Simple groups and straight lines form the whole composition and serve to make it clear and striking. It is the method of composition generally known as classicistic. At the same time there is a great deal of objective naturalism in this painting, a naturalism that determines its sober colouring, its accuracy of detail, its clear presentation of simple objects. This accuracy of detail was the result of a careful preliminary

*Illustrations accompanying this selection appear on page 511.

study of the model. A drawing for one of the female figures (Fig. 2) reveals this painstaking exactitude which is almost sculptural. This latter tendency came into prominence at a later, less naturalistic, stage of classicism, a stage in which this style was no longer the expression of the most advanced section of the middle class. In David's early period, however, the sculptural character of the figures was merely the result of his study of the model, a study which distinguished his figures from the picturesque, but often schematic and void, rococo figures. This naturalism of David is as characteristic for the taste of the rising middle class as his classicism; both are inseparable aspects of its objective rationalism. The combination of these two factors in David's *Oath of the Horatii* was the cause of its outstanding success. It must be remembered that naturalism had to assume a classicistic form in a historical composition of this kind in order to be accepted at all by the public of that time. For historical subjects could then only be rendered either in a baroque or a classicistic style. Truly objective naturalism, however, is much more compatible with the latter than with the former. On the other hand, only a historical picture could exercise any far-reaching influence on the public of that period. For there still existed a rigidly hierarchic scale in the social estimation of the several types of painting, a scale dating from the time when the artists had to fight for their social position, for their emergence above the artisan level. In this scale historical compositions were at that time still regarded as the highest category of painting. Classicism, based on naturalism, was thus the historically inevitable style of David's picture, a style which accurately reflected its social background.

Let us for a moment disregard this social background and examine the antecedents of this picture solely as regards its form and its content. Corneille's tragedy is its literary source; Poussin's work its formal

one. But in thus evoking the names of Poussin and Corneille we are reminded that David is linked with the art of the period of Richelieu and the young Louis XIV, a period in which the monarchy relied on the support of the new middle class in its efforts to accomplish its centralization programme against the opposition of the nobility. Such a period, characterized by the expansion of the middle class and its rise to a position of power, necessarily produced a classicistic art, i.e. an art arising out of the rationalistic conception of life peculiar to that class.[3] It was the most progressive art possible in the France of that time, just as absolute monarchy with its centralizing rationalism based on middle-class support was the most progressive political régime at that period.[4] Of course the classicism of Poussin and of David are not exactly alike; they cannot be; in spite of their close formal resemblance, in spite of the partial similarity of their social backgrounds. The whole atmosphere of the Court, the outlook on life of the upper middle class, could not, despite its rationalism, be as advanced in the mid-seventeenth century as that of the middle class 150 years later on the threshold of the Revolution. Similarly, in the sphere of art, the classicistic compositions of Poussin differ greatly from those of David in the degree of their naturalism, which is much more the case in David's work. It is this increased stress on naturalism—so characteristic of David and the taste of the rising middle class—which accounts for the fact that the various parts of the composition of the *Horatii* are not welded into anything like that complete unity which is so characteristic a feature of Poussin's work.

In this way we could retrace the line of development to even earlier stages: we could go back to the classicism of Raphael, the "inspirer" of Poussin, or to that of Masaccio, the "inspirer" of Raphael.[5] All these "classicistic", i.e., rationalistic and highly naturalistic, styles arose at socially and politically progressive moments in the

historical development of the bourgeoisie. Raphael's art reflects the secular and national ambitions of the Papacy, the only power with national potentialities in the Italy of that period, and at the same time its most advanced and highly organized financial and bureaucratic institution. The art of Masaccio appeared at the moment in which the Florentine upper middle class reached the zenith of its power.[6]

Thus, in all periods since the Middle Ages in which an advanced outlook arose from advanced economic, social and political conditions of the middle class, a classicistic art expressed the rationalism of that class. But in each period, in each country, we are concerned with a different stage in the development of the bourgeoisie, and the different classicistic styles themselves reflect these different phases. Here I must anticipate my account of the further development by pointing out that this phenomenon—classicism based on naturalism as the style of the upper middle class—is true only of the earlier phases of the development of the upper middle class; as this social stratum became increasingly powerful after the French Revolution, the naturalistic factor gradually came to suppress, and finally entirely destroyed, the classicistic scheme of composition.

We posed earlier the question, how a picture so surprising as the *Horatii* could suddenly appear in the same period as the sumptuous rococo paintings of Fragonard. The work of Fragonard and similar artists quite evidently reflects the real taste of the Court and of all social circles allied to the Court (especially the wealthiest men in France, the royalist *fermiers-généraux*, one of whom was Fragonard's chief patron). However, David's painting, though contemporary with baroque and rococo pictures, did not arise suddenly as is generally assumed, and as comparison simply with Fragonard would lead one to suppose. Throughout the second half of the eighteenth century, i.e., the time during which the new and revolutionary ideas of the bourgeoisie, the ideas of the Encyclopaedists, were ever more consistently developed and widely circulated, the artists were turning increasingly to classicism and naturalism. Suffice it to mention Greuze. His paintings, illustrating moral and sentimental themes of bourgeois life, were important antecedents of David's work. Sentimentality was a middle-class virtue. (It is no mere chance that the eighteenth-century cult of sentiment, just as that of democracy, came to France from the more advanced bourgeoisie of England.) The sentimentality of these pictures was a preliminary stage to the heroism in David's work; it was regarded as fundamentally sincere by the middle-class public who acclaimed it as a reply to the frivolousness and frequent superficiality of rococo painting. Greuze was related to David, as Diderot, who greatly admired Greuze's work, was to Robespierre. The heroism and the much more pronounced naturalism of David was only possible at a time when the Revolution was imminent. But Greuze's work of the sixties and seventies was already pointing in this direction. It is a remarkable fact that the principles according to which Greuze composed his large family paintings were also derived from Poussin. Simple groups and lines, the grave gestures of classicism, determined the composition of these works. But they did not as yet show the concentration later achieved by David. Their naturalism, though intentional, was more superficial. Under the mask of morality much rococo sensuality still appeared in the details. Greuze is typical for the transition from the open immorality of the rococo to the radical, consistently severe, morality of Revolutionary bourgeois classicism.

The names of David, Greuze and Fragonard will now convey concrete impressions of a series of different styles prevalent before the outbreak of the Revolution, styles which reflect the outlook of different classes, or of different phases in the development of single classes. They are an indi-

cation of the complex structure of the society of those years, that is to say, of the public for whom the historical pictures were annually exhibited in the Salon. To provide a more complete sketch of the historical and artistic situation of that time, I would mention a further group of historical pictures, commissioned, like the *Horatii*, by the Government. The style of these pictures is of great historical interest, for though basically baroque—the usual style of seventeenth- and eighteenth-century court aristocracies—this style nevertheless approaches the severe principles of classicistic composition (though, of course, by no means as consistently as that of David, the most progressive painter of those years). Moreover, these baroque compositions show naturalistic traits far more markedly than do the usual elegant rococo paintings with their mythological and allegorical themes. This is due to the fact that the subjects are more concrete. Some of these Government orders— and it is these with which we are alone concerned—demanded subjects from the recent history of France. Arising out of the programme of enlightened absolutism, these pictures were required to show the deeds of popular rulers, especially Henry IV. A subject executed by Vincent in 1779 characterizes the mentality of the populace in the days of the Fronde, when angered by the repressive methods of Mazarin and the Queen. It represents an incident on the Day of the Barricades in 1648: Mathieu Molé, first President of the *Parlement*, is urged by the crowd to firmer action to secure the release of his imprisoned colleagues (Fig. 4). The style of this picture is undoubtedly baroque. But its essentially modern feature—a feature which even relates it to a certain extent to the tendencies of the David group—is the naturalism of its figures and of its architectonic background. As a consequence, this picture, illustrating an episode from the history of the seventeenth century, painted in a baroque style trans-

fused, and partly suppressed by, naturalistic details, strikingly resembles romantic painting. It looks as if it had been painted half a century later.[7] The same is true, to cite one other example, of a picture for which Ménageot received the commission in 1781. It glorifies another popular monarch since it shows the *Death of Leonardo da Vinci* in the arms of Francis I (Fig. 5). The picture itself is at Amboise, a sketch for it in the Collection Mairet, Paris. The latter shows striking resemblances with romantic painting (especially of the Delacroix imitators), not merely in its composition, but also in its colouring. The Renaissance subject introduces a new colour scheme differing from that of rococo paintings, both by reason of its greater naturalism, and of its use of certain theatrical effects, e.g., the dramatic figure of the doctor in pitch-black in front of the dark-green background.

At this stage it suffices to note the existence, during the Louis XVI period, of pictures showing such striking similarities to romantic painting and to indicate their ideological source. We shall appreciate the reason for this resemblance only after our discussion of romanticism itself.

David also commenced his work in the baroque-rococo tradition. While still a young man, he had been recommended by Fragonard for the task of decorating the house of the notorious dancer Guimard. But during the seventies and especially the eighties, he gradually changed his style. The taste of a large section of the bourgeoisie was revolutionized as social and political conditions approached the crisis; the public now demanded more radical tendencies in art. It is impossible to understand David's development without taking this social background into consideration. Throughout these years he consistently developed towards a naturalistic classicism. He approached this aim by the study of styles of many different periods having the same tendency in common, or at least containing elements that could be

interpreted in this sense: ancient Roman sculpture and cameos, early seventeenth-century painting of the Bolognese and Roman schools (Carracci, Reni, Domenichino), the revolutionary art of Caravaggio, recent English engravings with classical subjects, etc.[8] Thus David created the style of the French bourgeoisie on the eve of the Revolution; the *Oath of the Horatii* is the culminating point of this development.

David's political views induced him actively to participate in the Revolution: he was made its art-dictator and belonged to the intimate circle of Robespierre's political friends. The great experiences of the bourgeois Revolution, David's intimate contact with daily events, exercised a profound influence on his art.

We can only realize the great step from the *Oath of the Horatii* to the *Oath of the Tennis Court* (1791, Versailles), if we take into account the official meaning of "historical composition" at that time. It was a great breach of the convention for an historical painter to take a contemporary occurrence and present it without allegorical trappings as an historical picture (i.e., as belonging to the most highly esteemed category of painting). This David did with his *Oath of the Tennis Court*. We can see even more clearly in this picture that, at this stage of the development, classicism and naturalism were inseparable. A contemporary event of great importance (the oath of the Deputies of the Third Estate that they would not leave their posts) inspired this classicistic-historical painting, and precisely for this reason the naturalistic factor necessarily predominated to a hitherto unheard-of extent. This is so, even though the composition is fundamentally an extension of the classicistic scheme of the *Horatii*. The gestures of the Horatii are multiplied in the gestures of the Deputies as they take the oath, but they are greatly enlivened and have all the tension of actuality. So long as classicism remained in

contact with reality, during the French bourgeois Revolution, it necessarily led to a more and more consistent naturalism.

This conclusion is supported not merely by the *Oath of the Tennis Court* or the *Death of Marat* (1793, Brussels)—the deeply moving pathos of which is largely due to the fact that David saw Marat on the day before his assassination, then also in his bath writing down his political ideas, and was able thus to reproduce from memory the position of the dead revolutionary with striking truth—it is confirmed also by David's portraits. While his earlier portraits were still to a greater or lesser degree influenced by the baroque tradition, those of the Revolution period are of a truly stupendous immediacy; they embody the consistent naturalism towards which his historical pictures were leading him. Characteristic portraits of this most fruitful period in David's career, in which art and life were so intimately related are, e.g., the portrait of the well-known Deputy *Barère* (Fig. 6), shown in a spontaneous attitude while at a meeting of the National Convention; or that of *Lepelletier de St. Fargeau* (Fig. 3), the famous champion of the Rights of Man, surprising in the directness of its appeal and depicting the ugliness of his features with a frankness that would have been impossible before the Revolution.

After the fall of the revolutionary Jacobins, representing the interests of the petty-bourgeoisie, a wealthier stratum of the middle class came to power under the Directoire. The new fashionable society which opened its doors even to former royalists, soon turned its back on the severe republican ideal with its far too puritan standards of morality. This social and political change put an end to David's political career; it also exercised a profound influence on his art. The large historical painting he produced during the Directoire period, he conceived in prison, into which he was cast for his allegiance to Robes-

pierre. It depicts the scene in which the Sabine women reconcile their Roman husbands and their Sabine relatives (1799, Louvre). This picture no longer shows the revolutionary political tendency that was so striking in the *Horatii* of 1784 or in the *Brutus* of 1789 (David was bold enough to paint the latter subject instead of the *Coriolanus* with which he had been commissioned by the Royal administration). If there is any political intention at all in the *Sabines* it is toward conciliation of the several factions, which was the conservative policy of the Directoire. With the changed outlook, we find a change of style in the picture. David no longer aimed at concentration and clarity; he now gave a rather overcrowded compilation of beautifully posed attitudes. In this picture David's classicism has retreated from the position of advanced and progressive naturalism he had attained in his historical paintings shortly before and during the Revolution; it has become almost sculptural. His former naturalism has by no means disappeared, but it is confined to the details and is no longer the dominant feature of the figures, now posed like statues. There is a tendency towards artificiality and, especially, towards elegance of line. The nude and semi-nude, barred during the strictly decorous Revolution, now plays an important rôle. David proclaimed his new style as a close approximation to Greek art; he began to study the Italian primitives and Greek vase painting. Taken as a whole, these stylistic features express the ideas of a fashionable society, preoccupied with the pleasures of life. It is this combination of joyfulness with a somewhat archaistic elegance which characterizes David's new style. His portraits during these years reveal a similar change. Thus, the portraits of M. Sériziat (1794, Louvre) or of Mme. Récamier (1800, Louvre) show an elegant simplification of line which, however, is totally different from the powerful simplicity and concen-

tration, the almost crude naturalism, of the portraits painted during the Revolution. The *élan* of the Revolution has vanished.

Under the Napoleonic régime David was again brought into close touch with contemporary events; he became the Emperor's *premier peintre*. This régime was a compound of rationalist absolutism, military dictatorship, bourgeois rule, liberal legislation, together with the resurrection and creation of an aristocratic court tradition; its art was similarly complex; moreover, it changed its character during the successive phases of the régime. The differences and divergent stylistic possibilities of the various types of painting were to some degree accentuated but they also to some extent converged more than hitherto. The latter tendency is the more significant from the point of view of art-development. David's most important period, when his position was unique among the painters of Europe, had by that time come to an end, nevertheless his work during the Napoleonic period is of great historical interest. He was commissioned by Napoleon to paint several large pictures of important ceremonial occasions in the Emperor's career. The fusion of classicism and naturalism in the *Coronation of Napoleon* (1808, Louvre) is even more intimate than in the *Oath of the Tennis Court,* for the subject was a solemn act of State that required to be presented naturalistically and correctly in all its ceremonial detail at the order of the Court. As a result, only remnants of a classicistic composition remain (especially in the large figures at the sides of the picture); the road towards naturalism was cleared even for the category of large ceremonial paintings. But in the historical pictures dealing with antiquity painted during these years (e.g., *Leonidas at Thermopylae,* 1814, Louvre) David's classicism has lost its former vitality, it has become rigid and exaggeratedly sculptural. Only the details and the overcrowded character of the composition as

a whole reveal traces of naturalism. David, trained in the traditions of the eighteenth century, could not discard the belief in the paramount importance of historical paintings dealing with classical subjects; on the other hand, such paintings could no longer have their former vitality, their immediate topical and progressive appeal in the drab reality of bourgeois existence, once that class had consolidated its dominating position. Hence, the classicism in David's historical paintings dealing with ancient history could no longer be a progressive factor; it necessarily became an obstacle to further progress in art. There is thus a division of David's art, according to its subject, into a classicistic type which is retrogressive, and a naturalistic type which is progressive.

This division becomes even more apparent in the work that originated during his Brussels exile (he was exiled by the Restoration government because he had voted for the execution of Louis XVI). Living in a purely bourgeois *milieu*, the former court-painter produced bourgeois portraits that are among the most naturalistic of any portraits dating from those years. But in this last period of his life his progressiveness is strictly confined to this sphere: there could be no greater contrast than that between the naturalism of his portraits and the lifeless, immobile, even academic classicism of his *Venus and Mars* (1824, Brussels). A great gulf divides the period of David's old age from the Revolutionary period, when he was topical in every sense of the word, when his life and his art, his politics and his historical paintings formed an inseparable whole.

NOTES

1 W. Friedländer, *Hauptströmungen der französischen Malerei von David bis Cézanne. I.— Von David bis Delacroix*, Leipzig, 1930.
2 F. Landsberger, *Die Kunst der Goethezeit*, Leipzig, 1931.
3 The conception of life, however, of the patrons of the artists is not necessarily the same as that which is expressed in the pictures ordered by them. But it is very significant that the chief patrons of Poussin were high officials, bankers and merchants, and not aristocrats. The case of Le Sueur, the imitator of Poussin's style, is quite similar.
4 The situation was entirely different in the latter part of the reign of Louis XIV, the period in which considerations of religion determined an irrational policy leading to a grave economic weakening of the country, the period of Madame de Maintenon, the death of Colbert, the revocation of the Edict of Nantes and the persecution of the Protestants, that economically most significant section of the French middle class. The style of painting at this latter period was no longer classicistic, but baroque: Delafosse, Antoine Coypel.
5 Let us take, for example, this line of development: Poussin, *Christ delivering the Keys to Peter* (Bridgewater House)—Raphael, *Christ delivering the Keys to Peter* (Victoria and Albert Museum)—Masaccio, *The Tribute to Caesar* (Florence, Carmine).
6 Almost immediately afterwards the power of this class declined rapidly.
7 Indeed, when, in 1843, a drawing by Vincent for this picture was exhibited, it had a great success in romantic circles.
8 Thus an engraving by Conway (1763) after Gavin Hamilton's *Hector and Andromache* influenced David's painting in 1783 of the same subject.

Cultural Context

14 The Carolingian Revival of Early Christian Architecture

RICHARD KRAUTHEIMER

In our century few scholar-teachers can claim the international distinction and respect—both for significant humanistic contributions to the understanding of such a broad range of topics as Early Christian architecture and Renaissance sculpture, and for dynamic classroom performances based on exacting analyses and syntheses of complicated matters clearly and simply presented—that Richard Krautheimer has earned in a brilliant career of more than forty years. This scholar's greatness is evident in his impressive bibliography of books and articles, his enthusiastically attended lectures and seminars, and his open receptiveness to ideas put forth by his students, as well as in the high reputation earned by some of them. No less extraordinary is the fact that today, at the age of seventy-four (in 1971), he continues to pursue as energetically as ever his many-sided scholarly activities and taxing teaching schedule at the Institute of Fine Arts of New York University, where he guides a host of students to continue his work.

Born at Fuerth, Germany, Krautheimer attended lectures at a number of distinguished German universities and received his doctorate from the University of Halle-Wittenberg in 1923. Among his teachers was Paul Frankl (1880–1962), a gifted teacher and historian of medieval architecture who had been a student of Heinrich Wölfflin. From Frankl, Krautheimer learned how to "read" a building, its history, the intentions of its architect, and every detail of its construction—in short, to become intimately familiar with every shred of its fabric in time and place. He adopted from him as the point of departure for his method the individual work of art, which serves as the basis to reconstruct the periodic style of that work and of other related monuments. Such a task is demanding and exacting, and it requires a critical mind and a passionate love of art and of hard work as well as a firm and full control of philological tools, many languages, Classical and modern, and knowledge of such related fields as theology, liturgy, philosophy, and cultural history, all of which Krautheimer learned to master and apply to the history of art.

Krautheimer's pioneering contribution to the historiography of art was the founding, contemporaneously with, but independently of, a few European colleagues, of that discipline within art history known as the iconography of architecture: see his "Introduction to an 'Iconography of Mediaeval Architecture,'" *Journal of the Warburg and Courtauld Institutes* V [1942], pp. 1–33. Succinctly defined in his own words, this discipline examines "the relation between the form of a building and its use beyond the realm of mere practicability, specifically between the form of a church and its dedication to a given Saint" ("Sancta Maria Rotunda," in *Arte del primo millennio, Atti del II° convegno per lo studio dell'arte dell'alto medio evo tenuto presso l'Università di Pavia nel settembre 1950,* ed. Edoardo Arslan [Turin, 1953], p. 21). In his masterly hands, the discipline has been broadened to such an extent that it includes social and cultural history (approaching what is known as *Kunstwissenschaft* or even *Kulturwissenschaft* in German), as is evident from one of his most brilliant papers, "The Carolingian Revival of Early Christian

Reprinted by permission of New York University Press from *Studies in Early Christian, Medieval and Renaissance Art* by Richard Krautheimer, © 1969 by New York University.

Architecture" (1942), a recently revised version of which appears below. Proceeding from a solid knowledge of individual monuments, this paper is an exemplary study of late 8th- and 9th-century buildings interpreted in the matrix of a broad cultural milieu; it is funda- mental to our understanding of early medieval art and civilization.

In addition to the aforementioned papers of 1942, the accomplishment of Kraut- heimer's published body of work can be measured from three major books: the *Corpus basilicarum christianarum Romae* (Vatican, 1937 ff.); *Lorenzo Ghiberti,* in collaboration with Trude Krautheimer-Hess (Princeton, 1956); and *Early Christian and Byzantine Arch- itecture* (Harmondsworth, Eng. and Baltimore, Md., 1965). The *Corpus* was just recently brought to completion, and the other two books are now being revised for new editions. The *Corpus* is a documentary analysis of the Early Christian churches of Rome from the 4th to the 9th century. By collaborating with field excavators, architects, and other spe- cialists to confront this imposing task, Krautheimer is able to summarize the chronology, topographic features, excavations, masonry, structural features, and historical impor- tance of these scores of basilicas. A wealth of concrete, detailed research also lies at the heart of his impressive Pelican History of Art, *Early Christian and Byzantine Architecture.* This handbook, a standard reference, presents an overall picture, rather than a mere catalogue, of hundreds of buildings erected around the Mediterranean, in the Middle East, the Balkans, and Russia. These two publications have established Krautheimer as one of the most important 20th-century scholars who have investigated the vast field of Early Christian, Byzantine, and medieval architecture (he has also written books on the German churches of the Mendicant Orders [1925] and on medieval synagogues [1927]). Yet from the beginning of his career, he was also investigating medieval and Renaissance sculpture, to which field his major contribution is his Ghiberti monograph. Written in col- laboration with his wife, Trude Krautheimer-Hess, this book took over twenty years to prepare. The Krautheimers' interpretation of the stylistic evolution and historical impor- tance of the Florentine master is based on solid documentary and philological evidence, an intimate familiarity with contemporary artistic and cultural developments as well as Classical and medieval iconography, and a sensitive aesthetic response to formal phe- nomena. The book is as magisterial a study on a Renaissance artist as Erwin Panofsky's *Albrecht Dürer,* 2 vols. (Princeton, 1943) or Charles De Tolnay's *Michelangelo,* 5 vols. (Princeton, 1943–60).

For a recent collection of Krautheimer's papers, see his *Studies in Early Christian, Medieval, and Renaissance Art* (ed. James S. Ackerman et al [New York, 1969]).

Some thirty years ago the development of ecclesiastical architecture from late Antiq- uity to the Romanesque period seemed fairly well established. The consensus of opinion was that it had evolved accord- ing to the following pattern: in the begin- ning there was the Early Christian basilica, and this was of the type represented in Rome by Old St. Peter's or St. Paul's — an atrium, surrounded by porticoes, was fol- lowed by a colonnaded nave with four side aisles; this led to a long narrow transept which in turn was terminated by a semi- circular apse. This T-type basilica was thought to have survived in Italy from the fourth to the twelfth century; the lack of the transept and of two of the four aisles was considered merely a reduction of the basic type. From Italy the scheme was sup- posed to have spread all over Europe from the fifth century on, and to have under- gone continuous transformation until in the eleventh century, Romanesque archi- tecture evolved from it.[1]

This historical conception was based on a point of view which considered Early

Christian architecture merely an occidental development and nothing but a forerunner of Romanesque architecture. Looking backward from the organized system of the Romanesque church, one saw in the Roman T-shaped basilica its still unorganized precursor. Early Christian and early medieval types which did not fit the picture were unconsciously disregarded.

This pattern has been shattered during the last decades: the rich Early Christian architecture along the shores of the Mediterranean was discovered, reaching from North Africa to Asia Minor and Dalmatia and, in the hinterlands of the Near East, from Syria to Armenia. The plain basilica of the T-type revealed itself as only one among numerous other quite different Early Christian solutions: the basilicas without transepts but with three apses, or with dwarf transepts, with twin towers and pastophories, with galleries above the aisles, with piers instead of columns, with triconch endings and east towers.[2] It became evident that Early Christian architecture presented an array of complex and unexpected features many of which had previously been considered to be innovations of the high Middle Ages. On the basis of this new knowledge of Early Christian architecture outside of Rome, the older conception of western architecture before the Romanesque period had to be revised. The "Orient or Rome" question arose. The "premier art roman,"[3] Asturian and Mozarabic architecture, and their relations with the Near East and with North Africa were traced.[4] Likewise it was realized that African and Asiatic elements had found their way into France, England, and Lombardy[5] throughout the pre-Romanesque period.

On the other hand these discoveries did not necessarily clarify the problem of early medieval architecture in the Occident as a whole. That the origin of its various types in different regions of the Near East was never clarified is after all only too understandable, given our fragmentary knowledge of the eastern as well as the occidental material. It is perhaps less understandable that more definite stress has not been laid upon the fact that the Near Eastern elements in early medieval architecture were not just accidental infiltrations, but that they formed the basis of this entire architecture.[6] Nor—with rare exceptions—has any attempt been made to define the position which the Roman Early Christian basilica occupied in this development.[7] The Roman plan on the one hand, and the different Near Eastern types on the other, seemed to stand side by side within European church architecture far into the beginning of the second millennium, and the choice of the prototypes—Roman or Near Eastern—appeared to be more or less arbitrary.[8]

Among the numerous questions involved we propose to deal with one limited and definite problem: the part which the Early Christian basilica of the Roman type played during the early Middle Ages up to around 900 A.D. To this end we must discard all types which share only those factors, such as the basilica layout, common to most Early Christian provinces throughout the Mediterranean world, but which combine this pattern with elements foreign to the Roman type, such as polygonal apses, galleries, pastophories, or triconchs.

This process of elimination discloses the surprising fact that actually in Early Christian times, i.e. up to the fifth century, the T-shaped basilica with one apse hardly ever appeared outside Rome, and that even in Rome itself it was anything but frequent. Throughout this period in the whole of Europe it seems to be represented by only three, or possibly four, edifices: old St. Peter's, and in Rome, St. Paul's, and perhaps S. Eusebio in Vercelli (Figs. 1[A], 2[C], 5, 9, 10, 11, and 12*),[9] Certainly it did not survive anywhere for any length of time, let alone for centuries, beyond the Early

*Illustrations accompanying this selection appear on pages 512 to 516.

Christian period in the most limited sense of the word. Whenever it appears after 400 A.D., and wherever it appears in Central Europe, it represents not a survival but a revival of some kind. Such a revival of the Roman Early Christian T-basilica can be noted several times during the high Middle Ages;[10] in the early Middle Ages only one can be ascertained, which takes place during the end of the eighth and the greater part of the ninth century. For convenience we will call these decades the Carolingian period.[11]

The revival in this period of the Early Christian architecture of Rome is the subject of our investigation. We shall also consider the ideological reasons for this revival, and the rôle which it played within the phenomenon which is generally known under the name of the "Carolingian Renaissance."

I

The Carolingian church of St. Denis would seem to represent one of the milestones within the development of Carolingian architecture. It is known mainly from literary references and from the sketch and the short article in which Viollet-le-Duc summarized the results of his rather rough excavations (Fig. 1[H]). Sources and excavations have both recently been reinterpreted and abundantly supplemented by Crosby.[12] What Viollet-le-Duc had found were not, as he believed, the remains of a church of 638 but those of an edifice which had been begun under Pepin, probably after 754,[13] and which was consecrated under Charlemagne in 775.[14] At the west end of the present twelfth-century chancel and corresponding to it in width were found the remnants of a semicircular apse. According to Viollet-le-Duc's plan, a transept extended in front of the apse, a long and narrow structure with a proportion of 1:4; if his plan can actually be relied upon, the transept was continuous and uninterrupted by any divisions. The nave, as we know from literary

sources, was bounded by colonnaded arcades and was roofed with a flat ceiling. A (wooden?) tower rose from the transept. There was possibly an atrium in front of the church.[15] A porch with two low towers was added to the building by Charlemagne.

Despite a number of deviations, such as the relatively narrow proportion of the nave and the slightly later west façade with its twin towers, St. Denis has always been considered a direct continuation of the Roman T-basilicas of the fourth century. Indeed, quite apart from its colonnaded arcades and its single apse, the existence of an atrium and of a continuous transept would recall the ground plan of an Early Christian basilica in Rome such as St. Peter's or late fourth-century St. Paul's outside-the-walls. Of course much of this comparison rests on the reliability of Viollet-le-Duc's transept plan: if we can really depend on it, the importance of St. Denis can hardly be overemphasized. Indeed the surprising thing about this plan is that nobody has ever shown any surprise about it. It was simply taken for granted that a building of the late eighth century should have continued the plan of the fourth-century Early Christian Roman basilica. This assumption is one of the common errors made in discussing the history of European architecture. In reality neither in France nor anywhere else is such a basilican plan with a continuous transept and a single apse known to have been used after the end of the fifth century. We know today at least a few things about the type of churches on French soil which preceded the abbey church of St. Denis;[16] and while it is possible (though by no means certain) that the very early ones of the fifth century[17] had something in common with the Roman Early Christian basilicas, not one among the churches erected in the following centuries shows the pattern of St. Denis. The sixth- or seventh-century church of St. Etienne at Paris was a relatively large edifice with a complicated narthex and possibly with lateral porches;

the known parts, at least, have nothing in common with the Roman type.[18] The contemporaneous oratory of Glanfeuil was a small three-naved building with three apses, covered with barrel vaults[19] like the small churches at Binbirkilisse in Anatolia.[20] St. Pierre in Vienne (fifth century) seems to have had pastophories flanking its main apse, a well-known eastern motive (Figs. 1[F], 15); galleries were arranged over the aisles as in the churches of Byzantium and its vicinity.[21] St. Martin at Autun (589–600),[22] a large building with a tripartite transept and with an apse, resembles a group of churches in Greece.[23] In the cathedral of St. Pierre at Geneva (sixth century),[24] the apse was flanked by two long protruding pastophories with apses, a pattern found in North African churches.[25] The trefoil and quatrefoil chapels of St. Laurent at Grenoble (sixth century) and of Venasque (about 600),[26] with their colonnaded screens along the walls, seem to indicate Palestinian, Egyptian, and North African models.[27] Nor do the plain rectangular box-churches of the period, such as St. Paul at Jouarre or Ste. Reine at Alésa[28] have any connection with Roman Early Christian architecture in particular: they represent a type which was commonly used throughout the Christian world up to the middle of the fourth century and which frequently seems to have survived as late as the eighth century. Not Rome but the eastern and southern coastlands of the Mediterranean from Dalmatia to North Africa inspired all this architecture. This is true not only for France but for practically the whole of Europe. In South England a single-naved plan, with chambers all along the nave and in place of the narthex, dominates the Kentish group from St. Peter and Paul in Canterbury (602–04) to St. Pancras (late seventh century) and Reculver (after 669);[29] frequently two of the chambers, evidently pastophories, protrude right in front of the apse like the wings of a dwarf transept. The type finds its closest parallels in the southern Alps[30] and in the hinterlands of the Adria.[31] Its origin is obscure but it is certainly not Roman. Occasionally from the late seventh century on, a church type with a long nave, a square choir, and sometimes a west tower, possibly of Irish origin, is found in Northumbria.[32] This Northumbrian type prevails among a few examples of pre-Carolingian ecclesiastical architecture in Germany[33] such as Büraberg or Fritzlar (732).[34] Yet alongside the Anglo-Irish plans, Near Eastern types appear also in Germany: at Aix-la-Chapelle, a small basilica with pastophories, resembling Syrian prototypes, preceded Charlemagne's Palatine Chapel to the north (Fig. 1[G]). Its date is doubtful; it may be seventh century.[35] The same layout is found in a church at Dompierre in Alsace.[36]

Nor are any instances of the Roman type to be found in early medieval architecture of either northern Italy or Spain. Spain follows prototypes in the Near East, evidently Asia Minor,[37] from San Juan de Baños (661) through the ninth and tenth centuries. Upper Italy as early as the fourth century works with types which are closely akin to, though not necessarily derived from, Near Eastern church plans. The first church of Sant' Ambrogio in Milan was a basilica without a transept but with three apses;[38] S. Lorenzo in Milan, likewise of the fourth century, is a central edifice with four protruding apses surrounded by a correspondingly shaped ambulatory,[39] like the cathedral at Bosra in Syria and the similar martyria at Antioch and Apamea;[40] the first church of Sant' Abbondio in Como (fifth century), with transept-like sacristies and with chambers all along the single nave, belonged to the same group as the Kentish and the related Dalmatian buildings.[41] Of later churches some show definitely Byzantine features, for instance S. Prosdocimo near Sta. Giustina at Padua, or SS. Tosca e Teuteria at Verona (eighth or ninth century).[42] S. Pietro in Marina at Sirmione follows a type of box-church[43]

with three apses which is well known in the Grisons[44] and which possibly originated in Egypt.[45] The churches of the Veneto and of the Romagna, finally, follow the Near Eastern type which from the fifth century on had prevailed in Ravenna. Thus Sant' Apollinare in Classe with its polygonal apse flanked by pastophories, and with its narthex flanked by west towers, finds its closest parallels in a church such as the Thecla basilica of Meriamlik in Cilicia.[46]

It may be possible (and I feel it will be possible some day) to distinguish between the different stages within this "Near Eastern architecture in the West" which covered the whole of Europe from the fourth and fifth through the eighth century: an earlier stage before 600 which is actually Near Eastern, and a later one which works with and transforms the Near Eastern prototypes into a new style of its own. Perhaps this importation of eastern and other Mediterranean prototypes into Central Europe did not always take the most direct route. While it seems reasonably certain that some patterns were carried directly from Egypt into southern France,[47] Near Eastern motives seem to have been imported to England via North Italy and Dalmatia,[48] to western France via Spain.[49] It is not even impossible that some eastern prototypes reached northern Europe by way of Rome.[50] For, remarkably enough, Rome too ceases to use the T-shaped Early Christian basilica after 400. S. Paolo f.l.m. (386ff.) is the last basilica with four aisles accompanying the nave and with a regular continuous transept; in the early fifth century S. Vitale (401–17),[51] Sta. Sabina (417–32), Sta. Maria Maggiore (ca. 420–40)[52] (Figs. 7, 8, 14), and SS. Giovanni e Paolo (410ff.)[53] reduce this type by omitting the transept. On the other hand, even in Rome, Near Eastern elements had made their appearance as early as the late fourth century: Sant' Anastasia[54] was laid out as a cross-shaped church between 366 and 384, perhaps similar to

buildings in Asia Minor; S. Lorenzo in Lucina (432–40)[55] had a long fore-choir in front of the apse and at least one pastophory adjoining the fore-choir like many churches in North Africa.[56] Contemporaneously Sto. Stefano in Via Latina[57] shows a similar arrangement. The tripartite transept of S. Pietro in Vincoli (440–50) points to Greece,[58] the polygonal apse and the fore-choir flanked by pastophories as seen at S. Giovanni a Porta Latina (ca. 500) to Constantinople and Asia Minor.[59] The trefoil choir of SS. Apostoli parallels that of the Church of the Nativity at Bethlehem.[60] Sta. Petronilla, S. Lorenzo f.l.m., and Sant' Agnese with their galleries readapt a Byzantine-Greek type, while Sta. Sinforosa on the Via Tiburtina, with its oblong piers and barrel-vaulted fore-choir, recalls a plan common in Asia Minor.[61]

To sum up, in not one single instance can the Roman type of the Early Christian basilica be traced anywhere in Europe from the middle of the fifth through the first half of the eighth century, either in Rome or outside.[62] Occidental architecture of this period depends on Near Eastern, and perhaps on North African and Irish, but certainly not on Roman Early Christian prototypes.

Seen within this whole development the plan of the abbey church of St. Denis as reconstructed by Viollet-le-Duc would seem to mark a turning-point in occidental architecture, a break with the Near Eastern tradition and a revival of a Roman Early Christian type. Even if we hesitate to accept without reservations Viollet-le-Duc's plan, the break would merely be postponed a few decades. For, thirty years after the consecration of St. Denis, the abbey church at Fulda shows with full clarity all the elements which at St. Denis may still be considered somewhat doubtful (Figs. 1[N], 16, and 17). The present church— it is now the cathedral of Fulda—is an early eighteenth-century construction; yet the aspect of the Carolingian structure and of a few tenth-century additions have been

established beyond doubt through excavations. Moreover several seventeenth-century reproductions and a number of ninth-century descriptions give the clearest possible picture of the original aspect of the structure.[63] At the same time the descriptions present an unusually exhaustive and remarkably vivid account of the history of the building, of its interior layout, and of the intentions of the builders, of the architects as well as of the abbots who commissioned the work.

The first large church on the site had been completed in 751 by Sturmi, the disciple and friend of St. Boniface, who had founded the convent in 744. To replace this older church, a three-naved or single-naved building with quite a large semicircular apse to the east,[64] a new structure was begun some time between 790 and 792 under abbot Baugulf.[65] In 802, when only the eastern parts of the building were completed,[66] Baugulf resigned, perhaps not voluntarily, and the monk Ratger succeeded him as abbot,[67] not quite to everybody's satisfaction. Ratger was possibly an experienced architect[68] and certainly he was bitten by the building bug. Indeed, things became so bad that in 812 the monks of the convent petitioned Charlemagne to stop the abbot from continuing the "enormous and superfluous buildings and all that other nonsense (inutilia opera) by which the brethren are unduly tired and the serfs are ruined." After all "everything should be done within limits (iuxta mensuram et discretionem) and the brethren should be allowed, according to the rule, to read at times and to work at other times."[69] This revolt, while not immediately successful, led in 817 to the forced resignation of Ratger and to his replacement by Eigil, who apparently had been one of the leaders of the opposition. In accordance with the platform on which he had been elected Eigil speedily brought the construction to a close:[70] the decoration was completed, and in 819 the relics of St. Boniface were transferred into the

western apse and the whole structure was consecrated.[71]

This information combined with the results of the excavations and of the investigation of the present baroque edifice gives a clear picture of the process of construction. Baugulf's new church, while certainly designed to be larger than Sturmi's earlier one, was still planned on a scale and on lines that did not radically depart from the existing building. Like the earlier church it had a semicircular apse, though this was 15 instead of 11.10 m. wide. Yet it certainly had a nave and two aisles; no transept separated the nave from the apse.[72] Aside from these few established facts, no further details are known; it is not even known whether columns or piers were intended to separate the nave from the aisles. When Ratger took over, radical changes were undertaken. In his project the nave was bounded by columns; remnants of their bases have been found. What is more important, he added a "western church and united it with the eastern one which already existed."[73] This allows for only one interpretation: he constructed the transept to the west, large remnants of which are still preserved. The decoration of the edifice may also have been begun under Ratger.[74] It is not certain whether he had also planned two hall-crypts, each with nine groin vaults carried by four columns, which were constructed and vaulted under the east and west apses under his successor Eigil by the new architect Racholph.[75] The pavement was laid and the altars were erected under Abbot Eigil.[76] For the main parts of the edifice, and for its plan as a whole, Ratger is responsible.

The building as it stands today, while seemingly a completely baroque structure, still contains considerable remnants of the ninth-century church. The eighteenth-century cathedral is directed westward like the old one instead of being oriented; it retains the length and width of the Carolingian basilica and has preserved the

proportion of nave to aisles; the two towers enclose the core of the two turrets, which in the tenth century were added to flank the east apse; and, most important, the three-storied structures which flank the baroque choir on either side contain the original west transept almost in its entirety.

Thus a fairly clear picture can be gained of the original edifice as laid out between 790 and 819. The nave, 63.30 m. long and 16.70 m. wide, was accompanied by two aisles; the total width was 33.40 m. Nave and aisles were separated by presumably ten columns on either side.[77] Some remnants of composite capitals postulate the considerable diameter of about 0.78 m. for the columns. A number of indications seem to suggest that they carried an architrave rather than an arcade.[78] The seventeenth-century reproductions show four (or five) rather large windows in the walls of the aisles in contrast to seemingly eleven in each clerestory wall of the nave (Figs. 16, 17). While to the east the nave ended in a semicircular apse,[79] to the west it terminated in a huge continuous transept. The wings of this transept protruded far beyond the lateral walls of the aisles; its ends were shut off from the rest of the transept by colonnades. Three tall windows opened in the short walls and in the east walls of each wing.[80] A second semicircular apse finally terminated the building to the west.

The specific character of the plan of Fulda and its kinship with that proposed for St. Denis can be clearly defined. Peculiar to it is not so much the arrangement of two apses as the way in which the west apse is related to a transept. The presence of two apses can be explained on liturgical grounds, for since Baugulf's project took over from Sturmi's church its site and its dedication to the Savior, the east apse could not be used for the relics of St. Boniface, which in the older church rested in the center of the nave under the cross altar.[81] Consequently to accommodate the body of the saint in a more dignified way, some kind of a structure had to be added by Ratger to the western end of the nave after 802. This does not, however, account for the particular form which was actually chosen for this western structure, a semicircular apse with a long transept in front of it and a continuous one at that, like the one on Viollet-le-Duc's plan of St. Denis. The addition in this particular form shows the revolutionary character of Ratger's project: by adding this long continuous transept he transformed the church of Fulda into a regular basilica of the "Roman" type.

The same Roman character appears in the structure as a whole. The enormous size of the edifice with a nave 63 m. long and a transept length of 77 m.; the wide openings of the apses, each 15 m.; the columns with composite capitals; the architrave (if indeed there was one); the bare, plain walls of the exterior, the long flow of the nave roof which is intersected by the transverse roof of the transept—everything points clearly to one prototype, the great Roman Christian basilicas of the fourth century. Thus if St. Denis was a basilica of the Roman type, it need no longer be regarded as an isolated instance; Fulda shows the very same characteristics, and it shows them on quite a different scale. The very size of the building evidences the difference between Fulda and St. Denis. St. Denis was quite a small building; it was not much larger than the contemporaneous "Near Eastern" types in occidental architecture, such as Sta. Maria in Cosmedin or SS. Nereo ed Achilleo (Figs. 1[B], 2[L, M]), and it was a great deal smaller than the Roman fourth-century basilicas. At Fulda the scale has undergone a decisive change: Ratger's new church was as large as St. John's in the Lateran (Fig. 13) and not much smaller than old St. Peter's in Rome (Fig. 1[N, A, B]). Moreover, the implications of the appearance of the "Roman"

Early Christian basilica in the North be-
came much more clearly evident at Fulda
than they could be at St. Denis.

For not only is the church of Fulda re-
lated in a more or less general way to the
prototype of the Roman fourth-century
basilicas; the relation to one particular
model can be definitely established, at
least for those parts of the structure that
were laid out by Ratger—the transept
and the elevation of the nave. Not only is
the transept continuous like that of St.
Paul's and St. Peter's, it is at the same time
a western transept, and it is extremely nar-
row in comparison to its length, its propor-
tion being exactly 1:5. Another peculiar
element is the use of colonnades to shut
off the outer ends of the transept. All
these characteristics appear in the tran-
sept of one particular basilica in Rome and
only there, namely in St. Peter's (Figs.
5, 6, 9). The proportions of the transept
in St. Paul's are different—1:3; and not
only was St. Peter's equipped with a west-
ern transept (the one at St. Paul's being
laid out at the east end), it also had the
colonnaded partition across the ends of
the wings (Figs. 1[A] and 2[C]). This
feature in itself is so very exceptional that
wherever it occurs it is a clear indication
of the use of St. Peter's as a prototype.
Likewise the architrave over the colon-
nades of the nave would point only to St.
Peter's among all the Roman basilicas with
transept. The two other early basilicas
in Rome with an architrave, the Lateran
and Sta. Maria Maggiore, had no tran-
sept (Figs. 1[B], 2[D], 7, 8, and 13).[82]
Even the measurements and proportions of
Fulda would seem to correspond to St.
Peter's in Rome.[83] There can be no doubt
that the architect who designed the tran-
sept at Fulda wanted it to be a real "Ro-
man" structure even to the scale employed.
As a matter of fact it is not only the plan of
the transept which proves that the monks
at Fulda wanted to be as Roman as the
Romans or even more so. There is other,

documentary, evidence for this. The
martyr's altar had been erected in the
western apse "according to Roman cus-
tom";[84] there his tomb is still preserved
at the former boundary line of transept
and apse. Thus it corresponds exactly to
the place where St. Peter's altar rose over
his tomb, and the specific kinship between
the Fulda abbey church and St. Peter's
in Rome manifests itself again: in contrast
to St. Peter's, the tomb of the saint at St.
Paul's is in the transept close to the nave
(Figs. 10 and 12). In 822 the cloister was
laid out at Fulda; it was arranged not to the
south, where the old one had been, but
Romano more to the west, because "thus
it was closer to the body of the saint."[85]
Taken by themselves, all these allusions to
Rome may seem of minor consequence; yet
when taken collectively, no doubt is left as
to the intentions of the builders of Fulda:
they wanted to create north of the Alps an
effigy of the great basilica of St. Peter's
in Rome. They sought to establish an equa-
tion between St. Boniface and his church
in Fulda and St. Peter and his sanctuary
on the Vatican Hill. In the fifty years fol-
lowing his death, St. Boniface had become
the protomartyr of the German part of the
Frankish kingdom. He was considered the
Apostle of the Germans in much the same
way in which St. Peter and St. Paul had
been considered for centuries the Apostles
of the Romans.[86] Although it is by no
means certain, a similar situation may have
prevailed at St. Denis, where the Apostle
of the Gauls was buried.[87] This analogy
of St. Boniface—and perhaps of St. Denis
—with St. Peter and St. Paul may help to
explain why possibly the church of the
Apostle of the Gauls, and certainly that of
the Apostle of the Germans, were the first
in the North to take up the plan of the great
proto-basilicas of Christianity in Rome.

II

These considerations lead to a more gen-
eral problem. The veneration of St. Peter

had grown constantly throughout the Frankish kingdom during the eighth century. Only Christ and the Virgin take precedence over him in the number of dedications of altars and churches.[88] This is only natural: the Roman Church was symbolized by St. Peter. Time and again his name was used to mean Rome and the papacy in particular.[89] Thus it is not surprising to see that, with the growing supremacy of Rome north of the Alps, the veneration of St. Peter and of his sepulchre in Rome also increased all over Central Europe. The rising importance of St. Peter, of his basilica, and of Rome were indissolubly linked together.

This veneration of St. Peter is but one element within a progressive Romanization of Christian Europe: from the early eighth century on the Gallican Church and the Irish monasteries within the Frankish kingdom, both strongly Near Eastern, were gradually eliminated, largely under Boniface's leadership, in favor of Roman institutions. This tendency increased during the second half of the century. Shortly after 754 the Roman mass was introduced into Metz and somewhat later into the whole kingdom to replace the Gallican liturgy.[90] Simultaneously, and in connection with the Roman liturgy, the Roman chant was transplanted to the North by members of the papal choir and by monks sent to Rome to study with the pontifical *schola cantorum*.[91] Through a decree of 789 all monastic orders were forced to submit to rules shaped after those of the Benedictines, one of the main points being the immediate jurisdiction of the Curia over all monasteries.[92] Foremost among the Benedictine monasteries were Fulda and St. Denis. At the same time Roman relics began to be transferred in large numbers to churches north of the Alps: as early as 765 Fulrad, the abbot of St. Denis, and later on his successors, brought Roman relics to St. Denis and then to convents in Alsace-Lorraine; simultaneously Roman relics were transferred to Bavaria.[93] Among the relics de-

posited at Fulda between 790 and 819, at least half came from Rome; the rest were a collection of local, Frankish, Dalmatian, and Near Eastern relics.[94] Roman saints competed more and more with the Frankish, Irish, and Near Eastern saints, who until then had been venerated almost exclusively throughout Gaul and the Rhineland.

This ecclesiastical policy of the Curia was paralleled by the general policy of the papal court as well as of the Frankish kings.[95] From 750 on, Rome asserted not only its spiritual but also its political influence north of the Alps, while Frankish policy gravitated more and more towards Italy and Rome. The Frankish court, impelled by ecclesiastical as well as by political reasons, became the foremost champion of ecclesiastical Romanization north of the Alps.[96] Through quite different interests a partnership developed between the Frankish and the papal courts, beginning with the visit of Pope Stephen II to Paris in 753, when Pepin and his sons were anointed as kings and undertook to protect the Roman Church and its possessions, and culminating in the coronation of Charlemagne as emperor on Christmas Eve in the year 800.[97]

In its effects, however, the coronation of 800 was more than a mere seal on the fifty-year-old collaboration between the Frankish kings and the popes. With the spread of Carolingian power over almost all the Christian parts of Europe there had arisen a new conception of rulership.[98] Charlemagne by his coronation laid claim to succession to the Roman emperors of Antiquity; since he dominated large parts of what had been their domain, he considered himself and his successors their legitimate heirs. From the coronation on, his official titles were those of the Roman rulers, Caesar and Augustus; one of his bulls shows a symbolic representation of Rome and the inscription *Renovatio Romani Imperii*;[99] Alcuin addressed him as "Flavius Anicius Carlus" with the names

used officially by the Roman emperors;[100] time and again contemporaries alluded to the Carolingian house as legitimate successor to the Roman emperors.[101] This conception clearly reveals an attempt to revive certain aspects of the Roman past; it formed the backbone of medieval policy for half a millennium to come.

A similar desire to revive a state of affairs which had supposedly existed in ancient times underlay the political philosophy of the papal court. Throughout the eighth century one of the aims of papal policy had been to create moral and legal justification for the claims of the Church to a secular territory in Italy and to a leading position in occidental politics. To this end a fiction was created which found its foremost expression in the famous spurious document of the Constantinian Donation. Its main thesis was that Constantine entrusted to Pope Sylvester as the successor to St. Peter the spirtual leadership of the world, and when transferring the capital of the Empire to Constantinople, and indeed because of this transfer, bestowed on the pope the territorial rule over Rome, Italy, and the West. On the basis of this fiction the pope could consider himself the *de iure* ruler of Europe; he had the power to delegate this right to those who were to govern—in other words to crown the emperors who were to practice these powers in his place.[102]

Obviously this fiction, like Charlemagne's conception of his empire, implied the ideal of re-creating a situation of the historical past. It involved the conception of cancelling half a millennium, during which the papacy had been dependent on Byzantium. It pretended to re-establish a state of affairs which had existed in late Antiquity, under Constantine, at the very moment when Rome and Christianity had been merged.

This revival of the past necessarily entailed a new interest in the city of Rome and its ancient institutions. In both the papal and Carolingian camp, there was a manifest desire to restore some of its ancient importance to Rome, the burial place of St. Peter, the former capital of the world, the imperial city.[103] In Rome itself something like a feeling for the Roman national past was revived with the support of the aristocracy of the city. Returning to ancient Roman terminologies which had ceased around 600, the Senate and people of Rome became again elements of importance, and again the term *Res Publica Romanorum* was used, now to signify the Roman element within the Empire.[104]

The same return to Roman customs took place in the Church; the Near Eastern element was eliminated, not so much because it was objected to but because new emphasis was given to Roman elements as such. While from 640 to 752 thirteen among twenty popes had been Dalmatians, Sicilians, Greeks, or Syrians, from the mid eighth century on the pontiffs were chosen with one exception from the families of the Roman aristocracy.[105] Greek churches and monasteries which had been so frequent in Rome during the previous centuries became quite rare.[106] Greek saints and festivals which had entered into the Roman missal during the seventh century[107] were replaced by Roman martyrs; Eastern relics which had occupied an important place in Rome during the sixth and seventh centuries[108] were superseded by Roman ones. Beginning with the middle of the eighth century and continuing through the first half of the ninth, Roman relics were brought in increasing numbers from the catacombs into the city.[109] A depository seems to have been formed for them, a depository from which relics were distributed all over Europe.[110] Consequently the cult of Roman martyrs gained a new importance; most of the churches erected in Rome during the period were dedicated to one or another of these Roman saints who, while sometimes Greek by birth and name, were considered Roman by right of their provenance from the Roman catacombs.

The goal of all these currents within the later eighth century was clearly a return to a period in Roman history which preceded the Byzantine domination. The idea was to renew the great Roman tradition of the Church, to create a *renovatio* of Rome as of old. Obviously the idea of a *renovatio* was bound to include the most heterogeneous concepts: a "Golden Age" of undetermined Antiquity; a pre-Byzantine Rome in which the Church had been more independent; a fictitious Constantinian Rome in which imperial power had been conferred on the pope; the Rome of the emperors which had been the capital of the world up to Constantine, the first Christian emperor; and last but not least the Rome of the first Christian centuries where so many thousands of martyrs had died, among them the Princes of the Apostles, and where Christ had built His Church on the rock of St. Peter.[111] All these different images of a Rome of the past were blended into one; and the ardent desire to revive the past was vital and compelling in the philosophy and policy of the eighth and ninth centuries. It is only natural that this idea of a return to the past should manifest itself in architecture as well.

III

Up to the very end of the eighth century, however, not one of the Roman churches reflects this new trend. Near Eastern types which had dominated the sixth and seventh centuries were still prevalent.[112] Indeed it seems at first glance a strange phenomenon that the very popes who were the champions of the process of Romanization in Central Europe and .of the re-Romanization in Rome did not apply these ideas to architecture. The church of Sant' Angelo in Pescheria, laid out by one of the leading popes of the Roman *renovatio*, shows a characteristic Near Eastern plan with three parallel apses.[113] Hadrian I (772–75) transformed Sta. Maria in Cosmedin (Fig. 2[L], into a typical Near

Eastern basilica, terminating in three apses with a long fore-choir flanked by pastophories and with sham galleries above the aisles.[114] Even Leo III (795–816) still followed the Near Eastern tradition in almost all his buildings: Sta. Susanna, evidently one of the first churches he erected, is again a basilica with galleries—this time, however, with only one apse[115]—while the church of SS. Nereo et Achilleo assumes a definitely Syrian type: its apse is flanked by two pastophories which are surmounted by upper stories (Fig. 2[M]).[116]

It was under the same Leo III, however, that a reaction against this predominance of Near Eastern elements took place in Roman ecclesiastical architecture, contemporaneously with the completion, north of the Alps, of the abbey. church of Fulda as a basilica of the "Roman" type.

The transformation of the church of Sant' Anastasia seems to have been the first step within this architectural reaction in Rome (Fig 18).[117] The present baroque edifice—it is one of the most beautiful and one of the least known examples of an early eighteenth-century church interior in Rome—contains a great number of older remnants. Evidently within the first years of Leo's pontificate (795–815),[118] a fourth-century cross-shaped church was transformed into a typical basilica. Its nave was separated from the aisles by colonnades which carried either an architrave or a series of arches. The cross arms of the older edifice were adapted to form a normal continuous transept between the new nave and the old semicircular apse, and consequently the new plan took on an appearance that closely resembled the Roman basilicas of the fourth century (Fig. 1[O]). A wide flight of steps in front of the façade led to what seems to have been a narthex with two openings on either side and, originally, with a row of supports along its front: a monumental approach was created corresponding to the monumental size which the whole building

had acquired in the course of the alterations and which, while much smaller than the fourth-century basilicas, strongly differed from the miniature eighth-century buildings in Rome and elsewhere (see Figs. 1 and 2). The eleven windows of the clerestory corresponded to the axes of the intercolumniations below and, although small in comparison to the windows of fourth- and fifth-century basilicas, were considerably larger than any windows found in the immediately preceding period, for instance at Sta. Maria in Cosmedin.[119] Their arches are formed of two rows of bricks—an old Roman device used frequently in the fourth and fifth centuries in Rome, but which had disappeared during the sixth century.

At Sant' Anastasia the relation to Roman fourth-century architecture, though obvious, is necessarily somewhat obscured by the fact that large parts of an older structure had to be incorporated into the new building. While the general kinship to early Roman ecclesiastical edifices is manifest, it would be hard to point out any specific Constantinian or Theodosian basilica which the architect of Leo III might have taken as his model. In another building of Leo III, however, such a specific relation becomes quite striking: Sto. Stefano degli Abessini, situated behind St. Peter's, seems to have been laid out in the later years of Leo's pontificate.[120] It was a normal basilica, quite small, with a continuous transept and with one semicircular apse; in front of the facade extended a narthex, supported by a series of columns and with lateral openings resembling those at Sant' Anastasia (see Fig. 19).[121] Only eight columns on either side separated the nave from the aisles. This time it is certain that these columns carried an architrave: remnants of it are still in situ (Fig. 19). The transept communicated with the aisles by twin openings. The triumphal arch leading from the nave into the transept was supported by T-piers with large columns next to them. A semi-circular apse termi-

nated the transept; underneath it extended an annular crypt, consisting of a semi-circular corridor along the curve of the apse wall and of a straight corridor which led from the apex of the apse to the square confessio under the high altar.[122]

The model from which the plan of Sto. Stefano is derived can be established in quite a definite way. The continuous transept, it will be remembered, had appeared only in two of the great proto-basilicas of the fourth century: St. Peter's and St. Paul's.[123] The twin openings between aisles and transept wings point to these same basilicas: the column in the center of the twin openings at Sto. Stefano is evidently nothing but a reminiscence of the pier, which in these prototypes with their four aisles had marked the end of the colonnades between the inner and outer aisles. The transept of Sto. Stefano does not protrude beyond the aisle walls and is rather wide in proportion to its length, exactly 1:3. This is the very proportion of the transept of S. Paolo f.l.m., quite different from the strongly protruding, extremely narrow transept of St. Peter's (Figs. 1[A, O], and 2[C]). On the other hand, the use of the architrave at Sto. Stefano indicates St. Peter's as a model, for of all the great basilicas in Rome only St. Peter's combines the architrave and the transept. While taking over the general layout of S. Paolo, the architect at Sto. Stefano fused it with elements carried over from St. Peter's.

One can hardly overemphasize the significance that these new edifices must have had in the Rome of Leo III. Up to his time and even during his own pontificate, the rich variety of Near Eastern motives had dominated the architectural production of the city. Evidently no architect had used the models established by the great imperial foundations of the fourth century, despite the fact that they had always been extant, in good state and highly venerated. With Sant' Anastasia and Sto.

Stefano degli Abessini the spell seems to be broken. The more complicated Near Eastern types with their pastophories and galleries are abandoned, and the simple beauty of the contrast between nave and transept, the opposition of clear horizontals and verticals in the architrave and the colonnade, seem to have come back to life. Paralleling the *renovatio* in the political field, and the revival of the cult of Roman saints and Roman martyrs, the architecture of the city of Rome likewise returned to its own past.

This revival of the Roman Early Christian basilica continued and gathered momentum under the pontificate of Paschal I (817–24). One can hardly help feeling that the beginnings of this architecture were closely tied up with his personal influence. Among the churches erected under his pontificate only the diaconia of Sta. Maria in Domnica still followed the older Near Eastern scheme of a basilica with three apses. He probably had been *praepositus* of Sto. Stefano degli Abessini when the new church was designed under Leo III,[124] and the two main churches erected under his own pontificate, Sta. Prassede and Sta. Cecilia, definitely belong to the new current.

With the church of Sta. Prassede, the architects of Paschal created a perfect example of this new style, an example which fortunately is also perfectly preserved, much better than either Sant' Anastasia or Sto. Stefano degli Abessini, its next of kin. Only the sixteenth-century murals of the nave and the three thirteenth-century diaphragm arches spanning it are later additions (Figs. 20 and 21).[125]

In plan the edifice again shows a nave, two aisles, a semicircular apse, and a continuous transept which opens toward the aisles with twin apertures. An annular crypt extends underneath the apse (Fig. 1[A, P]. The nave is bounded by columns which are surmounted by an architrave; windows with double arches pierce the clerestory, each corresponding

to the axis of one intercolumniation. All this resembles Sto. Stefano degli Abessini. The architect of Sta. Prassede, like the designer of Sto. Stefano, strove for the neat purity of the simple basilican plan with its clear contrasts. Sta. Prassede has also preserved at least a large part of its original decoration, which in its sister church has been lost. The apse still shows its resplendent mosaics: so do the "east" wall of the transept next to the apse, and the triumphal arch between transept and nave. A rich mural decoration, parts of which are preserved in the north transept, supplemented this array of colors. What is irretrievably lost—the marble incrustation of the apse wall[126]—can be reconstructed from the chapel of S. Zeno adjacent to the right aisle, where the blending of the rich colors of the mosaics in the vaults and of the marble incrustation on the walls is still preserved. If one adds to these remnants the marble paneling and the stucco decoration of the crypt and the ornamented portal leading to the chapel of S. Zeno, one understands the delighted enthusiasm with which the writer of the *Liber Pontificalis* described the splendor of the edifice and of its furniture:[127] the ciborium, the altar, the textiles. The aim of this architecture was evidently to create a contrast between the plainness of the structure, the bareness of the exterior, and the sumptuous wealth of the interior decoration.

At the same time, one should realize that Sta. Prassede was built on a scale much more monumental than anything in the previous period (see Figs. 1 and 2). Even Sto. Stefano, while larger than most churches of the seventh and eighth centuries, is small in comparison with Sta. Prassede, where nave and aisles communicate through twelve instead of nine intercolumniations and the absolute measurements have also increased.[128] Only Sant' Anastasia is similar in size, but there the length of the nave was conditioned by the Roman structures which had been re-

used. The size of Sta. Prassede, the plan with its T-transept and its single apse, the tall, narrow structure of the transept which is opposed to the nave in direction and in proportion; the colonnades with their architraves, the comparatively wide windows of the clerestory; the lavish mosaic and marble decoration of the interior and the sobriety of the exterior; the clear contrast of the parts in plan and elevation—the whole lay-out and style find their exact prototype in the great basilicas of the fourth century. Only as a revival of the architecture of the great Christian century can Sta. Prassede be explained.

And not only these general features but the details of the plan and even the building technique also point in the same direction. The small chapel of S. Zeno which is joined to the right aisle of the church (Fig. 20), a cross-shaped structure with a groin-vaulted center bay and barrel-vaulted wings, is one of the elements which would seem to hark back to the Early Christian period. It evidently represents a combination of mausoleum and memorial chapel.[129] Thus it recalls the mausolea of central plan which surrounded the *basilicae ad corpus* of the fourth century, S. Sebastiano[130] as well as St. Peter's or St. Paul's (Figs. 3, 5, 9, 10). Likewise it recalls the memorial chapels constructed for relics, which had grown up around these basilicas and around other ecclesiastical buildings at least during the fifth century. The custom seems to have disappeared after the late sixth century. The chapel of S. Zeno obviously revives the type in general as well as the particular cross pattern which had existed in the fourth century at St. Paul's outside-the-walls, and in the fifth century in the two chapels of St. John the Baptist and St. John the Evangelist adjoining the Lateran Baptistery.[131]

Even the technique of brickwork in this whole group of churches, from Sant' Anastasia on, seems to have reverted to that of the Early Christian period proper. Of course, brickmasonry had remained a common technique in Roman building throughout the sixth, seventh, and eighth centuries. It had been somewhat displaced by the use of *opus listatum*, but it had never completely disappeared. However, the technical standards of the fourth and fifth centuries had not been maintained. Old, pilfered, broken bricks were used; the courses were exceedingly irregular, at times closely packed, at others separated by very wide joints. The arches consisted of only one row of short voussoirs, and these voussoirs took on a radial position only far above the springing of the arch. The brickwork was interspersed with numerous bits of stone: Sta. Maria in Cosmedin provides a good instance of this technique. From the late eighth century on, however, the masonry becomes more regular, resembling that of the Early Christian period proper; the courses, while still undulating and not quite as regular as those of the old parts of St. John's in the Lateran or of Sta. Maria Maggiore, for example, are separated by joints of approximately even thickness; the arches are surmounted by double rows of voussoirs which assume a radial position right at the springings of the arches. Tufa stones disappear completely from the masonry. It is this building technique which characterizes the new parts of Sant' Anastasia, the contemporary parts of Sta. Susanna, and the basilicas of Sto. Stefano and Sta. Prassede. Comparison with the preceding period leaves no doubt that this change of technique finds its explanation in a conscious attempt to imitate the technique of the early centuries of Christian architecture in Rome.

These general features which link Sta. Prassede to the prototypes of fourth- and fifth-century architecture in Rome in general, are supplemented by a number of details which point specifically to St. Peter's as its model. The combination of an architrave in the nave with a transept, as will be remembered, is found only there. Moreover the particular shape of the transept of

Sta. Prassede points to the same source. It is a long and tall structure, extremely narrow. While quite different in scale,[132] its unique proportion of 1:5 corresponds exactly to that of the transept of St. Peter's, and to this transept only, among all the basilicas of the fourth century, and consequently to the transepts of later filiations of St. Peter's such as the abbey church of Fulda.

The atrium of Sta. Prassede is preserved only in remnants, but these remnants allow for a reconstruction. A square center courtyard was surrounded on at least three sides by porticoes, each consisting of five arches carried by columns; a fourth portico ran in all likelihood along the façade of the church.[133] A flight of steps leads and always led from the Via S. Martino, the ancient *Clivus Suburanus,* up to the atrium.[134] Such an atrium (especially one with a flight of steps leading to its entrance), familiar though it may seem, is not a common feature in the late centuries of Early Christian architecture in Rome. While it occurred, of course, in the fourth century, in St. Peter's and in St. Paul's and throughout the first half of the fifth century,[135] during the following period the atrium was apparently replaced by a plain arcaded portico along the façade, equivalent to the exonarthex of Near Eastern churches.[136] Sto. Stefano degli Abessini and Sant' Anastasia were still entered through a plain narthex of this sort. After three and a half centuries, Sta. Prassede is the first church to take up the more pretentious form of the complete atrium. It may even be no mere chance that the twenty-five steps which led to the atrium of Sta. Prassede corresponded in number to those by which one ascended to the atrium of St. Peter's.[137]

Sto. Stefano and Sta. Prassede are the most complete examples of this renascence of fourth-century types which in the decades between 800 and 820 manifests itself in Roman ecclesiastical architecture. Yet not all the elements, atrium,

transept, and so forth need correspond to the great fourth-century basilicas in order to relate a building to this revival of Early Christian architecture; nor need it be St. Peter's or St. Paul's which the Roman architects of the early ninth century had in mind. Only the early edifices follow the fourth-century pattern completely; later churches erected between 820 and 850 prefer other Early Christian models. There are three churches in this later group, Sta. Cecilia, S. Marco, and S. Martino ai Monti, and all of them are patterned after basilicas of the early fifth century. Sta. Cecilia, the earliest among them (Fig. 22), erected under Paschal I (817–24), already omits the transept.[138] Its nave was originally separated from the aisles by plain colonnades with arches rather than an architrave. While these elements differ, other features conform to the practice of the earlier ninth-century basilicas: like Sta. Prassede, Sta. Cecilia shows traces of a large atrium; the nave terminates in a single semicircular apse with an annular crypt underneath; the windows of the apse as well as those of the clerestory wall are topped by the characteristic double arches. As at Sta. Prassede, a memorial chapel was attached to the right aisle above the so-called "Bath of Sta. Cecilia," of circular rather than of cross shape (see Fig. 2[U]). S. Marco (827–44), though slightly later, seems to have been almost identical with Sta. Cecilia before it was transformed in the fifteenth and eighteenth centuries. It shows the by now familiar type (Fig. 23) with arcades bounding the nave, semicircular apse, annular crypt, and possibly an atrium in front.[139] Both S. Marco and Sta. Cecilia resemble the great early fifth-century basilicas without transept: at Sta. Sabina (Fig. 15), at S. Vitale, at S. Lorenzo in Lucina, at SS. Giovanni e Paolo,[140] we find the arcades bounding the nave, the plain circular apse, and—at least at Sta. Sabina and SS. Giovanni e Paolo—also the atrium. Significantly enough the number of columns in

the arcade which divides nave and aisle at Sta. Cecilia is twelve, exactly the same number as in the naves of Sta. Sabina, SS. Giovanni e Paolo, and S. Lorenzo in Lucina.

The latest church of the group, S. Martino ai Monti (844–47), clearly recognizable under the splendid seventeenth-century decoration of its interior (Fig. 24), differs somewhat from this pattern:[141] while its plan with nave, aisles, apse and—originally—atrium, resembles Sta. Cecilia, even in the use of twelve columns on either side of the nave and in its measurements,[142] the colonnades of its nave carry an architrave instead of arches. Thus the elevation seems to have been inspired not so much by Sta. Sabina and the related basilicas, but by Sta. Maria Maggiore with its architraved colonnades (Fig. 8).

The close of the "Renaissance of the Early Christian Basilica" in Roman architecture of the ninth century seems to be represented by two churches, both erected under the pontificate of Leo IV (847–55): Sta. Maria Nova, now S. Francesca Romana, and the church of the Quattro Coronati. While the two clerestory walls of Sta. Maria Nova[143] with their double-arched windows, the walls of the aisles, and one fragment of an architrave show that the nave of the small basilica was linked to S. Martino ai Monti, it cannot be established whether the church ended like Sta. Prassede in a transept and an apse with annular crypt, or whether as at S. Martino the transept was omitted. The porch, which instead of an atrium ran along the façade and along the front part of the right flank, clearly represents a departure from the "classical" type with atrium which had been re-established in Rome from 810 on, and a retrogression to the narthex type which had prevailed up to the end of the eighth century. The church of the Quattro Coronati (see Fig. 2[V]), in its original state would also seem to be closely akin to S. Martino or even more to Sta. Cecilia.[144] The atrium, the nave with twelve intercolumnia on either side, the semicircular apse, the annular crypt, the absence of the transept, the windows with double arches, everything seems to tally: there is even a square chapel adjacent to the left aisle with four columns in the corners, with a groined vault, and with three apses forming a kind of trefoil (see Fig. 2[U]), in position and function resembling those at Sta. Prassede and Sta. Cecilia.[145] Yet while all these features seem to coincide with the earlier churches, a number of elements at SS. Quattro Coronati depart from the norm: instead of continuing from the façade to the beginning of the apse, the series of columns was broken by a pier in the middle of the nave, on either side; a respond in front of the pier rose to the open timber roof. Thus the nave was divided into two large bays; a rhythmical element was introduced, quite foreign to the quiet flow of the colonnades in the other buildings of the renaissance movement of the ninth century. Likewise the atrium is surmounted by a clumsy square tower with a passage (Fig. 25). Its upper story exhibits four openings on each side, supported by small baluster-like piers.[146] The tower created a strong accent at the entrance to the atrium; it conforms perfectly to the rhythm created in the interior. Both rhythm and accentuation are foreign not only to Roman ninth-century architecture, but to Early Christian and medieval ecclesiastical architecture in Rome in general.

Thus the development of Roman architecture during the first half of the ninth century becomes apparent. During the last years of the pontificate of Leo III and during the pontificate of Paschal I, roughly speaking within the first two decades of the ninth century, the Near Eastern church types were superseded by a renaissance of Roman Early Christian models, more specifically of the great fourth-century basilicas, primarily St. Peter's and secondarily St. Paul's. The first renaissance group, which includes the transformation of Sant' Anastasia and the building of

Sto. Stefano degli Abessini and Sta. Prassede, is characterized in its technique of construction by the constant use of columns, by the improvement of the brick masonry, and by the use of double arches over the windows; in plan and elevation it is marked by the re-introduction of the atrium, by the re-establishment of a continuous transept, and by the re-appearance of an architrave over the columns. This first group is followed from 820 to 850 by a second one, which includes Sta. Cecilia, S. Marco, and S. Martino ai Monti. In contrast to the first, their main feature is the omission of the transept which points to a derivation of this type from fifth- rather than from fourth-century Early Christian models. More specifically the absence of a transept, together with the occurrence of an architrave over the colonnades, tends to establish Sta. Maria Maggiore as the prototype of S. Martino ai Monti, while the arcaded colonnades of Sta. Cecilia and S. Marco suggest inspiration from such prototypes as Sta. Sabina or SS. Giovanni e Paolo. The use of the smaller fifth-century basilicas as prototypes instead of the large fourth-century ones is evident. Possibly this change represents at the same time a shift from the shrines of the great Roman saints to those of lesser martyrs. Throughout the first half of the ninth century this whole movement is characterized by the plain beauty of the basilican plan, by the uncomplicated contrast of nave and transept or nave and apse, and the simplicity of the elevation. Emphasis is laid upon the quiet flow of the colonnades, the wide windows, the bare outer walls, the straight inner walls with their mosaics and marble incrustations, and the flood of light that fills the nave in contrast to the windowless dark aisles.

Shortly after the middle of the century the church of the Quattro Coronati introduced a number of quite unusual elements which cannot be explained through the Roman tradition. Yet SS. Quattro Coronati remained an exception; at the same time smaller churches such as Sta. Maria Nova more or less continued the "Renaissance" types without changing them decisively. After 860 ecclesiastical architecture in Rome seems to come to a standstill. Nothing worth mentioning was built in Rome from this date up to the end of the millennium.

IV

It is evident that the architectural revival conforms to the political and ecclesiastical *renovatio* movement which from the middle of the eighth century on had formed the backbone of the policy of the papal court. While the architectural renaissance in Rome follows about half a century in the wake of the political *renovatio*, the intimate connection between the two movements is obvious. Likewise it is evident that it parallels the acceptance of Roman Early Christian types north of the Alps. Fulda, and possibly St. Denis, revert to the identical Early Christian proto-basilicas from which Roman ninth-century architecture was derived, and stand against a similar ideological background. But, while this background is similar it is by no means identical; it has obviously different connotations north and south of the Alps and thus leads to a somewhat different course of architectural development. South of the Alps, in Rome, the movement was that of a *renovatio*; it was an attempt to revive the city's own glorious past by eliminating the "foreign" Near Eastern influence in architecture as well as in any other field. In the North, the basic element was not so much a *renovatio* in the proper sense; it was rather a movement towards Rome, an outgrowth of the general process of Romanization in the Frankish kingdom. The renascence of the Early Christian basilica has in the North a more specific, in Rome a more general character; while in the North it is limited to the emulation of the great proto-basilicas, in Rome after an

initial period it is inspired by the totality of Early Christian architecture of the fourth and fifth centuries.

Whether the two architectural trends, the one in the Frankish kingdom and the other in Rome, are merely parallel to each other or whether they are more directly related is another question.

If it could be definitely established that the Roman Christian type existed at St. Denis before 775, no doubt would be admissible as to the priority of the revival of the Roman Christian basilicas in the Frankish kingdom to the parallel development in Rome which took place after 800. On the other hand, Ratger's "Roman" project of 802 for Fulda would be exactly contemporary with the very first "Renaissance" basilicas in Rome: Sant' Anastasia was probably designed between 795 and 800, Sto. Stefano after 806. Theoretically an influence exerted by Roman ninth-century architecture on that of the North would be as possible as an influence in the reverse direction, moving from the North to Rome. A priori one might be inclined to assume that architecture north of the Alps must have depended of necessity on a previous architectural revolution in Rome; an impact coming from Rome always seems more natural than one exerted upon it. Still there is no need to deny offhand the possibility that the Roman architectural movement might have been inspired by an earlier development north of the Alps. Frankish workmen were used in Rome; they evidently even enjoyed a high reputation as carpenters and builders. Pope Hadrian I in two letters asked Charlemagne not only for beams for the repair of the roof of St. Peter's but also for a *magister* to supervise the work; Wilcharius, Bishop of Sens, was to direct the restoration, probably as a consulting engineer.[147] Works of art were also imported from France: after Hadrian's death Charlemagne had the Pope's epitaph sent to Rome, a slab of black marble from Port-

Etroit, decorated with an elegant rinceaux ornament à l'antique and an inscription in beautiful lettering.[148] One wonders whether architectural elements were not also imported from north of the Alps: the wooden tower which Stephen II erected over the nave of St. Peter's is an element which remained as unique in Rome as it was common in the North from the late eighth century on.[149] Thus it may be safe to conclude that during the second half of the eighth century, Rome was at least as willing to receive from the North as the North was eager to emulate earlier, and possibly contemporary, Roman prototypes.

While these possibilities remain open, it would seem that actually the churches at Fulda (and St. Denis) and the contemporary churches in Rome do not depend on each other. In none of the Roman churches of the ninth century are the ends of the transept wings shut off by colonnades as was done at Fulda in direct imitation of St. Peter's; none of them competes in size with the fourth-century proto-basilicas as did Fulda. It would seem that Ratger at Fulda and Leo III's architects in Rome had simultaneously yet independently reached similar solutions on the basis of a related historical ideology.

This situation changes when after 830 the plan which had appeared early in the century in Rome and in Fulda was taken up more generally north of the Alps.

The first church in Germany after Fulda to adopt the new style is the church of Sts. Peter and Marcellinus at Seligenstadt (see Fig. 1[R]). In 827 the relics of the saints had been transferred by Einhard, Charlemagne's ex-chancellor, to his country estate at Steinbach. Evidently irritated by the removal from Rome without their volition and dissatisfied with their new abode, the saints insisted on being transferred again and thus caused the construction of the new church at Seligenstadt between 831 and 840.[150] Nave and aisles communicated by nine brick arches on

either side, supported by slightly rectangular brick piers; the upper walls of the nave, like those of the aisles and of the transept wings consist of ashlar masonry. A triumphal arch supported by T-piers opens onto a continuous transept, rather wide in plan and based on a proportion of 1:4. The single semicircular apse had an annular crypt underneath.[151] While this plan certainly shows all the elements of the ninth-century revival, it is not derived from Fulda (or from St. Denis), nor does it depend directly on the fourth-century basilicas of Rome. The proportion of the transept, however, is identical with that of Sto. Stefano degli Abessini (see Figs. 1[R] and 19) and so is the number of nine intercolumniations per arcade, a number which among all the ninth-century churches of this type is found only at Seligenstadt and at Sto. Stefano.[152]

Thus it is hardly doubtful that Einhard's architect drew on the contemporary Roman churches. Nevertheless he combined with the Roman elements some features of quite different character: the oblong piers of the nave which he used instead of columns are more massive and solid than anything found in Rome, and still belong to the Near Eastern tradition; a towerlike structure seems to have risen from the west façade,[153] creating a strong vertical accent quite at variance with the long-drawn horizontal lines of Roman ninth-century architecture. The revived plan of the Early Christian basilica is fused with different elements, and this fusion dominates the subsequent development of the type north and south of the Alps from 830 to 870. In the Benedictine abbey church at Hersfeld (831–50),[154] a long nave bounded by eleven arches on columns and terminated by a huge continuous transept (see Figs. 2[S] and 26), quite "Roman" in aspect,[155] was flanked by two vertical accents; a group of three apses, not a single one as in the churches of the Roman type, rose to the east, while the west façade was surmounted by some tall towerlike structure.

Rival architectural masses with vertical accents balance one another at either end of the building; they manifest a conception of architecture which is diametrically opposed to the continuous flow and the simple contrast of masses which dominated the Early Christian basilicas in Rome as well as their eighth- and ninth-century derivatives in Rome and in the North, and which in Hersfeld still survives in the nave and in the transept.

A number of smaller buildings erected after the middle of the ninth century in the eastern parts of the Frankish Empire show a similar fusion of Roman-Christian with new architectural elements: the Frankfurt Stiftskirche, the Regensburg Alte Kapelle (both 840–47), the abbey church at Heiligenberg (873), the Frauenmünster at Zürich (874)[156]—all combine a small basilican nave and a continuous transept with rather elaborate structures at the west end, and with a group of three apses or a main apse flanked by sacristies, or with a longish fore-choir.[157] A comparable fusion seems to take place during the ninth century in a group of structures south of the Alps: even in Rome the entrance of the atrium of the Quattro Coronati, while not a regular west-work, is reminiscent of the arrangements at Hersfeld and possibly Seligenstadt. A similar isolated tower opposite the church, possibly as early as 797–818, surmounted the entrance side of the atrium of S. Salvatore at Cassino.[158] The plan of its transept with three semicircular apses perhaps depended on the supposedly contemporaneous analogous solution at the neighboring pre-Desiderian basilica of Monte Cassino.[159] At Farfa a west-work may have been added to the earlier church between 830 and 840.[160]

The place of the new fusion-types north and south of the Alps within the general development of medieval architecture can be sketched in a summary fashion. The conception of the building as a group composed of structural masses of diverse

shape, size, and height had already played a considerable part in what we called "Near Eastern architecture in the West" from the sixth through the eighth century. This Near Eastern tradition survived throughout the first half of the ninth century: Einhard's church at Steinbach (815–20) with its dwarf transepts, the quincunx central building at Germigny-des-Près (ca. 800), St. Philibert-de-Grandlieu (819–36; 836–53) with its dwarf transepts and its exterior corridor crypt, are a few instances selected at random.[161] Likewise the Northumbrian (?) western tower survived: the church on the Petersberg near Fulda (779/802–36) represents a late though not by any means the latest instance.[162] Out of a fusion of these older motives with one another and with certain Roman Early Christian elements a new style grew up late in the eighth century. At Centula (790–99)[163] the short basilican colonnaded nave of the church of St. Riquier seems to be almost crushed between the two enormous architectural groups at opposite ends of the building, the tower over the monks' choir with its dwarf transept wings (in all likelihood with inner galleries), and its long low fore-choir to the east and the similar tower-like west-work. The eye is led up from the aisles to the radiating wings of the east and west structures, from there to the turrets in the corners, to the nave, and finally to the spires which dominate the whole edifice. The single motives, the dwarf transepts, the western tower, the enormous spires may have been derived from the Near Eastern and Celto-Northumbrian foundations of early European architecture; yet they have been transformed into elaborate structures, each of which is composed of a number of units of different height and mass; they constitute multiform groups of diversified shape and outline which balance each other at opposite ends of the building. A new style develops which transforms the pre-Carolingian inspirations into something quite different and which, on the other hand, has little to

do with the contemporary revival of the Early Christian basilica in Rome and in the Frankish kingdom. Only a very few Roman Christian elements have been incorporated into the church at Centula, such as the colonnaded nave and the atrium, albeit with towers over the entrances. This new style becomes increasingly important throughout the Carolingian Empire during the ninth century; at Corvey, at St. Germain at Auxerre, at Cologne, at St. Gall, ponderous yet clearly organized west-works are balanced by equally dominating groups over the eastern ends of the edifice. Hersfeld and the related structures in the North as well as in Italy are nothing but a collateral of these trends: in them certain elements of the "Centula" type have been merged with others from the Roman Christian revival, yet without submerging these Roman Christian elements completely in the new style which was to dominate the future. It is this style with its counterbalancing masses at either end of the basilican nave which forms the basis of post-Carolingian and Romanesque architecture in Burgundy, in the Rhineland, in England —in all the regions which were dominated neither by the architecture of the premier art roman (which itself would seem to depend on the Near Eastern art in Europe) nor by the numerous post-Carolingian renascences of the Roman Early Christian basilica. For the Carolingian Renaissance of Early Christian architecture is only the first in a long series of attempts to follow Roman Christian prototypes. New renaissances follow one another from the late tenth through the twelfth century all over Europe, from southern Germany to Spain, from the Upper Rhine valley to Holland, and to southern Italy. Yet these revivals are not by necessity directly inspired by the Early Christian prototypes proper; frequently they depend less on them than on the Carolingian imitations of Early Christian architecture. Of course northern Spain and northern France early in the eleventh century experienced a gen-

uine Roman Christian renaissance directly dependent upon the Roman proto-basilicas: Ripoll, the cathedral of Orléans and St. Remy in Reims, with their four aisles and with the numerous chapels along the transept, can be explained only by a direct inspiration from St. Peter's. On the other hand there exists a contemporary movement in southern Germany and North Italy which would seem to depend rather on churches of the Carolingian Christian renaissance type such as Fulda or Hersfeld: the cathedrals at Augsburg, Mainz,[164] or Aquileia[165] with two aisles, with an overlong transept and with hall crypts are indicative of this. Similarly an Early Romanesque revival which takes place in the Upper Rhine valley during the second quarter of the eleventh century, e.g., at Strassburg, Einsiedeln, and Muri,[166] while seemingly inspired by Early Christian models, proves really to be influenced by the Carolingian basilicas of St. Gall and possibly by Fulda. Likewise in the third quarter of the century the Desiderian basilica of Monte Cassino with its three apses may have depended on its Carolingian forerunner[167] which would thus form an important link between the Early Christian period and the eleventh and twelfth centuries. The Monte Cassino type spread during the last quarter of the century to Campania and Apulia,[168] and early in the twelfth century to Rome. Strange as it may seem the Roman churches of the twelfth century, Sta. Maria in Trastevere, the upper church of S. Crisogono, or Sant' Eusebio do not depend directly either on the fourth- or on the ninth-century basilicas of the city; their transepts, which hardly protrude beyond the aisles, and their three apses give evidence that they depend on the great Benedictine abbey of Monte Cassino. A comparable situation prevails in later "Early Christian Renaissances." Indeed Carolingian buildings and their twelfth-century filiations rather than Early Christian originals determined the conception of Early Christian architecture

throughout the Renaissance and up to our own day: Brunellesco's "Early Christian" churches of S. Lorenzo and Sto. Spirito in Florence,[169] or the slightly later ones in Rome,[170] all follow churches like SS. Apostoli in Florence or Sta. Maria in Trastevere in Rome, not St. Peter's or St. Paul's. Far beyond the Carolingian period the development of medieval architecture was largely shaped by the architecture of the ninth-century revival.

Even this brief outline may help to indicate the decisive place which the Carolingian Renaissance holds within the development of medieval architecture in Europe. To state it explicitly: it marks the point at which European architecture turns from its Near Eastern background to the West and looks there, and more particularly to Rome, for new prototypes. From the fifth century up to the end of the eighth century Europe had been, one might almost say, a provincial country which depended almost wholly on the culture and the architecture of the littorals and the hinterlands of the Eastern Mediterranean. It was in no way connected with the tradition of Christian architecture in the West which in the fourth century had accepted the eminently sober and simple type of the Roman Early Christian basilica, and which through the following hundred years maintained it without changing it essentially. The Near East had entered upon the inheritance of late Antiquity with quite a different spirit: Kalât Simân, Hagia Sophia at Constantinople, the centralized churches of Antioch and Ephesos, the Menas basilica, had taken up and developed the types and the architectural conceptions of late Antiquity with a richness and an inventiveness which continually led to new forms and new solutions. While the Islamic conquest from the second quarter of the seventh century on arrested this lively and rich development in Syria, Egypt, and North Africa, this style continued unabated in the Byzantine Empire. But church architecture in the Occident up

to the end of the eighth century is merely a reflection of this post-antique Near Eastern art which continually changed form and which was extraordinarily alive. The achievement of the Carolingian Renaissance was to cut off the dependence of occidental architecture upon that of the Near East; this means at the same time that it brought to an end the reverberations of Near Eastern late-antique architecture in the Occident.

By introducing for the first time the type of the Roman Christian basilica into general European architecture, and by reintroducing it into Roman architecture, the Carolingian Renaissance replaced this living development of late-antique art with the revival of a form of the fourth and fifth centuries. The sobriety and simplicity of this obsolete form together with its monumental scale and its conception of plain surfaces and walls form a new element within western architecture. From the time of its revival at the end of the eighth and early in the ninth century, this new element becomes one of the essential constituents of medieval and post-medieval architecture in Europe: throughout the Romanesque and the Gothic period and deep into the Renaissance, the basilican plan remains basic to Christian church building; the same holds for the monumental size of the edifice, and for the proportions of its parts to each other. The fact that the cathedral of Amiens has nave, aisles, and a transept; that in its elevation arcades, triforium, and clerestory succeed each other; that the walls seem to consist of transparent screens: all this would seem to be rooted in the tradition of the fourth-century basilicas, which was revived and made known to the Occident by the architects of the Carolingian Renaissance. Obviously the fourth-century type was changed and this transformation took place largely during the Carolingian period. Near Eastern and possibly Irish elements persisted, for instance transept forms that separated the transept into a number of units; the façade, to which no emphasis was given in the Roman Christian basilica, becomes emphasized by west-works and sometimes by twin towers; the eastern parts are developed by the addition of the three-apse group or the fore-choir, both elements of Near Eastern derivation. These features, which are foreign to the Roman Christian basilica, are of utmost importance in evolving the styles of the Middle Ages. The stress laid on façades and choir parts leads to the complicated articulation of the exterior in Romanesque and still later in Gothic architecture; the partition of the transept is linked to the evolution of the segregated crossing, and through it to the articulation of the interior into the clearly segregated bays of the Romanesque and the Gothic systems. Both the Near Eastern and the Roman Christian tradition concur in creating medieval architecture: one terminates in, the other is introduced during, the Carolingian period, and both are merged into something new. The decisive rôle of the Carolingian Renaissance within this whole development of medieval architecture thus becomes evident.

V

Conversely, the dominant part which the renascence of Early Christian prototypes plays within Carolingian architecture may also have a bearing in redefining the meaning of the Carolingian Renaissance as such. Indeed the Early Christian revival apparently forms one of the basic and even indispensable constituents of this renaissance of Antiquity. This realization would seem to conflict somewhat with the view frequently held on the problem; for generally speaking it has been taken for granted time and again that the architects, painters, sculptors, and writers of the ninth century, when going back to Antiquity, would indiscriminately take anything for a model so long as it was antique and just because it was antique. It was assumed that they would do so since to them

antique art as a whole was an idea to be emulated, because of what they considered its "superiority," in which concept technical skill, precious material, illusionistic naturalism, and so forth were indissolubly interlinked. In architecture this thesis of an indiscriminate imitation of Antiquity may be valid as far as the elements of architectural decoration are concerned: Carolingian capitals north of the Alps, whether composite, Corinthian, or Ionic, seem with rare exceptions to be copied from Roman capitals in the Rhineland, and so also are mouldings and bases (Fig. 28). The models were evidently used because by their "superiority" they were recognized as antique, and because they were at hand;[171] they could be taken over wholesale since architectural decoration was void of specific content. Similarly Carolingian writers would use isolated phrases and terms chosen at random from any Roman author at their disposal. Yet what is true of the decorative elements does not necessarily pertain to the whole edifice within which these elements were used: the evidence seems to show that in the design of a church, preference among the prototypes of Antiquity was given to buildings of Christian Antiquity of the fourth or fifth century.

Of course one might say that this is no more than self-evident. Obviously the architect who in the ninth century was to design a church à l'antique would try to find a homogeneous model and—since it was churches he was looking for—he would be able to find this prototype nowhere but in the Christian art of Antiquity. Yet it was in no way self-evident that he would look for his model to the Christian art of Rome and would select his prototypes exclusively within the period from ca. 325 to 450. Why should he discard—or largely discard—the art of the eastern coastlands of the Mediterranean, where antique patterns had been kept alive without interruption, and which in a somewhat diluted form had constituted the very basis of pre-Carolingian art throughout the Occident, including Rome itself? Why should he so rarely use central plan types[172] or the basilicas with or without galleries which were still being erected in his own time throughout the Balkans? After all, they had inspired the whole pre-Carolingian period and were to inspire to a large degree occidental architecture of the early eleventh century. Why this complete about-face, which meant no less than abandoning the tradition of late antique art as manifested in the Near East and its western dependencies, and replacing it by a "rebirth" of the art of Rome? And in Rome itself, why should the architect confine himself to the architecture erected before the middle of the fifth century? Considerations of an archaeological character could hardly have impelled him to do so, since such a point of view did not exist in the Middle Ages. Only one answer is possible: the aim of the Carolingian Renaissance was not so much a revival of Antiquity in general as a revival of Rome, or specifically of one facet of the Roman past: the Golden Age of Christianity in that city.

While this fact easily explains why the Carolingian architect should look for his prototypes to the churches of pre-Byzantine Rome, it has more far-reaching implications. For whatever Rome was in the eyes of the Carolingian period—the Golden, the Imperial City, the mother of Europe, the capital of the world[173]—it invariably included this Christian element. Thus the question arises whether the Carolingian artist, when looking at the complex image under which Rome presented itself, would not quite as a matter of course and unconsciously always prefer such prototypes as either had, or else were apt to be loaded with, Christian connotations. Would that mean that he would always do so, even if the character of the prototype were not, as in the case of a church, necessarily implied by the "theme" of the copy? Would the Carolingian artist, even when thematically free,

still be inclined to give preference to Christian, or what he thought to be Christian, prototypes of Roman Antiquity?

Such a question is the more legitimate since this Christian interpretation of Antiquity seems to be clearly dominant in Carolingian literature. Here the problem can be more easily discerned since a greater amount of relevant source material has been preserved. As has frequently been pointed out, the intelligentsia at Charlemagne's court liked to play with nicknames and allusions drawn from pagan Roman literature;[174] the libraries of the Carolingian monasteries owned and copied many pagan writings, and the Carolingian authors frequently formed their entire style on these models.[175] Yet the fact is often overlooked that this knowledge of antique literature was far outweighed by the knowledge of and the preoccupation with Christian literature. Alongside the pagan nicknames, biblical ones were used in Charles's circle; and while hardly more than a dozen pagan writers were actually known and used by the Carolingian *literati*, Christian antique literature formed the real basis of their literary production: Prudentius, Augustine, Ambrose, Fortunatus, Orosius, Isidore were far more frequently drawn upon than Virgil, Horace, or Suetonius.[176] This is a clear analogy to the revival of the Early Christian types in architecture. Like the Early Christian basilicas, the Early Christian writings were selected because, while speaking the language of Antiquity, they express themes which were Christian and therefore entirely congenial to the Carolingian writer. What is far more relevant, however, is the particular way in which pagan authors were actually used as prototypes: unless they were studied merely for purposes of philology, grammar, syntax, or rhetoric (that is to say "void of content," and comparable to the way antique capitals or mouldings were used in Carolingian architecture)[177] either their writings or their personalities were frequently re-inter-

preted so as to make them acceptable to the mind of the ninth century which could see the universe only from a Christian point of view. The pagan elements were either expurgated[178] or transformed to impart a Christian meaning, or were taken to mean mere forces of nature; or else they were interpreted allegorically as "hidden truths" referring under the guise of pagan gods or pagan events to vices or virtues, to human life, or to Christ.[179] A similar *reinterpretatio christiana* is not infrequent with reference to the character of pagan authors: that Virgil, among all the classical poets, is the one most frequently used in Carolingian times, is of course due to the interpretation of his Eclogue iv as a reference to Christ, an interpretation which from the early fourth century throughout the Middle Ages made him a harbinger of the Lord, a *Christianus sine Christo*.[180] Similarly Pliny, Seneca, Cato, and possibly even Cicero[181] were considered forerunners of Christianity; Statius was even supposed to have been a Christian. Whenever, on the other hand, such an interpretation was clearly not possible, either because of the specific character of the ancient author or else because of the attitude of the Carolingian interpreter, his work was as a rule not accepted. Alcuin in his old age or Paschasius Ratbert or Walafrid Strabo refused to have anything to do with the "liar poets" of Antiquity: they recognized the incompatibility of the pagan writers with the Christian world of the ninth century. Indeed, the ninth-century literary renaissance of Antiquity can best be understood, it seems, if one realizes the basic relevance of the question whether a model of Antiquity was Christian or pagan, and if pagan, whether it was susceptible of Christian re-interpretation, or whether at least it could be made void of content. The choice did not lie simply between acceptance or refusal of pagan elements; it lay between either rejection or re-interpretation.[182]

To illustrate the parallel problem in

architecture we choose as an instance a well-known edifice, the Torhalle at Lorsch (Figs. 27, 28).[183] While the church of this famous monastery was a characteristic pre-Carolingian structure of 767, the gate-house may be slightly later. It is a small rectangular building, which stands iso-lated in the middle of a plaza on the axis of the atrium and the church, but at some distance from them. Three wide arches on both its long sides lead into an open hall on the ground floor; staircase towers on either end of the short sides ascend to a similar, though closed, room on the upper floor, with a painted Ionic order along its walls. The arches rest on four square piers with engaged columns; high above the arches the composite capitals of the columns carry a floating palmetto band in place of an architrave. Corresponding to this tripartite division of the lower section, the upper one is articulated by nine triangular gables which are carried by slender Ionic pilasters. This whole thin and unstable order is set against the background of a tapestry-like wall incrustation of red and white squares, diamonds, and hexagons.

The purpose of the structure has never been determined. The general assumption used to be that the whole edifice was noth-ing but a chapel. Indeed, the upper story may have contained from the very outset a chapel of St. Michael; however, this is not quite certain,[184] and it may have served any other ecclesiastical or even secular purpose. The lower story on the other hand was always open in front and rear and can have served only one purpose: to be walked through. The structure was always isolated between the entrance of the monastery and the atrium of the church. Thus, while not an entrance gate, it can have been nothing but a sumptuous arch across the road to the church, in func-tion reminiscent of a Roman triumphal arch.[185] In its form, also, the structure strongly recalls Roman triumphal arches. While the series of pilasters which artic-ulate the upper story of the Torhalle may

have been inspired by the series of pilasters along the dwarf galleries of such Roman city gates as the Porte d'Arroux at Autun, city gates can hardly have served as models for the whole structure.[186] Their constituent factor is the connection with a continuous wall. The isolation of the Lorsch gate-house, on the other hand, its freestanding position in the center of a plaza, the triple entrances, the piers with engaged columns in the lower section, the architrave-like band, all emphasize the resemblance to Roman triumphal arches. The separate upper story of the Torhalle with its large inner chamber, its architectural murals, and its exterior dec-oration of unsubstantial gables on slender pilasters would at first glance seem to con-tradict this comparison. Yet one must re-call that Roman triumphal arches often had attics above the archways, attics that were always vaulted, and in some instances even made accessible by stairs. Thus they would form regular stories above the thor-oughfare on the ground floor. While no general explanation seems to have been agreed upon for the function of these up-per stories in Antiquity, in at least one case the use of the vaulted attic as a tomb cham-ber or a cenotaph has been suggested.[187]

Thus from its form the Lorsch Torhalle would seem related to those Roman trium-phal arches with a chamber in their attic. Still the question remains whether the Carolingian architect had in mind just a vague idea of such an antique prototype or whether he thought of some specific monu-ment. Of course the whole of the Roman Empire was full of triumphal arches. Yet triumphal arches of the particular form found at Lorsch, raised on a platform, with a triple passage, with columns in front of the piers, and with an accessible upper story in the attic, are not numerous.[188] Only very few examples existed through-out the former Roman Empire, and the number becomes even smaller when one excludes the regions that had become practically inaccessible to the architects

of the Carolingian period, such as the Islamic territories in North Africa or the hinterlands of Hither Asia. Admittedly, all the single constituent elements of the Lorsch gate-house, or even several together, occur in different Roman triumphal arches; but the peculiar combination of all these elements in one single monument is extremely rare. Indeed triple arches with upper stories in the attic, and even more so those with upper stories which are accessible by stairs, seem to be limited to only two monuments: the Arches of Septimius Severus and of Constantine in Rome.[189] One of these two would seem to offer itself as the prototype of the strange Carolingian structure at Lorsch.

In a merely formal way the Torhalle might depend on either of the two arches; from an iconographical point of view the Arch of Constantine is more likely to have been the actual model.[190] It dominated medieval imagination much more than the Arch of Septimius Severus which, after all, for the Middle Ages held no significance at all. The pre-eminent position of the Constantinian monument shows even in ninth-century terminology: it has been pointed out that the term *arcus triumphalis* is used for ecclesiastical architecture for the first time in the biographies of Paschal I and Gregory IV in the *Liber Pontificalis;* as is well known, it designates the arch which leads from the nave to the transept and which prior to this time had been known as *arcus maior.*[191] It has also been shown that the new expression seems to have a twofold root: while it is linked with the image of the triumphant Christ which decorated the arch in Constantine's basilica of St. Peter, it is also meant to refer to the triumphal arches of Roman Antiquity. Yet the term *arcus triumphalis* which we use quite as a matter of course, heretofore had been very unusual in Antiquity.[192] In Rome a similar term, *arcu(s) triumph(is) insign(is),* occurs only once, and this precisely in the inscription on the Arch of Constantine. From there the expression could most easily have entered the architectural glossary of the papal biographers of the ninth century.[193] One may thus conclude that among all the arches in Rome, this one made a particularly strong impression on the imagination of the Carolingian period. One may assume that the authors of the biographies of Paschal I and Gregory IV, when using the term "triumphal arch" for ecclesiastical architecture, thought of the inscription on the Arch of Constantine; and that the architect of the Lorsch Torhalle, when designing his structure after the pattern of a Roman triumphal arch, chose the Arch of Constantine, a monument of Christian Antiquity, as his prototype.

To the Middle Ages, indeed, the Arch of Constantine was a monument of Christian Antiquity. It was known that the arch had been erected for the first Christian emperor in memory of the victory at the Milvian Bridge, the victory which, according to legend, had been foretold by the apparition of the Cross which led to the Emperor's conversion. The inscription on the Arch would quite naturally tend to corroborate such a Christian interpretation; for it stated that the victory had been won *instinctu divinitatis,* through the help of the Godhead,[194] and while this term actually reflects only the late antique belief in an impersonal deity, it was susceptible of the interpretation (and indeed was interpreted as late as the nineteenth century) as meaning the Christian God. Consequently this particular arch, which apparently recorded the victory of Christianity over Paganism and the battle which was linked to the conversion of Constantine, was bound to become in the conception of the Middle Ages a Christian monument and simultaneously the triumphal arch χατ᾽ ἐξοχὴν. Thus between the Arch of Septimius Severus, which could have no particular significance to the Carolingian period, or the Arch of Constantine which was full of Christian meaning, it seems rather likely that the designer of the

Lorsch Torhalle would prefer the latter as a model.

The pre-eminence of the Christian element among the Roman models of the Carolingian Renaissance manifests itself with greater clarity in the Palace of Aix-la-Chapelle. The architectural prototype of the Palace has not been established, and it would be premature to attempt its definition before the plan of the building is better known.[195] Thus, while the *material* model remains obscure, it nevertheless seems certain, that the *ideal* model, or at least one of the ideal models which Charlemagne and his advisors had in mind, was the Lateran in Rome: not the palaces of the Roman emperors on the Palatine which were preserved only in ruins, nor those of the Byzantine emperors at Constantinople which were extant, but the edifice which according to tradition as laid down in the Constantinian Donation had been Constantine's own palace, which the Emperor had given to the Church and which consequently had become the residence of the popes.[196] A considerable number of elements point in this direction and the concurrence of these indications leaves no doubt that to his contemporaries Charlemagne's Palace at Aix-la-Chapelle represented the Lateran and represented it in the medieval way, in which the presence of some outstanding features was sufficient, despite any formal dissimilarities, to make the original recognizable in a copy. To enumerate some of this evidence: in a number of documents the Palace at Aix is actually called "the Lateran" and while this term once refers only to part of the Palace, no doubt is left that in at least one case reference is made to the whole complex of buildings.[197] This latter reference is particularly revealing: for after having stated that Charlemagne built the Palace and that he called it the Lateran, the chronicler goes on to say that the Emperor assembled treasures from all his kingdoms in his Palace. Now we happen to know from other sources what some of the treasures were which had been carried to Aix-la-Chapelle, and while they differ widely in origin and in quality they all have one thing in common: they all seem to "represent" similar treasures which were kept at the Lateran in Rome. There was the bronze figure of a she-wolf or a she-bear which may have been brought from southern Gaul, and which throughout the Middle Ages stood in the vestibule of the chapel at Aix; it would seem to form a parallel to the Roman *Lupa* which throughout the Middle Ages was preserved at the Lateran.[198] Within the complex of the Palace rose the equestrian statue which had been brought from Ravenna to Aix-la-Chapelle immediately after Charlemagne's coronation in 800.[199] Whether the monument was originally meant to represent Theoderic, King of the Goths, or the Byzantine Emperor Zeno is rather irrelevant in this connection; for whomever it actually represented and whomever contemporaries thought it represented, it impersonated for them a ruler of Antiquity. Again this equestrian statue at Aix-la-Chapelle forms an obvious parallel to a Roman monument which up to the sixteenth century was one of the landmarks of the Lateran Palace,[200] the equestrian statue of Marcus Aurelius which played such a great rôle in the medieval interpretation of Roman monuments. Its medieval name, *Caballus Constantini,* was evidently derived from the neighboring Lateran Palace and its church, both of which bore the name of the great Christian Emperor throughout the Middle Ages. Could it be said that the collateral dedication of the Palatine Chapel at Aix-la-Chapelle to the Savior[201] was also intended to parallel the dedication of the Constantinian church in the Lateran?[202] All these indications concur; more obviously than the Lorsch Torhalle, the Palace at Aix attempted to emulate not just any Roman monument but a monument of Christian Antiquity in Rome—or what was supposed to be such a monument.

All these lines of evidence appear to lead in one direction: indeed one sometimes wonders whether they not only lead in the same direction but actually converge towards one point. Already the revival of the Roman proto-basilicas in the first decades of the ninth century north and south of the Alps, seems to give a hint: St. John's in the Lateran, St. Peter's, and St. Paul's are the three churches which the Constantinian Donation had credited to Constantine. In view of this tradition, the inscription at St. Paul's which clearly stated that the church had been rebuilt half a century after Constantine's death, was evidently disregarded. Like the imitation of St. Peter's and St. Paul's from Fulda to Sta. Prassede, the emulation of the Arch of Constantine and of Constantine's palace at the Lateran seems to center around Constantine and his period.

After all, the figure of Constantine formed a pivotal point in the whole philosophy of the Carolingian period. All Charlemagne's political ideas, his conception of a new Empire, and of his own status were based upon the image of the first Christian emperor. Numerous documents testify to the parallel which time and again was drawn between the Carolingian house and Constantine: the scribes of the papal chancellery, as well as other contemporaries throughout the last decades of the eighth century, addressed Charlemagne and referred to him as the "New Constantine";[203] the crown which Constantine was supposed to have given to Pope Sylvester was allegedly used in 816 by Stephen V for the coronation of Charlemagne's son, Louis the Pious;[204] Aix-la-Chapelle was in Carolingian terminology a *Nova Roma*, like Constantinople in the phraseology of the fourth century. Aside from these documents, visible proof of the equation between the Frankish emperor and Constantine was given by the famous mosaics in the triconch triclinium of Leo III in the Lateran (Fig 29). The apse of the building contained a mosaic with the Mission of the Apostles, the triumphal arch a group of three figures on either side. In its original state the group to the right represented St. Peter giving the pallium to Leo III and a standard to Charlemagne; in the group to the left Christ conferred the keys on a pope, probably Sylvester, and the labarum on Constantine.[205] Nothing could better illustrate the intended parallelism between the two emperors, both defenders of the Church: the Roman who was the first Christian upon the throne of the Caesars, and the Frank who succeeded him after half a millennium; nothing could show better the parallelism between the two popes, the one who received the rule over Rome and the West from the first Christian emperor, the other who bestowed this rule on a new emperor. As visualized in Rome, at the papal court, the parallelism is a characteristic example of medieval typology intended to illustrate the papal and the imperial policies. Beyond that it illuminates the conception which the Carolingian period had of Roman Antiquity: it seems as though Antiquity were epitomized in the Christian Rome of Constantine and Sylvester.

In this form, however, the point seems overstated. For while Charlemagne and his contemporaries paralleled the new Empire with that of Constantine, this comparison was seen against a larger background, against the idea of Charlemagne's legitimate succession to the Roman emperors *in toto*. One could perhaps say that the figure of Constantine was only selected because it was best suited to represent what the Carolingian period considered the true essence of a Roman emperor. For in the ninth century the conception of the Empire was necessarily limited by two qualifications, both of which were based on the general concept of history which had found its foremost expression in the Donation of Constantine: first, Charlemagne, while sometimes claiming in theory the whole former Roman world, as a rule limited himself to the Occident—and not only

for practical reasons. The Occident, with Rome as its capital, was the part of the Empire which according to the Constantinian Donation had been bestowed by Constantine on the pope. Consequently it was only the rule over the Occident which could be conferred by the pope on the new emperor. Byzantium, as well as the Islamic world, was not only outside the material power of Charlemagne but foreign to his philosophy. Second, and this is of greater importance in this discussion, the new Carolingian Empire could be Christian only, and only the Christians among the Roman emperors could be the legitimate forerunners of a medieval Christian ruler. Thus it was not the person of Constantine on whom the Carolingian concept of an emperor was focused; he merely symbolized the Christian ruler of the Empire. Consequently other representatives might be selected in his place. Yet the Christian connotation seems indispensable in order that a Roman emperor be eligible as a legitimate forerunner of the Carolingian house. Based on Orosius and ultimately on Augustine, a Christian interpretation of history had developed from the fifth century on: since history's function was to discuss the relation of mankind to God, only those among the Roman emperors were worthy of mention whose rule was marked either by some important Christian event or by the "Christian" virtues with which they had been endowed, or who were believed to have adhered secretly to Christianity. Further elimination then led to those who had actually been Christians; yet the selective principle permitted the inclusion only of those who had been "good Catholics," that is, who had fought Arianism.[206] Thus the list as a rule included Augustus, Trajan, Marcus Aurelius, Constantine, and Theodosius. Frequently, and especially in the Carolingian period, this list was contracted even more: all the great rulers were omitted or placed on the "bad" side of the ledger; only the two Christian, "Catholic" emperors, Constan-tine and Theodosius, were enumerated and were followed by the members of the Carolingian house, Charles Martel, Pepin, and Charlemagne. These are the "good" rulers, who were depicted in the frescoes of Ingelheim Palace about 820 and who were contrasted by the Poeta Saxo with all pagan heroes.[207] To the mind of the ninth century, Constantine and Theodosius were the only really lawful predecessors on the Roman throne of the new Carolingian emperors—the two who had linked true Christianity to sovereignty over the Roman world.

This fusion of Rome and Christianity underlies the whole of Carolingian policy; it corresponds perfectly with the conception which the Carolingian Renaissance had of Roman art, a conception in which Christian and Roman elements are linked to one another. While antique monuments without Christian connotations were not excluded a limine, the fact remains that antique buildings which had, or could have, such a Christian connotation—and thus pre-eminently the great Christian basilicas which had been founded by the imperial house, and what were believed to be the palaces and the triumphal arches of the Christian emperors—formed the real basis of the Carolingian revival.

Postscript (1969)

Some details in this paper need supplementation in the light of recent discoveries.

1) In 1942 I shared, of course, the common opinion which saw in the existing transept of St. John's in the Lateran a feature taken over from the Constantinian structure. Excavations undertaken by myself and Mr. Spencer Corbett have proved this to be wrong. The place of the transept in Constantine's Lateran basilica was taken by low projecting sacristies, and the present continuous transept is a medieval addition in imitation presumably of St. Paul's, St. Peter's, or their Carolingian

progeny. In this reprint I have therefore removed from the original text references to the transept of St. John's in the Lateran.

2) My suspicions regarding the existence of a continuous transept in the Carolingian church at S. Denis have been justified by the excavations undertaken by Jules Formigé (L'abbaye royale, pp. 50 ff., though with the erroneous date of ca. 636). The center bay of the transept was segregated and its wings projected but slightly beyond the aisles; but it remains undetermined, whether they were as high as the nave or lower.

3) Research over these past twenty-five years has also clarified the history of some of the churches mentioned by me in passing references. The tripartite transept of S. Tecla at Milan, rather than later churches in Greece, is the source of that at S. Pietro in Vincoli. S. Ambrogio in Milan was terminated by one single apse (Reggiori, La basilica ambrosiana, p. 28; Krautheimer, Early Christian and Byzantine Architecture, p. 131). The basilicas adjoining the palatine chapel at Aix-la-Chapelle have turned out both to be later additions to the main building (Vorromanische Kirchenbauten, p. 16). Also, contrary to what I thought, the recent finds at Ingelheim (ibid., p. 129) preclude a segregated crossing as definitely as I postulated; nor is it quite certain that the colonnades at Fulda carried an architrave (ibid., pp. 85 ff.). In Rome, Wolfgang Frankl, Spencer Corbett and I jointly have been able to confirm the earlier findings on the Carolingian basilicas, such as S. Maria Nova, S. Marco, S. Martino, S. Prassede, SS. Quattro Coronati and Sto. Stefano degli Abessini. But we have also established that SS. Nereo ed Achilleo was provided with galleries as well as with end towers; that the core of Sta. Susanna, including the galleries, apparently belonged to a fourth-century private basilica which was remodeled and decorated by Leo III; that—a point of some importance in the present context—the arcaded nave of the Quattro Coronati, including the dividing cross pier and diaphragm arch, replaced in the early twelfth century the trabeated unbroken colonnades of the Carolingian nave; and that Sto. Stefano degli Abessini was possibly built by Leo IV about 850 rather than fifty years before. (Corpus Basilicarum I, 220 ff.; II, 216 ff.; III, 87 ff., 135 ff., 232 ff.; IV, in press). G. Ferrari (Early Monasteries, passim), has brought out that contrary to previous assumptions the Greek monasteries of Rome in their majority were founded in the late eighth and early ninth centuries after the recrudescence of iconoclasm in the East. Falkenstein (1966) has called into question my interpretation of the palace at Aix-la-Chapelle as a "copy" of the Lateran, without convincing me, though. Finally, the studies of Crosby (1942 and 1953), Fisher (1962), Formigé (1960), Forsyth (1953), Grossmann (1955), Schlunk (1947), Verzone (1942) and of the Munich Zentralinstitut (1966 ff.), among others, have clarified many a problem of pre-Carolingian and Carolingian building, while Panofsky (1960) has thrown new light on the question of the Carolingian and other Renascences.

None of this affects the argument as presented. (Schafer Williams' suggestion of a mid-ninth century date for the fabrication of the Constantinian Donation, in two articles published in 1964, leaves me unconvinced.) Were I to write the paper today, I would change very little. I might tone down the statement that the revival of the Golden age of Christianity in Rome was the aim of the Carolingian Renaissance by saying that it was a major aim; and I would say that the reverberations of Near Eastern architecture in the Occident, rather than being ended by the Carolingian Renaissance, were forced into the limbo of undercurrents. Otherwise I stick to my guns.

ADDITIONAL BIBLIOGRAPHY

Crosby, S. McK. *The Abbey of St. Denis*, I (New Haven, 1942).

————. *L'abbaye Royale de Saint Denis* (Paris, 1953).

Falkenstein, L. *Der'Lateran' der karolingischen Pfalz zu Aachen* (Cologne, 1966).

Ferrari, G. *Early Monasteries in Rome* (Vatican City, 1957).

Fisher, E. A. *The Greater Anglo-Saxon Churches* (London, 1962).

Formigé, J. *L'abbaye royale de Saint-Denis* (Paris, 1960).

Forsyth, G. H. *The Church of St. Martin at Angers* (Princeton, 1953).

Grossmann, D. *Die Abteikirche zu Hersfeld* (Kassel, 1955).

Krautheimer, R. *Early Christian and Byzantine Architecture* (Pelican History of Art, Harmondsworth, 1965).

Krautheimer, R., Frankl, W., and Corbett, S. *Corpus basilicarum christianarum Romae*, II (Vatican City and New York, 1959); III (Vatican City and New York, 1967); IV, in press.

————. "La Basilica Costantiniana al Laterano," *RACrist.*, XLIII (1967); "Miscellanea E. Josi," II), 125 ff.

Panofsky, E. *Renaissance and Renascences in Western Art* (Stockholm, 1960).

Reggiori, F. *La Basilica di Sant' Ambrogio a Milano* (Florence, 1945).

Schlunk, H. in: *Ars Hispaniae*, II (Madrid, 1947), 225 ff.

Verzone, P. *L'architettura religiosa dell' alto medioevo nell' Italia settentrionale* (Milan, 1942).

Williams, S. "Le Ms. Saint-Omer 189 des fausses décrétales d'Isidore Mercator," *Bull. Soc. acad. des Antiquaires de la Morinie*, fasc. 381 (1964), 1 ff.

————. "The Oldest Text of the 'Constitutum Constantini,'" *Traditio*. XX (1964), 448 ff.

Vorromanische Kirchenbauten, ed. Zentralinstitut für Kunstgeschichte, I, II (Munich, 1966, 1968).

NOTES

1 This view dominated practically every history of architecture written between 1880 and 1925. See, e.g.: G. Dehio, *Geschichte der deutschen Kunst*, I (Berlin and Leipzig, 1921), 33.

2 This is not the place to give a complete bibliography of the discovery of Near Eastern Early Christian architecture. Suffice it to mention Strzygowski's numerous publications, and the writings of G. L. Bell, S. Gsell, S. Guyer, H. C. Butler, U. Monneret de Villard, etc.

3 J. Puig y Cadafalch, *La géographie et les origines du premier art roman* (Paris, 1935); cf. also his earlier publications.

4 G. G. King, *Pre-Romanesque Churches in Spain (Bryn Mawr Notes and Monographs)* (Bryn Mawr College, 1924).

5 J. Hubert, *L'art pré-roman (Les monuments datés de la France)* (Paris, 1938); A. W. Clapham, *English Romanesque Architecture before the Conquest* (Oxford, 1930); A. Kingsley Porter, *Lombard Architecture* (New Haven, 1917).

6 Both Hubert, *op. cit.*, pp. 167 ff. and O. Müller, *Die Einhartsbasilika zu Steinbach* (Diss. Leipzig, 1936), Seligenstadt, n.d., pp. 76 ff., stress this point, although neither attempts to distinguish the different origins of these infiltrations.

7 G. Weise, *Untersuchungen zur Geschichte der Architektur und Plastik des früheren Mittelalters* (Leipzig and Berlin, 1916), pp. 151 ff.; idem., *Studien zur Entwicklungsgeschichte des abendländischen Basilikengrundrisses . . . (Sitzungsberichte der Heidelberger Akademie . . . , Philos. histor. Klasse*, 21 Abh.) (Heidelberg, 1919), pp. 63 ff. While all too strict in his attempt to construe a development of pre-Carolingian architecture in Europe, Weise was quite right in determining the general position of the T-basilica in early medieval architecture. E. Weigand's objections on this particular point in *Byzantinische Zeitschrift*, XXIV (1923–24), 476 are hardly justified: the references to cross plans made in Early Christian and early medieval sources need not and probably do not refer to transepts of the Roman T-type; they may refer to anything from dwarf transepts to Greek cross plans.

8 This opinion still characterizes E. Lehmann, *Der frühe deutsche Kirchenbau (Forschungen zur deutschen Kunstgeschichte, 27)* (Berlin, 1938). If our interpretation of his text is correct (and even with a quite thorough knowledge of pre-1933 German it is not always easy to interpret his involved style) Lehmann realizes the existence of the Roman influence in German

architecture throughout the Carolingian and early Romanesque period. Yet he interprets it as a continuous "undercurrent" or "counter-current" which opposes the "bodenständig German" centralizing elements. Since Lehmann's book has been splendidly published and is evidently widely used, I feel it ought to be added that the reconstructions as well as the plans are frequently unreliable and should be used with great caution. The catalogue is the really useful part of the book.

9 Reliable reproductions of the original state of these basilicas are rare. The principal ones are, for Old St. Peter's: plan, Tiberius Alpharanus, *De basilicae Vaticanae antiquissima et nova structura*, ed. M. Ceratti (*Studi e testi*, 26) (Rome, 1914), Pl. I (our Fig. 9); interiors and exteriors: Jehan Fouquet, *Grandes Chroniques de Saint Denis* (P. Durrieu, "Une vue intérieure de l'ancien St. Pierre de Rome . . . ," *Mélanges G. B. De Rossi, Ecole Française de Rome, Mémoires*, XII. 1892, Supplément, pp. 221 ff.), Marten van Heemskerk (H. Egger and Ch. Huelsen, *Die Skizzenbücher des Marten van Heemskerk*, I [Berlin, 1910], Pls. 14, 15; II [1916], Pls. 67, 69, 70, 72), Jacopo Grimaldi, Barb. lat. 4410 and Barb. lat. 2733, *passim*; for St. Paul's: N. M. Nicolai, *Della basilica di S. Paolo . . .* (Rome, 1815), and L. Rossini, *Le antichità romane* (Rome, 1829), Pls. 98–101.

10 See above, pp. 369.

11 We shall use this term to embrace the whole or practically the whole of the territories dominated by Charlemagne and by his successors. On the other hand, we will restrict the use of the term chronologically to the period up to the end of the ninth century, in spite of the fact that in France the Carolingian house continued through almost the whole of the tenth century.

12 The discussion of St. Denis is based on Viollet-le-Duc's plan and description (*Dictionnaire raisonné d'architecture*, IX, [Paris, 1868], 228 and *idem*, "L'église impériale de Saint-Denis," *Revue archéologique*, n.s. III [1861], 301 ff., 345 ff.); these have to be revised following Mr. Sumner McK. Crosby's studies which will be published in his forthcoming book. I want to express my warm thanks to Mr. Crosby who kindly discussed with me the results of his excavations and his reconstruction of the Carolingian edifice. Mr. Crosby's excavations of the Carolingian structure will furnish for the first time a solid basis for reconstructing the building and for clarifying and revising Viollet-le-Duc's plan. Mr. Crosby has not yet been able to excavate within the transept and thus to verify Viollet-le-Duc's drawings on this point. [See now, however, Crosby, 1942 and 1953; Formigé 1960, in *Additional Bibliography*, p. 380 above].

13 J. von Schlosser, *Schriftquellen zur Geschichte der karolingischen Kunst* ("*Quellenschriften für Kunstgeschichte und Kunsttechnik*," N.F. IV) (Vienna, 1896), pp. 209 ff.; Suger, *De consecratione ecclesiae sancti Dionysii*, and *De administratione*, both in *Oeuvres complètes de Suger*, ed. A. Lecoy de la Marche (Paris, 1867).

14 The sources have been interpreted in different papers of L. Levillain: "L'église carolingienne de Saint Denis," *BMon*, LXXI (1907), 211 ff.; *idem.*, "Les plus anciennes églises abbatiales de Saint Denis," *Mémoires de la Société de l'histoire de Paris et de l'Isle de France*, XXXVI (1909), 143 ff.; *idem.*, "Etudes sur l'abbaye de Saint Denis a l'époque mérovingienne," *Bibliothèque de l'Ecole des Chartes*, LXXXII (1921), 5 ff.; LXXXVI (1925), 5 ff., 44 ff. While Levillain clarified the history of the abbey and proved that no church of 638 had ever existed on the site of the present St. Denis, his reconstruction of the Carolingian church *(BMon, loc. cit.)* has not been quite so fortunate. For the date after 754 at which the Carolingian church was begun, see M. Buchner, *Das Vizepapsttum des Abtes von St. Denis* (Paderborn, 1928), pp. 80 ff.

15 Mr. Crosby, on the basis of literary sources, assumes the existence of an atrium with colonnades.

16 Hubert, *L'art pré-roman*, *passim*, and the bibliography quoted by him.

17 The reconstruction of the fifth-century church of St. Martin at Tours is quite uncertain, but it may possibly have shown this plan.

18 A. Lenoir, *Statistique monumentale de Paris* (Paris, 1867), pp. 20 ff., Pls. XVII–XXI. For the date see P. Batiffol, *Etudes de liturgie et d'archéologie chrétienne* (Paris, 1919), pp. 288 ff.; a comparison with the similar ground plans of the Merovingian church of St. Martin at An-

gers and of the Kentish churches of the seventh century may help to determine the date more exactly. See below, note 29, and G. H. Forsyth, Jr., "The Church of St. Martin at Angers," *Antiquity*, X (1937), 400 ff; Hubert, *Op. cit.*, pp. 39 ff.

19 C. de la Croix, *Fouilles archéologiques . . . de Saint Maur de Glanfeuil . . .* (Paris 1899); Hubert, *op. cit.*, pp. 10 ff.

20 W. R. Ramsay and G. L. Bell, *The Thousand and One Churches* (London, 1909), *passim*.

21 J. Formigé, "Vienne. Abbaye de Saint Pierre," *Congrès archéol.*, LXXXVI (1923), 77 ff. and Hubert, *op. cit.*, p. 46, date the niches and columns along the aisle walls, and consequently the galleries, in the ninth century. From my own observations on the site I am quite sure that the niches and columns bond into the walls and that the galleries were original. See also R. de Lasteyrie, *L'architecture religieuse en France à l'époque romane* (Paris, 1912), p. 43.

22 Hubert, *op cit.*, pp. 11 ff., Pl. I a.

23 Γ. Α. Σοτηρίου, Αἴ παλαιοχριστιανιχαί δασιλιχαι τῆς 'Ελλαδος (Athens, 1931): Corinth, Nikopolis B.

24 L. Blondel, "Les premiers édifices chrétiens de Genève," (*Genava* X, 1933), 77 ff. has a good plan, yet with a slightly incorrect interpretation.

25 One might compare the large basilicas at Timgad and at Morsott; see S. Gsell, *Les monuments antiques de l'Algérie* II (Paris, 1900), 231 ff., 309 ff.

26 M. Reymond and Ch. Giraud, "La Chapelle Saint Laurent à Grenoble," *Bull. archéol.* (1893), pp. 1 ff.; Hubert, *op. cit.*, p. 103 assumes a later date without specifying his reasons. L. H. Labande, "Venasque. Baptistère, *Congrès archéol.*, LXXVI (1909), I, 282 ff.

27 Jerusalem, St. John the Baptist: H. Vincent and F. Abel, *Jérusalem nouvelle*, pt. 3 (Paris, 1923), pp. 642 ff.; Der-el-Abiad and Der-el-Akhmar near Sohag: U. Monneret de Villard, *Les couvents de Sohag* (Milan, 1925–26), *passim*. For the North African instances, see Gsell, *op. cit.*, II, 140 ff.

28 Hubert, *op. cit.*, pp. 18 ff.

29 Clapham, *op. cit.*, pp. 17 ff.

30 SS. Peter and Paul (below S. Abbondio, Como, fifth century); C. Boito, *Architettura del medioevo* (Milan, 1880), pp. 14 ff. and Kingsley Porter, *op, cit.*, II, 301 ff., whose doubts do not seem justified in view of Boito's careful description of the remnants; Romainmotier I and II (630 and 750 respectively); see J. Zemp, "Die Kirche von Romainmotier," *Zeitschrift für Geschichte der Architektur*, I (1907–1908), 89 ff. Contrary to Clapham's thesis, *op. cit.*, p. 13, the square rooms in front of the apse are not the wings of a regular transept; see Zemp, *op. cit.*, p. 90.

31 St. Peter im Holz-Teurnia (Carinthia): R. Egger, *Frühchristliche Kirchenbauten im südlichen Norikum* ("*Sonderhefte des Öesterr. archäol. Inst.*," IX) (Vienna, 1916), pp. 12 ff.; Mokropolje (Dalmatia), unpublished (I am indebted to Mr. E. Dyggve for a plan of the church); Majdan (Bosnia): W. Radinsky, "Die römische Ansiedlung von Majdan bei Varcar Vakuf," *Wissenschaftliche Mitteil. Aus Bosnien und Herzegowina*, III (1895), 248 ff.

32 Clapham, *op. cit.*, pp. 38 ff.

33 Lehmann, *op. cit.*, pp. 10 ff. and *passim*; see also Erich J. Schmidt, *Kirchliche Bauten des frühen Mittelalters in Südwestdeutschland* ("*Kataloge des Römisch-Germanischen Zentralmuseums zu Mainz*," II) (Mainz, 1932), to be used, however, with great caution.

34 Lehmann, *op. cit.*, pp. 109, 113, where previous bibliography is indicated.

35 P. Clemen, "Die mittelalterlichen Profanbauten. Die Kaiserpfalzen," *Deutscher Verein f. Kunstwissenschaft, Zweiter Bericht über die Denkmäler deutscher Kunst* (Berliin, 1912), p. 27; Lehmann, *op. cit.*, p. 106 where the date is suggested. There is no reason on earth to assume (as has been done by Schmidt, *op. cit.*, p. 42) that this north chapel was contemporaneous with the similar south chapel and like this later than the Minster. The results of the excavations make it quite clear that the north chapel was the first post-Roman structure on the site, that it was followed by the Minster proper, and that still later the south chapel was laid out as a pendant to the older structure to the north.

36 Weise, *op. cit.* (1916), pp. 142 ff.

37 King, *op. cit.*, *passim*.

38 Kingsley Porter, *op. cit.*, II, 582 ff.

39 G. Chierici, "Di alcuni risultati sui recenti lavori intorno alla Basilica di S. Lorenzo a Milano . . . ," *RACrist*, XVI, (1939), 51 ff.

40 J. W. Crowfoot, "Churches at Bosra and Samaria-Sebaste" (*Brit. School of Archaeology in Jerusalem, Suppl. Report 4*, 1937); W. A. Campbell, in *Antioch-on-the-Orontes*, III, ed. R. Stillwell (Princeton, 1941), 35 ff., where also a bibliography for the related churches will be found.

41 See above, n. 30.

42 Kingsley Porter, *op. cit.*, III, 511 ff.

43 *Ibid.*, III, 427 ff.

44 Disentis, St. Mary and St. Martin, see J. R. Rahn, "Die Ausgrabungen im Kloster Disentis," *Anzeiger für schweizerische Altertumskunde*, X (1908), 35 ff.; Müstair, St. Peter, see E. Poeschel, *Die Kunstdenkmäler des Kantons Graubünden*, II (Basel, 1937), 266 ff.; S. Steinmann-Brodtbeck, "Herkunft und Verbreitung des Dreiapsidenchors . . ." *Zeitschr. Schweiz. Arch. und Kunstgesch.*, I (1939), 65 ff.

45 Menas City, so-called consignatorium of the cemeterial basilica, see C. M. Kaufmann, *Die Menasstadt* (Leipzig, 1910), pp. 101 ff., fig. 46.

46 E. Herzfeld and S. Guyer, *Meriamlik and Korykos* (Manchester, 1930) pp. 4 ff.

47 A. Kingsley Porter, *The Crosses and Culture of Ireland* (New Haven, 1931), p. 79.

48 See above, notes 29, 30, 31.

49 King, *op. cit.*, pp. 61 ff.

50 Thus an iconostasis, a clearly eastern element, is enumerated among the objects which are expressly mentioned as having been imported by Benedict Biscop from Rome to England; see Beda Venerabilis, *Vitae sanctorum abbatum monasterii in Wiramuth et Girvum* (*PL.* XCIV, cols. 713 ff., especially 717 f.).

51 E. Junyent, "Le recenti scoperte . . . di S. Vitale," *RACrist*, XII (1939), 129 ff.

52 J. Berthier, *L'église de Sainte Sabine à Rome* (Rome, 1910); A. Schuchert, *S. Maria Maggiore zu Rom ("Studi di antichità cristiana,"* XIV) (Vatican City, 1939).

53 P. Germano di S. Stanislao, *La casa Celimontana* (Rome, 1894).

54 R. Krautheimer, *Corpus*, I (1937), 42 ff.

55 R. Krautheimer and W. Frankl, "Recent Discoveries in Churches in Rome," *AJA*, XLIII (1939), 388 ff.

56 Gsell, *op. cit.*, II, 137, n. 4; 141 ff.

57 L. Fortunati, *Relazione . . . degli scavi . . . lungo la Via Latina* (Rome, 1859).

58 R. Krautheimer, "S. Pietro in Vincoli and the Tripartite Transept," *Proceedings of the American Philosophical Society*, LXXXIV (1941), 353 ff.

59 R. Krautheimer, "An Oriental Basilica in Rome," *AJA*, XL (1936), 485 ff.

60 Krautheimer, *Corpus*, I, 77 ff.

61 E. Stevenson, "La basilica doppia di Sta. Sinforosa," *BACrist*, III (1878), 75 ff.

62 Only a few edifices seem at first glance to contradict this statement, such as S. Pancrazio in Rome, the remnants of the pre-Carolingian cathedral at Chur (E. Poeschel, "Zur Baugeschichte der Kathedrale und der Kirche S. Lucius in Chur," *Anzeiger für schweizerische Altertumskunde*, N.F., XXXII [1930], 99 ff.) and those of St. Andrew in Hexham (Clapham, *op. cit.*, pp. 43 ff.). All three are reconstructed as basilicas with nave and aisles and with a continuous transept.

 At S. Pancrazio—it is dated 625–38—a regular continuous transept would seem to be well preserved and one would suppose the edifice to have been an unusually early copy after St. Peter's. Yet in its present state the transept is really not continuous; it is separated into three parts by colonnades and upper walls which intervene between the center bay and the transept wings, and while the walls above the colonnades are (as I know from personal examination) twelfth-century, the colonnades themselves may be original. Thus the transept plan may have been not of the continuous type (as was suggested in *Proceedings of the Amer. Philos. Society*, LXXXIV [1941], 413), but of the tripartite type, similar to that of S. Pietro in Vincoli.

 The date of the cathedral at Chur, which is given as fifth century, is quite uncertain. Only

very few remnants of the structure have been excavated south of the apse, and these were taken by Poeschel *(op. cit.)* and by Hubert, *(op. cit.,* p. 49) to suggest a regular "Roman" transept. The scanty remains may as well belong to the transversal arms of a cross church like Sant'Anastasia in Rome, or to dwarf transept wings which would have been much lower than the nave. More likely they belong just to a protruding sacristy like those which characterize the fifth-century churches of Sant' Abbondio at Como and of Romainmôtier. J. Gantner *(Kunstgeschichte der Schweiz,* I, Frauenfeld [1936], p. 44), seems also to doubt Poeschel's reconstruction of Chur as having a continuous transept. Similarly the reconstruction of St. Andrew at Hexham as a basilica with transept has no basis whatsoever in the remnants excavated.

This quite unjustified preference given to the plan with continuous transept has resulted in erroneous reconstructions for buildings of the late eighth or the early ninth century also. The Palatine Chapel at Ingelheim, for instance, has been generally reconstructed as a basilica of the T-type with continuous transept (C. Rauch, in G. Rodenwaldt, *Neue deutsche Ausgrabungen* [Berlin, 1930], pp. 266 ff.; Lehmann, *op. cit.,* p. 118; Schmidt, *op. cit.,* pp. 132 ff.). The Palace at Ingelheim has been assigned various dates, either 774–78 (Lehmann, *loc. cit.)* or 807–17 (P. Clemen, "Der karolingische Kaiserpalast zu Ingelheim," *Westdeutsche Zeitschrift,* IX [1890], 54 ff., 97 ff.). Since the church is mentioned as early as the middle of the eighth century on the site of the palace, neither of the two dates needs refer to the present Palatine Chapel which might easily be older. Yet regardless of the date, the structure was neither a basilica nor did it have a continuous transept (Lehmann, *op. cit.,* fig. 85) or a transept with a segregated crossing (Rauch, *op. cit.).* Both these reconstructions neglect in an astounding way the results of the excavations as shown in Rauch's own plan (reproduced by Schmidt, *op. cit.,* Fig. 29). This plan shows that: 1) The "aisles" of the basilica were not aisles, but formed a series of chambers along either side of the single nave; two rectangular corridors and one square chamber are clearly marked to the south, one square and one very long rectangular chamber to the north. Narrow chambers (or could they have been closets? See C. de la Croix, "Poitiers. Monuments réligieux. Le Temple Saint Jean," *Congrès archéol.,* LXX [1903], 7 ff.) accompanied these chambers north and south respectively; they in turn were followed by one more rectangular room further outside. 2): the row of chambers seems to have continued along the west facade where in spite of the remnants of at least five north-south walls, the reconstructions give a continuous narthex. 3): the transept was certainly not continuous; the remnants of an L-shaped pier are clearly marked at the southeast end of the nave. On the other hand a regular segregated crossing is likewise out of the question: the stem of the L between the central bay and the south wing of the "transept" is considerably longer (2.20 m.) than that between central bay and nave (1.70 m.). Moreover the nave is considerably wider than the transept wing. Thus the opening of the "central bay" towards the nave was *ca.* 3.20 m. wider than its openings towards the transept wings and consequently probably also higher than those. *Ergo* the transept was neither continuous nor did it have a segregated crossing; but it consisted of a center part and two dwarf transept wings. That these were shut off from the central bay is also proved by the solid buttresses which flank the apse. The relatively weak walls between the openings of the central bay to the west, north, and south might be interpreted as having been "span walls" for a central tower. More likely, however, they were merely the foundation walls for a choir screen. With its single nave, its lateral chambers, and its dwarf transept, the plan of Ingelheim recalls that of Sant' Abbondio in Como, which is only about ten percent smaller, and that of St. Peter and Paul at Canterbury. To sum up: the Palatine Chapel at Ingelheim was not in any way related to the "Roman" type.

63 Interpretation of literary and visual sources: G. Richter, *Die ersten Anfänge der Bau- und Kunsttätigkeit des Klosters Fulda (Zweite Veröffentlichung des Fuldaer Geschichtsvereins)* (Fulda, 1900); idem, *Beiträge zur Geschichte des Heiligen Bonifatius (Festgabe zum Bonifatius-Jubiläum,* 1905), I (1905). Excavations: J. Vonderau, *Die Ausgrabungen am Dom zu Fulda, 1908–1913 (Sechzehnte Veröffentlichung des Fuldaer Geschichtsvereins),* Fulda (1919); idem, *Die Ausgrabungen am Dom zu Fulda . . . 1919–1924 (Siebzehnte Veröffentlich-*

ung des Fuldaer Geschichtsvereins), Fulda (1924). Since I am unable to find a copy of the latter publication, I cannot check on a few notes which I made from it some ten years ago. Extensive and reliable excerpts are given, however, in G. von Bezold, "Zur Geschichte der romanischen Baukunst in der Erzdiözese Mainz," *Marburger Jahrbuch für Kunstwissenschaft,* VIII/IX (1933), 1 ff.

64 A small chapel may have belonged to the first monastery of 744, remnants of which have been found on an axis diagonal to that of the present cathedral and therefore of the ninth-century church. Convent and chapel were destroyed to make room for Sturmi's church of 751. Of this structure nothing is known aside from the width of the nave and of the apse. Both had the same width, that is to say the apse did not recede. Whether the wall south of the nave wall was that of an aisle or of a building belonging to the monastery must remain an open question. Thus it cannot be established either whether this church was single naved (von Bezold, *op. cit.,* 10) or whether it was a basilica. In the latter case there is no reason for reconstructing it with columns rather than piers; nor is the length of its nave or the number of bays known. These points should be kept in mind with regard to reconstructions which make the edifice look like an Early Christian church of the type of Sta. Sabina (Lehmann, *op. cit.,* p. 2 and Fig. 76).

65 *Annales Fuldenses antiqui, MGH, SS.,* III, 117*; *Annales Sancti Bonifacii, MGH, SS.,* III, 117; *Annales breves Fuldenses, MGH, SS.,* II, 237. The date is given with slight variations as 790, 791, or 792.

66 *Catalogus abbatum Fuldensium, MGH, SS.,* XIII, 272.

67 *Annales Fuldenses, MGH, SS.,* I, 353.

68 *Catalogus abbatum Fuldensium, MGH, SS.,* XIII, 272, calls him *"sapiens architectus"* but this source is of the tenth century and therefore not quite dependable as to events 150 years earlier. Likewise another notice of the same source cannot be relied upon, according to which Ratger was already the architect of the building when under Baugulf the eastern parts of the nave were laid out. On the contrary the stylistic differences between nave and transept are evidence that the two structures could hardly have been designed by one and the same architect.

69 *MGH, Epist.,* IV, 548 ff., see Richter, *op. cit.* (1900), p. 10; Candidus, *Vita Eigilis, MGH, SS.,* XV, 1, 221 ff.

70 Candidus, *Vita Eigilis, MGH, SS.,* xv, I, 228 ff.

71 *Annales Fuldenses antiqui, MGH, SS.,* III, 117*; Candidus, *Vita Eigilis, MGH, SS.,* XV, I, 230; Candidus, *De vita Aeigili (vita metrica), MGH, Poet. L.,* II, 96 ff., particularly 111.

72 The projecting walls which in the reconstructions of Vonderau, *op. cit.,* (1925) and Lehmann, *op. cit.,* Fig. 87 separate the eastern bays of nave and aisles would seem to represent an interesting example of a Near Eastern fore-choir with flanking side rooms comparable to Near Eastern churches in Rome, such as S. Giovanni a Porta Latina. Unfortunately I cannot discover on what the assumption of these walls is based.

73 *Catalogus abbatum Fuldensium, MGH, SS.,* XIII, 272.

74 *Ibid.*

75 Candidus, *Vita Eigilis, MGH, SS.,* XV, I, 229; Candidus, *De vita Aeigili (vita metrica), MGH, Poet. L.,* II, 96 ff., particularly 111. Compare also SS., XV, I, 137.

76 Candidus, *Vita Eigilis, MGH, SS.,* XV, I, 229; Candidus, *De vita Aeigili (vita metrica), MGH, Poet. L.,* II, 96 ff.

77 The number of intercolumnia can be concluded from the number of windows as shown in the seventeenth-century reproductions of the old church (Richter, *op. cit.* [1905], Figs. 3 and 4); they are unfortunately not very clear. Still, von Bezold's assumption (*op. cit.,* p. 12) of eighteen intercolumnia does not seem necessary. The distance of about 4.90 m. from column to column, resulting from eleven intercolumnia less ten shafts, is rather wide; yet as von Bezold himself points out, it would be easily spanned by an architrave with relieving arches above.

78 First of all, early in the seventeenth century, Brower (*Antiquitates Fuldenses* [Fulda, 1612]; after him Richter, *op. cit.* [1905], XXXV) saw a long continuous inscription (which referred to a reconsecration of 948) *"super epistylia columnarum." Epistylia* has been interpreted to

mean architrave (von Bezold, *op. cit.*, pp. 6 ff.), which is undoubtedly incorrect; it means capitals (Lehmann, *op. cit.*, p. 113). Yet in spite of this incorrect translation of the term *epistylia*, von Bezold's reconstruction of an architrave seems to be more likely than Lehmann's reconstruction of arcades (*op. cit.*, p. 113). The inscription as read by Brower could not have been on the capitals of the columns (J. F. Schannat, *Diocesis Fuldensis, Frankfurt a.M.* [1727], p. 58 quotes Brower incorrectly ". . . *Epistyliis columnarum per totum Basilicae circuitum insculptum* . . ."); there is no room for any long continuous inscription on the capitals of a building. It was "*super epistylia*," above the capitals; thus it could only have been on an architrave; if it had been above the apex of an arcade it could hardly have been termed "*super epistylia*." Secondly, the reconstruction of the edifice really requires an architrave. The height of the nave is known to have been 21.10 m.; the original height of the aisles is given as 9.55 m. by a door which still exists, and which led from one of the tenth-century turrets to the roof of the aisles. If there had been arches above the columns the height of these arches, approximately 2.45 m. (see note 77), would leave only about 6.55 m. for the height of the column, including base and capital. This seems very low in proportion to the height of the aisle (1:1.45) and the nave (1:3.10). If, on the other hand, an architrave is assumed the height of the columns would have been *ca.* 9 m. Thus their proportion in relation to the height of the nave would have been 1:2.34 and would have corresponded much better to the proportion normally found in Carolingian structures.

	columns	total height	
STEINBACH	2.95 m.	: 8.20 m.	= 1:2.66
HÖCHST	4.60	: 12.40	= 1:2.7
WERDEN II	5.00	: 14.80	= 1:2.96
	arch	total height	
STEINBACH	3.60 m.	: 8.20 m.	= 1:2.28
HÖCHST	6.00	: 12.40	= 1:2.066
WERDEN II	6.40	: 14.80	= 1:2.3

79 The turrets shown in the seventeenth-century reproductions were added to the east apse after 937 (Vonderau, *op. cit.* [1924]). *passim*).

80 It seems somewhat doubtful whether the windows in the clerestory and those in the short walls of the transept as shown in these reproductions are of the ninth century. After all, the church was altered in 937–48; possibly, then, the upper parts of the whole structure, including the windows, were changed at that time. The windows in the east walls of the transept wings as shown in Münster's woodcut (Fig. 16), would seem to be original. There is obviously no reason to assume the existence of a segregated crossing in the western transept (Richter, *op. cit.*, Fig. 6).

81 Hrabanus Maurus, *Tituli ecclesiae Fuldensis*, v, Ad crucem, MGH, Poet. L., II, 206.

82 The present transept at Sta. Maria Maggiore is an addition of the thirteenth century; see A. Schuchert, *S. Maria Maggiore zu Rom* ("Studi di antichità cristiana," XV) (Vatican City, 1939), pp. 83 ff.

83 At St. Peter's the transept in the clear (according to Alpharanus, *op. cit.*, p. 7) was 390 palmi = 86.97 m. long and 78 palmi = 17.39 m. wide (one palmo being 0.223 m.). The walls were, as a rule, 6½ palmi (1.45 m.) and exceptionally 7 or 8 palmi (1.56 and 1.78 m. respectively) thick (*ibid.*, p. 12). Transposed into Carolingian scale, these measurements correspond to 256, 51, and 4½ Carolingian feet respectively (see chart, Schmidt, *op. cit.*, p. 36). The corresponding measurements at Fulda are 74.36 m. length, and 1.32 m. thickness of walls; thus the length taken from wall axis to wall axis is 75.68 m. If these figures are translated into Carolingian feet, the comparison does not work; but it *does* work if the change is made into Roman feet (one Roman foot = 0.2956 m.); then the length is 256 feet. In other words, the same figures were used in Fulda as in Rome; but while in Rome they had been taken in Carolingian feet, at Fulda they were translated into Roman feet. Also at Fulda they refer to the dis-

tances between the centers of the walls, while in Rome they are measurements taken in the clear. This latter difference is easily understandable: Ratger's agent in Rome could only report the clear measurements of St. Peter's, while the architect at Fulda would quite naturally use these same figures to lay out his plan from wall-center to wall-center according to the usage of the period. As to the strange difference of the foot scale employed. viz. the Carolingian in Rome and the Roman in Fulda, it seems at first glance quite topsy-turvy. Yet what happened is probably that the correspondent in Rome took the measurements correctly on the scale he knew to be in use north of the Alps. The architect in Fulda, on the other hand, on receiving the letter, evidently assumed them to have been taken in Roman feet, and contrary to local habit he preserved this Roman scale in his building.

84 The sources are not quite clear. The relevant verses (Candidus, *De vita Aeigili* [*vita metrica*], *MGH, Poet. L.*, II, 111), referring to the dedication of the church by the archbishop of Mainz in 819, run: *Martyris exhibuit ostra peplumque rigentem Insuper accumulans auxit pro seque suisque His ita perceptis gressum porrexit ad aram Pontificalis apex magno comitatus honore In parte occidua Romano more peractum Elevat interea populari voce repente Advena plebs kyrie eleison fit clamor ad astra.* "*Peractum*" is meaningless within the context; thus Richter, *op. cit.* (1905), XIII, and note 1, assumed it to read "*peractam.*" Then the meaning is clearly that, following Roman custom, an altar had been set up in the western apse of the church for the relics of St. Boniface.

85 Candidus, *Vita Eigilis, MGH, SS.*, XV, I, 231. Which Roman models the monks at Fulda had in mind cannot be established; possibly they thought of the Lateran, where a courtyard extended behind its western apse, possibly of atria, such as that of St. Peter's.

86 For the life and the importance of St. Boniface see the biography written by his disciple Willibald of Eichstätt, *MGH, SS.*, II, 331 ff.; cf. also *Allgemeine deutsche Biographie*, III (Leipzig, 1876), 123 ff.

87 Weise, *op. cit.* (1919), pp. 66 ff. Still, quite apart from the question whether St. Denis actually had the plan of a Roman Christian basilica, it is rather doubtful whether St. Denis was already considered the Apostle of the Gauls when his church was erected between 761 and 775. The conscious analogizing of the Parisian saint and the Princes of the Apostles has been proved to be due to the policy of Abbot Hilduin of St. Denis (Buchner, *op. cit., passim*). Between 830 and 835 Hilduin had a number of documents fabricated which purported to refer to the coronation of Pippin and the visit of Stephen II, and in which Saint Denis is continuously compared with Saint Peter and Saint Paul (Hilduinus, *Liber de sancto Dionysio* [excerpt], *MGH, SS.*, XV, 1, 2 ff.). Simultaneously the *Vita Dionysii* was written at St. Denis: in it the saint is for the first time identified with Dionysius the Areopagite from Corinth and reported to have been a disciple of St. Paul's; after St. Paul's death, St. Denis was supposed to have been sent by Pope Clement, St. Peter's third successor, to Paris and to have become the Apostle of Gaul. Yet this whole legend was created between 830 and 835, and it is questionable whether a parallel between him and St. Peter would have been drawn as early as 760–775. Cf. Buchner, *loc. cit.*; but see J. Havet, *Oeuvres*, I (Paris, 1896), "Les origines de Saint Denis," 191 ff.

88 Schlosser, *op. cit.* (1896), index.

89 For this and the following, cf. E. Caspar, *Geschichte des Papsttums*, II (Tübingen, 1933), 669 ff.

90 L. Duchesne, *Christian Worship* (transl. M. L. McClure) (London, 1904), p. 102, was the first to point out that this change took place before 768. Th. Klauser, "Die liturgischen Austauschbeziehungen zwischen der römischen und fränkisch-deutschen Kirche vom 8. bis zum 11. Jahrhundert," *Hist. Jahrbuch der Görresgesellschaft*, LIII (1933), 169 ff., assumes a date between 754 and 760.

91 See preceding note.

92 *MGH, LL.*, Section II, I, 62 ff. (789); cf. also *LL.*, Section III, II, 464 ff. (817).

93 W. Hotzelt, "Translation von Martyrerleibern aus Rom ins westliche Frankenreich," *Archiv für elsässische Kirchengeschichte*, XIII (1938); idem, "Translationen von Martyrerreliquien

aus Rom nach Bayern im 8. Jahrhundert," *Studien und Mitteilungen zur Geschichte des Benediktinerordens,* LIII (1935), 286 ff. We are referring to translations of actual relics rather than of *brandea* such as had been transferred previously.

94 Hrabanus Maurus, *op. cit., MGH, Poet. L.,* II, 205 ff.

95 Caspar, *op. cit.,* II, 669 ff.

96 Klauser, *op. cit.,* p. 169.

97 Whole libraries have been written about the question whether the Curia or Charlemagne or else some faction at the imperial court was the motivating force behind the policy that led to the coronation, and what the coronation was actually intended to mean. Probably it was a combination of forces in different camps, and the motives as well as the intentions of the various factions differed considerably: possibly, as Brackmann has suggested, the papal diplomats thought rather of a shadow *Imperium* created for and by "the Romans," that is, the papal court, while the Frankish diplomats had in mind a more universal *Imperium* of Roman antique character. See A. Brackmann, "Die Erneuerung der Kaiserwürde im Jahre 800," *Geschichtliche Studien Albert Hauck . . . dargebracht* (Leipzig, 1916), pp. 121 ff.; G. Laehr, *Die konstantinische Schenkung in der abendländischen Literatur des Mittelalters* ("Historische Studien, 166," Berlin, 1926); K. Heldmann, *Das Kaisertum Karls des Grossen* (Weimar, 1928), *passim;* A. Kleinclausz, *Charlemagne* (Paris, 1934), pp. 287 ff.

98 Heldmann, *op. cit.,* pp. 5 ff. probably goes much too far in alleging the purely spiritual character of Charlemagne's empire; both Brackmann and Kleinclausz, *op. cit.,* seem to come closer to the truth.

99 Kleinclausz, *op. cit.,* p. 307.

100 *Carmina, MGH, Poet. L.,* I, 226 ff.

101 Ermoldus Nigellus, *In honorem Hludovici, MGH, Poet, L.,* II, 5 ff., particularly lib. II, vv 67–68; lib. IV, vv. 268–269.

102 C. B. Coleman, *Constantine the Great and Christianity* (New York, 1914; text of Donation, pp. 228 ff.); Laehr, *op. cit.* It seems to be beyond doubt that the forgery originated in the chancellery of Paul I (757–67); see Coleman, *op. cit.,* pp. 209 ff.

103 See a list of quotations in P. Schramm, *Kaiser, Rom und Renovatio* ("Studien der Bibliothek Warburg" [Leipzig, 1929]), I, 37 f. Cf. also Einhard, *Vita Caroli Magni,* cap. 27 (ed. O. Holder-Egger, *Scriptores Rerum Germanicarum in usum scholarum* [Hanover and Leipzig, 1911], pp. 31 ff.).

104 F. Schneider, *Rom und Romgedanke im Mittelalter* (Munich, 1926), pp. 42 ff.

105 The *Liber Pontificalis* mentions the nationality of each pope at the beginning of the biography (*L.P.* I, *passim*). If those from Campania also can be considered to have been Greek in their education, the number rises to sixteen among twenty-three popes in the period from 619 to 752. The only non-Roman pope in the second half of the eighth century is Stephen III (768–72), a Sicilian who was educated in the (possibly Greek) monastery of S. Crisogono (*L.P.* I, 468).

106 Among the Greek monasteries are S. Giorgio in Velabro, Sta. Saba, Sant' Anastasia, Sta. Maria in Cosmedin, Sant' Anastasius ad Aquas Salvias (M. Mesnard, *La basilique de Saint Chrysogone à Rome* ["Studi di antichità cristiana," IX, Vatican City, 1935], pp. 54 ff.). The number and size of these Eastern monasteries was evidently strongly reinforced by refugees from the East during the first iconoclastic movement, 724/26–87. A new wave of Greeks entered Rome with the second flare-up of iconoclasm in the East, after 813, inferior to the first in size and importance: in that period the monastery of Sta. Prassede (817–24; *L.P.* II, 54) and the church of SS. Stefano e Cassiano near S. Lorenzo f.l.m. (847–55; *L.P.* II, 113) were given to Greek monks. See F. Schneider, *op. cit.,* pp. 113 ff.

107 See Klauser, *op. cit.,* p. 181, n. 42.

108 The relics of the Maccabeans were brought from Antioch to S. Pietro in Vincoli between 579 and 590; a relic of the manger of Christ was transferred to S. Maria Maggiore before 642; the martyrs from Salona were brought to S. Venanzio in 642; the head of Saint George was "rediscovered" between 741 and 752 and brought to his church in the Velabrum.

109 The translation of Sts. Primus and Felicianus to Sto. Stefano Rotondo, 642–49, is an isolated forerunner. The great translations commence in 752 (or 770) with the transfer of St. Sinforosa and her sons to Sant'Angelo in Pescheria. Under Hadrian I (772–95) the number of translations grew steadily; he transported large numbers of relics to Sta. Maria in Cosmedin, where he erected a special crypt for them. Leo III continued in the same line and Paschal I (817–24) was the most active pope in this direction. In the seven short years of his pontificate he transferred hundreds of relics into the city: Caecilia, Tiburtius, Valerianus, Praxedis, Zeno and their numerous companions took possession of their churches and altars in Rome. His successors kept on with this policy: the relics of a number of martyrs from the catacombs on the Via Latina were brought to Sta. Maria Nova, others to S. Martino ai Monti and to the Quattro Coronati.

110 P. Franchi de Cavalieri, "Le reliquie dei martiri Greci nella chiesa di S. Agata alla Suburra," *RACrist*, X (1933), 235 ff., especially 256; see also Hotzelt, *op. cit.* (1935), pp. 301 ff.

111 Schramm, *op. cit.*, I (1929), 3 ff.; Kleinclausz, *op. cit.*, pp. 289 ff.

112 See above, p. 354.

113 The church was built by either Stephen II in 755 or by Stephen III in 770; see Krautheimer, *Corpus*, I, 73 ff.

114 G. B. Giovenale, *La basilica di S. Maria in Cosmedin* (Rome, 1927).

115 Krautheimer, *AJA*, XLIII (1939), 398 ff. The approximate date of a building within the pontificate of a pope can frequently be concluded from the place it occupies within his biography in the *Liber Pontificalis*.

116 *Ibid.*, p. 392.

117 Krautheimer, *Corpus*, I, 42 ff.

118 It is the first church mentioned in Leo's biography, *L.P.* II, 1.

119 Giovenale, *op. cit.*, Pl. VII b.

120 G. Giovannoni, *La chiesa vaticana di San Stefano Maggiore, Atti della Pont. Accad.*, ser. III, Memorie, IV (Vatican City, 1934), reports on the previous state and on his reconstruction of the edifice. The foundation of the church in Leo's biography in the *Liber Pontificalis* (*L.P.* II, 28) follows the long list of gifts made to Roman churches in 806.

The present façade was erected in 1706; in the fourteenth century the aisles were destroyed and the present clerestory with its small windows was constructed, and simultaneously a diaphragm arch was built across the nave (Giovannoni, *op. cit.*, pp. 3, 10, 24).

121 *Ibid.*, pp. 3 ff.

122 Giovannoni, *op. cit.*, p. 13, who dates this crypt in the pontificate of Leo IV (847–55).

123 See above, note 9.

124 *L.P.* II, 52.

125 The old *titulus* of Sta. Prassede which is first mentioned in 491 (G. B. De Rossi, "Scoperta della cripta di S. Ippolito," *BACrist* [1882], pp. 56 ff., particularly pp. 64 ff.) had been repaired by Hadrian I (772–95) (*L.P.* I, 509). This restoration, however, was evidently insufficient, and a new church was started at some distance from the old building. Paschal's official biography (*LP* II, 54) and an inscription at the foot of the mosaic in the apse (G. B. De Rossi, *Musaici cristiani . . . delle chiese di Roma* [Rome, 1899], plate 25) attribute the new structure without any qualification to Paschal, and thus to the period between 817 and 824. The place of the report within the biography would suggest an early date within this period. On the other hand an inscription by the triumphal arch commemorates a mass transfer of relics from the catacombs into the church which was undertaken by Paschal (*LP* II, 63, n. 12); there the date is given as July 20, 817, which would be only six months after the Pope's election late in January. However, this inscription has been proved to be a copy made in 1730 from a thirteenth-century original which pretends to be ninth-century but contains a number of chronological and other errors (F. Grossi-Gondi, "La celebre iscrizione agiografica della basilica di Sta. Prassede," *Civiltà cattolica* [1916], I, 443; see also, *Idem*, "Excursus sulla paleografia medioevale epigrafica del secolo IX," *Diss. Pont. Accad.*, ser II, XIII [1918]; see especially p. 173). If in spite of this rather dubious pedigree there were any truth in the date mentioned

by this inscription, the brief lapse of time between it and Paschal's election would suggest the possibility that the church had actually been begun before Paschal attained the pontificate.

The edifice as it presents itself today has never been properly studied. The present decoration of the interior was executed around 1600 (G. D. Franzini, *Roma antica e moderna* [Rome, 1653], pp. 357 f.). A. Muñoz ("Studii sulle basiliche romane di S. Sabina e di S. Prassede," *Diss. Pont. Accad.*, ser II, XIII [1918], 117 ff., fig. 5) was the first to point out that the diaphragm arches were not an original part of the building; indeed he found the original columns well preserved within the piers that carry the arches and was able to point out that the arches obstructed some of the original windows; possibly the piers consist of two parts, of the thirteenth and sixteenth century respectively. For the rest following remarks are based on my own survey of the building made in connection with the preparation of the *Corpus Basilicarum*, in collaboration with Messrs. A. Todini, W. Frankl, and (since 1956) S. Corbett.

126 P. Ugonio, *Historia delle stationi di Roma* (Rome, 1588), c. 299.

127 *LP* II, 54.

128 The total interior length of the edifice is about 46 m. (156 R. ft.), its width 26 m. (about 87 R. ft.); this is almost one and a half times the measurements of Sto. Stefano which is 33 m. by 19.50 m.

129 It was erected as a mausoleum for Paschal's mother, Theodora Episcopa, and as a chapel for the relics of St. Zeno and two other saints. See *L.P.* II, 55 and 56, n. 14; De Rossi, *Musaici*, *op. cit.*, text for Pl. 23. The inscription referring to Theodora Episcopa is mostly modern (Grossi-Gondi, "Excursus," p. 173).

130 F. Fornari, "Il rilievo del complesso monumentale di San Sebastiano," *Atti del III° Congresso di archeologia cristiana* (Rome, 1934), pp. 315 ff. (see our Figs. 3, 4).

131 At St. Paul's, a cross-shaped structure, possibly contemporaneous with the basilica, adjoined the south wing of the transept (Fig. 10). It presented the pattern of the chapel of S. Zeno: the square bay in the center was covered by a groined vault and supported by four columns in the corners, and the four shallow wings were surmounted by barrel vaults. Whether this structure was a mausoleum proper is not quite clear; it may have been a memorial chapel erected in honor of some relic which had been deposited within. The anonymous guide *La basilica di S. Paolo sulla Via Ostiense* (Rome, 1933), p. 93 mentions that when in 1930 the chapel was transformed into a baptistery, bones and fragments of fourth- and fifth-century frescoes were found. For the similar chapels at S. Giovanni in Fonte near the Lateran see Ph. Lauer, *op. cit.*, p. 54; for those at St. Peter's, the Alpharanus plan (Fig. 9).

132 It is about 30 m. (100 R. ft.) long and 6.25 m. (21 R. ft.) wide.

133 Remnants of the porticoes along the flanks and on the entrance side of the atrium are preserved in the walls of the courtyard in front of the church and in the houses of the neighborhood. The existence of the fourth portico in front of the façade of the basilica can be deduced from the traces of a roof across the façade of the basilica, and from the distance which the last support would have had from the façade, which is considerably greater than the usual intercolumnium of the porticoes.

134 The level of the atrium corresponds to that of the nave. The level of the street is 3.30 m. lower; since the level of the ancient street was somewhat lower even than that of the present one (R. Lanciani, *Forma urbis Romae* [Milan, 1893], Pl. 23), a flight of steps must always have led up to the entrance of the atrium.

135 Whether the third great fourth-century basilica, St. John's in the Lateran, had one is undetermined. Atria can be proved to have existed at S. Clemente late in the fourth century (E. Junyent, *Il titolo di S. Clemente* ["Studi di antichità cristiana," VI, Rome, 1932]); and at SS. Giovanni e Paolo, ca. 450 (Krautheimer, *Corpus*, I, 267 ff.). At Sant'Agata dei Goti, ca. 470, an atrium of reduced form is still preserved.

136 A narthex without an atrium is found as early as 440–61 at Sto. Stefano in Via Latina; a similar one may have existed ca. 500 at S. Giovanni a Porta Latina. In the third quarter of the eighth century the Roman portico in front of Sant' Angelo in Pescheria was used as a narthex for that church, and as late as the early ninth century a narthex existed at SS. Nereo ed Achilleo.

137 Ugonio, op. cit., c. 298v, mentions the number of steps at Sta. Prassede. As to St. Peter's, see Alpharanus' plan (Fig. 9).

138 Krautheimer, Corpus, I, 94 ff.; in Paschal's biography (LP II, 57) the foundation of Sta. Cecilia follows that of Sta. Prassede at some distance.

139 S. Marco has never been properly dealt with from the point of view of its architectural history. Because it is located within the Palazzo Venezia, Premier Mussolini's official residence, any thorough investigation has been practically impossible for the past fifteen years. Thus we have to rely on notes made after frequent brief visits and a few insufficient plans. The titulus is mentioned from the fourth century on (LP I, 202); it was repaired by Hadrian I (LP I, 500) and completely rebuilt by Gregory IV (827–44) (LP II, 74 ff.). Later restorations took place under Paul II (1464–71) and Cardinal Quirini (1728–38): see Ph. Dengel, H. Egger and others, Palast und Basilika San Marco in Rom (Rome, 1913); D. Bartolini, La sotterranea confessione di S. Marco (Rome, 1844). A well-head with an inscription of the ninth century now in the portico came possibly from the atrium (G. B. De Rossi, "Secchia di piombo trovata nella Reggenza di Tunisi, § II, Simbolismo cristiano dell'aqua," BACrist, ser. I, an. 5 [1867], 78).

140 See above, p. 354.

141 R. Vielliard, Les origines du titre de Saint-Martin aux Monts à Rome ("Studi di antichità cristiana," IV [Rome, 1931]).

142 Sta. Cecilia is 44 m. long and 23.60 m. wide, S. Martino 45 m. long and 23.28 m. wide.

143 A. Prandi, "Vicende edilizie della basilica di Sta. Maria Nova," Rendiconti della Pont. Accademia (1937), pp. 197 ff., where some results of my investigations of the year 1935 are published.

144 A. Muñoz, Il restauro della chiesa . . . dei SS. Quattro Coronati (Rome, 1914); H. Thümmler, "Die Baukunst des 11. Jahrhunderts in Italien," Römisches Jahrbuch für Kunstgeschichte, III (1939), 149 ff. The titulus of the Quattro Coronati is first mentioned in 595 and goes back possibly to the fourth century (LP I, 326, n. 13). It was completely rebuilt by Leo IV (LP II, 115). In 1144/45 a restoration cut off the first six bays of the original nave and transformed this part into a second atrium; the aisles of the ninth-century church were eliminated, and the six eastern bays of the former nave subdivided so as to form a considerably smaller church, consisting of a nave and two aisles with galleries above, a transept, and the (original and therefore incongruously large) apse; see Muñoz, op. cit., passim.

145 Possibly also the chapel contiguous to the right aisle belonged to the original building.

146 Muñoz, op. cit., pp. 7 ff., has dated this tower in the high Middle Ages; still the shape of the balusters, the character of the masonry, and the double arches of the openings leave no doubt that as a whole this tower forms part of the original ninth-century plan. Only the pointed entrance arches on the ground floor are a high-medieval transformation of the original ninth-century entrance.

147 MGH, Epist., III, 592 ff. (799–80); 609 f. (781–86).

148 G. B. De Rossi, "L'inscription du tombeau d'Hadrien Ier," Ecole française de Rome, Mélanges d'archéologie et d'histoire, VIII (1888), 478 ff.; Hubert, op. cit., p. 99.

149 LP I, 454. The transfer of the relics of Sts. Denis, Rusticus, and Eleutherius from St. Denis to S. Silvestro in Rome has been occasionally cited as proving the existence of Frankish influence in Rome in the eighth century; see Kingsley Porter, op. cit., I, 67, n. 3 (the reference made there to the seventh century is, of course, a mere lapsus calami). Since however the whole story of the transfer belongs to the group of spurious documents fabricated at St. Denis under Abbot Hilduin (see above, note 87) and is taken up in Roman sources only after 850 (LP II, 145, 152 ff.) no conclusions can be drawn from it.

150 Einhardus, Translatio . . . , MGH, SS., XV, I, 239. The original structure of the church at Seligenstadt was uncovered a few years ago and the results published by O. Müller. Neither his final report nor the one by A. Schuchert, Die Gruftanlage der Märtyrer Marcellinus und Petrus zu Rom und Seligenstadt (Mainz, 1938), are available to me at this time. I have to rely on the preliminary reports: O. Müller, "Die Einhartsbasilika zu Seligenstadt," Deutsche Kunst und Denkmalpflege, XXXVIII (1936), 254 ff.; idem, "Die Einhartsbasilika zu Seligenstadt,"

Forschungen und Fortschritte, XII (1936), 254 ff.; XIII, 1937, 373 ff., and A. Schuchert, "La basilica dei SS. Marcellino e Pietro a Seligenstadt sul Meno," *RACrist*, XV (1938), 141 ff.

151 The results of the excavations as published by Müller and Schuchert, *op. cit.*, are contrary to a reconstruction of the transept with a segregated crossing such as is indicated in their plans. This has already been corrected by Lehmann, *op. cit.*, Fig. 106 and p. 140. The details of the crypt do not seem to be quite definitely established.

152 No rule can be established for the number of intercolumniations in the large fourth-century basilicas; St. Peter's has twenty-three, St. Paul's and Sta. Maria Maggiore twenty-one intercolumniations. On the other hand in the smaller basilicas of the fifth century, and likewise in the "pseudo-Early Christian" basilicas of the ninth century, the number of intercolumniations seems anything but arbitrary. The occurrence of thirteen intercolumniations seems to be particularly frequent: that number is found in the fifth century at Sta. Sabina, at S. Lorenzo in Lucina, at SS. Giovanni e Paolo, and possibly at Sta. Prisca; in the ninth century at Sta. Cecilia, S. Martino ai Monti, and Sta. Susanna. Evidently their twelve supports were meant to suggest the number of the apostles. Sometimes only ten of these twelve supports are free-standing, while the remaining two are formed by the pilasters at either end of the row of supports; thus the number of intercolumniations results in eleven, as is the case in the fifth century at S. Pietro in Vincoli, in the ninth century at Sant'Anastasia, at Fulda, and at Hersfeld. In smaller churches twelve supports are occasionally achieved by arranging seven arches in each of the two arcades (Sant'Agata dei Goti). Eight supports—the figure corresponding to Resurrection and to the Beatitudes (Candidus, *Vita Eigilis, MGH, SS.*, XV, 1, 231)—occur only rarely: at S. Clemente late in the fourth century, at Sto. Stefano degli Abessini, and at Seligenstadt in the ninth. While in every one of these cases it is evidently the solids which represent the symbolical number, twelve or eight, in the ninth century it is also frequently the number of intervals that counts. Sta. Prassede and SS. Nereo ed Achilleo in Rome, and the church of S. Salvatore (near Monte Cassino), have their naves bounded by twelve intercolumniations on either side; the small churches at Höchst, Steinbach, Heiligenberg, and possibly that of Frankfurt by six. This change from the number of solids, i.e., columns, to the number of voids, i.e., distances, may be of far greater importance for the history of architecture than one might be inclined to think at first: it may mean that the edifice is no longer considered as consisting of solids only, but that the intervals between the solids enter into the conception of the architect and of the spectator.

153 Weise, *Untersuchungen*, pp. 104 ff.

154 For the results of the excavations which uncovered the ninth-century basilica and its small eighth-century predecessors inside the present south transept, see J. Vonderau, *Die Ausgrabungen der Stiftskirche zu Hersfeld in den Jahren 1921 und 1922 ("Achtzehnte Veröffentlichung des Fuldaer Geschichtsvereins"* [Fulda, 1925]), and von Bezold, *op. cit.*, p. 18. What is preserved today are the magnificent ruins of an eleventh-century construction (1038–1144); yet this edifice departs only slightly from the ninth-century structure. The nave was two bays longer than it is at present, and the main apse, instead of being preceded by a long fore-choir, was joined directly to the transept. The structure which terminated the nave at the west end was perhaps not too different from the eleventh-century arrangement in which an entrance hall on the ground floor is topped by a western apse, the whole being flanked by two tall turrets. Vonderau, *op. cit.*, was inclined towards reconstructing a twin tower façade; H. Reinhardt, "Das erste Münster zu Schaffhausen," *Anzeiger für schweizerische Altertumskunde*, XXXVII (1935), 241 ff., thought of a regular west-work.

155 The proportion of the transept, 1:4, is never found among churches of the Early Christian period or the eighth- and ninth-century revival in Rome. The still unexplained remnants around the main apse at Hersfeld resemble the beginning of an ambulatory-like crypt and certainly look different from the outside crypts which extend behind the apses of Centula and of St. Philibert-de-Grandlieu.

156 G. Schönberger, *Beiträge zur Baugeschichte des Frankfurter Doms ("Schriften des historischen Museums,"* 3 [Frankfurt, 1927]), 7 ff.; *Die Kunstdenkmäler von Bayern, Oberpfalz*, XXII, ed. F. Mader (Munich, 1933), 13 ff.; Schmidt, *op. cit.*, p. 115; J. Zemp, "Baugeschichte

des Frauenmünsters in Zürich," *Mitteilungen der Antiquarischen Gesellschaft in Zürich*, XXV (1914), 5 ff.

157 There is no reason for reconstructing the main apse at Heiligenberg as rectangular (Schmidt, *loc. cit.*; but see Lehmann, *op. cit.*, p. 115). The existence of square sacristies at either side of the apse at Frankfurt is possible (Schönberger, *op. cit.*, pp. 9 ff.).

158 A. Pantaloni, "Problemi archeologici Cassinesi," *RACrist*, XVI (1939), 271 ff., particularly 277 ff. and 283, n. 4.

159 *Ibid.*, 272 ff.

160 *Ibid.*, 279 and G. Croquison, "I problemi archeologici Farfensi," *RACrist*, XV (1938), 37 ff., particularly 56 ff.; see also H. Thümmler, *op. cit.*, pp. 141 ff., particularly p. 211 and p. 224. The date of the Farfa west-work seems, however, somewhat doubtful; possibly it is as late as the eleventh century.

161 O. Müller, *Die Einhartsbasilika zu Steinbach* (Diss. Leipzig, 1936), Seligenstadt (n.d.); J. Hubert, "Germigny-des-Pres," *Congrès archéol.*, XCIII (1930), 534 ff.; R. de Lasteyrie, "L'Eglise de St. Philibert-de-Grandlieu," *Mémoires de l'Académie des inscriptions et belles lettres*, XXVIII (1911), 1 ff.

162 Weise, *Untersuchungen*, pp. 78 ff.

163 The reconstruction of the abbey church of St. Riquier at Centula is based on some descriptions and *tituli* (Schlosser, *op. cit.*, 253 ff., no. 782 ff.) and one seventeenth-century engraving after a (lost) eleventh-century reproduction of the church. They have been carefully used by W. Effmann, *Centula-St. Riquier, Forschungen und Funde*, Bd. 2, Heft 5 (Münster, 1912); see, however, the important corrections in H. Beenken, "Die ausgeschiedene Vierung," *RepKunstW*, LI (1930), 207 ff., particuarly 211 ff. Hubert's suggestion (*op. cit.*, 79 ff.) to reconstruct the crossing as a kind of central edifice added to the nave is hardly acceptable.

164 Von Bezold, *op. cit.*, pp. 21 ff.; R. Kautzsch, *Der Mainzer Dom* (Frankfurt, 1925).

165 *La basilica di Aquileia, a cura del comitato per le ceremonie del IX centenario* (Bologna, 1933).

166 Gantner, *op. cit.*, 132 ff.

167 See above, p. 368.

168 When previously discussing this particular revival ('San Nicola in Bari und die apulisiche Architektur des 12. Jahrhunderts," *Wiener Jahrbuch für Kunstgeschichte*, IX [1934], 5 ff.), I was of course quite mistaken in assuming (p. 18 f.) that Cluny had exerted any influence on the building of Monte Cassino. K. J. Conant's excavation (reproduced in J. Evans, *The Romanesque Architecture of the Order of Cluny* [Cambridge, Mass., 1938], p. 64) has proved that Cluny had nothing to do with this Early Christian groundplan. On the other hand the importance of Monte Cassino for Apulia (Bari, S. Nicola, first stage; Trani, S. Nicola; Otranto Cathedral and others) and Campania (Salerno Cathedral, Amalfi Cathedral, Ravello Cathedral, and S. Giovanni del Torre, etc.) has been proved correct. See also Thümmler, *op. cit.*, pp. 216 ff.

169 In this connection it is interesting to see that Vasari actually thought Brunellesco's Romanesque prototypes to have been of Carolingian origin; see G. Vasari, *Vite de' pittori . . .* , "Proemio" (ed. G. Milanesi, I [Florence, 1906]), 235.

170 Krautheimer, "S. Pietro in Vincoli," *Proceedings Amer. Philos. Soc.*, 84 (1941), 364 ff.

171 W. Meyer-Barkhausen, "Karolingische Kapitelle in Hersfeld, Höchst a.M. und Fulda," *Zeitschrift für bildende Kunst*, LIII (1929/30), 126; idem, "Die Kapitelle der Justinuskirche in Höchst a.M.," *JPKS*, LIV (1933), 69 ff.; H. Kähler, *Die römischen Kapitelle des Rheingebietes* ("Römisch-germanische Forschungen," 13 [Berlin and Leipzig, 1939]). The capitals with full leaves may form an exception; as Meyer-Barkhausen (*op. cit.*, 1933) has pointed out, they may be derived from Rome. There they are frequently found from the first century on; best-known examples are those at the Colosseum. Still, one can possibly go even further: St. Paul's was filled with capitals of this type (F. W. Deichmann and A. Tschira, "Die frühchristlichen Basen und Kapitelle von S. Paolo fuori le mura," *Mitteilungen des Deutschen archäologischen Instituts, Römische Abteilung*, LIV [1939], 99 ff.) and it may be legitimate to ask whether the preference given to such capitals in Carolingian architecture north and south of the Alps was not due to their occurrence in one of the proto-basilicas.

172 The Palatine Chapel at Aix-la-Chapelle would seem to be the outstanding exception to this statement. While I am inclined to link it up with other central edifices rather than with S. Vitale, there can be no doubt of its derivation from Near Eastern prototypes.

173 See above, p. 359 f.

174 H. Dümmler, s.v. "Alcuin," in: Allgemeine deutsche Biographie, I (Leipzig, 1875), 343 ff.

175 G. Becker, Catalogi bibliothecarum antiqui (Bonn, 1885); J. W. Thompson, The Medieval Library (Chicago, 1939), pp. 54 ff.

176 A. Ebert, Allgemeine Geschichte der Literatur des Mittelalters, II (Leipzig, 1880); M. Manitius, Geschichte der lateinischen Literatur des Mittelalters, I (I. von Müller, Handbuch der klassischen Altertumswissenschaften, IX, pt. 2, I [Munich, 1911]).

177 Aside from the grammarians and rhetoricians, Terence would have to be included in this group.

178 As early as the fourth century, this procedure is recommended by St. Jerome, Ep. 70 (PL, XXII, cols. 664 ff.). For Christian additions made to pagan writers in the Carolingian period see, e.g., Ebert, op. cit., p. 19.

179 Ebert, op. cit., pp. 70 ff.; see Theodulf, De libris quos legere solebam et qualiter fabulae poetarum a philosophis mystice pertractentur, MGH, Poet. L., I, 543 ff.

180 D. Comparetti, Vergil in the Middle Ages, transl. E. F. M. Benecke, (London, 1895), passim; see also T. W. Valentine, "The Medieval Church and Vergil," Classical Weekly, XXV (1931–1932), 65 ff.

181 Comparetti, op. cit., pp. 98 ff. Seneca was known not so much by his genuine writings but by the spurious letters he was supposed to have addressed to St. Paul, see MGH Poet. L., I, 300.

182 Lupus de Ferrières would seem to be an outstanding exception; see C. H. Beeson, Lupus of Ferrières (Cambridge, Mass., 1930).

183 F. Behn, Die karolingische Klosterkirche von Lorsch (Berlin and Leipzig, 1934), pp. 70 ff.

184 The fresco of St. Michael on the upper floor is of the fourteenth century; see Behn, loc. cit.

185 While F. Schneider, "Der karolingische Thorbau zu Lorsch," Korrespondenzblatt des Gesammtvereins der deutschen Geschichts- und Altertumsvereine, XXVI (1878), 1 ff., certainly went too far in assuming that the Lorsch gatehouse was a regular triumphal arch erected possibly for the victory of Louis the German over the Arabs, he was the first to suggest the comparison with triumphal arches as such.

186 R. Schultze, "Das römische Stadttor in der kirchlichen Baukunst des Mittelalters," Bonner Jahrbücher, CXXIV (1917), 41. Of course it must be borne in mind that any medieval copy in architecture would tend to mix the principal prototype with details borrowed from other models (see "Introduction to an 'Iconography of Medieval Architecture,'" in R. Krautheimer, Studies in Early Christian, Medieval, and Renaissance Art [New York, 1969], pp. 115–50).

187 K. Lehmann-Hartleben, "L'arco di Tito," Bulletino communale, LXII (1934), 89 ff. K. Grube, Die Attika an römischen Triumphbögen (Diss. Karlsruhe, 1931), assumes the function of the attic to have been merely structural, a statement which does not seem quite convincing.

188 H. Kähler, s.v. "Triumphbögen," in A. F. Pauly and G. Wissowa, Realencyclopädie des klassischen Altertumswissenschaft, 2. Reihe, XIII, Halbband (1939), cols. 373 ff., gives a fine survey of the problems and good lists of the monuments which are either preserved or else known through literary or illustrative sources. For our particular problem one would need a list indicating which arches were still preserved in the ninth century. Only for Rome can such a list be compiled from the late eighth-century itinerary of the Anonymous of Einsiedeln (R. Lanciani, "L'itinerario d'Einsiedeln," Monumenti antichi . . . della R. Accademia dei Lincei, I [1891], 437 ff.), and from the twelfth-century Mirabilia (P. Schramm, Kaiser, Rom und Renovatio [Leipzig and Berlin, 1929], II, 76).

189 Lehmann-Hartleben, op. cit., p. 114, n. 80. It might be objected that both the Arch of Septimius Severus and that of Constantine have full—not engaged—columns in front of the piers, contrary to the arrangement at the Torhalle. Yet considering the peculiar character of medieval copies, the engaged columns of Lorsch may be derived either from misinterpreted drawings of the Roman arches, or else from arches with engaged columns like those at Mainz,

Reims, or Orange, which are different in other respects but may have exerted a collateral influence; see above, note 186.

190　For the history and the architecture of the Arch of Constantine, see H. P. L'Orange, *Der spätantike Bildschmuck des Konstantinsbogens* ("Studien zur spätantiken Kunstgeschichte," X [Berlin, 1938]), 1 ff. with bibliography.

That, as at Lorsch, a chapel was connected with the Arch of Constantine is certain, and this would seem to have considerable bearing on the matter; unfortunately it cannot be proved that this chapel already existed in the ninth century, nor can it be established whether it occupied the upper story of the arch as did that at Lorsch. It is first mentioned in 1230 as *S. Salvatore de arcu Trasi*. C. Huelsen, *Le chiese di Roma nel Medio Evo* (Florence, 1925), p. 431, locates the chapel near the Arch; indeed a small building, possibly the chapel, appears east of the monument in drawings up to the early seventeenth century. On the other hand, these same drawings frequently show the remnants of a medieval tower surmounting the east corner of the arch; it cannot be established whether this belonged to a fortification or whether it had any connection with a chapel in the attic.

191　For this and the following see C. Huelsen, "Zu den römischen Ehrebögen," *Festschrift zu Otto Hirschfelds sechzigstem Geburtstage* (Berlin, 1903), pp. 423 ff.

192　According to Huelsen, *op. cit.*, pp. 424 ff., it occurs in only four inscriptions on North African arches of the third and fourth centuries, and in one passage in fourth-century literature (Ammianus Marcellinus, *Libri gestarum qui supersunt*, XXI, 15, ed. C. U. Clark [Berlin, 1910], I, 249). St. Jerome's translation of the Vulgate, I Kings 15: 12, uses the kindred term *fornix triumphalis*.

193　It may possibly have entered by way of eighth-century glossaries; see Huelsen, *op. cit.*, p. 424, n. 4. Huelsen, *op. cit.*, p. 425, n. 1, also points out "dass es bemerkenswerter Weise gerade zwei constantinische Denkmäler (i.e., the Arch of Constantine and the arch at the end of the nave of St. Peter's with its inscription referring to the triumph of Christ) gewesen zu sein scheinen, denen der Ausdruck Triumphbogen seine weite Verbreitung verdankt."

194　The former assumption that these words represent an alteration of an original inscription referring to Jupiter has long been proved wrong (*CIL*, VI [Berlin, 1876], 236 ff., no. 1139; De Rossi, *BACrist*, I [1863], 58).

195　P. Clemen, *Die romanische Monumentalmalerei in den Rheinlanden* ("Publikationen der Gesellschaft für rheinische Geschichtskunde," 32 [Düsseldorf, 1916]).

196　Coleman, *op. cit.*, p. 324.

197　B. Simson, *Jahrbücher des fränkischen Reiches unter Ludwig dem Frommen*, I (1874), 83, n. 3; *MGH, LL.*, Sectio III, II, 464, n. I, "in domo Aquisgrani palatii quae Lateranis dicitur," seems to use the name Lateran only for the arch-chaplain's apartment within the palace, where a synod was held in 817. Yet another mention of a synod held in 836 (*MGH, LL., Section III, II 705*) ". . . Aquisgrani palatii in secretario basilicae sanctae genetricis Dei Mariae quod dicitur Lateranis . . ." refers possibly, and a remark in the *Chronicon Moissiacense* (*MGH, SS.*, I, 303) certainly, to the whole palace: "*Fecit autem ibi et palatium quod nominavit Lateranis et collectis thesauris suis de regnis singulis, in Aquis adduci praecepit . . .*" Simson, *loc. cit.*, has intimated but not proved that this reference was made erroneously by the chronicler.

198　The parallel has been pointed out by St. Beissel, "Die Wölfin des Aachener Münsters," *Zeitschrift des Aachener Geschichtsvereins*, XIII (1890), 317 ff.; it has been contended by P. Clemen, *Romanische Monumentalmalerei*, p. 700, n. 5, but Clemen's reasoning to the effect that the bronze at Aix represented a bear and not a wolf is hardly valid. The more refined details of zoölogy did not mean so much to the Middle Ages and certainly not in this case where any animal which looked somewhat like a wolf would suffice to stand for the Roman Lupa. Southern Gaul as the country of origin for the Aix bronze has been suggested by A. C. Kisa, "Die römischen Antiken in Aachen," *Westdeutsche Zeitschrift für Geschichte und Kunst*, XXV (1906), 38 ff. The Roman Lupa is first mentioned as being preserved at the Lateran in the tenth century (*MGH, SS.*, III, 720), yet there is reason to assume that the figure

was always there from Antiquity on; see R. Lanciani, *Ancient Rome in the Light of Recent Excavations* (New York, 1890), pp. 21 and 285. Unfortunately I can find no proof for Lanciani's assertion (p. 285) that as early as the ninth century the *Lupa* is mentioned as standing at the Lateran.

199 Agnellus, *Liber Pontificalis Ravennatis* (MGH, SS., Rer. Langob., p. 338); see also Walafrid Strabo, *Versus . . . de imagine Tetrici* (MGH, Poet, L., II, 370 ff).

200 H. Jordan, *Topographie der Stadt Rom*, I, 2 (ed. C. Huelsen) (Berlin, 1907), 245.

201 Poeta Saxo, *De gestis Caroli Magni*, V, *vv.* 431 ff. (MGH, SS., I, 274).

202 The name of St. John instead of that of the Savior appears first in 870; see *Itinerarium Bernardi monachi*, in T. Tobler and A. Molinier, *Itinera Hierosolymitana* (Geneva, 1879), p. 318. The date "shortly before the year 1000" as given by C. Huelsen, *Le chiese di Roma* (Florence, 1925), p. 272 should be corrected accordingly.

203 *MGH, Epist.*, III, 586 ff.; IV, 203 ff.

204 Ermoldus Nigellus, *In honorem Hludovici* II, I, *vv.* 424 ff. MGH, Poet, L., II, 36.

205 The present mosaic was made between 1736 and 1744 from an older one which was destroyed at that time (G. Rohault de Fleury, *Le Latran au moyen âge* [Paris, 1877], pp. 539 ff.). This older one in turn was a copy executed in 1625 from the badly damaged original; while the group to the right was well enough preserved to leave no doubt as to the identity of those represented, the group to the left had completely disappeared before 1564. The restorers of 1625, however, worked from a drawing evidently made before 1564, on which this group was still preserved. Thus the copy made between 1736 and 1744 from their restoration seems to be a reasonably reliable reproduction of the original. The date of the original can be established by the title *rex* given to Charlemagne in the inscription; it must precede the coronation as emperor, and thus can be dated between the election of Leo III (795) and the coronation (800). See N. Alemanni, *De Lateranensibus parietibus* (Rome, 1625); P. Schramm. *Zeitgenössische Bildnisse Karls des Grossen* (Leipzig, 1928), pp. 4 ff.; G. Ladner, "Mosaici . . . nell' antico palazzo Lateranense" *RACrist*, XII (1935), 265 ff.

206 For the Christian interpretation of Roman history see Fredegarius, *Chronicae*, Lib. II (MGH, SS., Rer. Merov II, especially 55 ff.).

207 Ermoldus Nigellus, *op. cit.*, IV, *vv.* 245 ff. (MGH, Poet. L., II, 65; Poeta Saxo, *op. cit.*, V, *vv.* 645 ff:; MGH, SS., I, 278 ff).

ART HISTORY AND THE HISTORY OF IDEAS

Intellectual History (Geistesgeschichte)
15 The New Relationship to Nature
MAX DVOŘÁK

Kunstgeschichte als Geistesgeschichte, art history as the history of ideas (or of the human mind) is a method commonly associated with the name of Max Dvořák, a brilliant Austrian scholar of Czech descent who was born in Roudnitz (Bohemia) in 1874 and held the chair of art history at the University of Vienna from 1909 until his death in 1921. The son of the archivist of the radically pro-Bohemian and anti-German prince Georg von Lobkowitz, Dvořák as a student was profoundly disillusioned with the intellectual tenor of his times and, having little faith in learning and scholarship, contemplated becoming a writer before he finally decided to undertake a course of historical studies at the University of Vienna, where he received his doctorate under the political and intellectual historian Theodor von Sickel (1826–1908) in 1897. As a graduate student, Dvořák had attended the lecture courses of two renowned art historians at the University of Vienna, Franz Wickhoff (1853–1909) and Alois Riegl, whose method of research and interpretation of Classical and Western medieval art had inspired him and re-established his faith in learning and scholarship. Since he had also been attracted to the paintings of the French Naturalists of the 19th century and of such Northern artists as Edvard Munch, he began to pursue a career in art history rather than history, though always within the framework of a definite intellectual point of view. In 1909, at the age of 35, he became a full professor (*Ordinarius*) and the successor to Wickhoff (Riegl had died in 1905) in the chair of art history at the University of Vienna. (In the following year, a second chair was created at Vienna, to which the Czech-born scholar Josef Strzygowski was appointed; see page 2).

By this time, Dvořák had made important contributions to the understanding of the visual arts. The most significant of his early studies was his critical work on the Van Eyck brothers and the problem of distinguishing their respective shares in the execution of the Ghent Altarpiece, published as "Das Rätsel der Kunst der Brüder van Eyck" (in *Jahrbuch der kunsthistorischen Sammlungen des Allerhöchsten Kaiserhauses* XXIV [1904], pp. 161–317; repr. as a separate paper, 1925). This piece of scholarship remained the basis for subsequent research; indeed, Dvořák's penetrating observations have not been supplanted even by recent, thorough X-ray examinations of the altarpiece. Moreover, by placing the art of the Van Eycks within a larger context, Dvořák conceived of a continuous evolutionary development from the Early Renaissance to Impressionism, in which greater naturalism was achieved, he maintained, due to both ever increasing technical skill and the assimilation of the formal values of Italian Trecento art into Northern manuscript illumination about 1400. (The related point of view of Erwin Panofsky, in his magisterial *Early Netherlandish Painting* of 1953, is clearly indebted to the early thought of Dvořák.)

Reprinted from Max Dvořák, *Idealism and Naturalism in Gothic Art*, trans. R. J. Klawiter (Notre Dame, Ind.: University of Notre Dame Press, 1967), pp. 77–104.

By the second decade of this century, Dvořák had begun to reformulate his thinking. With the advent of German Expressionism and Surrealism—Dvořák was a friend of Oskar Kokoschka and was later to write an introduction to a series of the painter's lithographs (1921)—he began to realize that a crisis of naturalism had befallen the development of painting. His new mode of thought focused on idealism, on the spiritual forces that lend shape to the creative process, and it was expressed in lectures he delivered at the University of Vienna and published in his major work, *Idealism and Naturalism in Gothic Art* (trans. R. J. Klawiter [Notre Dame, Ind., 1967; first pub. 1918]), which reappeared in a posthumous collection of his essays that was entitled *Kunstgeschichte als Geistesgeschichte; Studien zur abendländischen Kunstentwicklung* (Munich, 1924) by its editors, the Viennese art historians Karl M. Swoboda and Julius Wilde. Although that title was not of Dvořák's own choosing, it points to his interpretation of Gothic art as deriving from the prevailing medieval Christian Weltanschauung that lies beyond material experience and thus reflects a purely spiritual and transcendental global outlook. The persuasiveness of *Idealism and Naturalism* issued from Dvořák's thorough training in cultural and intellectual history as well as in medieval theology. The English rendering of this pioneering intellectual interpretation of art that is presented herein deals with the new relationship of medieval art to nature. Dvořák's new art history influenced the conceptions of two of his students, Dagobert Frey (1883–1962), who wrote on medieval and Renaissance art, and Frederick Antal (see above, page 339) who specialized in late 18th- and 19th-century art, as well as the noted Rembrandt scholar Otto Benesch (1896–1964).

Dvořák was one of a small number of art historians who, during World War I and the rise of German Expressionism and Surrealism, began to devote serious attention to the 16th-century style now known as Mannerism. While Heinrich Wölfflin had characterized Mannerist art as a degeneration of the norms of classical beauty exemplified in the paintings of, say, Raphael, Dvořák in his last years conceived of it as reflecting a positive aesthetic, specifically a profound metaphysical and spiritual crisis of its age. His thoughts were expressed in lectures in Vienna but were published only posthumously (in *Kunstgeschichte als Geistesgeschichte* and in his *Geschichte der italienischen Kunst im Zeitalter der Renaissance; akademische Vorlesungen,* 2 vols. [Munich, 1927–29]; the translation by John Coolidge of Dvořák's "El Greco and Mannerism," in *Magazine of Art* XLVI [1953], pp. 14–23, omits some of his most pertinent observations). His interpretation of Mannerist art was molded into a modern concept by such scholars as Arnold Hauser, Wylie Sypher, Gustav R. Hocke, and Josef Paul Hodin and has been applied to the art of more modern periods. These more recent writings may lack the intensity of Dvořák's genius but not his conviction as to the validity of art history as the history of ideas.

Medieval spiritualism whose significance for art one at the present time can only surmise rather than actually know formed the vast basis for the return to nature and the sensible world formally as well as objectively.[1] As I have already indicated, this process was based upon a new universal, spiritual compromise with finite reality that was considered to be a type of stage for the actualization of meritorious deeds; even more, it was recognized as a necessary prerequisite for the eternal life of the elect. In art this compromise was expressed by a new perspective vis-à-vis nature; it utilized an approach which no longer considered nature as something axiomatically meaningless in the interpretation of artistic tasks and goals—it was rather to be

[1] Notes to this selection begin on page 409.

counted among the very means for the realization of these goals, although, of course, within specific limitations.

This change and its concomitant innovations are most clearly evident in the representation of the human body; here a transformation was effected whose progress, at least in its earlier stages, can be viewed more clearly in the plastic arts than in painting where traditional compositions based upon other presuppositions retained their influence for a much longer period of time. Later the situation was to be just the reverse. The concentration of interests upon supernatural truths in the early Middle Ages had as one primary result the reduction of the human body to a totally subservient role. Consequently in artistic representations the human form assumed a lifeless, rigid, almost wooden character similar to its counterpart in archaic Greek art. The stylistic progress of medieval art in sculpture as well as in painting is embodied in the austere, rigidly perpendicular figures which the medieval world inherited as a legacy from early Christian antiquity. In this form of art the figures confront the viewer face to face, are loosely united by means of various external gestures and are more narrowly bound by a certain inner spiritual potentiality shared by all. The vigorously agitated forms employed intermittently throughout the Middle Ages were likewise an inheritance from the great historical cycles of early Christian art but functioned solely as isolated vestiges of the past, just as in contemporary art Baroque motifs are still occasionally used and yet in no sense can they be said to represent the spirit of twentieth-century art.

When the later medieval spiritual orientation had begun to concentrate anew upon man as a creature of this world, the formerly rigidified human figures in art once again became alive, not however by being reduced again to their classical point of origin nor by developing in a direction similar to that pursued by the ancient Greeks but by surmounting the classical art of the Greeks which had also endeavored to wrest a stronger degree of immediate vitality from the older oriental forms of art as well as from their own archaic forms. With the Greeks, however, this revitalization rested primarily upon observation and representation of motifs of physical motion which, present in specific pictorial conceptions, were reduced to their natural essence [German original: natürliche Gesetzmässigkeit] and originality as well as to their organic union; at the base of these self-same motifs lay volitional act. Thus it was that man was to be reflected in art as a spiritual being but only within the mirror of material act. In the newer Gothic art forms, however, this consideration was entirely out of the question since its whole historical development was based primarily upon an attempt to surmount the artistic materialism of classical Greek and Roman art.

Consequently even the statues or the individual figures in paintings continued to retain their wooden character for quite some time—indeed it was not until the techniques of Renaissance art had made considerable progress that this hyper-constraint began to wane in spite of the minor, isolated accomplishments that had been achieved prior to the major Renaissance advances in the representation of physical motifs of motion.[2] Some other means, therefore, must have been employed to circumvent the lifelessness, the crystalline immobility of the older medieval figures, namely a spiritual vivification. By means of the expression of the spiritual in man, be it in general as the representation of a unifying spiritual tendency or in particular as the reflection of a spiritual contact or a psychic characteristic, a new life was breathed into the dead figures. This new, postclassical naturalism proceeds, therefore, from an interpretation of man as a spiritual personality,

and it is here that one encounters the fundamental factor in the new development of art—a conception which could not fail to exercise a decisive influence on man's entire relationship to all of nature. This was also a necessary consequence of the historical development of Christian art which from its very inception, as I have repeatedly affirmed, took spiritual situations and not specific actions as the basis for its statuary art, with reference either to the individual figure or the compositional groups. However in the earlier stage of this development the psychic base-element of the artistic conception was almost entirely impersonal, namely a higher spiritual force that governs everything which occurs. It is for this reason that at times an abrupt contradiction arose between the psychic event and its physical counterpart, a contradiction which of necessity must appear paradoxical and barbaric to the modern viewer who is accustomed to a reciprocal harmony of both of these factors. After the former metaphysical *Weltanschauung* had been combined with a relative recognition of earthly, physical values, the psychocentric interpretation of being continued, however, to remain as decisive as it had been for all of life's manifold relationships, among which is also to be reckoned man's relationship to nature. But a basic difference is discernible in the fact that this spiritualization was not sought exclusively in transcendental substances, interpreted as it were as a dominating force beyond the scope of natural phenomena and events, but was rather wherever possible united to these transcendentals in the form of sense perception and psychic experience.[3] The most important consequences of this development can be thus summarized.

Initially it should be noted that the first accomplishment, or the most important step toward a complete transformation of the ideality in the representation of the human being, is to be found within the historical development itself. This transforma-

tion was not based on bodily mechanics, which however had been artistically mastered to the highest degree of perfection, but rested rather in essence on spiritual priorities, primarily degrees of ethical excellence. The goal of this newer art was not the formation of ideal bodily figures through whose material beauty of form and of conformity to established norms [German original: *Gesetzmässigkeit*] the realm of the higher, more edifying verities in the course of reality, was to be artistically attained; rather its goal was spiritual individualities that were to confront the humdrum reality of daily life with the concept of an intellectually and ethically higher humanity.

However one is not to conclude that bodily beauty had been axiomatically excluded. Indeed until the period of Gothic hegemony in the arts such physical beauty had been opposed or at best had played a minor role.[4] Only the divine figures and the angels in early medieval and Romanesque art retained a shimmer of classical perfection of form. For in the mass of the figures virtually no trace of this classical perfection can be found. At the beginning of their development in the seventh and eighth centuries as well as in their final lingering vestiges in Romanesque art, the majority of these figures appear to be distorted, disproportionate, grotesque and caricatured and thereby minimize if not actually invalidate the theories of either a gradual loss of the classical canon of art or of a gradually surmounted primitivism.[5] The mummy-like character of these representations is explained by the fact that the artist of the Middle Ages sought to suppress everything which was reminiscent of bodily excellence or which would exult the cult of the body or this life. This does not imply, however, that the characteristically ugly was exaggerated as is occasionally the case in contemporary art. When everything vigorous and materially effective had been deleted from the object to be depicted in art, the old class-

ical canon of forms was automatically transformed into a withered phantom of senile proportions. This characteristic was all the more recurring because it corresponded to the basic tendencies of the artistic interpretation striven for by the medieval artist; this became consistently more evident especially when in conjunction with new medieval solutions to formal problems (as for example in the ninth and eleventh centuries) the attempt was made to incorporate classical formal constructions as well as classical solutions into the more recently evolved medieval formulations. The early Middle Ages had ideals independent from such constructions and any traces of the glorification of the human body found in art up to approximately the twelfth century are more the vestiges of past ages or some practical formula than they are new advances in artistic technique.

Of course the very employment of strictly classical formulations does indicate an incipient transformation of values more in keeping with the progressively advancing worldly orientation of spiritual interests, a change of which the artist was doubtlessly aware. The Greek concept of beauty was reintroduced in literature and was justified by appealing to principles formulated principally by St. Augustine and the "neo-Platonic pseudo-apostle, the aesthetician among the Fathers of the Church," Dionysius the Areopagite,[6] the commentary of whose works played such an important role within the framework of the Thomistic theory of art and to whose memory and fame Dante erected an imperishable monument. The classical themes of aesthetic speculation were taken up again but to be sure were given a new content. While for St. Augustine the point of origin of all artistic ideas was the absolute transcendental beauty of God which was expressed as "the living rhythm and the purely spiritual form and unity of the enormous poem which is the world,"[7] the philosophers of the Gothic age were

wont to concede to beauty a purely worldly sphere wherein, however, it was to be conjoined with the quality *honestum*, which in the words of St. Thomas Aquinas is to be interpreted as *spiritualis decor et pulchritudo*.[8] Out of this combination arose a new concept of artistic beauty and sublimity in which the materially beautiful form appears as the expression of spiritual excellence. The Gothic representations of the Virgin Mary are an image of lovely feminine grace; those of the holy knights illustrate the embodiment of noble, youthful power; the apostles and confessors of Christ are veritable forms of imperturbable manliness. The holy figures were meant to be of an obvious, bodily beauty and in this respect, both in art and on aesthetic principle, a new way was opened which would lead not only to the world of the senses but over and above this to the world of classical art; this was a direction in art as tenable for the contemporary world as it was for the Middle Ages. Yet the emphasis did not rest primarily on physical characteristics, but rather strove to accentuate the spiritual properties which informed them, as for example, the charm of the tenderly sensitive woman; the will of a Christian champion, at once firm and yet resigned to the will of God, a combatant in the army of Christ to whom every form of presumption is foreign; the mild, illumined wisdom of the founders and teachers of the new humanity.

It is this union of the spiritualistic idealism of the Middle Ages with the new affirmation of mundane existence that formed the origin of the new artistic interpretation of man, a conception which I have designated as a striving after the representation of the spiritual personality and which could only lead to new presuppositions concerning the representation of the physical nature of man. By their very nature spiritual personalities demand a bodily individualization and although at first a strong degree of stylization, determined by the guilding principles of

Christian ethics, can be observed in this individualization, in such schemata it is not a matter of the synthesis of the individual to a unified corporeal ideal as it had been in classical art but is rather the attempt to capture the similitude of the nature shared by each of the various individuals. Although this endeavor to objectify in art a strictly metaphysical principle may have stamped the creations of the first period of this new art with a particular conventional character, it did not result in any progressive synthesis but enhanced a progressive individualization which had already derived renewed impetus from the further development of the new spiritual-mundane organization of society in Church and State; consequently in this manner it can be said to signify the beginning of a process which even today cannot be considered concluded despite a few later reversals.

Not only the concept of personality had changed; even the relationship to the entire external world had become something quite different once an interest in this world for its own sake had been rekindled by transferring the emphasis of human speculation to those psychic phenomena which separated the Christian from the classical era. In perpetuating a transformation that had already begun with the philosophical and artistic problems of late antiquity, Christianity with its belief in salvation and its ethics based on the intentions of the will taught mankind to subordinate its interpretation of the world to the spiritual welfare of the soul and to the Christian way of life. Thus Christianity instructed man to take cognizance first and foremost of the emotional life and the religious, that is the spiritual interests of the individual. Therefore sentiments and faith, the powers of sight and thought as well as man's individually conditioned needs and experiences became the measure of his relationship to the external world which man had now begun to conceive as a projection of the spirit. This discovery of the world as a reflection of individual consciousness comprised the second fundamental accomplishment of this development of art; this reflection strove to the fore when man's vision had once again been directed to the world about him and was focused on three aspects of human life. In the representation of man the new spiritualization and introspection were expressed in a threefold manner.

1. In the representation of the psychic contact between the individual figures. For a long time psychic relationships or conflicts did not function as an independent problem of art but wherever they did evolve from the narration to be represented they were emphasized incomparably more than they had been previously and formed an integrating part of the artistic interpretation of man. By way of example one need only consider the various versions of the Visitation. Even in Romanesque art the scene was conceived in the sense of the typically classical, materially motivated grouping of individual figures; this conception was transformed in Gothic art into an almost motionless, spiritual union to be replaced somewhat later by the form of a psychic dialogue.

2. In the representation of the emotions, their expression was not only intensified, as can be observed in the figures of the various Crucifixions, but even those psychic processes, which for the first time in the history of art were conceived as something passive—from the quiet, inwardly directed absorption into self to the most powerful emotions of joy or sorrow—had now become recognized as independent subjects of the creative imagination to be juxtaposed to the scenic plots being portrayed, or even at times to supplant them.

3. In the relationship to the external world. In the rows of statues adorning the façade of a Gothic cathedral, one can observe that the majority of the figures are in no way related to one another, but rather they range beyond any form of ac-

tion over and above symbolic allusion. Nevertheless they are figures filled with an inner tension based not upon an act of the will but stemming rather from a receptive psychic process—upon the power of vision perhaps, or maybe upon the conscious awareness of impressions which unite each individual figure with the external world. Nothing can more poignantly illumine the basic difference of this newer art vis-à-vis the art of classical antiquity than can this characteristic which clarifies the old adage that it was Gothic art which freed man's vision. This is true not only with reference to what was to be portrayed but equally so in reference to the artists themselves. Since perception, that is the viewing of the world as a product of the spirit, had gained ascendancy over the former view of the world, the nature of things demanded that the relationship between art and reality be equally radically transformed. In place of an objective perfection or a projected embodiment of the highest concept of a formal proposition involving a sweeping solution to the manifold problems confronting reality *face en face* in the form of its individual manifestations, there now emerged a receptive attitude vis-à-vis the limitless multiplicity of natural forms and the phenomena of life.[9] This attitude heralded the advent of nature studies in an entirely new and formerly undreamed of meaning of the word [German original: *nie dagewesene Bedeutung des Wortes*]. Man became the center of art but in a sense totally different from that which he maintained in classical art. He was now not the object but rather the subject of artistic truth and legitimacy. The measure of artistic values was no longer based on the norms established by the accomplishments of previous generations but rather was the direct result of newly acquired experiences and observations. Graeco-Roman classicism had endeavored to suppress as far as possible the subjective element in art; however in Gothic art this subjective factor was to

form the most important point of reference in any artistic creation, not only through the relationship it bore to any metaphysical explanation of the substance and external manifestations of the created world, a relationship that dominated the initial period of development of Christian art, but of far greater import it was now to find an equally potent expression in all phases of daily life. This shift in emphasis was to exercise a powerful influence on art in a twofold manner—extensively as well as intensively. The pictorial concepts of classical art were definitely limited despite their diversity; now, however, there were to be basically no inhibiting factors since the observable world, that is the world of subjective impressions knows no limitations. Thus in the Middle Ages, *in principle* at least, the entire visible world had become for art and everything related to it a posited and solvable problem, although *in fact* the mastery of this domain was to be a gradual process not as yet completed. Although this new, more comprehensive discovery of nature was united to the love of nature inherent in the younger Germanic tribes, it must nevertheless be emphasized that in the preceding centuries neither the poetry nor the plastic arts of these peoples had offered any basis for such a union. At best, therefore, one can speak only of a disposition innate to these peoples in the face of which the actual extension of the goals and tasks of art, by means of unlimited observation of nature, was without a doubt a determined, historically conditioned experience, analogous to the rise of the empirical sciences.

In a similar manner, it would be inaccurate to attempt to explain this entire historical process which precipitated a new relationship to nature—or as one is more apt to say, the discovery of the human person and nature—as a form of self-assertion of these new people vis-à-vis the traditional dictates and controls of the Church over their lives or to define it in terms of a secular Renaissance movement of man-

kind independent of all ecclesiastical constraint. This is not the case at all since the new attitudes were definitely rooted in the Christian spiritualism of the Middle Ages without which the new interpretation of art would be just as unthinkable as are the new sciences, the new poetry, the new worldly orientated social consciousness or the new secular *joie de vivre*. To be sure, on the basis of an extremely complicated historical development, a conditional secularization of the spiritual authorities had occurred, not, however, in opposition to the religious culture of the Middle Ages but within the framework of this medieval culture. Moreover it utilized the latter's fundamental principles for its own end. The new significance of the spiritual personality of man and the new interpretation of nature as well as the decisive points of view within this re-formation itself were founded, therefore, on developmental cycles which cannot be separated from that transformation of mankind which found its expression in Christianity.

It is evident that such a change would necessitate an extensive revision [German original: *eine weitgehende Überwindung*] of traditionally accepted concepts of art. In the period preceding the High Middle Ages the themes to be portrayed were limited to specific traditional cycles, newly conceived in various manners by either extending them or reducing their scope. Nevertheless these themes continued to operate within a highly concentrated circle of pictorial concepts, an area certainly much poorer than its early Christian presuppositions. About the middle of the twelfth century these barriers disappeared and a new world of imagination was opened to art in an apparently unlimited fullness—traditional topics were reworked and revitalized embracing countless new epic and lyrical themes of both a religious and a secular nature. This topical enrichment of art was not less extensive than the similar revolution in the art of the nineteenth century vis-à-vis the Renaissance

and Baroque periods; moreover the main difference was that the extension of the realm of art in the late Middle Ages was accomplished less within the area of objective observation of nature (although even here the greatest revolution had also been effected) and concentrated rather on the narrative elements to be depicted.

The fact that the whole of medieval art had a strongly literary and illustrative character has been frequently, indeed justifiably, emphasized;[10] consequently it is only natural that this specifically narrative character should be expressed in the plastic arts to the extent that the ecclesiastical and secular literary interests of the period, permeated by a fresh blossoming of the life of the imagination, were expanded and transformed. Here it is not only a matter of the necessity to provide new works with illustrations; it is rather another example of an independent parallel phenomenon. Thus the endless narratives of the stained-glass windows were in one sense an ecclesiastical reflection of the chivalric epics of knighthood. The references to cycles of literary imagery were, however, so frequent that one can observe their decisive influence not only in the representations of historical or poetic events but also in every description of life and nature as well as in the reproduction of individual objects.[11] It is certainly not pure chance that the extensive encyclopedic knowledge of the Middle Ages, for example the *Speculum* of Vincent of Beauvais, and the late medieval pictorial subject matter agree to such a great extent—a common source gave rise to both the scholastic and the contemporary objects to be represented in art.[12]

The origin of this varied pictorial enrichment of the twelfth and thirteenth centuries was not, as it had been in antiquity, either sense impressions or primary pictorial conceptions but was rather a theoretical system of knowledge, a formative process which, derived from contemporary literary sources, determined not only the

course of medieval art but also the entire consequent direction of European art as a whole. Therefore in contradistinction to oriental and classical art where the area of artistic reprèsentation was limited from the very beginning to specific material relationships and artistic problems, European art acquired both an almost unlimited program and a scientifically expanding character expressed at first only in the naive extension of basic interests; yet this character later transformed the entire concept of the artistic itself.

Far more radical than the transcending of the traditional material to be reproduced by art was the conquest of the traditional view of form. Even in the most unfavorable cases this victory can be unmistakably established, even there where a representational type of long duration had been adopted and, as if it were sanctified by tradition, violently withstood any form of change, for example in the representation of the figure of Christ or the Madonna. A Romanesque representation of the Virgin Mary or of Christ (be it viewed either as a specific type or in its particulars—for example the treatment of the garments, the various forms of the bodies, the designs and pattern figures, the relationship between form and surface or between light and shadow) appears clearly to be a member of a line of development whose uninterrupted genealogical lineage can be traced back to the period of classical antiquity. This continuity is completely lost in Gothic art. Even though at times the traditional composition was retained, the various forms and technical solutions inspired by this composition were wholly new, no longer based on tradition but rather upon a new and independent interpretation of nature, which interpretation is particularly unmistakable in representations more or less independent of the older pictorial devices.

A transformation in the formal problems, that is in the "how" in the reproduction of nature, was necessarily precipitated by the disarrangement of the relationship between the artist, nature and the work of art. The decisive psychological factors of subjective perception and observation also had to play a large part in the reproduction of form and all the various formal as well as spatial relationships.

Fidelity to nature no longer consisted of a knowledge of nature raised to the level of a conceptual norm or perfection of form but was rather felt to reside in the actuality of the observed phenomenon, that which was characteristic of the individual. Thus it was a completely different and new fidelity to nature that triumphed with Gothic art, a concept not only new vis-à-vis its object or even its spiritual content, but one which, stylistically new to its very last stroke, irrevocably vanquished classical art for all times despite numerous apparent reversals. The significance of the new Gothic naturalism does not lie in individual, formal or practical advances and accomplishments but rather in the fundamental fact, which was to prove so decisive for all time in the entire cultural sphere of the Western world, that in Gothic art an artistic interpretation of nature prevailed that was entirely different from its classical prototype and this situation was analogous to the position of classical nature concepts vis-à-vis their oriental forebears. A new mankind, emerging from the most violent spiritual revolutions, began to disclose nature artistically anew when viewed from their newly acquired points of view and spiritual interests. The development of postclassical art cannot be understood if this fact is not kept constantly in mind.

Indeed one might ask why this new Gothic naturalism whose influence can be observed in the postmedieval era and which one might call an individual-receptive naturalism never developed beyond certain limited initial stages, although it was of decisive significance in as far as it dealt with direct observation of nature. This can be explained from its tran-

scendental-idealistic presuppositions described above. For above the world of the senses, above life, above the truth and joy of nature, as man understands the word, stood God's revelation, the sphere of a transcendental, religious ideality, a being that obeyed laws other than those discernible by the senses or grasped by man's reason, a being not to be ascertained by transitory, secular values alone.[13] It is this eternal and immaculate transcendental world that art is to approach and by which it lifts the viewer upward in its wake—not only by means of an ideal abstraction as in the previous periods of Christian art when body and spirit traveled their separate ways, but now rather through a union of spiritual content with a physical effect of ideal and bodily beauty, an effect to which beauty must be subordinated although it itself is both limited as well as conditioned by the content.

Thus the representation of the Virgin Mary was supposed to be more than a mere image of a beautiful woman, a humanly lovely mother; it was at the same time supposed to embody the heavenly sweetness of the Mother of God in her immortal ideality. And if the Apostles and martyrs were characterized as spiritual personalities, this characteristic with its naturalistic auxiliary means of expression was based upon the endeavor to concretize before the gaze of the viewer representatives of a metaphysically absolute, eternal and holy community. This artistic endeavor did not strive solely to realize didactic aims (a fact so frequently and yet one-sidely pointed out); nor did it merely instruct man in the ways of the church by means of a painted or sculptured theology. On the contrary it strove to no less a degree to effect formations of the imagination in which anthropomorphic religious conceptions could be condensed as pictorial figures of the ideal as they had once been depicted in the art of Greece.

They appear less new to modern man than do the Grecian figures because they were not iconographically new as were the latter, but were for the most part based upon old, and in many ways antique, devices. And yet they were just as new as the new interpretation of nature! They derived from a concept of ideality basically different whose point of departure was no longer metaphysical projection of sense experience as it had been in Greek art; here the reverse was true, for the general significance of the artistic results of medieval art was measured by their relationship to transcendental spiritual values. How infrequently has the epoch-making importance of this fact been considered! What a wealth of new horizons, of infinitely new possibilities of artistic conception and effect was contained in this transposed view of art which conceived the physical form in art as the adequate expression of abstract psychic processes, a form both subordinated to these processes and at the same time deriving its ideality from them. Classical art could attain its greatest flowering and its profoundest influence on life by objectifying bodily and cosmic conformity to basic laws, or beauty or harmony within specific creations of the imagination. And yet within this physical objectivity lay also a limitation which sooner or later could only effect an end to the rise of this same classical art. On the other hand an equal danger was concealed in the pure spiritualism of late classical and early medieval art, that is the danger of ultimately losing every possibility of the progress rooted in physical experience or in the perception and practical knowledge of life. In contrast to these two systems of artistic idealism, the late Middle Ages offered a third one wherein objective reality and the beauty of material form were raised to the level of an adaptable expression of transcendentally spiritual values or the universal and individual struggle for ideal, ethical progress of mankind.

Just as the new naturalism had derived from the basic spiritualizing of all relationships of life so also a new secularly ideal-

istic orientation of art arose from this same source, namely a new relationship of art to the ideas and emotions which move humanity. A line of development was thus established whose ultimate result was that the product of artistic creation, without losing its relationships to physical life, was hereafter to participate, to a far greater degree than it had in earlier periods of art, in great spiritual movements and to derive its source of transformation and rejuvenation from these very movements as well as from nature. This form of immediate participation ranged from the overpowering pathos of new universal ideals of mankind as a whole down to the silent confession of a subjective experience of an individual soul.

In Gothic art the primary concern was only the establishment of a link uniting the artistic values of worldly existence with the transcendental world order, or more specifically a bond between worldly beauty and the ideals of a Christian life. In this union, however, lay a further source for the transformation of old Christian pictorial base-types—the ancestral line of those personifications of a spiritualized beauty combined with either a depth of feeling or with certain ethical merits. In a sense analogous to the idols of bodily perfection prevalent in the art of the ancients, although operating under modified presuppositions and in conjunction with these classical modes of perfection, these base-types exercised a repeated influence on the idealizing portrayal of man in all subsequent periods of art. In Gothic art, however, they became as were the prefigurative incunabula of a spiritualized concept of beauty which was to play so great a role in contemporary ecclesiastical and secular poetry. Only thus is it explicable that one still encounters these base-types objectively limited in a period where there certainly can be no discussion of a timidity in the representation of nature.

And yet it was not only a matter of new ideal-types. Everywhere one can observe the genesis of a new interpretation of beauty in which, vis-à-vis classical art, a new standard had been established; however the interpretation effected was not only in reference to the spiritual elements of beauty but to its physical aspects as well. Although forms expressive of power and energy had not completely vanished, a striving for subtle delicacy and graceful lightness began with increased frequency to replace the Hellenistic figures composed in the style of the symmetrical harmony of a systematic physical culture as well as the massive, thick-set human forms elicited by the Roman sense of might or the plump figures resulting from the early medieval use of every aspect of bodily beauty. Irrespective of the various transformations this striving underwent between the twelfth and sixteenth centuries, it constantly preserved its connection with an ideality for which edifying emotions and an altruistic disposition as well as patterns of life based upon spiritual brotherhood, spiritual excellences, asceticism and an inner sense of subjectivity were far more important than bodily perfection and individual or public consciousness of power.

In this strong dependence upon spiritual content there lay at the same time, however, a certain fluctuation, an alternating approach to nature and then withdrawal from reality, an oscillation wholly unknown to the consistent development of classical art with its objective problems. The great realists who executed the north portal of Chartres[14] are hardly a generation younger than the masters in Moissac, Vézelay or Souillac who "created those abstruse figures born of hatred and anger, denying as nothing else in all the world the classical beauty of supple movement and the heathen cult of the hero, those forms rattling like skeletons beneath their outer garments, reflecting as it were what the hollow-eyed inmates of the medieval monasteries yearned to become: a pure soul annealed in the fire of mystic ecstasy, a spirit united to a body only to the same

extent that a fragrance adheres to the ash particles of burned incense, a soul humbled in humility and borne yet aloft in yearning, which, while lying prone upon the floor like a broken reed crushed by a storm, still casts its gaze heavenward as a lily lifts its calyx."[15] In Bamberg the mighty spiritual pathos of the prophets of the St. Georg choir—a masterpiece of sculpture that might be described as the first part of a trilogy of powerful representations of pre-Christian prophetic figures, a trilogy whose second part is formed by the prophets and sibyls of Giovanni in Pistoia, the third part of which ("large things cast their shadow before them") encompasses the divine figures of the Sistine Chapel—was succeeded by the subtle epic quality of an art which, presiding beyond all spiritual conflicts, created its harmonically noble forms out of the comforting assurance flowing from a joyful consciousness of God's presence.

And yet the inverse is also evident, for the almost brutally lifelike portraits of the founders of the religious houses in Naumburg were produced hardly more than a generation after the creation of Lettner's sculptured figures in Wechselburg and Halberstadt,[16] forms lyrically transported through pain and self-surrender in the being God. This prelude to a great mobility of spiritual content was based not only on the opposition between schools of thought and artists' studies but arose to no less a degree from the greater and more immediate dependence of artistic creation upon everything which moved the spiritual life of the age; moreover this dependence was greater and more immediate when compared to the relationship between life and art in classical antiquity, but it necessarily resulted from the evaluation of all things from the point of view of the exigencies of the life of the soul. This evaluation was peculiar to Christian art because of its basic character.

From these same sources, however, flows the astonishing wealth of imagination in Gothic art, that restless search for innovation in the invention of motifs which are not only to contain new impressions of nature but which are continuously to nourish the imagination. How basically different from the limitation of the classical spirit which "could find rest and satisfaction in the furrows of its triglyph" was "this strange joy of the new art in creating again and again new dream-like formations, in inventing forms which had the advantage of not only being new but also of bearing within themselves the germ of perpetual innovations."[17] The epoch of great imaginative art that according to Dilthey extends from the middle of the fourteenth century to the middle of the seventeenth century was actually introduced earlier through Gothic art.

Just like Peter Bruegel's peasant scenes, Rabelais' or Caravaggio's works, the series of Northern genre-painters, in word or picture, are rooted in Gothic naturalism; and thus are spun out connecting threads uniting the Gothic world of the imagination and Dürer's "Apocalypse," Bosch's ghost stories, Altdorfer's idyls, Rembrandt's ghetto fairy tales, the spirit world of *Macbeth* and *A Midsummer Night's Dream* or the figures in which Spain's greatest poet raised the phantasmagoria of the imagination itself in the reflected image of an overpowering irony to the very subject matter of his own creation. And indeed it is not simply a matter of a continuation of the Gothic! Radical revolutions in spiritual interests, revolutions which I shall discuss later, lie between these varied epochs. It was, however, of decisive significance for the development of the new art that in the Gothic period the tremendous spiritual activity which flowed from the double source of a dying as well as a newly arising culture was diverted to the area of an artistic interpretation of nature and life, for inasmuch as this intellectual fermentation stood before the gateway of the medieval world-regeneration it was bound on the other hand with the remains of the

classical objective reconstruction of the physical world in art, and yet on the other hand it was at one with the initial attempts to overcome this classical, this objective bias and thus to attain a world image founded on subjective perception and conviction.

The vernal stages of the imagination's undisputed sway were limited, as were all the other new methods in Gothic art, by the transcendental presuppositions from which these stages had developed. Thus I have arrived once again at the point of departure of this study—namely those stylistic characteristics of Gothic art which, anchored in a basically idealistic *Weltanschauung*, had set a priori a specific limitation to each form of imitation of nature and thus to any enrichment of art.

NOTES

1 A beautifully stated, definitive formulation of this whole process can be found in Thomas Aquinas: "God rejoices absolutely in all things because each one of them stands in actual agreement with His being" (cf. *Jungmann* [Josef Jungmann, *Aesthetik*, 3d ed., 2 vols. (Freiburg im Breisgau, 1886), vol. I], p. 92).

2 This will be discussed later at greater length, especially when treating the problems of the new statuary, monumental style. Without a doubt the renewal of statuary art, which in the age of artistic antimaterialism had lost every justification for existence, is to be traced back either directly or indirectly to classical stimuli. In no sense, however, can one speak of either attempts to imitate classical models or of a sense of competition with classical statuary. Is it really true, as has been asserted, that the man of the Middle Ages was entirely stupid and blind to the beauty of a classical reproduction of the human body? Is the only reason why the Middle Ages ignored this form of art actually that the artists of this period had no understanding of or appreciation for the sublime excellences of their classical prototypes, since they themselves were completely ignorant in the reproduction of the human form? That this was not the case is unequivocally proven by the fact that, although classical influences can be repeatedly observed in Northern European art, until the dawn of the Renaissance with but few exceptions there were neither attempts nor tendencies to enrich the solutions of artistic problems in this direction or to oppose classical statuary with something individualistically new or different. In spite of the surging Renaissance movement in the thirteenth century, all attempts in this vein, even in statuary art, remained timorous and were practically ineffectual—until suddenly in the fifteenth century a revolution, arising from causes which will be discussed within a different context, occurred. Between the "Venus" of Pisa and let us say Donatello's bronze figure of "David" lies a chasm which demands an explanation more penetrating than the mere assumption of a newly acquired understanding of classical art ushered in by naturalistic progress. Certainly the naturalistic accomplishments of Gothic art were the external prerequisites for this transformation, but in no sense were they the actual inner cause thereof.

3 Cf. Kurt Freyer, "Entwicklungslinien in der sächsischen Plastik des dreizehten Jahrhunderts," *Monatshefte für Kunstwissenschaft* (Leipzig, 1908–1922), Vol. IV (1911), pp. 261 ff. This article is a noteworthy attempt to reach an understanding of the artistic problems of Gothic sculpture within one particular region limited by time and place.

4 Thus Paulinus Nolanus, when besought by Sulpicius Severus for a portrait of himself and of his wife, refused the request with the words: "Qualem cupis ut mittamus imaginem tibi? Terreni hominis an coelestis? Scio quio tu illam incorruptibilem speciem concupiscis, quam in te rex coelestis adamavit" (Epistola XXX, *Patrologia Latina*, Vol. LXI [1847], cols. 322–325; quotation located in col. 322). (Translator's note: "What type of portrait do you desire that we send you? That of the earthly or the celestial man? I know that you desire that incorruptible species which the King of Heaven loved in you.") That which had to appear to the classically educated bishop as incompatible with the essence of art and, therefore, as a sufficient reason for refusing the requested portrait was gradually transformed in the following generations into the

point of departure in art for a wholly new representation of man. Similar views are repeatedly expressed by medieval writers: "Quid namque eorum, quae in facie lucent, si internae cuiuspiam sanctae animae pulchritudini comparetur non vile ac foedum recto appareat aestimatori?" (Bernard of Clairvaux, in *Sermonese in Cantica*, no. 27, *Patrologia Latina*, Vol. CLXXXIII [1854], cols. 912–921; quotation located in col. 913). (Translator's note: "For what of those qualities, which shine forth in the human countenance, will not appear vile and corrupted to one who judges rightly, if it be compared to the interior beauty of any holy soul?"). Or the words of St. Thomas Aquinas: "Perfectissima formarum id est anima humana, quae est finis omnium formarum naturalium" (*Quaestiones Disputatae*. "De spiritualibus Creaturis," q. 1, a. 2: "Utrum substantia spiritualis possit uniri corpori"). (Translator's note: "The most perfect of all forms is the human soul which is the end of all natural forms." Cf. St. Thomas Aquinas, "De spiritualibus Creaturis," *Opera omnia*. Edited by S. E. Fretté. Paris: Vivès, 1875, Vol. XIV, p. 12, col. 2.) According to St. Thomas, and in agreement with the art of his age, psychic and bodily beauty no longer signify an insurmountable contradiction in terms, for which reason, therefore, he sought a more narrowly constricted delimitation. While physical beauty was considered to be the lowest degree of beauty (pulchritudo ima, extrema) by St. Augustine, the classicist among the Fathers of the Church (cf. *De vera Religione*. Bk. 1, c. 40, n. 74, *Patrologia Latina*, Vol. XXXIV [1841], col. 155), St. Thomas attempted to do justice to the bodily factor of man as well as to his spiritual side; this view definitely corresponded to the new art of his own day: "Visio corporalis est principium amoris sensitivi. Et similiter contemplatio spiritualis pulchritudinis vel bonitatis est principium amoris spiritualis" (*Summa Theologica*, Prima Secundae, q. 27, a. 2). (Translator's note: "Corporal vision is the principle of physical love. And likewise the contemplation of spiritual beauty or goodness is the principle of spiritual love." For the Latin version cf. *Opera omnia*, Vol. II, p. 102, col. 1; for an English translation cf. *The Summa Theologica* in 3 Vols. Translated by the Fathers of the English Dominican Province. New York, et al.: Benziger Brothers, 1947, Vol. I, p. 707.)

5 The cadaverous heads, which are for the contemporary viewer perhaps the most horrifying examples of this type of art, were created only as late as the twelfth century at the very outset of the new Gothic art, and the direction from which they had originated dominated individual schools of art even in France and even at a time when the new style had been completely developed. Cf. Vöge [Wilhelm Vöge, *Die Anfänge des monumentalen Stiles im Mittelalter*, Strasbourg, 1894], p. 44, illustration no. 15.

6 Borinski [Karl Borinski, *Die Antike in Poetik und Kunsttheorie vom Ausgang des klassischen Altertums bis auf Goethe und Wilhelm von Humboldt*, 2 vols., Leipzig, 1914–24, vol. I], p. 73.

7 Ernst Troeltsch, *Augustin, die christliche Antike und das Mittelalter*. München-Berlin: Öldenbourg, 1915, pp. 112 ff. Cf. also Alois Riegl. *Die spätrömische Kunstindustrie nach den Funden is Österreich*. 2 Vols. Wein: Österreichische Staatsdruckerei, 1901–1923, pp. 211 ff.

8 Cf. St. Thomas Aquinas, *Summa Theologica*, I, sec. q. 5, 27 and 39 and II, sec. q. 145, a. 2, as well as his commentary to the *De Divinis Nominibus* of Dionysius the Areopagite, c. 4, lect. 5. (Translator's note: *Summa Theologica* in Aquinas' *Opera omnia*, Vol. I: Pars Prima, q. 5 ["De bono in communi"], pp. 17–21; q. 27 ["De processione divinarum personarum"], pp. 117–120; q. 39 ["De personis ad essentiam relatis"], pp. 134–162; Vol. III: Secunda Secundae, q. 145 ["De honestum"], a. 2 ["Utrum honestum sit idem quod decorum"], pp. 484–485. For an English translation of the questions in "Pars Prima" cf. *Aquinas-Pegis*, Vol. I, pp. 42–50 ["On Good in General"], pp. 274–281 ["The Procession of the Divine Persons"], pp. 363–381 ["The Persons in Reference to the Essence"]: English version of the question in "Secunda Secundae" cf. *The Summa Theologica of St. Thomas Aquinas*. Translated by the Fathers of the English Dominican Province. New York, et al.: Benziger Brothers, 1912, QQ. CXLI–CLXX, pp. 42–49 ["Of Honesty"], especially pp. 44–46 ["Whether the Honest is the same as the Beautiful"]. For Aquinas' commentary on the work of Dionysius the Areopagite cf. "In Librum Beati Dionysii de Divinis Nominibus" in *Opera Omnia*. Vol. XV, pp. 259–405; c. 4, lect. 5 pp. 305–307 ["De pulchro divino et qualiter attribuitur Deo"]. There is no English translation available to date.)

9 This new conception of artistic truth is also expressed in the writings of St. Thomas Aquinas: "Ad Hoc [. . .] ergo quod vere aliquid sit imago, requiritur quod ex alio procedat, simile ei in

specie, vel saltem in signo speciei." *Summa Theologica*, I, q. 35, a. 1. (Translator's note: "I answer . . . therefore that for a true image it is required that one proceeds from another like to it in species or at least in specific sign." Cf. *Aquinas-Pegis*, Vol. I, p. 339.) A similar thought is to be found in his commentary on the works of Pseudo-Dionysius: ". . . [nam] pulchrum addit supra bonum ordinem ad vim cognoscitivam illud esse huius modi" (c. 4, lect. 5). (Translator's note: Cf. *Sancti Thomae Aquinatis Opuscula Theologica* [quorum specialem mentionem facit De-Tocco]. Opusculum VII: "In Librum Beati Dionysii de Divinis Nominibus," Caput 4, lectio 5: "De pulchro divino et qualiter attribuitur Deo," from the *Opera Omnia*. New York: Musurgia Publishers, 1950, Vol. XV, p. 307, col. 2. Translation: ". . . that it be thus in some manner, as regards man's cognitive faculties, he ranked the order of the beautiful above the order of the good.") Duns Scotus goes even farther when he states: "Nunc autem in toto opere naturae et artis etiam hunc videmus, quod omnis forma, sive plurificatio, semper est de imperfecto et indeterminato ad perfectum et determinatum. . . ."("De rer. princ.", q. 8, a. 4: 28, p. 53b, Leidener edition, 1639). (Translator's note: Cf. "Quaestiones Disputates de Rerum Principio." Quaestio 8, articulus 4:28 in *B. Ioannis Duns Scoti . . . Quaestiones Disputates de Rerum Principio. Tractatus de Primo Rerum Omnium Principio.* New edition by R. P. Marianus Fernandez Garcia, O.F.M., Ad Claras Aquas [Quarachi] prope Florentiam: Ex Typographica Collegii S. Bonaventurae, 1910, p. 170. Translation: "Thus, however, in the total manifestation of nature and art, we always perceive this order, [namely] that all external form and reproduction [thereof] are always imperfect or indeterminate with regard to that which is perfect and determinate.")

10 In the Middle Ages the following verses of Prudentius were often paraphrased: "Non est inanis aut anilis fabula—Historiam pictura refert, quae tradita libris—veram vetusti temporis monstrat fidem . . ." (*Liber Peristephanon*. Hymnus IX, in Migne, *PL*, Vol. LX, col. 434–435). (Translator's note: "[A] fable is not inane or silly—[a] picture refers to [a] historical fact which is transmitted through books [and] illustrates the actual reality of ancient times. . . .") In the early Middle Ages the practical aim of these verses was naively stressed. Gregory the Great once wrote to Bishop Serenus: "Pictures in the House of God ought to be for simple men that which books are to the learned." (Cf. *Monumenta Germaniae Historica Epistolarum Tomus II. Liber IX*, epistola 208. Berlin: Weidmann, 1899, p. 195.) (Translator's note: Dvořák's quotation would seem to be a paraphrase of the remarks of St. Gregory the Great which are as follows: "Idcirco enim pictura in ecclesiis adhibetur, ut hi qui litteras nesciunt saltem in parietibus videndo legant, quae legere in codicibus non valent." Translation: "Therefore, picture[s] are brought into churches so that those who are illiterate might nevertheless, by looking upon the walls, read about those things which they are not able to read in books.") The decrees of the Synod of Arras of the year 1025 reflect similar views (cf. Didron, *op. cit.*, p. 6). Since the twelfth century, references to the ideal worth of art have generally replaced the pedagogical basis in such considerations. Compare, for example, the following: St. Thomas Aquinas, *Summa Theologica*, I, q. 75, a, 5c; II, sec. q. 167, a. 2c and the treatise of St. Bonaventure "De reductione artium ad theologiam." (Translators' note: This treatise can be found in *S. Bonaventurae Opera Onmia*. Vol. V. Florentiam [Florence]: Ex Typographia Collegii S. Bonaventurae, 1891, pp. 319–325.)

11 Cf. the statement of St. Bernhard: "Ligna et lapides docebunt te—quod a magistris audire non possis." (Tranlator's note: "Lines and stones will teach you what you will not be able to hear from teachers.") Concerning medieval symbolism cf. Borinski, *op. cit.*; concerning the particular role of the *exemplum* in medieval art cf. Julius von Schlosser, "Zur Geschichte der künstlerischen Überlieferung im späten Mittelalter," [*Jahrbuch der kunsthistorischen Sammlungen des Allerhöchsten Kaiserhauses*], Vol. XXIII, p. 284 and his "Materialien zur Quellenkunde der Kunstgeschichte," Sitzungsberichte (meeting notes) of [*Almanach der Österreichischen Akademie der Wissenschaften*], Vol. I: 77 (1914), Section 3, p. 86.

12 Cf. Liliencron, [Freiherr Rochus von Liliencron, *Über den Inhalt der allgemeinen Bildung im Zeitalter der Scholastik*, Munich, 1876]; concerning the relationships between the *Speculum* of Vincent of Beauvais and the contemporary art of his period cf. Emile Mâle, *L'Art réligieux du XIIIe siècle en France. Etude sur l'iconographie du moyen âge et sur ses sources d'inspira-*

tion. Paris: Colin, 1902. (Translator's note: the original edition appeared in Paris: Leroux, 1898.) It must be emphasized, however, that here it was undoubtedly not a matter of direct borrowings.

13 According to Vincent of Beauvais, man ascends from the lower to the higher degrees of knowledge, and thus through the perception of created being to the knowledge of God; man ascends, therefore, from the consideration of an image to the comprehension of its primal idea. (Cf. Liliencron, *op. cit.,* p. 13).

14 Cf. Vöge, "Die Bahnbrecher des Naturstudiums um 1200," [*Zeitschrift für die bildende Kunst*], Vol. XXV (1914), pp. 193 ff.

15 Cf. Arthur Weese, *Die Bamberger Domskulpturen,* 2nd edition. Strassburg: Heitz, 1914, p. 160.

16 Cf. Adolph Goldschmidt, "Das Naumberger Lettnerkreuz im Kaiser-Friedrich-Museum in Berlin," [*Jahrbuch der königlichen preussischen Kunstsammlungen*], Vol. XXXVI (1914), pp. 137 ff.

17 John Ruskin, *Gotik und Renaissance.* Translated from the English by Jakob Feis. This work forms Vol. II of the series "Wege zur Kunst." Strassburg: Heitz, 1898. (Translator's note: *Wege zur Kunst. Eine Gedankenlese aus den Werken des John Ruskin.* Aus dem Englischen übersetzt und zusammengestellt von Jakob Feis. 4 vols. Strassburg: Heitz (Heitz und Mündel), 1898.

Vol. I: Extracts from various books;

Vol. II *(Gotik und Renaissance):* Extracts from *The Stones of Venice;*

Vol. III *(Vorlesungen über Kunst):* A translation of the greater part of *Lectures on Art;*

Vol. IV *(Aratra Pentelici):* A translation of the greater part of that work [cf. *The Works of John Ruskin,* Ed. by E. T. Cook and Alexander Wedderburn. New York: Longmans, Green, and Co., 1912, Vol. XXXVIII, p. 38]).

Concepts of Periodicity

16 Renaissance and Renascences

ERWIN PANOFSKY

This second paper by Erwin Panofsky, published in 1944, deals with the problem of the periodic concept of the Renaissance—which he believes started in the first half of the 14th century in Italy—as opposed to earlier renascences, or revivals, of antiquity in Western art. Panofsky maintains that the Italian Renaissance was preceded by two earlier renascences, the first, the short-lived Carolingian revival of Classical images in the 9th century, and the second, a 12th-century revitalization of Classical art forms and literature, neither of which, in his view, brought about a total reintegration of Classical form and Classical content. Because there was a new historical consciousness, a trend toward individualism, an increasing preoccupation with a scientific approach to nature, and a dissolution of the compartmentalization characteristic of the later Middle Ages, the Italian Renaissance was able to achieve such a reintegration of form and content, and one that was "total and permanent." To buttress his interpretation of the Renaissance, he cites relevant works of art and literature.

Though it has been challenged by scholars of different disciplines in recent decades, this conception of the Renaissance is traditional in art historical thought (see Carl Neumann, "Ende des Mittelalters? Die Legende der Ablösung des Mittelalters durch die Renaissance," *Deutsche Vierteljahrsschrift für Literaturwissenschaft und Geistesgeschichte* XII [1934], pp. 124–71). Panofsky acknowledges his indebtedness to the views of his friend Aby Warburg (1866–1929), the noted German art and cultural historian (see his *Gesammelte Schriften,* ed. Gertrud Bing [Leipzig and Berlin, 1932]). While the present paper is a revision of an address delivered at New York University, its points of view had been set forth, in part, in his and Fritz Saxl's "Classical Mythology in Mediaeval Art" (in *Metropolitan Museum Studies* IV [1933], pp. 228–80). In 1952, Panofsky delivered ten lectures at Uppsala University on "The Renaissance Problem in the History of Art," and four of these lectures were subsequently revised and considerably expanded in his well-illustrated *Renaissance and Renascences in Western Art* (Stockholm, 1960; 2d ed., 1965). From the time he undertook work on his doctoral dissertation on Albrecht Dürer, submitted in 1914, the Classical tradition in the art of the West remained a major interest of this great humanist.

For many centuries the history of Europe has been divided into three periods: Antiquity, the Middle Ages, and the Modern Era, the latter ushered in by the Italian Renaissance. This scheme determines the curricula of our colleges and universities; it underlies the organization of our museums and Learned Societies; it plays a part in our everyday speech and thought. No matter where the main incisions are made (as a rule Antiquity ends approximately with the 5th Century A.D. while the Modern Era begins somewhere around 1400 in Italy and somewhere around 1500 in the countries north of the Alps): we generally conceive of history in terms of those

Reprinted with the permission of Mrs. Panofsky. This article, originally published in *The Kenyon Review* VI (1944), pp. 201–236, is now superseded by the author's book *Renaissance and Renascences in Western Art* (Stockholm, 1960; 2d rev. ed. Uppsala, 1965; Harper Torchbook, New York, 1969).

three periods and thereby accept the Italian Renaissance as a, quite literally, epoch-making event.

This system of periodization was, characteristically, evolved by the Renaissance itself, and it was summed up, about the middle of the 19th Century, by two great scholars, Jules Michelet of Paris and Jacob Burckhardt of Basle. However, their all-too-impressive characterization of the Renaissance as "the discovery of the world and of man"—apparently implying that the Middle Ages had not been aware of either —was bound to arouse opposition. Generations of scholars set out to prove what Michelet and Burckhardt had never seriously questioned: that the Italian Renaissance, howsoever defined, did not emerge like Athene from the head of Zeus. It was shown that innumerable tendencies, ideas, inventions and discoveries credited to the Modern Era had announced themselves in the Middle Ages; that, conversely, the Renaissance was connected with the Middle Ages by a thousand ties; and that the heritage of classical Antiquity had never been lost beyond recuperation. It was conceded that the threads of tradition had been very thin at times, but it was also realized that there had been vigorous revivals long before the "Medicean Age." Thus the Italian Renaissance seemed to have lost its uniqueness; and in recent years, there has been a growing tendency to discard the idea of periodization altogether and to perceive nothing but continuity. "Human nature," writes one of our most distinguished historians, "tends to remain much the same at all times" (which, however, does not prevent him from making a sharp distinction between what even he cannot help calling the Middle Ages and "distant Greece and Rome").

We are faced with three questions. First, was there such a thing as an Italian, or main, Renaissance which started some time in the 14th Century and reached a climax in the 16th and the 17th? Second, if so, had it been preceded by a compara-

tively steady development, or was it only the last and most effective of several analogous revivals? Third, if the latter, what is the difference between all these "renascences"? Do they differ from one another only in scale or also in structure? And, if they differ in structure, is it still justified to assign to the Italian, or main, Renaissance a special position in comparison with which the earlier revivals remain "mediaeval" phenomena even though they deserve the name of renascences?

As we now use it, the term Renaissance— Wiedererwachsung, as Albrecht Dürer translated it as early as about 1525— implies two apparently different ideas. In a wider sense, it denotes a rebirth of higher culture in general, presupposing, of course, that higher culture in general had been dead, or nearly dead, in the preceding period ("renatae literae, renata ars"). In a narrower sense, it denotes a rebirth of classical Antiquity following a complete, or nearly complete, breakdown of classical traditions ("rinascimento dell' antichità"). In the first or wider sense, Renaissance means a universal efflorescence of art, literature, philosophy, science and social accomplishments after a period of decay and stagnation; in the second or narrower sense, it means a creative form of classicism.

Since the notorious quarrel of the "Anciens et Modernes" in 17th Century France, the words "classicality"—let alone "classicism"—and "modernity" have come to express a seemingly irreconcilable contrast. But for the Renaissance itself—beginning with Petrarch, the first to formulate the notion of a "new era" dawning after an "age of darkness"—they were almost synonymous. True, when the writers' interests extended to the domains of art and natural science new elements were bound to enter the concept of rinascimento. Filippo Villani, writing about 1400, saw the revival of the plastic arts not so much in a reversion to Antiquity as in a

reversion to nature, from which they "had strayed away in childish fashion through the ignorance *(inscicia)* of the painters." And Leonardo emphasized, in addition to verisimilitude ("that picture is the most praiseworthy which most closely conforms to the thing it imitates"), the indispensability of a mathematical foundation ("whoever blames the supreme wisdom of mathematics feeds upon confusion"). But as yet no conflict was felt between the affirmation of naturalism and mathematical precision on the one hand, and the reaffirmation of classical standards on the other. On the contrary, in following nature instead of submitting to a conventional code of "rough" and "stiff" stylization, and in substituting a rational theory of proportions and perspective for "mere practice" and "uncontrolled caprice," the artists seemed to have regained what classical Antiquity had already possessed and what had been submerged only by the combined effects of barbarous invasion and ecclesiastical bigotry. The Renaissance believed its "modern" style *(maniera moderna)* to be nothing but the "good antique style" *(buona maniera antica,* ending with the reign of Constantine), revived in opposition to the "old style" *(maniera vecchia* as distinguished from *maniera antica)* of the "dark ages" *(le tenebre).*

We, too, will find it advisable to accept this admittedly one-sided identification of *"renatae literae, renata ars"* with *"rinascimento dell' antichità"* as a preliminary basis for discussion. In doing this, we can, for the time being, evade the ticklish questions of relevance and value. For even he who would deny that the Renaissance was an important, let alone a "fortunate," event may be brought to admit that it was a peculiarly intensive form of reversion to classical Antiquity. Further, we can legitimately confine our observations to the Western world. For, in the Byzantine sphere there was too much survival of classical traditions to admit of full-scale revivals;

Byzantium could and did serve as a permanent storehouse of "dehydrated" classical art forms and concepts, but it would never have reached a "Modern Era" even if the Turks had not marched in in 1452.

1.

It is no accident that the anti-Renaissancist attacks have mostly come from those who are not obliged to take a professional interest in the aesthetic aspect of civilization. The importance, or even the factuality, of the Italian Renaissance has been questioned by historians of economic and social developments, of political and religious situations and, most particularly, of natural science; but rarely by students of literature and hardly ever by historians of art.

It is indeed difficult to deny that Politian's description of, let us say, the Rape of Europa is more Ovidian than that of an anonymous French poet of about 1320, and this not in the letter but in spirit. Politian treats the original with no less freedom than the author of the *Ovide Moralisé* (he even appropriates several motifs from his mediaeval forerunner); and he, too, transposes the Latin hexameters into vernacular verse. But he is, like Ovid, voluptuously impassioned and poetic where the earlier poet is soberly descriptive and pedestrian. He conjures up the wind-swept vision of a classical myth where the poor Northerner gives a detailed and rambling account of an outlandish kidnapping story. The mere juxtaposition of the three texts will speak for itself.

Ovid (*Metamorphoses,* II, 870):

Cum deus a terra siccoque a litore sensim
Fissa pedum primis vestigia ponit in undis,
Inde abit ulterius, mediique per aequora
 ponti
Fert praedam, pavet haec litusque ablata
 relictum
Respicit, et dextra cornum tenet, altera
 dorso

Inposita est; tremulae sinuantur flamine
vestes.

Ovide Moralisé, II, 5051 ss.:

Tant a cil la bele enchantée
Que sor le dos li est montée
Cele, qui ne le cognoist pas.
Li dieus l'enporte pas pour pas,
Tant qu'il se boute en mer parfonde.
Des lors s'en court par la grant onde,
Et sor son dos sa prie emporte.
Trop s'esbahist et desconforte
La pucele, et trop a grant doute.
Le rivage esgardé et la route
Des puceles sor le rivage,
Qui grant doute ont en lor courage
De lor dame, que ravir voient:
Des oeulz en plorant la convoient.
La pucele biau se contient:
La corne a la destre main tient,
Et l'autre sor le dos li met.
Li dieus de nagier s'entremet,
Tant que mer passe. En Crete vient

Politian (*La Giostra*, I, sts. 105, 106):

Nell' altra in un formoso e bianco tauro
Si vede Giove per amor converso
Portarne il dolce suo ricco tesauro,
E lei volgere il viso al lito perso
In atto paventoso: e i be' crin d'auro
Scherzon nel petto per lo vento avverso:
La veste ondeggia e in drieto fa ritorno:
L' una man tien al dorso, e l'altra al corno.

Le ignude piante a se ristrette accoglie
Quasi temendo il mar che lei non bagne:
Tale atteggiata di paura e doglie
Par chiami in van le sue dolce compagne;
Le qual rimase tra fioretti e foglie
Dolenti 'Europa' ciascheduna piagne.
'Europa,' sona il lito, 'Europa, riedi' —
E'l tor nota, e talor gli bacia i piedi.

The difference, it is hoped, will be evi-
dent from a translation which is inten-
tionally literal. First the Ovid:

But now the god, little by little, sets the
cloven imprints of his feet into the first
waves, away from the land and the dry shore;
thence he goes farther, and carries his prize
through the waters of the high sea. She is
struck with terror and, borne away, looks
back to the relinquished shore; her right
hand grasps his horn, the other clings to his
back. Her fluttering garments billow in the
breeze.

Then the *Ovide Moralisé:*

So much has he charmed the beautiful one
that she has mounted on his back, she who
did not know him. The god carries her off
step by step until he plunges into the deep
sea. Then he runs through the big wave and
carries his prey off on his back. Greatly
stunned and discomfited is the damsel and
much in fear. She looks upon the shore and
upon the path of the maidens on the shore
who in their minds have great fear for their
mistress whom they see abducted; weeping,
they follow her with their eyes. The damsel
carries herself well, she holds his horn with
her right hand and places the other on his
back. The god sets out to swim so as to cross
the sea. He comes to Crete. . . .

And the Politian:

In the other [panel] one sees Jove, trans-
formed into a beautiful white bull by the
power of love, as he carries away his sweet
rich treasure; and her, in a posture of terror,
as she turns her face to the lost shore. Her
lovely golden hair plays upon her breast in
the contrary breeze, and her gown billows
and flutters back. One hand clings to his
back, the other to his horn.

She draws her bare feet close onto herself as
though afraid of the sea lest it might wet
them. Thus, crouching down with fear and
pain, she seems to call out in vain to her
sweet companions; but they have remained
amid the flowers and verdure and, grief-
stricken, each of them wails "Europa!"
"Europa," resounds the shore, "Europa, come
back!" And the bull swims on [or: looks
around?], and now and then he kisses her
feet.

In the domain of the Fine Arts—and we
should bear in mind that the very idea of
separating architecture, sculpture and

painting from the humbler crafts and skills, and of uniting them under the heading of "*arti del disegno*," is an innovation of the Italian Renaissance, utterly foreign to mediaeval thought—the resurgence of classicising tendencies is so evident that we are apt to dismiss it because of its very obviousness. We would no longer say that Cinquecento architecture, sculpture and painting are admirable because they conform to the standards of classical Antiquity, and that Gothic architecture, sculpture and painting are obnoxious because they do not. But we can hardly deny that, quite apart from the question of "better" or "worse," Palladio's Villa Rotonda (Fig. 2*) is more closely akin in form and essence to the Pantheon (Fig. 1) than the choir of Amiens Cathedral (Fig. 3) is to either; and that the same is true of Sansovino's *Bacchus* in relation to, let us say, the *Angel Gabriel* in Reims (Fig. 16, left) on the one hand, and the Apollo Belvedere on the other. And the point is that there was an interval of more than 1100 years between the Pantheon and Amiens Cathedral, and an interval of almost 1600 years between the Apollo Belvedere and the *Angel Gabriel*; whereas only about 300 years separate Amiens Cathedral and the *Angel Gabriel* from the Villa Rotonda and Sansovino's *Bacchus*, respectively. If we should insist on using Italian architecture and statuary for comparison we might refer to the Cathedrals of Orvieto or Milan instead of Amiens and Reims, in which case the chronological interval between Renaissance and Gothic would even shrink to a mere two hundred or one hundred years; and if we should stay in the North and substitute for Amiens and Reims the Parish Church at Annaberg in Saxony or the sculptures by Tilmann Riemenschneider this interval would be reduced to almost zero. Something fairly decisive, then, must have happened in Italy during the 15th Century.

Thus the historian of art and literature, at least, will have to admit the reality of an Italian Renaissance which, with surprising impetus, superseded a period of utter non-classicality. However, this period of utter non-classicality, which we call Gothic, had not come at the end of a steady decline of classical traditions. It had followed upon a phase of comparative classicism, and this in turn had been preceded by a succession of *rapprochements* and estrangements.

The first of these *rapprochements*, already emphasized by Antonio Manetti in the 15th Century, is known as the Carolingian revival. During and after the disruption of the Roman Empire the interrelated and overlapping processes of barbarization, orientalization and Christianization had indeed resulted in an almost general eclipse of classical culture. Oases were left, or established, in certain places in Italy, in the south of Gaul, in Spain and, especially, in the British Isles; but just those regions which were to form the nucleus of the Carolingian Empire represented, from the classical point of view, a cultural vacuum. As happens so often in history, it was precisely in this vacuum that could occur the conflux and fusion of forces which was to produce a new, specifically North-West European civilization; and chief among these forces was, naturally enough, the classical or, to speak more exactly, Roman heritage. When Charlemagne set out to reform political and ecclesiastical administration, communications, art, literature, scholarship, and even script, his guiding idea was the "*Renovatio Romani Imperii.*" He had to invite a Briton as his chief adviser in cultural matters, and his grandson had to enlist the help of an Irishman to obtain a good translation of Dionysius the Pseudo-Areopagite's Greek; but it all amounted, to quote from a contemporary writer, to an "*Aurea Roma iterum renovata.*"

* Illustrations accompanying this selection appear on pages 517 to 520.

The reality and magnitude of this movement cannot be questioned. In ninety-eight out of a hundred cases the fact that we can read the Latin poets, historians and scientists in the original is due to the industry of Carolingian scribes, for very few Roman classics seem to have been copied between about 600 and the end of the 8th Century. Nor can it be doubted that the Carolingian writers learned their lesson well. Their often excellent verses in classical meters fill four fat volumes of the *Monumenta Germaniae Historica,* and their ear became astonishingly sensitive to the refinements of Latin prose. Thanks to Charlemagne, writes Lupus of Ferrières about 835 to Eginhard, the biographer of the Great Emperor, the studies have raised their heads; now (meaning, under Louis the Pious whose reign struck Lupus as a let-down after the fervent beginnings) they are again disparaged, and writers "begin to stray from that dignity of Cicero and the other classics which the best of the Christian writers also sought to emulate." But in Eginhard's work—epoch-making indeed in that it reinstated biography as a fine art, taking Suetonius' *Lives of the Emperors* as a model—Lupus still finds "that elegance of meaning, that exquisiteness in the connection of ideas" which he admires in the classics (whom he simply calls *"auctores"*): "In it, I perceive sentences not encumbered and involved with overlong periods but perfect in their measured length."

In architecture, sculpture and painting the back-to-Rome movement had to compete with orientalizing tendencies on the one hand, and with insular influences on the other. For the same British Isles which had been the most important refuge of classical traditions in literature and scholarship had developed a revolutionarily anti-classical style in the arts of design. However, the presence of these opposing forces stimulated rather than weakened the energy of the revivalist impulse.

Charlemagne's Palace Chapel at Aix-la-Chapelle is, in a general way, patterned after the Early Byzantine Church of S. Vitale in Ravenna; but it received a west front suggested by Roman city gates, and its exterior was enlivened, not by the oriental blind-arcades as seen in S. Vitale but by Corinthian pilasters of anxiously classical cast. In the *Torhalle* at Lorsch (Fig. 4) the polychromatic facing of the wall harks back to the pre-Carolingian period; but its conception and structure—not to mention its orthodox composite capitals—presuppose the Arch of Constantine and, possibly, the Colosseum. The idea of incorporating towers with the basilica, so fundamentally important for the development of later ecclesiastical architecture, originated, it seems, in Asia Minor; but the plan of the basilica itself was programmatically revised *"Romano more,"* that is to say, after the fashion of the three great Roman Basilicas, St. Peter's, St. Paul's, and St. John's in the Lateran. For, from the Carolingian point of view, Constantinian architecture was no less but perhaps even more "classical" than the Pantheon or the Theatre of Marcellus—just as a *"Tulliana gravitas"* was found and greeted in the Christian Fathers.

In the representational arts—all but extinct on the pre-Carolingian continent—the spirit of classical Antiquity looms even larger. Stylistically, the vivacity of insular design remained a powerful influence throughout; but as far as the repertory of motifs is concerned, the fantastic interlaces and animal patterns of Irish-Anglo-saxon art were largely restricted to metal ornament and calligraphy, and the oriental component had been virtually neutralized by the beginning of the 9th Century. Instead the artists turned to the classical tradition as far as it was accessible to them—both physically and psychologically—in Roman gems and coins and, above all, in late-antique or Early Christian book illuminations and ivory carvings mostly of the 4th and 5th Centu-

ries; for, as could already be observed in architecture, no sharp distinction was made between pagan and Christian Antiquity.

Thus vegetal decoration began to rival with insular design even in the initials and ornament pages of illuminated manuscripts. Miniatures and ivory plaques were framed with egg-and-dart patterns, *rinceaux* borders or acanthus bands; and a determined effort was made to recapture the "illusionistic" values of Graeco-Roman art: to do justice to the human figure as a natural organism, to space as a three-dimensional medium, and to light as that which conditions the surface appearance of all solid bodies. For the greater part these "illusionistic" values had been lost or suppressed for several centuries; the Anglosaxon school had turned this loss into a gain by converting the figure and its environment into a rigidly stylized and superbly decorative pattern of planes and lines (Fig. 5); but on the pre-Carolingian continent figural representations, if attempted at all, verged upon the grotesque (Fig. 6).

Compared with such 8th Century renderings, the white-robed *Evangelists* in what may have been Charlemagne's personal Gospel Book, softly modelled and gracefully posed in front of a naturalistic landscape background, give an impression so deceptively antique that they have been ascribed—not quite convincingly—to artists from Byzantium (Fig. 7). The *Perseus* from a 9th Century manuscript in Leyden might almost have stepped out of a Pompeian mural (Fig. 17); and the hillocky scenery in the Utrecht Psalter, alive with classical buildings and personifications, bucolic animals and light-dissolved trees (Fig. 8), evokes the memory of Campanian *topographiae* and of the famous Odyssey Landscapes in the Vatican Library.

To mention classical personifications and Perseus is to hint at what is, from our point of view, perhaps the most important aspect of the Carolingian *renovatio*. Classical personifications of natural forces such as Oceanus and Tellus, Sol and Luna, Hiems and Aestas, Atlas and Orcus, had already been admitted to Biblical scenes in such Early Christian examples as the 5th Century archetype of the Utrecht Psalter; and classical personifications of human emotions such as Cupid and Jest, Ire and Patience, had been given active parts, also in the 5th Century, in Prudentius' *Psychomachia* (equally a favorite of Carolingian copyists), which describes the combat between the Christian Virtues and the Vices. But Perseus was an unregenerate pagan. Like all the other constellations and the planets—most of which we still designate by analogous appellations— he was, in name and appearance, a purely mythological character; in copying the illustrated *Aratea* manuscripts in which all these mythological pictures occur, the Carolingians showed a remarkable lack of Christian prejudice. They also copied numerous other illustrated books of a purely secular nature: treatises on zoology, botany and Roman public offices; the Comedies of Terence; calendars; and encyclopedias.

In short, in addition to reinstating classical motifs and methods of treatment the artists of the 9th Century revived what we shall henceforth refer to as classical "images": figures or groups of figures classical not only in form but also in content. And chief among these were the pictures of the Greek and Roman gods and demigods who thus came to be transmitted to the mediaeval world in their authentically pagan shape and form.

The Carolingian revival, which virtually ended with the death of Charles the Bald in 877, was followed, to borrow from C. R. Morey, by "a period as barren as the seventh century"; and this was succeeded by a new efflorescence which began, roughly speaking, a hundred years later. This new efflorescence is often spoken of as the "Ottonian Renaissance" with reference to its manifestations in Germany, and as the

"Anglosaxon Renaissance" with reference to its manifestations in England. But in spite of these sobriquets it does not concern us here. It was a revival in the sense of a recovery, but not in the sense of a reversion to classical Antiquity. The miniatures produced in the schools of Reichenau and Winchester, St. Bernward's bronze doors in Hildesheim, and the altar frontal given by Emperor Henry II to the Cathedral of Basle, all these resplendent works drew from sources one step removed from those which had inspired the Carolingian artists. They were based upon Carolingian art itself, upon the contemporary Byzantine production, and upon such Early Christian works as did not attempt to preserve the Graeco-Roman "illusionism." En reculant pour mieux sauter, the artists of around 1000 selected their models with an eye on the high-mediaeval future rather than on the classical past.

In the 12th Century, however, when art had reached the stage of Romanesque and theology the stage 'of scholasticism, we do find a renascence movement in the sense here under discussion; or, to be more exact, two parallel and contemporary renascence movements, both continuing into the 13th Century, both deliberately reverting to classical sources, but significantly different from one another in place as well as in the direction of interests.

One of these high-mediaeval renascence movements is known to art historians as "proto-Renaissance." In contrast to the Carolingian renovatio and the Ottonian and Anglosaxon recoveries, as they might be called, this "Proto-Renaissance" was a Mediterranean phenomenon, taking its inception in Southern France, especially in Provence (the ancient Provincia Romana) and in North Italy. In further contrast to the Carolingian revival, it approached the classical past not only more directly but also with an aspiration to monumentality. Architecture resumed, in addition to hitherto neglected details, the Roman techniques of vaulting large longi-

tudinal rooms. In the representational arts the interest shifted from book illumination, ivory carving, goldsmith's work, glyptography, and modelling in stucco to major sculpture in stone; and this drew inspiration from Roman, Gallo-Roman and, occasionally, even Greek statuary rather than from ivory plaques and miniatures of the 4th and 5th Centuries.

In its initial stages and on its original homeground, however, this "proto-Renaissance" style followed classical art in accidentals rather than in essence. In St.-Gilles, Arles and Autun, in Modena, Borgo San Donnino and Venice the Roman and Gallo-Roman models were imitated with respect to general composition, drapery motifs, facial types and surface texture (Figs. 9 and 10), but not as yet with an eye for those less tangible qualities which are in our minds when we speak of "classical beauty" or "classical perfection"; by which we mean the idealization of the human and animal form within the limits of the natural, the organic correspondence between the body and garment, and, most important, that freedom and balance of posture and movement—known as contrapposto—which gives the impression that the figure is self-sufficient or, in a quite literal sense, self-centered—crystallized around and controlled from a center or axis within itself.

Only when "proto-Renaissance" sculpture had been drawn into the orbit of an architecture which, though far from classical in all other respects, was based on the very principle of concentrating all mass around centers or axes—in other words, when the style of Romanesque Provence and Languedoc had wandered to Early-Gothic Ile-de-France and Champagne —only then did surface classicism, as it might be called, develop into intrinsic classicism. The Apostles in the Portal of the Last Judgment in Reims, especially the two magnificent, stylistically isolated figures of SS. Peter and Paul, are, in this sense, infinitely more classical than the Apostles of Arles and St.-Gilles, not to men-

tion the fact that the head of *St. Peter* bears an unmistakable physiognomical similarity to that of Antoninus Pius (Figs. 11 and 12). In the tympanum of the same portal the interest in classical Antiquity went so far as to suggest the inclusion of figures evidently patterned upon the reclining effigies on Roman sarcophagi and of two Resurrected rising from urns instead of from normal graves, implying that they had been buried according to pagan, not to Christian custom (Fig. 15). A climax of the development was reached in the famous Visitation group (Fig. 16), so classical in posture, costume, hairdress and facial type that it was long believed to be 16th Century work whereas its real date is toward 1230.

In Italy a similar climax was, characteristically, not reached until about a generation later. There is good reason to believe that the Campanian school called into life by Frederick II already drew from Early-Gothic as well as classical sources, and this assumption is a certainty in the case of the works by Nicola Pisano who, about 1260, included a slightly remodelled Dionysus among the witnesses of the Presentation of Christ (Figs. 13 and 14), transformed a Hercules into a personification of Christian Fortitude, and borrowed extensively from a Phaedra sarcophagus long accessible to but never exploited by the artists of Pisa. (Similarly another Roman sarcophagus, preserved at Reims from time immemorial, was suddenly "discovered" by one of the sculptors who, about 1225, decorated the capitals in the choir.)

Both in France and Italy, however, this "proto-Renaissance" was not to last. In Italy, Nicola Pisano's own son started a Gothic revolution (or counter-revolution), and it was from this less academic style rather than from the lingering traditions of Nicola's classicism, that arose the *"buona maniera moderna"* of Jacopo della Quercia and Donatello. In France, the classicism of the Reims *Visitation* was soon sub-merged by an altogether different current exemplified by the *Mary Annunciate* right next to the *Elizabeth* and exactly contemporary with it; and next to the *Mary Annunciate* there can be seen the figure of the *Angel Gabriel*, produced only about ten or fifteen years later, which is of pure High-Gothic style, without a trace of classicizing tendencies (Fig. 16). How High-Gothic ornament was purged of all such classical motifs as centaurs and sirens, how the acanthus was replaced by ivy, oak leaves and watercress, and how the Corinthian capital was anathematized, is known to all. To this High-Gothic development the "proto-Renaissance" had made a most important contribution, and it is not quite fair to speak of the classicism of Reims as a "frustrated" effort (it may be said, for instance, that the famous "Gothic sway" is nothing but a *contrapposto* in disguise). But the point is that the classical elements had been so completely absorbed in the process as to become entirely invisible.

The other renascence movement which sprang up in the 12th Century may be called "proto-humanism" as opposed to "proto-Renaissance." While the "proto-Renaissance" came into being in regions where the Antique was, and in a measure still is, an inherent element of civilization, always alive under the surface of subsequent developments, "proto-humanism" was centered in regions where the Antique was, and in a measure still is, an object of self-conscious enthusiasm rather than a natural heritage; it originated in the closely interconnected areas on either side of the Channel, viz., North France and England. Small wonder that here the interest in the classical world, rekindled at about the same time as in the Mediterranean South, was of an erudite and literary character and often took a genuinely antiquarian turn. "We are like dwarfs who have alighted on the shoulders of giants," said Bernard of Chartres; "we see more numerous and distant things, not by virtue of our

own keen vision or our own stature but because we are raised aloft by their gigantic magnitude."

An urge was felt to go back to the Greek fountainheads of philosophy and natural science. (It is revealing that even a purely theological text, the writings of Dionysius the Pseudo-Areopagite, was translated afresh about 1160, after three centuries had been satisfied with the translation made for Charles the Bald.) Enormous emphasis was placed on the study of the Roman classics, however secular, and on good Latin; and a vivid interest was taken, not only in the anecdotic content but also in the legendary and religious background of classical literature. It was in the same 12th Century that a poet from Britanny, Benoit de St.-More, retold the story of Troy in French, thereby making the world of Virgil accessible to mundane society, and that an English scholar, possibly Alexander Neckham, wrote the standard handbook of classical mythology, known as the "Mythographus III."

A novel enthusiasm was also aroused by the visible remains of Roman civilization; but until the "proto-Renaissance" movement had spread to Chartres and Reims, they appealed, significantly, to the curiosity and imagination of the scholar, connoisseur and poet rather than to the imitative instinct of the stone carver. There came into being an entirely new type of antiquarian literature as represented by the *Graphia Aureae Urbis Romae*, the *Mirabilia Urbis Romae* and the *Heraclius sive de coloribus Romanorum*. An English don, Magister Gregorius, not only admired and described the Roman antiquities, both buildings and sculptures, but also measured some of the edifices. Henry, Bishop of Winchester about 1150, acquired in Rome a number of statues made by pagan artists "*subtili et laborioso magis quam studioso errore*"; and Hildebert of Lavardin praised the ruins of the Eternal City in distichs so polished in form and sensitive in feeling that they were long ascribed to a poet of the 5th Century.

It will always remain a memorable fact that Guido Colonna had to turn to a Breton, and Petrarch to an Englishman, when they wished to acquaint their Italian countrymen with the gods and heroes of their own ancestors. But as for the Northern world itself, "proto-humanism" shared the fate of the "proto-Renaissance." In the course of the 13th and 14th Centuries the content of classical philosophy, historiography and poetry was as completely "absorbed" in the mediaeval system of thought and imagination as the classical *contrapposto* was in the "Gothic sway"—partly through scholastic reinterpretation (as was the case with Aristotle), partly through modernizing, often paraphrastic translation into the vernacular (as was the case with Livy, Valerius Maximus and ultimately Aristotle, too), and partly through the reckless superimposition of a "Christian" meaning (as was the case with Ovid and the Mythographers). Unlike Bernard of Chartres, John of Salisbury, Bernardus Silvestris, or Alanus ab Insulis, the great scholastics of the 13th and 14th Centuries no longer read, or cared to read, Cicero, Virgil and Horace in the original, and the days of classicizing verse-making were over. "Look for a [Latin] poet," says Hauréau, "you will not find a single one; the hexameter and the pentameter have gone out of fashion; little rhythmical pieces, now pious now obscene—that is the whole poetry of the time." In fact the very idea of Thomas Aquinas or William of Ockham writing a poem in elegiac couplets strikes one as almost ludicrous.

2.

Our two first questions, then, can safely be answered in the affirmative: there was an Italian, or main, Renaissance, and this was preceded by two earlier renascences. What remains is the third and more absorbing question as to the difference among these three.

The Carolingian men of letters, we remember, preserved, transcribed, emended and at times commented upon all classical

manuscripts within their reach and could write excellent Latin prose and verse. But none of them could have thought of composing an epic entitled "Venus and Adonis," a play about the Death of Orpheus or a pastoral staged in Arcady. Similarly, the Carolingian artists were skilful and interested enough to make successful copies of what we have termed classical "images"—figures, or groups of figures, in which classical form was happily united with classical content. But none of them could have thought of employing this treasury of images as a vocabulary with the aid of which new visual poems might be written. They would either leave such images in their original context, as when they copied entire illustrated manuscripts; or they would transfer them to another medium, as when they adorned an ivory fan with scenes from Virgil's *Bucolics* or a circular silver table—now lost—with a kind of celestial map; or they would carry them over, lock, stock and barrel, into a Christian narrative, as when the niches of the Evangelists were beset with simulated gems or when renderings of the Crucifixion were enriched by perfectly classical personifications of the Sun and the Moon, the Earth and the Ocean. But with this mere retention of classical images the matter ended.

The Jupiters and Perseuses in the Carolingian *Aratea* manuscripts, the Sols and Lunas in the Carolingian Crucifixion plaques, and the Atlases and River Gods in the Utrecht Psalter are classical enough in appearance and often very spirited in behavior; yet they have not attained the status of free agents. They are either confined, as an insect to a piece of amber, to the prison of an established context, or immobilized by having been transplanted to the foreign soil of a Christian narrative. It took Raphael and Titian to invent such compositions as *Jupiter Embracing Cupid* or *Perseus Delivering Andromeda* (Fig. 19)—compositions, that is, in which classical images, recreated rather than retained, are able to grow, to change and to mul-

tiply within what appears to be their native sphere.

To put it briefly: the Carolingians salvaged the classical sentences and concepts in their writings; and they were able to use them, as it were, by way of quotation. It was beyond their power and their wish to activate them.

The process of activation started with the "proto-Renaissance" and "proto-humanism" of the 12th Century. Now artists as well as poets began to "play around" with classical images and themes instead of merely salvaging them; but they did this under a peculiar condition the results of which strike the modern beholder at times as decidedly funny. When a 12th Century poem, such as Bernardus Silvestris' *Liber mathemathicus* or Alanus ab Insulis' *Anticlaudianus,* is written in classical meter and employs a studiedly classical vocabulary, it does not as a rule project its theme into the classical past but expresses the writer's own opinions and experiences. (It should be noted, in this connection, that even Hildebert of Lavardin is careful to justify the destruction of so much pagan beauty as a prerequisite for the victory of the Cross.) When, on the other hand, the writer deals with such subjects as the Trojan War or the stories of Ovid he prefers the vernacular—or at least a very non-classical Latin—and always characterizes the costume, manners, speech and environment of his characters in terms of purely mediaeval imagination.

A similar phenomenon can be observed in the representational arts. Wherever a sculptor or painter borrows a figure or a group from a classical work of art he almost invariably invests it with a non-classical, viz., Christian, meaning; conversely, wherever he borrows a theme from classical poetry, mythology or history he almost invariably presents it in a non-classical, viz., contemporary, form.

As for the mediaevalization of classical motifs by the infusion of Christian content, we need only remember the examples already adduced: the transformation of

Antoninus Pius into St. Peter, of Dionysus into a witness of the Presentation of Christ, of funerary effigies into the Resurrected, of Roman matrons and Phaedras into Virgin Marys (Figs. 11-16). On the façade of St. Mark's in Venice there can still be seen two large reliefs, walled in as companion pieces: one, a Roman work of the 3rd Century, depicts Hercules Carrying the Erymanthean Boar—the other, executed almost exactly one thousand years later, employs the same composition, suitably changed as to costume and attributes, for a representation of the Saviour Carrying the Human Soul in the Guise of a Stag.

The mediaevalization of classical subject matter by presentation in contemporary form could be exemplified by literally thousands of instances. Hector and Andromeda, Aeneas and Dido, Jason and Medea are represented as courtly knights and ladies fighting or disporting themselves in a mediaeval setting. Jupiter appears as a mediaeval ruler, his raven occasionally nimbed after the fashion of St. Gregory's dove. Europa sits on her harmless-looking bull in the 14th Century riding dress, and Thisbe waits for Pyramus on a Gothic tomb slab whose inscription *"Hic situs est Ninus rex"* is preceded by the then indispensable cross (Fig. 20).

After the Carolingian salvage of classical images, then, we have, beginning with the 12th Century, a revitalization of classical art forms within the limits of a non-classical program, and, on the other hand, a revitalization of classical subject matter within the limits of a non-classical mode of depiction. It may be thought that this curious dichotomy resulted only from the fact that the sculptors of St.-Gilles, Reims, Pisa and Venice worked from visual models whereas the illustrators of the Ovid paraphrases or the *Roman de Troie* had to rely on textual sources. This is of course both true and important. It can be shown, however, that a divorce of classical form from classical content took place, not only in the absence of a representational tra-

dition, but also in spite of a representational tradition still available. Even where the Carolingian salvage action had rescued those authentic classical "images" which still preserved a perfect union of classical form with classical content, this union was deliberately abandoned or even destroyed in the 13th and 14th Centuries.

The last Prudentius manuscript (which, incidentally, contains the Pyramus and Thisbe miniature reproduced in our Fig. 20) dates from 1289; then the tradition breaks off. The Carolingian Terence manuscripts, conscientiously reproducing the gestures, costumes and masks of the Roman stage, were copied—with their classical features gradually diluted but always recognizable—up to the end of the 12th Century; after that, there is a gap of more than two hundred years, and when the Comedies were illustrated again (first in the *Térence des Ducs* of ca. 1408) the pictures show 15th Century personages in a 15th Century setting. In the illustrations of astronomical texts, finally, the classical images, faithfully copied by the 9th Century artists, were retained, with changes limited to style, for approximately three hundred years. From the middle of the 13th Century, however, they, too, were replaced by entirely different ones, either borrowed—or rather re-borrowed—from Arabic sources or freely developed from textual descriptions. Thus the figures of the constellations wandered back to the West in a thoroughly orientalized and, if one may say so, de-mythologized form. Perseus, for instance, with his posture changed so as to conform more closely to the actual position of the stars and dressed up in oriental costume, looks like a Persian prince rather than a Greek hero (Fig. 18) and carries, owing to a visual misunderstanding, a demon's head instead of the *caput Medusae* (which, by the way, is why we speak today of the star Algol, *Ra's al Ghul* meaning "head of the demon"). The figures of the planets were even entirely discarded in favor of new ones, con-

structed on the basis of freshly imported astrological texts, so that Venus appears as a young lady smelling a rose, Jupiter as a rich gentleman with gloves in his hand, and Mercury as a Bishop (Fig. 21).

It was for the Italian Renaissance to reintegrate classical form with classical content, and it was by this reintegration that the classical images—first salvaged, then split asunder and finally recomposed—were really "reborn" (Fig. 19). But even in Italy, not to mention the Northern countries, the Gothic tradition did not succumb without a struggle. In the more conservative paintings, engravings and book illuminations of the Quattrocento (an instructive example being the well-known *Vergilius Riccardianus* of about 1470, which is more nearly akin to the mediaeval *Roman de Troie* manuscripts than to the Vatican Virgil of the 5th Century) Helen and Paris, Venus and Aeneas, Orpheus and the Maenads are still depicted *alla francese* and not *all'antica*. It took the energies of Mantegna, Pollaiuolo, Botticelli and other determined modernists to pave the way for Raphael, Correggio and Titian.

This would appear to answer the third of our questions. The two mediaeval renascences, the Carolingian revival on the one hand, and the "proto-Renaissance" and "proto-humanism" of the 12th and 13th Centuries on the other, differ not only in scale but also in structure. But they differ less essentially from one another than both of them differ from the Italian, or main, Renaissance. For, to put it very briefly, the two mediaeval renascences were limited and transitory, the Italian *"rinascimento dell' antichità"* was total and permanent.

The Carolingian renascence pervaded the whole of the Empire and left no sphere of civilization untouched. But it was limited in that its artistic activities did not as yet include major sculpture in stone; in that the models selected for imitation were, as a rule, productions of the minor arts and did not antedate the 4th and 5th Centuries; and in that classical concepts

and images were salvaged but not yet activated. The renascence of the 12th and 13th Centuries, on the other hand, sought and achieved monumentality, penetrated to the imitation of statues and reliefs of much higher antiquity, and emancipated classical concepts and images from what we have called their quotation status. But it was limited in that it represented only a special current within the larger stream of contemporary civilization and was restricted to certain particular regions; in that there was, according to these regions, a marked distinction between a recreative and a literary or antiquarian response to the Antique; and in that, in art as well as in literature, classical form and classical content were not assimilated or even retained as a unity. Both these renascences, finally, were transitory in that they were followed by periods of relative or—in the case of Gothic—nearly absolute estrangement from the classical past.

How things were changed by the Italian, or main, Renaissance can be illustrated by a small but significant incident. The manuscript the illustrations of which include the *Perseus* reproduced in Fig. 17 had been left untouched for about four hundred years. Then a well-meaning scribe saw fit to repeat the entire text in 13th Century script *(text illustration)*. He still could read the beautiful "Rustic Capital" of the 9th Century, but he evidently thought that it would stump his contemporaries and all future readers. But we, men of the 20th Century, find the Carolingian "Rustic Capital" much easier to read than his spiky "Gothic"; and this tells the whole story in

S UNT ALIAE STELLAE QUA CAUDA BELUA FLECTIT
Q VAQ CAPUT PISCIS MEDIA REGIONE LOCATAE
N ULLUM NOMEN HABENT NEC CAUSA E-NOMINIS ULLA
S ICTENUIS CUNCTIS IAM PENE EUANUIT ARDOR

S unt alie stelle qua cauda belua flectir.
Q naq capur pisas media regione loatsr
fl ullum nomen haborc nec cauda est n6is ulla
S ic tenuis cunctis iam pone euanuit ardor.

a nutshell. Our own script and letterpress derive from the Italian Renaissance types which had been patterned, in conscious defiance of the Gothic tradition, upon Carolingian models which in turn had been evolved on a classical basis. The "Gothic" script, one might say, symbolizes the transitory nature of both mediaeval renascences. Our modern script and letterpress proclaim the fact that the Italian Renaissance had come to stay.* Thereafter, the classical element in our civilization could be opposed (though it should not be forgotten that opposition is merely another form of dependence), but it could not disappear again. Even in Mannerism and Baroque, even in our own post-Impressionist era (see Maillol, Picasso, Chirico or Salvadore Dali) the amount of classicality is a matter of accent and interpretation rather than one of presence or absence. In the Middle Ages there was, in relation to classical Antiquity, a cyclical succession of assimilative and non-assimilative phases. From the Renaissance classical Antiquity is constantly with us, whether we like it or not. It lives in our mathematics and natural sciences. It has built our theatres and movie houses as opposed to the mediaeval mystery stage. It haunts the speech of our cab driver as opposed to that of the mediaeval peasant; and it is firmly entrenched behind the thin but thus far unbroken glass walls of history, philology and archaeology.

The rise of these three disciplines—utterly absent from the Middle Ages in spite of all the Carolingian and 12th Century "humanists"—evinces a truly fundamental difference between the mediaeval and the modern attitude toward classical Antiquity —a difference which makes us understand the essential strength and the essential weakness of both. In the Italian, or main,

Renaissance the classical past was looked upon from a fixed, unalterable distance, quite comparable to the distance between the eye and the object in that most characteristic invention of the same Renaissance, focussed perspective. As in perspective, this distance prohibited direct contact— owing to what may be called an ideal projection plane—but permitted a total and objectivized view. Such a distance is absent from both the mediaeval renascences.

The Carolingian revival had been started because it was felt that a great many things needed overhauling: the administrative system, the liturgy, the script, the Latin and the arts. When this was realized people turned to Antiquity—both pagan and Christian, and even with a strong initial emphasis on the latter—much as a man whose motor car had broken down and can neither be repaired nor replaced might fall back on a Lincoln 1928, inherited from his grandfather, which, when reconditioned (and let us not forget that the Carolingians constantly speak of *renovatio* and not of "rebirth"), will still give excellent service and may even prove more comfortable than the newer model had been. In other words, the Carolingians approached Antiquity with the feeling of legitimate heirs who had neglected or even forgotten their property for a time and now put it to precisely those uses for which it had been intended.

The high-mediaeval attitude toward classical Antiquity, on the other hand— just like that toward Judaism—is characterized by an ambivalence which we, having gone through the Italian *"rinascimento,"* find very hard to reexperience. The Old Testament was recognized as the foundation of the New, so that the Apostles —an interesting analogy to the above mentioned *aperçu* of Bernard of Chartres—

* It is amusing to note that even the Nazis had ultimately to give up an eight years' attempt to enforce the general use of the allegedly German "Gothic" and had to revert to the "normal," viz., classical script, not without claiming, of course, that this was in reality even more German in character (W. W. Schutz and B. de Sevin, *German Home Front*, London, 1943, p. 187).

could be represented on the shoulders of the Prophets. But at the same time, nay, on the same portal, the Synagogue could be depicted as a blind, benighted enemy, surmounting a Jew whose eyes are put out by the devil (Fig. 22). Similarly, there was, on the one hand, a sense of unbroken connection or even continuity with classical Antiquity, linking the mediaeval German Empire to Julius Caesar, mediaeval music to Pythagoras, mediaeval philosophy to Plato and Aristotle, mediaeval grammar to Donatus—and, on the other, the consciousness of an insurmountable gap that separated the Christian present from the pagan past. The classical sphere was not approached historically but naively, as something far-off yet still present and, for this very reason, both assimilable and potentially dangerous. It is significant that the classical philosophers and poets used to be depicted in the same oriental costume as the Jewish Prophets, and that the 13th Century spoke of the Romans and their monuments as *"sarrazin"*: heathenish in a quite contemporary sense.

For want of this perspective distance classical civilization could not be viewed as a coherent cultural system in which everything belonged together. On the contrary, every classical phenomenon, instead of belonging to all the other classical phenomena, had to have one point of contact, and also one point of divergence, with the mediaeval present; it had to satisfy both the sense of continuity and the feeling of opposition. Now we can see why the union of classical form and classical content, even if still retained in Carolingian times, was bound to break apart. To the mature mediaeval mind Jason and Medea were acceptable as long as they were represented as a knight and damsel playing chess in a Gothic chamber, and a classical goddess was acceptable as long as she did service as a Virgin Mary. But a classical Thisbe waiting by a classical mausoleum would have been an archaeological reconstruction incompatible with

the sense of continuity; and a Venus classical in form as well as content would have been a diabolical idol anathematized by the aversion to paganism.

This high-mediaeval ambivalence—as opposed to the Carolingian feeling of legitimacy—thus not only sharpened the interest in pagan monuments but also, under certain circumstances, the fear of them. The same Magister Gregorius who studied and measured the Roman antiquities with the detached curiosity of an antiquarian, and not with the acquisitive instinct of a Carolingian copyist, experienced with wonder and uneasiness the "magical" attraction *("magica quaedam persuasio")* of a too beautiful statue of Venus which compelled him to visit it three times although his lodgings were two miles away. It was, in fact, in the "proto-humanistic" 12th Century that there sprang up those truly terrifying legends, revived by Heinrich Heine and Prosper Mérimée, about the young man who put his ring on the finger of a classical Venus and thereby fell prey to the devil.

The "distance" created by the Italian, or main, Renaissance deprived Antiquity of this reality. The classical world ceased to be both a possession and a menace—and became, instead, the object of an everlasting nostalgia. Both the mediaeval renascences, regardless of the differences between the Carolingian *renovatio* and the revival movements of the 12th Century, were free from this nostalgia. Antiquity, like the old Lincoln in our homely simile, was still around, so to speak, and its parts could be salvaged or reappropriated whenever necessary. The Italian or main Renaissance came to realize that Antiquity—now *"Sacrosancta Vetustas,"* "hallowed Antiquity"—was a beautiful thing of the past, lost like Milton's paradise but capable of being regained by emulation and reconstruction *in toto*. Petrarch, the first in whom this new attitude became articulate, inveighs against the "Dark Ages" which separated him, irrevocably, from the clas-

sical past and sees the "dawn" of a new era precisely in such an attempt at total emulation and reconstruction. And by the middle of the 15th Century, when the dawn had come—or was believed to have come—we find the term *"medio evo,"* the "Middle Ages," which explicitly formulates and sanctions that all-important consciousness of "distance." Both in the 9th and in the 12th Centuries it would have been unthinkable—or, if thinkable, plainly heretical—to divide history into two eras of light separated by one of darkness, and thereby to affix the stigma of obscuration to the advent of Christianity. On the contrary, history was, and had to be, conceived as a continuous development from pagan darkness to Christian light: from the era "before the Law" through the era "under the Law" to the era "under Grace."

In sum, the Italian Renaissance looked upon classical Antiquity from a historical distance; therefore, for the first time, as upon a totality removed from the present; and therefore, for the first time, as upon an ideal to be longed for instead of a reality to be both utilized and feared. The pre-Gothic Middle Ages had left Antiquity unburied, and alternately galvanized and exorcized its body. The Renaissance stood weeping at its grave and tried to resurrect its soul. And in one fatally auspicious moment it succeeded. This is why the mediaeval concept of Antiquity was so concrete and, at the same time, so incomplete and distorted; whereas the modern one is, in a sense, abstract but more comprehensive and consistent. And this is why the mediaeval revivals were real but transitory whereas the Italian, or main, Renaissance was, in a sense, academic but permanent. Resurrected souls are somewhat intangible but they have the advantage of being immortal and omnipresent. Therefore the rôle of classical Antiquity in the modern world is a little elusive but, on the other hand, pervasive—and changeable only with a change in the form of our civilization as such.

3.

In conclusion, let us cast a fleeting glance upon the questions, happily evaded thus far, of relevance and value.

Since Ranke's dictum about the *Unmittelbarkeit* of every era in relation to God, historians are shy of statements to the effect that one period of history was "better" or "worse" than another. Such statements are indeed extremely tenuous, especially in the absence of a definite frame of reference; even this writer—who, as an art historian, would not hesitate to declare that, by and large, the 9th and 12th Centuries are "better" periods than the 7th or 10th—would be reluctant to contend that Bramante's St. Peter's and Michelangelo's Sistine Ceiling were "better" than Reims Cathedral and the stained-glass windows of Chartres. However, to deny that the Italian Renaissance wrought a change for the better is not tantamount to denying that it wrought a change that was relevant. Rather it is the very fundamentality of this change which makes it impossible to evaluate the Modern Era against the Middle Ages in terms of "better" or "worse."

One of the leading anti-Renaissancists has recently dismissed the relevance of the *"rinascimento dell'antichità"* by the following simile: "A girl of eighteen, dressed up in the clothes which her grandmother wore when a girl of eighteen, may look more like her grandmother as she was then than her grandmother herself looks now. But she will not feel or act as her grandmother did half a century ago." Taking up this simile, we may answer: If this girl decides to adopt the clothes of her grandmother for good and wears them all the time in the serious conviction that they are more appropriate and becoming than those she used to wear before, this very decision not only indicates but actually presupposes a change in her whole personality and way of life—a change not sufficient to make her a duplicate of her grandmother (which no one has claimed to be true of

the Renaissance period in relation to classical Antiquity), but basic enough to make her "feel and act" quite differently from the way she did as long as she believed in slacks and polo shirts.

However, the Renaissance was not a change of costume but a change of consciousness. From Petrarch on, the world was sure that history had entered a new phase; and, to quote from an instructive essay by T. E. Mommsen, "it is precisely this notion of a 'new time' which distinguishes the Italian Renaissance from all the so-called earlier 'Renaissances.'" Here, then, we have at least a "notion," a novel view men took of themselves and their historical situation, and not a mere masquerade. But for those historians who refuse to consider "intangibles" a "notion" is even less convincing than a change of costume. According to them the fact that the Renaissance believed itself to be a new era does not prove that it was one. The men of the Renaissance, it is argued, simply deluded themselves as well as posterity, and did not even scruple to minimize the accomplishments of their mediaeval forerunners. For—and this is the decisive argument—practically all the attitudes, inventions and discoveries which have been credited to the "new era" already existed during the Middle Ages, except for the fact that in the Renaissance there was a little more of them.

The Renaissance, it has been said, cannot be hailed as a period in which the individual became more autonomous and conscious of himself, for mediaeval artists signed their works on very many occasions. Classical philology and archaeology were nothing new, for Lupus of Ferrières, as we well know, collated manuscripts under Louis the Pious and Magister Gregorius measured the Pantheon about 1200. Awakening of a feeling for nature? Marbod of Rennes wrote a charming poem on his little country place at the beginning of the 12th Century, and Bishops and professors climbed mountains long before Petrarch's "epoch-making" ascent of Mont Ventoux. Revolution of natural science? Nicole Oresme taught the heliocentric system as early as in the 14th Century; and Robert Grosseteste and Roger Bacon had telescopes even in the 13th.

Now there are certain things which thus far have not been shown to exist in the Middle Ages, and they happen to be precisely those which may well be construed as manifestations of a trend toward individualism on the one hand, and of an increasing interest in a scientific approach to nature on the other: quantitative experimentation in physics; anatomy by actual dissection; a theory of art which was no longer a code of generally accepted rules but a rational discipline equipping the artist for his individual encounter with reality (especially focussed perspective which subjects the picture to a mathematical construction and yet allows the painter to determine the premises of this construction at will); book printing and the techniques of woodcut and engraving by means of which one man could disseminate his ideas or inventions all over the world. But let us assume that even these accomplishments could be shown to have existed in the Middle Ages: what would it prove?

As the difference between the Crusades and the earlier pilgrimages to Jerusalem is not so much a question of numbers as a question of purpose and effect, so the difference between the Modern Era and the Middle Ages is not whether there were more and better telescopes about 1620 than about 1260 but for what purpose and with what effect they were used. And here, indeed, the contrast is enormous. Grosseteste used his, as he informs us himself, to read inscriptions at an unbelievable distance and to count the ears in far-off cornfields. Galileo used his to investigate the universe. In other words, if you hand a telescope to the 13th Century nothing happens at all; if you hand it to the 17th there will ensue a new interpretation of the world which will lead to the idea of the

infinity of interstellar space—whereas Grosseteste wrote a special treatise to prove that the universe was finite—and ultimately endanger the position of God. If you teach the heliocentric system in 1370 nobody cares, not even the Church (Oresme died, unmolested, as Bishop of Lisieux); if you do it two hundred years later you will encounter serious trouble because you will have started a revolution of thought.

Why is it that the same things were effective or, from an ecclesiastical point of view, dangerous in the Renaissance while they were ineffective or harmless in the Middle Ages? Because, pace so many distinguished colleagues, circumstances— and that means, in history, the minds of men—had changed after all. The printing press had made accessible to all what had previously reached only a few. Social problems had assumed a personal and psychological rather than collective and practical character. (A sentence like Dürer's "Here in Venice I am a gentleman, at home I am a parasite" could not have been written by any mediaeval painter.) In short, the individual had in fact become intensely conscious of his more independent and, for this very reason, more problematic position in relation to God, society and his own self.

This can be demonstrated, not by trying to prove that more and longer pastorals were written in the 16th Century than in the 12th, but by pointing out that Sannazaro's Arcadia and Tasso's Aminta are pervaded by a spirit of "sweetly sad" longing for the innocence and bliss of nature which amounts to a negation of all mediaeval ideas as to the destination of man (from this point of view Petrarch's ascent of Mont Ventoux remains a memorable event, not because he was the first to undertake such a venture but because he was the first to be sentimental about it); not by trying to prove that more and sounder information about the classical deities is found in Gyraldus' Syntagmata than in the

"Mythographus III" or in the Gesta regum Anglorum by William of Malmesbury, but by pointing out that Titian and Shakespeare looked upon Venus neither as an antiquarian curiosity nor as a heathenish demon but as a poetic reality; not by trying to prove that more and greater artists signed their works about 1500 than about 1300—which is not even true because the greatest often felt that the very personality of their style made a signature superfluous —but by pointing out that the artist of the Renaissance, whether signing or not, represented a type of person simply unknown in the Middle Ages.

In the Middle Ages a painter could be a good painter or a bad painter, and he could be a sinner or, in exceptional cases, a saint. But he could not be a "scientist" basing himself, as Leonardo demanded, on mathematics and experiment. And on no account could he be a genius. He was credited with the power to produce, like every human being possessed of reason and a healthy body, but not with the power to "create"; for creation was the prerogative of God. This truly revolutionary idea did not appear until the 15th and 16th Centuries when people began to talk of "inspiration" with reference to the poet and the artist, when Michelangelo (who signed only one work in all his life) was called "divino" and when Dürer asserted that a good painter, creating "every day new shapes of men and creatures the like of which was never seen before nor thought of by any other man," had an "equality to God." Psychologically and sociologically the modern artist did not become any happier by this promotion, and it is no accident that the very notion of creative genius was bound up, from its very inception, with the idea of melancholy. But he certainly began to work, to live and to be looked upon in a spirit essentially different from that of the Middle Ages.

A favorite humanistic symbol of the artist was Prometheus, and a favorite humanistic symbol of man in general was, accord-

ingly, Hercules. We all remember the classical story of Hercules at the Crossroads, obliged to make his choice between Virtue and Pleasure (or Vice) and deciding for the former. One wonders why this eminently moral story, though transmitted by such popular and respectable authors as Cicero, was never illustrated or even quoted in the Middle Ages. The answer is: just because it is such an eminently moral story, that is to say, because it places the ideas of good and evil on an entirely human plane. In the Middle Ages there was no Virtue, for that would have meant a kind of perfection within the limits of the terrestrial world. There were only virtues derived from the one Virtue that is Christ. And consequently there was no human being free to make an autonomous decision between Virtue and Vice but only one free to accept or to reject the grace of God— free, not to walk this way or that, but to allow himself to be carried away by either an angel or a devil.

If one wants to perceive, at one glance, the difference between the Middle Ages and the Renaissance one may compare Sebastian Brant's *Fools' Ship* of 1494 with Erasmus of Rotterdam's *Praise of Folly* of 1512. Brant, without a trace of tolerance or irony, inveighs against more than a hundred kinds of human folly, firmly convinced that he is right and that everybody else is wrong. Erasmus also ridicules human folly. But he, the most intelligent man of the century, does this by pretending to speak in the name of Folly herself. Whatever is said must therefore be interpreted as his opinion as well as hers. In one of the chapters Erasmus—or Folly—thus assails, apparently as grimly serious as Brant, the foolishness of old women still going to drinking parties, still using make-up, still hiring gigolos, still removing hair from the strangest places. But what is the conclusion? "Such capers are laughed at by everyone, and with good reason, as being the silliest in the world. Yet the old ladies are satisfied with themselves, and in the mean time they swim in pleasure and anoint themselves all over with honey; they are happy, in a word, by courtesy of me. And as for the people who find it all too ridiculous, I want them to mull over the question whether it is not better to lead this sort of honeyed life in folly than to look for a rafter, as the phrase goes, suitable for a hanging." Folly, then, first attacks foolishness and then defends it. Being Folly, her attack should really mean justification and her defense the opposite. But since she speaks in the name of Erasmus as well as in her own it also works out the other way: the attack may be serious but no less serious would then be the defense—the insight into the fact that "to be engrossed in folly, to err, to be deceived, not to know" is simply "to live as a man."

In an ironical double-twist like this there does appear a humanism—and a humanity —utterly foreign to the Middle Ages. In the Middle Ages reason could question faith and faith could question reason. But reason could not question itself and yet emerge with wisdom—even though Robert Grosseteste had a telescope.

Unit Ideas

17 Ad Imaginem Dei: The Image of Man in Mediaeval Art

GERHART B. LADNER

Gerhart Ladner is an internationally renowned scholar uniquely qualified in two distinct fields of inquiry, history as well as art history. Born in Vienna in 1905, he studied those two subjects at the University of Vienna, where he received his Ph. D. under the art historian Julius von Schlosser in 1930. His dissertation on Italian painting of the 11th century was published in the *Jahrbuch der kunsthistorischen Sammlungen in Wien*, n. s. V (1931) pp. 33–160. From 1931 to 1933, Ladner was secretary of the Austrian Commission of Historical Iconography of the Comité International des Sciences Historiques, and from 1933 to 1938, he was a Fellow of the Austrian Historical Institute in Rome. Since 1938, he has taught medieval history at the University of Toronto and the Pontifical Institute of Medieval Studies affiliated with it, Notre Dame and Fordham universities, and, since 1963, the University of California at Los Angeles. He has been a member of the Institute for Advanced Studies at Princeton, a Guggenheim Fellow, and a Bollingen Fellow, and has been named Faculty Research Lecturer for 1971 at the University of California.

Ladner's interests cover many areas of inquiry, especially the general history of ideas, the relation of church and state in the Middle Ages, Byzantine iconoclasm and image theory, papal portraiture, iconography, and other aspects of art history. His five books and nearly fifty papers (through 1968) testify to his extraordinary learnedness, scholarly imagination, and humanism. In 1941, he began publication of the fundamental corpus of papal portraiture of antiquity and the Middle Ages (*I ritratti dei papi nell'antichità e nel medioevo* [Vatican]). His other art historical contributions include important papers on the mosaics and frescoes of the medieval Lateran palace in Rome (in *Rivista di archeologia cristiana* XII [1934], pp. 35–70), the concept of the image in Byzantine iconoclasm (1931, 1940, 1953, 1959), the square nimbus in art (in *Mediaeval Studies* III [1941], pp. 15–41), the symbolism of the cross in the writings of St. Gregory of Nyssa and St. Augustine (in *Late Classical and Mediaeval Studies in Honor of Albert M. Friend, Jr.*, ed. Kurt Weitzmann [Princeton, 1955], pp. 88–95), vegetation symbolism and the concept of the Renaissance (in *De Artibus Opuscula XL: Essays in Honor of Erwin Panofsky*, ed. Millard Meiss [New York, 1961], pp. 303–22), and a host of papers on medieval portraiture. His *Idea of Reform: Its Impact on Christian Thought and Action in the Age of the Fathers* (Cambridge, Mass., 1959) is a masterly monograph that earned the Haskins Gold Medal of the Medieval Academy of America in 1961 (rev. 1967 in a Harper Torchbook ed.). In this profound study, Ladner focuses especially on the concept of man's image-likeness with God, as expounded in Genesis I: 26–27, and the divers interpretations of this idea by the Church Fathers. In the Wimmer Memorial Lecture of 1962 at Saint Vincent College, Latrobe, Pennsylvania, he traced the development of medieval formulations of the concept from early Christianity to Bernard of Clairvaux and tried to relate this development to visual images of the human figure as they were created during the same period, advancing the thesis that the Christian doctrine of man's image-likeness with God may be reflected in the representation of man in art. His lecture was published as *Ad Imaginem Dei: The Image of Man in Mediaeval Art* (Latrobe, Pa., 1965), which appears below.

Reprinted from Gerhart B. Ladner, *Ad Imaginem Dei: The Image of Man in Mediaeval Art*, "Wimmer Lecture, 1962" (Latrobe, Pa.: The Archabbey Press, 1965).

Another eminent medieval art historian has said that this little book "should be read by every historian of mediaeval art" (Ernst Kitzinger). While realizing that "a direct causal nexus between . . . theological views and the practice of art can not be established," Ladner maintains that "these views and their vicissitudes represent attitudes of the mind which among other things nourished the conception of the human image which can be perceived in the works of art themselves." Thus his methodology brings to mind that of Erwin Panofsky's *Gothic Architecture and Scholasticism* (Latrobe, Pa., 1951; Meridian Book), which likewise was initially delivered as a Wimmer Memorial Lecture. While the books of both men disclose an intimate knowledge of art as well as medieval literature and philosophy, Ladner's *Ad Imaginem Dei* interprets material produced over a much longer span of time—art and literature that nonetheless, as in the case of Panofsky's book, are dealt with from a challenging and unified point of view. Such bold studies, so rare in contemporary scholarship, demonstrate how the gulf that currently exists between art history and other humanistic disciplines can be bridged in a meaningful, relevant manner.

In the Middle Ages the central tenet of Christian theology was also the greatest justification of Christian art. It was the Incarnation which made religious art legitimate. We may assume that a realization of this fact tended to void the Old Testament prohibition of images of God and man which was still operative in the first two centuries of the Christian era and which delayed the rise of Christian art. The elaborate explication of the consequences which the doctrine of the Incarnation had for art we owe to the anti-iconoclastic Byzantine theologians of the eighth and ninth centuries, but incarnational thinking no doubt underlies the practice of a specifically Christian art since its beginnings in the late third century. In such an art Christ must necessarily be the most important figure. His visualization was possible because He had become man. *A fortiori* it was possible for all men to be represented in art, for man was not only created in the image and likeness of God, but also renewed, reformed in the image-likeness of Christ, who as the perfect image of God had nevertheless assumed a human body.[1]

As early as the late second century we find in St. Irenaeus a theory of divine-human image-likeness according to Genesis 1:26[2] which seems to be a perfect expression of the spirit of earliest Christian art, if not a presupposition for its possibility. "In previous times," that is to say, before the coming of Christ, Irenaeus writes, "man . . . was said to have been made according to the image of God, but he was not shown as such. For the Word according to Whose image man was made was still invisible. . . . But when the Word of God was made flesh . . . He truly showed the image by becoming what His image was. . . ."[3] The emphasis is here clearly on the visible showing of the image through Christ's Incarnation; before that event the image of God had not been visible either in Christ or in man.

Tertullian's view is similar to that of Irenaeus. He holds that when God formed man, he already thought of the Incarnation and that the divine image-likeness then received by Adam was a likeness to the future Christ Incarnate.[4]

On the basis of such an interpretation of the doctrine of the image-likeness between man and God one cannot expect, and one actually does not find, in the earliest works of Christian art an image of man which essentially differs in its appearance from that which was more or less common to the late classical artistic milieu. No attempt was made to represent in the image

of man or of Christ as man anything but their human nature, a nature which Christ had found worthy of assumption. This also implied—and I am only referring to a generally known fact—that the iconographic and stylistic formulas used by early Christian art to render the appearance of Christ Incarnate and of Christian man were at first the same as those used by the pagan artists for pagan gods and men.[5]

A motif much favored by late pagan and by earliest Christian funeral art on third- and fourth-century sarcophagi was that of the sage or philosopher shown in the act of reading or teaching.[6] These figures are often, but not always, portraits. They are represented either as standing en face or more impressively as seated on a chair, as in the so-called Plotinus sarcophagus (Fig. 1);*[7] in sarcophagi of this latter type the profile or near-profile view is more usual (Torlonia sarcophagus, Fig. 2).[8] These compositions are of great interest since they not only foreshadowed certain types of the image of the Christian saint, especially of evangelists, apostles, and prophets, but also contributed to the formation of the earliest iconography of Christ Himself.

In the earliest period of Christian art the similarity between the Christian and pagan image of man is so great that it is impossible to decide in the case of the philosopher figures whether they have a Christian or a pagan meaning except when they are accompanied by strictly biblical scenes, as in the sarcophagus of S. Maria Antiqua (Fig. 3).[9]

It is well established that the motif of the reading, teaching, or pondering philosopher on these Christian and pagan sarcophagi is an adaptation of an old classical scheme used for portraits of philosophers, poets, and authors in general. The poet inspired by his Muse, as seen, for instance, in the sarcophagus of M. Sempronius Nicocrates in the British Museum (Fig. 4),

was a variant of this motif. This variant could be translated into a group consisting of a pagan or Christian sage with a female disciple, which is found, for example, in the sarcophagus of the Palazzo Sanseverino.[10]

What matters most in our context is the fact that on sarcophagi which were definitely Christian, such as the late third- or early fourth-century sarcophagus in the Museum of Velletri (Fig. 5),[11] just as on pagan ones, the artists in representing the perfect sage or the pious woman used the types of the corporeal image of man created by Graeco-Roman classical art which, in spite of all variations, still constituted a generally recognized idiom in which the natural though idealized appearance of the human species could be expressed. At times new expressions of peace and holiness or of expectation and awe seem indeed to hover over the faces even of the earliest Christian figures (Figs. 3, 5, 8, 9, 10),[12] but all this is not sufficiently pronounced to distinguish these types, and even the portraits, clearly from contemporary specimens of pagan art such as certain reliefs from the Arch of Constantine or the Cornutus group in the Vatican (Figs. 6, 7).[13] And this, to repeat it, is not surprising. Image-likeness with God was the essence of Christian man, but we have learnt from the texts of Irenaeus and Tertullian that this image relation could be seen in terms of the incarnational body of Christ, which is of the same nature as the body of every man.

The conclusions so far reached are confirmed by even the most cursory glance at the earliest images of Christ Himself. The crucial point here is that no effort was made to represent the God-Man in a radically more spiritualized way than ordinary man; there was no attempt in any way to suggest Christ's own image relationship to God the Father, which is purely spiritual. In this connection it is of the greatest

* Illustrations accompanying this selection appear on pages 521 to 528.

significance that one of the earliest icono-graphic types of Christ is closely linked to that of the Christian philosopher and therefore indirectly also to that of the pagan philosopher.[14] In a relief of the sec-ond half of the third century in the Palazzo dei Conservatori (Fig. 8), the facial types of the Christian philosopher and of Christ are practically identical.[15] Similarly, the earliest representation of Christ as teacher, in the scene showing the Sermon on the Mount on the polychrome relief fragments of the Museo delle Terme of c. 300 (Fig. 9),[15a] is almost certainly derived from a classical relief or statue of a philos-opher.[16] In both cases the type of Christ is the type of a perfect and even God-like man, but still of a man.[17]

We now turn from the image of Christ and of Christians to the scene of the crea-tion of man. One of the earliest examples of the making of the first man is found on the so-called dogmatic sarcophagus (of the beginning of the fourth century [Fig. 10][18]) in the Lateran Museum (no. 104). Here the first scene in the upper register shows the creation of the first man and woman by the Divine Trinity, with all three persons shown as bearded men of identical facial type. For a long time this attempt to portray the whole Trinity in human form was to remain almost unique.[19] More often early Christian art, in conformity with Holy Scripture and patristic theology, repre-sented God the Creator in the guise of the Word through which He created every-thing, that is to say, as the Logos, as Christ.[20] A striking example of this prac-tice can be seen in the very next scene of the same Lateran sarcophagus, where God, standing between Adam and Eve after the fall, has the same beardless features as Christ in the scenes of His terrestrial life which are shown in the other reliefs of the sarcophagus.

It is worthwhile to note that from the earliest times in the history of Christian art the creation of man could be visualized as being carried out by a God who appears in human form. This must not be simply taken for granted; often enough in Chris-tian art of the fourth and subsequent cen-turies an act of God is expressed in a merely symbolic fashion, for instance, by a hand reaching down from the highest heaven. This is the case even in one ver-sion of the story of the creation of man, which we know only from Byzantine Octateuchs of the Middle Ages (Fig. 11), but which probably goes back to the Hel-lenistic-Jewish illustration of the Septua-gint.[21] It would seem at any rate that the Christian iconography of man's creation was at least in one of its roots related to that aspect of Christian doctrine on man's image-likeness to God which was form-ulated most clearly by Irenaeus, by Tertul-lian, and even as late as c. 300 by Method-ius of Olympus.[22] In the history of art as well as of doctrine this conception of the image of man may perhaps best be called incarnational.[23]

But this, of course, was not the only aspect either of early Christian and medi-aeval image doctrine or of the correspond-ing imagery of God and man. Though the incarnational aspect was not to disappear, there was also a second and equally impor-tant one which may be called the spiritual aspect. It too is very old and found its first clear doctrinal formulation in Clement of Alexandria, who said in *Stromata V*, 14: ". . . image of God is the divine Logos . . . , but image of the image is the *mind* of man."[24]

For Clement, then, the image relation between man and God is purely spiritual, an epochal doctrine later taken up by Origen, Gregory of Nyssa, Ambrose, Au-gustine, in fact, by almost all of the Fathers. We may note here, however, that in this conception of image-likeness the Greek Fathers—and above all Gregory of Nyssa—attributed a very important role to man's freedom to opt for the good or the bad, for the spiritual or the merely mate-rial.[24a] This to them was an essential part of his dignity as man—a thought which in

the west we shall not find so clearly expressed until the age of Bernard of Clairvaux. Furthermore, according to Clement and Origen and many of their intellectual progeny, an important difference exists between image and likeness. The *eikon*, the image, is the state or condition of primitive creational integrity; the *homoiosis*, the likeness or similitude, was given to man at the time of his creation only potentially, as a disposition still to be fulfilled. The Greek Fathers ever so often compared man's re-assimilation to the image of God after the fall to the cleansing of a painting, spoiled, but not completely ruined, by the application of wrong colors or by the accumulation of dirt. According to Origen, man must implore God to delete all these accretions so that the image will shine again in its creational splendor. It will then become as close to its divine archetype as an image in a cleansed and polished mirror. This is a favorite metaphor of Gregory of Nyssa, in which he made use of Plato's and perhaps also of Plotinus' mirror similes. Man's soul finally was likened to a sculpture the form of which had to be separated from the rock of brute matter, carved out and smoothed until it conformed to the thought of the supreme artist—thus again Gregory of Nyssa in the tracks of Plotinus' first *Ennead*.

In all these comparisons similarity is the term of reference which links the man-God relation to the image-prototype relation. In the man-God relationship this similarity is conceived as purely spiritual. Also, creational and incarnational image-likeness between God and man is stressed less than man's reform toward that same image-likeness, a reformation which will culminate in the resurrection of a real but spiritual body.[25]

The question now arises of what repercussions, if any, this spiritual conception of the image-likeness between God and man had on early Christian and mediaeval art.

The painter and mirror metaphors certainly show that physical similarity between an image of man and man himself still loomed very large in the view of the figurative arts which Christianity had inherited from classical antiquity. And yet, the strong and repeated emphasis on cleansing and polishing, on the removal of wrong colors in painting and of brute matter in sculpture, manifests a certain "etherealization" of the concept of the image which corresponds with that spiritualization of late ancient illusionism, which one meets in art at least from the fifth century onward, in such works as the mosaic image of St. Ambrose in the Chapel of St. Victor at St. Ambrogio in Milan (Fig. 14).[26]

In Byzantine art the double concern with the preservation or revival of classical and early Christian illusionism on the one hand, and the formulation of an abstract hieratic style on the other, is even more obvious. The quasi-sacramental role of the sacred icons made it absolutely necessary that images of man, from Christ Incarnate down to the simple Christian, should make visibly and clearly manifest both corporeal humanity and divine spirituality. The image of Christ above all was believed to be in actual contact with Him in His divine-human unified person through the faithful rendering of a hallowed type of His physical appearance.[27] It was the peculiar greatness of Byzantine art that it was able to evoke most vividly the spiritual and supranatural without ever completely discarding the natural and incarnational. The complementary character of the hieratic and the illusionistic elements can be observed, for instance, in the typical twelfth century Pantocrator image of Cefalù (Fig. 12).[28] Even the most illusionistic images of saints or angels (Vision of Ezekiel in the ninth-century Gregory Nazianzen manuscript of Paris, Fig. 13)[29] are raised to a supra-naturalistic level by characteristic moods of poignant loveliness or serene dignity which point

beyond natural beauty; while on the other hand even the most hieratic effigies of Christ or of saints and ordinary mortals (seventh-century mosaic of St. Demetrius and donors at St. Demetrius in Salonika, Fig. 15)[30] preserve a basic amount of residual naturalism.[31] In a sense the image of man in Byzantine art is the perfect artistic expression of the *spiritual* aspect of the doctrine of image-likeness between God and man. For, without ever quite giving up the natural substratum of the human body, it manages negatively by dematerialization and positively by mood and manner to express through bodily form the presence of the immaterial soul, and the whole realm of spirit to which it belongs. All this is in full accordance with the Greek Christian conception of the body and of the soul's function in regard to it. To use the terminology of St. Basil the Great, the soul must rid the body of all *polysarkia*,[32] that is to say, of the all too carnal; it must restore the body as far as possible to that spiritual beauty which it had possessed in its first creation in the mind of God and which it will again possess fully and permanently in the resurrection.

In the West, too, the view that image-likeness with God is to be sought in the mind was the prevailing one among both the Fathers and the mediaeval theologians. St. Augustine formulated it very clearly,[33] but he also gave it important new and lasting modifications. First, he stressed the rational character of the creational image more strongly than its freedom; as to full and true liberty, he almost identified it with the effects of divine grace. Secondly, he established a far-reaching analogy between the ternary structure of the human soul and the divine Trinity. Man is a Trinitarian image because in him memory or consciousness of self corresponds to the Father, intelligence to the Son, and will or love to the Holy Spirit.[34] This doctrine of human-divine image-likeness is so obviously analogical that there is less place for that tremendous emphasis on similarity

and assimilation of man to God which is found in the Greek Fathers.

Nevertheless, the idea of similarity remains important to Augustine, but he adds new shades of meaning to it. He sees the whole world built up from numbers. The numbers which can be perceived in things of nature and art constitute an aspect of the forms of these things. They are derived from the supra-corporeal "intellectual" numbers which are immediate to God. On the highest, inner-Trinitarian, level similarity is the same as numerical equality. In nature and art it often amounts to numerical proportion between parts or between the whole and its parts.[35] The concept of similarity can thus be moved to the realm of mathematical beauty; and there can be little doubt that in the West thinking along Augustinian lines encouraged an abstract view of everything connected with the concept of the image.

Increasing abstractness of the image of man can be observed in early mediaeval western art, even in those areas where early Christian and Byzantine traditions and influences were particularly strong such as they were in Rome. This may be illustrated by examples from papal portrait iconography of the sixth to the ninth century where, in images of Pelagius II (Fig. 16), Gregory the Great (Fig. 17), John VII (Fig. 18), and Paschal I (Fig. 19), increasing triangularity of the faces can be clearly perceived.[36]

It is impossible, however, to measure exactly the effect of the Augustinian theory of the image and of similarity and, in particular, of his version of the doctrine of human-divine image-likeness, on early mediaeval western art as a whole. It is often difficult to isolate significant western traits from the recurrent influence of the Byzantine image of man; the latter's strong spiritual elements could also, as we have seen, tend toward abstract expression, though of a somewhat different kind. Furthermore, the western Barbarian peoples entered Christian history with an

abstract style of their own which was to blend inextricably with the various types of the spiritual and more or less abstract style already developed in the Christian East and West.

I am referring here not so much to extreme abstraction as found, for example, in certain products of Hiberno-Saxon art such as the famous evangelist symbol of the late seventh-century Book of Durrow (Fig. 20),[37] or the Matthew of the St. Gall Codex 51 of the turn of the eighth century (Fig. 21),[38] where the human figure, though ultimately based on late classical models, is submerged in the free play of a world of ornamental phantasy. I should rather like to draw attention to those epochal events in western mediaeval art in which first efforts were made by Barbarian, that is to say, non-Mediterranean, artists to create a more clearly recognizable image of man for their newly-converted fellow countrymen, so that the sacred content of Christianity could be visually represented in its natural as well as in its supranatural aspects.

Perhaps the greatest of these events was the illustration of the Lindisfarne Gospels with portraits of the four evangelists in the very last years of the seventh century.[39] The Lindisfarne St. Matthew (Fig. 24) is a new venture, equally new whether confronted with other Hiberno-Saxon evangelists or compared with what might be called its brother-figure, the Ezra of the Codex Amiatinus in the Biblioteca Laurenziana at Florence (Fig. 23), with which it has a common source. This source was no doubt an image of Ezra in one of the now lost Cassiodorian Bibles, probably the so-called Codex Grandior.[40] The Lindisfarne painter obviously did not want to use for the human figure the abstract schemes of current Hiberno-Saxon art, and he had the good fortune of having available the Ezra image in the Bible Codex of Cassiodorus which had been brought to the nearby monastery of Wearmouth-Jarrow less than a generation earlier. The Cassiodorian

Ezra image was a late classical author-portrait of a type which in Byzantine art had been used for evangelists at least since the sixth century[41] and which is itself a variant of the Graeco-Roman image of the philosopher or poet. Except for the significant fact that the Ezra of the Amiatinus and the Matthew of Lindisfarne are engaged in writing rather than in reading for themselves or to an audience, the type is the same as that which had been used for the representation of the Christian wise man already in earliest Christian art. It now stands at the beginning of great Christian art among the Barbarians.

As far as hieratic monumentality is concerned, the Lindisfarne evangelists go far beyond the classical style of the Christian or pagan philosopher reliefs on third- or fourth-century sarcophagi. At the same time the spiritual grandeur belonging to an inspired author is more tellingly expressed by the linear and relatively abstract simplicity of the Lindisfarne Matthew than by the somewhat debased illusionism of the Ezra figure in the Codex Amiatinus, which probably repeats rather faithfully the original image of Ezra in the Cassiodorian Codex Grandior.

It was the purpose of the illuminator of the Lindisfarne Gospels to make the physical appearance of man a mere function of spiritual meaning and didactic purpose. Concretely, this function is the transmission of the divine Gospel. The existence of the body is not denied as in the Book of Durrow or in the St. Gall Codex 51, but it exists chiefly as a vehicle for the all-important act of inspired writing.

In the picture of the fourth evangelist the Lindisfarne painter went even further in this direction. He transcended the act of writing and replaced it by a more monumental attitude. St. John (Fig. 22) is turned frontally toward the spectator or audience; the solemn en face posture and the open scroll evoke the role of the evangelist as the sacred voice of the Lord. It has recently been suggested by Dr. D. Wright[42]

that the model for the Lindisfarne portrait of St. John did not belong to the author-portrait type which we find in the Ezra picture of the Amiatinus and in the other Lindisfarne evangelists, but must have been an image of Christ Himself in Majesty. The combination of frontal posture, a youthful face with long curly hair, and a characteristic gesture of the right hand—found similarly, for instance, in an early Byzantine relief of Christ from the Studios Monastery in the Archaeological Museum at Istanbul (Fig. 25)[43]—would support such an iconographic derivation, though it cannot be denied that frontal images of seated evangelists existed already in early Christian (early Byzantine) times[44] and served as models for Carolingian evangelists in *en face* posture. If Dr. Wright's hypothesis is correct, we would be encountering here, just as in early Christian art, a close connection between basic types of the image of man and the image of Christ. In creating his new image of man the Lindisfarne artist would have used side by side or combined two of the great motifs of early Christian art: the throne image of Christ and that of the Christian philosopher or sage in his chair.

Without entering upon the problems connected with the Carolingian miniatures of evangelists and of the *Maiestas Domini*, I shall briefly discuss the representation of the creation of Adam and Eve in the Carolingian illumination of the Bible. Here the link between the images of man and of his creator is just as clearly perceptible as it was on early Christian sarcophagi. There is a good reason for this. It has been proved by Wilhelm Köhler that the Grandval Bible in London (Fig. 26) and the Vivian Bible in Paris, both from the School of Tours, depend on an early Christian illustrated Bible from the first half of the fifth century.[45]

In these two Bibles, as well as in the somewhat later Bible of S. *Paolo fuori le mura*, the creation of Adam and Eve is represented in accordance with early Chris-tian iconography:[46] God the Creator appears in the guise of the divine Logos Christ. This Christ is youthful as Adam. He is God, but His features are the same as those of the man whom he has created. Just as on the early Christian sarcophagi, so in the Carolingian miniatures, God and man can appear the same because God was to assume the flesh of man.

The process of absorption of late classical and early Christian style and iconography in painting, which begins with the Lindisfarne Gospels in the late seventh century and reaches a culmination in the astonishing classicism of the Vienna Coronation Book (Fig. 27)[47] in the early ninth, was one of the great achievements of the Anglo-Saxon and Carolingian Renaissances. Together with renewed classical influence, we cannot fail to observe a certain renewal also of the incarnational aspect of the image of man in art. Yet again this was not an exclusive development, and the spiritual aspect was soon to come to the fore.

Ever since Gregory the Great western thought had stressed the didactic role of the art image[48] more than eastern thought had, with the double result that early medi-aeval western art is on the whole both strongly symbolic and strongly eschatological in character: it is both a visible language and a suggestion of invisible things still to come.

It is true that in their controversy with the Byzantine image theologians the Carolingians, especially the authors of the *Libri Carolini*, deprecated all images of art; their didactic and also their decorative value was recognized, but as evocations of the divine and the holy they were considered only a poor second compared with language and literature. The image-likeness between God and man, which is spiritual, was expressly contrasted with that between a man and an artist's image of man.[49] This latter image-likeness was conceived as purely corporeal, since only the body can be represented in the

image.[50] Such a view of course stood in absolute opposition to that of the contemporary Byzantine upholders of the sacred images as vehicles of the divine.

To the authors of the *Libri Carolini,* then, and to other Carolingian theologians of the early ninth century, images seemed all too material. But, as so often in the history of art, practice proved stronger than theory. And indeed, though the materials of a work of art cannot be dispensed with and though bodies must be the immediate subject matter of art, cannot its form nevertheless suggest the immaterial? Late Carolingian and Ottonian art answers this question very clearly in the affirmative.

The beginnings of a new spiritual style appear in the reign of Charlemagne's son, Louis the Pious; and its first great examples come from the school of Reims. The famous Utrecht Psalter is less important for the history of the effigy of man than the Ebo Gospels (between 816 and 835), with their amazing evangelist portraits (Fig. 28).[51] The illusionistic style of the Vienna evangelists still shines through, but the human image has here become engulfed in a hurricane of spiritual excitement which makes hairs stand on end, eyes open and bulge, clothes crease and cling, and even the trees of the background bend and weave.

There are many other great expressions of spiritual experience in Carolingian art of the later ninth century and then especially in German Ottonian art of the tenth and eleventh. Though Ottonian art too could at times fall under the spell of late classical illusionistic models,[52] it tended on the whole toward spiritualization which expresses itself in increasingly linear or cubic abstraction from nature. The main bent of this art was towards an abstract supra-naturalistic style which evolved through the tenth and eleventh centuries until a maximum of hieratic spirituality was reached around 1100. Among the spiritual traits which are characteristic of the

image of man in the West during these two centuries, the gaze of the eyes and the gestures of the hands are particularly significant.

The eyes are usually wide open so that much of the white eyeball shows. Very often they are turned far to one side. The resulting expression is one of awe, expectation, even fear (Munich Gospel Book of Otto III, Fig. 29). Always there is a suggestion of supranatural meaningfulness, an evocation of eschatological tension. The hands with their elongated fingers have a life of their own (Munich Book of Pericopes of Henry II, Fig. 30). The dramatic gestures of these hands literally and most effectively point to the extraordinary and supranatural character of the persons and events represented.[53]

Let us now see whether the character of the image of man in the period just discussed has any parallels in late Carolingian and Ottonian theological and spiritual developments.

Here we must first of all consider the profound image doctrine of John Scot Erigena which goes far beyond that of the earlier Carolingian theologians. It owes much to Greek Christian thought, but in some respects modifies it.

In the eighth and early ninth centuries the Venerable Bede, the authors of the *Libri Carolini,* and Alcuin had simply continued the prevalent patristic tradition according to which the image-likeness of the human to the divine is spiritual, that is to say, located in the rational part of the soul.[54] John Scot's image doctrine reaches farther down into the corporeal realm, but only in order to spiritualize it as well. He considers the body itself an image of the divine image in the soul, and he thus reverts to the Greek view of man as intermediate between spirit and matter.[55] Yet he does not stop here, for he holds that the soul has an important share even in the creation of the material body as well as in its respiritualization: through the

mediatorship of a quasi-vegetative vital movement (*motus vitalis* or *vita materialis*) the body is formed by the mind.[56] It is not surprising, therefore, that in illustrating the Trinitarian analogies in man John Scot does not adopt for his own the Augustinian merely psychological ternaries, such as that of memory, intelligence, and will, though he knows and mentions them,[57] but the more complex cosmic as well as spiritual sequence of essence, power, and energy or action, which he could find in Ps.-Dionysius the Areopagite and in Maximus the Confessor,[58] and the related one of mind or intellect, reason, and interior sense, which except for a slight modification is likewise taken from Maximus.[59] The last member of this second ternary—*sensus interior,* which Scot also called by the Aristotelian term *dianoia*—is particularly important, because it forms the immediate link between the world of the external senses and reason, which again leads to higher intelligence.[60]

It would seem that the image doctrine of John Scot, which forms a very important part of his entire philosophical and theological system, corresponds to Carolingian art in general through its interest in the corporeal cosmos within a transcendent framework and to late Carolingian art in particular because of its tendency to see the body as a transparency of spiritual realities. While John Scot is very close to the Greek Fathers whom he translated and commented—Gregory of Nyssa, Ps.-Dionysius, Maximus the Confessor—his anthropology is even more radically spiritual than theirs, for he believed that in the return of all things to God the resurrected body will not only be spiritualized, but altogether absorbed in spirit.[61] Only Origen seems to have gone so far—and he only tentatively;[62] the extremes of Origenist spiritualism, which incidentally was one of the sources of Byzantine iconoclasm,[63] were at any rate rejected or transformed by the Greek Church. We have

seen earlier how the image concept of orthodox Greek Christian thought had found a suitable realization in the spiritually transfigured corporeality of Byzantine art.

In the early mediaeval West the development was somewhat different. On the one hand, iconoclastic tendencies remained much more moderate than in Byzantium;[64] on the other, the spiritual character of the images of art themselves was more one-sided, less perfectly balanced with the incarnational aspect of the image of man. Late Carolingian and Ottonian art, in spite of all Byzantine influences operative in them, did not consistently adopt the Byzantine synthesis of the natural and the supra-natural.

A generation before John Scot wrote his *De divisione naturae* his spiritual monism was, as we have seen, anticipated by Carolingian art; and Ottonian art was still animated by a kindred spirit. The cosmological drama described by the great Irish theologian ends with the re-absorption of the cosmos in God's spirit. In the art of this whole period the image of man often seems to be waiting for, to be straining towards the last things; to gaze upon, to point towards eschatological events. It is probably not an accident that the development of a full-fledged iconography of the Last Judgment took place in the period between the late ninth and the early twelfth century (Book of Pericopes of Henry II in Munich, Fig. 31).[65]

While the exact extent of John Scot's influence upon the two centuries following his own is hard to determine, it is certain that his work—however exceptional in range and depth—marks a general trend toward an eschatologically-minded spirituality.[66] This spirituality is the animating force, for instance, of the Cluniac reform movement and to some extent also of the so-called Ottonian Renaissance, especially in its later stages, under Otto III and his successors.[67] Yet, in the tenth and eleventh centuries it expressed itself no longer

in a metaphysical system, but rather in an ethical and ascetic attitude, above all in a reawakening of the old biblical and monastic motive of the fear of God, *timor Dei*. Odo of Cluny, commenting on a verse of Ecclesiastes, goes so far as to say: "He who does not fear God, ceases to be a man;" and the purpose of Holy Scripture, according to him, is just this, to make us fear the Last Judgment.[68] The note of the fear of God is sounded a little later by another prominent writer of the tenth century, Rather of Liège, who also gives a significant definition of what man should be: "The word *vir* (man) comes from *virtus* (virtue) also from *vireo* (to be vigorous), which is composed of *vis* (strength) and *rego* (to rule). . . . Avoid then feminine softness and solidify your mind in virtue. . . . This you will be able to do if, exerting your energy, you will elevate the strength of your mind to the stars, will subject the flesh to the soul, and the soul to God, and will be hard (*rigidus*) and inflexible." Even the weaker sex should be manly in mind (*vir mente*), though it be woman in the flesh.[69] It is interesting to see how manhood is here conceived in terms of a denial of the softness of the flesh and an assertion of spiritual single-mindedness to the point of inflexible hardness. This is a frame of mind which is not far distant from the appearance of the image of man in the art of the same period: here, too, we find a moving away from the soft modellings of the natural body, a general hardening of forms toward a strictly hieratic style, which can be seen, for example, in the Bamberg manuscript of the *Moralia* of Gregory the Great of c. 1100 (Fig. 35).[70]

The Ottonian and post-Ottonian image of man is, however, not always ascetically hardened, not always frozen in eschatological awe; it can also suggest quiet and silence, an interior lightness of the corporeal burden, an ardent and yet serene outpouring of the soul toward God, as in the early eleventh-century golden

antependium from Basel in the Musée Cluny at Paris (Figs. 33 and 34)[71] or in the so-called *Liber florum* of Thiofrid of Echternach at Gotha of the turn of the same century (Fig. 32).[72] Such spiritual experiences are well described by a Benedictine mystic of that period, John of Fécamp. I quote from his *Confessio theologica* (written before 1018), which is a long mental prayer to Christ:

O Life by which I live, Hope to which I cling, Glory which I wish to attain, hold you my heart, rule my mind, direct my understanding, lift up my love, support my soul, and draw the mouth of the spirit which thirsts for thee up to the supernal streams. Let the uproar of the flesh be stilled, . . . let even the soul itself be silent in itself and transcend itself by not thinking itself. . . . Give the secret of quiet to my body and soul. . . . Behold, while my mind sighs for the divine vision and according to its capacity, prostrate [before thee], meditates and utters thy glory, O Lord, even the burden of the flesh oppresses less: the tumult of thoughts ceases, the weight of mortality and of miseries does not as usual dull the mind, everything is silent, all things are calm. The heart is on fire, the soul rejoices, memory is alive, understanding is alight, and the whole spirit, inflamed by the desire for the vision of thy beauty, sees itself caught up into the love of invisible things.[73]

As already mentioned, the spiritualization of the image of man in western art reaches a limit around 1100. In the effigy of Bishop and Abbot Durandus at Moissac (Fig. 36)[74] or in the *Maiestas Domini* of a Limoges Missal in Paris (Fig. 37),[75] the bodily appearance of man is highly geometricized in outline and relief or in color planes of more than natural beauty. The compositional schemes in which the human image finds its place achieve great monumentality, not only in the eschatological *Maiestas Domini*, but also in such relatively more mundane pictures as the apotheosis of the papacy of the Hildebrandian age in the Lateran palace, of which late Renaissance and Baroque

copies have preserved at least a faint shadow (Fig. 38).[76]

One might well say that by the end of the eleventh century spiritualization had reached an apex beyond which it was hardly possible to go; and the first half of the twelfth century was therefore to be a turning point in the history of the image of man in Christian art as well as in the further development of the doctrine of man's image-likeness to God.[77]

As far as the human image in art is concerned, natural traits in increasing number were inserted into a still relatively abstract style. At first these natural traits have a particularized and, so to speak, symbolic character; they leave untouched the spiritual eminence of the hieratic whole in which they have their definite place, function, and meaning. It would lead much too far to explain fully how the beginnings of a new naturalism are related to the revival of monumental sculpture, in other words, to Romanesque statuary art. This story has often been told, by no one better than by my illustrious predecessor as Wimmer lecturer, Professor Erwin Panofsky. He has shown what the new discovery of sculptural mass or massiveness meant for the development of figurative art.[78] I shall try to continue his line of thought within the context of the present subject. In one sense the sculptural mass of early Romanesque art, just as the surface and line of relief and painting around 1100, is an abstract geometric limit of the natural toward the spiritual. Yet, as Panofsky has pointed out, this sculptural mass is also a symbol of the irreducible remnant of the body's brute materiality, much more so, of course, than the relatively bulkless substratum of relief or painting. The massiveness of Romanesque sculpture at first so completely dominated the representation of the human figure that the various parts of the body were conceived of only as parts of that massive unity. The knee of an early Romanesque statue, for instance, is not

yet an evocation of the real organic knee; but it takes the knee's place as it were within the immobile block or the mobile turbulence of the whole figure (capital at Plaimpied, Fig. 39, Tympanum of Moissac, Fig. 40).[79] The bulging volume of the knee is even greatly overstressed in many of these statues in order to express its function all the more drastically. The same is true, *mutatis mutandis,* for all the other parts of the body, for the eyes with their often tense and staring look, for the mouth with its somewhat strained smile—characteristics which have with good reason invited comparison between Romanesque and Greek archaic sculpture.[80] It is the singling out of the parts of the body according to their function as well as according to their supra-individual meaningfulness which, I think, entitles one to speak here of symbolic naturalism.[81]

In the case of the famous Cappenberg effigy of Frederick Barbarossa (Fig. 41),[82] for instance, parallel literary descriptions of the emperor suggest that the consciously joyful expression of the face, concentrated in mouth and eyes, was meant to signify smiling serenity and imperturbable hilarity, the artful arrangement of the hair to enhance the imperial majesty. If the biographer speaks of the emperor's honorable and manful legs, we must interpret this, too, in the context of the *honor imperii,* a concept which plays a great role in Barbarossa's political program.[83]

While the symbolic use of natural features was at first particularized and fragmentary, it gradually led to a general enlivening of the image of man: naturalism became more unified and at the same time more animated. Soul and body came closer together. In the preceding centuries spiritualism had striven to devaluate the body, now it began to penetrate it. This, as well known, was one of the great changes brought about in early Gothic art, the first burgeoning of which occurred at St. Denis and Chartres between 1140

and 1150, though the Romanesque style continued strongly elsewhere. While at first glance the wonderful statues of the ancestors of Christ on the West façade of the Cathedral of Chartres (Figs. 42 and 43) seem almost frozen in hieratic immobility, one soon discovers their inner life in the however limited organic fulness of their bodies, in the imperceptible animation of their gently smiling or thoughtful faces. It is still a restrained, almost secret life which gives to these statues their special and moving beauty. This beauty is hardly surpassed, though greatly enriched, by the further development of the human figure in twelfth-century art toward a much more clearly organic style which reaches a truly classical stage in the first half of the thirteenth century, classical in the sense of a synthesis of natural and spiritual elements (Chartres North door, Sainte Modeste, and South door, St. Gregory the Great, Figs. 44 and 45).[84]

The great transformation of the human image from the Romanesque to the Gothic of course also affected the image of Christ and received a more profound meaning by the humanization of the conception of the divine Saviour Himself, to the mystical basis of which I shall revert presently. This humanization becomes obvious if one compares with one another twelfth- and thirteenth-century throne images of Christ: the strict supranaturalism of the Maiestas Domini of St. Sernin at Toulouse (around 1100) (Fig. 46), the symbolic naturalism of the capital of Plaimpied (early twelfth century) (Fig. 39), the beginnings of organic naturalism on the Porte Royale of Chartres (c. 1150) (Fig. 47), the full synthesis of naturalism and supranaturalism in the Last Judgment of the center door of the façade of Notre Dame at Paris (c. 1220–30) (Fig. 48).[85]

By the early thirteenth century, then, the Christian image of man has again become incarnational, but it has nevertheless remained spiritual. The incarnational image of the thirteenth century is greatly different from that of the fourth, a thousand years of spiritualization have left their indelible mark.

The difference can perhaps be best appreciated if we return once more to the representation of the creation of man by God. Let us note first the progression from the particularized or symbolic archaic naturalism of Romanesque art—as in the creation of Eve from the bronze doors of Novgorod of the mid-twelfth century (Fig. 49)—to the generalized, organic and yet spiritual, so to speak classical, naturalism of the Gothic style—as in the creation of Adam from the early thirteenth century North portal of Chartres (Fig. 50). In the Novgorod relief[86] rudimentary attempts at naturalism in the rendering of the body and of physical and psychological movement are obvious, but have not yet reached the stage of organic unification or of a deeper relationship between the figures. In the Chartres group on the contrary an effortless intimation of organic life flows into a natural and yet mysterious relationship between God, who here, too, appears in the guise of the divine Logos, and Adam, who, about to awake, rests in His lap. The deep spirituality which permeates this scene in spite of the relatively naturalistic style will become more evident if we compare it with the creation of Eve on the early fourth-century dogmatic sarcophagus of the Lateran (Fig. 10), where in spite of the religious intention the creating Trinity as well as the protoplasts still almost completely lack that transformation of physical appearance, and especially of facial expression, which would make visibly manifest the underlying Christian spirit. The three Trinitarian persons are almost indistinguishable in this respect from ancient philosophers, and Adam and Eve look like lifeless potter's models. Compared to such literalness of conception, the Chartres group may strike us all the more as the embodiment of spiritual qualities: of Christ's divine goodness and love, of Adam's human trust and hope.

The changes which occurred in the image of man during the twelfth and early thirteenth centuries were not unrelated to similar developments in contemporary thought.

First it should be mentioned that the symbolic naturalism of Romanesque art is paralleled by an increase of organological metaphors in various ideological fields. It is well known that John of Salisbury in his famous definition of the body politic compares the prince to the head, the senate to the heart, the judges to eyes, ears, and tongues, officials and knights to the hands, financial officials to the stomach, the peasants to the feet, and so on.[87] It is less well known that several theologians and philosophers of the twelfth century conversely held that the parts of the human body symbolized the parts of the natural, political, and spiritual cosmos. Already Honorius Augustodunensis, following Isidore of Seville, saw heaven symbolized by the head, sun and moon by the eyes, the air by the breast, the sea by the stomach, the earth by the feet, stones by bones, trees by the nails, grass by hair.[88] St. Hildegard of Bingen went far beyond Honorius or Isidore: the whole Fourth Vision of her *Liber divinorum operum* is an elaborate macrocosmic-microscosmic symphony of organological-physical symbolic correspondences.[89] William of Conches, on the other hand, in his *Philosophia* not only compares the head to the heavenly sphere or to the castle in a city— these are old metaphors—but also the arms to its defenders, the stomach and knees to the women and craftsmen of the city, the hips and legs to the merchants, the feet to the peasants.[90] For Richard of St. Victor finally the head symbolizes free will, the heart wholesome counsel, the foot fleshly desire.[90a]

The way in which the body is divided into symbolical parts by these authors is akin to the particularized, emphatic and at times explicitly symbolical rendering of the limbs and features of the human image in the art of the same period (see, for instance, the capital with Job at Saint André-le-Bas in Vienne, of c. 1152, Fig. 51).[91]

The more general and more unified animation of the corporeal image of man in later twelfth- and early thirteenth-century art has even closer parallels in contemporary thought. For, the artistic development was accompanied, and at least in its later stages perhaps influenced, by the rise of a new psychology the importance of which for art has already been suggested by W. Köhler,[92] E. Panofsky,[93] and R. Grinnell[94] and should be investigated fully. All I can do is to draw attention to a few interesting texts.[95]

Within the chronological limits of this lecture Albertus Magnus' and Thomas Aquinas' Aristotelian conception of the soul as form or organizing and unifying principle of the body, cannot be discussed,[96] though this doctrine should be kept in mind as the logical end of the ideological developments which we shall encounter.

The new psychology made the relationship between body and soul a subtly graded one; this was quite different from the rather abrupt and uncompromising opposition of mind and matter in early mediaeval thought. Even John Scot, while he had known and used such late classical and patristic concepts as *motus vitalis* and *sensus interior,* which link body to soul and soul to mind, had attributed to them almost purely spiritual functions—their corporeal quality had almost evaporated in the dynamic sweep of his spiritual monism. The thinkers of the twelfth and early thirteenth centuries returned to the premediaeval psychological tradition by closer adherence to the classical elements in Augustine and Boethius and also increasingly by absorbing newly discovered Neoplatonic, Hermetic, Greek and Arabic medical, and finally Aristotelian material.[97] They were thus in a position to make it much clearer than even Scotus—whom

incidentally they also used and adapted—that the experience of the corporeal senses is necessary for the soul's activity and that reason itself cannot function without them.

The fountainhead of the new psychology can be found, perhaps, in Hugh of St. Victor's treatise On the Union of Body and Spirit. In this little work he tries to find an intermediary between the spirit and the body; if there was none there could be no meeting between the two. From the point of view of the body, this middle entity is sensibility (sensus), from the point of view of the spirit it is imagination (imaginatio), for sensibility becomes imagination once it reaches the soul, whence there is further ascent to ratio or scientia, to intelligentia or sapientia, and thus to God.[98] This doctrine was continued in the school of St. Victor[99] and in a more or less modified form spread beyond it, for instance, to the school of Chartres[100] and surprisingly enough to the Cistercians Ailred of Rievaulx, Isaac of Stella, and Alcher of Clairvaux. All these authors built their science of the spiritual life on a foundation of up-to-date psychological and physiological knowledge.

Isaac of Stella's development of these ideas in his Epistle On the Soul, addressed to Alcher of Clairvaux, is of special interest for our subject because he establishes continuity between the sensual images of bodies which enter the soul through imagination and the image-likeness of man to God in the highest part of the soul.

From sensibility, Isaac says, comes imagination. Sensibility perceives true bodies, whereas imagination perceives only likenesses and images of true bodies, whence it is called imagination. Since these images are not true bodies, imagination is, as it were, an elongation or evaporation from corporeal things; and, nevertheless, it does not quite reach the incorporeal. And yet, there is a certain similarity between these two, namely between the highest part of the body (sensibility) and the lowest part of the spirit (imagina-

tion). The spirit and the flesh can be easily and fittingly united where their extreme borders touch, that is to say, in the imaginative realm of the soul, which is almost body, and in the sensible realm of the flesh, which is almost spirit. The highest part of the soul, that is to say, the intelligence or mind, carries the image and likeness of that which is above it, namely God, whence it could become susceptible to receive Him and could even be assumed to personal union with Him. Why then should the highest part of the flesh, that is to say, sensibility, which carries a likeness of the soul, not be susceptible to the soul's essence for a personal union with it?[101]

I have given this close paraphrase of a rather lengthy text, because Isaac of Stella's attempt to save both the distinctness of body and spirit and the close kinship which nevertheless exists between them constitutes, I think, a significant parallelism with the synthesis of the spiritual and the corporeal, the ideal and the natural in late twelfth- and early thirteenth-century art.

Besides, it is very remarkable that the relation between body and soul is conceived as a personal union analogous to the hypostatic union of the divine and human natures in Christ. This doctrine, too, seems to have its origin in Hugh of St. Victor;[102] it is found also in Isaac's contemporaries and fellow Cistercians Ailred of Rievaulx[103] and Alcher of Clairvaux.[104] One may see here a confirmation of our previous observations which pointed to a reawakening in the twelfth century of the incarnational aspect of the image of man, which in the early mediaeval west had been largely eclipsed by the spiritual and eschatological aspect. Such a view is further supported by a third Cistercian theologian, Helinand of Froidmont, who flourished at the end of the twelfth century and in the first third of the thirteenth. In his little work on self-knowledge he uses almost the same reasoning as Irenaeus concerning the image-likeness of the human to the

divine in relation to the body and to the Incarnation. "Before the Incarnation of the Word," he writes, "only the internal form" (that is to say, the soul) "of man was similar to God, but beginning with the Incarnation of the Word even the external form" (the body) "of man became the form of God."[105]

We must now finally turn, however briefly, to the greatest of all Cistercians, to St. Bernard of Clairvaux, whose well known aversion to the art of his time and whose radical bent toward spiritualization of the human body seems to remain outside those trends of twelfth-century thought and art which I have tried to describe. Yet the contrast is more apparent than real.

It is true enough that Bernard condemned artistic luxury in general, but we must also remember that in particular and concretely he objected to the Romanesque art of the first half of the twelfth century, and quite especially to the half animal, half human monsters of Romanesque sculpture (see, for instance, the trumeau of Souillac, Fig. 52, and a capital from Notre Dame du Port at Clermont Ferrand, Fig. 53).[106] One might perhaps say that Bernard rejected the peculiar greatness of early Romanesque art and failed to recognize its deep spirituality, which was both awesome and subtle in a manner which ran counter to the single-minded ardor of the great Cistercian's ethos.[107] On the other hand, he probably did not know or realize that a new and different style was just beginning at St. Denis and Chartres. We cannot tell how he would have reacted to the fuller humanism of late twelfth- and early thirteenth-century art, in other words to early Gothic art.

Secondly, and more importantly, Bernard of Clairvaux in his own way participated in his century's new attitude toward man by making the idea of freedom dominant in his doctrine of human-divine image-likeness. Also, though not the first, he was one of the first to emphasize with new accents man's love of the human

Christ as an indispensable stepping stone in the ascent to a purely spiritual love of God.[107a]

For Bernard the content of man's image relation to God is not so much cognitional as volitional; it is situated not so much in the intellect as in the rational soul's capacity to choose the good or the bad. It is defined as that imperishable freedom from necessity which is called liberum arbitrium, free will.[108] Bernard, and his friend William of Saint-Thierry as well, here reasserted an element which had been important in the Greek patristic tradition, especially in Gregory of Nyssa, but had not been very conspicuous in the Augustinian climate of the West, except for adumbrations in John Scot Erigena.[109] To posit free will as the main content of the divine image in man was to assert once again the dignity of man's intermediate place and function in the universe: he has the choice between what is above his nature and what is below it because by his nature he is a spiritually animated body.

On this earth liberum arbitrium—aided by liberum consilium, or freedom from sin through grace, and expecting liberum complacitum, or freedom from misery in heaven[110]—is largely concerned with the soul's rational control of its body. This control must be exercised not in a spirit of violence or fear, but in a spirit of love. Bernard expresses this beautifully when he says that free will should govern the body suaviter, gently, without sadness, without imposing a necessity.[111]

For St. Bernard love is the only way to God. Love for God is love for Christ and Christ is incarnate. Love for Christ therefore must begin with love for Christ's body, for His caro, His very flesh. We cannot and must not forget either His Passion or His Resurrection. Only along this road can the spiritual God be reached by men.[112]

The great surface events of Bernard's life brought it about that his humanism was traversed by spells of fanaticism.

This cannot detract from the fact that in the deeper layers of his thought and being he had already moved away from the austere spirituality of the tenth and eleventh centuries. Just as the spirit of early Gothic art (Chartres, Porte Royale, Fig. 43), so the core of Bernard's spirit is *suavis* rather than *rigidus*, moved by *caritas* rather than *timor*. Free will is for Bernard the essence of man's image-likeness with God, for only through liberty can man achieve his dignity in body and soul, without which he cannot aspire to spiritual union with God which remains the ultimate goal.

In spite of many vicissitudes, this idea of the dignity of man was to persist through late mediaeval and early modern times. In this respect the Italian Renaissance is certainly the heir of the so-called Renaissance of the Twelfth Century. Pico della Mirandola's famous oration *On the Dignity of Man*, for instance, which bases this dignity on free will,[113] stands in the tradition not only of pagan and Christian antiquity and of the Cabala, but also in that of twelfth- and thirteenth-century thought; and Raphael's image of man would not

have been possible without the art of the Gothic cathedrals.

The disintegration of the incarnational image after the age of the Baroque, a disintegration which was probably unavoidable, has not yet been followed by a new spiritualization of the Christian image of man, comparable to the greatest works of the Middle Ages. Whether in Christian art a fully abstract non-objective, that is to say, non-human, style can capture the divine is to many still an open question. Dante's ultimate vision of the Blessed Trinity in the *Divine Comedy* would seem to suggest that the answer is in the negative:

> In that abyss
> Of radiance, clear and lofty, seem'd methought,
> Three orbs of triple hue, clipt in one bound.
> .
> And I therein, methought, in its own hue
> Beheld our image painted.[114]

And yet, there may be other possibilities. Artists do not exclusively live "in the world of man, things, and images;"[115] and perhaps there exists "something like a sacral abstraction which belongs to the Holy Spirit."[116]

NOTES

1 The thesis here proposed that the Christian doctrine of man's image-likeness with God may be reflected in the representation of man in art, does not overlook the fact that a direct causal nexus between such theological views and the practice of art cannot be established. It is only claimed that these views and their vicissitudes represent attitudes of the mind which among other things nourished the conception of the human image which can be perceived in the works of art themselves. In view of the vastness of the subject I shall restrict myself to the period from c. 300 to c. 1200 and can deal with only a few of the many aspects of the image of man in mediaeval art. I wish to thank especially Professor Erwin Panofsky and Professor Kurt Weitzmann for a number of very valuable suggestions, and Dr. James John for stylistic and terminological improvement of the text. After completion of this essay I read the illuminating study by W. Schöne, "Die Bildgeschichte der christlichen Gottesgestalten in der abendländischen Kunst," in *Das Gottesbild im Abendland* (Witten und Berlin, 1959), which, I was happy to see, in more than one way corresponds with my own interpretation of the history of the image of God Incarnate and of man in Christian times.

2 This is not the place to discuss the problem of the original meaning of the relatively late text Genesis 1:26 f.: ". . . Let us make man to our image and likeness . . . And God created man to his own image . . . ," especially the question whether both concepts, "image" and "likeness," are terminologically indebted to anthropomorphic ideas of God, current in the ancient Orient, or whether "likeness" on the contrary modifies "image" in the sense that it negates equality

and thus expresses that distance between God and man which is implicit also in the prohibition of idols according to Exodus 20:4 f. and 23, Deuteronomium 4:16–19 and 5:8 f. and which is in general characteristic of most of the Old Testament; for this latter view see the careful and convincing study by W. Hess, O. S. B., "Imago Dei (Gn 1, 26)," *Benediktinische Monatschrift* XXIX (1953) 374 f. n. 12, 376–378. There seems to be little doubt at any rate that in earliest Christianity man's image-likeness to God was seen in close conjunction with Christ, the God-Man, who is the image of the Father. On this point cf. H. v. Campenhausen, "Die Bilderfrage als theologisches Problem der alten Kirche," *Zeitschrift für Theologie und Kirche* XLIX (1952) 33 ff., now also in *Das Gottesbild* (cited in note 1); furthermore G. van der Leeuw, *Der Mensch und die Religion* (Basel, 1941) 125 f., 140 ff.

3 *Adversus haereses* V, 16, 2, ed. Harvey II, 368: Ἐν τοῖς πρόσθεν χρόνοις ἐλέγετο μεν κατ' εἰκόνα Θεοῦ γεγονέναι τὸν ἄνθρωπον, οὐκ ἐδείκνυτο δε. Ἔτι γὰρ ἀόρατος ἦν ο Λογος οὗ κατ' εἰκόνα ο ανθρῶπος εγεγονει . . . Ὁποτε δε σαρξ εγενετο ο Λογος του Θεοῦ . . . τὴν εικονα εδειξεν αληθως αυτος τοῦτο γενόμενος ὅπερ ἦν ἦ εικὼν αυτοῦ Cf. also *Proof of the Apostolic Preaching* 22, translated and annotated by J. P. Smith, S.J. (*Ancient Christian Writers* XVI, Westminster, Md., 1952) 61.

4 Tertullian, *De resurrectione mortuorum* VI, 3–5, *Corpus Christianorum* II/II, 928: . . . (with regard to Genesis 2:7) Quodcumque enim limus exprimebatur, Christus cogitabatur, homo futurus, quod et limus . . . (and with regard to Genesis 1:26) id utique quod finxit, "ad imaginem Dei fecit illum," scilicet Christi . . . Ita limus ille iam tunc imaginem induens Christi futuri in carne non tantum Dei opus erat sed et pignus.

5 Recently Theodor Klauser, "Studien zur Entstehungsgeschichte der christlichen Kunst," *Jahrbuch für Antike und Christentum* I (1958) 20 ff., II (1959) 115 ff., III (1960) 112 ff., has shown and explained more exactly than all previous archaeologists had done how two very early motifs of Christian imagery, the Orans and the Good Shepherd, were developed out of the corresponding motifs of late Roman pagan art, in which the praying figure, whether a portrait or not, signified *pietas* and the sheep-bearer *philanthropia*. The "physical" types of the figures were taken over unchanged; neither their style nor their iconography was essentially affected by the change from pagan to Christian content.

6 Cf. H. I. Marrou, MOYCIKOC ANHP (Grenoble, 1938); F. Gerke, *Die christlichen Sarkophage der vorkonstantinischen Zeit* (Berlin, 1940) 246 ff.; T. Klauser, *op. cit.*, III, 112 ff.

7 For the "Plotinus" sarcophagus of c. 270 in the Lateran Museum cf. Marrou, *op. cit.*, 47 ff.; G. Rodenwaldt, "Zur Kunstgeschichte der Jahre 220 bis 270," *Jahrbuch des deutschen archäologischen Instituts* LI (1936) 102 ff.; Gerke, *op. cit.*, 289 ff., plate 50.

8 For the philosopher sarcophagus of the Museo Torlonia (after 250) cf. Marrou, *op. cit.*, 102 f.; Rodenwaldt, *op. cit.*, 101 f.; Gerke, *op. cit.*, 271 ff., plate 49, also 226 ff. for the seated profile type in general.

9 For the sarcophagus of S. Maria Antiqua (third century) cf. Klauser, *op. cit.*, III, 116 f.; J. Wilpert, *I sarcofagi cristiani antichi* I (Rome, 1929) plates I, 2 and III, 1; Marrou, *op. cit.*, 92; Gerke, *op. cit.*, 259 ff. The faces of the Orans and the philosopher on the sarcophagus of S. Maria Antiqua are unfinished; they were meant to be finished as portraits of a husband and wife to be buried in the sarcophagus.

10 For the Nicocrates sarcophagus (of c. 300) cf. A. H. Smith, *A Catalogue of Sculpture in the Department of Greek and Roman Antiquities, British Museum* III (London, 1904) 323 f., no. 2313 (fig. 44). For the Sanseverino sarcophagus (third century) cf. Marrou, *op. cit.*, 96; Wilpert, *op. cit.*, I, 9, plate II, 3; Klauser, *op. cit.*, III, 115 f.—For the iconography of the poet and his Muse cf. A. Baumstark, "Eine antike Bildkomposition in christlich-orientalischer Umdeutung," *Montshefte für Kunstwissenschaft* VIII (1915) 111 ff.; C. R. Morey, *The Sarcophagus of Claudia Antonia Sabina* . . . (*Sardis* V/I, 1924) 64 ff., A. M. Friend, Jr., "The Portraits of the Evangelists in Greek and Latin Manuscripts," *Art Studies* 1927 and 1929, especially Part I, 141 ff.; K. Weitzmann, in *Archäologischer Anzeiger* 1933, 1/2, 345 ff.

11 Cf. Wilpert, *op. cit.*, I, plate IV, 3; Marrou, *op. cit.*, 73; Gerke, *op. cit.*, 73 ff.; Klauser, *op. cit.*, III, 117 f.

12 This fact has, I believe, been somewhat exaggerated by F. Gerke, *Das heilige Antlitz* (Berlin, 1940); cf. also his "Ideengeschichte der ältesten christlichen Kunst," *Zeitschrift für Kirchengeschichte* LIX (1940) 17 f.

13 See, for instance, the acclaiming men in the lower tier of the *Liberalitas* relief of the Arch of Constantine (Fig. 6), who differ hardly at all in type and expression from contemporary Apostle figures; cf. H. P. L'Orange, *Der spätantike Bildschmuck des Konstantinsbogens* (Berlin, 1939) plates 16 f.; similarly, the statue of a boy from the funereal group of Cornutus in the Vatican Museum, of c. 270–280 (Fig. 7) (L'Orange, *op. cit.,* Text, fig. 47), differs very little from youthful Christian figures. In general cf. the excellent remarks of L'Orange, *op. cit.,* 227 f., who rightly draws attention to the similarity in type and style between the Constantinian reliefs of the Arch of Constantine and those of the so-called dogmatic sarcophagus of the Lateran Museum (for which cf. above, p. 435). L'Orange, *Studien zur Geschichte des spätantiken Porträts* (Oslo, 1933), especially 21 ff., has also shown that the wide open somewhat staring eyes, which are so characteristic of late ancient portraits, occur in pagan as well as in Christian works. That such eyes could be regarded as charismatic in both pagan and Christian milieus seems indicated also by literary evidence. As far back as c. 200 the funereal inscription of Abercius (cf. H. Strathmann and T. Klauser, in: *Reallexikon für Antike und Christentum* I [1950] 12 ff., for the almost certainly Christian origin of the inscription) calls Christ a pure shepherd who has great eyes that look everywhere. On the other hand, as late as c. 500 the eyes of the Neoplatonic philosopher Isidorus are described in a literary portrait by his disciple Damascius of Damascus, in Photius, *Bibliotheca*, Cod. CCXLII, Migne, *Patrol. Graec.* CIII, 1253 Af. (quoted by L'Orange, *Spätantikes Porträt* 91) as fixed and yet all-seeing, and as perfect images not only of the soul but also of the divine emanation which dwells in it.

14 In other early Christian types of the image of Christ, too, the pictorial conception of the God-Man remains as "anthropomorphic" as it was in such classical prototypes as Hermes Criophorus, Orpheus, and Apollo.

15 This has been noticed also by Gerke, *Sarkophage* 284 ff., especially 294. Cf. Wilpert, *op. cit.,* I, plate III, 4; Marrou, *op. cit.,* 89 f. J. Kollwitz, *Das Christusbild des 3. Jahrhunderts* (Münster, 1953) 21 f., thinks that the philosopher, too, is Christ, but he is hardly right; Marrou, *op. cit.,* seems to have shown that in this early period Christ as teacher is not represented in profile view.

15a Cf. Wilpert, *op. cit.,* II, plate CCXX, 1; Gerke, *Sarkophage*, 207 ff., plates 33 ff.

16 See, for instance, S. Reinach, *Répertoire de la statuaire grecque et romaine* III (Paris, 1904) 183, no. 4. Gerke, *op. cit.,* 207 ff. and especially 227 f., no doubt rightly connects this image of Christ with the type of the Cynic philosopher, though he perhaps underestimates possible influence of images of Zeus or Asclepius.

17 Marrou, *op. cit.,* 270 ff., has convincingly shown that the iconographic scheme of the reading and teaching philosopher, be he pagan or Christian, preceded that of the reading and teaching Christ. Cf. also F. Gerke, *Christus in der spätantiken Plastik* (Berlin, 1940) 7 ff. for the relationship between the "Christus philosophicus" and the "Christian philosopher" in earliest Christian art.

18 Cf. Wilpert, *op. cit.,* I, plate LXXXXVI; Gerke, *Sarkophage*, 193 ff., especially 199 f.; L. de Bruyne, "L'imposition des mains dans l'art chrétien ancien," *Rivista di Archeologia Cristiana* XX (1943) 175 ff.: "La création de l'homme."

19 For two early Christian Trinitarian sarcophagus reliefs, akin to the Lateran sarcophagus, in Die and Campli (Wilpert, *op. cit.,* I, plates CXXXVII, 6 and CVI, 2) cf. Gerke, *op. cit.,* 196, n. 4.

20 For this whole problem cf. A. Krücke, "Zwei Beiträge zur Ikonographie des frühen Mittelalters," *Marburger Jahrbush für Kunstwissenchaft* X (1937) 5 ff.: "II. Über einige angebliche Darstellungen Gott-Vaters im frühen Mittelalter."

21 This fact was kindly called to my attention by Professor Kurt Weitzmann. Cf., for instance, T. Ouspensky, *L'octateuque de la Bibliothèque du Sérail à Constantinople* (Sofia, 1907) Al-

bum, plate X, 21. The third-century frescoes in the Synagogue of Dura show the hand of God reaching down from heaven on several occasions. For the Old Testament concept of the hand of God as symbol of a God who, as a whole, is beyond human conception cf. H. Schrade, *Der verborgene Gott* (Stuttgart, 1949) 132.

22 In his dialogue *Symposium* I, 4 (24), *Griech. Christl. Schriftst. Methodius* 13, Methodius said that Christ assumed a human body in order that man could imitate Him better: as if He had painted His picture for us so that we could imitate Him, its painter. Thus a very literal conception of man's image-likeness with God was still possible in the early fourth century. In this connection sarcophagus no. 135 of the Lateran Museum of the mid-fourth century would be of great interest if one could assume that Adam as well as Christ was here originally bearded. According to Wilpert, *op. cit.*, II, plate CCVI, 7, the heads of both Adam and Christ and several others are new. They are indicated as lost by R. Garrucci, *Storia dell'arte cristiana* V (Prato, 1879) plate CCCXVII, 1, but he has inserted them after P. Aringhi, *Roma Subterranea* II (Rome, 1651) p. 399, and G. Bottari, *Sculture e pitture sagre . . . della Roma Sotterranea* III (Rome, 1754) plate CLXXXXV, 1. If these two authors are to be trusted, Adam was originally bearded just as Christ. The present restitution must have been made before 1890; cf. J. Ficker, *Die altchristlichen Bildwerke im christlichen Museum des Laterans* (Leipzig, 1890) 77 f.; also O. Marucchi, *I monumenti del Museo Cristiano Pio-Lateranense* (Milan, 1910) plate XX, 7.

23 As an artistic invention the representation of the creation of man by the Logos in human form characteristically owes much to the classical motif of the making of man by Prometheus. For this well known fact cf., for instance, Gerke, *op. cit.*, 192 f., especially for the Christian transformation of motifs taken from the Prometheus iconography, also for the relationship of these transformations to the theology of Irenaeus; cf. furthermore K. Weitzmann, *Illustrations in Roll and Codex* (Princeton, 1947) 177 ff.

24 Clement of Alexandria, *Stromata* V, 14, *Griech. Christl. Schriftst., Clem. Alex.* II, 388: . . . εἰκὼν μὲν γὰρ Θεοῦ Λόγος θεῖος . . . , εἰκὼν δ᾽ εἰκόνος ανθρωπινος νοῦς.

24a Cf. H. de Lubac, "Esprit et liberté dans la tradition theologique," *Bulletin de littérature ecclésiastique* XL (1939) 121 ff.; J. Gaïth, *La conception de la liberté chez Grégoire de Nysse* (Paris, 1953).

25 For these two paragraphs cf. my study "The Concept of the Image in the Greek Fathers and the Byzantine Iconoclastic Controversy," *Dumbarton Oaks Papers* VII (1953) 12, and my book *The Idea of Reform* (Cambridge, Mass., 1959) 85 ff.

26 Cf., for instance, W. F. Volbach, *Frühchristliche Kunst* (Munich, 1958) 25 and fig. 132.

27 Cf. G. B. Ladner, "Origin and Significance of the Byzantine Iconoclastic Controversy," *Mediaeval Studies* II (1940) 142 ff.; E. Kitzinger, "The Cult of Images in the Age before Iconoclasm," *Dumbarton Oaks Papers* VII (1954) 83 ff.

28 Cf. O. Demus, *The Mosaics of Norman Sicily* (London, 1949) 3 ff.

29 For the Gregory Nazianzen of the Bibliothèque Nationale in Paris, Ms. grec 510, fol. 438v, cf. H. Omont, *Miniatures des plus anciens manuscrits grecs de la Bibliothèque Nationale . . .* (Paris, 1929) 30 and plate LVIII.

30 Cf. A. Grabar, *Byzantine Painting* (Skira, 1953) 51.

31 Cf. E. Kitzinger, "Byzantine Art in the Period between Justinian and Iconoclasm," *Berichte zum XI. Internationalen Byzantinisten-Kongress, München 1958* (Munich, 1958) 47. See also Kitzinger, "Some Reflections on Portraiture in Byzantine Art," *Mélanges G. Ostrogorsky* (Recueil des travaux de l'Institut d'Etudes byzantines VIII, Belgrade, 1963), where the author shows that in Byzantine art illusionistic elements are frequently more dominant in images of Christ, of angels, of saints than in portraits of contemporary persons where an abstract style often prevails, without altogether excluding the marks of individual identity.

32 Basil, *Regulae fusius tractatae* 17, 2, Migne, *Patrol. Graec.* XXXI, 964C.

33 For instance, in *De Genesi ad litteram* III, 20, *Corp. Script. Eccles. Lat.* XXVIII, 1, 86: . . . in eo factum hominem ad imaginem Dei in quo inrationalibus animantibus antecellit. Id autem est ipsa ratio vel mens vel intelligentia. . . .

34 For the Trinitarian analogies in the soul according to St. Augustine cf., for instance, É. Gilson, *Introduction à l'étude de saint Augustin*, third ed. (Paris, 1949) 286 ff., also 204 ff., for Augustine's teaching on the will and on freedom. On the one hand Augustine equates *voluntas* and *liberum arbitrium*, on the other hand he distinguishes the latter from *libertas;* the natural *liberum arbitrium* of the image, as distinct from the supranatural gift of *libertas* to do the will of God, is less emphasized by him than it was by Gregory of Nyssa and will be later by Bernard of Clairvaux (see above, p. 447).

35 Cf., for instance, K. Svoboda, *L'esthétique de saint Augustin et ses sources* (Brno, 1933) 108 f.; Ladner, *Idea of Reform* 187 f., 218 f.

36 Cf. G. B. Ladner, *Die Papstbildnisse des Altertums und des Mittelalters* I (Città del Vaticano, 1941) 66 ff., 76 f., 90 f., 136 f., and 140.

37 Cf. now *The Book of Durrow. Evangeliorum Quattuor Codex Durmachensis*, ed. A. A. Luce, G. O. Simms, P. Meyer, L. Bieler (Olten etc., 1960).

38 Cf. E. H. Zimmermann, *Vorkarolingische Miniaturen* (Berlin, 1916) 99 ff., 240 ff., plate 189a.

39 We have here, among other things, a specific case history in primitivism and the overcoming of primitivism—this latter term understood in the sense of E. H. Gombrich; cf., for instance, his *Meditations on a Hobby Horse* (London, 1963) 8 f., also his essay "Achievement in Mediaeval Art," reprinted there, 73–77.—In Italy, perhaps in Rome herself, a hundred years earlier a somewhat similar, but not yet so consistent, attempt at blending limited naturalism with monumental simplicity was made on behalf of a Barbarian milieu in the decoration of the Cambridge Gospels, which were in all probability taken from Rome to England by St. Augustine of Canterbury. Cf. F. Wormald, *The Miniatures in the Gospels of St. Augustine, Corpus Christi College* (Cambridge, 1954).—For the Lindisfarne Gospels see now *Evangeliorum Quattuor Codex Lindisfarnensis*, edd. T. D. Kendrick, T. J. Brown, R. L. S. Bruce-Mitford, H. Roosen-Runge, A. S. C. Ross, E. G. Stanley, A. E. A. Werner (Olten etc., 1956–60); also the excellent remarks by E. Kitzinger, in: *The Relics of Saint Cuthbert* (Oxford, 1956) 223 ff., 297–302.

40 Cf. E. A. Lowe, *Codices Latini Antiquiores* III (Oxford, 1938) 8, no. 299; B. Fischer, "Codex Amiatinus und Cassiodorus," *Biblische Zeitschrift*, Neue Folge, VI/1 (1962) 57 ff.

41 In a general way the portrait of Marc in the Rossano Gospels—cf. A. Muñoz, *Il codice purpureo di Rossano* (Rome, 1907) plate XV—is of this type, even though it is still accompanied by a female figure, derived from the classical Muse (cf. above note 10 and Friend, *op. cit.,* I, 107 f., 141 f.).

42 In an unpublished lecture, delivered at the College Art Association meeting in New York in 1959. I am very grateful to Dr. Wright for letting me read the manuscript, also for drawing my attention to the article of B. Fischer, cited in note 40, and to the Studios relief, reproduced in Fig. 25.

43 Cf. J. Kollwitz, *Oströmische Plastik der theodosianischen Zeit* (Berlin, 1941) plate 48. The gesture goes back to Antiquity: it was originally the gesture of clasping the opening of the garment in front of the breast, as in the statue of Aeschines in the Museo Nazionale at Naples (cf. A. Hekler, *Greek and Roman Portraits* [London, 1912] plate 53). It can be found in not a few late ancient portraits and early Christian images of saints and of Christ (cf. the well known Berlin relief of Christ and two Apostles from Constantinople of c. 400, reproduced by Volbach, *Frühchristliche Kunst* Fig. 73), but not it seems in evangelist portraits.

44 Cf. the Matthew and John portraits in the late sixth century Rabbula Gospels: *Evangeliarii Syriaci vulgo Rabbulae in Bibliotheca Medicea-Laurentiana (Plut. I. 56) adservati ornamenta*, edd. C. Cecchelli, J. Furlani, M. Salmi (Olten etc., 1959) f. 9b; cf. Friend, "Evangelists" II, 7.

45 W. Köhler, *Die karolingischen Miniaturen* I, 2 (Berlin, 1933) 164–212, plates I, 50 (fig. 26) and 70.

46 This seems to be the case also for the Bamberg Bible, though it follows in part a different iconographic tradition; cf. Köhler, *op. cit.,* I, 2, 102 ff. For the date of the S. Paolo Bible cf. E. H. Kantorowicz, "The Carolingian King in the Bible of San Paolo fuori le Mura," *Late Classical and Mediaeval Studies in Honor of Albert Mathias Friend, Jr.* (Princeton, 1955) 287 ff.

47 Cf. Köhler, *op. cit.*, III (1960) 20 ff., plate III, 26.

48 Cf., for instance, J. Kollwitz, "Bild und Bildertheologie im Mittelalter," in: *Das Gottesbild im Abendland* (Witten, Berlin, 1959) 109.

49 *Libri Carolini* I, 7, *Monum. Germ. Hist., Leg.* III *Concil.* II Suppl. 22 and 24: Quod non ad adorandas imagines pertineat quod scriptum est: "Creavit Deus hominem ad imaginem et similitudinem suam" . . . Quisquis . . . ita hominem ad imaginem et similitudinem Dei factum sicut ad imaginem hominis imaginem ab artifice formatam esse credit, aliquid in Deo corporeum . . . credere se ostendit. . . .

50 Cf. Agobard of Lyons, *Liber de imaginibus sanctorum* 28, Migne, *Patrol. Lat.* CIV, 222: Nam si ulla imago esset adoranda vel colenda creatoris potius esset quam creaturae. Nempe hominem fecit Deus ad imaginem et similitudinem Dei. Homo autem facere non potest quidquam in quo sit similitudo hominis in mente ratione. Nam si exprimit utcunque sculpendo vel pingendo aliquam similitudinem corporis aut membrorum, hoc utique exprimit quod minimum est in homine, non quod maximum. Certe si adorandi fuissent homines, vivi magis quam picti, id est, ubi similitudinem habent Dei, non ubi pecorum vel quod verius est lapidum sive lignorum vita sensu et ratione carentium.

51 For the Ebo Gospels cf. A. Boinet, *Miniatures carolingiennes* (Paris, 1913) plates LXVI–LXIX; G. Swarzenski, "Die Karolingische Malerei und Plastik in Reims," *Jahrbuch der Preussischen Kunstsammlungen* XXIII (1902) 81 ff.

52 See especially the Egbert Codex; cf. H. Jantzen, *Ottonische Kunst* (Munich, 1947) 74 ff.

53 For the Gospel Book of Otto III and the Book of Pericopes of Henry II, Clm. 4453 and Clm. 4452 of the Bayerische Staatsbibliothek in Munich, cf. A. Grabar and C. Nordenfalk, *Early Medieval Painting* (Skira, 1957) 203 ff. In general cf. H. Schrade, *Vor- und frühromanische Malerei* (Köln, 1958) 204 ff.

54 Cf. Beda, *Comment. in librum Genes.* I, *Venerabilis Bedae Opera . . .* , ed. J. A. Giles VII (London, 1844) 23 f.: Non ergo secundum corpus, sed secundum intellectum mentis ad imaginem Dei creatus est homo; he goes on to say that there is a divine likeness also in the erect, heavenward directed, posture of the human body — a topos that reaches far back into Antiquity. Dependent on Bede is Rabanus Maurus' *Comment. in Genes.* I, 7, Migne, *Patrol. Lat.* CVII, 460B; cf. also *id., De universo* VI, 1, *loc. cit.*, CXI, 141A. — Alcuin, *De animae ratione* 5, Migne, *Patrol. Lat.* CI, 641A: Est quoque anima imagine et similitudine sui conditoris in principali sui parte, quae mens dicitur, excellenter nobilitata; also *ibid.* 6, *loc. cit.*, 614C, where Alcuin uses Augustine's Trinitarian-psychological analogies, as do the *Libri Carolini* I, 7, *loc. cit.*, 24. — Angelomus of Luxeuil (middle of the ninth century), *Comment. in Genes.,* Migne, *Patrol. Lat.* CXV, 122A, and Remigius of Auxerre (late ninth century), *Comment. in Genes.,* Migne, *Patrol. Lat.* CXXXI, 57A, locate the *imago* in the rational part of the soul.

55 John Scot, *De divisione naturae* II, 27, Migne, *Patrol. Lat.* CXXII: 585D f.: Anima namque imago Dei est, corpus vero imago animae . . . ; also II, 9, 536A f.: Ad hoc . . . inter primordiales rerum causas homo ad imaginem Dei factus est, ut in [eo ?] omnis creatura et intelligibilis et sensibilis, ex quibus veluti diversis extremitatibus compositus unum inseparabile fieret, et ut esset medietas atque adunatio omnium creaturarum (Scot here refers to Maximus the Confessor).

56 *De div. nat.* II, 24, *loc. cit.*, 580A f.: . . . non enim dubitamus trinitatem nostrae naturae (on the Trinitarian structure of man see below), quae non imago Dei est, sed ad imaginem Dei condita . . . non solum de nihilo esse creatam, verum etiam sub se adhaerentes sibi sensus sensuumque officinas totumque hoc corpus suum mortale dico creare . . . also IV, 11, 790C ff.: Materialis autem vita . . . imago quaedam animi est et, ut ipse dicit (this refers to Gregory of Nyssa's *De hominis opificio* 12, Migne, *Patrol. Graec.* XLIV, 161D), speculum speculi, ita ut animus divinae naturae forma sit, vitalis autem motus, qui etiam materialis vita vocatur, cum ipsa materia forma sit animi ac veluti secunda imago, per quam animus etiam materiae speciem praestat. Ac per hoc quadam ratione per humanae naturae consequentiam totus homo ad imaginem Dei factus non incongrue dicitur, quamvis proprie et principaliter in solo animo imago subsistere intelligatur, eo ordine ut animus quidem a Deo . . . , vitalis autem

motus ab animo, postremo per vitalem motum ab animo materia formationis suae causam accipiat. . . . Quapropter . . . vitalis motus talis ratio reddenda est, ut nihil aliud sit ipse praeter quandam copulam et juncturam corporis et animae . . . per quam corpus ab anima formatur, vegetatur et administratur. . . . Illud . . . ineffabili quodam silentio administrare non desinit alimenta quibus corpus nutritur et custoditur singulis quibusque partibus distribuens. . . . For the origins of the concept of *vitalis motus* and its use by the Greek and Latin Fathers cf. my *Idea of Reform* 220 f. n. 28; it is related to the *rationes seminales* and therefore both vegetative-biological and metaphysical. For the use of the concept by John Scot cf. H. Bett, *Johannes Scotus Erigena* (Cambridge, 1925) 60, 62. It would seem incidentally that the end of the text *De div. nat.* IV, 11, here quoted is dependent on Augustine, *De musica* VI, 17, 58, Migne, *Patrol. Lat.* XXXII, 1192 f., where the key terms *silentium* and *ministrare* occur in connection with the *vitalis motus*.

57 *De div. nat.* II, 32, *loc. cit.*, 610B f.; cf. V, 31, 942A.

58 *De div. nat.* I, 44, *loc. cit.*, 486; I, 48, 490A f.; II, 23, 568A f.; V, 9, 881A; V, 31, 942A; cf. M. Cappuyns, *Jean Scot Erigène* (Louvain, Paris, 1939) 338 f. The Greek equivalents for Scot's *essentia, virtus,* and *operatio* are οὐσία, δύναμις, and ἐνέργεια. Cf. Pseudo-Dionysius the Areopagite, *De coelesti hierarchia* XI, 2, Migne, *Patrol. Graec.* III, 284D, and *De divinis nominibus* IV, 1 and 23, *ibid.,* 693B and 724C. For both Maximus and Pseudo-Dionysius see P. Sherwood, O. S. B., *The Earlier Ambigua of Saint Maximus the Confessor and His Refutation of Origenism* (Rome, 1955) 103 ff., for the latter also H. U. v. Balthasar, *Kosmische Liturgie: Das Weltbild Maximus' des Bekenners,* 2nd ed. (Einsiedeln, 1961) 336 f.

59 *De div. nat.* II, 23 f., *loc. cit.*, 572C—579B; cf. IV, 16, 825A ff.; cf Cappuyns, *loc. cit.* The Greek equivalents for Scot's *animus* (*intellectus, mens*), *ratio,* and *sensus interior* are νοῦς, λόγος, and διάνοια (or αἴσθησις, see following note). For Maximus the Confessor cf. *Ambigua* 91, Migne, *Patrol. Graec.* XCV, 1112D f.; see also A. Schneider, *Die Erkenntnislehre des Johannes Eriugena* I (Berlin, Leipzig, 1921) 47 ff., and v. Balthasar, *op. cit.,* 287.

60 John Scot's terms *dianoia* = *sensus interior* constitute a terminological contribution of his own, since Maximus had used not διάνοια, but αἴσθησις. The internal sense *sentit extra corpus* (not *per corpus,* cf. *De div. nat.* IV, 16, *loc. cit.,* 825B). For the ancient, especially Aristotelian, origins of this concept cf. *The Great Ideas: A Syntopicon of Great Books of the Western World,* edd. M. J. Adler and W. Gorman (Chicago, etc., 1952) II, 718, 720 f.; it is also found in Augustine, especially *De libero arbitrio* II, 3 ff., Migne, *Patrol. Lat.* XXXII, 1244 ff., and *Confessiones* VII, 17, *ibid.,* XXXII, 745, also *De Trinitate* XI, 3, 6 ff., *ibid.,* XLII, 988 ff There does not seem to be a direct connection here with the doctrine of the spiritual senses, for which cf. K. Rahner, "Les débuts d'une doctrine des cinq sens spirituels chez Origène," *Revue d'ascétique et de mystique* XIII (1932) 113 ff., and J. Ziegler, *Dulcedo Dei* (Münster, 1937) 58 ff. I cannot enter upon the complicated history of the relationship between the ancient and early mediaeval concepts of *sensus interior* on the one hand and *phantasia, phantasma,* and *imaginatio* on the other. As we shall see below, *sensus* and *imaginatio* will emerge as distinct, but patently related concepts more clearly in the twelfth century than in the earlier Middle Ages.

61 *De div. nat.* V, 37, *loc. cit.*, 986D ff., John Scot says that even St. Paul spoke of a spiritual body in the resurrection (I Cor. 15:44) only out of condescension toward simple and timid souls. Quisquis autem sancti Ambrosii Gregoriique Theologi (Gregory of Nyssa) necnon . . . Maximi . . . diligentius dicta inspexerit, inveniet profecto non mutationem corporis terreni in caeleste corpus, sed omnino trasitum in ipsum purum spiritum, non in illum qui aether, sed in illum qui intellectus vocitatur, cf. also V, 20, 893D.

62 Cf. Origen, *De principiis* III, 6, 1 (end), 3 (end), 4–9, *Griech. Christl. Schriftst., Orig.* V, 282, 285 ff.

63 G. Florovsky, "Origen, Eusebius and the Iconoclastic Controversy," *Church History* XIX (1950).

64 Cf. J. Kollwitz, in the article quoted in note 48, pp. 110 ff.; also my article "Der Bilderstreit und die Kunst-Lehren der byzantinischen und abendländischen Theologie," *Zeitschrift für Kirchengeschichte* L (1931) 12 ff.

65 The oldest surviving examples are the ninth century wall paintings of Münster in Switzerland. Cf. L. Birchler, "Zur karolingischen Architektur und Malerei in Münster-Müstair," in: *Frühmittelalterliche Kunst: Akten zum III. Internationalen Kongress für Frühmittelalterforschung* (Olten, Lausanne, 1954) 225 ff.

66 The existence of such a trend is a fact. The view that the end of the world was expected exactly for the year 1000 has been rightly discarded by historians; cf., for instance, C. Pfister, *Études sur le règne de Robert le Pieux* (Paris, 1885) 322 ff., and C. J. Hefele and H. Leclercq, O.S.B., *Histoire des conciles* IV, 2 (Paris, 1911) 901 ff., n. 1. Nevertheless, it can hardly be denied that in the west eschatological expectations were very strong during the two centuries which preceded and followed the passing of the first millennium; cf. H. Focillon, *L'an mil* (Paris, 1952) ch. 1: "Le problème des terreurs." It must be remembered that St. Augustine, *De civitate Dei* XX, 7–9, ed. B. Dombart (Leipzig, 1905) II, 418 ff., had considered it probable that the "thousand years" during which according to Apoc. 20, 2 ff. the devil would be kept in check should be identified with Christian history, though he had refused to take the figure thousand literally and in all likelihood had expected the end of the world long before the year 1000. Yet Christian history went on, and in the pre-Hildebrandian era, before c. 1050, the undaunted expectation of the imminent Second Coming of Christ continually stimulated the eschatological spirituality of an age in which emperor and monk were the guardians of a world waiting for the Last Judgment (cf. E. Rosenstock, *Die europäischen Revolutionen* [Jena, 1931] 115). The long and apparently continuing postponement of the Parousia may however have had something to do with the consolidation in the Hildebrandian reform movement of a terrestrial and yet profoundly spiritual, hierarchical and yet mystical Church, guided by a renewed papacy, a development which is paralleled in art during the second half of the eleventh and the earliest part of the twelfth century by a spiritualization even more integral and radical than that of the late Carolingian and Ottonian ages (see pp. 440, 442 f.).

67 For the imperial "spiritualism" of the Ottonian and early Salian period, paralleled to some extent by contemporary monarchical thought elsewhere in the west and greatly influenced by Byzantium, cf. G. Tellenbach, *Church, State and Christian Society* (Oxford, 1959) 56 ff., and E. H. Kantorowicz, *The King's Two Bodies* (Princeton, 1957), ch. III: "Christ-Centered Kingship," especially 61 ff. Just as in Byzantium, so also in the Ottonian Empire there is close assimilation of the emperor to Christ, as *imago* or *vicarius Christi.* The ruler is the image of God *par excellence.* Pictorially, the west goes even beyond Byzantium in this respect. P. E. Schramm, *Die deutschen Kaiser und Könige in Bildern ihrer Zeit 751–1152* (Leipzig, 1928) Text 94 f., has shown how, for instance, in the Ottonian School of Reichenau, the facial type of Otto III imitates that of Christ (see also *ibid.,* 112 for the portrait of the Emperor Henry II as compared to the image of Christ in the Sacramentary of Henry II from Regensburg). Among the Normans such conceptions survived most tenaciously; in Norman Sicily, for example, in the pictorial assimilation of Roger II to Christ, cf. E. Kitzinger, "On the Portrait of Roger II in the Martorana in Palermo," *Proporzioni* III (1950) 31 ff.

68 Odo of Cluny, *Collationes* I, 1, Migne, *Patrol. Lat.* CXXXIII, 520C f.: Omnis vero ejusdem Scripturae intentio est, ut nos ab hujus vitae pravitatibus compescat. Nam idcirco terribilibus suis sententiis cor nostrum quasi quibusdam stimulis pungit, ut homo terrore pulsatus expavescat et divina judicia, quae aut voluptate carnis aut terrena sollicitudine discissus oblivisci facile solet, ad memoriam reducat. . . . Apostolus . . . subjunxit: "Nescientes (sic!) suademus hominibus timorem Dei" (cf. 2 Cor. 5:11). Hinc alias: "Deum time et mandata ejus observa, hoc est omnis homo" (Ecclesiastes 12:13). Quibus verbis ostenditur quod is qui Deum non timet homo esse desiit.

69 Rather of Liège, *Praeloquia* I, 1, 2, Migne, *Patrol. Lat.* CXXXVI, 149A f.: . . . Time Deum . . . pro Dei timore te contine, filios in Dei timore educa. . . . *Ibid.* II, 1, 2, *loc. cit.,* 190A: Vir es, a virtute necne a vireo vel a viribus sive vi et rego verbo (this seems to be a modification of Isidore, *Etymolog.* XI, 2, 17, ed. W. M. Lindsay II [Oxford, 1911]). Femineam devitans mollitiem, in virtute solida animum . . . quod tunc facere praevales, si viribus nitens vim animi ad sidera eleves, carnem animae, animam subigas Deo, rigidus semper et inflexibilis. . . . *Ibid.* II, 2, 3, *loc. cit.,* 191A: . . . Vir itaque mente, mulier carne. . . .

70 Bamberg, Staatsbibliothek, Cod. Bibl. 41, fol. 231r; cf. A. Grabar and C. Nordenfalk, *Romanesque Painting* . . . (Skira, 1958) 152.

71 Cf. H. Swarzenski, *Monuments of Romanesque Art* (Chicago, 1953) 45 and plates 41 f., with bibliography, and especially W. Otto, "Reichenauer Goldtreibarbeiten," *Zeitschrift für Kunstgeschichte* XIII (1950) 57 ff., also 39; Otto shows very well how the volume of the figures is to some extent "dematerialized" and transcended by the resplendent lustre of the golden material.

72 Thiofrid of Echternach, *Flores epitaphii sanctorum* (this is the title according to M. Manitius, *Geschichte der lateinischen Literatur des Mittelalters* III [Munich, 1931] 95), Gotha, Herzogliche Bibliothek, Cod. I, 70, fol. 98v; cf. Schrade, *Vor- und frühromanische Malerei* 95 f.

73 John of Fécamp, *Confessio theologica* III, 30, edd. Dom J. Leclercq and J.-P. Bonnes, *Un maître de la vie spirituelle au XI^e siècle: Jean de Fécamp* (Paris, 1946) 176: Tu vita qua vivo, spes cui inhaereo, gloria quam adipisci desidero, tu mihi cor tene, mentem rege, intellectum dirige, amorem erige, animum suspende, et in superna fluenta os sitientis te spiritus trahe. Taceat quaeso tumultus carnis. . . . Sileat sibi et ipsa anima et transeat se, non cogitando se. . . . Secretum quietis da corpori et animae meae. . . . *Ibid.*, III, 32, *loc. cit.*, 182: Ecce dum divinae theoriae mens mea suspirat et tuam, Domine, prone pro captu suo meditatur et loquitur gloriam, ipsa carnis sarcina minus gravat: cogitationum tumultus cessat, pondus mortalitatis et miseriarum more solito non hebetat, silent cuncta, tranquilla sunt omnia. Cor ardet, animus gaudet, memoria viget, intellectus lucet, et totus spiritus ex desiderio visionis pulchritudinis tuae accensus in invisibilium amorem rapi se videt.

74 Cf. M. Schapiro, "The Romanesque Sculpture of Moissac," *The Art Bulletin* XIII (1931) 257, where the author excellently describes the reduction of the remnants of the older, still relatively naturalistic, style and the development of Romanesque "archaism" (cf. below note 79) out of this reduction.

75 Paris, Bibliothèque Nationale, Ms. lat. 9438, fol. 58. Cf. V. Leroquais, *Les sacramentaires et les missels manuscrits des Bibliothèques publiques de France* I (1924) 213 ff.

76 Cf. Ladner, *Papstbildnisse* I, 202 ff.

77 The process in art is well described by A. Boeckler, "Die romanischen Glasfenster des Augsburger Domes und die Stilwende vom 11. zum 12. Jahrhundert," *Zeitschrift des Deutschen Vereins für Kunstwissenschaft* X (1943) 159 ff.

78 E. Panofsky, *Die deutsche Plastik des 11. bis 13. Jahrhunderts* (Munich, 1924) Text 13–19 and 42–46. Cf. now also H. Keller, "Zur Entstehung der sakralen Vollskulptur in der ottonischen Zeit," *Festschrift für Hans Jantzen* (Berlin, 1951) 71 ff., for anticipations of sculpture in the round in the Ottonian period, such as the Madonnas of Essen and Paderborn or the St. Fides of Conques.

79 For Plaimpied cf. P. Deschamps, *La sculpture française, époque romane* (Paris, 1947) 83 f.; for Moissac the study by Schapiro, cited in note 74.

80 Cf. Schapiro, *op. cit.*, 251 f.

81 See also my *Papstbildnisse* I, 5 f., 184 f., 215, 220.

82 H. Grundmann, *Der Cappenberger Barbarossakopf* (Köln, Graz, 1959). Cf. also P. E. Schramm and F. Mütherich, *Denkmale der deutschen Könige und Kaiser* (Munich, 1962) 180 and 409 no. 173.

83 For the literary portrait of Frederick Barbarossa see especially Rahewin, *Gesta Friderici I* IV, 86, *Script. Rer. Germ.* (1912) 342 ff., and cf. Grundmann, *op. cit.*, 50 ff., who has shown how Rahewin used Sidonius Apollinaris' description of the Visigothic King Theodoric II and Einhard's Life of Charlemagne, but transformed these models to serve the characterization of Barbarossa. For the concept of the *honor imperii*, which is found, for instance, in Rahewin, *op. cit.*, III,*22 and 24, *loc. cit.*, 195 and 197, and in the Treaty of Constance between the emperor and Pope Eugene III of 1153, cf. P. Rassow, *Honor Imperii* (Munich, 1961) 78 ff., who gives a new edition of the Treaty of Constance. Cf. now also H. Fillitz, "Der Cappenberger Barbarossakopf," *Münchner Jahrbuch der bildenden Kunst*, Folge III, Bd. XIV (1963) 39 ff., where the author argues convincingly that the city wall with turrets and battlements, over

which the bust of the emperor arises, symbolizes Rome and the Roman Empire, as it does on many seals.

84 For the sculptures of Chartres, both their program and their style, cf. now A. Katzenellen-bogen, *The Sculptural Programs of Chartres Cathedral* (Baltimore, 1959).

85 For the façade of Notre Dame cf. W. Sauerländer, "Die kunstgeschichtliche Stellung der Westportale von Notre-Dame in Paris," *Marburger Jahrbuch für Kunstwissenschaft* XVII (1959) 1 ff.

86 Cf. A. Goldschmidt, *Die Bronzetüren von Novgorod und Gnessen* (Marburg a.L., 1932) plate II, 34.

87 John of Salisbury, *Policraticus* V, 2, ed. C. C. I. Webb I (Oxford, 1909) 282 f. For an ecclesi-ological rather than political anticipation of John's organological metaphors, which dates from c. 1058, see Humbert of Silva Candida, *Adversus Simoniacos* III, 29, *Monum. Germ. Hist., Libelli de Lite* I, 235.

88 Honorius Augustodunensis, *Elucidarium* I, 11, Migne, *Patrol. Lat.* CLXXII, 1116B f.: Caput . . . est rotundum in coelestis sphaerae modum, in quo duo oculi ut duo luminaria in coelo micant; quod etiam septem foramina ut septem coelum harmoniae ornant. Pectus, in quo flatus et tussis versantur, simulat aerem, in quo venti et tonitrua concitantur. Venter omnes liquores ut mare omnia flumina recipit. Pedes totum corporis pondus ut terra cuncta susti-nent. . . . Cf. Isidore of Seville, *Different.* II, 17, 48 ff., Migne, *Patrol. Lat.* LXXXIII, 77D ff.

89 Hildegard of Bingen, *Liber divinorum operum simplicis hominis*, Pars I, Visio IV, Migne, *Patrol. Lat,* CXCVII, 807 ff., especially c. 14 ff., *loc. cit.,* 813C ff.

90 William of Conches, *Philosophia*, ed. C. Ottaviano, *Un brano inedito della "Philosophia" di Guglielmo di Conches* (Naples, 1935) 21: . . . homo microcosmus, idest minor mundus appel-latur. In eminentiori etenim loco habet caput ad celi similitudinem, forma rotunda precellens; pedes terram calcantes sicut ipsa terra inferiori sunt loco; brachia vero et cetera membra ut alie mundi partes inter untraque sunt collocata. Concordat etiam civitate Socratis imaginaria (cf. Plato, Laws 745B, 848D): est enim caput quasi arx Palladis in eminentiori loco civitatis positum; iuxta illud vero brachia tamquam prudentes et fortes ad arcem tuendum collocata; sunt venter et genua quasi muliercule et eiusdem civitatis opifices; coxe autem et crura sunt negotiatores huc et illuc discurrentes; pedes autem sunt agricole. Cf. also Ernald of Bon-neval (near Chartres, d. after 1156), *Hexaemeron*, Migne, *Patrol. Lat.* CLXXXIX, 1529, and Alcher of Clairvaux, *De spiritu et anima* (in the Middle Ages believed to be by St. Augustine) 37, Migne, *Patrol. Lat.* XL, 807.—The comparisons of the head with the sphere of heaven and with the castle (and *capitolium*) in the city occur also in Bernardus Silvestris, *De mundi universitate*, edd. C. S. Barach and J. Wrobel (Innsbruck, 1876) 64. They could be found al-ready in Cassiodorus, *De anima* 8 f., Migne, *Patrol. Lat.* LXX, 1293C and 1295A, in Isidore of Seville, *Differentiae* II, 17, 48 f., Migne, *Patrol. Lat.* LXXXIII, 77D f., in Rabanus Maurus, *Tractatus de anima* 5 and 11, Migne, *Patrol. Lat.* CX, 1114C f. and 1119A f.

90a Richard of St. Victor, *De statu interioris hominis* I, 2, Migne, *Patrol. Lat.* CXCVI, 1118B.

91 Cf. P. Deschamps, *French Sculpture of the Romanesque Period, Eleventh and Twelfth Cen-turies* (Florence, Paris, 1930) 47, plate 49B.

92 W. Köhler, "Byzantine Art in the West," *Dumbarton Oaks Papers* I (1941) 85 ff.

93 Panofsky, *op. cit.,* 65 ff.

94 R. Grinnell, "Iconography and Philosophy in the Crucifixion Window at Poitiers," *The Art Bulletin* XXVIII (1946) 171 ff.

95 One of the best introductions into the many-faceted new psychology of the twelfth century is the article of H. Michaud-Quantin, "La classification des puissances de l'âme au XIIe siècle," *Revue du moyen âge latin* V (1949) 15 ff., with which I became acquainted only when the text of this study was written; cf. references in note 98.

96 For Albertus Magnus cf. A. Schneider, *Die Psychologie Alberts des Grossen (Beiträge zur Geschichte der Philosophie des Mittelalters* IV/5, Münster, 1903) 14 f.; for Thomas Aquinas cf. É. Gilson, *Le thomisme*, 5th ed. (Paris, 1948) 263 ff., especially 275 ff.

97 Cf. K. Werner, "Der Entwicklungsgang der mittelalterlichen Psychologie von Alcuin bis Al-

bertus Magnus," *Denkschriften der Kaiserlichen Akademie der Wissenschaften*, Philosoph.-Histor. Classe, XXV (Vienna, 1876) 69 ff.; A. Schneider, *Die abendländische Spekulation des 12. Jahrhunderts in ihrem Verhältnis zur aristotelischen und jüdisch-arabischen Philosophie* (*Beitr. z. Gesch. d. Philos. d. Mittelalt.* XVII/4, 1915).

98 Hugh of St. Victor, *De unione corporis et spiritus*, Migne, *Patrol. Lat.* CLXXVII, 285A f.: "Quod natum est ex carne caro est et quod natum est ex spiritu spiritus est" (John 3:6). Si nihil inter spiritum et corpus medium esset, neque spiritus cum corpore neque corpus cum spiritu convenire potuisset. Multum autem distat inter corpus et spiritum; longe sunt a se duo haec. Est ergo quiddam quo ascendit corpus, ut appropinquet spiritui, et rursum quiddam quo descendit spiritus ut appropinquet corpori. . . . Corpus sensu ascendit, spiritus sensualitate descendit; item spiritus ascendit contemplatione, Deus descendit revelatione. Theophania est in revelatione, intelligentia in contemplatione, imaginatio in sensualitate, in sensu instrumentum sensualitatis et origo imaginationis. . . . *Ibid.*, 286D–287A: . . . quod summum est in corpore, propinquum est spiritui et in ipso vis imaginandi fundatur, supra quam est ratio. . . . Est itaque imaginatio similitudo sensus in summo corporalis spiritus et in imo rationalis, corporalem informans et rationalem contingens. Sensus namque . . . extrinsecus corpus contingens formatur ipsamque formam ex corporis contactu conceptam intrinsecus reducens . . . ad cellam phantasticam colligit eamque illi parti puriori corporei spiritus imprimens imaginationem facit. . . . Sic itaque ab infimis et extremis corporibus sursum usque spiritum incorporeum quaedam progressio est per sensum et imaginationem: quae duo in spiritu corporeo sunt. Postea in spiritu incorporeo proxima post corpus est affectio imaginaria, qua anima ex corporis conjunctione afficitur, supra quam est ratio in imaginationem agens. Deinde ratio pura supra imaginationem, in qua ratione supremum est animae a corpore sursum. Quando autem ab anima sursum itur ad Deum, prima est intelligentia: . . . praesentia divina . . . sursum informans rationem facit sapientiam sive intelligentiam, sicut imaginatio deorsum informans rationem scientiam facit. Cf. H. Ostler, *Die Psychologie des Hugo von St. Viktor* (*Beitr. z. Gesch. d. Philos. d. Mittelalt.* VI/1, 1906) 73 ff. As other contemporary writers (see immediately below), so also Hugh of St. Victor probably took the sequence *sensus, imaginatio, ratio, intelligentia* from Boethius, *De consolatione philosophiae* V, 4, 27 ff., *Corpus Christianorum* XCIV, 97 (cf. Michaud-Quantin, *op. cit.*, 16), yet the whole text quoted seems to be related also to Augustine, *De Trinitate* XI, 3, 6 ff., *Patrol. Lat.* XLII, 988 ff. For the history of the localization of the various faculties of the soul in various parts of the brain cf. W. Sudhoff, "Die Lehre von den Hirnventrikeln in textlicher und graphischer Tradition des Altertums und Mittelalters," *Archiv für Geschichte der Medizin* VII (1913) 149 ff.—As for the concept of the *spiritus corporalis* or *corporeus*—not to be confused with the incorporeal spirit—it, too, is common among twelfth century thinkers in the west, where it received increasing vogue through the Latin translation and transmission of the ancient (Arabo-Greek), and especially Galenian, medico-philosophical tradition by Constantinus Africanus and others. William of Conches, for instance, in his "*Philosophy*" only reproduces this tradition when he subdivides the bodily spirit into *spiritus* (or *virtutes*) *naturalis, spiritualis, and animalis*, which are concerned with nutrition and generation, with circulation and respiration, and with sensation and innervation, respectively; cf. the version printed among the works of Honorius Augustodunensis, *De philosophia mundi* 18 ff., Migne, *Patrol. Lat.* CLXII, 91 ff. Cf. also William of Saint-Thierry, *De natura corporis et animae* I, Migne, *Patrol. Lat.* CLXXX, 700B ff., and Alcher of Clairvaux. *De spiritu et anima* 20–22, Migne, *Patrol. Lat.* XL, 794 f., who speaks of *vis naturalis, vis vitalis*, and *vis animalis*. In general see Werner, *op. cit.*, 71, 82 ff., 123, Schneider, *Abendländ. Spekulation* 56 f., C. Baeumker, *Des Alfred von Sareshel (Alfredus Anglicus) Schrift De motu cordis* (*Beitr. z. Gesch. d. Philosoph. d. Mittelalt.* XXIII/1–2, 1923), and especially Michaud-Quantin, *op. cit.*, 19.

99 Cf. Godfrey of St. Victor (d. after 1194), *Microcosmus*, ed. P. Delhaye (Lille, Gembloux, 1951), 46 ff.—Achard of St. Victor (d. 1171), *Tractatus de discretione animae, spiritus et mentis*, ed. G. Morin, in: *Aus der Geisteswelt des Mittelalters . . . M. Grabmann . . . gewidmet* (*Beitr. z. Gesch d. Philosoph. d. Mittelalt.* Suppl. vol. III/1, 1935) 252 ff., has a somewhat different

sequence: from *caro* via *anima* (which contains *sensus* et *sensualitas*) and via *spiritus* (which contains *imaginatio*) to *mens*.

100 Cf. W. Jansen, *Der Kommentar des Clarenbaldus von Arras zu Boethius De Trinitate* (Breslau, 1926) 45 ff.; T. Gregory, *Anima Mundi* (Florence, 1955) 167 (for William of Conches).—Especially in the school of Chartres (Adelard of Bath, William of Conches, etc.), but not only there, one also finds number and musical harmony as links between body and soul; this is of course due to the Platonic tradition, in which Boethius was particularly important and which continued into Carolingian times; see the survey by C. H. Talbot in his introduction to the edition of Ailred of Rievaulx's *De anima* (cited below, note 103) 41 f.

101 Isaac of Stella, *Epistola de anima*, Migne, *Patrol. Lat.* CXCIV, 1881B f.: De sensu ergo oritur imaginatio. . . . Sensus vera corpora . . . percipit . . . , imaginatio vero ipsorum verorum tantum similitudines et imagines, unde imaginatio nominatur: quae cum non sint vera corpora . . . , elongatio quaedam et evaporatio a corporeis est imaginatio nec tamen ad incorporeum pervenتio, extremi spiritus corporei conatus, sed non ad incorporeum perventus. Impossibie etenim est, quod corpus est, in spiritum attenuari, vel quod spiritus est, in corpus incrassari. . . . Sunt tamen utriusque quaedam similia, corporis videlicet supremum et spiritus infimum, in quibus sine naturarum confusione personali tamen unione facile necti possunt. . . . Itaque quod vere spiritus est, et non corpus, et caro quae vere corpus est, et non spiritus, facile et convenienter uniuntur in suis extremitatibus, id est in phantastico animae, quod fere corpus est, et sensualitate carnis, quae fere spiritus est. Sicut enim supremum animae, id est intelligentia sive mens . . . , imaginem et similitudinem sui gerit superioris, id est Dei, unde et ejus susceptiva fore potuit et ad unitionem personalem etiam, quando ipse voluit, absque ulla demutatione naturae fuit assumpta, sic et supremum carnis, id est sensualitas, gerens similitudinem animae, cur ad personalem unionem ejus non suscipiat essentiam? . . . Cf. W. Meuser, *Die Erkenntnislehre des Isaak von Stella*, Diss. Freiburg i. B. (Bottrop, 1934) especially 5 ff., 19–25; Grinnell, *op. cit.*, 187 ff.

102 Hugh of St. Victor, *De sacramentis* II, 1, 11, Migne, *Patrol. Lat.* CLXXVI, 405A f.: Dicit autem Scriptura: "Sicut anima rationalis et caro unus homo, ita Deus et homo unus est Christus" (this is taken from the *Symbolum Athanasianum*, cf. Ostler, *op. cit.*, 88). Videte similitudinem. Bene dico anima et caro est homo et iterum bene dico homo est persona. Et rursum bene dico anima et caro est una persona. Nevertheless, Hugh points out, this *similitudo* is only partial, since with regard to Christ it can be said that God is Christ and a person and that man is Christ and a person, whereas it cannot be said of the soul alone or of the flesh alone that they are man and are a person. Hugh had been partly anticipated by Odo of Cambrai, who, *De peccato originali* III, Migne. *Patrol. Lat.* CLX, 1087D f., compares man with the Triune God and contrasts the personal union of different substances in man with the one essence of God instead of comparing the former with the hypostatic union of two natures in Christ.

103 Ailred of Rievaulx, *De anima* I, ed. C. H. Talbot (London, 1952) 86: Nunquid non potuit anima rationalis sine his sensibus inesse corpori? Nullo modo . . . corpori huic . . . anime subtilitas posset inherere nisi per vim sentiendi . . . , que ita subtilis est et vicina spiritui, ut pene spiritus sit, sepe autem pro sui subtilitate spiritus vel vite spiritus appelletur (cf. above note 98 for the *spiritus corporeus*). Ita et Verbum Dei, cuius comparatione omnia quodammodo possunt dici corporea, nullo modo posset ita adherere carni, ut una cum eo esset persona, nisi mediante illa natura, que ceteris omnibus subtilior est et divine nature vicinior, id est spiritu rationali.

104 Alcher of Clairvaux, *De spiritu et anima* 14, Migne, *Patrol. Lat.* XL, 789 f. (this section of Alcher's work seems to be taken over almost literally from the *Epistola de anima* which Isaac of Stella had addressed to him, cf. above).

105 Helinand of Froidmont, *De cognitione sui* 8, Migne, *Patrol. Lat.* CCXII, 729D: Ante incarnationem Verbi similis erat Deo sola forma interior, sed ab incarnatione Verbi facta est forma Dei ipsa quoque hominis forma exterior.—We are here close to the age of St. Francis of Assisi, who could say in his *Fifth Admonition*: "Take heed, O man, in what excellent state the Lord God has placed you, for He created and formed you in the image of His beloved Son ac-

cording to the body and in His likeness according to the spirit" (cf. H. Boehmer, *Analekten zur Geschichte des Franciscus von Assisi* [Tübingen, Leipzig, 1904] 43). The profound impact of Franciscan thinking on the image of man in thirteenth- and fourteenth-century art lies beyond the scope of this study.

106 Cf. Bernard of Clairvaux, *Apologia ad Guillelmum Sancti-Theoderici Abbatem* 12, 29, Migne, *Patrol. Lat.* CLXXXII, 915D f.: Caeterum in claustris coram legentibus fratribus quid facit illa ridicula monstruositas, mira quaedam deformis formositas ac formosa deformitas? Quid ibi immundae simiae? quid feri leones? quid monstruosi centauri? quid semihomines? quid maculosi tigrides? quid milites pugnantes? quid venatores tubicinantes? Videas sub uno capite multa corpora et rursus in uno corpore capita multa. Cernitur hinc in quadrupede cauda serpentis, illinc in pisce caput quadrupedis. Ibi bestia praefert equum capram trahens retro dimidiam, hic cornutum animal equum gestat posterius.

107 For that phantastic world of Romanesque sculpture which St. Bernard envisaged cf. best H. Focillon, *L'art des sculpteurs romans* (Paris, 1931), especially 192 f. — M. Schapiro, "On the Aesthetic Attitude in Romanesque Art," in: *Art and Thought . . . in Honour of Dr. Ananda K. Coomaraswamy* (London, 1947) 134–137, rightly points out that Bernard did not even see — or did not want to see? — these Romanesque monsters as symbols of demons, but simply as snares of idle curiosity.

107a Actually in the spiritual literature of the time the beginnings of the devotion to the humanity of Christ — which always remains a devotion in view of His divinity — go back to the late eleventh century, the age of John of Fécamp and Anselm of Canterbury; cf. A. Wilmart, O. S. B., *Auteurs spirituels et textes dévots du moyen âge* (Paris, 1932) 62 f., 506 f., J. Leclercq, O. S. B., "Drogon et saint Bernard," *Revue Bénédictine* LXIII (1953) 128 ff., id., "Études sur saint Bernard et le texte des ses écrits," *Analecta Sacri Ordinis Cisterciensis* IX (1953) 190.

108 Bernard of Clairvaux, *Tractatus de gratia et libero arbitrio* 9, 28, Migne, *Patrol. Lat.* CLXXXII, 1016B: . . . imaginem quidem in libertate arbitrii . . . ; solum liberum arbitrium sui omnino defectum seu diminutionem non patitur, quod in ipso potissimum aeternae et incommutabilis divinitatis substantiva quaedam imago impressa videatur. . . . *Ibid.*, 2, 4, *loc. cit.*, 1003C: Est vero ratio data voluntati, ut instruat illam non destruat. Destrueret autem, si necessitatem ei ullam imponeret. . . .

109 For Gregory of Nyssa see, for instance, *De hominis opificio* 4 and 16, Migne, *Patrol. Graec.* XLIV, 136B f. and 184B; cf. J. Gaïth, *La conception de la liberté chez Grégoire de Nysse* (Paris, 1953) 40 ff., J.-M. Déchanet, O. S. B., *Aux sources de la spiritualité de Guillaume de Saint-Thierry* (Bruges, 1940) 43 ff., H. de Lubac, "Esprit et liberté dans la tradition théologique," *Bulletin de littérature ecclésiastique* XL (1939) 124 f. — See also Hugh of Amiens (Archbishop of Rouen 1130–1164), *Tractatus in Hexaemeron* II, 34, ed. F. Lecomte, *Archives d'histoire doctrinale et littéraire du moyen âge* XXXIII — 1958 (1959) 259; Richard of St. Victor, *De statu interiori hominis* 3, Migne, *Patrol. Lat.* CXCVI, 118C f.

110 These three concepts are linked by Bernard to his distinction of *imago, similitudo* and *gloria* in the divine-human image-likeness, a distinction which is of patristic origin (at least as far as the first two terms are concerned, cf. above p. 435 f.): the image is a creational gift, the likeness — though founded in creation and aided by grace — is an ascetic achievement, which will finally issue into the glory of heaven. Cf. *De gratia et libero arbitrio* 3 and 9, *loc. cit.*, 1004D ff. and 1016B ff., and see É. Gilson, *La théologie mystique de saint Bernard* (Paris, 1947) 65 ff. and 106.

111 *De gratia et libero arbitrio* 10, 34, *loc. cit.*, 1019B f.: Sic ergo et liberum arbitrium suo conetur praeesse corpori, ut praeest sapientia orbi "attingens" et ipsum "a fine usque ad finem fortiter" (Wisdom 8:1), imperans scilicet singulis sensibus et artubus tam potenter, quatenus non sinat regnare peccatum in suo mortali corpore nec membra sua det arma iniquitati, sed exhibeat servire justitiae. Et ita jam non erit homo servus peccati, cum peccatum non fecerit: a quo utique liberatus jam libertatem recuperare consilii, jam suam incipiet vindicare dignitatem, dum divinae in se imagini condignam vestierit similitudinem, imo antiquam reparaverit venustatem. Curet autem haec agere non minus suaviter quam fortiter, hoc est non ex tristitia aut ex necessitate, quod est initium non plenitudo sapientiae: sed prompta et alacri volun-

tate, quod facit acceptum sacrificium, quoniam hilarem datorem diligit Deus (cf. 2 Cor. 9:7). Sicque per omnia imitabitur sapientia, dum et vitiis resistet fortiter et in conscientia requiescet suaviter.

112 See, for instance, Bernard's *Sermo* XX, 5, 6–9, edd. J. LeClercq, C. H. Talbot, H. M. Rochais, *S. Bernardi Opera* I (Rome, 1957) 118 ff. Cf. Gilson, *op. cit.*, 101 ff.

113 Giovanni Pico della Mirandola, *Oratio* (*De hominis dignitate*), ed. E. Garin (Florence, 1942) 105 f.: (God speaks to Adam) . . . Definita ceteris natura intra praescriptas a nobis leges coercetur. Tu nullis angustiis coercitus pro tuo arbitrio, in cuius manu te posui, tibi illam praefinies. Mundum te mundi posui, ut circumspiceres inde commodius quicquid est in mundo. Nec te caelestem neque terrenum, neque mortalem neque immortalem fecimus, ut tui ipsius quasi arbitrarius honorariusque plastes et fictor in quam malueris tute formam effingas. Poteris in inferiora quae sunt bruta degenerare; poteris in superiora quae sunt divina ex tui animi sententia regenerari.

114 Dante, *Paradiso* XXXIII, 115–117 and 127–132:
Ne la profonda e chiara sussistenza
de l'alto lume parvermi tre giri
di tre colori e d'una contenenza

. .

Quella circulazion che sì concetta
pareva in te come lume reflesso,
da li occhi miei alquanto circunspetta
dentro da sé, del suo colore stesso,
Mi parve pinta de la nostra effige;
Per che 'l mio viso in lei tutto era messo.

115 É. Gilson, *Painting and Reality* (*Bollingen Series* XXXV, 4, New York, 1957) 280; cf. also 268 and 294 ff. for excellent remarks about the problem of representational and nonrepresentational Christian art.

116 H. U. v. Balthasar, *Verbum Caro* (Einsiedeln, 1960) 117 f.

Additional Note, concerning ninth and twelfth century image theory (cf. notes 59 f. on John Scot and notes 98 and 101 on Hugh of St. Victor and Isaac of Stella):

It is very interesting to see how in Byzantium—which had reached its own synthesis of the natural and supranatural in art long before the western High Middle Ages achieved anything comparable—the eighth and ninth century iconophile theoreticians of the image had stressed the Aristotelian concept of imagination (φαντασία) as a bridge between sense and mind, very much in the manner later found in Hugh of St. Victor and other psychologist-theologians of the twelfth-century West. Cf. the excellent remarks by Gervase Mathew, O.P., *Byzantine Aesthetics* (London, 1963) 117 ff., and the following texts quoted by him: John of Damascus, *De fide orthodoxa* II, 20, Migne, *Patrol. Graec.* XCIV, 940A f., and Theodore of Studion, *Epist.* II, 36, Migne, *Patrol. Graec.* XCIX, 1220B f.; according to the latter not only *phantasia* but also *aisthesis, doxa,* and *dianoia* lead from sense to mind *(nous)*; *dianoia* is the originally Aristotelian concept which we found in John Scot as identical with *sensus interior*. For John Scot's concept of *phantasia* and its relation to *sensus corporeus* and *sensus interior,* cf. also E. de Bruyne, *Études d'esthétique médiévale* I (Brugge, 1946) 366, and R. Assunto, *La critica d'arte nel pensiero medioevale* (Milano, 1961) 77; see also de Bruyne, *op. cit.* II, 219–227, about *sensus corporeus* and *sensus intellectualis* or *spiritualis*, about *imaginatio*, and about *affectio imaginaria* or *imaginatio moderatrix* in the School of St. Victor, and Assunto, *op. cit.*, 142 f., about *sensus* and *imaginatio* in William of Conches.

KEY TO SOURCES OF ILLUSTRATIONS

ACL: A.C.L., Brussels

Albany Inst.: Albany Institute of History and Art, Albany, N.Y.

Alinari–ARB: Alinari–Art Reference Bureau, Ancram, N.Y.

Alinari–Giraudon: Alinari–Art Reference Bureau, Ancram, N.Y., and Giraudon, Paris

Anderson–ARB: Anderson–Art Reference Bureau, Ancram, N.Y.

Andrews: Wayne Andrews, Grosse Pointe, Mich.

Arch. Inst., Princeton: Archaeological Institute of America, Princeton, Committee for the Excavation of Antioch and its Vicinity

Arch. Record: Architectural Record, New York (June 1948), copyright 1948 by McGraw Hill, Inc., with all rights reserved

Arch. Rev.: Architectural Review, 88 (Dec. 1940), Pl. 18

Archives: Archives Photographiques, Paris

Belcher: Joseph Belcher, George Whitefield: A Biography (New York: American Tract Society, 1857), opp. p. 83

Belluschi: Pietro Belluschi, Boston

Bib. Nat.: Bibliothèque Nationale, Paris

Bishop: Lewis H. Bishop, Warsaw, N.Y.

Böhm: Osvaldo Böhm, Venice

Borlui: Borlui, Venice

Brandeis: Brandeis University, Waltham, Mass.

Briggs: Martin S. Briggs, Puritan Architecture (London: Lutterworth Press, 1946).

Chi. Arch. Photo.: Chicago Architectural Photographing Co.

Chiodi: Chiodi, Hingham, Mass.

Columbia: Department of Fine Arts, Columbia University, New York

Essex Inst.: Essex Institute, Salem, Mass.

Felici: Fotografo Pontificio, G. Felici, Rome

Fiorentini, Alinari–ARB: Fiorentini and Alinari–Art Reference Bureau, Ancram, N.Y.

Fotocielo: Fotocielo, Rome

Fot. Unione: Fototeca Unione, Rome

French Emb.: French Embassy Press and Information Division, New York

Friends of Touro: Society of Friends of Touro Synagogue, Newport, R.I.

Gabinetto: Gabinetto Fotografico Nazionale, Rome

Gallagher: H.M.P. Gallagher, Robert Mills (New York: Columbia U. Press, 1935), opp. p. 78

Germ. Arch. Inst.: German Archaeological Institute, Rome

Giorgio Cini: Fondazione Giorgio Cini, Venice

Giraudon: Photographie Giraudon, Paris

Gottscho-Schleisner: Gottscho-Schleisner, Inc., Jamaica, N.Y.

Green: The Green Studio, Ltd., Dublin

Hedrich-Blessing: Hedrich-Blessing, Chicago

Heffernan: James Heffernan, New York

Hirmer: Hirmer Fotoarchiv, Munich

Historical Soc. of Pa.: Historical Society of Pennsylvania, Philadelphia

Hitchcock: H. R. Hitchcock, In the Nature of Materials (New York: Duell, Sloan and Pearce, 1942), Fig. 119

Houvet: E. Houvet, Chartres

Howland and Spencer: R. H. Howland and E. P. Spencer, The Architecture of Baltimore: A Pictorial History (Baltimore: Johns Hopkins Press, 1953), Pl. 36

Hoyle, Doran, and Berry: Hoyle, Doran, and Berry, Inc., Boston

IFA–NYU: Institute of Fine Arts, New York University

IFA–Offner: Institute of Fine Arts, New York, Richard Offner Collection

Jaffe: Kunstanstalt Max Jaffe, Vienna

Kersting: A. F. Kersting, London

Kidder Smith: G. E. Kidder Smith, New York

Lib. Cong.: Library of Congress, Washington, D.C.

Marburg–ARB: Marburg–Art Reference Bureau, Ancram, N.Y.

Maryland H.S.: Maryland Historical Society, Baltimore

MAS: MAS, Barcelona

Menzies: Elizabeth G. C. Menzies, Princeton, N.J.

Met: Metropolitan Museum of Art, New York

Min. Ed., Algiers: Ministère de l'Education Nationale, Algiers

Murphy: Murphy, Downey, Willford, and Richman, St. Louis

Nat. Council Churches: Planning Church Buildings, © 1945 by Bureau of Church Building, National Council of Churches

Nat. Monuments Record: National Monuments Record, London

Neth. Info.: Netherlands Information Service, New York

Novosti: Novosti Press Agency, Moscow

Philadelphia: Philadelphia Museum of Art

Pontif. Commis.: Pontif. Commis. di Archeologia Sacra, Vatican City

Powell: J. Powell, Rome

R.C.H.M.: R.C.H.M. England, Crown Copyright

R.I.H.S.: Rhode Island Historical Society, Providence

R.I.S.D.: Museum of Art, Rhode Island School of Design, Providence

Radio Times Hulton: Radio Times Hulton Picture Library, London

Roger-Viollet: Roger-Viollet, Paris

Ronbier: Jean Ronbier, Paris

S.P.N.E.A.: Society for the Preservation of New England Antiquities, Boston

Sandak: Sandak, Inc., New York

Sansoni: Guido Sansoni, Florence

Smithsonian: Smithsonian Institution, Architectural Drawings Office, Washington, D.C.

Soprin., Florence: Soprintendenza alle Galerie, Florence

Soprin. Mon.: Soprintendenza ai Monumenti nel Lazio

Soprin., Venice: Soprintendenza alle Galerie, Venice

Steinkopf: Walter Steinkopf, Berlin

Stoller: © Ezra Stoller (ESTO), Mamaroneck, N.Y.

Stoney: From *Plantations of the Carolina Low Country* (Charleston, S.C.: Carolina Art Association, 1938), Samuel Gaillard Stoney, historian and author of the text: Albert Simons, F.A.I.A., and Samuel Lapham, Jr., F.A.I.A., editors and compilers

Townsend: W. J. Townsend, *A New History of Methodism* (London: Hodder and Stoughton, 1909), Vol. I, Pl. 17

U. Michigan: University of Michigan Fine Arts Department, Ann Arbor, Mich.

Upjohn: E. M. Upjohn, *Richard Upjohn, Architect and Churchman* (New York: Columbia U. Press, 1939), Fig. 68

Varlez: G. Varlez, Autun

Vatican: Vatican Photo Archives

Ware: W. R. Ware, *The Georgian Period* (New York: U.P.C. Book Co., 1923), Vol. 6, Pl. 375

Wertenbaker: Reproduced by permission of Charles Scribner's Sons from *Founding of American Civilization*, p. 78, by Thomas J. Wertenbaker. Copyright 1938 Charles Scribner's Sons; renewal copyright © 1966 Thomas Jefferson Wertenbaker

Winstone: Reece Winstone, A.R.P.S., Bristol, England

Wischnitzer: Rachel Wischnitzer, *Synagogue Architecture in the United States* (Philadelphia: Jewish Publication Society of America, 1955), Pl. 6

Zumbühl: Zümbuhl, St. Gall. Switzerland

Guido da Siena and A.D. **1221**
RICHARD OFFNER

above: 1. GUIDO DA SIENA. *Madonna and Child.* Palazzo Pubblico, Siena. [*Anderson–ARB*]

above right: 2. GUIDO DA SIENA. *Madonna and Child and Four Saints,* dossal No. 7. Pinacoteca, Siena. [*Alinari–ARB*]

right: 3. Workshop of GUIDO DA SIENA. *Madonna and Child.* Uffizi, Florence. [*Alinari–ARB*]

far right: 4. Workshop of GUIDO DA SIENA. *Madonna and Child.* Pinacoteca, Siena. [*Anderson–ARB*]

below right: 5. Workshop of GUIDO DA SIENA. *Madonna and Child and Four Saints,* dossal No. 6. Pinacoteca, Siena. [*Alinari–ARB*]

bottom left: 6. VIGOROSO DA SIENA. *Madonna and Child and Four Saints,* polyptych. Pinacoteca, Perugia. [*Anderson–ARB*]

bottom right: 7. COPPO DI MARCOVALDO. *Madonna and Child.* S. Maria dei Servi, Orvieto. [*Alinari–ARB*]

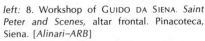

left: 8. Workshop of GUIDO DA SIENA. *Saint Peter and Scenes,* altar frontal. Pinacoteca, Siena. [*Alinari–ARB*]

below left: 9. GUIDO DA SIENA. *Madonna and Child* (detail). Palazzo Pubblico, Siena. [*IFA–Offner Coll.*]

below: 10. GUIDO DA SIENA. *Madonna and Child* (detail). Palazzo Pubblico, Siena. [*IFA–Offner Coll.*]

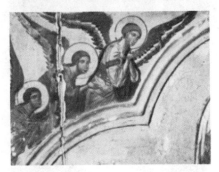

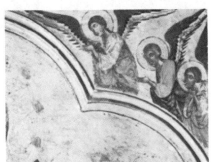

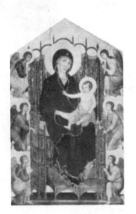

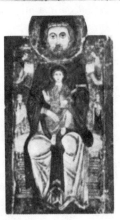

left: 11. GUIDO DA SIENA. *Madonna and Child and Four Saints,* polyptych (detail). Pinacoteca, Siena. [*IFA–Offner Coll.*]

center: 12. DUCCIO. *Madonna and Child.* S. Maria Novella, Florence. [*Soprin., Florence*]

right: 13. *Madonna and Child.* Sienese, early 13th century. Saracini Collection, Siena.

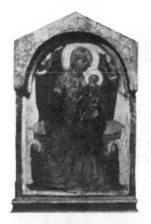
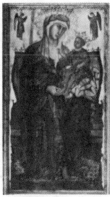

top left: 14. Follower of GUIDO DA SIENA. *Madonna and Child.* Czartoryzski Museum, Cracow

top center: 15. COPPO DI MARCOVALDO. *Madonna and Child.* S. Maria dei Servi, Siena. [*Alinari–ARB*]

top right: 16. School of CIMABUE. *Madonna and Child.* Louvre, Paris. [*Archives*]

above left. 17. GUIDO DA SIENA. *Madonna and Child* (detail). Palazzo Pubblico, Siena. [*IFA–Offner Coll.*]

above right: 18. Altar frontal. Sienese, 1215. Pinacoteca, Siena. [*Anderson–ARB*]

below left: 19. GUIDO DA SIENA. *Madonna and Child* (detail). Palazzo Pubblico, Siena. [*IFA–Offner Coll.*]

below right: 20. GUIDO DA SIENA. *Madonna and Child* (detail). Palazzo Pubblico, Siena. [*IFA–Offner Coll.*]

Geertgen tot Sint Jans' 'The Legend of the Relics of St. John the Baptist'
ALOIS RIEGL

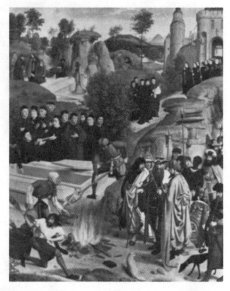

right: 1. GEERTGEN TOT SINT JANS. *The Burning of the Bones of St. John the Baptist.* Exterior of right wing, High Altar of the Johannites. Kunsthistorisches Museum, Vienna.

left: 2. GEERTGEN TOT SINT JANS. *The Burning of the Bones of St. John the Baptist* (detail of group of five Johannites and seven lay brothers).

right: 3. GEERTGEN TOT SINT JANS. *The Burning of the Bones of St. John the Baptist* (detail of five Johannites in procession).

469

Principles of Art History
HEINRICH WÖLFFLIN

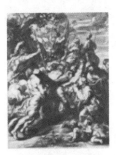

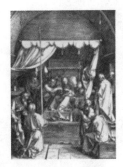

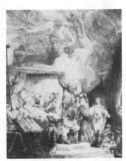

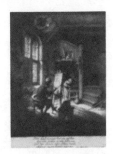

above left: 1. REMBRANDT. *Deposition.* Etching. Rijksmuseum, Amsterdam.

above center: 2. ALBRECHT DÜRER. *The Death of Mary.* 1510. Woodcut. Albertina, Vienna.

above right: 3. REMBRANDT. *The Death of Mary.* Etching. Rijksmuseum, Amsterdam.

far left: 4. PETER PAUL RUBENS. *Bearing of the Cross.* Engraving by P. PONTIUS.

left: 5. ADRIAAN VAN OSTADE. *The Artist in His Studio.* Etching. Rijksmuseum, Amsterdam.

below left: 6. REMBRANDT. *Christ Preaching.* Etching. Rijksmuseum, Amsterdam.

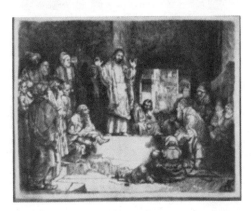

right: 7. DIRK VELLERT. *Saul Coming to the High Priest.* Drawing. 1524. Albertina, Vienna.

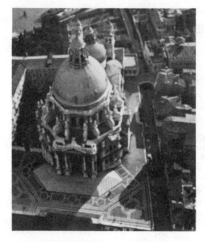

S. Maria della Salute:
Scenographic Architecture and the Venetian Baroque
RUDOLF WITTKOWER

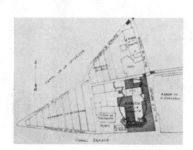

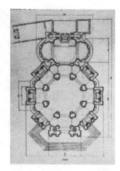

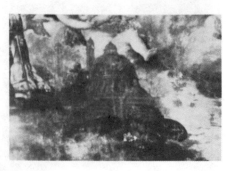

top left: 1. BALDASSARE LONGHENA. S. Maria della Salute, Venice, aerial view. [*Borlui*]

top right: 2. Site of S. Maria della Salute with the church superimposed on the older buildings (after Piva).

above left: 3. Diagrammatic map of the area near S. Maria della Salute.

above center: 4. Plan, S. Maria della Salute. [*Columbia*]

above right: 5. Reconstruction of Longhena's model (drawn by Colin Rowe).

right: 6. BERNARDINO PRUDENTI. *The Cessation of the Plague* (detail). S. Maria della Salute.

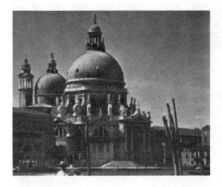

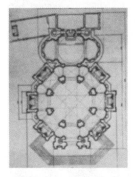

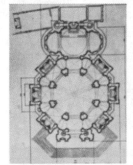

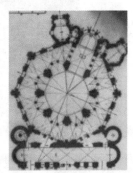

top left: 7. Façade, S. Maria della Salute. [*Kidder Smith*]

top right: 8. Plan, S. Maria della Salute (with explanatory lines drawn by the author). [*Columbia*]

above left: 9. Plan, S. Maria della Salute (with explanatory lines drawn by the author). [*Columbia*]

above center: 10. Plan, S. Maria della Salute (with explanatory lines drawn by the author). [*Columbia*]

above right: 11. Plan, S. Vitale, Ravenna. [*Columbia*]

right: 12. Section, S. Maria della Salute.

below right: 13. Section, S. Maria Canepanova, Pavia. [*Columbia*]

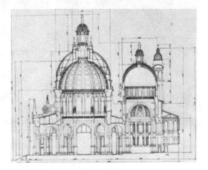

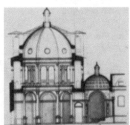

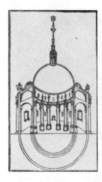
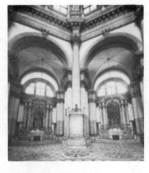
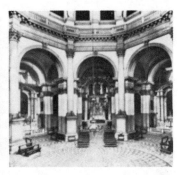

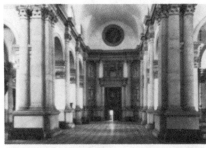

above left: 14. *Temple of Venus* from the "Hypnerotomachia Poliphili." [*Columbia*]

above center: 15. S. Maria della Salute, view from the center of the rotunda. [*Giorgio Cini*]

above right: 16. S. Maria della Salute, view from the main entrance. [*Böhm*]

left: 17. ANDREA PALLADIO. S. Giorgio Maggiore, Venice. [*Böhm*]

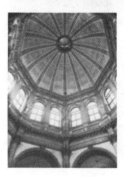
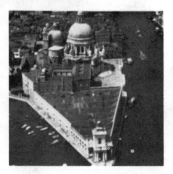
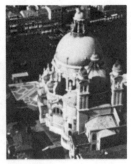

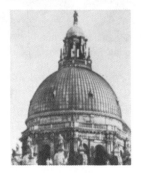

above left: 18. S. Maria della Salute, view into dome. [*Giorgio Cini*]

above center: 19. S. Maria della Salute, aerial view. [*Borlui*]

above right: 20. S. Maria della Salute, aerial view. [*Borlui*]

right: 21. Dome, S. Maria della Salute. [*Alinari–ARB*]

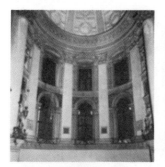

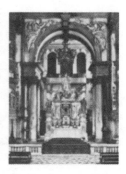

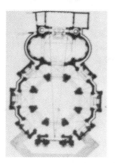

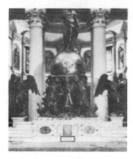

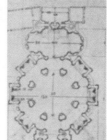

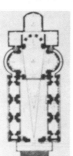

above left: 22. Apse in the presbytery, S. Maria della Salute. [*Giorgio Cini*]

above center: 23. ANDREA PALLADIO. Il Redentore, Venice. [*Giorgio Cini*]

above right: 24. S. Maria della Salute, view toward the high altar. [*Böhm*]

far left: 25. High altar, S. Giorgio Maggiore. [*Böhm*]

left: 26. S. Maria della Salute, with principal measurements inscribed by the author.

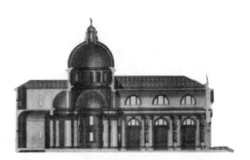

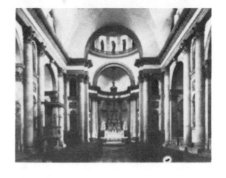

above left: 27. S. Maria della Salute, with visual lines drawn in.

above center: 28. Plan, Il Redentore, with visual lines drawn in.

above right: 29. Section, Il Redentore.

right: 30. Il Redentore, view from the entrance. [*Böhm*]

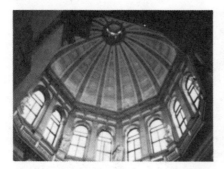

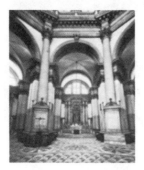
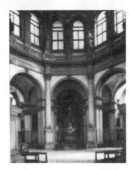
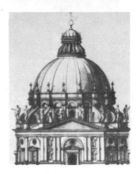

top left: 31. S. Maria della Salute, view into dome. [*Kidder Smith*]

top right: 32. Scrolls, S. Maria della Salute. [*Kidder Smith*]

above left: 33. S. Maria della Salute, view from center of the rotunda. [*Giorgio Cini*]

above center: 34. S. Maria della Salute, view toward the high altar. [*Giorgio Cini*]

above right: 35. Plan and elevation from La-bacco, *Libro di Architettura*, 1558. [*Columbia*]

below left: 36. S. Maria della Salute, elevation from *L'Architettura*, I, 1955. [*Columbia*]

below right: 37. Front of a chapel, S. Maria della Salute. [*Alinari–ARB*]

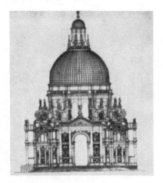
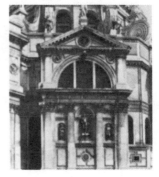

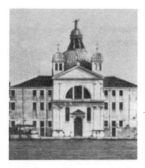 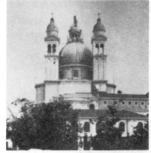 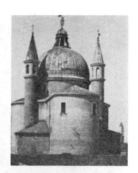

above left: 38. ANDREA PALLADIO. Façade, Chiesa delle Zitelle, Venice. [*Giorgio Cini*]

above center: 39. S. Maria della Salute, rear view. [*Soprin., Venice*]

above right: 40. Il Redentore, rear view. [*Fiorentini, Alinari–ARB*]

right: 41. S. Maria della Salute, aerial view. [*Borlui*]

below left: 42. S. Maria della Salute from the Grand Canal. [*Giorgio Cini*]

below right: 43. Plan and elevation from Labacco, *Libro di Architettura*, 1558. [*Columbia*]

bottom right: 44. ANDREA PALLADIO. "Frons Scenae" of the Teatro Olimpico, Venice.

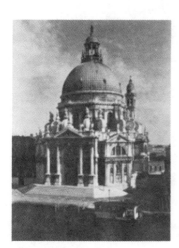

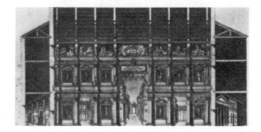

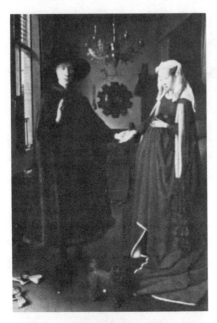

Jan van Eyck's
'Arnolfini' Portrait
ERWIN PANOFSKY

left: 1. JAN VAN EYCK *Giovanni Arnolfini and His Bride.* 1434. Oil on panel, 33 x 22½". National Gallery, London (reproduced by courtesy of the Trustees).

below left: 2. *A Roman Marriage Ceremony,* engraving after a Roman sarcophagus. (From P. S. Bartoli, *Admiranda Roman. Antiquitatum . . . Vestigia,* Rome, 1693. [*Met*]

below: 3. Johann von Holtzhausen (ob. 1393) and His Wife, Gudela (ob. 1371). Sarcophagus. Cathedral, Frankfort-am-Main. [*Marburg–ARB*]

right: 4. *The Marriage of David and Michal,* from a French psalter of c. 1323. Bayerische Staatsbibliothek, Munich.

The Survival of Mythological Representations in Early Christian and Byzantine Art and Their Impact on Christian Iconography
KURT WEITZMANN

top left: 1. Plate from *The Iliad*. Ambrosiana, Milan.

above left: 2. Silver plate. Hermitage, Leningrad.

above right: 3. Etruscan urn. Ostia.

left: 4. Silver oenochoe (detail). Cabinet des Médailles, Paris.

below left: 5. Silver dish with a hunting scene. Dumbarton Oaks Collection.

below right: 6. Mosaic pavement (detail). Antioch.

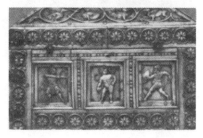

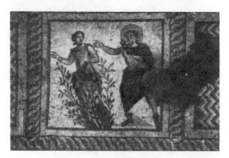

top left: 7. Miniature. Bibliothèque Nationale, Paris.

top right: 8. Floor mosaic, Piazza Armerina. [*Fotocelere, Turin*]

above left: 9. Vase (detail). Treasury, S. Marco, Venice. [*Böhm*]

above center: 10. Lamp. Benachi Collection, Alexandria.

above right: 11. Ivory casket. Byzantine. Dumbarton Oaks Collection. [*Giraudon*]

left: 12. *Apollo and Daphne,* detail of mosaic pavement from Antioch. Art Museum, Princeton University.

below left: 13. *The Birth of Dionysus,* miniature. Patriarchal Library, Jerusalem.

far left: 14. Silver plate with Hippolytus and Phaedra(?). Dumbarton Oaks Collection.

left: 15. Roman sarcophagus (detail). Girgenti.

below left: 16. Mosaic pavement (detail). Antioch.

below right: 17. Floor mosaic. Vatican Museum.

center left: 18. Mosaic (detail). Narthex, S. Marco, Venice. [Bohm]

center right: 19. Bronze plate (detail). Cairo Museum. [Jaffe]

above left: 20. Marble relief (detail). Museo Capitolino, Rome. [Alinari-ARB]

above right: 21. Miniature from the Book of Kings. Vatican Library.

top left: 22. Miniature. Marciana, Venice.

top right: 23. Iliac tablet (detail). Cabinet des Médailles, Paris.

above: 24. Iliac tablet (detail). Museo Capitolino, Rome.

left: 25. Octateuch. Vatican Library.

right: 26. Papyrus (fragment). Bodleian Library, Oxford.

below left: 27. Ivory pyxis. Trier Museum.

below right: 28. Etruscan urn (detail). Museo Archeologico, Florence.

top left: 29. *Moses Receiving the Law,* ivory pyxis. Dumbarton Oaks Collection.

top center: 30. Pyxis. Hermitage, Leningrad.

above: 31. Sarcophagus (fragments). Louvre, Paris[*Marburg—ARB*]

above right: 32. Miniature from a Gospel Book. Staatsbibliothek, Munich.

right: 33. Iliac tablet (detail). Museo Capitolino, Rome.

below left: 34. Ivory. Schlossmuseum, Stuttgart.

below center: 35. Icon. Monastery of St. Catherine, Mt. Sinai. [*U. Michigan*]

below: 36. Ivory pyxis. Swiss National Museum, Zurich.

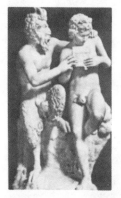

above left: 37. Marble altar. Uffizi, Florence. [*Soprin., Florence*]

above center: 38. Ivory. Staatliche Museen, Berlin.

above right: 39. Fresco. S. Maria Antiqua, Rome.

far left: 40. Marble group. Museo Nazionale, Naples. [*Alinari–ARB*]

left: 41. Mosaic icon. Dumbarton Oaks Collection.

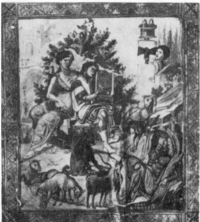

above: 42. *David Composing Psalms,* psalter. Bibliothèque Nationale, Paris.

above right: 43. Fresco (detail). Pompeii.

right: 44. Mosaic pavement (detail). Antioch.

The Dome of Heaven
KARL LEHMANN

left: 1. East dome, S. Marco, Venice. [*Alinari–ARB*]

below left: 2. Ceiling, Tomb of the Monkey, Chiusi.

below center: 3. Center of adytum ceiling, Temple of Bel, Palmyra.

below right: 4. Bracelet from Tarquinia.

above: 5. Vault decoration, Hadrian's Villa, Tivoli. [*IFA–NYU*]

right: 6. Painting of ceiling, Bliznitza Tumulus.

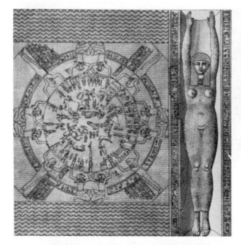

left: 7. Stone ceiling, Dendera. [IFA–NYU]

above: 8. Mosaic floor. Vatican Museum, Rome. [Vatican]

above left: 9. Mosaic floor, Zaghouan.

above center: 10. Vault decoration, Hadrian's Villa, Tivoli. [IFA–NYU]

above right: 11. Mosaic vault decoration, Baptistry, Albenga. [IFA–NYU]

below left: 12. Center of dome in narthex, Church of Koimesis, Nicaea.

below right: 13. Mosaic floor, Antioch. [Arch. Inst., Princeton]

top left: 14. Mosaic floor, Münster, near Bingen.

top right: 15. Mosaic floor, Synagogue, Beth Alpha. [*IFA–NYU*]

above left: 16. Mosaic floor, Gaul.

above center: 17 Decoration of dome, S. Prisco, Capua.

above right: 18. Mosaic floor, Hippone. [*Min. Ed., Algiers*]

right: 19. Vault of inner narthex, Kahrie Djami, Istanbul. [*Powell*]

left: 20. Mosaic floor, Trier. [*IFA–NYU*]

above: 21. Corner of a painted tomb-ceiling, Alexandria. [*IFA–NYU*]

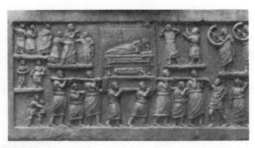

above left: 22. Early Christian mosaic floor, Die.

above right: 23. Funeral relief, Aquila Museum. [*Alinari–ARB*]

left: 24. Painted decoration of dome, El Bagaouat.

above left: 25. Painted ceiling, Pompeii. [*IFA–NYU*]

above center: 26. *Meleager and Dioscures*, Etruscan mirror.

above right: 27. Stuccoed dome, Domus Aurea, Rome.

right: 28. Stuccoed vault, Domus Aurea, Rome. [*IFA–NYU*]

left: 29. Ceiling decoration, Hadrian's Villa, Tivoli. [*IFA–NYU*]

above center: 30. Dome, S. Giovanni in Fonte, Naples.

above right: 31. Decoration of dome, S. Costanza, Rome.

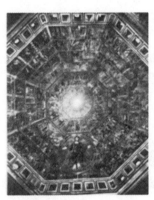

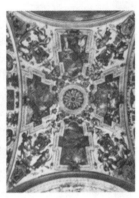

above left: 32. Cupola, Baptistry, Florence. [*Alinari–ARB*]

above center: 33. Vault of Sala Ducale, Vatican, Rome. [*Vatican*]

above right: 34. Vault, Lateran Palace, Rome. [*Alinari–ARB*]

below left: 35. Stucco decoration of Caldarium apse, Forum Baths, Pompeii.

below right: 36. Mosaic decoration of a fountain, Herculaneum. [*Alinari–ARB*]

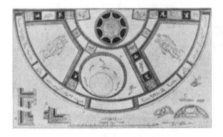

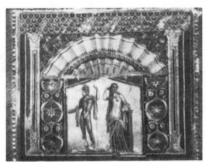

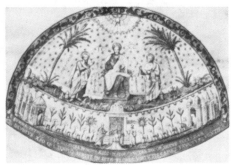

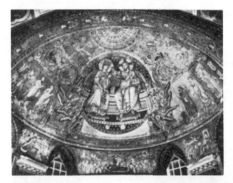

above left: 37. Painted decoration of an apse, Domus Aurea, Rome.

above right: 38. Apse mosaic, St. Peter's, Rome.

left: 39. Apse mosaic, S. Maria Maggiore, Rome. [*Alinari–ARB*]

above left: 40. *Sirens Supporting the Symbols of the Evangelists.* Staatsbibliothek, Munich.

above center: 41. Vault of the Scarsella, Baptistry, Florence. [*Alinari–ARB*]

above right: 42. Painted vault, Rome (after an old drawing).

right: 43. Mosaic floor, Terme dei Magazzini Republicani, Ostia. [*Anderson–ARB*]

above: 44. Vault of a chapel, Archbishop's Palace, Ravenna. [*Alinari–ARB*]

top right: 45. Vault of presbyterium, S. Vitale, Ravenna. [*Alinari–ARB*]

above right: 46. Vault of chapel, S. Giovanni in Laterano, Rome.

right: 47. Mosaic floor, Quirinal, Rome.

below left: 48. Central pillar, Tomba del Tifone, Tarquinia. [*IFA–NYU*]

below center: 49. Mosaic floor, Algeria. [*IFA–NYU*]

below right: 50. Ceiling, Catacomb of Lucina, Rome.

above left: 51. Section of vault, Windischma-
trei Church.

above right: 52. Vault, Church of St. John,
Pürgg.

left: 53. Vault, S. Pietro, Civate.

below left: 54. Painted ceiling, Pompeii.

below: 55. Spandrel, Arch of Septimius Sev-
erus, Leptis Magna.

bottom right: 56. Dome of tomb, El Bagaouat.

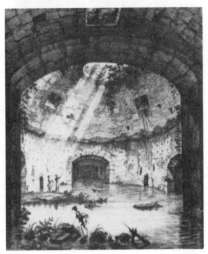

top left: 57. *Theodosius and St. Gregory.* Bibliothèque Nationale, Paris.

top right: 58. Section of wall decoration, House of Caecilius Jucundus, Pompeii [*IFA–NYU*]

above left: 59. Frigidarium, section, Stabian Baths, Pompeii.

above right: 60. "Temple of Mercury," Baiae.

below left: 61. Restored section, Pantheon, Rome.

below: 62. Vault decoration, Palatine, Rome.

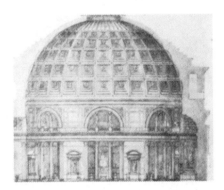

above: 63. Decoration of a dome, described by John of Gaza.

top right: 64. *Throne of Chosroes,* Flemish tapestry, Saragossa. [*MAS*]

above left: 65. Dome of bath, Quseir Amra.

above center: 66. *Observatory,* Fol. 13. Dresden.

above right: 67. Detail of wall decoration, Pompeii.

below left: 68. Pentecost cupola, S. Marco, Venice. [*Alinari–ARB*]

below right: 69. *Pentecost,* Bibliotheque Nationale, Paris.

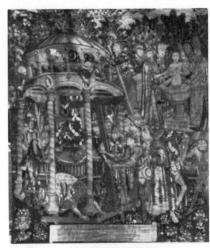

Light, Form and Texture in Fifteenth-century Painting
E. H. GOMBRICH

left: 1. Light on absorbent and reflecting surfaces (after E. J. Sullivan).

above left: 2. LEONARDO DA VINCI. Diagram of light and luster.

above right: 3. JAN VAN EYCK. *Madonna with the Canon van der Paele.* Museum, Bruges.

left: 4. DOMENICO VENEZIANO. *The Virgin and Child with Saints.* Uffizi, Florence. [Alinari–ARB]

below left: 5. DUCCIO. *The Healing of the Blind.* National Gallery, London.

below center: 6. Portrait, Graeco-Egyptian. A.D. 2nd century. British Museum, London.

below right: 7. Byzantine Master. *Enthroned Madonna and Child.* National Gallery of Art, Washington, D.C. (Andrew Mellon Collection).

above left: 8. Tuscan Master. *Head of St. Michael.* Vico l'Abate.

above right: 9. GIOTTO. *Head of the Virgin,* from the *Last Judgment.* Arena Chapel, Padua. [*Alinari–ARB*]

left: 10. CIMABUE(?). Angel. S. Francesco, Assisi.

below left: 11. GIOTTO. *Madonna Ognisanti.* Uffizi, Florence. [*Alinari–ARB*]

below right: 12. DUCCIO. *Madonna Rucellai.* S. Maria Novella, Florence. [*Alinari–ARB*]

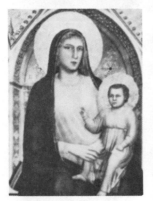

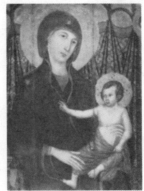

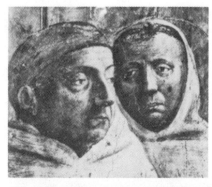

left: 13. MASACCIO. *Heads of Bystanders,* from *The Chairing of St. Peter.* S. Maria del Carmine, Florence.

below: 14. FRA ANGELICO. *Scenes from the Life of St. Nicolaus.* Vatican, Rome.

bottom left: 15. Netherlands Master. *The Coronation of the Virgin.* Musée Royal, Brussels. [ACL]

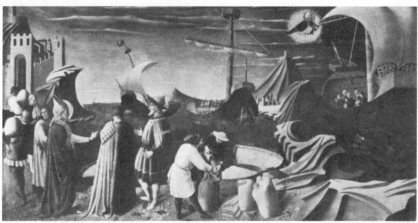

below center: 16. HUGO VAN DER GOES. *Head of the Virgin,* from the *Portinari Altar.* Uffizi, Florence.

below right: 17. LEONARDO DA VINCI. *Head of the Virgin,* from *The Virgin of the Rocks.* Louvre, Paris. [*Alinari–ARB*]

A Psychotic Artist of the Middle Ages
ERNST KRIS

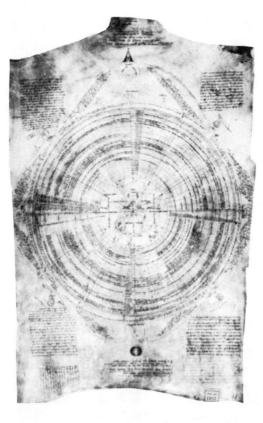

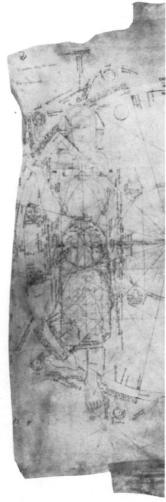

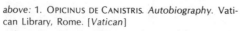

above: 1. OPICINUS DE CANISTRIS. *Autobiography*. Vatican Library, Rome. [*Vatican*]
right: 2. OPICINUS DE CANISTRIS. *Christ and the Universe.* Vatican Library, Rome. [*Vatican*]

Art and Freedom
in Quattrocento Florence
FREDERICK HARTT

right: 1. MASACCIO. *Trinity with the Virgin and St. John and Donors.* S. Maria Novella, Florence. [*Soprin., Florence*]

below left: 2. DONATELLO. *St. Mark.* Orsanmichele, Florence. [*Soprin., Florence*]

below center: 3. LORENZO GHIBERTI. *St. Matthew.* Orsanmichele, Florence. [*Soprin., Florence*]

below right: 4. DONATELLO. *St. Mark,* detail. [*Soprin., Florence*]

bottom left: 5. NANNI DI BANCO. *The Four Crowned Martyrs.* Orsanmichele, Florence. [*Alinari–ARB*]

bottom right: 6. LORENZO GHIBERTI. *The Sacrifice of Isaac,* competition relief. Bargello, Florence. [*Alinari–ARB*]

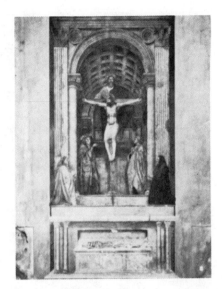

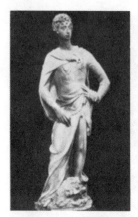
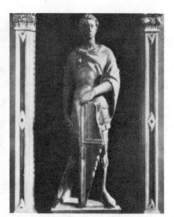

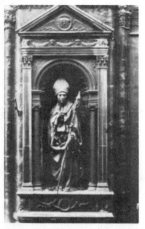

top left: 7. DONATELLO. *David.* Marble. Bargello, Florence. [*Alinari–ARB*]

top right: 8. DONATELLO. *St. George.* Orsanmichele, Florence.

above: 9. DONATELLO. *St. George and the Dragon,* relief. Orsanmichele, Florence. [*Alinari–ARB*]

right: 10. DONATELLO. *St. Louis of Toulouse,* temporarily replaced in original niche by Donatello and Michelozzo at Orsanmichele. [*Soprin., Florence*]

below: 11. MASACCIO. *The Tribute Money.* Brancacci Chapel, Florence. [*Alinari–ARB*]

below right: 12. MASACCIO. *The Death of Ananias.* Brancacci Chapel, Florence. [*Soprin., Florence*]

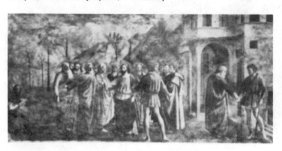
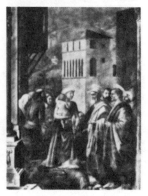

Religious Expression
in American Architecture
DONALD DREW EGBERT

left: 1. St. Luke's Church, near Smithfield, Va. 1632. [*Lib. Cong.*]

below left: 2. Interior, chancel, St. Luke's Church. [*Sandak*]

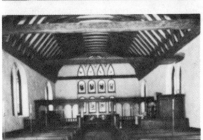

above right: 3. Augustus Lutheran Church, Trappe, Pa. 1743. [*Philadelphia*]

right: 4. Exterior, sanctuary, Augustus Lutheran Church. [*Philadelphia*]

below: 5. Interior, Augustus Lutheran Church. [*Philadelphia*]

below right: 6. Old Ship Meeting House, Hingham, Mass. 1681; enlarged 1730 and 1755. [*Chiodi*]

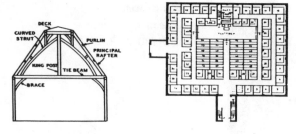

above: 7. Section and plan, Old Ship Meeting House.

left: 8. Congregational Chapel, Horningsham, Wiltshire, England. 1566. [*Briggs*]

below left: 9. Congregational Chapel, Walpole, Suffolk, England. 1647. [*Briggs*]

below right: 10. Interior, Congregational Chapel, Walpole. [*Briggs*]

left: 11. Dutch Reformed Church, Albany, N.Y. 1715. [*Albany Inst.*]

above: 12. Dutch Reformed Meeting House, Bergen, N.J. 1680. [*Wertenbaker*]

above left: 13. Dutch Reformed Church, Willemstad, Holland. 1586. [*Neth. Info.*]

above center: 14. Interior, Dutch Reformed Church, Willemstad. [*Neth. Info.*]

above right:. 15. Town Hall, Abingdon, Berkshire, England. 1677. [*Radio Times Hulton*]

left: 16. Quaker Meeting House, Jordans, Buckinghamshire, England. 1688. [*Winstone*]

below left: 17. Quaker Meeting House, Stony Brook, N.J. 1760. [*Menzies*]

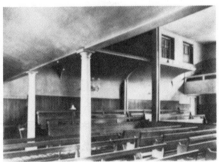

above right: 18. Interior, Quaker Meeting House, Philadelphia. 1812. [*Historical Soc. of Pa.*]

right: 19. Elder Ballou Meeting House, Cumberland, R.I. 1740. [*Lib. Cong.*]

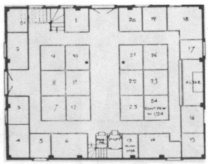

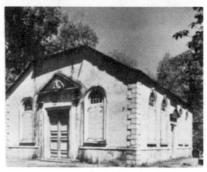

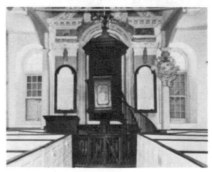

top left: 20. St. Paul's Church, Wickford, R.I. 1707. [*Andrews*]

top right: 21. Plan, St. Paul's Church. [*R.I.S.D.*]

above left: 22. St. James' Church, Goose Creek, S.C. 1711. [*Andrews*]

above right: 23. Interior, St. James' Church. [*Andrews*]

below left: 24. Plan, St. James' Church. [*Stoney*]

below center: 25. St. Martin-in-the-Fields, London. 1721–26. [*Kersting*]

below right: 26. Plan, St. Martin-in-the-Fields. [*Nat. Monuments Record*]

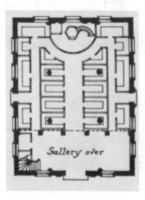

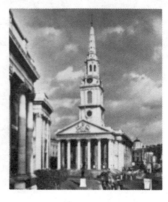

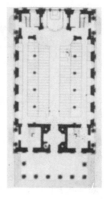

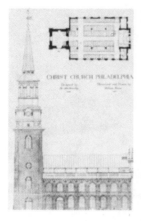

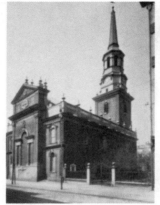

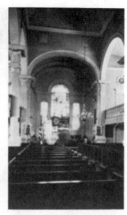

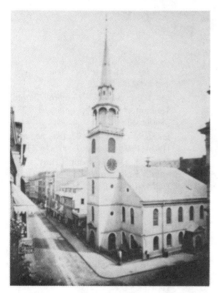

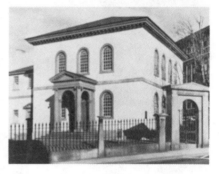

above: 31. Touro Synagogue, Newport, R.I. 1763. [*Friends of Touro*]

below: 32. Plan, Touro Synagogue. [*Wischnitzer*]

top left: 27. Side elevation and plan, Christ Church, Philadelphia. 1727–1754. [*Ware*]

top center: 28. Exterior, Christ Church. [*Essex Inst.*]

top right: 29. Chancel, Christ Church. [*Essex Inst.*]

above left: 30. Old South Meeting House, Boston. 1730. [*S.P.N.E.A.*]

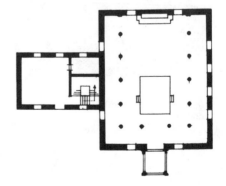

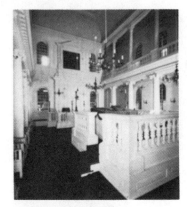

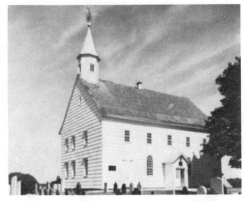

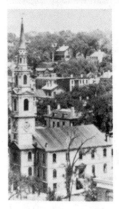

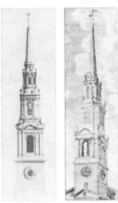

top left: 33. Interior, Touro Synagogue. [*Lib. Cong.*]

top right: 34. Old Tennent Church, Tennent, N.J. 1731; enlarged 1751. [*Andrews*]

far left: 35. First Baptist Meeting House, Providence, R.I. 1775. [*R.I.H.S.*]

left: 36. Design from Gibbs *(left);* spire, First Baptist Meeting House *(right).* [*S.P.N.E.A.*]

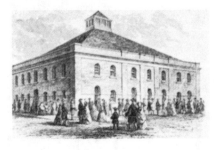

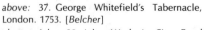

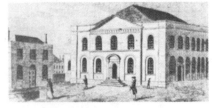

above: 37. George Whitefield's Tabernacle, London. 1753. [*Belcher*]

above right: 38. John Wesley's City Road Chapel, London. 1778. [*Townsend*]

right: 39. Methodist Chapel, Mawgan-in-Meneage, Cornwall, England. c. 1830. [*Arch. Rev.*]

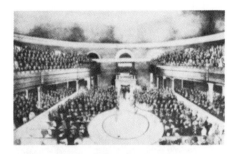

top left: 40. Sansom Street Baptist Church, Philadelphia. 1808–09. [*Gallagher*]

top right: 41. Octagon Unitarian Church, Philadelphia. 1813. [*Gallagher*]

above left: 42. First Presbyterian Church, Princeton, N.J. (before addition). 1836–37. [*Menzies*]

above right: 43. Cathedral of the Assumption, Baltimore (alternate design in Gothic Revival style). [*Smithsonian*]

above left: 44. Cathedral of the Assumption, Baltimore. 1806. [*Andrews*]

left: 45. Cathedral of the Assumption, section as originally designed. [*Howland and Spencer*]

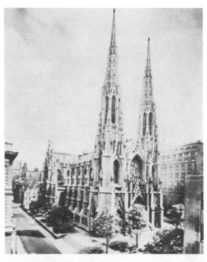

above: 46. Chapel of St. Mary's Seminary, Baltimore. 1806. [*Maryland H.S.*]

right: 47. St. Patrick's Cathedral, New York. 1850–79. [*Archbishopric of N.Y.*]

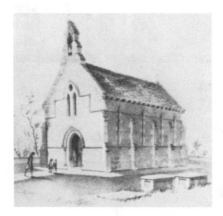

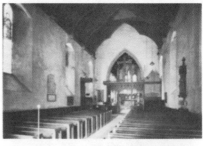

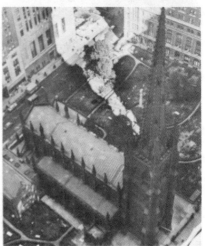

above left: 48. Anglican Church, Littlemore, England. 1835–36. [*R.C.H.M.*]

above right: 49. Interior, Anglican Church, Littlemore. [*R.C.H.M.*]

right: 50. Trinity Church, New York. 1839–46. [*Heffernan*]

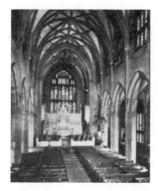 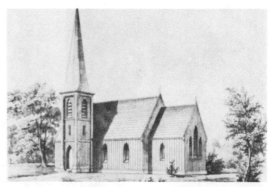

 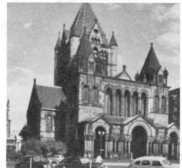

top left: 51. Interior, Trinity Church, New York.

top right: 52. Country Church Design, from *Upjohn's Rural Architecture* (1852). [*Upjohn*]

above left: 53. Trinity Church, Warsaw, N.Y. 1854. [*Bishop*]

above center: 54. Trinity Church, Boston. 1873–77. [*Andrews*]

above right: 55. East Liberty Presbyterian Church, Pittsburgh, Pa. c. 1935. [*Hoyle, Doran, and Berry*]

right: 56. Interior, East Liberty Presbyterian Church. [*Hoyle, Doran, and Berry*]

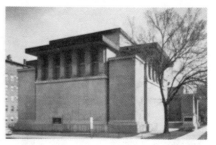

above: 57. Congregational Church, Lyme, Conn. 1815–17. [*Sandak*]

top right: 58. First Presbyterian Church, North Hollywood, Calif., unexecuted plan. c. 1940. [*Nat. Council Churches*]

above right: 59. Unity Temple, Oak Park, Ill. 1905–06. [*Hedrich-Blessing*]

right: 60. Plan, Unity Temple. [*Hitchcock*]

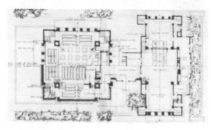

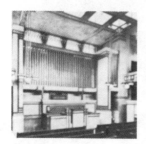

above center: 62. First Unitarian Meeting House, Madison, Wis. 1951. [*Andrews*]

above left: 61. Interior, Unity Temple. [*Chi. Arch. Photo.*]

above right: 63. Interior, First Unitarian Meeting House. [*Andrews*]

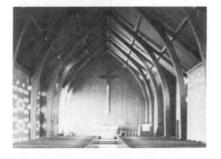

top left: 64. Wayfarer's Chapel, Palos Verdes, Calif. 1951. [*Andrews*]

top right: 65. Tabernacle Church of Christ, Columbus, Ind. 1940. [*Hedrich-Blessing*]

above left: 66. Interior, Tabernacle Church of Christ. [*Hedrich-Blessing*]

above right: 67. Zion Lutheran Church, Portland, Ore. 1950. [*Belluschi*]

right: 68. Interior, Zion Lutheran Church. [*Belluschi*]

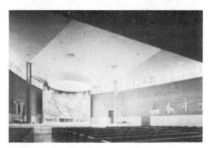

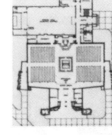

above: 69. Church of the Resurrection, St. Louis, Mo. 1954. [*Murphy*]

above: 70. Plan, St. Clement's, Alexandria, Va. 1949. [*Arch. Record*]

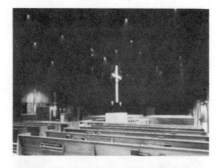

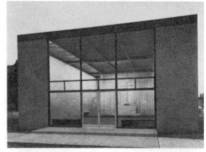

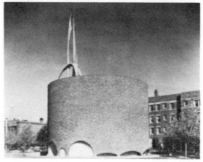

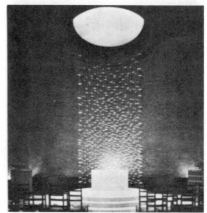

top left: 71. Interior, St. Clement's. [*Gottscho-Schleisner*]

top right: 72. Chapel of St. Saviour, Illinois Institute of Technology, Chicago. 1952. [*Hedrich-Blessing*]

above left: 73. Chapel, Massachusetts Institute of Technology, Cambridge, Mass. 1955. [*Andrews*]

above right: 74. Interior, Chapel, Massachusetts Institute of Technology. [*Stoller*]

below: 75. Brandeis University Chapels, Waltham, Mass. 1954–56. [*Brandeis*]

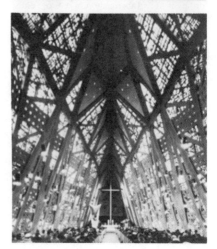

above: 76. First Presbyterian Church, Stamford, Conn. 1958. [*Stoller*]

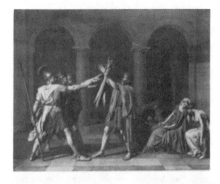

Reflections on
Classicism and Romanticism
FREDERICK ANTAL

left: 1. Jacques Louis David. *The Oath of the Horatii.* [*Archives*]

below left: 2. David. Study for a figure in *The Oath of the Horatii.* Bayonne Museum.

below center: 3. David. Drawing of Lepelletier de Saint Fargeau. [*Bib. Nat.*]

above right: 4. François André Vincent. *Molé and the Partisans of the Fronde.* [*Archives*]

above: 5. Ménageot. *Death of Leonardo da Vinci.* Collection Mairet, Paris.

right: 6. *Portrait of Barère* (formerly attributed to David).

512

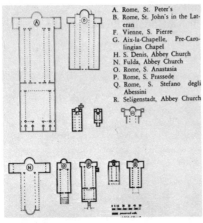

A. Rome, St. Peter's
B. Rome, St. John's in the Lat-
 eran
F. Vienne, S. Pierre
G. Aix-la-Chapelle, Pre-Caro-
 lingian Chapel
H. S. Denis, Abbey Church
N. Fulda, Abbey Church
O. Rome, S. Anastasia
P. Rome, S. Prassede
Q. Rome, S. Stefano degli
 Abessini
R. Seligenstadt, Abbey Church

The Carolingian Revival
of Early Christian Architecture
RICHARD KRAUTHEIMER

left and below left: 1–2. Comparative chart of plans. The sketches are not exact in details but are drawn to the same scale (Hoffmann).

below: 3. Exterior, S. Sebastiano, Rome, model of reconstruction by Pacini.

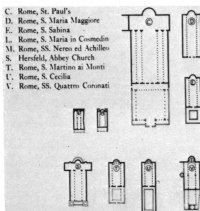

C. Rome, St. Paul's
D. Rome, S. Maria Maggiore
E. Rome, S. Sabina
L. Rome, S. Maria in Cosmedin
M. Rome, SS. Nereo ed Achilleo
S. Hersfeld, Abbey Church
T. Rome, S. Martino ai Monti
U. Rome, S. Cecilia
V. Rome, SS. Quattro Coronati

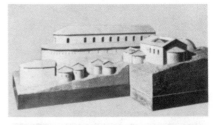

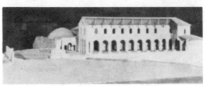

below: 5. Constantinian basilica of St. Peter, Rome, reconstruction by Frazer..

above: 4. Interior, S. Sebastiano, Rome, model of reconstruction by Pacini.

below: 6. St. Peter's, Rome, Constantinian transept, drawing by Heemskerck.

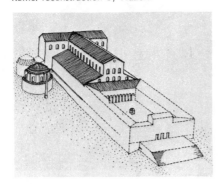

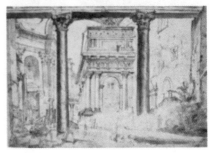

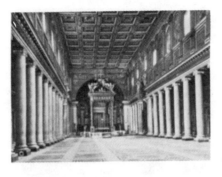

top left: 7. Interior nave, S. Maria Maggiore, Rome. [*Anderson–ARB*]

top right: 8. S. Maria Maggiore, Rome, 5th-century church, reconstruction by Corbett.

above left: 9. Constantinian basilica of St. Peter, Rome, 16th-century plan by Alpharanus. [*Vatican*]

above right: 10. St. Paul's Outside the Walls, Rome, plan before 1823. Palazzo Venezia, Rome.

left: 11. St. Paul's Outside the Walls, Rome, air view. [*Fotocielo*]

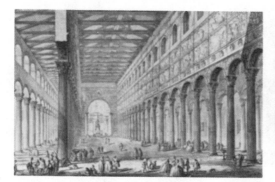

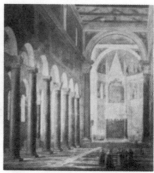

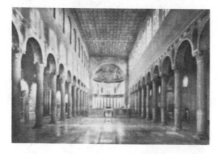

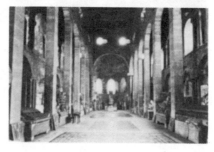

top left: 12. Interior, St. Paul's Outside the Walls, Rome. 18th century engraving by PIRANESI. [*Met.*]

top right: 13. S. Giovanni in Laterano, Rome, interior before 17th-century remodeling. Fresco in S. Martino ai Monti.

above left: 14. Interior, S. Sabina, Rome. [*Alinari–ARB*]

above right: 15. Interior, St. Pierre, Vienne.

above left: 16. Exterior from east, Abbey Church, Fulda. 15th-century woodcut by SEBASTIAN MÜNSTER.

left: 17. Exterior from south, Abbey Church, Fulda. Painting from Bishop's Palace, Fulda, 1648–1704.

top left: 18. Exterior, Sant' Anastasia, Rome, drawing by Heemskerck. Kupferstichkabinett, Berlin. [*Steinkopf*]

top right: 19. Interior, S. Stefano degli Abessini, Rome. [*Felici*]

above left: 20. S. Prassede, Rome, isometric reconstruction by Corbett.

above right: 21. Interior, S. Prassede, Rome. [*Anderson–ARB*]

below: 22. Plan, S. Cecilia, Rome.

right: 23. Interior, S. Marco, Rome. [*Gabinetto*]

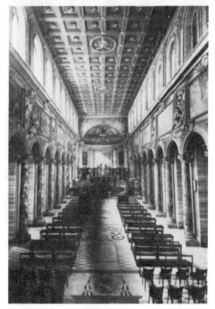

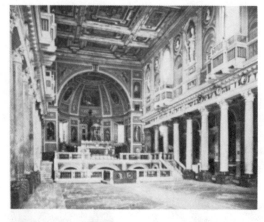

left: 24. Interior, S. Martino ai Monti, Rome. [*Gabinetto*]

below left: 25. Entrance tower, SS. Quattro Coronati, Rome. [*Fot. Unione*]

below center: 26. Interior, Abbey Church, Hersfeld. [*Marburg–ARB*]

below right: 27. Exterior, Torhalle, Lorsch. [*Marburg–ARB*]

below: 28. Capital, Torhalle, Lorsch. [*Marburg–ARB*]

right: 29. Triclinium of Leo III, Lateran, Rome, engraving by ALEMANNI. [*Vatican*]

Renaissance and Renascences
ERWIN PANOFSKY

left: 1. Pantheon, Rome. [*Alinari–ARB*]

below left: 2. Choir, Amiens Cathedral. [*Roger-Viollet*]

below: 3. ANDREA PALLADIO. Villa Capra ("Villa Rotonda") near Vicenza. [*Alinari–ARB*]

bottom left: 4. The Carolingian "Torhalle," Lorsch. [*Marburg–ARB*]

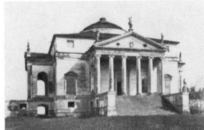

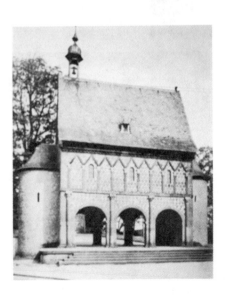

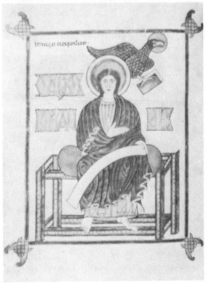

right: 6. *St. Luke,* from the *Gundohinus Gospels.* 751–54. Bibliothéque Muncipale, Autun. [*Varlez*]

far right: 7. *St. Matthew,* from the *"Schatzkammer" Gospels.* Early 9th century. Kunsthistorisches Museum, Vienna.

far left: 8. Details from the *Utrecht Psalter.* 816–35. University Library, Utrecht.

left: 9. Abbey Church, St.-Gilles, detail of entablature. Mid-12th century.

above: 10. Gallo-Roman entablature. Musée d'Acquitane, Bordeaux.

right: 11. *St. Peter* (detail). Reims Cathedral. c. 1220–25.

above left: 12. *Antoninus Pius.* Museo Nazionale, Rome. [*Anderson–ARB*]

above center: 13. NICOLA PISANO. *Presentation of Christ* (detail). c. 1260. Baptistry, Pisa. [*Alinari–ARB*]

above right: 14. *Dionysus,* detail from a Classical marble vase. Camposanto, Pisa. [*Alinari–ARB*]

left: 15. *Seven Resurrected,* detail from *Last Judgment.* 1220–25. Reims Cathedral. [*Giraudon*]

below left: 16. *Visitation* and *Annunciation.* Angel Gabriel, c. 1240–45; other figures, c. 1227–30. Reims Cathedral. [*Giraudon*]

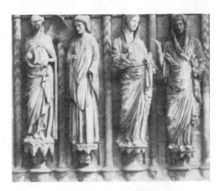

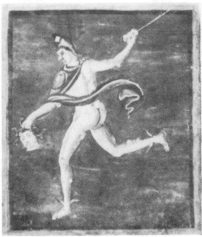

right: 17. *Perseus,* from a Carolingian manuscript. University Library, Leyden.

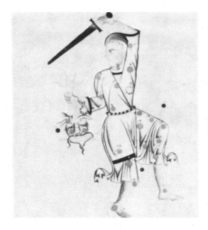

top left: 18. *Perseus,* from a south Italian manuscript. Mid-13th century. Bibliothèque de l'Arsenal, Paris.

top right: 19. TITIAN. *Perseus Delivering Andromeda.* Wallace Collection, London.

above left: 20. *Pyramus and Thisbe,* from a French manuscript. 1289. Bibliothèque Nationale, Paris.

above right: 21. *Saturn, Jupiter, Venus, Mars,* and *Mercury,* from an Italian manuscript. Mid-14th century. Staatsbibliothek, Munich.

right: 22. *Apostles Standing on the Shoulders of Prophets, Synagogue,* and *Jew Blinded by the Devil.* c. 1240. Bamberg Cathedral. [*Marburg–ARB*]

Ad Imaginem Dei:
The Image of Man in Mediaeval Art
GERHART B. LADNER

left: 1. "Plotinus" Sarcophagus. Lateran Museum, Rome. [*Germ. Arch. Inst.*]

right: 2. Philosopher sarcophagus. Museo Torlonia, Rome. [*Germ. Arch. Inst.*]
below: 3. Christian sarcophagus. S. Maria Antiqua, Rome. [*Germ. Arch. Inst.*]

below: 4. Philosopher sarcophagus of M. Sempronius Nicocrates. British Museum, London.

below: 5. Christian sarcophagus. Velletri Museum. [*Germ. Arch. Inst.*]

below: 6. Liberalitas Relief, Arch of Constantine, Rome. [*Soprin. Mon.*]

522 Gerhart B. Ladner

left: 7. Cornutus group (detail). Vatican Museum, Rome. [*Germ. Arch. Inst.*]

above: 8. Christian sarcophagus. Palazzo dei Conservatori, Rome. [*Pontif. Commis.*]

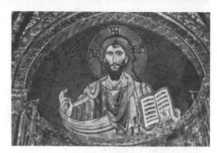

center left: 9. *Sermon on the Mount,* polychrome relief fragments. Museo Nazionale delle Terme, Rome. [*Germ. Arch. Inst.*]

center right: 10. "Dogmatic" sarcophagus. Lateran Museum, Rome. [*Anderson–ARB*]

above left: 11. Octateuch, *Creation of Adam.* Library of the Seraglio, Istanbul.

above right: 12. Pantocrator. Cefalù Cathedral. [*Anderson–ARB*]

right: 13. GREGORY NAZIANZEN. *Vision of Ezekiel.* Bibliothèque Nationale, Paris.

top left: 14. *St. Ambrose.* Chapel of St. Victor, S. Ambrogio, Milan. [*Fot. Unione*]

top center: 15. *St. Demetrius and Donors.* St. Demetrius, Salonika. [*Hirmer*]

top right: 16. *Pelagius II.* S. Lorenzo Outside the Walls, Rome. [*Anderson–ARB*]

above left: 17. *Gregory the Great,* from the *Boethius Diptych.* Museo Civico, Brescia.

above center: 18. *John VII.* Grotte Vaticane, Vatican City. [*Vatican*]

above right: 19. *Paschal I.* S. Cecilia in Trastevere, Rome. [*Alinari–ARB*]

right: 20. Symbol of St. Matthew, from the *Book of Durrow.* Trinity College, Dublin. [*Green*]

top left: 21. *St. Matthew,* Cŏd. 51. Library, St. Gall. [*Zumbühl*]

top center: 22. *St. John,* from the *Lindisfarne Gospels.* British Museum, London.

top right: 23. *Ezra,* Codex Amiatinus. Biblioteca Laurenziana, Florence. [*Sansoni*]

above left: 24. *St. Matthew,* from the *Lindisfarne Gospels.* British Museum, London.

above center: 25. Relief of Christ and Peter. Archaeological Museum, Istanbul.

above right: 26. *Creation of Adam* and *Presentation of Eve,* from the *Grandval Bible.* British Museum, London.

right: 27. *St. Matthew,* from the *"Schatzkammer"* *Gospels.* Kunsthistorisches Museum, Vienna.

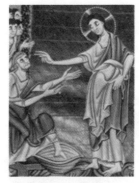
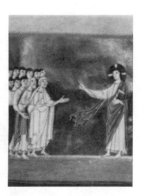

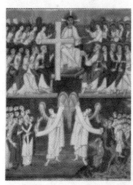

above left: 28. *St. Matthew,* from the *Ebo Gospels.* Municipal Library, Epernay.

above center: 29. *Footwashing of the Apostles,* from the *Gospel Book of Otto III.* Bayerische Staatsbibliothek, Munich.

above right: 30. *Christ's Annunciation of Pentecost,* from the *Book of Pericopes of Henry II.* Bayerische Staatsbibliothek, Munich.

far left: 31. *Last Judgment,* from *Book of Pericopes of Henry II.* Bayerische Staatsbibliothek, Munich.

above center: 32. *Thiofrid,* from Thiofrid of Echternach, *Liber Florum.* Herzogliche Bibliothek, Gotha.

left: 33. *St. Benedict and St. Michael,* Basel Antependium. Musée Cluny, Paris. [*Giraudon*]

below: 34. *Empress Kunigunde,* Basel Antependium. Musée Cluny, Paris. [*Giraudon*]

above left: 35. *Gregory the Great, Moralia, Job and His Wife,* Cod. Bibl. 41. Staatsbibliothek, Bamberg.

above center: 36. *Durandus.* St. Pierre, Moissac. [*Archives*]

above right: 37. *Maiestas Domini,* Ms. Lat. 9438. Bibliothèque Nationale, Paris.

above: 38. COSTANTINO CAETANI. *Popes of the Investiture Struggle.* 1638. Lateran Palace, Rome. [*Vatican*]

right: 39. *Christ.* Plaimpied Church. [*Ronbier*]

top left: 40. *Maiestas Domini,* tympanum of main door, St. Pierre, Moissac. [*French Emb.*]

top right: 41. *Frederick Barbarossa.* Parish Church, Cappenberg.

above left: 42. *Ancestors of Christ,* Porte Royale, Chartres Cathedral. [*Houvet*]

above center: 43. *Holy Queen,* Porte Royale, Chartres Cathedral. [*Houvet*]

above right: 44. *Sainte Modeste,* North Door, Chartres Cathedral. [*Houvet*]

right: 45. *Gregory the Great,* South Door, Chartres Cathedral. [*Giraudon*]

far right: 46. *Maiestas Domini.* St. Sernin, Toulouse.

top left: 47. *Maiestas Domini,* Porte Royale, Chartres Cathedral. [*Houvet*]

top right: 48. *Christ as Judge,* facade, center door, Notre Dame, Paris. [*Alinari–Giraudon*]

above left: 49. *Creation of Eve.* Novgorod Cathedral. [*Novosti*]

above center: 50. *Creation of Adam,* North Portal, Chartres Cathedral. [*Giraudon*]

above right: 51. *Job,* St. André-le-Bas, Vienne. [*Archives*]

far left: 52. *Demonic Animals,* pillar from West Portal, Abbey Church, Souillac. [*Giraudon*]

left: 53. *Struggle between Virtues and Vices,* capital, Notre Dame du Port, Clermont-Ferrand. [*Giraudon*]